IMAGING ARISTOTLE

IMAGING ARISTOTLE

Verbal and Visual Representation in Fourteenth-Century France

CLAIRE RICHTER SHERMAN

UNIVERSITY OF CALIFORNIA PRESS

BERKELEY LOS ANGELES LONDON

The Publisher gratefully acknowledges the contribution of the Samuel H. Kress Foundation, which made possible the color plates for this book.

The Publisher also acknowledges with gratitude the contribution by the Art Book Endowment Fund of the Associates of the University of California Press, which is supported by a major gift from the Ahmanson Foundation.

University of California Press, Berkeley and Los Angeles, California

University of California Press, Ltd., London, England

Library of Congress Cataloging-in-Publication Data

Sherman, Claire Richter.
 Imaging Artistotle: verbal and visual representation in fourteenth-century France / Claire Richter Sherman.
 p. cm.
 Includes bibliographical references and index.
 ISBN 0-520-08333-4
 1. French language—To 1500—Style. 2. Oresme,
 Nicole, ca. 1320–1382—Contributions in translating.
 3. Illumination of books and manuscripts, Medieval—France.
 4. Illumination of books and manuscripts, French. 5. Translating
 and interpreting—France—History. 6. Art and literature—France—
 History. 7. France—Civilization—1328–1600. 8. Aristotle—
 Appreciation—France. 9. Aristotle—Politics. I. Title.
 PC2875.S53 1995
 448′.0271—dc20 94-7127

Printed in the United States of America
9 8 7 6 5 4 3 2 1

The paper used in this publication meets the minimum requirements of
American National Standard for Information Sciences—Permanence of Paper for Printed Library Materials, ANSI Z39.48-1984.

To My Husband and Son

CONTENTS

ILLUSTRATIONS

FIGURES

ACKNOWLEDGMENTS

I should like to thank the following libraries and curators: Léon Gilissen (retired) and Pierre Cockshaw, Bibliothèque Royale Albert Ier, Brussels; R. E. O. Ekkart, formerly of the Rijksmuseum Meermanno-Westreenianum, The Hague; and François Avril, Bibliothèque Nationale, Paris. I am grateful to the owner of Charles V's first copy of Oresme's translations of the *Politics* and *Economics* for allowing me to examine the manuscript and for making photographs and slides available to me.

During my visits to France, I remember particularly the hospitality extended by the late Raymond Cazelles at the Musée Condé, Chantilly. The staff at the Institut d'Histoire et de Recherche des Textes in Paris was most helpful. Sylvie Lefèvre in particular was very generous in sharing her work and helping me with mine. Carla Bozzolo of the Centre National de la Recherche Scientifique, section on the Culture Ecrite du Moyen Âge Tardif (CEMAT), advised me on the dating of MS 2668 of the Bibliothèque de l'Arsenal.

In the United States, I should like to thank the reference librarians and study facilities staff, especially Bruce Martin, of the Library of Congress. The library of the National Gallery of Art was also a valuable resource. I am particularly grateful to Thomas McGill and George T. Dalziel, who dealt so graciously and competently with many interlibrary loan requests.

Among the many individuals who helped with this study are members of the former scholarly community of the Library of Congress. Among this group, I should like to thank Ellen Ginsberg, Marianne Meijer, and Amy Simowitz for their assistance with bibliographic and linguistic problems. I cannot adequately express my appreciation for the expert help of William MacBain, with whom I collaborated on the translations of Nicole Oresme's texts. In this difficult task Prof. MacBain was an unfailing source of patience and wisdom. Natalie Zemon Davis, the late Carl Nordenfalk, and especially Paul Oskar Kristeller contributed valuable information. For reading parts of the manuscript and offering helpful advice, I am grateful to Robert Ginsberg, Mary Martin McLaughlin, Robert Mulvaney, Lilian M. C. Randall, Melvin Richter, J. B. Ross, and Charity Cannon Willard. For their support of this project, I should like to thank Pamela Askew, Mary D. Garrard, H. Diane Russell, and Barbara and Fred Stafford.

I wish to express appreciation to the past and present deans of the Center for Advanced Study in the Visual Arts, National Gallery of Art: Henry A. Millon, Marianna Shreve Simpson, Steven A. Mansbach, and Therese O'Malley. Both as a fellow in 1981–82 and a member of the Center staff since 1986, I have benefited from their warm endorsement of my research. The help of my colleague Curtis A. Millay in preparing this manuscript for publication merits special acknowledgment.

For their support of this study, I thank the American Council of Learned Societies, the American Philosophical Society, the National Endowment for the Humanities, and the National Gallery of Art for the award of a Robert H. Smith Curatorial Fellowship.

I am, as always, indebted to my husband, Stanley M. Sherman, and my son, Daniel J. Sherman, for their help. Among their many contributions I value their patience as traveling companions and their indispensable assistance with editorial and photographic matters.

Washington, D.C.
March 1993

ABBREVIATIONS OF PRINCIPAL MANUSCRIPTS

FIRST SET, IN LARGE FORMAT

A *Les éthiques d'Aristote,* Brussels, Bibl. Royale Albert Ier, MS 9505–06 (formerly MS 2902)

B *Les politiques et le yconomique d'Aristote,* France, private collection

SECOND SET, IN SMALL FORMAT

C *Les éthiques d'Aristote,* The Hague, Rijksmuseum Meermanno-Westreenianum, MS 10 D 1

D *Les politiques et le yconomique d'Aristote,* Brussels, Bibl. Royale Albert Ier, MS 11201–02 (formerly MS 2904)

INTRODUCTION

Under royal patronage, the translation of Aristotle's authoritative texts from Latin to French by Nicole Oresme constitutes an important and little-known development in medieval secular culture. Dating from the 1370s, two sets of manuscripts, both from the library of King Charles V of France, contain the first known cycles of images to accompany the complete texts of the *Nicomachean Ethics* and *Politics.* The brief treatise known as the *Economics,* also included in the manuscripts, was then considered an authentic work of Aristotle. Critical editions of the texts acknowledge their importance as the first complete versions in a vernacular language. Yet the cycles of illustration of the king's manuscripts have not received equal attention, particularly in relationship to the texts. The separation in the scholarly tradition of a study of the texts of the translations on the one hand and the images on the other has brought about an underestimation of the full dimensions of the translations' cultural significance. Treatment of the manuscripts as integrated systems of communication raises many interesting questions about how verbal and visual patterns of meaning were constructed, combined, and modified. My interpretation for the late twentieth century of a complex process of fourteenth-century culture led me to widen the scope and method of my research.

My interest in Charles V's four Aristotle manuscripts grew out of my work on the king's patronage and iconography. Initially, the problem appeared simple and iconographic, for the programs of illustration could not be found among the numerous Latin versions of these texts and were thus unique to the new vernacular translations. To interrogate the motives and functions of these programs, I soon realized that I had to move beyond the hunt for pictorial sources and examine the relationships between texts and images. This line of inquiry led me to consider the importance of Oresme's translations qua text. The published critical editions showed that Oresme adhered to academic tradition in supplying extensive glosses and commentaries. His inclusion of glossaries of new and unfamiliar terms made me suspect that the illustrations, too, probably had didactic functions related to the new audience for these vernacular translations.

The crucial textual link lay in Oresme's prologues to his translations. In his introduction to the *Ethiques,* he identified his audience as the king and his counsellors. The language and content of the prologues led me to investigate the possible

social and political dimensions of the king's commission of the Aristotle translations. This line of research raised questions relating to the king's larger project of commissioning more than thirty translations of both ancient and medieval texts. The first involved the new audience for translations of the *Ethics* and *Politics* and the implications for the diffusion of medieval Aristotelianism beyond clerical and university boundaries.

Next I studied the manuscripts themselves to see whether Oresme's linguistic concerns affected the placement, size, and content of the illustrations. At this point, a codicological approach proved essential. By examining the manuscripts as integrated physical structures, I began to see how their calligraphic and decorative organization worked with the illustrations and textual elements to organize the reader's understanding. For example, Oresme's introductory paragraphs and chapter headings highlight key concepts. I speculated whether in an analogous way placement of the illustrations at the beginning of each major text division pointed to way-finding and indexical functions linking text and image.

Who could have devised these extraordinary programs of illustration? For clues to their probable author, I looked at the career of the translator, Nicole Oresme, chosen by Charles V. Oresme's innovative Latin works in such diverse fields as mathematics, physics, and economic theory had established him as one of the outstanding intellects of the late medieval period. Oresme's long-standing relationship to Charles V as unofficial mentor suggested Oresme as catalyst of the Aristotle project.

From this framework I tested various forms of evidence that Oresme may have designed the programs of illustration. Again, the close links between the images and texts provided vital indications of the truth of such a hypothesis, particularly the correspondence of inscriptions in the images to various neologisms and unfamiliar terms. What were the connections between the representational modes of the illustrations and Oresme's authorship of the programs? Did certain of his rhetorical strategies in the translations apply to their visual analogues? Following this train of thought, I wondered if Oresme's training in Aristotelian thought had affected the illustrations' individual visual structures, that is, the textual sequence, format, and internal division of the picture field. From analyzing individual images, I proceeded to question whether Oresme's awareness of Aristotle's thought influenced the appearance of images as essential elements in the reader's cognitive processes. I had then to consider whether the illustrations themselves constituted another level of the translation, in which Oresme selected and explained important concepts.

Oresme's role as designer opened for discussion the nature of his collaboration with the book trade to produce the manuscripts in question. Colophons that identified the scribe of the second set of Charles V's manuscripts as Raoulet d'Orléans suggested that the latter's graphic intervention could offer important evidence about how he worked with Oresme. As author of the programs of illustration, Oresme would also have had to provide instructions for the various miniaturists and their workshops. Because specific documentation is lacking, I refer to the

unknown heads of these ateliers by the traditional term, *masters,* although I acknowledge the possibility that women could have headed these workshops.

Awareness of this collaborative process led to a comparison of the editorial formats and visual programs of the first and second sets of Charles V's copies of the *Ethiques* and *Politiques.* Such a procedure seemed useful in determining both the common and separate functions of the two cycles of illustrations and in providing clues to their contemporary reception. I also speculated on the possibility of another dimension to the reception process: the translator's continued interaction with his audience by means of oral explication.

Turning from an analysis of the programs of illustration in relationship to the texts and the manuscripts, I examined issues of cultural history relating to the broader significance of the Aristotle translations. Recent works on the development of the medieval and early printed book, for example, provided an important perspective on the verbal re-presentation of Aristotelian and other texts originally designed for university audiences. And analyses of rhetorical theory, patronage, and political goals of translations brought the realization that the transfer of meaning from one language to another is related to a similar transfer from verbal to visual language. I thus view Charles V's copies of the Oresme translations as cultural artifacts, as well as physical objects and self-contained systems of information.

I recognized also the crucial role that imagery plays in cognition and memory. Recent scholarship has emphasized Aristotle's own articulation of these ideas and Oresme's knowledge of them, and of other medieval approaches to psychology. These analyses led me to appreciate the inherent value of the images within the manuscripts, including the use of certain visual cues and mnemonic devices.

Other directions in recent scholarship also broadened the focus of my inquiry, particularly studies of gender roles and social class in medieval culture. Such insights have encouraged me to view the programs of illustrations as indications not only of the views held by the translator and his primary audience, the king and his counsellors, but also of the political and social mentality of contemporary secular culture. In my own field, critiques of the objective stance of traditional art history have encouraged me to voice my own interpretation of these manuscripts as another level of the translation process.

The organization of *Imaging Aristotle* emphasizes the interrelationships between texts and images in Oresme's translations. The first of this study's three major parts is divided into three chapters. Chapter I considers the scope and political and cultural meaning of Charles V's translation project. The second chapter discusses the king's patterns of patronage and interaction with Oresme, as well as the development of the latter's French writings. In the context of contemporary manuscript production in Paris, the last chapter of the first section analyzes Oresme's role as master of the text and designer of the illustrations. Part II of the study, comprising eleven short chapters, compares the programs of illustrations in Charles V's two *Ethiques* manuscripts according to textual sequence. The first official library copy (MS *A*, Brussels, Bibl. Royale Albert Ier, MS 9505–06) is compared to the second, smaller portable one (MS *C,* The Hague, Rijksmuseum Meermanno-West-

reenianum, MS 10 D 1). Among the major points discussed are the representational modes of personification and allegory, as well as gender, iconographic precedents, and visual structures. Part III repeats the organization of Part II in its comparison of the king's manuscripts of Oresme's translations of the *Politics* and *Economics*. The sister manuscript of *A* in the first set is MS *B* (France, private collection); and in the second, MS *D* (Brussels, Bibl. Royale Albert Ier, MS 11201–02), completes MS *C*. In this section, a contrasting representational mode offers paradigms of the body politic within varied and inventive visual structures. I also discuss the way the illustrations treat contemporary social classes as references to the formative historical experiences of the patron and the primary audience. The conclusion draws together the findings on the interrelationships among the three parts of the study and sums up the significance of Oresme's translations of the three Aristotelian texts. Four appendixes then provide descriptions of the manuscripts' contents, structures, and histories. A fifth appendix transcribes and translates the text of a unique second instruction to the reader preserved in Charles V's first copy of the *Politiques* (MS *B*).

Concentration on the historical context of Oresme's translations in the first part of this study establishes the themes of the interrelationships between the visual and verbal representations of Aristotle's texts. The narrower focus on individual images in the two succeeding sections reflects, perhaps ironically, a broader aim of this study: a consideration of images as an integral element of the cognitive structure of the medieval manuscript book.

THE HISTORICAL CONTEXT OF

ORESME'S TRANSLATIONS

I ROYAL PATRONAGE OF VERNACULAR TRANSLATIONS

The rapid increase in translations from Latin into the vernacular is a hallmark of fourteenth-century cultural history.[1] The process had begun by the beginning of the thirteenth century, when social, political, and economic conditions in western Europe created a climate favorable to the spread of literacy among the lay population. Among the new audiences who read for pleasure, business, or both, were members of the royal bureaucracies, the feudal nobility, merchants, and growing numbers of the middle class living in towns or cities.[2] Earlier waves of translations addressed to a learned and largely clerical audience had made accessible many works of the Greek and Roman scientific and philosophical corpus previously unknown to medieval culture. These Latin translations are closely tied to the rise of universities in the twelfth and thirteenth centuries.[3] The appropriation and assimilation of classical and Arabic texts into medieval Christian culture through the mediation of the university curriculum marks a significant turning point in Western thought.

Less well known, however, is the process by which authoritative texts in Latin were translated into the vernacular. Such translations involve another stage in the appropriation of classical culture by secular patrons and audiences, who chose the language, texts, and channels for the dissemination of knowledge.[4] Accurate versions of serious and scholarly works on philosophy, theology, and natural science became available in modern languages.[5] Although a rich body of literary texts in vernacular tongues had long existed, the fourteenth century witnessed the development of modern languages as instruments of abstract and scientific thought.

Modern scholarship has linked a preference for the vernacular by lay audiences to the growth of personal libraries and to new methods of reading.[6] Certain types of vernacular literature composed for aristocratic circles, such as chansons de geste, romances, and poetry, were intended for oral performance. Also read aloud was the popular thirteenth-century compilation in verse known as the *Histoire ancienne jusqu'à César*. Around 1200 French prose became the favored vehicle of vernacular historiography. During the course of the thirteenth century, members of the nobility commissioned for a French-speaking laity historical texts chronicling royal deeds written in the vernacular.[7] Of great importance is the translation from Latin into French of the official national history in 1274 by Primat, a monk of Saint-Denis, the royal abbey entrusted with this responsibility. The moral value of his-

tory as a guide to contemporary rule, the creation of a mythic French past, and the appeal to a lay audience provided important models for the political context of vernacular translations.[8]

The practice of composing original works in or translating them into French vernacular prose did not, however, suddenly eliminate the oral recitation of written texts. But Paul Saenger dates to the middle of the fourteenth century a shift among the aristocracy from oral performance or reading in small groups to silent, visual reading. As Saenger explains, the practice of individual reading and advances in the compilation of texts had begun during the thirteenth century in academic circles to enable students to master texts of the university curriculum. Such improvements encouraged the demand for and production of new vernacular texts.[9]

During the second half of the thirteenth century, royal patrons and members of the nobility closely tied to court circles commissioned various translations of serious or scholarly works in French prose.[10] As a young man, King Philip IV ordered translations of Giles of Rome's influential Mirror of Princes text, intended for the political and moral counsel of rulers, the *De regimine principum,* and later of the perennial medieval favorite, Boethius's *De consolatione philosophiae.*[11] The pace of translations accelerated during the first half of the fourteenth century, when French queens and princesses, unschooled in Latin, encouraged the commission of vernacular works.[12] Among the texts chosen for translation into French by royal patrons were works of history, classical mythology, liturgical and biblical texts, and treatises of moral instruction and personal devotion.[13]

The father of Charles V, King John the Good, who reigned from 1350 to 1364, continued the royal tradition of patronage of vernacular texts and of sumptuously illustrated manuscripts. As the founder of the royal library housed in the Louvre and as the first French king to envisage a program of artistic patronage for political ends, John the Good set an important precedent for his son. While still duke of Normandy, John commissioned the translation of James of Cessola's *De ludo scaccorum* from John of Vignai. After his accession to the throne, King John ordered from Master Jean de Sy a vernacular version of the Bible.[14] After the battle of Poitiers in 1356, the imprisonment of the French monarch interrupted this ambitious project. Even in captivity, King John ordered both religious and secular books written in French.[15]

The most important secular translation commissioned by King John was Pierre Bersuire's French version of Livy's *History of Rome.* Bersuire, a Benedictine, was a longtime resident of Avignon, which, as the temporary seat of the papacy, was an important cultural crossroads. Bersuire's translation profited both from the manuscripts in the papal library and from his contacts with Petrarch. The famous humanist may have furnished the translator with missing portions of Livy's text.[16] After Bersuire's return to Paris from Avignon in 1350, he seems to have enjoyed the protection of King John. Bersuire and Petrarch, whose friendship continued by correspondence, met again in Paris, when in 1361 the latter served as an ambassador to the French court of Galeazzo Visconti, ruler of Milan. In an address congratulating King John on his return from his English imprisonment, Petrarch deeply impressed his audience, including the future Charles V.[17]

Completed by 1356, Bersuire's translation of the first, third, and fourth Decades of Livy's *History of Rome* is the first word-for-word translation of a classical work executed on French soil.[18] In his prologue addressed to the king, Bersuire emphasizes that Livy's narrative contains valuable information for contemporary princes. The war between France and England may have increased the practical appeal of Livy's text in its account of Rome's policy on defense of native territory, conquest of foreign lands, and aid to allies.[19] On another level, Bersuire's emphasis on the Roman rise to world dominance from humble beginnings had particular relevance because of the mythical descent of French rulers from the Trojans, legendary founders of Rome. The appropriation of Livy's work by French royalty sounds the theme of the *translatio studii,* the transfer of linguistic, military, and cultural dominance.[20]

From a practical standpoint, Bersuire's compilation of the text shows his understanding of the need to re-present the work for his lay audience. To make Livy's text easier to follow, the translator breaks up the three main sections (Decades) into short chapters introduced by titles. Intermingled with the texts are sets of notes or comments, entitled *Incidens,* that furnish the reader with information about unfamiliar Roman place names, terms, people, events, and institutions.[21] To aid the reader in comprehending the many new terms he introduces into French, Bersuire provides a glossary of some eighty terms arranged at the beginning of the text in rough alphabetical order.[22] Also influential on later translations is Bersuire's method of transforming Latin words into French ones by changing the endings or spelling.[23] By this method of *calques,* Bersuire added forty-three neologisms to French.

King John's commission provided an important precedent for Charles's translation project, particularly for Oresme's French version of Aristotle's works. The French translation of such an authoritative classical text as a guide to political rule is noteworthy. Also significant are the linguistic methods and compilation features configured to re-present the work to a new lay readership.

POLITICAL AND CULTURAL IMPLICATIONS

The increasing linguistic preference for the vernacular had political and cultural implications. By the last third of the fourteenth century, French had gradually replaced Latin as the language used for many types of administrative records and documents. During the reign of Charles V, members of the chancellery prepared drafts for the king's approval written in cursive script.[24] Charles V wrote and signed letters in French and annotated and corrected documents in the vernacular.[25] This increased use of French in royal administration gave the language greater prestige and helped to break down the traditional distinction between literate Latin-reading clerics and laymen, who were considered illiterate because they had at most limited knowledge of Latin. This statement does not imply that knights, lawyers, and social groups involved in public administration knew no Latin at all. Recent studies indicate that groups used Latin for business or professional purposes

and for religious observance.[26] The existing evidence indicates, however, that the Latin proficiency of Charles V, his court, and high officers was insufficient to understand classical or medieval authors whose works interested them.[27] Indeed, in their justifications of producing vernacular versions of antique texts, the translators' complaints about the difficulties of classical Latin style, syntax, and terminology go beyond topoi of their inadequacy.[28]

The increased use of the vernacular in public life also shows a nationalistic aspect.[29] Pride in the beauty of the French language is a theme of Oresme's prologues in translations commissioned by Charles V.[30] The first phase of the Hundred Years' War undoubtedly heightened consciousness of the French language as a distinctive national characteristic. Many prologues written by Charles V's translators refer to current political issues, especially to the natural superiority of the French nation to their English enemies.[31] A related motif in Oresme's prologues is his compliment to the lay audiences he addresses. He identifies them in two ways. First, he names the officers of government, including the king and princes. His second category is a vague, broader grouping of Frenchmen of high intellect.[32] Oresme's positive attitude toward the French language also appears in the prologue of his translation of the *Politics* when he observes: "As Cicero puts it in his *Academica,* authoritative works on weighty matters are delightful and most agreeable to people when written in the language of their country."[33]

Oresme's claim of the broad appeal of French translations to a lay public receives confirmation in Monfrin's study of the numbers of manuscripts of vernacular translations and their owners from the thirteenth century to early printed editions of these texts.[34] While some of these readers came from royal and aristocratic circles, also represented are lawyers and other professionals, government officials, members of the Parlement of Paris and the *haute bourgeoisie* who had personal libraries.[35] Finally, as Charles V's program indicates, French translations also had a political function.

THE SCOPE OF CHARLES V'S PROGRAM OF TRANSLATIONS

Charles V commissioned more than thirty translations of authoritative classical and medieval works as part of a conscious policy to legitimate the new Valois dynasty. He placed his encyclopedic library, housed in a tower of the Louvre, at the disposal of the intellectuals in his employ. His carefully organized collection included Mirror of Princes texts on the moral and political education of rulers as well as political treatises and historical writings.[36] Among the histories was the king's copy of the *Grandes chroniques de France,* written at court and updated through Charles V's own reign with an emphasis on political issues.[37]

A social and moral justification of Charles V's program of translations occurs in Nicole Oresme's prologue to his French version of Ptolemy's *Quadripartitum.* As models, Oresme alludes to two principal translations commissioned by John the Good: the French version of the Bible by Jean de Sy and Bersuire's vernacular rendition of Livy.[38] In her biography of Charles V and other writings, Christine

de Pizan also stresses the moral and educational functions of the translations, citing the king's concern for future generations. Executed by the most qualified masters, these translations provide moral instruction in all the arts and sciences.[39] In her poem entitled the *Chemin de long estude,* Christine specifies even more clearly the ethical intent of the king's program of translations:

> Et moult fu noble oeuvre et perfaitte,
> Faire en françois du latin traire,
> Pour les cuers des François attraire
> A nobles meurs par bon exemple.

> (And it was a noble and perfect action to have [them]
> translated from Latin into French to attract the
> hearts of the French people to high morals by good
> example.)[40]

Various prologues to the translations commissioned by Charles V make similar points about the social and political value of the enterprise. In the preface to his translation of St. Augustine's *City of God,* Raoul de Presles states: "vous avez voulu estre translaté de latin en francois pour le profit et utilité de votre royaume, de votre peuple et de toute crestienté" (you have desired [it] to be translated from Latin into French for the benefit and advantage of your kingdom, and all Christendom).[41] As Delisle points out, the phrase "l'utilité du royaume et de toute la crestienté" also appears in the official document which states that Charles V paid the translator for his work.[42] Repeated in other acts of Charles's reign, such language places the translations in the context of an articulated public policy.[43]

Yet it would be a mistake to ignore Christine's many references to Charles V's translation program to substantiate his intellectual character and his taste for books and learning. Charles's earliest commissions reveal his personal interests and approach to ruling. Sponsored by Charles before his accession to the throne, these earliest translations are astrological treatises. The texts date from about 1360, when as regent he faced serious challenges to the survival of the monarchy. Consistent with the practice of medieval rulers, Charles sought knowledge of the immediate and long-range outcome of events through astrological prediction. For example, a section of Robert de Godefroy's French version of the *Liber novem judicum* (*Le livre des neuf anciens juges d'astrologie*) contains a timely discussion of the disposition of the territory that once belonged to a king who has now lost his lands.[44]

Several translations dating from the years after Charles's accession to the throne in 1364 show a broadened subject matter. Among this group are French translations of two religious works, the *Homilies of Saint Gregory* and the *Treatise on the Soul* (*Traité de l'âme*) by Hugh of St. Victor;[45] the French versions by Pierre Hangest date from 1368. The manuscript appears in all the inventories of Charles V's library and was written by Raoulet d'Orléans, the scribe of the king's second set of the *Ethics* and *Politics* translations.[46] Historical works were translated at the end

of the 1360s by the Carmelite Jean Golein. Golein, along with Nicole Oresme and Raoul de Presles, is one of the three translators most favored by Charles V. In 1369 Golein completed a French version of the shorter works of the influential Dominican Bernard Gui. (A year earlier an unknown translator produced Gui's *Les fleurs des chroniques.*) Before 1373 Golein also translated a massive universal history, *Les chroniques d'Espagne ou de Burgos,* written by Gonzalo of Hinojosa, bishop of Burgos.

Christine de Pizan's discussion of Charles V's translation project concentrates on works dating from the 1370s, when the program took on an overt political and moral tone. In their prologues, which show their exchanges of texts and ideas, the translators are aware that their work corresponds to the ancient and medieval classics chosen by the king for translation: Christine's "les plus notable livres" (the most noteworthy books). Among them are three works by Aristotle rendered in the vernacular by Nicole Oresme: the *Ethics,* the *Politics,* and *On the Heavens.* The first dates from 1370 to 1372; the second, after 1372; and the third, from 1377. Christine does not mention the pseudo-Aristotelian *Economics,* which Oresme also translated. Since this short work was frequently included with the *Politics,* she may have thought it unnecessary to name it separately.[47] As famous as the Aristotelian works are two texts of St. Augustine. The *City of God* (*Cité de Dieu*) was translated by Raoul de Presles between 1371 and 1375, and the *Soliloquies* (*Soliloques*), by an unknown translator. Of great importance to a medieval ruler is a classic of political thought, the *Policraticus* (*Policratique*) of John of Salisbury, translated around 1372 by the Franciscan Denis Foulechat. Also a great medieval favorite is the scientific encyclopedia, Bartholomaeus Anglicus's *On the Property of Things* (*Propriétés des choses*), translated in 1372 by Jean Corbechon. By 1375 the first four books of the well-known text by the Roman historian Valerius Maximus, *Factorum et dictorum memorabilium libri novem* (*Faits et dits dignes de mémoire*) were translated by the Hospitaller Simon de Hesdin. Christine pays particular attention to a translation of the Bible entrusted to Raoul de Presles around 1375.

Christine's list highlights only the most important translations commissioned by Charles V. She lumps together what she calls a "tres grant foison d'aultres" (a great abundance of others). A varied group of texts dates from the 1370s, including Jacques Bauchant's vernacular version of *Les voies de Dieu* (1372), a devotional work by St. Elizabeth of Hungary. Also omitted are the French translations of Seneca's *De remediis fortuitorum* (*Des rémèdes ou confors de maulx fortunes*), as well as of Petrarch's *De remediis utriusque fortunae* (*Les rémèdes de l'une et de l'autre fortune*), completed in 1377 by Jean Daudin. Daudin also rendered into French Vincent of Beauvais's *De eruditione filiorum nobilium* (*L'enseignement des enfants nobles*). Jean Golein's translations of the 1370s do not figure in Christine's list either. In 1370 Golein completed his French version of Cassian's *Collations* and, four years later, the *Rational des divins offices* (Durandus's *Rationale divinorum officiorum*), including the important *Traité du sacre.* Golein claims that this short but vital text on the procedures and symbolism of coronation ceremonies is a translation.[48] Golein's last certain translation for Charles V, in 1379, is a Mirror of Princes text, *L'information des princes.*

Also not included in Christine's list is the anonymous version dating from 1372 of Thomas of Cantimpré's *Bonum universale de apibus* (*Livre du bien universel des mouches à miel*). Nor does she cite Jean Daudin's 1374 vernacular rendition of another work by Vincent of Beauvais, the *Epître consolatoire*. Absent also is one of the most influential political tracts of the period, *Le songe du vergier,* translated by an unknown person with interpolations from the contemporary—but not identical—treatise entitled the *Somnium viridarii*. Finally, two other translations of the 1370s need mention. From 1373 there dates a translation (*Rustican*) of the *Ruralium commodorum libri XII* by Peter of Crescenzi. Only fifteenth-century copies survive of this encyclopedic treatise on agriculture. Totally lost is the French version of the astronomical tables of Alphonso, king of Castile (*Les tables astronomiques d'Alphonse, roi de Castille*).

Although only a partial guide to Charles V's translation project, Christine's list of over thirty translations is enlightening. It shows Charles's broad vision and boldness in bringing into the orbit of secular French culture the most authoritative Latin works of pagan and Christian origin, encompassing secular moral and religious texts, classics and recent writings on political thought, and works on education, astrology, history, and natural science. Christine rightly emphasizes the royal initiative that promoted and directed the program and outlines its moral and political dimensions. She also provides the clues to determining its broader cultural aims.

THE TRANSLATIO STUDII

It is significant that Christine de Pizan follows her discussion of the translations sponsored by Charles V with a chapter on his close relationship to the University of Paris. As the seat of the university, a primary center of learning in the Christian West, the city of Paris merits the title of the "new Athens."[49] By presenting one version of the *translatio studii,* the topos of the transfer of antique culture and military power from Greece to Rome, she takes up the tradition dating from the twelfth century that France had taken possession of the Roman heritage.[50] To emphasize the foundations of French national superiority, the *translatio studii* theme was absorbed into royal historiography and merged with an allegorical interpretation of a primary monarchical symbol, the fleur-de-lis.[51]

The idea of the *translatio studii* takes on a new resonance in Oresme's prologue and particularly in the apologia for his translation of the *Ethics* and the *Politics*.[52] As noted above, Oresme quotes Cicero in affirming the pleasure of writing in one's native language. Oresme also takes a historical and cultural view of language and notes that, just as Greek letters and power gave way to Latin and the Roman empire, Latin is being replaced by French as the language of learning. Oresme emphasizes the value of French as a "langage noble et commun a genz de grant engin et de bonne prudence" (a noble language shared by people of great discernment) and as the obligation to translate "telz livres en françois et baillier en françois les arts et les sciences" (such books into French and [to] make available the arts and sciences in French) as a legal transmission of culture.[53]

In Christine's version of the *translatio studii* theme, the prominence of Paris encompasses both the university and Charles V's patronage of art and letters. A personal and dynastic model for the studious and enlightened monarch was the emperor Charlemagne. Several similarly worded prologues of translations commissioned by Charles draw parallels between Charlemagne's love of learning and that of his Valois namesake.[54] For example, Jean Golein's preface to the *Rationale of Divine Offices* refers to Charlemagne as the "droit patron" (true patron) of the kings of France, especially of Charles V. The translator connects Charles V's Christian faith, shown by the use on his coins of the legend *Christus vincat, Christus regnat, Christus imperat* (Christ conquers, Christ reigns, Christ rules), with his "estude et sapience" (study and wisdom) and victories against the English.[55] Thus, the traditional themes of faith, wisdom, and chivalry embodied in the fleur-de-lis are attributed to the kingdom of France and its ruler, Charles V.

In addition to the favorable cultural analogies that Golein makes between Charlemagne and Charles V are the specific political benefits attributed to Charles by association with the Carolingian ruler. Golein asserted that Charles V descended directly through the male line from Charlemagne.[56] Charles V himself encouraged the linking of his rule with that of Charlemagne by various strategies.[57] The so-called scepter of Charlemagne was apparently commissioned for, and used in, Charles V's own coronation. Now in the Louvre, the scepter features a representation of the emperor seated in majesty. Several miniatures from the *Coronation Book of Charles V,* ordered by the king as a souvenir of, and guide to, the actual ceremony held in 1364, show him holding a scepter that closely resembles the Louvre object.[58] Thus, the effigy of Charlemagne so prominently displayed on the very symbol of monarchic sovereignty represents a bold visual coupling of Charles V's rule with that of the Carolingian emperor. Moreover, Charles collected relics and celebrated the feast day of St. Charlemagne in his chapel.[59]

In a more concrete political context, Charles V cultivated another fiction connected with Charlemagne. Embodied in the formula *rex imperator in suo regno* (the king is emperor in his kingdom), this argument made by royal apologists contends that the kings of France were not subject to imperial or papal sovereignty. The premise is that Charlemagne did not intend his own patrimony, the kingdom of France, to be subject to himself or to anyone else who held the title of Holy Roman Emperor.[60] Among the many references in the translations sponsored by Charles V to the *rex imperator in suo regno* formula, three stand out. In the preface to his French version of Cassian's *Collations,* Golein mentions his patron as he who holds and governs the kingdom and empire of France. Golein's treatise on the coronation ceremony included in the translation of the *Rationale of Divine Offices* not only speaks of "l'empereur de France" but also asserts that Charlemagne left the sacred banner known as the oriflamme in France "en signe d'empire perpetuel" (as a sign of eternal empire).[61] In outspoken fashion, *Le songe du vergier,* which in 1378 adapted a Latin text composed three years earlier, adds to the original work an assertion that the king of France is emperor in his own kingdom. Invocation of this formula counters English claims to disputed territory, such as Guyenne,

and more generally, accounts for the legal inability of the king of France to alienate or surrender any part of the realm. These bold interpolations probably reflect Charles V's direct intervention in the writing of the translation.[62]

At about the same time, a visual application of the *rex imperator in suo regno* formula can be found in an illustration accompanying an account of the visit in 1377 and 1378 of Charles V's uncle, the Holy Roman Emperor Charles IV. Among the novel scenes that explain these events in the king's copy of the *Grandes chroniques de France* is a representation of the entry into Paris of Charles IV, his son Wenceslas, and Charles V. Leading his imperial visitors, the French king rides on a white horse that symbolizes his sovereignty.[63]

Thus, the translations commissioned by the king emphasize the cultural and political superiority of the French nation under the leadership of Charles V. The translators' prologues contend that this ruler carries on the heritage of piety, learning, and military victories of his namesake and purported ancestor, the emperor and saint Charlemagne. In such a context, Charles V's translation program ushers in a new phase of the *translatio studii,* in which, under monarchic patronage, a transfer of learning and power is expressed in works written in the French language.

HUMANISTIC CURRENTS

While the retrospective, political aspects of Charles V's program of translations are important, his policy of encouraging works in the vernacular also reflects a personal interest in and contemporary taste for the classical past and early Italian humanism. An important precedent is John the Good's sponsorship of Bersuire's translation of Livy. Although King John's copy does not survive, in an inventory of 1373 the custodian of Charles V's library describes in unflattering terms the writing, illumination, and illustration of this manuscript.[64] Indeed, the oldest extant illustrated copy of Bersuire's translation is one from Charles V's collection. The colophon in the king's hand states that he was responsible for having the book written, illuminated, and brought to completion. The elaborate cycle of illustrations attests to the king's taste, an analogue of his preference for the vernacular.[65]

Ties with Petrarch and Avignon may also have influenced Charles's interests. Perhaps the king recalled his encounter with Petrarch in Paris. In 1361 during a diplomatic mission, the Italian humanist failed to deliver to the French court a scheduled discourse on Fortune. To compensate, Charles V may have commissioned in 1376 the first translation of Petrarch's work: the French version by Jean Daudin of the *De remediis utriusque fortunae.*[66] In another direction, Petrarch's devotion to St. Augustine's *City of God* may have spurred Charles V to order Raoul de Presles's translation of this text.[67] This hypothesis seems plausible in view of Presles's reliance on the Latin commentaries on the *City of God* by two English friars, Nicholas Trevet and Thomas Waleys. Both men were longtime residents of Avignon with strong humanist interests.[68] Presles focused on the wealth of infor-

mation about ancient Greek and Roman culture provided by the first half of the *City of God* and the later Latin commentaries. Indeed, Presles writes that because theology was not his specialty, he does not comment on the second half of the text, and Laborde states Presles's translation was popular precisely because of its wealth of anecdotes about classical heroes and other subjects from ancient history rather than its religious content.[69] In addition, the elaborate cycles of illustrations that often accompany the popular translation by Presles made the texts more accessible and appealing to lay audiences.[70]

In the French version of the first four books of Valerius Maximus's medieval favorite, the *Faits et dits dignes de mémoire,* the translator, Simon de Hesdin, depends heavily on the earlier commentary of 1342 written in Naples by Fra Dionigi da Borgo San Sepolcro. Fra Dionigi's patron was King Robert the Wise of Anjou, whose court was an early center of Italian humanism.[71] The illustrations of the French translation, executed between 1375 and 1379, clearly indicate this interest in classical culture. A French version of Seneca's letter to Lucilius commissioned by a high official of the Angevin court also found a place in Charles V's library.[72] King Robert also commissioned a copy of the missing fourth Decade of Livy's *History of Rome.*[73] Two of three manuscripts associated with the Angevin court in Naples that later belonged to Charles V and his brother the duke of Berry also deal with Roman history.[74] Thus, the relationship between the French court in Paris and that of Naples suggests another channel to early humanistic currents in Italy.

The sponsorship by Charles V of illustrated manuscripts of Bersuire's translation of Livy, as well as those of Simon de Hesdin's vernacular version of Valerius Maximus and of Presles's influential rendition of St. Augustine, contributed to their popularity and dissemination among lay audiences. Although it is difficult to separate the humanistic elements of these translations inspired by contacts with Petrarch, Avignon, and Naples from traditional French medieval classicism, both strands may have motivated the original and subsequent demands for these texts. And while the translations of classical works form just one part of Charles V's program, they constitute a distinctive aspect of his personal taste and that of his generation. With their extensive, if not always correct, explanations of classical allusions, Nicole Oresme's translations of Aristotle's *Ethics* and *Politics* exhibit a similar fascination with the culture of the ancient world.

2 INTELLECTUAL AND POLITICAL TIES BETWEEN NICOLE ORESME AND CHARLES V

The relationship between Oresme and his patron provides another context for the Aristotle translations.[1] Although scholars now agree that Oresme was not Charles's childhood preceptor,[2] it seems likely that he served as an informal intellectual adviser. Oresme's early writings in French provide evidence that by the late 1350s he had attracted the prince's attention. Miniatures in manuscripts commissioned by Charles clarify not only his relationship to Oresme but also some of the future king's interests.

Details of Oresme's early life are sparse. He was probably born near Caen sometime in the early 1320s. His name first appears in a document of the University of Paris dated 1348 among the masters of the Norman nation and as a scholarship holder of the College of Navarre. After teaching arts and then theology, he became a master of theology in 1356. Oresme probably studied with Jean Buridan, head of the College of Navarre, which was founded in 1304 by Queen Joan of Navarre, wife of King Philip IV. Buridan, an interpreter of Aristotle, was also an important nominalist and natural philosopher and may have influenced Oresme's thinking.[3] Since Oresme was at the leading center of Aristotelian studies in Europe, he would have been infused with a thorough knowledge of the Philosopher's thought. The first group of Oresme's writings date from the late 1340s to the early 1350s, when Oresme was teaching in the arts faculty. Among these unpublished works are collections of individual questions on selected topics, a method of scholastic argument, six of which concern works of Aristotle. A second group of Oresme's writings in Latin on mathematics and physics addressed to scholarly audiences probably dates from the late 1340s to the early 1360s.

In 1356 Oresme was named Grand Master of the College of Navarre, a royal foundation, around the same time that scholars believe he came to the attention of the royal family. That year marked a low point in the fortunes of the new Valois dynasty that had succeeded the last Capetian king, Charles IV, in 1328. The accession to the French throne of King Philip VI, the first of the Valois line and father of John the Good, had precipitated the Hundred Years' War. At the decisive battle of Poitiers that ended the first phase of the Hundred Years' War, in 1356, King John the Good and the flower of French chivalry were defeated and captured by the English. Leadership of France fell to the Dauphin Charles, eldest son

of John. Only eighteen years old, Charles faced the threat of civil war. Certain aristocratic factions sided with the English claimant to the French throne, King Edward III. Opposition to the Valois dynasty also arose from Charles the Bad of Navarre. His mother, Queen Joan II of Navarre, was the daughter of Louis X, one of the last Capetian kings. But the exclusion of women from inheriting the French throne either directly or passing it to a male heir negated the claims of both Edward III and Charles the Bad.[4]

Other threats to the Valois monarchy came in the late 1350s from a revolt in Paris led by Etienne Marcel, provost of the wool merchants, who allied himself with Charles the Bad. In 1358 the peasant revolt called the Jacquerie broke out. Furthermore, a financial crisis, partly caused by the need to raise the ransom for the captured king, brought cries for monetary reform. The various meetings of the Estates General between 1355 and 1358, summoned to raise money first by John the Good and then by Charles, brought pressure for political and monetary reform of the monarchy. A particular sore point was the king's continued debasement of the coinage. Disaffection with royal power was widespread and extended to members of the faculty of the University of Paris, among them Nicole Oresme. As master of the College of Navarre, he may have been an adherent of the faction supporting Charles the Bad.[5]

ECONOMIC COUNSEL

Under these circumstances of extreme civil unrest, about 1356 or 1357 Oresme wrote the first version of his influential treatise *De moneta* (On the Debasement of the Coinage),[6] the first medieval treatise on economics. Heated in tone and outspokenly critical, *De moneta* states that the coinage is not the property of the sovereign but belongs to the entire community.[7] Regulation of it, therefore, is not the prerogative of the monarch alone but of a gathering of the kingdom's inhabitants. Furthermore, the coinage cannot be altered without the consent of the people's representatives. In this treatise, Oresme borrows essential arguments from both the *Nicomachean Ethics* and the *Politics*. From the *Politics* come the distinction between tyranny and monarchy and the warning that power should not be unduly concentrated in any one segment of the community. Oresme's argument that the king's economic powers are subject to regulation by law and custom also derives from the *Politics*.[8]

Drawing on the authority of these citations from Aristotle, Oresme wrote a second Latin version of *De moneta*, seemingly in response to the mood of crisis caused by the defeat at Poitiers and John the Good's captivity. Although the tone of the tract is unfriendly to monarchy, the advice offered may have attracted the attention of the Dauphin. In any case, the wording of the reference to a reader in the conclusion of a French translation of *De moneta*—called the *Traictié des monnoies*—attributed to Oresme suggests that the vernacular version was addressed to Charles.[9] Although the date of this translation presents problems, the final section suggests that between 1357 and 1360 personal ties existed between Oresme and

the Dauphin.[10] This does not mean that the *Traictié des monnoies* was necessarily Oresme's first writing in French. Oresme himself named the *Livre de divinacions* as his earliest work in the vernacular. If, as some scholars propose, this treatise dates from between 1356 and 1357, the *Traictié des monnoies* could follow it in the last few years of this decade.[11]

In any case, historians generally accept that Oresme's suggestions in the *De moneta* for reforming the currency were followed in December 1360 by John the Good.[12] Emile Bridrey points out that the language in preambles to a series of royal ordinances dealing with financial policy derives from key terms used by Oresme in *De moneta* and its French translation.[13]

Another type of evidence confirms Oresme's political and intellectual influence with Charles while he was acting as regent. In 1359 Oresme was secretary of the king and had direct access to members of the royal family, including the sovereign—or in this case, the regent Charles. If commanded to do so by the king, a secretary was entitled to sign acts, and Oresme did so in 1359 (document now lost).[14] Although at this time the rank of secretary was less powerful than in later periods, the holder of this position was nonetheless an intimate officer of the king.[15] Further corroboration of the Dauphin's faith in Nicole Oresme's acumen can be found in a document of 1360. According to Bridrey, in that year Oresme was given the delicate mission of obtaining a substantial loan from the city of Rouen.[16] Oresme's advice to Charles in a period of great crisis forms a practical basis for his relationship with the future king. In this connection, the relevance of Aristotelian ideas advocated by Oresme as a basis for reform constitutes a precedent for his translations of the *Ethics* and the *Politics*.

THE QUESTION OF ASTROLOGY

Although little information survives about Charles's formal education, inventories and extant manuscripts from his library indicate that he began collecting books well before his accession to the throne. Lys Ann Shore has found that Charles's library contained more than thirty manuscripts of astronomical and astrological texts in French.[17] In the Middle Ages astrology connoted the study of the celestial bodies both for a rational understanding of the physical nature of the universe and as a pseudo-scientific system to predict the outcome of an individual or collective event. Scholars disagree on which aspect of the subject attracted Charles's attention. In his recent study on Oresme's *De causis mirabilium,* Bert Hansen takes the position that Charles was predisposed to the irrational side of astrology seen in the king's "official and public commitments to the reality of magic and marvels." As evidence he cites "Charles's patronage of astrologers, his support for the translating, writing, and copying of astrology books, his collection of talismans, and his founding of the College of Master Gervais at the University of Paris for the study of astrology and astrological medicine."[18] By contrast, Charity Cannon Willard believes that Charles's interest in astrology centers on its "investigation of the physical world as part of a single philosophical activity concerned with the search for reality and truth."[19] Willard bases her judgment on the kinds of books Charles

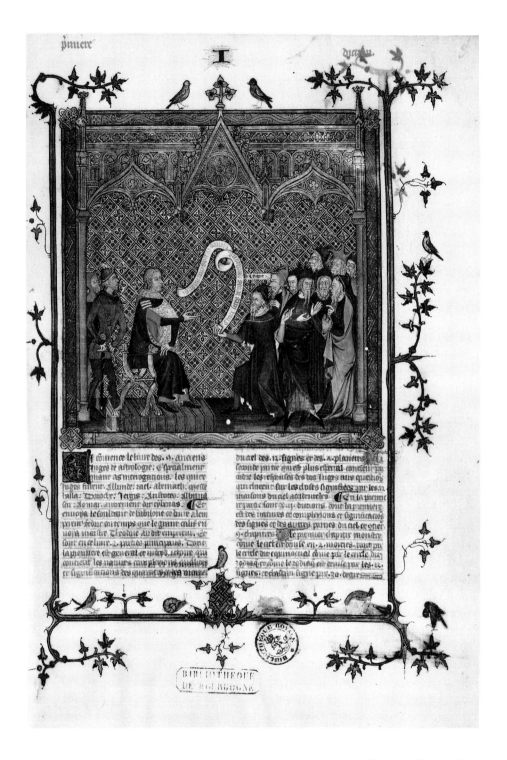

FIGURE I　*The Future Charles V Disputes with the Nine Judges of Astrology. Le Livre des neuf anciens juges d'astrologie.*

collected, as well as on the description of the king's knowledge of the subject by his biographer, Christine de Pizan.[20]

Christine herself was the daughter of Charles's astrologer, Tommaso de Pizanno, summoned from Bologna in 1365 to serve at the king's court. Before and after he ascended the throne, Charles employed a series of astrologers. Of course, catastrophic events such as the Hundred Years' War and the Black Death obviously encouraged the taste for and belief in astrology. The English called an astrologer, said to have predicted the French defeat at Poitiers, to enliven the captivity of John the Good, while another escorted the king back to France.[21]

Charles commissioned several books on astrology written in French before his accession to the throne, which may shed light on his attitude toward the subject. The earliest of them is *Le livre des neuf anciens juges d'astrologie,* a translation by Robert Godefroy of the *Liber novem judicum.* The text is dated to Christmas Eve 1361 by Godefroy, identified in another of the works as the Dauphin's "astronomien."[22] Of particular interest is the unusual frontispiece of the 1361 text (Fig. 1). In Godefroy's absence, the Dauphin addresses Aristotle, the foremost and only identified member of the "neuf anciens juges." The philosopher holds an inscribed banderole that indicates his willingness to answer the questions posed by the prince.[23] The miniature is exceptional not only for its likeness of Charles but also for its depiction of him as the enthusiastic agent of intellectual inquiry. The astrological text contains practical advice on war, pestilence, and dreams drawn from the writings of ancient and Arabic sages.[24] Aristotle's leading role in the frontispiece corresponds to his position in the text, where his authority on celestial matters remains preeminent.

The Dauphin also commissioned two treatises on astrology from another of his household astrologers, Pélerin de Prusse. The first, on the twelve houses of the planets, is dated 11 July 1361; the second, on the astrolabe, 9 May 1362.[25] In the prologue to the first treatise the author refers not only to Charles's insistence on clear writing in French but also to his avid search for instruction on astrological lore that affects rulers. A miniature in a manuscript in St. John's College, Oxford, shows Charles receiving the work from the author while engaged in active dialogue with him (Fig. 2). Although Charles's likeness is conventional, the miniature features a well-organized room furnished for scholarly purposes that corresponds to Christine de Pizan's glowing description of the king's private study.[26] The elaborate horoscopes of the royal family added to the treatise in 1377 attest to the king's lasting interest in the texts of this manuscript.[27] Thus, the first two works commissioned by Charles in the early 1360s show that he viewed astrology as a way to control political events rather than as a disinterested investigation of natural philosophy. Yet the Dauphin's active intellectual engagement with the subject shows him to be capable of developing more theoretical areas of learning.

Charles's enthusiasm for astrology may well have aroused the anxiety of his mentor. Oresme was a fierce opponent of using astrology to predict the future.[28] In general, Oresme disliked the irrational approach of astrology, as he preferred to account for terrestrial phenomena by natural causes rather than by occult celestial

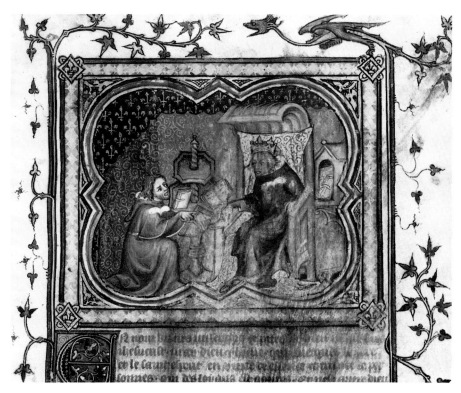

FIGURE 2 *Charles V Receives the Book from Pélerin de Prusse.* Nicole Oresme, *Traitié de l'espere,* and Pélerin de Prusse, *Astrological Treatises.*

influence. His theory that celestial motions were incommensurable meant that their configurations would not be repeated. This notion nullifies a basic premise of astrological prediction.[29]

Oresme's French writings on astrology offer concrete examples of the dangers faced by rulers who depended on this form of knowledge. In his *Livre de divinacions* he addresses "princes and lords to whom appertains the government of the commonwealth." Although not directed to Charles specifically, Oresme gives historical examples of rulers whose reigns ended disastrously because of their attempts to predict the future.[30] He does not totally deny the value of astrology to the ruler but separates its scientific aspects from reliance on divinations and occult practices.[31] Oresme stresses that the most basic form of knowledge for a ruler is the science of politics. Oresme's description of politics as "architectonic" and as the "princess and mistress of all human science"[32] in the prologue of his translation of Aristotle's *Politics* reveals his pedagogical motivation in translating the *Ethics* and the *Politics* conceived in the spirit of Mirror of Princes literature. This educative tone substantiates the tradition that Oresme served as mentor to the Dauphin.

The first translation commissioned from Oresme by Charles also reinforces their close personal and intellectual ties. Not surprisingly, the text is an astrological

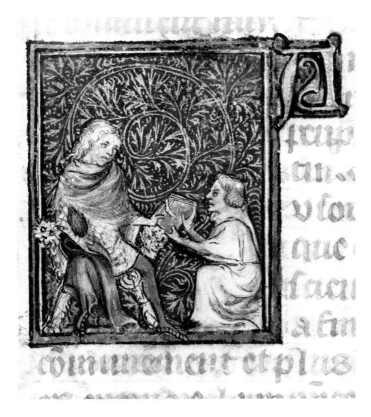

FIGURE 3 *The Future Charles V
Receives the Book from Nicole Oresme.*
Ptolemy, *Le Quadripartit.*

treatise based on Plato of Tivoli's Latin version of the *Quadripartitum* of Ptolemy
with commentary by Ali ibn Ridwan.[33] Both the attribution and date of the manu-
script are controversial. Delachenal's arguments that Nicole Oresme (not his
brother the less-known Guillaume Oresme) was the translator are persuasive, as is
Clagett's dating of it between 1357 and 1360.[34] Delachenal refers to the ideas and
language that later reappear in Oresme's prologues to his translations of the *Ethics*
and the *Politics.* Among them are the translator's praise of the beauty of the French
language and of the royal house for commissioning works in this tongue.[35] Fur-
thermore, in several glosses of the *Ethiques* and the *Politiques* Oresme mentions in
familiar terms the French version of the text.[36] Reference to "Charles, hoir de
France, à present gouverneur du royalme" (Charles, heir to the crown of France,
at present regent of the kingdom), seems to limit the date to the return in 1360
of John the Good from captivity in England. Another kind of evidence for attrib-
uting the treatise to Nicole Oresme is the tiny illustration at the head of the first
column of the prologue (Fig. 3). The style of the miniature confirms an early
dating of the text, while its iconography makes it the earliest known example of
an informal dedication portrait from Charles's iconography.[37] The appearance of
the iconographic type of the intimate presentation portrait testifies to a one-to-

one relationship between prince and author. Charles's mantle, shoulder-length hair, and beard are features repeated incisively in Figure 1. By contrast, the figure of Oresme, who looks squarely at the Dauphin, is far more substantial than that of the wispy prince. The short, chubby portrait type of Oresme is consistent with similar images in the later dedication scenes of his translations of the *Ethics* and the *Politics*.

Oresme's favorable comparison of the valiant kings of France to the Roman emperors who had sponsored translations of Greek classics into Latin hints at the theme of the *translatio studii*. More specifically, Oresme is thinking of John the Good's patronage of Jean de Sy's translation of the Bible and Pierre Bersuire's French version of Livy.[38] The prologue states that, with these precedents in mind, Charles commissioned the present translation of a work that contains the most noble science: astrology that is free of superstition and composed by excellent and accepted philosophers.[39] In other words, Oresme says, this text of the *Quadripartitum* is an example of the kind of knowledge about the physical world that does honor to the prince and benefits the public good.[40]

Oresme's work of mathematical astronomy, his *Traitié de l'espere* (On the Sphere), is not specifically addressed to Charles.[41] The concluding chapter, however, mentions that the treatise is intended to be useful knowledge for every man, especially for a prince of noble mind.[42] Oresme is writing for a lay audience, similar to the one mentioned in his version of the *Quadripartitum*. The copy of the text in the king's library strengthens the hypothesis that Oresme had Charles in mind as a primary reader. In fact, the *Traitié de l'espere* precedes the treatises by Pélerin de Prusse discussed above. In a miniature from this manuscript, Charles is reading and studying by himself (Fig. 4). Seated in a high-backed chair, he holds one book open on his lap, while he consults another lying on his revolving book-stand. The fleur-de-lis pattern on the walls and floor allude to his rank. Although the portrait is conventional, the image establishes Charles as an active seeker after knowledge. Indeed, the presence of the armillary sphere suggests that Charles is pondering the subjects treated in Oresme's work. Despite certain problems with the date of this manuscript, the text and image of the *Traitié de l'espere* testify not only to Charles's intellectual character but also to a type of knowledge about the celestial world Oresme considered appropriate for both a layman and a prince.

Certain features of the book emphasize its pedagogical character. Among them is the large historiated initial on folio 2 depicting a scholar (possibly a conventional portrait of the author) pointing at an armillary sphere. Dominating the text is a series of rather crude, but clearly labeled, diagrams explaining basic concepts in the text. The glossary of sixty-eight scientific and technical terms supplied by Oresme also addresses the general, educated reader.[43] The inclusion of Oresme's treatise on acceptable "astronomical" knowledge in the same manuscript as Pélerin de Prusse's astrological works is ironic. The compilation indicates the difficulty of Oresme's task in defining the boundaries of knowledge that he considers beneficial to Charles.

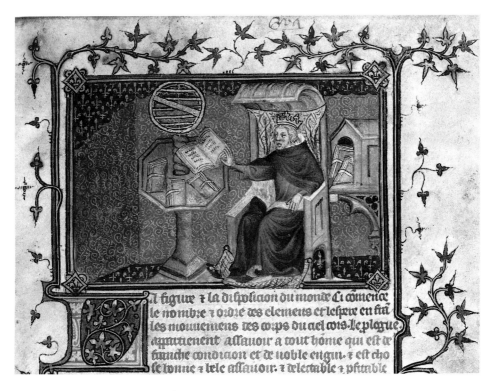

FIGURE 4　*Charles V Studies Astrology.*
Nicole Oresme, *Traitié de l'espere,* and
Pélerin de Prusse, *Astrological Treatises.*

While the dating of Oresme's early writings is controversial, the motivation for his shift from Latin to the vernacular seems clear. As soon as he developed political ties with Charles and his circle, he found it necessary to express his ideas in French. In order to exert his influence, he had to recast not only his language but also the formulation and compilation of his treatises. These early writings in French provided the model for Oresme's more elaborate and sophisticated translations of the 1370s.

ORESME'S LATER CAREER

After Charles's accession to the throne in 1364, Oresme continued to enjoy the confidence of the new sovereign. Two years earlier, Oresme had been appointed canon of the cathedral of Rouen, where he was named dean shortly before Charles's coronation. In 1363 he was made a canon at the Sainte-Chapelle, Paris. Upon completion of the Aristotle translations, with royal support he became bishop of Lisieux in his native Normandy. He held the post from 1377 until his

death five years later. Oresme also undertook official missions for the king, such as a journey in 1363 to Avignon to persuade Pope Urban VI to remain in that city under Charles V's protection. In an official document of 1377 Oresme is called counsellor of the king, although his appointment to that position may have come earlier. In his prologue to the *Politiques,* Oresme refers to himself as Charles's chaplain. Oresme played a conspicuous part in two important ceremonial occasions of the reign. During the visit in 1378 of the king's uncle, Emperor Charles IV, Oresme was a member of the delegation that escorted him to Vincennes. Later, the chronicles mention him among those taking part in the funeral ceremony of Queen Jeanne de Bourbon.[44] Oresme's long service to the crown included diplomatic and political acts, as well as less measurable intellectual contributions. Among them, his translations of Aristotle's works are highly significant, culminating his long personal and political ties with Charles. In these works, Oresme remained consistent with his earliest French writings, in which Aristotle's thinking served as a model for the prince's right conduct and rule.

3 NICOLE ORESME AS MASTER OF THE TEXTS

CHANGING STRUCTURES OF THE MEDIEVAL BOOK

As master of the texts, Oresme inherited a long classical and medieval tradition regarding the theory and practice of translation. His approach would have been especially mindful of Roman rhetorical theory and its application to moral philosophy and political science, particularly to issues of practical wisdom. Interpretive and exegetical techniques drawn from ancient and medieval rhetorical treatises affected the style and content of the "replacement" texts composed for and directed to new audiences.[1] Like rhetoric, the translations themselves are part of a system of communication captured within the physically delimited space and structure of the codex. As the recent study by Mary Carruthers demonstrates, the medieval book is designed as a complex cognitive structure that helped the reader to understand the text.[2] Through layout, writing, methods of compilation, and organization, medieval texts were fashioned to advance certain psychological processes, of which memory and recollection are the chief tools of cognition.[3] Carruthers's study emphasizes the role of internal and external imaging in Aristotelian and medieval memory theory.[4] In both the design and compilation of his texts, as well as in the programs of illustrations, Oresme's strategies as a translator appear to reflect his awareness of, and response to, these rhetorical and cognitive traditions.

Nicole Oresme's arrangement and compilation of his translations for a lay readership include features unusual in vernacular texts of this period. Aids for the reader, such as an alphabetical, cross-referenced index of noteworthy subjects in the *Politiques* are, however, not Oresme's invention. During the thirteenth century, the need to retrieve certain types of information for specific audiences and newly created institutions governed developments in the layout, arrangement, and apparatus of original, as well as of authoritative, works composed in Latin. One source of this change was the founding of the mendicant orders, whose mission was to deliver sermons to the laity and to write works combating heresy. Consequently, preachers required access to authoritative texts that were organized in such a way as to permit retrieval of specific topics that formed the basis of sermon materials. Collections of exempla, biblical concordances, and *distinctiones* are among the reference books specifically developed for sermon writers.[5]

In addition, the growth of universities during the thirteenth century brought better organization to manuscript production and the book trade under university

control.[6] Teaching and scholarship required, instead of collections of excerpts, study of original texts essential to the training of orthodox preachers and theologians. Both students and professors had to locate quickly precise references on specific subjects. To facilitate research, books were broken down into chapters or even smaller units. Tables of contents, indexes, and chapter summaries aided readers in consulting texts.[7] As Malcolm Parkes has indicated, the arrangement and accompanying apparatus for university texts brought significant changes in the *mise-en-page* of the manuscript book.[8] Among the devices that made scholastic texts easier to read was rubrication, which marked sections of the text and indicated the source of glosses. In analytical tables of contents, alternating red and blue initials divided chapters one from another, while red ink was used for headings and black for subheadings. Running titles and other locators became standardized features that helped readers find their way through materials required for professional purposes. Such devices were associated with psychological theories and practices to promote cognitive mastery of texts.

Although these developments first occurred in religious texts, law and medical schools adapted these methods of organization and compilation to works in their own fields.[9] Also a beneficiary of these new procedures was the corpus of Aristotelian works that became available in Latin translations during the thirteenth century. Indeed, the process of assimilating the structure of Aristotle's works to Christian thought promoted the development of various research tools, including those mentioned above. From about 1250 Aristotle's works on logic, natural science, and the *Ethics* were accompanied by alphabetical indexes.[10] In fact, alphabetical order as a system of organizing references was a conspicuous feature of guides to Aristotle's works.[11] For example, the reference system for a topic includes the title of the work, the volume and chapter numbers, and a letter of the alphabet indicating placement within a chapter.[12] Robert Grosseteste, bishop of Lincoln, who in 1246 to 1247 made the very influential translation from Greek into Latin of all ten books of the *Nicomachean Ethics,* not only added notes to the Greek commentaries but also compiled a summary of the important points in each chapter. The aim of this summa, called *Tituli,* was to help the reader understand and remember the text.[13] In a magisterial work, Martin Grabmann discusses the vast array of commentaries, summaries, excerpts, and tables of contents that accompanies the Latin translations of the Aristotelian corpus and facilitates its appropriation by and assimilation to medieval intellectual life.[14]

For the most part, such developments in the organization and arrangement of the book were directed to a clerical audience. But during the fourteenth century, historical works commissioned by courts or royal patrons were equipped with alphabetical indexes and other finding aids. Thus, a manuscript of the *Faits des Romains,* written between 1324 and 1331 at the Angevin court at Naples, contains a large Latin table of contents.[15] In 1330 a second edition of a universal history written for King Philip VI is equipped with an alphabetical table of contents, a device hitherto unfamiliar to lay readers.[16] During the fourteenth century, writings in the vernacular gradually acquired the apparatus, methods of compilation, and the *mise-en-page* previously limited to Latin works.[17]

Oresme's translations of the *Nicomachean Ethics* and the *Politics* are the first extant, complete translations of Aristotelian texts in a modern language. According to Albert D. Menut, who made the critical editions of these works, the translation of the *Ethics* was done first and must have been begun at least a year earlier than 1370, the date given in the translator's prologue.[18] In turn, Oresme probably based his French version of the *Ethics,* here referred to as the *Ethiques,* on a manuscript of a revised edition of the Grosseteste translation made in Paris about 1270. For his own commentary, Oresme drew extensively on Albert the Great and on Thomas Aquinas's *Commentary on the Nicomachean Ethics,* as well as on later commentaries by Walter Burley and Jean Buridan.[19] Oresme made only one redaction of the text, of which the oldest known copy is MS *A,* dated after 1372.[20]

Oresme's French version of the *Politics,* referred to here as the *Politiques,* is based on the translation from Greek into Latin by William of Moerbeke dating from about 1270.[21] Léopold Delisle identified Oresme's own copy of his French version that serves as the basis of the critical edition by Albert D. Menut.[22] Delisle discovered that Oresme made three separate redactions of his translation of the *Politics.* Usually included with the *Politics* is a short treatise, the *Economics.* No longer considered an Aristotelian work, the *Economics* has a complex history. In his critical edition and translation of Oresme's French version, referred to here as the *Yconomique,* Menut traces its varied sources, including William of Moerbeke's Latin translation from Greek originals.[23]

Oresme was thus working with authoritative translations that bore equally authoritative and worthy commentaries. The medieval Latin of these translations had evolved as the international language of communication of a clerically dominant elite. The thirteenth-century translations of the Aristotelian corpus greatly enriched medieval Latin as an instrument of both abstract thought and social control.[24] These works relied on principles of interpretation and commentary inherited from ancient Rome, modified by the Christian exegetical tradition, and composed in an academic format appropriate for its clerical audiences.

Oresme continued the academic format of the Latin Aristotle translations and in doing so appropriated for the vernacular their authoritative status.[25] He was aware of the tension between the richness of the Latin sources and the limitations of the vernacular. In re-presenting Aristotle to a new and well-defined lay audience, he had a definite didactic goal.[26] Among his problems was making the works intelligible in a language that lacked conceptual, syntactic, and lexical subtlety. In the "Excusacion et commendacion de ceste oeuvre" (Apologia for and justification of this work) Oresme states: "Et comme il soit ainsi que latin est a present plus parfait et plus habondant langage que françois, par plus forte raison l'en ne pourroit translater proprement tout latin en françois" (And if it is the case that Latin is at present a more perfect and richer language than French, it is all the

more obvious that one could not translate all of Latin into French).[27] Furthermore, the Aristotelian works require understanding of a technical philosophical and political terminology. The translator acknowledges the difficulty in another passage of the "Excusacion":

> D'autre partie, une science qui est forte quant est de soy ne puet pas estre bailliee en termes legiers a entendre. Mais y convient souvent user de termes ou de moz propres en la science qui ne sont pas communelment entendus ou cogneüs de chascun. Mesmement quant elle n'a autre fois esté traictiee et excercee en tel langage. Et telle est ceste science ou regart de françois.

> (On the other hand, a science that is difficult in itself cannot be rendered in terms easy to understand. But it is often appropriate to use terms or words proper to the discipline which are not commonly understood or known to everyone, especially when it has not already been treated and handled in such a language. And such is this discipline in regard to French.)[28]

Oresme was faced with a not unusual conflict between adhering to the literal meaning of the Latin translations, which were often obscure in themselves, and presenting a clear, if more general, sense of the texts. He puts the problem this way:

> Par quoy je doy estre excusé en partie se je ne parle en ceste matiere si proprement, si clerement et si ordeneement comme il fust mestier; car, avec ce, je ne ose pas esloingnier mon parler du texte de Aristote, qui est en pluseurs lieux obscur, afin que je ne passe hors son intencion et que je ne faille.

> (For which reason I am to be excused in part if I do not express myself as appropriately, as clearly, and as methodically as is required; for in matters like these I do not dare to depart from Aristotle's text, which is often obscure, lest I go beyond his meaning or fall short of it.)[29]

Oresme took up this challenge in several ways. To enrich the vernacular vocabulary, he introduced over 450 neologisms.[30] Many were *calques,* Latin adaptations of Greek words provided with French endings.[31] Oresme also used double translations, a method of explanation that provided synonyms connected by a conjunction. He occasionally added an exposition of short phrases or clauses, as well as a gloss that further defines a word, its etymology, or both.[32] In some instances he omits passages from the text and makes changes to simplify and clarify the Latin translation. Oresme followed the pattern of the medieval translator who, in offering a replacement text, was "master of the author."[33] His glosses and commentaries were primary vehicles of his authorial identity.

Oresme's translations of Aristotle are early examples of transferring to a modern language sophisticated methods of arranging and compiling learned texts. As noted above, Oresme may have followed the example of Pierre Bersuire's glossary of unfamiliar words placed at the beginning of his translation of Livy's *History of Rome*. An even earlier example of such a glossary is, however, found in a moral treatise produced in Flanders at the end of the thirteenth century, *Li ars d'amour, de vertu, et de boneurté*.[34]

Oresme's *Traitié de l'espere* is the first of his French works equipped with an alphabetical list of some sixty-seven words following the last chapter. A two-line initial introduces each new letter of the alphabet. A word is placed in the first of three columns. In the second, Roman numerals mark its location within the chapter. And in the third, a letter denotes the place within the chapter where the word is first defined. The letters appear in the designated places in the margins of Charles V's copy of the text (Oxford, St. John's College, MS 164). Oresme includes an explanation of how the glossary works.[35]

This system is less useful to the reader than a glossary that collects at the end of the volume all the definitions of new words. This was the procedure Oresme followed in Charles V's first copy of his translation of the *Ethics*. The glossary of fifty-five words is entitled "La table des moz divers et estranges" (The table of explanations of difficult words). An introductory paragraph describes the purpose of the glossary and how to use it.[36] The fact that Oresme explains the meaning of alphabetical order shows that this system of organizing references was not familiar to his readers.[37] He includes twelve words transliterated from Greek, as well as philosophic, linguistic, ethical, or political terms. The definitions are full and clear, with references to glosses, book and chapter locations in the text, and synonyms.[38]

As a reflection of the greater interest of the *Politics* to both patron and translator, the glossary is longer and more developed than in the *Ethiques*. The table of explanations of difficult words comprises some 132 words, some of which repeat terms explained in the *Ethiques*. Although the *Politiques* word list does not refer to specific locations in the text, it includes cross-references to the *Ethiques* and cites various sources in the Bible or classical authors as examples of the meaning of a word. Oresme also gives contemporary exemplars of Greek words. For instance, he cites as an example of the term *demagogue* Jacques d'Artevelde, a Flemish leader of a mid-fourteenth-century insurrection against the French. Following the short prologue, the *Politiques* also includes an instruction to the reader that singles out a series of words essential to an understanding of the text. The translator refers to the chapter titles and the glossary as finding aids, since Oresme is aware of the many neologisms introduced in his translations. Among the essential and unfamiliar terms mentioned are four of Aristotle's six forms of government.[39]

A special feature of the *Politiques* is the index of noteworthy subjects, the "Table des notables." Here are found examples of essential terms defined in the glossary,

such as *citoien,* with references to books and chapters. Seven different citations of *citoien,* ranging from one sentence to several lines, are offered to clarify the content and context of a term possibly unfamiliar to the contemporary reader.[40] Multiple entries are arranged according to order of appearance in the text: citation of a term in Book II will precede one that appears in Book III. Oresme also includes cross-references to related terms. Since the index of noteworthy subjects follows an alphabetical organization according to key terms, Oresme provides a list of them as a preface to the "Table des notables." He calls this feature "Les mos par quoi l'en trouve les notables" (the words by which one finds the notable topics) and includes a paragraph describing its purpose and use.[41] The words total 112 and range from discussions of morality and immorality and the upbringing and education of children to political terms and institutions. The extensive entries for *cité* (nineteen), fourteen for *gent sacerdotal* (priestly class), twenty-three for *lays* (laws), and twenty-five for *policie* (regime) not only summarize the most important topics in the text but present Oresme's opinions about them.

The amount of space devoted to the glossary and index indicates the significance attached to them: twenty folios in *B* and fifteen in *D.* Furthermore, in *B* the calligraphic presentation of the key words preceding the index and of the "Table des notables" itself is lavish. Painted initials with pen flourishes and line endings, as well as rubrics and alternating red and blue capital letters, facilitate the sequential and separate reading of these verbal aids so densely packed with information.[42]

PREFATORY AND EXPLANATORY MATERIALS

While the index and glossary that accompany Oresme's translation of the *Ethics* and the *Politics* are relatively novel features in contemporary book compilation, other elements designed to direct the reader through the books were standard for the time. Chapter headings for each book precede the text, while numbers at the top of the folio called running titles indicate the number of the book. Written in the margins, chapter numbers direct the reader to specific subdivisions within the text. Summary paragraphs in rubrics usher in new books, while text endings clearly demarcate one unit from another. Among the most important features to direct the reader through a text are the division into chapters and the summary list of chapter headings at the beginning of each book or text division. Oresme apparently increased the number of chapters, shortening and rearranging the Latin translations, since smaller units of difficult subject matter are easier to grasp, especially when they are accompanied by summaries of their contents.[43] Oresme also summarized the content of each entire book in a short introductory paragraph.

Oresme offered guidance to the reader, unusual for the time, in his lengthy "Proheme" to the *Ethiques* and in the accompanying "Excusacion et Commendacion de ceste Oeuvre."[44] While the prologue to the *Politiques* is much shorter than that of the *Ethiques,* Oresme gives more specific instructions to the reader for the use of the book. As previously noted, this short text explains the system of compi-

lation Oresme used. Furthermore, MS *B,* Charles V's first copy of the *Politiques,* contains an apparently unique second instruction to the reader.[45] In it, Oresme explains the meaning of the bifolio frontispiece. All the prefatory materials indicate Oresme's awareness of linguistic problems in translating the complex Latin texts into a less-developed language and the necessity of directing the reader to the glossaries and indexes that will clear a path through these difficult works.

GLOSSES AND COMMENTARIES

In his glosses and commentaries to the *Ethics* and *Politics* Oresme follows an ancient tradition of scholarship. Through the centuries the works of Aristotle had accumulated an impressive wealth of commentaries, including those of Byzantine and Arabic writers that were incorporated in the twelfth- and thirteenth-century translations from Greek and Arabic into Latin. The process of assimilating the Aristotelian corpus to the structures and beliefs of Christian theology produced extremely important commentaries by Thomas Aquinas and Albert the Great during the thirteenth century, and in the fourteenth, by Walter Burley, Jean Buridan, and others, mentioned above. Yet it does not follow that Oresme had to follow this path in vernacular translations addressed to a nonacademic audience. Indeed, although other translations commissioned by Charles V, such as that of the *City of God,* contain explanatory materials within the text, they do not include the scholarly apparatus of the clearly separated gloss or commentary.[46] As Menut suggests, Oresme may have wished to keep intact the authoritative and scholarly character of the Aristotelian works without neglecting the moral and intellectual guidance of the reader.[47] As noted above, by preserving the academic form of the Latin translations, he was appropriating or transferring their authority to the vernacular. The translator may also have relished the opportunity not only to demonstrate his knowledge of the texts and scholarly tradition but also to place on the same level as the great commentators his opinions and resolution of knotty problems.

The proportion of glosses (defined as short, explanatory notes) to commentaries (extended interpretations or discussions) in Oresme's translations of Aristotle vary considerably. For example, the *Ethiques* contains only three commentaries and the *Yconomique,* six. By contrast, the *Politiques* contains many commentaries, as does the translation of a fourth Aristotelian work, *On the Heavens.* Especially in the *Politiques* Oresme addresses leading issues of the day and tries to reconcile Aristotle's views with those of the contemporary world.[48]

Susan Babbitt has analyzed the types of glosses in the *Politiques,* which in many cases apply also to the *Ethiques* and *Yconomique.*[49] The first group explains a particular aspect of the text. For example, a gloss can explicate the purpose or location of a segment of the text in the sequence of Aristotle's argument, or it can provide a cross-reference to another part of the work in which a topic is discussed. Oresme also uses a gloss to summarize certain points or to finish a sentence. In another category, Oresme is concerned with definitions of words, their etymologies, or identification of persons or places. Yet another type provides concordances from

biblical, patristic, or antique sources that buttress a particular Aristotelian argument or statement. If Oresme does not find a statement acceptable, in some instances he will contradict "the Philosopher." Such glosses may relate to Oresme's explanation of obscure or ambiguous passages in Aristotle's text. On such occasions, he may call on earlier commentators for help in working out the sense of the text portion. Sometimes in glosses Oresme raises his personal objections to ideas in the texts or views held by earlier commentators. Even more interesting is Babbitt's identification of the commentaries in the *Politiques* that cover one or more folios. Among the topics covered are church-state relationships, problems within the church, types and values of kingship, and various ethical, political, and philosophical discussions.[50] Indeed, recent scholarship considers that Oresme's commentaries on the *Politics* are important contributions to the understanding and interpretation of Aristotle's text.[51] Unlike previous commentators, Oresme set out to interpret Aristotle in the light of contemporary institutions. In turn, his commentaries on issues of the day, such as the need for reform of the church, became the basis of further interpretation during the later fourteenth and fifteenth centuries.[52]

Between the two sets of Charles V's manuscripts of the *Ethiques* and *Politiques* the format of the separation of text from gloss differs considerably. By far the more elegant arrangement is found in *A* (Fig. 11) and *B* (Fig. 55). In them the text is written in two narrow columns of thirty-five lines in script larger than the glosses in the four surrounding margins. *Renvois,* or linking symbols, appear next to a word, phrase, or passage as a sign that it is the subject of a gloss. This symbol is repeated in front of the gloss. Rubrics repeating the key words of the gloss help to link the two parts separated from each other on the page. This layout has the advantage of maintaining the continuity of the text in a way a gloss inserted directly in the text column does not.[53] As Menut observes, if the gloss expands to the length of a commentary, its added length would extend over several folios and disturb the clarity and neatness of the format. Such a layout, borrowed from civil-law manuscripts, is appropriate for volumes of large size. Production is more expensive, since a relatively smaller amount of text can fill a folio and a less uniform layout is required. It is, therefore, not surprising that the smaller, portable set of the *Ethiques* and *Politiques* (*C* and *D*) produced for Charles V abandoned this elaborate format. On the first folio of the *Politiques* the worthy scribe Raoulet d'Orléans explains the system: "Je, Raoulet d'Orliens, qui l'escri, ay mis le texte premier, ainsi signé *T;* est après la glose s'ensuit, ainsi signée *O,* qui fait Oresme (I, Raoulet, who transcribed it, have placed the text first, designated thus [as] *T;* then the gloss follows, designated thus [as] *O,* which was done by Oresme).[54] With the extensive commentaries in the *Politiques,* this layout, in which gloss immediately follows the text passage, is more practical, as well as less expensive.

TRADITION AND INNOVATION IN THE ILLUSTRATIONS

Illustrations of the Latin versions of the *Ethics* and the *Politics* are limited to historiated initials, most frequently representations of Aristotle teaching. Therefore the

development of programs of illustrations for the French translations of these texts is a significant occurrence. The taste for illustrations in vernacular texts gradually developed during the thirteenth and fourteenth centuries as a reflection of the preferences of their patrons.[55] As was discussed in Chapter 1, the Capetian and early Valois monarchs built up a tradition of commissioning French translations of Latin texts that had not been previously illustrated. As Ruth Morse points out, the commission of vernacular translations, presented in expensive illustrated copies, conferred prestige and power on the patrons.[56]

Charles V shared this predilection and took an active part in the production of manuscripts that were particularly important to him.[57] In her biography of Charles V, Christine de Pizan describes the king's "active supervisory role in the making of the volumes that entered his collection."[58] Several documents that specify payments for parchment indicate the king's personal involvement in book production.[59] Recent studies emphasize Charles V's role in the editing and rewriting of texts that had important political implications.[60] Two colophons in his *Coronation Book* and his copy of Bersuire's translation of Livy specify that the king had the books illustrated.[61] François Avril believes that Charles V may have requested, and had a hand in composing, an explication of an unusual frontispiece of a *Bible historiale* commissioned by him.[62] Charles V's taste for heavily illustrated manuscripts of French translations of Latin texts is analogous to his preference for the vernacular. Illustrations concretize and update concepts of the source language. Indeed, as detailed analysis of the *Ethiques* and *Politiques* cycles will reveal, the function of many images is that of a visual glossary or definition of neologisms or unfamiliar terms introduced into French by Oresme. Another dimension of this analogy is the appearance in the art of this time of a more naturalistic style manifest in portraiture and the representation of landscape.

In two respects the programs of the *Ethiques* and the *Politiques* differ from those of other vernacular translations commissioned by Charles V. First, these are the only illustrations that consistently employ inscriptions embedded in or surrounding the text. This inscribing of the verbal within the visual is essential to the didactic and mnemonic functions of the illustrations.[63] Second, except for frontispieces to various types of texts and the cycle of the *Cité de Dieu* illustrations, the *Ethiques* and the *Politiques* programs offer more than usually complex visual structures, characterized by departure from a column format and division of the picture field into two or three registers. These features show special care in linking image and text to order and direct the reader's understanding of the works.

ORESME'S ROLE IN DESIGNING THE PROGRAMS OF ILLUSTRATION

Oresme's multifaceted career does not include any obvious connection with the visual arts. Yet his training in Aristotelian and scholastic logic may have spurred him to emphasize definition and demonstration as essential tools of both verbal and visual arguments. Likewise, his absorption of Aristotelian, Roman, and medieval rhetorical works may have guided his organization of the visual structures of

the programs. His choice of contrasting representational modes of personification, metaphor, and allegory for the *Ethiques* and paradigm for the *Politiques* and *Yconomique* may reflect the application of general rhetorical strategies.

In a different vein, Oresme's many writings on natural science involve theories of vision and perception, light, and color.[64] Furthermore, Oresme was familiar with the importance Aristotle himself assigned to images. For example, in Oresme's *De causis mirabilium* and his *Questiones super libros Aristotelis de anima,* he devotes many passages to discussing theories of cognition and memory based on the Philosopher's classic works.[65] In the *De memoria et reminiscentia* and the *De anima,* Aristotle assigns a crucial role to images in the processes of human thought and memory. As Janet Coleman states: "What we perceive and thereafter conceive must be imageable by the mind. Not only is memory pictorial but Aristotle assumes the world can be known empirically: signs, words, images do correspond for the most part to objective reality in a satisfactory way."[66] Frances Yates and Mary Carruthers also have shown that scholastic memory treatises and other medieval texts emphasize the role of visual images in locating and assimilating ethical concepts.[67] By inscribing verbal concepts within the illustrations' pictorial field, Oresme could enrich the scope of his arguments and, by association, imprint words and images within the memory of the reader.

Oresme's writings on physical and natural science may connect with an interest in aesthetics taken up in various and sometimes unexpected contexts. One such instance is the concept of proportion. An early Latin writing, *De proportionibus proportionum,* discusses the topic in mathematical terms.[68] The concept of proportion in relationship to the body politic is a feature of Oresme's influential treatise *De moneta. Proporcion* and *proporcionalité* are neologisms Oresme introduced into French while translating the section on Distributive Justice in Book V of the *Ethiques.*[69]

Oresme's theoretical interests and training may well have affected his planning of the program of illustrations. But his role of designer took place within a well-defined system of book production.[70] Patrick de Winter points out that along with the *libraires,* official booksellers, and *stationnaires,* "the equivalent of modern publishers," *écrivains,* or scribes, had considerable responsibility for the execution of a manuscript. *Ecrivains* not only carried out the system of rubrication and laid out the book but also hired the illuminators, miniaturists, and perhaps the binders for luxury books.[71] Among the official *écrivains* of Charles V was Raoulet d'Orléans, who worked on two manuscripts of the king's copies of the *Ethiques* and the *Politiques, C* and *D.*[72] Raoulet d'Orléans was one of the most honored copyists of his time. Twelve manuscripts dating from 1362 to 1396 carry his signature,[73] and his composition of several long verse colophons to manuscripts that he copied reveal his self-confidence and pride. In one of them, a *Bible historiale* presented to Charles V, he mentions the lavish nature of the book's decoration and praises the efforts of the person who brought it together. The implication is that he acted as the coordinator of the book's production.[74]

Oresme worked closely with Raoulet in re-editing the layout and text revisions of the second set of Charles V's copies of the *Ethiques* and the *Politiques.*[75] As

master of the text, the translator would also have designed the revised program of illustrations, as he would have done for the first two copies of his translation of the *Ethics* and the *Politics*. Independently, or with Raoulet's help, Oresme would have forwarded instructions to the miniaturist responsible for the execution of the illustrations. Since new illustrations were required, scholars assume that the translator who had knowledge of a given work would have been the person to furnish such instructions. The outstanding example of such an explicit, verbal set of instructions occurs in Jean Lebègue's edition of Sallust dating from 1418 to 1420. The illustrations in a surviving manuscript correspond exactly to these instructions.[76] Contemporary with the *Ethics* and the *Politics* translations, a manuscript of a moral treatise, *Le miroir du monde,* includes instructions to the illuminator for a series of fifteen images of virtues and vices.[77] A related, if rare, tradition in fourteenth- and fifteenth-century French manuscripts provides a written explication to the reader of an unusual or complicated program of illustration. The earliest surviving example is contained in the Belleville Breviary of about 1330.[78] François Avril discovered an anonymous guide to the meaning of an unusual frontispiece to the second volume of a *Bible historiale* commissioned by Charles V.[79] As noted elsewhere, Oresme furnished such an explanation at the beginning of the king's first copy of the *Politiques*. Another contemporary example of a program of illustration based on written instructions to the illuminator is the presentation copy of Raoul de Presles's translation of Augustine's *City of God*.[80] Here, Sharon Smith found that the iconography of various illustrations depends on certain obscure passages of glosses furnished by the translator, who alone would have been familiar with their content. The same observation holds true for key illustrations in Charles V's copies of the *Ethiques* and the *Politiques*.[81] In other words, the illustrations constitute another level of translation of concepts and other interpretive materials familiar only to Oresme.

Unfortunately, no written program for the illustrations of the *Ethiques* and the *Politiques* survives. Nor are there traces in the margins of Charles V's copies of these texts of abbreviated verbal instructions to the illuminator, rough sketches, or notes for background color or patterns, notes so meticulously recorded in Charles V's copy of the *Grandes chroniques de France*.[82] Yet, as the discussion in Parts II and III will disclose, Oresme's role as designer of the programs of illustrations of his translations of the *Ethics* and the *Politics* emerges from the close relationship between the illuminations and his texts, glosses, glossaries of difficult words, and index of noteworthy subjects.

PERSONIFICATIONS AND ALLEGORIES AS COGNITIVE AND MNEMONIC SUBJECT GUIDES

The Programs of Illustrations in Charles V's
Copies of the *Livre d'éthiques*

4 PRELIMINARY CONSIDERATIONS

Among the valuable information contained in Oresme's prologues to his translations of the *Ethics* and the *Politics* is his identification of the readers and the functions of the works.[1] In stressing the universal and historical authority of the works, Oresme insists on the primacy among the Philosopher's writings of these texts.[2] Regarding them as two halves of one work, Oresme describes the *Ethics* as a "livre de bonnes meurs" (book of good morals), aiding the individual to live the good life, while he designates the *Politics* as the guide to the "art et science de gouverner royaumes et citéz et toutes communitéz" (the art and science of governing kingdoms and cities and all other communities).[3] The two are interconnected inasmuch as the goal of the political community is to help the citizens to lead the best life defined in the *Ethics,* while the *Politics* is concerned with the systematic study of the ideal political community.

In praising God for providing his people with a ruler "plain de si grant sagesce" (full of such great wisdom), Oresme identifies Charles V as the most crucial member of his audience. For, the translator asserts, after the Catholic faith, nothing is more beneficial to the king's subjects than a knowledge of the *Ethics,* which teaches an individual to be a "bon homme" (good man).[4] Thus, Oresme rightly establishes a context for the translations within the tradition of Mirror of Princes texts: both the *Ethics* and *Politics* are deeply concerned with the education of the young and the conduct of rulers.

Oresme's prologue to the *Ethiques* mentions not only the prince but his counsellors as readers who will profit from study of these works. Since the *Politics* deals with the science of government, Oresme links knowledge of these texts with the common good: "ceste science appartient par especial et principalment as princes et a leurs conseilliers" (this knowledge concerns first and foremost princes and their counsellors).[5] Oresme goes on to say that the study of all books brings about "affeccion et amour au bien publique, qui est la meilleur qui puisse estre en prince et en ses conseilliers, après l'amour de Dieu" (attachment to and love for the public good, which is the best kind of love a prince and his counsellors could have after the love of God).[6]

In addition, Oresme includes an unnamed group, identified only as "autres" (others), who will also profit by French versions of the *Ethics* and *Politics,* since the Latin texts are so difficult to understand:

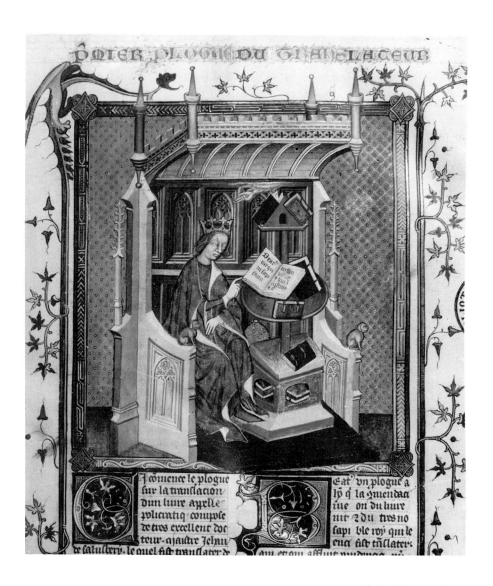

FIGURE 5 *Charles V Reads in His Study.* John of Salisbury, *Le policratique.*

le Roy a voulu, pour le bien commun, faire les translater en françois, afin que il et ses conseilliers et autres les puissent mieulx entendre, mesmement *Ethiques* et *Politiques,* desquels, comme dit est, le premier aprent estre bon homme et l'autre estre bon prince.

(The king has desired for the sake of the common good to have them translated into French, so that he and his counsellors and others might better understand them, especially the *Ethics* and the *Politics,* of which, as they say, the first teaches one to be a good man and the second, a good prince.)[7]

In short, Oresme identifies his "autres" as persons of influence with little knowledge of Latin. Their understanding of the texts in French translation will benefit the common good. Thus, the moral and social values of the texts make the translations instruments of benevolent public policy. As noted previously, other passages of the *Ethiques* prologue declare that as these works were transmitted from Greece to Rome, so now they are translated into French. Under enlightened monarchic patronage, the translations of Aristotle's writings form part of a *translatio studii* directed to an informed circle of French readers.

Throughout the fifteenth century, the subsequent readership of the translations generally belonged to the groups mentioned by Oresme. Later manuscripts of Oresme's translations were owned by members of the royal family, royal counsellors, members of the nobility, and the municipal government of Rouen.[8] Not surprisingly, the number of manuscripts of the *Ethiques, Politiques,* and *Yconomique*—with one printed edition by Vérard dating from 1488 to 1489—is relatively small, compared to such popular works as the French versions of Valerius Maximus or Livy. Monfrin cites twenty-one manuscripts of the *Ethiques,* seventeen of the *Politiques,* and ten of the *Yconomique.*[9] Then, as now, the market for scholarly books was limited. The difficult subject matter and the learned nature of Oresme's word-for-word translations and their extensive commentary certainly contributed to their limited popularity. Historical texts with strong narrative threads or anecdotal features obviously had greater appeal as recreational reading than weighty works by the Philosopher. Nevertheless, illustrated copies of the *Ethics, Politics,* and *Economics* were not only collected but consulted throughout the fifteenth century.

READING THE TRANSLATIONS

Although the intended audience for Oresme's translations of the *Ethics* and *Politics* is easily identified, it is less clear how these books were read and used. If definitive answers are lacking, some suggestions can be made by piecing together different types of evidence. As for the primary audience, Charles V himself, several miniatures in vernacular works show him as a solitary, silent reader in his study (Figs. 4 and 5).[10] The frontispieces of manuscripts in the king's library represent him immersed in the perusal of Oresme's *Traitié de l'espere* and the Foulechat translation of John of Salisbury's *Policraticus.*[11] Furthermore, the dedication frontispiece of *A* shows in the lower left quadrilobe a king and his associates with books in front of them listening to a lecture (Fig. 7).[12] Here the point is that the king and his companion read individually from their own copies of the text discussed by the lecturer. The miniature of the frontispiece also illustrates the following passage from Oresme's *Ethiques* prologue: "Et en puet l'en bien dire ce mot de *l'Escripture:* 'Audiens sapiens sapientior erit'—'le sage sera plus sage de oÿr ceste science'" (And in this regard one can well cite this phrase of Scripture [Prov. 1:5]: 'Audiens sapiens sapientior erit'—the wise man will become even wiser from hearing this knowledge).[13] Both the text and the image suggest that individual reading was supplemented by oral explication of the text.[14]

In addition, the contemporary political treatise *Le songe du vergier,* a translation commissioned by Charles V and completed in 1378, notes that daily the king "lit ou fait lire devant luy de Ethyques, de Pollitiques ou de Yconomiques, ou d'autres moralités, pour savoir que appartient au gouvernement de tout seigneur naturel" (reads or has read to him [parts of] the *Ethics* and the *Politics,* and the *Economics,* or other moral treatises, to know what is important for the task of anyone who is born to rule).[15] Christine de Pizan relates that especially in winter the king "se occupoit souvent à ouir lire de diverses belles hystoires de la Sainte Escripture, ou des *Fais des Romains,* ou *Moralités de philosophes* et d'autres sciences jusques à heure de soupper" (often spent his time listening to readings from various stories drawn from Holy Scripture, or the *Deeds of the Romans,* or the *Moral Reflections of Philosophers* and other books of knowledge until the supper hour).[16] Readings from the *Ethics,* a source of both earlier and contemporary Mirror of Princes texts, belong to the category of moral teachings mentioned in the passage cited above and this one: "*Item,* et lui, comme circonspect en toutes choses, pour l'aournement de sa conscience, maistres en theologie et divinité et touz ordrez d'Eglise lui plot souvent ouir en ses collacions, leurs sermons escouter, avoir entour soy" (Item, and he, ever attentive to whatever might further improve his mind, liked to surround himself with masters in theology and divinity, and all clerical orders of the Church, to hear their conversation at table, and to listen to their sermons).[17] Christine repeats in her *Livre de la paix* that Charles V was in the habit of "souvent ouir, et à certaines heures et jours leccons de sapience" (often listening on specific days and hours to readings from books of wisdom).[18]

Charles V's enjoyment of intellectual interaction with members of his entourage described by Christine is confirmed in two prologues of translations commissioned by him. A passage in the prologue to the *Songe du vergier* refers to a past controversy: "Et, mon tres redoubté Seigneur, en la presance de Vostre Majesté ceste doubte a esté aultre foiz disputée, par maniere d'esbatement et de collacion" (And, my most revered lord, in the presence of your majesty this question was debated once before at table and in a lighter vein).[19] Oral discussion is mentioned by Raoul de Presles in the dedicatory epistle of his *City of God* translation. At the end of his narrative on the origins of the oriflamme, he interjects the phrase "comme vous m'avez oy raconter" (as you have heard me tell).[20]

It is known, too, that there were officially designated *lecteurs du roi,* who read and explained texts to the king. Vincent of Beauvais fulfilled this function for St. Louis.[21] Christine de Pizan tells us that Gilles Malet, Charles V's librarian and *valet de chambre,* was a favorite reader of the king.[22] Thus, the custom of public oral reading and explication at the French court had a considerable tradition.

Charles V may have particularly requested oral explication from Oresme on certain passages or questions relating to difficult or intriguing matters. For example, a *Quaestio* added by Oresme to his commentary on a passage from Book IX of the *Ethics* is one of the few lengthy interpolations he inserted into the text.[23] The discussion, choosing one of three worthy persons to be saved from execution, is a topic Oresme may have included for his patron's benefit, as it lends itself to oral argument and debate.[24] In this case, Oresme could have used as points for

discussion the elaborate inscriptions that form a kind of internal dialogue within the miniature.

Indeed, the inscriptions that are a distinctive feature of the miniature cycles in *A* and *C* can furnish important clues on how the books were read. Embedded within the pictorial field and emphasized by a banderole, the inscriptions act as a reference, locating or summarizing a key concept, unfamiliar term, or neologism (Fig. 12). Guided by the inscriptions, the reader can consult the explanation furnished by the translator in the chapter titles preceding the miniature, the glossary of difficult words, or the index of noteworthy subjects placed at the end of the text.

The inscriptions also allow the reader to connect verbal information with the concrete imagery of the miniatures. An analogue to the vernacular language, in many cases the pictorial representation translates abstract ideas or terms borrowed from Latin into familiar visual modes. Such visual language includes personification and allegorical figures arranged in a coherent structure and clothed in contemporary dress. A preference for concrete visual imagery may correspond to the mental habits of readers accustomed to similar use of language in the vernacular.[25] The inscriptions may also have played a crucial role in forming associations between the verbal and the visual by singling out words as memory devices, perhaps for oral repetition by the reader. The persistence of aural habits of reading, or *lectio,* may have encouraged sounding out a word featured in the inscription to locate, associate, and assimilate the verbal concept with visual imagery.[26]

As was discussed in the previous chapter, scholars have recently recognized the cognitive and affective powers assigned to images in medieval faculty psychology and scholastic memory treatises. V. A. Kolve stresses the role of memory in making mental images the road to understanding and retaining verbal concepts.[27] Sight and hearing are separate pathways to the castle of Lady Memory, a metaphor used by Richard de Fournivall and illustrated in an early fourteenth-century French manuscript of *Li bestiaires d'amour* (Fig. 18).[28] Referring in part to Frances Yates's seminal work, *The Art of Memory,* Kolve emphasizes that Albert the Great and Thomas Aquinas assign to visual images the ability to fix general concepts in the mind by attaching them to specific details and places located within an imagined geographical or architectural structure.[29] Moreover, the great scholastics find in visual images affective powers that can move the soul to positive ethical action.

The inscriptions and images of Charles V's illustrated copies of the *Ethiques* unite through their functions as memory aids the verbal concept and its visual realization within a clearly defined pictorial field. In fact, an architectural memory gateway, similar to that of the Fournivall miniature, is a distinctive feature of the cycle in MS *A*.

In short, reading Oresme's translations may have combined individual study and oral explication. In view of the long intellectual relationship between Charles V and Oresme, as well as of the limited time available for the king and his counsellors to make their way through the lengthy and weighty translations, oral explications of crucial sections of the text by Oresme seem plausible. In both processes, the illustrations—particularly the inscriptions—had important didactic and mnemonic functions.

The analyses of the pictorial cycles in Charles V's copies of the *Ethiques* (*A* and *C*), and also of the *Politiques* and the *Yconomique* (*B* and *D*), assume the illustrations' general functions as visual definitions and re-presentations of abstract ideas.[30] As noted above, the illustrations rely on well-known representational modes of embodying abstract ideas to define key ideas in the text. In all the miniatures of the *Ethiques* program, personifications constitute the basic unit of representation. Individual miniatures are generally placed on the same folio as the list of chapter titles to permit the reader's quick identification of the principal subjects discussed. Not only inscriptions but also attributes or appropriate costumes facilitate association of the personification with the verbal concept. Interpretation of the personification's psychological or moral character may be limited. In *A* and *C* the typical Christian iconography of the virtues, or of other suitable personifications, is adapted without explicit reference to the text's classical and pagan content. Personifications appear as laconic subject guides in Books III, IV, and VIII of *A*.

A second category of illustrations, personification allegories of virtues or of other abstract philosophical ideas discussed, occurs in the cycles of both *A* and *C*. The term *personification allegory* here connotes a more active animation or profound psychological characterization of the personifications than that of the table of contents type.[31] Of course, the personification allegory also functions as a visual table of contents, but it defines moral or spiritual relationships among several personifications. Personification allegories emphasize unfamiliar notions in the text by extended visual metaphors, in which kinship is frequently employed as a device to explain underlying relationships of identity, power, and social standing. Such imagery tends to be more novel and ambitious than that of simple personification.

The last category of *Ethiques* illustrations, the decision allegory, involves a moral or spiritual choice on the part of a personification or other figure. Erwin Panofsky uses the term to characterize the illustrations in Book VII of *A* and *C* (Figs. 35 and 36).[32] The only other instance of a decision allegory occurs in the exceptional miniature for Book IX in *C* (Fig. 41). Of the three categories of illustrations in the *Ethiques* cycle, the decision allegory is the most unusual.

VISUAL REDEFINITIONS AND THE FUNCTIONS OF THE MANUSCRIPTS

Although the three categories of illustrations appear in both *A* and *C,* they are used as visual definitions in varying frequency and complexity. To make the point another way, the visual definitions of *A* are redefined in almost every instance. Why do these changes occur in two such closely related manuscripts executed for the same patron? An important clue comes from the different functions of *A* and *C* within Charles V's library. In its large size (318 × 216 mm) and every aspect of its appearance, *A* is a luxury presentation copy intended for consultation in the king's library and not for circulation.[33] Gold and colors are lavished on the orna-

mental capitals, the vignettes, and the eleven miniatures. An elaborate layout borrowed from thirteenth- and fourteenth-century manuscripts on canon and civil law separates the text, written in two narrow columns of thirty-five lines per folio, from Oresme's surrounding commentary (Fig. 11). The formality of design expresses the luxurious nature of the book. Finished after 1372, *A* is a magnificent testimony to Charles V's enlightened patronage. In *A* only two of the eleven illustrations occupy the width of the entire text block in a half-page, almost-square format. While the scribe has been identified only as associated with Raoulet d'Orléans, the miniaturist is known as the second Master of the Bible of Jean de Sy, also called the Boqueteaux Master. Greatly favored by Charles V, this illuminator and his shop, who also participated in the illustration of *B,* produced a series of lively and expressive miniatures of generally high quality.▪

In contrast, *C* is smaller in size (218 × 152 mm). Like its companion volume *D* containing the *Politics* and *Economics* translations by Oresme, *C* is considered to have served as a portable volume designed as a pocketbook.[34] Written by the well-known and official scribe of Charles V, Raoulet d'Orléans, as was *D, C* is altogether more modest than *A.* In *C,* text and commentary are intermingled in a two-column format, while the ornamental decoration is more limited and figures are represented in grisaille enhanced by color washes. Indeed, the presumed function of *C* as a "reading copy" for the king accounts for the changes in its program from its model, *A.* The didactic character of the *C* cycle is marked. For example, a wordier series of inscriptions gives more information about the contents of each book, and the format and size of the miniatures also expand. Not only virtues (as in *A*) but their opposing vices are represented in the illustration for Books III and IV in *C.* Indeed, all the illustrations of *C* act as frontispieces for each book and occupy the width of the text block. The redefinitions and expansion of the program in Books I through V of *C* made the dimensions of the miniatures inadequate. As a result of overcrowding, the vertical dimensions of the miniatures for Books VI through X gradually increased. Dated 1376, *C* chiefly represents the work of the miniaturist known as the Master of the Coronation of Charles VI.[35]

Differences between the programs of *A* and *C* may have arisen from reactions to the first manuscript by patron and translator. In some instances, Charles V may have judged that certain miniatures in *A* did not advance the reader's understanding of the text. Colophons and other evidence reveal that the king took an active part in specifying and correcting texts and illustrations that he himself commissioned.[36] It is, therefore, possible that the incentive for a revised program of illustrations came from Charles V. Indeed, the king may have made specific recommendations to Oresme, for the difficult text of the *Ethics* is the first lengthy work Oresme translated to require a program of illustrations. Oresme may have lacked time, experience—or both—to provide detailed instructions to the illuminator. For those books in the *Ethics* for which iconography and models existed without additional adaptation, Oresme may have thought that only brief instructions were necessary. For those that demanded more explicit indications for definition of more unfamiliar concepts or terms, his instructions may have been misunderstood by the illuminator. Or perhaps Oresme did not foresee the precise visual form of

the translation of his instructions. Still another explanation is that Oresme may have relied too heavily on the scribe or supervisor of the book without allotting time for revisions.

Certain features of C support these suggestions. For one thing, by 1376, by which date C was produced, Oresme had designed the program of miniatures for B. The counterpart of A, B is the first illustrated copy of Oresme's French translations of the *Politics* and *Economics* executed for Charles V[37] and is only slightly later in date than the *Ethiques*.[38] The program of B is far more elaborate than that of A, indications both of the greater importance of the *Politiques* text and Oresme's greater experience as designer by the time C and D, Charles V's second illustrated copies of the *Ethiques, Politiques,* and *Yconomique,* were revised. Perhaps because of Oresme's knowledge of the production process, the D cycle does not show extensive revisions from its model B in the same pattern followed by C and A.

The scribe Raoulet d'Orléans was also involved in the production of C and D. He was a highly competent and experienced practitioner who probably supervised the conversion of the elaborate layouts of A and B to a simpler and less expensive format. An example of Raoulet's importance is his ingenious intervention to explain verbally certain obscure features of an important illustration revised in D.[39] Raoulet must also have had a role in responding to the internal revisions of C, when the inadequate scale of the first five miniatures was greatly enlarged in the second half of the book to accommodate the expanded program. Thus, the process of visual redefinition is a complex one, in which translator, patron, scribe, and illuminators played significant, if not clearly designated, parts. Although the reasons and process underlying the extensive visual redefinitions of A remain conjectural, the didactic nature of the revisions in C is obvious. For one thing, the more restrictive quadrilobe format of the A miniatures gives way in C to rectangular or square pictures that occupy the width of the text block. This expanded field allows space for more inscriptions and figures. Moreover, a two-register format in seven of the C illustrations and a three-tiered arrangement in another are indications of a more complex program.

The didactic character of the C program leads not only to more elaborate verbal information and division of the pictorial field but also to a redistribution of the three representational modes established in A. Apart from the dedication miniatures, there are five personification allegories in A, but only three in C. Instead, in C, a preference for complete subject guides is obvious. In Books III and IV vices accompany the appropriate virtues, while in Books VI and VIII examples drawn from everyday life are sometimes juxtaposed with personifications. Yet the climactic image of C is a monumental personification allegory of unusual aesthetic quality and intellectual complexity. Overall, the program of C strives for "the whole picture" in terms of expanded visual tables of contents combined with consistency in details of costume and attributes. In a class by itself, however, is the decision allegory for Book IX mentioned above. Because of experiments with the complex process of re-editing and redefining verbal and visual relationships in C, the deliberate didacticism of the program does not always meet the goal of more complete or more profound interpretation of the text.

5 DEDICATION FRONTISPIECES
(Book I)

A comparison of the dedication scene of *C* with those of *A* reveals a different approach to illustration. All three, however, belong to the intimate type of dedication portraits, marked by the direct communication of the king with authors or translators, without the intervention of courtiers or officials.[1] The intimate dedication portrait confirms the king's intellectual character and his enjoyment of the company of the writers and translators in his entourage. The close relationship between Charles and Oresme, for example, is documented in the dedication scene of Oresme's translation of Ptolemy's *Quadripartitum* (Fig. 3), dating from 1361 or 1362.[2]

As the first miniature in the manuscript (Figs. 6 and 6a), the dedication scene of the prologue exemplifies the usual format of the *A* illustrations. The miniature is tied to the design of the folio both in its width, equal to that of a column, and in its height, equal to sixteen lines of text. Links to the decorative structure of the folio are also strong. Figure 6 receives emphasis by its relationship to the initial *E,* the outer frame, and the foliate border. The inner frame of Figure 6, a red, white, and blue quadrilobe, is a typical feature of this manuscript and many others of the period. Also standard for the illuminations of this cycle is the simple double outer frame and the gold lozenges that fill out the area between the outer rectangle and the quadrilobe. The rose fleur-de-lis background is used in the first six miniatures of the *A* cycle. Although it plays a decorative role, it also alludes to the patron's royal status—here explicitly, elsewhere implicitly. Figure 6, moreover, follows the major color scheme of the cycle, based on a red-gold-blue triad. Charles V, wearing a blue mantle trimmed with white fur, stands out against the gold curtain and the rose fleur-de-lis outlined in black. Oresme's costume, a more subdued blue-gray, falls into the same color range. Red accents are found in the baldachin, the book, and the bystander's mantle. Gold is more prominent than usual, used here not only in the curtain but also in the faldstool and crown.

The baldachin and fleur-de-lis motifs of Figure 6, repeated in the dedication scene of Figure 7, are indebted to the famous presentation scene by Jean Bondol representing Charles V and Jean de Vaudetar, the donor of the book, a *Bible histori-ale,* dated 1371 (Fig. 8).[3] The style of Figure 7 is also closer to that of the Bondol prototype. The convincing gestures and expressions of the king and translator suggest that this dedication scene, part of the elaborate frontispiece, was executed

FIGURE 6 *Charles V Receives the Book from Nicole Oresme. Les éthiques d'Aristote*, MS *A*.

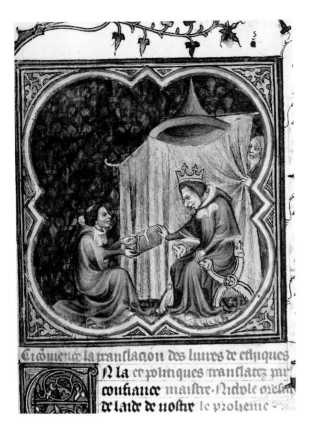

Ci commence la translacion des liures de ethiques
Et la et politiques translatez par
confiance maistre-Nichole oresme
de laide de nostre le probleme

FIGURE 6A Detail of Fig. 6.

by the head master of the Jean de Sy shop. The excessively large head and trun-
cated body of Charles V in the prologue dedication (Fig. 6), in contrast, suggest
that a member of this atelier was entrusted with this more modest miniature.
Whereas the image of the king in Figure 6 is more conventional and his appear-
ance more youthful than in Figure 7, the portraits of Oresme are both individual-
ized. Also similar in both dedications is the gold curtain, suspended from rods and
set obliquely to the picture space; its boxlike character defines the royal sphere.
Although its abbreviated form permits no conclusions, it suggests an enclosed
chamber or other private space as the locale of the presentation.[4]

The documentary function of Figure 6 is related to its position at the head of
the first column of text on folio 1 of the manuscript. The illustration identifies
those who set in motion the translation contained in the volume presented. Kneel-
ing at the left is the translator, whose name appears in the three-line rubric written
under the miniature: "Ci commence la translacion des *Livres de Ethiques et Politiques*
translatéz par maistre Nichole Oresme" (Here begins the translation of the books

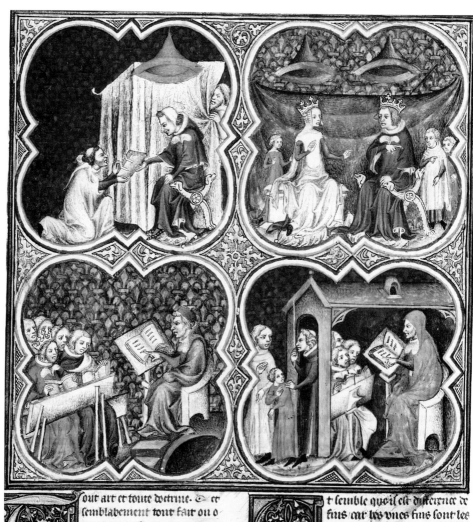

out art et toute doctrine. ☞ et
semblablement tout fait ou o
pracion et election apprent a
desirent aucun bien. pour ce par
leient bien les auteurs en disat
ainsi. bie est ce q toutes chof desirt.☞

t semble queil est difference de
fins car les vnes fins sont les
opinacions ⟐. les autres sont
aucunes ocuures.☞. ou choses
faites lois les opinacions ou fa
cons et ces ocuures sot meilleu

FIGURE 7 Above, from left: *Charles
V Receives the Translation from Nicole
Oresme, Charles V and His Family;* be-
low, from left: *A King and His Counsel-
lors Attend a Lecture, The Expulsion of a
Youth from a Lecture. Les éthiques d'Aris-
tote, MS A.*

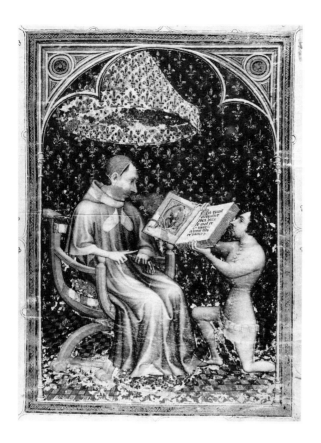

FIGURE 8 Jean Bondol, *Charles V*
Receives the Book from Jean de Vaudetar.
Bible historiale.

of the *Ethics* and *Politics* translated by Master Nicole Oresme).[5] The next sentence, highlighted by an elaborate six-line foliated and dentellated initial *E* names the patron:

> En la confiance de l'aide de Nostre Seigneur Jhesu Crist, du commandement de tres noble et tres excellent prince Charles, par la grace de Dieu roy de France, je propose translater de latin en françois aucuns livres lesquelx fist Aristote le souverain philosophe, qui fu docteur et conseillier du grant roy Alexandre.

> (Confident of the help of Our Lord Jesus Christ, at the command of the most noble and most excellent Prince Charles, by the grace of God, king of France, I propose to translate from Latin into French some books written by Aristotle, the supreme philosopher, who was the teacher and counsellor of the great king Alexander.)[6]

The crown and faldstool associated with the king seated on the right establish the royal identity of Charles V. Two other features of this introductory sentence are worthy of comment. First, Oresme gives himself an important role in the enterprise by using the phrase "je propose." Then he sets up a discreet but flattering parallel between Charles V and himself, the contemporary equivalents of Alexander and Aristotle, in their roles as ruler and counsellor, pupil and teacher. Following a medieval custom, the translator's appropriation of Aristotle's identity as author carries out this theme on a visual level.

Oresme also points to the value of the text, recognized by "pluseurs docteurs catholiques et autres" (many Catholic doctors [of the Church] and other authorities), and its universal reputation "en toutes lays et sectes" (in all religions and sects), from the time of its composition to the present day.[7] The translator does not neglect to pay tribute to the wisdom and intellectual interests of his patron.[8] Charles V's love of study and learning not only promotes the common good but unites the two men. These mutual interests and long personal ties are commemorated in Figure 6a, particularly in the direct glances and friendly expressions of both parties. While Oresme's kneeling posture expresses his respect, his knee and hands penetrate the space occupied by the king. Moreover, the left side of the book held by Oresme is supported on the right by Charles V. The volume's red color, highlighted against the gold curtain, emphasizes the book as both document and symbol of the concrete tie that exists because of their mutual efforts. Finally, the gesture of Oresme's left hand indicates the act of handing the book over to the king, a moment of gratification to both translator and patron.

THE DEDICATION FRONTISPIECE: THE UPPER REGISTER

The dedication scene of *A* (Fig. 7) is not a self-contained unit but one of four quadrilobes that make up a miniature occupying half the folio. The exceptional size of the illustration, the second largest of the manuscript, indicates the importance of the folio. The double set of dentellated and foliated initials that introduce the six lines of text below the miniature gives a decorative emphasis to the folio. The contrasting red and blue geometric backgrounds accentuate the symmetrical composition of the miniature, enhanced by the color scheme of the inner frames. The use of gold for the lozenges on all edges of the quadrilobes and in the curtain on the upper left completes the sumptuous effect of the overall design. In a minor key, the pinks, blues, reds, and golds of the exterior frames, initials, and leaves weave a decorative unity with the major color chords of the miniature.

The quadrilobes are the same size as that of Figure 6 and are laid out symmetrically, with the central squared tip of the lower one reaching up to touch the corresponding part of the upper one. The left and right edges of each quadrilobe line up with the text block and are equal to the width of each of the two text columns; the central gold lozenges span the space between the columns.[9]

An interpretation of the four miniatures can begin by analyzing this first scene. Placed on the upper left, it begins a sequence that proceeds from left to right,

beginning at the top. In one sense, the miniature inaugurates the book's emphasis on the theme of education, beginning with Charles V's instruction by Oresme in general and extending to the specific knowledge contained in the *Ethics* and *Politics*. The changes in iconography from the prologue dedication (Fig. 6) may also indicate a temporal sequence. The king's homely coif lends an informal quality to the less official character of Figure 7. The king's smile conveys an intense, personal relationship between patron and translator. Charles V glances at Oresme, whose head now overlaps the royal sphere. Moreover, the translator's movement toward the king is reinforced by the gesture of Oresme's left hand, which seems to loosen the book's lower clasp. The suggestion of opening the book indicates a further step in the temporal sequence, either in the narrow sense of proceeding with the next step in the presentation ceremony or with a wider suggestion of disclosing the reasons the translations were commissioned and the appropriate audiences for them. In Figure 7 the illuminator's style—its fluent rendering of movement and naturalistic corporeality—helps to intensify the close relationship between Oresme and Charles V and their expressions of pleasure in the completion of the jointly undertaken project.

The second scene, on the upper right, emphasizes the king's role in making the teachings of the *Ethics* available to his family by commissioning the translation. Although Charles V's portrait is more generalized than in the dedication scene, the facial features suggest that this scene is meant to refer to him and his family. By 1372, the date of the colophon of *A,* Charles V and Queen Jeanne de Bourbon had three children.[10] Precedents for a king giving instructions about the education of his family come from various Mirror of Princes works. This theme is standard in French translations with royal connections of Giles of Rome's *De regimine principum.* Repeating Aristotle's emphasis on the importance of educating the young, a French translation of Giles's text, *Li livres du gouvernement des rois* executed for King Philip IV in 1296 by Henry of Gauchi, stresses the responsibility of the ruler for his children's education. The royal offspring must possess greater goodness, learning, and virtues than those of their subjects.[11] A lavishly illustrated mid-fourteenth-century text closely related to Giles's work, the *Avis au roys* (New York, The Pierpont Morgan Library M. 456) makes a similar point in the rubrics of a section devoted to the education of princes.[12] Furthermore, the *Avis au roys* contains two illustrations that represent a king giving instructions on the upbringing of his family.[13] In Charles V's own library, an illustrated manuscript of another Mirror of Princes text, *Le gouvernement des rois et des princes,* has a frontispiece with a four-quadrilobe structure (Fig. 9). On the upper right, a king and his family are depicted in a fashion similar to that of Figure 7.[14]

Ties between the tradition of French Mirror of Princes texts and the upper right quadrilobe of Figure 7 are noticeable in Oresme's prologue to the *Ethics* translation and in Book I. Both the *Ethics* and *Politics* define the goals of earthly existence and constitute the "science civile" (civic science).[15] Oresme characterizes the *Ethics* as a book of "bonnes meurs, livre de vertus ouquel il enseigne, selon raison naturel, bien faire et estre beneuré en ce monde" (good moral values, a book of virtues that teaches, according to natural reason, to act justly and be

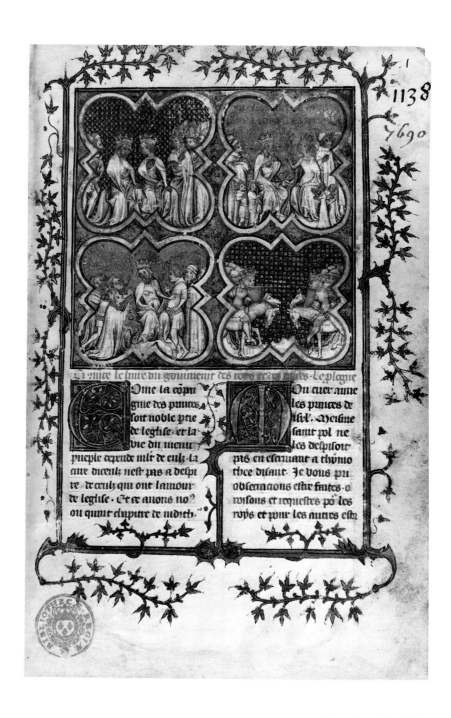

FIGURE 9 Above, from left: *A King and Queen Speak with Prelates, A King and His Family;* below, from left: *A King Rendering Justice, A King and Warriors on Horseback. Le livre du gouvernement des rois et des princes.*

blessed in this world).[16] By commissioning French translations of the *Ethics* and *Politics,* Charles V is discharging his duties as ruler and as father. The "livre de bonnes meurs" will benefit the royal family and the common good of the realm. Indeed, the analogy between the father-son relationship and that of a king to his subjects is a theme of a gloss in Book VIII of the *Ethiques.*[17]

In Figure 7 Charles V's commanding gesture toward his son illustrates his authority over his family. Yet the queen who receives his instructions also has a role to play. Crowned and seated below her own baldachin, Jeanne de Bourbon turns toward Charles V in a listening pose, indicated by her upraised arms. French queens were traditionally entrusted with the early education of their children. In an ordinance of 1374 dealing with the succession, Charles V made Jeanne de Bourbon chief guardian of the royal children.[18] Thus, this scene illustrates contemporary historical practice and goes beyond the Aristotelian text and Oresme's translation in which queens do not figure. This extratextual allusion both confirms the origin of this scene in the Mirror of Princes and the personal references of the upper register.

The depiction of the royal family is quite formal, dominated by the gold crowns, gray-green curtain, and twin blue baldachins set against the rose-and-black fleur-de-lis background. Still, the use of gold is restrained, limited to several small areas, such as the crowns, faldstools, and the cloths below the queen's bench and king's chair. Blue is the dominant color, repeated in Charles V's robe and the baldachins, as well as in the underskirt of the queen's dress, with its fur yoke and pale rose folds. Red accents appear at the peripheries in the robes of the princess and her younger brother, whereas the Dauphin's costume, with its two distinctive ermine bands on the right shoulder, echoes the colors worn by his mother. The aggressive folds of the dull gray-green curtain unite the two halves of the composition and establish a planar and spatially ambiguous setting. Frontality is avoided by the turn of the royal couple's bodies and tension is added to the otherwise static scene by their hand gestures. As the upper register moves from translator and patron to the royal family, so an implied narrative suggests temporal movement, from the commission to the practical diffusion of the ideas—based on the Mirror of Princes literature—to be found in the translation.

THE DEDICATION FRONTISPIECE: THE LOWER REGISTER

In the lower register, however, personal references give way to a more general, allusive tone. If the top two quadrilobes are related to the *Ethics,* the bottom pair refers to the *Politics.* Even more than the upper scenes, the lower ones have a strong narrative content, again related to the important Aristotelian emphasis on education.

On the lower left, a scholar seated on a raised chair is lecturing or commenting on an open book, possibly the present translation. His audience, seated at desks, consists of two full-length figures in the front row, holding open copies of books, and three others, whose heads are visible behind them. A gold crown identifies

the bearded man on the left as a king. The head of the man between the two front figures peers anxiously at the book held by the king's ostensibly younger neighbor. The title of the third chapter of Book I of Oresme's *Ethics* translation links this miniature to the text: "Ou tiers chapitre du proheme il monstre quelz personnes sont convenables pour oÿr ceste science" (In the third chapter of the prologue he demonstrates what persons are appropriate listeners of this science).[19] As previously noted, Oresme's prologue emphasizes the value of the science of politics to princes and their counsellors.[20] Oresme adds to his invocation of classical authorities the passage of Scripture mentioned earlier: "Audiens sapiens sapientior erit"—"le sage sera plus sage de oÿr ceste science."[21] Thus, the audience that will benefit by knowledge of the texts is precisely the one represented in the lower left miniature: a king and his advisers. This audience is not only reading but listening to an oral explication, perhaps the equivalent of Oresme's commentary on these texts. The miniature also reveals that this is not the usual clerical audience that gathered for school lectures, but lay people, whose intent expressions convey their concentration on understanding the text of the *Politics*.[22]

In the remaining quadrilobe on the lower register, within a simple structure that, for pictorial reasons, lacks a front wall, another lecture is being given, this time by a hooded master. This teacher is seated on a raised chair with lectern, similar to that of his counterpart on the left. His audience, however, is smaller: two full-length figures are in the front and the head of another appears behind them. The two, who hold open books, listen attentively to the lecturer, who points to the second of three lines of the text. At the same time, a child is being led through the door away from the lecture. His adult companion looks anxiously at a stern, tonsured master holding in his hand a threatening rod. The expulsion of the youth indicates an educational experience unsatisfactory for the youth and possibly disruptive for the class. The text states: "Et pour ce un joenne homme n'est pas convenable audicteur de politiques, car il n'est pas expert des faiz qui aviennent a vie humainne" (And for this reason a young man is not a suitable audience for politics, for he is not experienced in the things that can happen in life).[23] Oresme elaborates in a gloss: "Mais le joenne d'aage ne la puet pas plainnement entendre pour ce que il a peu veü d'experiences et si est plus tempté de desirs corporels" (But those young in years cannot give their full attention to it because they have seen few happenings and in any case are more tempted by bodily desires).[24] According to the text, the adults in the audience profit by the knowledge contained in the text because they are governed by reason. In short, the youth proved to be an inappropriate audience, and his expulsion contrasts an unsuccessful attempt at education with a beneficial adult experience.

This point comes across partly by the repetition in the two lower scenes of the same composition: a single seated figure on the right faced by groups of students on the left. The additional motifs of the school building and the three figures on the left in the right quadrilobe are variations on the theme. Color differentiates the lower two quadrilobes as well: rose fleur-de-lis are on the left, blue ones on the right. Continuing the contrast, scarlet is worn by the king on the left, blue by his companion, whereas blue is worn by the master on the left, and red by his

counterpart. This use of red emphasizes the important figures of the errant child and the lecturer, while paler tones are reserved for the less active ones. The red-and-blue opposition of backgrounds and major figures sets up a structure of verticals and horizontals that relates the quadrilobes of the lower register to those of the upper. The decorative system, particularly the two six-line initials, continues the color harmony.

While the interpretation of left to right and upper to lower sequence seems generally correct, other readings are also possible. For example, the education of Charles V by Oresme on the upper left relates to the ideal audience below. Likewise, the steps taken in the upper right scene to assure the education of Charles V's children show in the scene below the effects of subject and age on a successful learning experience. Indeed, the two scenes of the lower register may present Oresme's attitudes toward education, that is, pictorial comments designed by the commentator and translator of the texts. Such intellectual daring, wit, and irony are characteristic of Oresme and are also a subtle tribute to the presence of these qualities in Charles V—his patron, student, and primary audience.

THE DEDICATION FRONTISPIECE OF MS *C:* GENERAL FEATURES AND THE UPPER REGISTER

Perhaps the subtleties of the nonverbal, visual comments of Figure 7 proved too elusive for the patron and other concerned readers. In any case, the dedication frontispiece of *C* (Fig. 10 and Pl. 1) underwent substantial revision. Setting the tone for the increased didacticism, substantial inscriptions added to the miniature attempt to clarify the meaning of the scenes, now reduced from four to two. Figure 10 also establishes another precedent followed in the other nine illustrations of the *C* cycle. Instead of the quadrilobe frames and columnar format of most of the *A* illustrations, those in *C* occupy the full width of the text block. Frequently, but not always, they occur at the top of the folio. The *C* illustrations thus become more prominent, since they function as frontispieces to each book of the text. The less elaborate and expensive character of *C* resulted in the substitution of grisaille forms for the brilliantly colored figures of *A*. Yet with added touches of gold and colored washes, these grisaille figures stand out strongly against their colored backgrounds. Highly refined, the elaborate geometric or swirling patterns are executed in peach or blue tones and outlined in gold, black, and other colors. The peach tones of the background of the upper register in Plate 1 contrast sharply with the deep blues of the lower zone. Although the miniatures of *C* have simple, two-banded frames, they are usually tied to the marginal borders by foliage motifs, which in turn often connect with the large initial below the illustrations. In Figure 10 the dragon drollery of the right margin reinforces the links between the miniature and the decorative structure of the folio.

Whereas the extraordinary inscriptions of the upper register of Figure 10 indicate that the scribe, Raoulet d'Orléans, must have had an important role in executing the miniature, Nicole Oresme undoubtedly chose the texts. Two elaborate and delicately delineated scrolls accompany the scene of the king receiving a

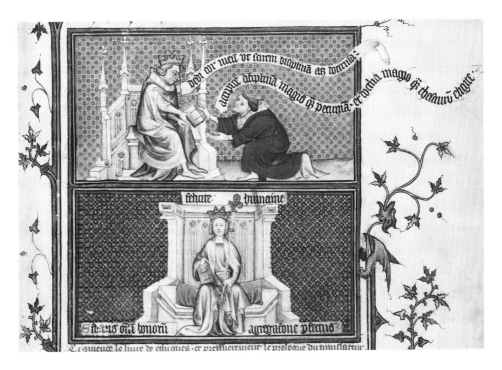

FIGURE 10 Above: *Charles V Receives the Book from Nicole Oresme;* below: *Félicité humaine. Les éthiques d'Aristote,* MS C.

book from the translator. The book, held by each man and containing the present translation, is the focus of the verbal messages. One scroll unfurls at the level of Charles V's chin; the other curves around Oresme's head. The inscriptions are written in heavy black ink, a departure from the usual brown used elsewhere in the manuscript. Also unusual is the extension of the scrolls beyond the frame of the miniature into the right margin; in fact, the inscription around Oresme touches the very edge of the folio. With the exception of the phrases surrounding the personification in the lower register, the use of Latin for these messages is unique in this translation and signals the exceptional weight and authority associated with words in Latin. Not surprisingly, the inscriptions are taken from familiar scriptural passages. The scroll next to Charles V reads: "Dedi cor meum ut scirem disciplinam atque doctrinam," or "I devoted myself to learning discipline and doctrine."[25] The scroll around Oresme, derived from Proverbs 8:10, advises: "Accipite disciplinam quam pecuniam, et doctrinam magis quam thesaurum eligite," or "Choose learning rather than money and choose instruction more valuable than treasure." Couched in biblical language, the inscriptions invest the secular and pagan texts with religious sanction. Also, the messages on the scrolls make explicit

the theme of education, which in the frontispiece of MS *A* (Fig. 7) remains more allusive. Furthermore, the elimination of Charles V's family from the dedication scene concentrates attention on the king's motives in educating himself.

As the words spoken by each man separately, the inscriptions also point to the relationship between Charles V and Oresme. The message on the scroll next to the king indicates that by his specific commission of the Aristotle translations he fulfills his obligations as a wise ruler.[26] In doing so, he heeds Oresme's strong admonition, which confirms the translator's position as moral and intellectual adviser to the king. Indeed, the much shorter inscription and humbler tone of Charles V's declaration contrasts with the lengthy quotation Oresme selected for himself. Also conveying the translator's standing is his choice of a quotation, used here to address the king, that habitually employs the imperative mood of the verb.

The composition likewise emphasizes the prominent role Oresme assumes by the authority of the inscriptions. While the dedication scene is another example of the intimate type, certain aspects of the miniature show a greater formality than the analogous illustrations of *A* (Figs. 6 and 7). For example, in Figure 10 the king's frail form is enclosed in an intricate thronelike structure.[27] In addition, the king looks down at the book as much as he regards the translator. Depicted in profile, Charles V does not, as in Figures 6 and 7, directly establish eye contact with Oresme. Also missing are the warm smiles of both parties. Despite his distance from the king, Oresme, whose head is represented in a fuller, three-quarter view, tilts his head upward to glance at the king. Although only the translator's hand advances into Charles V's sphere, his kneeling form dominates the picture space. Just as his portrait is more amply and naturalistically rendered than the conventional, doll-like image of the king, Oresme appears as the more solidly represented figure. And while Charles V is confined within the throne, Oresme's bulky form, placed on a separate stagelike strip, spreads out laterally. The deep blue of his robe overwhelms the gentle grisaille tones of his patron's figure. Oresme's is the only figure in the *C* cycle whose costume is painted.[28] Even the additions to the translator's prologue of *C* of his name and title, "Je Nicole Oresme doyen de l'eglise nostre dame de Rouen" (I, Nicole Oresme, dean of the church [cathedral] of Our Lady of Rouen), suggest the expansion of Oresme's role in the translation enterprise. In *A* no title is included, and his name, "maistre Nichole Oresme," appears in the opening rubrics but not in the prologue text. The presentation miniature of *C,* dated 1376, shows the evolution in visual form of Oresme's relationship with the king. From the early, intimate presentation scene accompanying his first French translation for his patron, Ptolemy's *Quadripartitum* (Fig. 3), to the dedication portrait of *C,* Oresme assigns himself an increasingly dominant role.

THE DEDICATION FRONTISPIECE: THE LOWER REGISTER

A second seated, crowned form who holds a book occupies the lower register of Figure 10. Unlike the parallel figure of Charles V, the representation is not a historical personality but a personification of the opposite sex. Her crown and

scepter mark her as a queen, and her domination of the whole picture signifies her importance in the frontispiece.[29] The French inscription identifies her as Félicité humaine, or Human Happiness. As a major subject of Book I, the phrase *Félicité humaine* occurs frequently in the chapter headings that follow the illustration, justifying the reason for her prominence. Figure 10 is placed on folio 5, at the head of the prologue and apologia of the translator. As a rule, chapter headings precede the illustration. In this case, however, the function of the miniature as a frontispiece and the relationship of the upper register to the prologue probably account for the change in order. Furthermore, an introductory sentence of Book I contains these words: "Ou premier livre, il met son proheme et traicte de felicité humainne en general" (In the first book he sets forth his prologue and discusses human happiness in general).[30] Thus, instead of the two narrative scenes in the lower register of *A* (Fig. 7) that deal only indirectly with education and the proper audiences for the translations, Figure 10 clearly identifies the principal subject of both Book I and the entire text.

Félicité humaine is further defined by Latin inscriptions that flank the base of her throne. On the left, there appear the words "Stans omnium bonorum" (abode of the highest good); on the right, "agregatione perfectus" (union of all that is good). The mixture of languages in the inscriptions is puzzling. Why was Latin used for the characterization, but not for the identification, of Félicité humaine, which derives from the text of the translation? As with the biblical verses of the upper register, this recourse to extratextual sources confers on the image dignity and authority equal to those associated with the historical personalities of the upper register. Oresme may also have attempted to enrich the spiritual attributes of Félicité humaine verbally since her appearance does not differentiate her from other seated and crowned figures. Unlike the inscriptions of the upper register, those of the lower zone are not harmoniously integrated with the composition. The rectangular band at the top is placed asymmetrically in relation to the throne, and the spacing of the two words is awkwardly interrupted by the scepter.[31] In other words, the designer of the miniature failed to integrate the prominent inscriptions with the figural element.

The high social standing of Félicité humaine is conveyed by her frontal pose, which is associated with a ruler seated in majesty. The motionless effect thus created suggests an ideal realm, contrasting with the historical and personal space inhabited by Oresme and Charles V, who are depicted in three-quarter and profile views respectively.[32] The gold of her cushion, book, belt, scepter, and crown further signal her sovereignty. These attributes are appropriate to Human Happiness, who in Aristotle's definition personifies the good toward which all knowledge and human activity aim. In the *C* illustrations, Félicité humaine is the only personification awarded a crown. The book she holds may relate to the text passage that states, happiness is achieved by "discipline et par estude" (discipline and study).[33] Her costume recalls Oresme's comparison of Félicité to a well-dressed person ("bien vestue de robes").[34]

The royal attributes of this figure may also cause the reader to associate her with the king seated almost directly above her. Félicité holds a book that is almost

identical with the one held by Charles V. Félicité's frontal pose and outward-looking gaze emphasize the book's ability to open the way to Human Happiness. Could it not be inferred that the "doctrina et disciplina" revered by the king could bring about Human Happiness? Oresme writes in the prologue of the beneficial effects on the common good brought about by a love of learning, the most desirable pursuit (after religion) of princes and their advisers. The love of knowledge avowed in the upper register by Charles V is further linked to Félicité humaine by two emblems of French royalty: the fleur-de-lis of her crown and her scepter. Human Happiness, then, is a result of Charles V's wisdom in pursuing knowledge that benefits his kingdom. The present translation into French, containing the ethical values and political ideals necessary for good government, is an example of such conduct. Félicité humaine is thus the spiritual consort of Charles V. Several devices link the historical ruler of the upper zone to the ideal sovereign of the lower: parallel placement of the figures, display of the book, and repetition of royal symbols. Even the use of French to identify Human Happiness reinforces the association. The timeless excellence symbolized by Félicité humaine connects queenship with lofty spiritual ideals, a relationship that acknowledges feminine powers in a manner foreign to the text. This first depiction in the sequence of illustrations of positive abstract concepts by female personifications continues, however, an iconographic pictorial tradition inherited from classical antiquity.

Because of the different functions of the manuscripts in the king's library, the dedication frontispieces of *A* and *C* reflect different approaches to text-image relationships. The substantial reworking of the program of Figure 10 represents part of an editorial and visual redefinition. Without substantial changes in the text, the alteration from the allusive, nonverbal mode of Figure 7 to the didacticism of Figure 10 suggests a response to a critique of the former, possibly initiated by Charles V himself. Ambiguities in the meaning of both frontispieces, despite the attention lavished upon them by patron, translator, scribe, and miniaturists, hint at the complex processes involved in the visual representation of Oresme's *Ethics* translation.

6 VIRTUE AS QUEEN AND MEAN
(Book II)

DEFINITION AND LOCATION OF A BASIC CONCEPT

Because the frontispieces of *A* and *C* emphasize the dedication portraits rather than the specific contents of Book I, the illustrations for Book II (Figs. 11, 11a and 12, 12a) provide the first representative examples of how the miniatures promote the reader's understanding of the text. Both verbal and visual representations of key concepts in Book II are difficult tasks. Oresme had to make clear in French Aristotle's generic definition of virtue, a principal subject of Book II of the *Nicomachean Ethics*. Such a definition follows from the discussion in Book I that the goal of human life is Human Happiness, characterized as an activity of the soul in accordance with rationality and virtue. What constitutes virtue (*Arete*) or excellence of character is a foundation of Aristotle's ethical thought: "Virtue, then, is a state of character concerned with choice lying in a mean, i.e. the mean relative to us, this being determined by a rational principle, and by that principle by which the man of practical wisdom would determine it."[1] From this generic definition Aristotle proceeds in Books II through V to discuss individual moral virtues. While the familiar four cardinal virtues—Fortitude, Temperance, Justice, and Prudence—figure extensively in Books II through VI, they are not grouped together in any particular order.[2]

Oresme's definition of virtue closely follows the English translation cited above.[3] His translation shows his awareness of Aristotle's method of generic definition by including the French words *gerre* (genus), *diffinicion* (definition), and *difference* in chapter headings and glosses of Book II, as well as in the glossary of difficult words at the end of the volume. Although these words are not neologisms, Oresme seeks to establish their precise logical and philosophical connotations. The emphasis on definition thus relates both to Oresme's rhetorical strategies as a translator and to Aristotelian and scholastic methods of argument. Such efforts also belong to his campaign to make the vernacular an effective instrument of abstract thought. Also included in the glossary is *habit,* a noun included in the definition.[4]

The importance of the generic definition of virtue in Book II is reflected in the relationship of the illustrations in *A* and *C* to the folios on which they appear (Fig. 11, Pl. 2, and Fig. 12). Linked by the Roman numeral *II* of the running titles to the second book, both miniatures stand at the top of the folio. The miniature in *A* is the only one in the manuscript linked to the column that has this distinction.[5]

Furthermore, this image is one of the two largest illustrations of the group that spans a single column in *A*.[6] In both *A* and *C* the sprays of the leafy border point to the miniatures. In the same way, below Figures 11 and 12 the large foliated initials of the letter *C,* embellished with brightly colored leaves and gold accents, draw the eye upward to the illustrations. Special directional emphasis is given to Figure 11 on the upper right margin by the vigorous movement of the dragon drollery.

Plate 2 derives added resonance from the brilliant color of the surrounding verbal and visual elements. The alternating red and blue paraphs, present also in Figure 12, are repeated in the rubrics of the key words in the glosses, the line endings, and the *renvois,* or symbols linking text and gloss. The vivid red, white, and blue of the elongated quadrilobe frames and surrounding gold lozenges of Plate 2 enliven the peripheries of the miniature. Indeed, the three figures of the *A* illustration, itself placed symmetrically in relation to the first of two units of text and gloss, receive strategic emphasis by their placement at the points of the quadrilobes.[7] In contrast, the simpler character of *C* limits the framing and border elements of Figure 12.

In both images, then, the layout of the folios serves as an integrated system of numeric and visual cues that aid the reader's cognitive processes. What other means communicate to the reader the identity and character of the generic definition of virtue? A process of verbal repetition of the key word *vertu* written on the inscription above the central figure of the *A* and *C* miniatures is one important device. This internal text links the words to all but one chapter heading of Book II. *Vertu* also occurs in the rubrics of Oresme's summary of the book's contents that appear on the preceding folio: "Ci finent les rebriches du secont livre de Ethiques ou il determine de vertu en general" (Here end the rubrics of the second book of the *Ethics,* where he examines the nature of virtue in general).[8] Placed between the chapter headings and the first paragraph of the text of Book II, the illustrations of *A* and *C* function as subject guides to a major theme.

The location of the word *vertu* leads the reader to Chapters 7 and 8, where Oresme defines the term. Another inscription unfurling on a scroll next to the figure of Virtue reads: "Le moien est ceste" (this is the mean). The heading for Chapter 8 locates the specific place in the text where the two key words of the inscriptions, *vertu* and *moien,* are associated: "Ou .viii.[e] chapitre il monstre encore par autre voie que vertu est ou moien et conclut la diffinicion de vertu" (In the eighth chapter he shows again by another way that virtue is at the midpoint [the mean] and concludes the definition of virtue).[9] In a succinct passage Oresme states the gist of Aristotle's theory of the mean as the moral capacity to respond appropriately in a given situation in respect to action or emotion. Oresme puts it this way:

> Donques vertu est habit electif estant ou moien quant a nous par raison determinee ainsi comme le sage la determineroit. Et cest moien est ou milieu de .ii. malices ou vices, desquelles une est selon superhabundance et l'autre selon deffaute. . . . Et vertu fait le moien trouver par raison et eslire par volenté. Et pour ce, selon la diffinicion de vertu, elle est ou milieu ou ou moien.

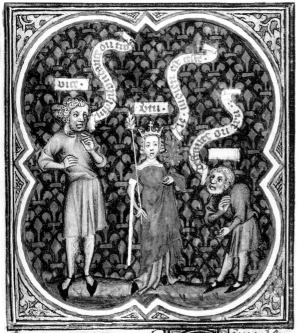

(Thus virtue is a characteristic [habit] involving choosing the mean relative to our-
selves determined by a rational principle as the man of wisdom would define it.
And this mean is the midpoint between two evils or vices, one of which is condi-
tioned by excess and the other by deficiency. . . . And virtue finds the mean by rea-
son and chooses it by action of the will. And therefore, according to the definition
of virtue, it is at the midpoint or mean.)[10]

This passage also makes clear that an appropriate or "mean" response avoids the
extremes (the ".ii. malices ou vices") of reactions that are either too great or
too small.

VIRTUE AS QUEEN AND MEAN IN MS *A*

Following Aristotle's method of generic verbal definition, Oresme's translation
clarifies in French essential concepts associated with the terms. At first glance,
Figure 11 seems like a labeled diagram in which inscriptions demonstrate the ver-
bal arguments. Yet further study of the miniature reveals unexpected subtleties.
To begin with, the personification of Virtue, at the center, seems in no way excep-
tional. Wearing a crown and holding a scepter in her right hand and a blooming

FIGURE 12 *Excès, Bonne volenté, Vertu, Cognoissance, Deffaute. Les éthiques d'Aristote, MS C.*

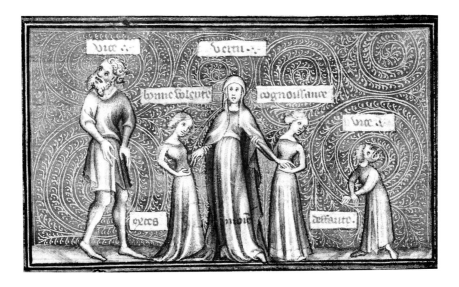

FIGURE 12A Detail of Fig. 12.

branch in her left, she stands facing the reader. From the inscription stating that the mean is here, it becomes clear that the word *moien* has a double meaning. *Moien* refers not only to the moral mean in respect to a proper action or emotional response but also to the center or midpoint of the picture field physically occupied by Vertu.

The scale of her figure is also the mean or norm between the two extremes standing to either side. On the left Excess (Superhabondance) is represented as a youthful, clumsy giant whose gaze is focused ruefully on the tranquil figure of Vertu, an upright vertical accent stabilizing the composition. The rectangular label inscribed *Vice* identifies him; the scroll next to him characterizes his negative quality as "Superhabondance ou trop" (excess or too much). His abnormally large size visually expresses by means of scale departure from the mean. On the other side of Vertu stands Too Little (Deffaute), personified by the shrunken, aged figure of a hunchback dwarf, whose fault is spelled out on the winding scroll to the left of his head as "deffaute ou peu" (lack or too little). The word *vice* is absent from the horizontal band above his head. Is this omission an error, or a deliberate attempt to associate the emptiness of the label with moral blankness, the deficiency that the figure embodies? In this case the lack of a sign naming the vice corresponds to the essence of his moral character.[11] Indeed, Aristotle states that many vices have no names, including the one that renders people deficient in regard to pleasure.[12] The diagonal line of descent of the rectangular inscriptions from the height of Superhabondance first to the mean position of Vertu and then to the low point of the empty scroll of Deffaute confirms such a reading. Although it is fitting that this vice is nameless, the adjoining scroll identifies him.[13]

Abstract verbal concepts are vividly expressed not only through scale and position but also through costumes and gestures. Credit for this goes to the Jean de Sy Master, whose lively style imparts a distinctive character to the miniature. The clumsiness of the giant Superhabondance, shown by his outspread right elbow and feet sprawling on the ground plane, suggests a lack of containment that helps define his moral stance. In contrast, the illuminator depicts the pinched, inward movement of the aged, hunched dwarf, emphasized by the feet set closely together. In both instances, posture, age, and gesture indicate moral states: Superhabondance with the excesses of youth, Deffaute with the abstinence of old age. The physical abnormalities of the giant and the dwarf also connote departure from moral norms. Although the vices edge away from the center of the pictorial and—by analogy—the moral field, their gazes are directed to Vertu, embodying the mean. The vivid red of her fashionably cut red robe and the narrow white fur sleeves emphasize her central role. Her gold crown set atop her modishly braided locks as well as the light brown scepter and blooming branch framing her face are distinctive color accents.

Vertu is the only one of the three figures to assume a frontal position. Her placement, reinforced by the vertical points of the quadrilobe, establishes the axial symmetry of the composition and makes visible the notion of holding firm to the moral center. It also signals an ideal status associated with royalty.[14] Representing Virtue as a ruler conveys the generic nature, leadership, and sovereignty of the concept. The association of these positive values suggests the high social status enjoyed by medieval French queens.[15] The prominent, dark red fleur-de-lis background alludes not only to Charles V but also to his consort, Queen Jeanne de Bourbon. In the dedication frontispiece of *A,* Figure 7, the upper right quadrilobe depicts this queen with a similar fashionable dress and hairstyle.[16]

Vertu's standing as a queen has other social implications. Her embodiment of high moral values is associated with noble and royal status. In contrast, the vices or extremes of Superhabondance and Deffaute are personified by lower-class male figures, identified by their short tunics. This is the first of many instances in the illustrations of the *Ethiques* and *Politiques* in which costumes signal to the reader distinctions between socially positive or negative values. Perhaps it is significant, too, that the vices are active male presences whose movements and three-quarter poses stand out sharply from the motionless frontality of the female personification. Ironically, the grotesque vices are endowed by the illuminator with a vitality and individuality completely lacking in the morally ideal figure of Vertu.

The program of this illustration ingeniously clarifies Aristotle's generic verbal definition of Virtue as a mean. In a personification allegory, Oresme's program opposes abstract concepts, a traditional medieval theme and rhetorical device.[17] Employing visual metaphors that effectively juxtapose and distinguish morally positive from morally negative values, Oresme imposes on the personifications an order based on scale and division of the picture field. The visual structure creates analogies between the proportions of the personifications and their deviations

from the moral norm. Superhabondance, a term used in Oresme's text, stands for the generic extreme of Too Much. The vice's position on the left reflects prior sequence in the text definition of this concept. On the right, the smallest figure, Deffaute, is equated with the opposite fault of deficiency. Both Superhabondance and Deffaute are respectively too large or too small in proportion to the mean, personified by Vertu, who stands in the middle of the picture field. While Figure 11 exemplifies a simple demonstration of proportional relationships, Oresme employs it effectively in ordering the visual metaphor. An expert in mathematical theories of ratios and proportions, Oresme provides a more concrete example of his thinking on such topics in the illustration of Book V (Fig. 24). Finally, another ordering principle relates the "off-center" positions of the vices to their moral characters.

With its logical process and ordering of the visual definition, the subtle personification allegory establishes a close relationship between text and image. The discussion thus far establishes conclusively that as master of the text only Oresme could have devised such an ingenious and witty program. Moreover, the translator shows a considerable imagination in clothing the abstract notions of Excess and Deficiency in the compelling guises of a giant and a dwarf respectively. For these actors appear in neither Aristotle's text nor Oresme's. In their creation Oresme may well have intended the image to fix in the reader's mind moral teachings that "are set out in order" by means of "corporeal similitudes."[18] Familiar with Aquinas's thinking on artificial memory, which reflects Aristotle's theories on the subject, Oresme may have consciously sought to have the reader recollect the teachings of the Philosopher by associating them with distinctive visual forms, "*imagines agentes*—remarkably beautiful, crowned, richly dressed, or remarkably hideous and grotesque."[19] Such a description suits the figures of Vertu and the two vices. Moreover, such "corporeal similitudes" also had the function in scholastic memory treatises of inspiring the beholder to virtuous action. For Charles V, Oresme's primary reader, both the images of Figure 11 and its background would have encouraged his participation in and assimilation of its meanings. The activation of the ground with its large red fleur-de-lis outlined in black allowed the king to "put himself in the picture" by identifying first with the royal symbol and then with the central personification of Virtue.

Oresme's achievement in devising the program of Figure 11 is even more impressive in view of the lack of known precedents. Erwin Panofsky points out that the representation of virtue as a generic concept, totally secular in context, is a landmark in medieval art.[20] Although a miniature in the Morgan *Avis au roys* representing Vertuz parfaite (Fig. 13) can in some respects claim priority to Figure 11 as a depiction of generic virtue, the opposing vices and the notion of a mean are missing.[21] In any case, the ordering and images of Oresme's ingenious visual definition command admiration for their lively and deceptively simple character successfully realized in the illuminator's inimitable representations of the giant and the dwarf.

deuoit nue leuer de terre se elle y gisoit. Et pour
tant il est aucune fois mestier que li seigneur
aient aucuns esbatemens et leeses ordenees
en ieus et en fais honestes selon leur condition
et leur estat. Comment une uertuz senz lautre
lan ne puet auoir parfaitement. xxvj.

Cecin qui
ueut auoir
une uertuz
parfaite il faut
quil ait toutes
les autres uer-
tuz; quar les
uertuz ont une
tele connexion et tele conuenience que lan
ne peut auoir lune senz lautre parfaitement.
La raison en est tele. quar qui ueust auoir
une parfaite uertuz il faut de necessite quil ait
la uertuz de prudence la quele donne cognois-
sance dou moyan ou quel uertuz est gardee et si
donne cognoissance de la fin a laquele uertuz est
ordenee et prudence ne peut souffrir deformite
ne desordenance contraire a uertuz. Et pour tant
les uertuz sont si entrechainees que lune dy
celles ne peut estre senz prudence et prudence ne

FIGURE 13 *Perfect Virtue and Cardinal Virtues. Avis au roys.*

The success of the personification allegory in *A* is shown by the limited revisions made in the equivalent miniature of *C*. Despite these continuities, both subtle and obvious differences exist between Figure 12 and its model. For one thing, the vertical orientation of Figure 11 in *A,* dependent on the dimension of the column of text and gloss, gives way in Figure 12 to a horizontally oriented image as wide as the entire text block. Furthermore, the elimination of the interior quadrilobe of the *A* miniatures permits a freer disposition of the pictorial space. The frontispiece character of this and other miniatures of the *C* cycle is unique among fourteenth-century illustrated manuscripts of the *Ethiques*.[22] Perhaps the influential precedents of certain miniatures in *B* brought about the decision to adopt the frontispiece format for the illustrations of *C* and *D*. Whatever the reason, the frontispiece emphasizes the importance of the miniatures. The uniform placement of the miniature serves as a stable, repeated visual cue that associates the summary functions of the image with the beginning of each book. Recognition that the frontispiece offers a more regular and unimpeded field appropriate to the didactic aims of the *C* cycle may have come from any or all of the people entrusted with the production of the manuscript: the scribe, the translator, the illuminator, or the patron.

The rectangular shape of Figure 12 accommodates two more figures standing on each side of Vertu.[23] The first is identified as Bonne volenté (Desire to Do Good) and the second as Cognoissance (Knowledge). Both are represented as young girls dressed in a simplified type of contemporary costume. They wear gold fillets in their blond hair.[24] Their identical physical appearance suggests that they are twin sisters, matched by analogy in the possession of similar moral qualities. Such metaphors of kinship to express relationships among a "society of concepts" are widely used in the *Ethiques* programs.[25] The twins' support of Vertu's arms implies that they are her companions, handmaidens, or daughters. Verbal sources accounting for the presence of the twins come from a passage in Oresme's text stating that knowledge of one's actions and the desire to achieve good are essential states of mind for attaining virtuous conduct.[26] The text does not, however, pair these concepts or in any way identify them as twins. Oresme may have invented the kinship metaphor to make more concrete and memorable the psychological states required for excellent or virtuous action.

In accordance with the increased didacticism of the cycles, other changes may reflect Oresme's concern for completeness and consistency of detail. Unlike the case of Figure 11, where the word *vice* is missing for Deffaute, all the inscriptions in Figure 12 are filled in, placed horizontally, and shortened. Perhaps the change in the Deffaute label suggests that the allusion to deficiency as a moral shortcoming or nameless vice was too subtle. The decision to omit the descriptive scrolls used for the vices in Figure 11 means that the reader must depend solely on visual devices, such as the scale relationships, to grasp the essential character of the personifications. Even Vertu has lost her scroll establishing the association between her and the concept of the mean. Yet after the figure was in place, the scribe,

Raoulet d'Orléans, wrote the word *moien* on her mantle. The location of the word and the lack of the usual rectangular box framing the inscription suggest an unplanned addition. Oresme may have judged the verbal reinforcement necessary because the increased height of Vertu (relative to Excès) and the presence of the twins may have obscured visual understanding of the concept of the mean.

Figure 12 inaugurates another important change in the *C* cycle: Vertu is no longer pictured as a queen but is clad in loose, flowing garments and a head covering that combine features of the garb worn by widows and members of female religious communities. Immediate precedents for such costume are found in the representation of certain personifications of the *A* cycle (Figs. 15, 20, 33, and 35). The dress of Vertu in Figure 12 reflects a long tradition in medieval depictions of both virtues and vices traceable to a tenth-century *Psychomachia* manuscript. A classical type of female draped figure is the ancestor for such costume.[27] Although the garments of Vertu in Figure 12 do not replicate those of any specific order of nuns or of widows, the costume effectively neutralizes female sexuality. The garb of Vertu also suggests a timeless character, shorn of explicit secular, contemporary, and royal associations created by the costume and attributes of the same personification in Figure 11. In *A,* two other personifications, Justice and Félicité (Figs. 24 and 42) are also represented as queens, while in *C* only Félicité humaine (Fig. 10) is depicted as a crowned ruler. Perhaps in the process of revising the program of *A,* Oresme realized that queenship is not even figuratively a divisible concept. Whatever the reasoning, except for the personifications of Happiness (Figs. 10 and 43) in *C,* representations of virtues and female vices consistently wear the nunlike garb.

One consequence of this change in costume is the loss of clear social and class distinctions between Vertu and the vices. Yet Figure 12 retains other essential characteristics of the personification allegory established in the *A* illustration, such as the proportional relationships and ordering of the picture field. Moreover, several nuances of meaning unique to Figure 12 are indeed notable. For example, the inclusion of Bonne volenté and Cognoissance expands the notion of a strong, ethically positive center. The two vices, separated from Vertu and the mean by the twins, are relegated to the sides, or extremes, of the picture space. This distance symbolically embodies the departure from the normative mean demonstrated by the placement of Excès and Deffaute. This effect of physical and moral alienation is enhanced by the way that the vices dramatically turn their heads not toward Vertu (as in Fig. 11) but away from her toward the limits of the picture field, again symbolic of moral extremes. The turning of the heads may relate to the concept that the two extremes are more opposed to each other than they are to the mean.[28] This dynamic movement contrasts with the frontality and stability of Vertu. The gold spirals that animate the warm apricot color of the background emphasize the lively turnings of the vices' heads.

The personifications of Figure 12 stand out effectively against the agitated background, much like actors taking a bow on a narrow stage after the curtain has fallen. The style of the Master of the Coronation of Charles VI (or a member of his shop) lacks the tension and excitement of that of the Jean de Sy Master, who

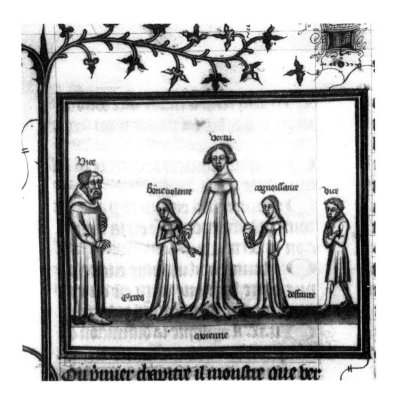

FIGURE 14 *Vice of Excess, Desire to Do Good, Virtue, Knowledge, and Vice of Too Little. Les éthiques d'Aristote,* Chantilly, Musée Condé.

executed Figure 11. Yet as noted previously, despite the changes in the program, the essential meaning of the personification allegory established in Figure 11 remains intact. Although Vertu is no longer a queen, by scale and position she remains the mean. In comparison, a later fourteenth-century illustration of Book II, based on Figure 12, reverts to the older principle of hieratic scale (Fig. 14), thereby destroying the essence of Oresme's strategy.

Although the integration of the fleur-de-lis background with the lively forms of Figure 11 seems consistent with the royal character of the manuscript, the tranquil and meditative rendering of Figure 12 is also suitable to the more private function of the manuscript as Charles V's reading copy. In short, Figures 11 and 12 are auspicious examples of Oresme's collaboration with miniaturists and scribe to produce images that ingeniously convey complex verbal notions in a lucid and deceptively simple manner.

If Oresme delivered an oral explication, private or public, of the main points of Book II, the illustration of Figure 11 could have served as vital talking points. The visual metaphors of the Giant, Dwarf, and Queen would have made discussion of key points of Aristotle's verbal definitions concrete and vivid, whether or not the illustrations were available or familiar to the audience.

7 COURAGE, MODERATION, AND THEIR OPPOSITES
(Book III)

The illustrations for Book III of the *Ethiques* present subjects more familiar to the reader than those of Aristotle's generic definition of virtue and the theory of the mean. Figures 15, 15a and 16, 16a depict personifications of Fortitude (Courage) and Temperance (Self-Control). Since both Fortitude and Temperance (Actremmpance in *A,* Attrempance in *C*) belong to the quartet of cardinal virtues long associated in medieval art with the ideal ruler, the reader probably did not require extensive verbal or visual explication of these concepts.[1] Unlike Plato in the *Republic,* Aristotle does not discuss the cardinal virtues in the *Ethics* as unified or related ideas.[2] Instead, he considers them as individual moral virtues to which he applies his generic definition of virtue and the theory of the mean. Moreover, in Book II, among other individual virtues and vices, Aristotle had already introduced Fortitude and Temperance and their opposites.[3] These two virtues are illustrated in the order of Aristotle's discussion: Fortitude is first, Temperance second.[4]

While the personification allegories illustrating Book II serve as subject guides, they also provide a profound interpretation of linked concepts. Figures 15 and 16, by contrast, depict separate personifications. Their function is indexical and limited to that of a visual table of contents.[5] To aid the reader in locating textual explanations that correspond to the inscriptions in the miniatures, the illustrations are placed on the same folios as the list of chapter headings. Yet unlike the illustrations of Book II, which take up an important position at the head of a column (Fig. 11) or of a folio (Fig. 12), both Figures 15 and 16 occupy less prominent places that tie them more closely to the chapter headings and their subject guide function. Figure 15 stands at the bottom of the second column of folio 39 in *A* immediately following the chapter headings and the rubrics for the first chapter of Book III. Figure 16 occupies the second of three divisions of the folio immediately above the introductory paragraph and chapter headings for Book III. Compared to the illustration of Book II in *A* (Fig. 11), the reduced size of Figure 15 indicates its lesser importance within the cycle.[6] Yet Figure 15 was considered important enough that the usual quaternion structure was disrupted and a new gathering of ten leaves was begun with the chapter headings and illustration of Book III. So although Figures 15 and 16 no longer occupy the top place of their respective folios, their functions as visual tables of contents receive recognition by their relationship to the text and the decorative elements of the folio layouts.

The familiar concept of Fortitude or Courage is *Fortitudo* in Latin; in medieval French the equivalent noun was *force*. Oresme changed the Latin ending to introduce *Fortitude* as a neologism.[7] If the reader is unfamiliar with the term included in the inscription of Figure 15, the meaning can be found in the glossary of difficult words supplied by Oresme: "C'est la vertu moral par laquelle l'en se contient et porte deüement et convenablement vers choses terribles en fais de guerre, si comme il appert ou tiers livre; et par especial ou .xvi.ᵉ chapitre en glose" (It is the moral strength by which one controls and bears oneself appropriately and fittingly in the face of the terrible events of war, as is revealed in the third book, in particular a gloss of the sixteenth chapter).[8] The titles for Chapters 14 through 21 include the word *Fortitude* and provide another system for the reader to find locations in the text itself where the inscription of Figure 15 is repeated.

The visual definitions of Fortitude in these two images represent the virtue as male. Such a choice, an acceptable and traditional alternative to the depiction of Fortitude as female, has obvious advantages. First, a masculine Fortitude more naturally associates the sphere of activity of this virtue with conduct on the battlefield, an exclusively male domain. Second, the representation of Fortitude as an armed knight signifies the warrior class, one of the three estates of medieval society. In Figure 15 the addition of a crown to the representation, as well as the conspicuous fleur-de-lis background, specifically associates Fortitude with a virtue possessed by the king of France. A direct precedent for such an identification occurs in an illustration from the Morgan *Avis au roys* (Fig. 17). In this miniature, the king not only carries a sword but holds a measuring stick, symbolizing reason. The representation is connected with the rubric emphasizing that "bon princes doit avoir force par mesure" (a good prince must possess courage with moderation).[9] Moreover, a subsequent passage identifies Courage (called Force) with "li bon roy de France" (the good king of France).[10] Although Charles V was not an active military leader, Christine de Pizan continues to associate him with the warrior role of French kings.[11]

The forward-moving figure of Fortitude (Fig. 15) is seated on his blue-draped mount and clad in armor. As he advances into battle, his frown and tight grip on his horse's reins, as well as his upright posture, express consciousness of danger. The horse's bent leg and open mouth echo his rider's alert response to approaching danger. A sense of compelling motion is conveyed by the horse's fluttering drapery, which overlaps the quadrilobe frame.

The right half of Figure 15 is occupied by a second cardinal virtue, Actrempance, or Temperance. Oresme defines the nature of Actrempance in Chapter 22: "Or avon nous dit devant que actrempance est moienneresse vers delectacions et les modere" (Now we have said earlier that temperance is the mean [midpoint] in the direction of pleasure and serves to moderate the latter).[12] He elaborates in a sentence from the first gloss in this chapter, which compares Fortitude with

Left column:

Apres comence le tiers liure dethiques
ou quel il determine daucuns principes
de fais ou doperacions humaines iusques
au .xiiij.e chapitre. Et apres determine de .ij.
vertus qui sont vers les passions qui regardent
principaument la vie humaine. Et contient
tout le liure .xxvij. chapitres.

ij. premier chapitre il determine prin
cipaument de ce qui est uoluntaire p
uiolence.

u second il monstre plus aplein que
cippe fautte iaour nest pas prement
uoluntaire.

u tiers il determine de ce que est ni
uoluntaire par ignorance.

u quart il determine quelle cippe est
uoluntaire.

u quint il determine de
election.

u .vj.e il monstre par especial que elec
tion nest pas opinion. et conclut que
est election.

u .vij.e il monstre de quelles cippes
doit estre conseil.

u .viij.e il met la maniere et lordre
de conseillier.

u .ix.e il determine de conseil par com
paroison et ou regart de election.

u .x.e il determine de
uolunte.

n le .xj.e il monstre que uertus z ma
lices sont uoluntaires et exclud une
erreur contraire.

u .xij.e il reprenue un motif ou racine
de lerreur dessus dicte.

u .xiij.e il reprenue un autre motif
ou racine de lerreur dessus dicte.

u .xiiij.e il comence traictier de forti
tude. et premierement il enquiert la
matiere et obiect de ceste uertu.

u .xv.e il determine du fait ou operaci
de fortitude.

u .xvj.e il determine des fais ou opera
ons des vices opposites a fortitude.

u .xvij.e il fait mencion de cinq autres
manieres de fortitude non vraie et de
termine de la premiere.

Right column:

u .xviij.e chapitre il determine de la .ij.e
maniere de fortitude non vraie.

u .xix.e il determine de la tierce maine
re de fortitude non vraie.

u .xx.e il determine la quarte manie
re de fortitude non vraie.

u .xxj.e il declaire la maniere coment
fortitude regarde delectacion et tristece.

u .xxij.e il comence a determiner de la
uertu datrempance. et moustre que elle
est en delectacions de toucher et de gouster.

u .xxiij.e il monstre come actrempance
et desactrempance sont es delectacions
dessus dictes.

u .xxiiij.e il monstre quel est le fait
de desactrempance vers delectacions et
tristeces.

u .xxv.e il determine du vice opposite
a desactrempance et des condicions de
celui qui est actrempe.

u .xxvj.e il comparage le vice de desa
trempance au vice de paour ou couardie.

u .xxvij.e chapitre il comparage le vice
de desactrempance aus pechiez des enfans.

Ci finent les rubriches du tiers liure dethiques
Ou premier chapitre de ce tiers liure dethiques il
determine principaument de ce qui est uoluntaire
par uiolence.

Come il soit ainsi que uertu
est en passions et en operaci
ons des quelles celles qui sont fai
tes uoluntairement sont a

FIGURE 15 *Fortitude, Actrempance. Les
éthiques d'Aristote, MS A.*

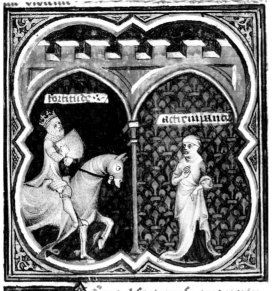

FIGURE 15A Detail of Fig. 15.

Temperance: "Item, fortitude resgarde les choses qui sont corrumpables de vie humaine. Et actrempance resgarde celles qui la conservent ou en singulier comme boire ou mengier, ou en son espece comme fait ou culpe charnel" (Item, Fortitude concerns things that are capable of corrupting human life. And Temperance concerns those which preserve it either individually, like drinking or eating, or in its species, as in the sin of the flesh).[13] Thus, the pairing of the two virtues not only follows the textual sequence but also presents a contrast for explication by Oresme.

The program for Figure 15 effectively juxtaposes the two virtues. Fortitude looks to the right, Actrempance to the left. The first wears blue garments set against a background of red fleur-de-lis; the second is clad in red and rose set against a dark blue field of the same motif. The traditional female gender of Actrempance, whose wary glance and upraised hand express an appropriate spiritual alertness and restraint, contrasts with the masculine activity and movement of Fortitude. The latter is active and engaged; the former, detached and contemplative. The widowlike wimple worn by Actrempance further accentuates her spiritual character of moderation in respect to bodily pleasures. The miniaturist has imbued the two virtues with expressive qualities consistent with their verbal definitions.

The likeness and difference between Fortitude and Actrempance explained in the gloss cited above also emerge from other aspects of the pictorial design. The two virtues are united in one quadrilobe, but within the common space they inhabit separate rooms,[14] divided by a central column supporting two pointed

37

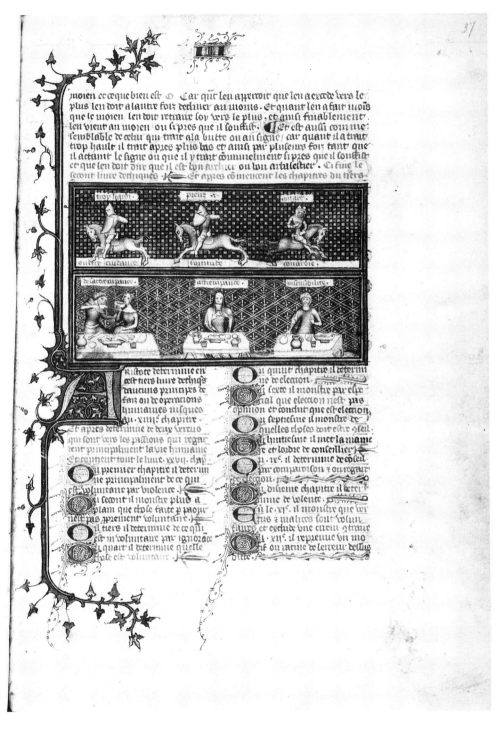

FIGURE 16 Above, from left: *Oultrecuidance, Fortitude, Couardie;* below, from left: *Désattrempance, Attrempance, Insensibilité. Les éthiques d'Aristote,* MS *C.*

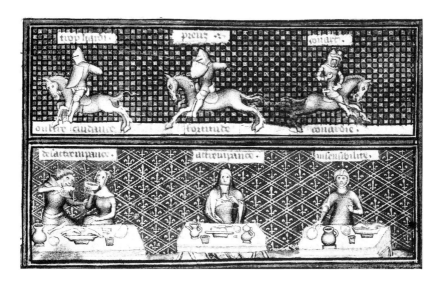

FIGURE 16A Detail of Fig. 16.

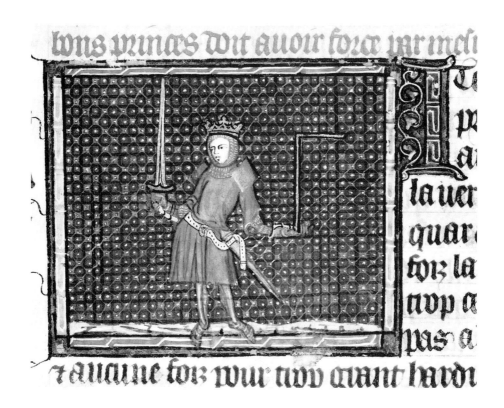

FIGURE 17 *A French King as an Exemplar of Courage. Avis au roys.*

arches. These arches are in turn topped by a rectangular wall segment with a large central spandrel and two smaller ones terminating in a row of seven crenellations. The gray color suggests a stone structure, although its practical function is difficult to determine. Initially this wall, or gateway motif, appears in two miniatures of *A* beginning with Books III and IV (Figs. 15 and 20) as a means of separating two representations. But in the remaining illustrations of the cycle, except for that of Book VII, the wall is undivided, embracing a single representation. While it is possible to explain the prevalence of the crenellated wall motif as a decorative device, its repetition in the miniatures of *A* may also have symbolic connotations. In various literary and visual images, personifications of the virtues are often placed within a tower, castle, or city wall setting. The crenellated wall motif here generally connotes a stronghold: a safe or fortified place in which the virtues exist. This tradition is a feature of the medieval iconography of the virtues.[15]

The crenellated wall motif could also function as a memory gateway. As noted earlier, medieval memory treatises stress the usefulness of visual images in fixing in the mind general concepts by associating them with distinctive corporeal forms located within architectural places.[16] The brightly lit crenellated wall and arches of Figure 15 correspond in a general way to the tower or castle gateway inhabited by Lady Memory in Richard de Fournivall's *Li bestiaires d'amour* (Fig. 18).[17] Set within the gateway under identical pointed arches silhouetted against contrasting backgrounds, stand strikingly opposed figures (Fig. 15). Connected by the inscriptions with verbal concepts, the individualized personifications of Fortitude and Temperance lend themselves to association with the appropriate left or right location within the gateway. The symmetrical division of the crenellated wall by the central column in Figure 15 encourages visual identification of each half of the picture field with the specific personification. Like two painted sculptures, Fortitude presses forward on the left like an equestrian statue, countered on the right by the still, columnar form of Actrempance. Coordinated also with the central vertical division of the quadrilobe, the separate spaces of the two virtues within the memory gateway are identified with distinctive but juxtaposed verbal concepts and visual images. Simple as it appears, the structure of Figure 15 mirrors not only the order of the text but also its spiritual dimensions. The juxtaposition of opposing concepts, reinforced by gender and color contrasts, corresponds also to rhetorical theory.[18]

THE EXPANDED SUBJECT GUIDE OF THE *C* MINIATURE

The expansion of both visual imagery and verbal identification in Figure 16 offers a subtle critique of the program of Figure 15. No longer confined by the width of the text column, quadrilobe frame, or gateway setting of Figure 15, the miniature for Book III in *C* (Fig. 16) returns to a horizontally oriented two-register format first employed in the frontispiece of this manuscript. Like Figure 15, the upper zone of Figure 16 depicts Fortitude in the central position. Here, however, the vices opposed to Fortitude are represented in off-center places: Rashness (Oul-

FIGURE 18 *Lady Memory and the
Doors of Sight and Hearing.* Richard de
Fournivall, *Li bestiaires d'amour.*

trecuidance) on the left and Cowardice (Couardie) on the right. The same scheme
is followed on the lower register. Temperance (Attrempance) occupies the center
between the vices of Self-Indulgence (Désattrempance) on the left and Insensibil-
ity (Insensibilité) on the right. In addition to the nouns identifying the personifi-
cations written on the shallow ground plane below the figures, adjectives further
characterizing them are inscribed on rectangular bands above their heads. Thus,
"trop hardi" above Oultrecuidance applies to one who "excede et superhabunde
en oser ou en emprendre vers les choses terribles" (is foolhardy and rash in daring
and in undertaking terrible things).[19] The other extreme, the "couart," lacks daring
and experiences too great fear. Oresme explains in a gloss: "Et en tant comme il
deffaut en oser il est appelé couart en françois" (And inasmuch as he lacks daring,
he is called a coward in French).[20] *Preuz* is translated as "valiant" and reinforces
the definition of Fortitude previously cited.

The adjectival reinforcements of the upper register help differentiate the re-
markably similar figures of Oultrecuidance, Fortitude, and Couardie. The striking
resemblance between the first two may well reflect Aristotle's idea that "rashness is
thought liker and nearer to courage and cowardice more unlike."[21] This concept,
expressed in terms of visual identity, could, without the descriptive adjectives,

obscure the more important distinction between the vice and the virtue. Since Fortitude is not distinguished from Oultrecuidance or Couardie by scale, the device used in the Book II miniatures (Figs. 11 and 12), the positions and directions of the figures are the decisive visual means of communicating their moral qualities. The notion of virtue as a mean, established by the scheme of Figures 11 and 12, is again associated with the midpoint of the picture field here occupied by Fortitude. Likewise, the vices of excess and deficiency occupy the same places on left and right as their generic predecessors, the giant and dwarf of the Book II illustrations. The scheme of a central norm and its moral opposites on each side appears to repeat the preference for a triadic organization allied to Aristotle's mnemonic theory.[22] In Oresme's discussion of Oultrecuidance and Couardie in Chapter 16 of Book III, the former is discussed first.[23] Thus the position of an image on the left of the picture field once again relates to order in the text. An extratextual device, however, reinforces the notion of Couardie's moral stance established by his pose. By moving in the opposite direction taken by Oultrecuidance and Fortitude and by raising his helmet, Couardie shows that the lack of daring makes him flee the battlefield. This witty and ingenious notion shows another instance of Oresme's inventiveness as author of the program of illustrations.

In the lower register the virtue of Attrempance occupies the central position held above by Fortitude. Unlike the latter and his opposing vices, Attrempance and the extremes on either side of her are identified by nouns but not characterized by adjectives. Perhaps the actions of the figures on the lower level were deemed to be sufficiently distinguished one from another to make their points without verbal reinforcements. For Attrempance is no longer a still, standing form, detached from any specific activity, as she is pictured in Figure 15. Instead, her moral position in respect to bodily pleasures and pains is exemplified by the vignette in which she is the central actress. In Figure 16 Attrempance is seated behind a table furnished with food and implements for eating and drinking. The picture of sobriety in her nunlike robe, the virtue sits alone sipping from a cup. Her upright posture and frontal pose also convey a detached and abstemious attitude. Without any reference to scale, the notion of the mean is, as in the upper register, expressed by the virtue's central position. The repetition of the scheme devised in the upper register helps, however, to reinforce the notion of the central mean surrounded by the two extremes. An illustration in the Morgan *Avis au roys* (Fig. 19) exemplifies Attrempance by representing a king seated at a table laden with food and drink and furnished with four gold vessels. He holds his finger to his lips in a gesture that conveys restraint and self-control based on reason.[24] Although Figure 16 relies on similar exemplification of the concept personified in Figure 15, the pictorial notion of the mean developed in this illustration and in the Book II miniatures of *A* and *C* appear to be original features of Oresme's programs.

The vice of Self-Indulgence, or Désattrempance, is personified and exemplified in Figure 16 by a man and a woman seated before a bountiful table. Fashionably dressed, the man reaches out with his left hand to touch the woman's arm, while

FIGURE 19 *A French King as an Exemplar of Temperance. Avis au roys.*

he prepares to attack a large portion of food he holds to his mouth. About to drink from a big bowl, his partner is shown with a smart contemporary hairdo of braided tresses. Her dress features a low-cut bodice and tight sleeves that differentiate her costume from the modest garments of Attrempance and Insensibilité. The inclusion of a male figure in the scene makes clear that "delectation charnel" includes sexual as well as gastronomic excess.[25]

The opposite vice, on the right, is associated with deficiency rather than excess. Insensibilité is a rare human defect, applying to persons deficient with regard to pleasures.[26] Indeed, Insensibility is not natural since even animals enjoy eating. Oresme terms this vice "inhuman."[27] In Figure 16 a woman in widow's garb, also seated at a table, personifies Insensibilité. Yet although she reaches for an object on the table, she neither eats nor drinks. Her headdress gives some further clue to her identity. Of a more worldly nature than the nunlike veil of Attrempance, the head covering of Insensibilité sports a central point, or horn. This unusual feature characterizes the personification in Book IV (Fig. 21) of the vice of Avarice. Also a vice of deficiency, Avarice is in medieval thought associated with usury, a practice often connected with money lending by the Jews. As a mark of their inferior status in Christian society, Jews of western Europe were forced to wear pointed hats or hoods.[28] In 1326, following the council of Avignon, a papal bull decreed that Jewish women wear a veil with horns, called a *cornalia*.[29] Why Insensibilité is

identified with a Jewish woman is more puzzling than the similar association of Avarice. The vices share, however, a lack of common human feeling, a failing often attributed to Jews in anti-Semitic literature. Furthermore, the Jewish dietary laws forbid the eating of certain foods favored by Christians. Such deviance from common standards of enjoyment may have further contributed to the identification of Jews with Insensibilité. Since such allusions are extratextual, the negative associations were presumably understood by readers on the basis of the horned headdress. Thus, a rare moral deficiency is associated with a small minority of contemporary society regarded as inhuman and aberrant.

In short, the illustrations for Book III in *A* and *C* are not as prominent as those for Book II, and their imagery is less innovative. Nevertheless, within the overall programs of illustration they are significant. Figure 15 introduces the motif of the crenellated wall, which stands for the stronghold of the virtues and a memory gateway. The juxtaposition of associated but sharply differentiated ethical concepts also follows Aristotelian theories of memory and rhetoric taken up in medieval sources.[30] On two levels Figure 16 carries out the mean and extremes scheme in a concise and witty manner. Thus both miniatures fulfill their functions as visual definitions and subject guides in styles appropriate to the manuscripts they illustrate.

8 GENEROSITY, MAGNANIMITY, PROFLIGACY, AND AVARICE
(Book IV)

LIBERALITÉ AND LE MAGNANIME IN *A*

The illustrations for Book IV in *A* and *C* (Figs. 20, 20a and 21, 21a) fit the same pattern as those of the preceding book. The subjects chosen for illustration and definition fall into the categories of familiar moral virtues of particular relevance to the conduct of rulers. Like the arrangement of Figure 15, the two subjects of Figure 20 are separated by a central column carrying two arches surmounted by a crenellated wall segment. On the left is depicted Liberalité (*eleutheriotes*), best translated in English as Generosity. Her male counterpart on the right is identified as Le Magnanime, a term called *megalopsychia* in Greek and translated into English as Magnanimity or High-Mindedness. Although the personifications again contrast a simply clad female in widowlike garb with a royal male figure, their postures and attitudes are reversed from those of Figure 15. Liberalité is found on the left, because discussion in the text of this subject occurs in the first three chapters. In fact, rubrics directly above and below the miniature in both Figures 20 and 21 tie illustration and text closely together. But the words *Le Magnanime* do not occur until the headings for Chapters 15 to 17 of Book IV. Once again, left-to-right order of representation reflects sequence in the text. Such an arrangement orients the reader first to the location and then to the association of these concepts. Thus, by relating text to images in the proper sequence, the reader will begin the process of recollection described by Aristotle.[1]

The contrasting red and blue fleur-de-lis grounds and costumes of the main figures in Figure 20 contribute to the color harmony of the pictorial, calligraphic, and decorative elements of the folio. The extensive use of gold in the right half of the miniature gives special weight to that part of the representation, yet gold is also present on the left side. Liberalité, who stands next to a pink table containing gold coins and vessels, is dispensing part of her hoard to figures placed at the left edge of the picture. The nature of Liberalité's action makes clear that her sphere encompasses money or riches. Oresme must have been aware that the question of expenditure involved a change in the type of ethical problem discussed in Book III, as his introductory words make plain: "Ci aprés commence le quart livre ouquel il tracte des vertus morales qui ne resgardent pas si principalment vie humainne comme font fortitude et actrempance" (Here begins the fourth book in which he discusses the moral virtues, which are not so fundamentally concerned with human life as are Fortitude and Temperance).[2]

FIGURE 20　*Liberalité, Le Magnanime.*
Les éthiques d'Aristote, MS A.

FIGURE 20A Detail of Fig. 20.

The first paragraph of Book IV of the *Ethics,* and Oresme's translation of it, define Liberalité as the mean regarding the getting and spending of money. While this subject does not deal with such basic human qualities as fear and self-control, the right attitude toward expenditure of money and riches is a topic of great concern to rulers.[3] Aristotle concerns himself with the political and social issues relating to the expenditure of funds in Book V of the *Ethics* and in several places in the *Politics.* But not surprisingly, the Morgan *Avis au roys* makes an immediate connection between Liberalité and the ideal ruler. An illustration from this manu-script (Fig. 22) represents a king who wears a fleur-de-lis crown holding out coins to groups on his left and right. This ruler thus carries out the injunction that appears in the rubrics: "Comment bons princes doit avoir la plesent vertu de liberalité" (How a good prince must have the pleasing virtue of liberality).[4] Of course, the ruler must avoid the vices associated with expenditure, Prodigalité or Fole largesce (Too Much) or Illiberalité (Too Little). These vices are discussed extensively in the opening and subsequent sections of Book IV of the *Ethics,* but they are not represented in Figure 20.

The personification of Liberalité in Figure 20 guards her treasure trove. Stand-ing on the ample ground plane at some distance from those requesting largesse, Liberalité does not look directly at them. Her outward gaze and turn of the head

FIGURE 21 Above, from left: *Prodi-galité, Liberalité, Avarice;* below: *Convoitise, Les éthiques d'Aristote,* MS C.

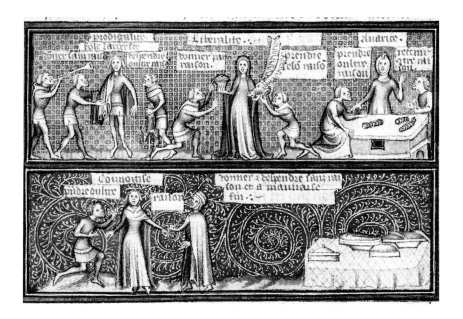

FIGURE 21A Detail of Fig. 21.

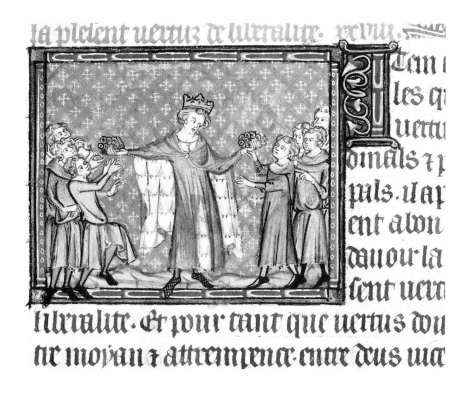

FIGURE 22 *A French King as an Exemplar of Generosity. Avis au roys.*

express restraint of attitude and action. Although the gesture of her right arm symbolizes generosity, that of her left one protects the riches spread out on the table. The total impression of her upright stance, costume, and body language emphasizes that Liberalité is a mean. The gifts that she bestows must have a good purpose and must be directed "to the right people," in "the right amounts, and at the right time, with all other qualifications that accompany right giving."[5]

Perhaps another explanation of Liberalité's detachment lies in an attempt to distinguish her as a spiritual force inhabiting an ideal realm, an attempt that is difficult to realize for several reasons. Unlike Attrempance in Figure 15, who does not act, Liberalité appears as an agent involved in the everyday world. The male actors and the treasure-laden table emphasize the earthly sphere and recipients of Liberalité's domain. This technique of exemplifying in everyday terms the workings of the virtues, noted in Figure 16, goes back more than a century.[6] Moreover, the naturalistic style and contemporary costume of the representation counter any perception of her as a purely spiritual force.[7] Thus, several elements of the visual definition lend an ambiguity to Liberalité's ontological status that is absent in the text.

A depiction of a different sort of virtue occupies the right half of Figure 20. Like Liberalité, the main figure, Le Magnanime, receives recognition from a group of kneeling people. This regal, crowned figure is seated on a low faldstool in front of a gold curtain. These insignia of high rank are symbols of Le Magnanime's ethical and social status. Le Magnanime possesses "great-souledness," or self-respect, while his merits deserve honor. Such a person already has other virtues, and this one augments them as "a sort of crown of virtues."[8] Obviously, Le Magnanime is a person of great standing in the community. The values he embodies and his inward and outward deportment are important elements of Aristotle's definition of High-Mindedness. Indeed, Aristotle seems to have composed a psychological portrait that Oresme takes up in the chapters devoted to Le Magnanime. In a typically thorough manner, Oresme enumerates thirty-three characteristics of Le Magnanime.[9] Oresme makes the point that it does not matter whether one speaks of the virtue of Magnanimity, or of the person who "oeuvre selon ceste vertu" (acts according to this virtue).[10] Later Oresme reiterates that the condition of Magnanimity concerns not only accepting honors but also possessing "richesces et puissances, grans offices ou estas" (riches and powers, great offices, or stations).[11] Without any mention of specific political office, Oresme's discussion puts the virtue in the orbit of those associated with actual or ideal rulers. Indeed, an illustration of the Morgan *Avis au roys* depicts a seated king who holds a red heart, emblem of generosity of spirit and feeling (and other qualities) encompassed by the virtue of Magnanimity (Fig. 23).

The representation of Le Magnanime in Figure 20 shows a ruler of exalted status receiving recognition from others of high estate. The unusually oriented vertical scroll emphasizes his position. The seated monarch is identified as the Holy Roman Emperor by virtue of his distinctive hoop crown. The foremost kneeling figure is himself a king, who, with a deferential gesture, lifts a gold crown from his head. A second man, clad in red, gapes in awe at Le Magnanime. In

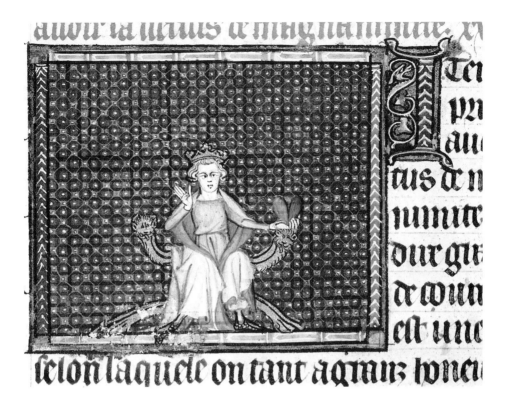

FIGURE 23 *A French King as an Exem-*
plar of Magnanimity. Avis au roys.

contrast, the seated ruler, separated from his adorers by a side of the curtain,
glances warily in their direction. The gesture of his right hand suggests decorum
and deliberation. Le Magnanime accepts the honors due him owing to his rank
and moral excellence, but he is not overly impressed by such recognition.[12] All in
all, the visual portrait of Le Magnanime authoritatively records the grand manner
described in Aristotle's text and Oresme's translation.

Within the simply ordered subject guide of Figure 20, the two figures depicted
point to two virtues associated with the ideal ruler. Placed within separate spaces,
the active female and contemplative male personifications are united by the mem-
ory gateway, brilliantly lit and emphasized by the contrasting grounds against
which they act their appropriate roles. Again, as advocated in rhetorical and
mnemonic theory, juxtaposition and opposition, underscored by gender and color
contrasts, promote the association of the verbal concepts named in the inscriptions
with the appropriate images. Furthermore, the arcade motif is a classic technique
in mnemonic theory; it uses "space-between-columns" to locate the things to be
remembered.[13] Here, the combined allusions of the architecture and fleur-de-lis
to the kingdom of France as the seat of the depicted virtues may have aroused an
unexpected negative reaction from Charles V.

As noted earlier, the revisions of Figure 20 in the *C* miniature (Figs. 21 and 21a) present certain departures from the precedent set up between Figures 15 and 16. In Figure 21 the single-level treatment of the two subjects of the model (Fig. 20) is modified to a two-register format, in which the virtues retain the mean, central position and the vices are relegated to the sides. Thus, in Figure 21 the reader might expect on the upper level depictions of Liberalité in the center and the vice of Too Much on the left and Too Little on the right. A similar pattern for Le Magnanime would logically follow below. Although such expectations are fulfilled in the upper register of Figure 21, in the lower zone they are not. Two possible explanations may underlie the abandonment of Le Magnanime. The first concerns the difficulty of representing the two associated vices. Oresme discusses the concept of excess, Vanity or Vainglory, called "*chaymes,* fumeus et presumptueus," and the vice of deficiency, Small-Mindedness, or *pusillanime.*[14] The problems of finding intelligible visual equivalents for these vices are substantial, but not impossible, for someone of Oresme's ingenuity.

Perhaps a political motivation inspired the rejection of the representation of Le Magnanime. In Figure 20 the personification wears the crown of the Holy Roman Empire. In tribute, a second ruler removes his crown. It is possible that Charles V opposed this visual homage to the emperor. During the visit in 1377 and 1378 to France of his uncle, the Holy Roman Emperor Charles IV, Charles V asserted in various rituals that he was not subordinate to his relative. Furthermore, it was a commonplace of the political propaganda of Charles V's reign that the king of France was emperor in his own kingdom.[15] Thus, Charles V may have objected to the treatment of Le Magnanime as the Holy Roman Emperor in Figure 20 and may have suggested that this depiction of the subject be changed in the revised program of *C.*

In fact, the negative reception of the first version may have inspired the tremendous visual and verbal embellishment of the second. The increased didacticism of the program results in a proliferation of information that threatens the intelligibility of the illustration. Lengthy inscriptions are one source of the overall clutter, such as those that not only name but characterize Liberalité and three associated vices. Furthermore, individual scenes depicting additional figures and objects augment the particular virtue and vices. This tendency to show these moral or immoral forces in scenes from everyday life continues the examples of Figures 15 and 16.

In the center of the upper register stands Liberalité wearing appropriate nunlike garb, signs of her spiritual and sexually neutral status (Fig. 21). Her ability to strike the mean in the giving and spending of money or material goods is described by two phrases on either side of her: "donner par raison" (give as directed by reason) and "prendre selon raison" (take according to reason). Her gift of a gold vessel to the man kneeling on her right signifies her generosity and reinforces the verbal message. But she also is willing to accept the gift of a stag's head offered to her by

the identically clad figure kneeling on her left. This spectacular tribute probably alludes to the climactic stage in the medieval hunt ceremony: the presentation of the stag's head to the highest-ranking person.[16] In contrast to the nunlike garments of Liberalité, her mundane male companions wear fashionable costume: short, close-fitting tunics with hoods, low belts, hose, and long, pointed shoes.

The vice of excess in expenditures, on the upper left, is called Prodigalité or Fole Largesce. Like Fortitude, Prodigalité is a male personification. His sphere of operation is visually described as masculine: acquiring money and spending it on hunting. Prodigalité's weaknesses are characterized as "donner sanz raison" (giving without reason) and "despendre oultre mise" (spending without measure). The vice is surrounded by three figures. On the far left, a figure sounds a horn. Next to him, another man seems to take away Prodigalité's cloak. On the other side, a third figure presents Prodigalité with two small hinds. The latter figure, along with the man with the horn—who probably sounds a call to join in the sport— suggests a further allusion to hunting and an example of "spending without reason." The gift of the two small animals contrasts with the large stag's head offered to Liberalité. The first is an inappropriate gift typical of Prodigalité, who "exceeds in giving and not taking, and falls short in taking."[17] Indeed, Oresme is so concerned with the failings of this vice that he includes *prodigalité* and *prodige* in the glossary of difficult words.[18] The visual references to hunting in the scenes of Prodigalité and Liberalité are consistent with a medieval tradition of opposing the sport as a wasteful pursuit.[19]

The third scene of the upper register represents Avarice, the vice of deficiency opposed to Prodigalité. To be more precise, Avarice is one of two vices that Oresme terms Illiberalité, or lack of generosity.[20] Oresme explains in a gloss that Illiberalité is a word rarely used in French or Latin; for this reason he probably decided to avoid it in the visual definitions of Figure 21.[21] Instead, he uses two more familiar terms, Avarice and Convoitise. The former is defined and depicted above; the latter, below. Avarice represents a more serious defect than Prodigalité, which can be remedied by age, experience, and lack of funds. Avarice's faults consist of taking too much ("prendre oultre raison") and giving too little ("retenir oultre raison"). Personified as a female figure, she stands behind a table on which rest three piles of gold coins. Her gesture of grasping in her right hand the coins received from a kneeling man exemplifies her first fault, while her upraised left palm indicates that she rejects the request of the boy on her right to part with her holdings. His plight is also conveyed by the pleading gestures of his hands.

Like Insensibilité, her counterpart in Book III (Fig. 16), Avarice wears a widow's headdress. Here it is germane to recall Oresme's remark in a gloss that women are generally stingier than men and the aged are more so than the young.[22] Avarice's head covering also sports a horn even more clearly than that of Insensibilité. As noted above, in the Middle Ages Jews were engaged in usury.[23] Moreover, in western Europe Jewish women took part in financial transactions. Since the text cites usurers among people in "operacions illiberales" (occupations incompatible with generosity), the association of Avarice with the Jews is a natural one.[24] The extratextual visual allusion shows not only the extent of anti-Semitic attitudes and

psychological stereotypes but also techniques of providing visual cues that update and enliven familiar concepts.

The other aspect of Illiberalité is represented as a male in the lower register of Figure 21. Convoitise (Covetousness) is almost a twin of Prodigalité, below whom he stands. The inscription on both sides of Convoitise describes one aspect of his character: taking beyond what is reasonable ("prendre oultre raison"). Like Avarice, his grasping quality is indicated by his hands, which stretch out to grasp the coins offered by two elegantly clad men. An even longer inscription, somewhat confusingly placed between the figures and the table, defines another side of his failings: giving and spending without reason and for a bad purpose ("donner et despendre sanz raison et a mauvais fin"). The richly laden table on the right probably refers to a wasteful form of expenditure, the counterpart of the greed depicted on the left. The love of bodily pleasures, or "délectacions corporelles," exemplified by the food heaped on the table recalls the vice of Désattrempance in Figure 16. It is not surprising, then, that the self-indulgence of Convoitise is linked with extravagant expenditure in both Aristotle's text and Oresme's translation.[25] Oresme's choice of Convoitise as the sole subject of the lower register of Figure 21 leads to various difficulties in interpreting the illustration. It is not easy to connect the three scenes of the upper register with the single scene on the left and the table on the right of the lower. While it is possible that the empty center alludes to the absence of virtue in Convoitise, there is no verbal or visual reinforcement of such a notion. It is true, however, that the placement of Convoitise on the left, his frontal position, and his contemporary dress align him morally and visually with Prodigalité. Indeed, the similar appearance of the two personifications may allude to the presence of these qualities in one person. Yet the absence of a second figure on the right and the separation from Convoitise of the inscription are confusing. The relation between Avarice and Convoitise as parts of a single vice does not come across either. The departure from the triadic scheme in the lower register thus leads to puzzling gaps in the illustration. Neither Figure 20 nor 21 is among the most exciting images in their cycles. If the first seems cryptic and somewhat conventional, the second errs on the side of discursiveness. In the parlance of the *Ethics,* one attempts "too little," the other, "too much." Charles V's negative reaction to Figure 20 may have inspired Oresme to expand the subject guides in Figure 21 and to abandon alternative schemes of visual order that so effectively link text and image. Perhaps Oresme intended to rely on these lengthy inscriptions as talking points for an oral explication regarding norms of expenditure: this was a subject he deemed particularly relevant to the appropriate conduct of his primary audience.

9 THE CENTRALITY OF JUSTICE
(Book v)

The center of the *Nicomachean Ethics* is the discussion in Book V of Justice. Justice is central, too, as a fundamental moral virtue that extends beyond the individual to regulate proper conduct within a political community. Thus Justice occupies a central place both within the *Ethics* and the *Politics*.[1] Although Aristotle does not completely depart from Plato's concept of Justice as an "immutable, eternally valid, and universal idea," he considers it as a virtue operating within a political and social context.[2] For Aristotle, Justice is based on a system of law: the ultimate sovereign that governs, for the good of its members, the ethical relationships within a political community among men of free and equal status. Compared to a narrower, legal sense of the term in English, Justice in Greek (*Dikaiosyne*) connotes righteousness or honesty. Aristotle distinguishes between a general or universal type of Justice, "the whole of goodness . . . being the exercise of goodness as a whole . . . towards one's neighbour," and Particular Justice.[3] Justice represents, and is identical with, perfect virtue, not only as an individual moral state but as a quality that governs relationships to other people. Although part of universal or general Justice, Particular Justice is concerned with behaving fairly or, as Aristotle terms it, "equally" to other men.[4] In turn, Particular Justice is itself divided into two types. The first of these is Distributive Justice, "which is the justice shown by the whole state in distributing offices, honours, and other benefits among its members."[5] The second kind of Particular Justice is Corrective or Remedial Justice, which adjusts or awards on a fair basis damages or punishments among individual parties.

As king of France, Charles V had a particular interest in Aristotle's definition of Justice. Since antiquity, Western thought emphasized that Justice (along with Temperance, Fortitude, and Prudence) is one of the four cardinal virtues, or essential moral qualities, required by the ideal ruler.[6] In various conceptual and historical contexts, Justice is connected with the ruler or state, an embodiment of the supreme, ethical force guiding the regime and articulated in a system of laws enacted and enframed by the sovereign power of government. The influential genre of the Mirror of Princes literature, subject to changing concepts of Christian kingship, reiterates the identification of Justice with the ideal ruler. To take one important example, John of Salisbury's *Policraticus* of 1159 views the king as an image

of equity and the mediator between divine and human law.[7] The same text conceives of the state as a natural organism, "a kind of body of which the king is the head; and in turn the king must rule according to the higher reason which participates in justice and equity."[8] The integration of Aristotle's *Ethics* and *Politics* within Christian political and social thought, and specifically in the Mirror of Princes literature, promotes a more secular and naturalistic frame of reference. Giles of Rome's influential *De regimine principum* (ca. 1282) associates the ruler's most important function with his moral character and ability to act and judge wisely for the good of the whole community.[9]

Preceded by Thomas Aquinas's treatise of the same title, Giles of Rome's work was written for the heir to the French throne, Philip the Fair. As was mentioned in Chapters 1 and 4 above, Philip commissioned a French version of Giles's text from Henri de Gauchi, *Li livres du gouvernement des rois.* The closely related mid-fourteenth-century text, the Morgan *Avis au roys*, shows the reduction of complex Aristotelian texts to simple pedagogical maxims. Following a long tradition, this work associates Justice with the ideal prince. But Aristotelian definitions of Distributive and Remedial Justice now appear. The *Avis au roys* also states the ruler's obligation to maintain the rights, liberties, and freedom of his subjects.[10] The function of the king as dispenser of Justice had concrete application during the expansion of the French monarchy in the thirteenth and fourteenth centuries. The king's power to legislate and administer laws grew considerably, while the supremacy of royal justice over the courts of princes and the church played an important role in Capetian claims of sovereignty. Using precepts taken from Roman law, legal theorists articulated the supremacy of the king's courts in judicial matters. On grounds of the common welfare and defense of the realm, a climax in the monarchy's claim to sovereignty came at the turn of the fourteenth century during Philip the Fair's confrontation with the papacy.[11]

During the same period, mystical language and visual symbols forcefully articulated claims that God had chosen the rulers and people of France over those of other nations.[12] The myth of sacral kingship also asserted that God had bestowed on French rulers Wisdom, Piety, and Justice.[13] Indeed, Philip the Fair himself stated that the kingdom of France surpassed all others as the seat of Justice.[14] The example of Louis IX, canonized as St. Louis in 1297 and known as a holy and wise dispenser of Justice to his people, buttressed these claims.[15]

In response to internal and foreign threats to the Valois dynasty, Charles V and his publicists restated the identification of royal sovereignty with law and justice. Treatises and ordinances used mystical formulas associated with sacral kingship, as well as language derived from natural and Roman law theories.[16] Commissioned by Charles V around 1376 and finished in 1378, *Le songe du vergier* is a prime example of a tract designed to bolster the monarchy's claims of sovereignty. A fictional dialogue between a cleric and a knight, the *Songe* rehearses the perennial conflicts between church and state and comes down firmly on the secular side.[17] Such concepts as that the territory is inalienable from the crown and that the king is emperor in his own kingdom assert his sovereignty.[18] Inserted in the *Songe* is a

detailed list of the king's specific rights and powers.[19] In a very different tone, the lengthy preamble to the *Songe,* tinged with mystical allusions, celebrates the name of Charles V as the signifier of the clear light of peace, truth, and justice.[20]

The iconography of Charles V features a symbol rooted in the king's identification with Justice. Several images in his *Coronation Book* show him holding one of the distinctive emblems of the French monarchy. The *main de justice,* a rod surmounted by an ivory hand, not only signifies the monarch's duty to rule and to embody the principles of Justice but also sets the French king apart from other rulers.[21] Charles V's keen awareness of the value of ritual in confirming his prerogatives as the supreme source of Justice may well have prompted Oresme to take special pains in formulating Aristotle's authoritative definition of this fundamental moral and political virtue.

THE DESIGN OF THE JUSTICE FOLIO IN MS *A*

The arrangement of folio 89 signals the beginning of Book V, the midpoint of the ten books of the *Ethics* (Fig. 24 and Pl. 3). The lavish enframement marks its importance and sets it apart from the three previous text illustrations, which were tied to the column (Figs. 11, 15, and 20). The Justice miniature on folio 89 shares the rich decoration, two-register format, and frontispiece status only with the dedication scene of *A,* the introduction of Book I (Fig. 7). But Figure 24 surpasses this folio in its vertical dimension.[22] Also, the single figural group in the undivided picture space of the upper register of Figure 24 is unique in the entire cycle.

Folio 89 begins a new gathering that separates the leaf from Book IV. As another indication of the illustration's unusual importance, Figure 24 reverses the usual order by preceding rather than following the chapter headings. The miniature becomes the central element of the design, bracketed between the arching leaves of the upper border (see Pl. 3) and the large, six-line foliate initial below it. In turn, Justice légale (Legal Justice), the main figure of the upper register, occupies a central position. She stands directly below the Roman numeral identifying the book and on axis with a line that symmetrically divides the text columns and the two miniatures of the lower register.

THE VISUAL DEFINITION OF JUSTICE: THE UPPER REGISTER

The focus of the design is the splendid miniature, divided into two registers. The order corresponds to the textual sequence of the two main aspects of Justice defined by Aristotle. First, in the upper zone a visual definition of Justice in its universal or legal sense employs a complex personification allegory (Fig. 24a). The lower register (Fig. 24b) depicts Particular Justice, concerned with fairness in individual cases, divided into two subtypes: Justice distributive (Distributive Justice) on the left; Justice commutative (Remedial Justice) on the right. The struc-

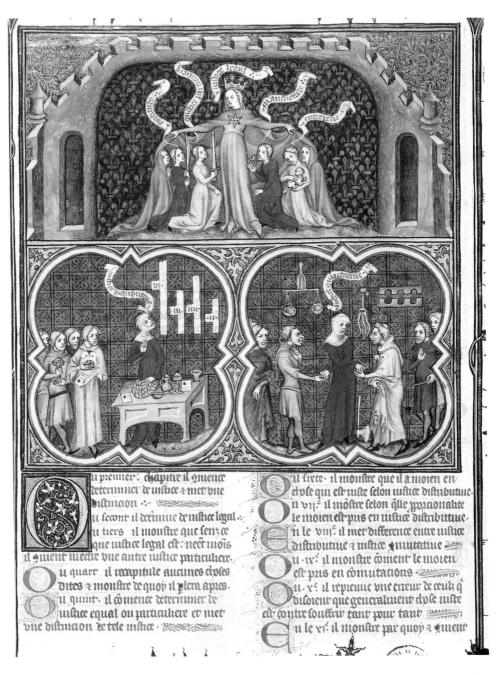

FIGURE 24 Above, from left: *Justice légale* with *Fortitude, Justice particulière, Mansuétude, Entrepesie*; below: *Justice distributive, Justice commutative*. *Les éthiques d'Aristote*, MS A.

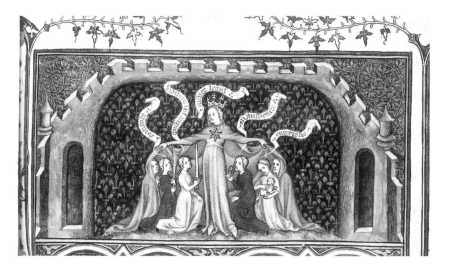

FIGURE 24A Upper register of Fig. 24.

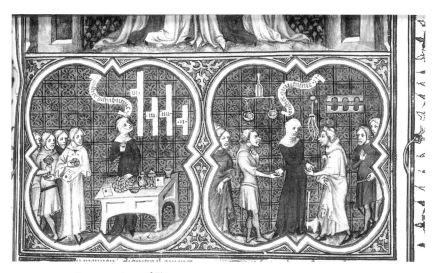

FIGURE 24B Lower register of Fig. 24.

ture of the miniature's upper and lower registers corresponds to the generic and specific definitions of Justice respectively.

As noted above, the undivided space of the upper register offers an important clue to its privileged status. The inscription above the central figure, Justice légale, identifies the subject. Since the adjective *légale* is a neologism introduced by Oresme, the contemporary reader might have been puzzled by the meaning of the inscription. To overcome the problem, Oresme gives a definition of this term in the glossary of difficult words. Justice légale, Oresme states, is Universal Justice

that contains every virtue. He then directs the reader to Chapter 2 for further information.[23] On folio 89 itself, the title for Chapter 2 directly below the miniature affords another access point to the definition of Justice légale. The inscription thus has lexical and indexical functions that link text and image.

The choice of the term *Justice légale,* instead of the synonymous *Justice universele,* stresses that in Oresme's text Justice is identified with obedience to positive or man-made law.[24] Yet a certain tension exists between the secular and political emphasis in Oresme's definition and several formal and iconographic aspects of its visual analogue. The system for ordering the image of the upper register employs devices that communicate simultaneously worldly and transcendent associations. For example, the central position of the main figure has a twofold significance. In one sense, her placement alludes to her embodiment of the mean, as in the scheme fashioned by Oresme for the depiction of Virtue in Book II (Fig. 11). In the context of Book V, Justice légale fixes the mean in regard to personal and social relationships and in reaching fair and just judgment. Her verticality conveys notions of uprightness and standing fast. But her preponderant size abandons the association established in Figure 11 of the ethical mean with physical scale. Instead, a reversion to a non-naturalistic canon signals that large scale stands for spiritual or political supremacy. In this case, the reference symbolizes the primacy of Justice légale in the hierarchy of moral virtues, as well as a supernatural status.

The sheltering mantle of Justice légale also has multiple associations. This important motif expresses the virtue's characteristics of benevolence, protectiveness, and inclusiveness. The six smaller forms she harbors are subordinate to her and contained within her. In a visual and conceptual sense, they are "daughter" virtues. Of the six depicted, four are named: Fortitude, Justice particulière (Particular Justice), Mansuétude (Gentleness) and Entrepesie (Conciliation). Of these, Fortitude and Mansuétude are the first and third of the virtues in Oresme's text that form part of Justice légale.[25] Justice particulière is a daughter too, as she is a special type of Justice, different from, but also part of, Justice légale. The meaning of the neologism *Entrepesie* is more problematic. The late Professor Menut suggested in a letter that the word, probably derived from *entre* and *peser* (to weigh between) means mediation or conciliation.

Although the metaphor of Justice and her daughters exists in medieval legal and ethical sources, the four named in the miniature of folio 89 do not match up with any fixed group.[26] Also ambiguous are the associations of the attributes held by the daughters. The palm held by Fortitude, the sword proferred by Justice particulière, the ring extended by Mansuétude, and the dog cuddled by Entrepesie can apply to them or to their mother. For example, as a cardinal virtue, Fortitude can appropriately carry a palm, which can also signify the victory of a secular or heavenly ruler.[27] Of course, the sword is traditionally associated with Justice, while the ring can allude to the eternal nature and sovereignty of this trustworthy virtue.[28] This grouping may reflect Oresme's personal selection of significant concepts.

The maternal aspect of Justice légale creates a powerful visual metaphor of nurturant qualities, whose clear order and structure relate many aspects of the

virtue's moral qualities to each other. From the relationship between mother and daughter another range of allusions emerges that further illuminates the character of Justice légale. The protection she offers her daughters refers to her mercy, compassion, and responsibility. The mantle she extends is emblematic of these qualities. To both contemporaries and the modern viewer, the outspread cloak calls to mind the iconographic type known as the Madonna of Misericordia, or Mercy. A recent study by Christa Belting-Ihm clarifies the subtly interwoven roots of this archetypal image. Old Testament, Roman imperial, legal, Christian, and other sources account for the shifting content in which the protective mantle theme appears.[29] As testimony of the expansion of the Madonna of Misericordia theme in the thirteenth century, an image in a manuscript of Averroes's commentary on Aristotle's *Metaphysics* shows the fluid boundaries between the secular and religious realms. A historiated initial of an English manuscript[30] depicts Philosophy sheltering her daughters, the seven liberal arts.[31]

A legal source connected with the conceptual roots of the protective-mantle motif relates to the adoption ceremony followed in medieval courts. An important part of the ritual was the adoptive father's spreading a cloak over the child.[32] A similar gesture made by high-ranking people—particularly queens—shielded defenseless persons (especially women) from criminal acts.[33] Within a purely secular context, the mid-fourteenth-century Morgan *Avis au roys* manuscript shows both feminine and masculine exemplars of protectiveness. Perfect Virtue shelters the smaller cardinal virtues beneath her cloak (Fig. 13).[34] On a more earthly level, two miniatures from the same manuscript represent French kings as shields of their people (Figs. 25 and 26). Thus, by the fourteenth century the mantle motif appears in both secular and religious contexts and is not limited to female exemplars.

Figures 25 and 26 clearly raise the connection between political sovereignty and Justice. In Figure 24 Justice légale is represented as a queen as well as a mother. What general and specific significance does queenship have in this miniature? According to Aristotle, Universal or Legal Justice is virtue in its fullest sense and holds a sovereign position among civic virtues. Oresme describes Justice légale as "la plus tres noble de toutes les vertus" (the most noble of all the virtues).[35] In regard to the Madonna of Misericordia type, a spiritual affinity exists between Justice légale and Mary the Queen of Heaven, who embodies mercy and serves as advocate and mediator for humanity. The gold crown of Justice légale is similar to that worn by French queens, who similarly enjoy the highest social status. Moreover, French queens vow in their coronation oaths to be "merciful and generous to the poor and to widows and orphans." This phrase appears in the order of 1364 followed in the coronation of Jeanne de Bourbon.[36] Indeed, the rod that the queen receives is associated in the liturgy with virtue and justice. As noted above, medieval queens traditionally exercise a legal prerogative of harboring defenseless people, particularly women, from attack or wrongdoing. It is, therefore, not unexpected to find in a drawing of Charles V and his family visual confirmation of the links between a French queen and legal tutelage. Illustrating a charter dated 1374, the right part of the drawing depicts Queen Jeanne de Bourbon sheltering her daughters (Fig. 27). The date of the document coincides with the year

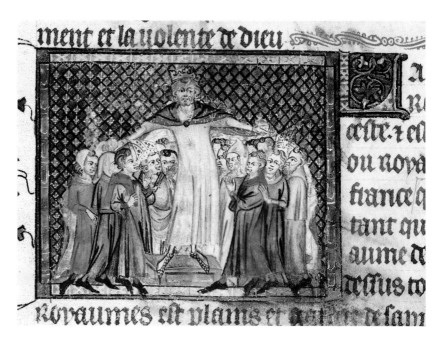

FIGURE 25 *A French King Protects His Subjects. Avis au roys.*

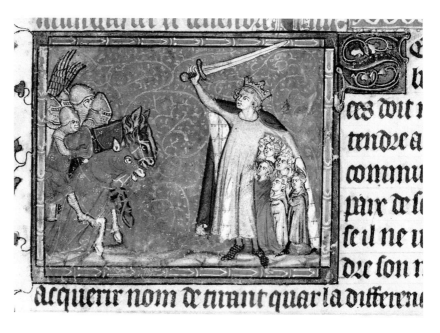

FIGURE 26 *A French King Shields His Subjects from an Enemy. Avis au roys.*

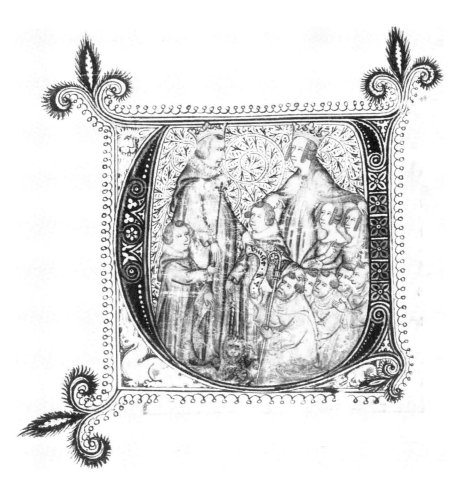

FIGURE 27 *Charter with Charles V,*
Jeanne de Bourbon, Their Children, and
the Monks of Royaumont Abbey.

in which Charles V made the queen legal guardian of the royal children, if he died while they were still minors.[37] Within MS *A* allusions to Jeanne de Bourbon occur in the image on the upper right of the frontispiece (Fig. 7) and in the crowned, fashionably clad figure of Vertu introducing Book II (Fig. 11).

The star on the figure's bodice could also have reminded Oresme's primary audience of another secular context for this emblem connected with French royalty. The chivalric Order of the Star was founded by King John the Good in 1351. The representation of an important meeting of the order later became a full-page illustration in Charles V's copy of the *Grandes chroniques de France* (Fig. 28). Anne Hedeman relates this prominent miniature to two main themes in this manuscript: French superiority over the English and the continuity of the Valois succession. Another element of particular interest in the context of Figure 24a is the order's ties to the cult of the Virgin.[38]

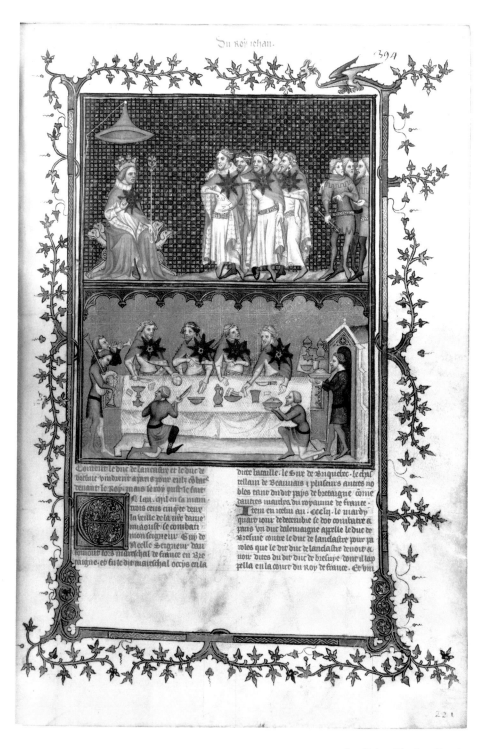

FIGURE 28 *Order of the Star. Grandes chroniques de France.*

The crown is not the only attribute of Justice légale with a dual frame of reference. For example, the flowing locks and youthful appearance of the virtue link her again with the Virgin Mary. The contemporary queen, Jeanne de Bourbon, also appears with unbound tresses during her coronation.[39] The gold star adorning the breast of Justice légale recalls the attribute of Mary as Star of the Sea. Yet a perfectly secular context for Justice's star is the explicit passage in the *Ethiques* that "neither evening or morning star" is as wonderful as she.[40] Moreover, the vivid "royal" blue mantle of Justice légale is appropriate not only for Mary but also for the queen of France. In short, like motherhood, queenship has secular and religious dimensions.

Despite the multivalent character of Justice légale, the setting and background of the representation emphasize her secular roots. Repeating the motif of the *rinceaux* above, her form is a human analogue of the architectural feature that dominates the upper register. A large central opening in the shape of a flattened arch surmounted by crenellations is flanked by two smaller turreted, round arches. This construction can be interpreted as an expansion of the crenellated-wall motif noted in earlier and subsequent miniatures of the *A* cycle. It is consistent with the previous interpretation of this motif as a stronghold or citadel of the virtues in the miniatures of Books III and IV (Figs. 15 and 20) to consider its extension in Figure 24a as connoting a city gateway. Such a reading accords with the key concept in Book V that Legal Justice operates in and orders the social relationships of a political community, Aristotle's city-state. In other words, the reader could associate Legal Justice with its place of operation: the city represented in medieval form. Figure 24a thus provides another example of Frances Yates's and Mary Carruthers's observations on scholastic memory systems. Here, an ideally beautiful personification of a moral concept, identified by an inscription, is associated with an architectural setting. Furthermore, the placement of Justice légale at the middle and largest opening of a triple archway reinforces her centrality. In a similar vein, the setting becomes a memory gateway in which the central place corresponds both to sequence in the text and to the importance of the concept. Here the triadic scheme sets off smaller, lateral, dark openings with brightly lit sills as ordering devices with which the reader can locate and separate mentally the particular definitions and lesser forms of Justice distributive and Justice commutative depicted in the lower register from the generic formulations of the upper zone.[41]

The memory gateway setting suggests another set of associations. The extended central portion resembles a shrine inhabited by Justice.[42] Justice légale acts, then, as a tutelary guardian, both securing and ruling the political community. Of course, the concept of Justice as a virgin goddess has a long tradition that encompasses the classical Astraea, the mysterious figure of Virgil's Fourth Eclogue, and the Virgin Mary.[43]

If the figure of Justice légale suggests a supramundane ideal, the prominent setting anchors her in a worldly foundation represented by the city wall. The large rose fleur-de-lis pattern of the background invites the informed reader, aware of the claims that France was the chosen seat of Justice on earth, to link visually the

city gate with the fleur-de-lis. This process connects Justice légale with a person and a place: the ruler and kingdom of France.

The upper register of Figure 24 confirms the centrality and complexity of the ideas traditionally associated with Legal Justice. Although the extent of religious meaning retained by this image of Justice légale is impossible to determine, the virtue reigns as a heavenly queen over an ideal and static realm. The text states that Universal Justice functions through man-made law to assure the happiness of the public welfare realized in a political community.

JUSTICE PARTICULIÈRE: THE LOWER REGISTER

In contrast to the universal and ideal sphere depicted in the upper register, the lower half represents Justice particulière, who operates in concrete and mundane situations. The lower register depicts two aspects of Particular Justice. Although the term does not figure in the inscriptions (Fig. 24b), it is defined in Chapters 1, 3, 4, 5, and 6 of Oresme's text. In addition, the glossary states that Justice particulière is synonymous with Justice équale; in modern French, Justice égale. In this context *égal* is best translated as "fair." Justice particulière thus connotes the principle of fair dealing by establishing a mean in regard to two types of actions. On the basis of merit, the first distributes goods or honors held by the political community. The second assesses penalties or awards damages as they concern the actions of individuals. Aristotle's division of Particular Justice into two parts finds visual reflection in the lower register occupied by Justice distributive on the left and Justice commutative on the right. The placement of Justice distributive reflects prior sequence in the text. The domain of Justice distributive includes three main concepts: fairness, the notion of the mean, and relativity. The latter also implies a system of proportions, since "just distribution" is concerned with relationships among four terms: two people and two things.[44]

In Figure 24b, the image of Justice distributive offers an ingenious visual definition of these complex ideas corresponding to Oresme's clear explanation of them. The tricolor quadrilobe isolates and frames the field of action. In contrast to the city gateway motif of the upper register, a table furnishes an interior setting. The center of attention is Justice distributive, who once again holds down the center, the visual and verbal analogue of the ethical ideal. Identified by the inscription unfurling above her head, she wears the familiar widowlike headdress and simple robe characteristic of Attrempance and Liberalité. Her actions also recall the representation in Book IV of Liberalité (Fig. 20). In Figure 24b Justice distributive is meting out rewards to four figures. Of these, two—seen only partially—may be bystanders or witnesses. The one closer to Justice distributive holds a pile of coins in one hand, and in the other, a document bearing a red seal. The second full-length figure holds a gold chalice. All four glance anxiously at Justice distributive, who presides over a table covered with stacks of gold coins and vessels and documents. These items symbolize the material rewards, honors, or offices given

to deserving individuals by the political community. In this context, charters bestowing land or office are intelligible medieval signs of such awards.

With one hand on the coins in front of her and the other upraised in a reflective gesture, Justice distributive seeks guidance in meting out fair shares from a set of rectangular measuring rods. Written like the inscriptions with brown ink on white ground, the rods' sizes are proportionate to the numbers marked on the short projecting sides: ".vi.," ".iii.," ".iiii.," and ".ii." The reader is prepared for the introduction of the key notion of finding the mean by a system of proportions in the first two chapter headings of the right text column. From the titles for Chapters 6 and 7 comes the information linking the mean and proportion with Justice distributive. If the reader is puzzled by the word *proporcionalité,* a neologism according to Menut, Oresme defines the term and its application in the first gloss of Chapter 7. In the next sentence, Oresme arrives at the set of figures written on the measuring rods above the head of Justice distributive: "Ces deux porporcions doubles sont equales et ce est appellé proporcionalité; si come nous diron en la proporcion de .vi. a .iii. est equale a la porporcion de .iiii. a .ii." (These two double proportions are equal and this is what is called proportionality, as we say the proportion of six to three is equal to the proportion of four to two).[45]

To clarify the relationships among the four terms of this proportional system, in Chapter 7 Oresme substitutes numbers for letters in the text and several glosses.[46] The measuring rods of Figure 24b give an example of a double proportional relationship, identical with that established by Oresme in the first gloss of Chapter 7 cited above. If the merit of the first person (A) has a value of six, double that of the second man (B), fixed at three, the reward of A, fixed at four (C), will be twice that given to B, fixed at two (D), or 6:3 = 4:2.

In the left half of the scene, a visual demonstration of the proportions indicated on the measuring rods is enacted. The coins and document held by the foremost figure, whose feet overlap the frame and who stands closest to Justice distributive, represent an instance of the two-to-one ratio of the awards, since the figure next to him holds only a single object, a chalice. Figure 24b is the unique example of Justice distributive to feature the numbered measuring rods in all the illustrated copies of Oresme's translation of the *Ethics.*[47] The inclusion here of the proportionally sized rods constitutes another important argument that Oresme designed the program of this illustration. The particular set of numbers on the rods appears only in a gloss composed by Oresme, and his substitution of numbers for the usual letters that define the proportional relationships is consistent with his scientific and mathematical training. As previously noted, he wrote a treatise on the subject of proportions.[48] Although the system of proportions illustrated on the measuring rods is not elaborate, its prominence within the larger visual definition reflects Oresme's subtle turn of mind and his fondness for visual conceits.

The lower right quadrilobe of Figure 24 represents the second subdivision of Particular Justice invented by Aristotle: Remedial Justice, or Justice commutative.[49] In another metaphor of kinship, consistent with the mother-daughter one of the upper register, the identical appearance of Justice distributive and Justice commu-

tative shows that they are twin sisters. Yet their fields of operation as judges are different. Justice commutative acts to "rectify a wrong that has been done by awarding damages."[50] Whether an act involves breach of contract or a civil or criminal wrong, "in both cases the injury is regarded as done to an individual, and in both the judge's object is not to punish but to give redress."[51]

Which verbal and visual devices convey the distinctive functions of Justice commutative? In the second column directly below the miniature, the titles for Chapters 8 and 9 contain key words. The terms *Justice commutative* and *commutacions* respectively locate for the reader the places where this concept is defined. The inscription *Justice commutative* above the personification provides the link between text and image. The visual ordering of the lower right quadrilobe clarifies the judgment between two parties by placing one on each side of Justice commutative. Certain attributes associated with this type of justice further emphasize her sphere of operations. Suspended on her right is the balance, a traditional symbol of fair judgment. On her left, at the same level, a scourge and a stock are depicted, while an axe rests on the floor. Although the text outlines a system of proportions for arriving at the mean in the disputes mediated by Justice commutative, the device of measuring rods is not repeated here. Deployed like the instruments of Christ's Passion, the less complex but familiar symbols of judgment and punishment create positive and negative areas of the picture field.[52]

Justice commutative stands in the center, the judge who is a living embodiment of the law. She occupies the middle ground in her search for the mean. By definition, judges serve as "moienneurs, comme ceulz qui actaingnent au moien quant ilz viennent et actaingnent a justice. Et donques chose juste est moiene et le juge est moien en tant comme il fait equalité" (mediators, as those who achieve the mean when they come [to judge] and [in fact] achieve justice. And thus the just thing is the mean and the judge is the mean inasmuch as he acts fairly).[53] The gesture of Justice commutative conveys another essential aspect of the good judge: evenhandedness or impartiality. Her crossed hands express her function of taking away from one and giving to the other party the fair share of damages or penalties.

The direction of Justice commutative's glance toward the person on her left indicates the probable nature of her judgment. She looks sadly toward the tonsured cleric, whose costume contrasts with the fashionably clad secular figure on her right. Moreover, the closeness of the scourge and the axe to the cleric's figure are further clues that his case is lost. The contemporary reader was familiar with the perennial disputes between the relative legal powers of ecclesiastic and civil courts when clerics were involved. The claims of the secular power triumph decisively in the *Songe du vergier* and its Latin predecessor. Although Oresme's text does not address this issue, the illustration makes a point favorable to royal justice sure to please his patron.

THE SISTER JUSTICES

The separate visual definitions of each register now lead to consideration of the formal and expressive character of the miniature as a whole. The personal partici-

pation of the Jean de Sy Master in its execution is another clue to its prominence. The liveliness of his painterly touch is as crucial in creating meanings as Oresme's extensive formulation of the program or the calligraphic and decorative framework produced by the scribe and other members of the atelier. Characteristic of this collaborative enterprise is the use of color as an element unifying borders, text, and miniature (see Pl. 3). As noted above, the "royal" blue mantle of Justice légale associates her with both Mary and the French monarchy, as do her gold crown and star. Two of the four daughter and sister virtues, Fortitude and Mansuétude, stand out in their red robes as essential parts of Justice légale, while the other two, clad in pale pink, serve as foils to the more assertive tones. In the lower register, the color used to represent the central figures reverses from blue to red. More subdued hues prevail in the lower scenes for depiction of minor figures: pale pink verging on white for the parties at law and olive green for bystanders or witnesses. For the two Justices below, the repeated color in their identical costumes reinforces the metaphor of double kinship.

The brilliant red of the twin Justices attract attention to them as symbolic and physical centers of the composition.[54] The mean position here does not contrast with extremes placed on left and right (as it does in Fig. 11). Instead, the two Justices embody separate means or measures of arriving at just or fair actions. The conjunction of their vertical poses with the central triangular breaks of the framing quadrilobes accentuates their symbolic central positions. While Oresme makes the point that the Justices of the lower register act as living embodiments of the law, it is the illuminator who endows them with convincing gestures that make them the psychological centers of the compositions. The inner awareness of Justice distributive is conveyed by her upraised hand and the pronounced turn of her head. Compassion and impartiality are qualities imparted to Justice commutative by her facial expression and hand movements. In contrast to the static and literally supernatural form of Justice légale, these twin Justices are more human in scale and animation.

The sister Justices below also command the dramatic centers of their compositions. Although identified as subtypes of Justice particulière, they also act as judges, whose decisions affect those anxiously awaiting them. The fact that the witnesses and parties "at law" are all masculine apparently repeats traditional gender role segregation: women exert power as spiritual forces but only male protagonists inhabit the public realm. Yet several elements in this miniature, and others of the *A* cycle, tend to blur this basic distinction. The shared psychological tension of the actors and judges and their physical proximity pictorially fuse the spiritual and worldly realms. Nevertheless, the Justices are slightly elevated above the figures surrounding them, and Justice distributive is separated from the others by the table. But in the lower right scene Justice commutative's hands touch those of the disputants. Most important in negating a distinction between ideal and earthly spheres of action is the highly naturalistic and expressive figure style. Always more comfortable in representing the everyday world (Fig. 33), the Jean de Sy Master creates animated and authoritative female judges. Although the text specifies masculine judges, the iconographic tradition of female personifications of Justice pre-

vails here. Drawing his inspiration from the world around him, the illuminator envisions women who act in a similarly authoritative manner. Although the widowlike dress of the sister Justices does not reveal social class, the no-nonsense robes and deportment of these figures can connect them with women the Jean de Sy Master may have encountered in business, welfare, or craft transactions. In these and other fields, decision making and distribution of funds were important parts of women's work. Certainly the authoritative visual role of these female Justices represents a significant departure from the male-centered text. If the social and ontological status of the twin Justices remains ambiguous, no doubts arise about their aesthetic and psychological domination of these two scenes. Not for the first time in medieval art does the human and transitory realm appear more compelling both to artist and audience than the conventional and remote world of supramundane existence.

THE VISUAL REDEFINITION IN *C*

In comparison to Figure 24, the illustration for Book V in MS *C* does not receive the same emphasis. Figure 29 (and Fig. 29a) is the same size as other miniatures in the first half of the book and conforms to the normal structure of the manuscript in its relationship to the text. Placed after the chapter headings, the miniature in *C* does, however, occupy the top of the page. It shares this elevated frontispiece status only with the illustration of Book II and the dedication page. The *rinceau* of the upper left border points toward the inscription identifying the main figure and the Roman numeral indicating the number of the book. The rubrics of the first chapter immediately below the miniature set off the sober coloration of the small grisaille figures and the pale brown ink of the inscriptions. In contrast, the jewellike background of the upper register and the wild floral motif in bright blue tones of the lower zone sound an exotic note.

With minor changes, the general iconographic scheme established in Figure 24 continues in Figure 29. In the top zone Justice légale shelters her daughters. Below, the picture field is divided between representations of Justice distributive on the left and Justice commutative on the right. Although the revisions from *A* to *C* eliminate the quadrilobes, the concept of two separate scenes remains, but without any demarcation. Consistent with the pattern adopted in *C,* all three Justices are depicted as nunlike figures.[55] One consequence of this change is that Justice légale is no longer a queen, even though her gold star and large scale indicate her supernatural status. The two Justices below have lost their vitality, as well as the prominence conferred by the bright red robes they wore in Figure 24. Indeed, the two lower scenes of Figure 29 lack the distinctive psychological and physical tensions among the witnesses and parties at law. The frontality adopted for all three types of Justice here conveys an undifferentiated majesty. The sameness of the type brings about a static, lifeless quality reflected in the boneless, unarticulated forms of the tiny figures.

Certain editorial revisions in Figure 29 sharpen or blur essential relationships present in Figure 24. For example, the inscriptions no longer unfurl dramatically but are placed neatly in a uniform, rectangular format above the heads of the three main figures, and the caption identifying Justice légale is placed above the frame. Her daughters have lost their individual attributes and labels and instead share a collective identity. The inscription "les vertuz," inserted on the underside of Justice légale's cloak, suggests that this identification was an afterthought. The addition of a seventh daughter permits a division into a familiar sequence suggesting four cardinal and three theological virtues. Although inappropriate in the Aristotelian context, such a series is more uniform than the six daughters in Figure 24, of whom two are nameless. Furthermore, the somewhat ungainly city gateway of Figure 24 gives way to a more elegant stone tabernacle with two small side turrets and a central fleur-de-lis boss. As a whole, the structure suggests a temple or shrine of Justice, a feature of a twelfth-century legal treatise.[56] This reworking of the city gate motif of Figure 24 reinforces the argument in favor of the image's secular orientation. The location of the shrine of Justice in France is conveyed by the motif of the fleur-de-lis common to the central boss and to the pattern of the background.

The crowded lower register contrasts greatly with the compression and isolation of the representation of Justice légale above. Set against a strong branching pattern, twelve figures (five on the left, seven on the right) are crowded into a very small space. The dramatic approach to these scenes in Figure 24 yields in Figure 29 to a more didactic method. Additional inscriptions are necessary as a consequence of the sameness of the sisters' actions. This strategy further overburdens the picture field. In the left scene, Justice distributive no longer disburses gold, precious objects, or offices, as is the case in Figure 24b. Using the conventional symbol of the scale, she literally weighs the claims of a pair of clerics on the left against those of two secular people on the other side. On the table in front of her lie a gold miter and a sword, symbols of the two competing sources of authority. Not surprisingly, the larger pan of her scale comes down on the secular side. The inscription at the bottom, "departir a chascun selon les merites" (distribute to each one according to his merits), reinforces the visual action. This revision of the analogous scene in *A* makes explicit the more allusive reference there to the struggle between the secular and ecclesiastic courts.

Even lengthier inscriptions crowd the scene featuring Justice commutative. Unlike the compassionate and impartial judge of Figure 24, this one sits in a full-length, frozen, frontal position. She holds a balance in her right hand, a sword in her left. The second attribute alludes to the penalties Justice commutative can impose. The evenly poised pans of her scale indicate her impartiality, as she fulfills her function to "rendre a chascun le sien" (to render each one his due). Below the groups of figures on each side of her are identical inscriptions. "Advocas et tesmoins" (lawyer and witness) designate two of the three men. The last set of inscriptions, "discussion" and "execucion urgens," identifies twin aspects of a court case. The figure on the left of the scene, a court official who holds a baton or rod, affirms the legal nature of the proceedings. A feature of Figure 24b is the

FIGURE 29 Above: *Justice légale and the Virtues;* below: *Justice distributive, Justice commutative. Les éthiques d'Aristote,* MS C.

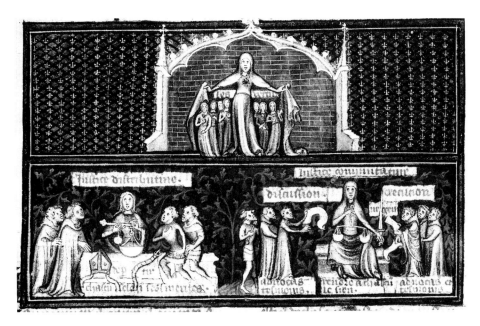

FIGURE 29A Detail of Fig. 29.

judgment of Justice commutative between civil and clerical litigants. In Figure 29, however, such a contest shifts to the opposite scene featuring Justice distributive, while the case presided over by her sister concerns a more general category of legal action.

Depersonalization of the sister judges in MS *C* reflects their loss of activity. Physical distance and spiritual separation from the parties at law are accentuated by their rigid postures and frontal stares. Perhaps the very liveliness of the female judges of Figure 24 prompted a negative critique by the king, the translator, or both. In any case, their counterparts in Figure 29 revert to a more passive and traditional representational mode.

PARALLEL DIRECTIONS

Despite their unusual character, the illustrations in *A* and *C* are not the first examples of visual allusions to Aristotle's concepts of Justice. Earlier trecento fresco programs have been associated with the influence in Italy of native thinkers trained in France to apply Aristotelian ethical and political concepts to the structures of the Italian city-state.[57] For example, recent scholarship has postulated various Aristotelian contexts for Giotto's famous figures of Justice and Injustice in the Arena Chapel in Padua. Consecrated in 1305, the structure reflects an elaborate drama of Christian salvation. References to the foundation of the state on principles of law and justice are expressed in the central position of Justice on the lowest zone of the wall (Fig. 30). More specifically Aristotelian are the subtypes of Distributive and Remedial Justice. Although not identified verbally, they are depicted by groups of classically inspired figures placed on the pans of the scales held by Justice.

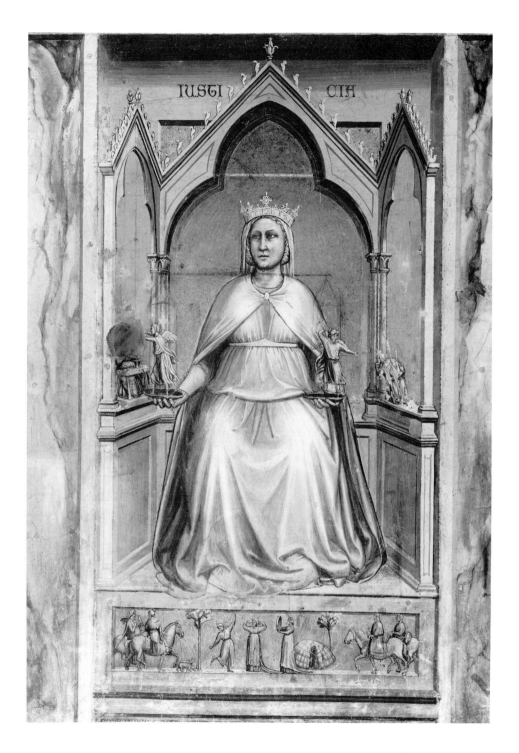

FIGURE 30 Giotto, *Justice*. Padua,
Arena Chapel.

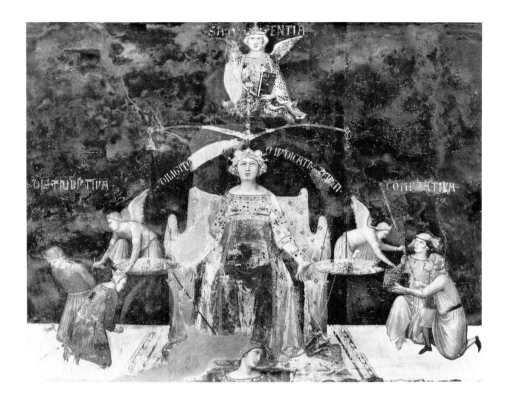

FIGURE 31 Ambrogio Lorenzetti,
Justice.

On the left, a small winged form acting as Distributive Justice bestows a reward on a (now headless) figure seated at a desk.[58] An implicit reference to Remedial Justice occurs on the right, in the pan held by the virtue's left hand. There, a Jupiter-like figure cuts off the head of a man placed on the arm of Justice's throne.

The major theme of Ambrogio Lorenzetti's fresco cycle of Good and Bad Government, decorating the Sala dei Nove of the Palazzo Pubblico, Siena (dating from 1337 to 1340), is the association of Peace and Justice with Good Government (Fig. 31). Until recently art historians generally accepted the assertions in Nicolai Rubenstein's classic article of the connection of the Sala dei Nove program with Aristotelian and Thomistic concepts.[59] Quentin Skinner opposes these Aristotelian links by stressing the ideological connections of Lorenzetti's frescoes with thirteenth-century Italian prehumanist rhetorical writers on city and republican government.[60] After a lengthy analysis of the iconography, including the choice and distribution of the virtues and vices, Skinner singles out as the most important source of Lorenzetti's program Brunetto Latini's encyclopedia of 1263, *Li livres dou trésor*. Although Latini's work was based on the paraphrase of the *Nicomachean Ethics* by Hermannus Alemannus and not on the Grosseteste translation, Skinner emphasizes the differences between Aristotelian concepts of the virtues and vices, and

Latini's.[61] Instead, Skinner stresses the Ciceronian and Latin character of Latini's moral thought and its direct reflection in Lorenzettian iconography.[62] Although more reluctant to limit the texts chosen by the artist or a learned adviser, Randolph Starn also favors Latini's work as an analogue to the frescoes in their use of the vernacular, encyclopedic structure and extended discussion of the virtues and vices.[63] Chiara Frugoni, who underscores the importance of biblical and other religious writings, also hesitates to limit the textual sources of the Lorenzetti frescoes. Like Starn, she emphasizes the importance of the vernacular inscriptions.[64]

Although scholars disagree on the iconographic sources of the Palazzo Pubblico program, they stress the fundamental importance of Justice in the elaborate central allegory and its extensive inscriptions. Justice is a young, crowned, and richly clad figure who is seated frontally (Fig. 31). The figure of Sapientia (Wisdom), issuing from a divine realm, floats above her head. Directly below Justice, linked by a cord, Concordia relates her to the central figure variously identified as Good Government, the ideal public authority of Siena, or the Common Good (Fig. 53). Inscriptions identify smaller winged figures on either side of Justice. Hovering on the left of the throne, Distributive Justice crowns a kneeling figure, while she prepares to behead another person with arms bound behind him. On the right, level with the main figure's left hand, Remedial Justice gives weapons to one man and reaches into a box, probably to reward another.[65] In Lorenzetti's program, the large female figure corresponds to Legal or Universal Justice. In turn, the central and biggest figure, the masculine ruling authority, is flanked by an expanded series of cardinal virtues, including another depiction of Justice.[66] This one holds a sword in her right hand and a crown in her left. A severed head resting on her lap implies that she has the power to reward the just and to punish the unjust ruler.[67]

Thus, in trecento Italy the Giotto and Lorenzetti allegories establish a political context for the representation of Justice with Italian/Latin prehumanist and/or Aristotelian roots. In a broad sense, certain similarities link Figures 24 and 29 to those of the Paduan and Sienese cycles. Also, the ordering of the four images shares common features. All conform to practices suggested in scholastic memory treatises. Embodied in human, idealized forms, clothed in striking dress, and identified by inscriptions, the ethical concepts associated with the virtues are placed in a specific architectural context located within a larger scheme. Their size reflects their importance in regard to subtypes of related personifications.[68] Particularly relevant is the concept of Legal Justice, a supernaturally large form embracing in a similar sequence the subtypes of Distributive and Remedial Justice.

Despite these general resemblances, the images in *A* and *C* have a distinctive French character. The political context and place of operation of Figures 24 and 29 are associated with the kingdom of France, identified by the prominent fleur-de-lis motif. Also different from the Giotto and Lorenzetti allegories are the specific ordering principles adopted in the images of *A* and *C*. The concept of Justice légale as a universal or embracing principle is more fully developed by means of the mantle motif and the inclusion of the daughter virtues. Moreover, in the miniatures of *A* and *C,* Justice légale is a sovereign ruler herself, dominant in the highest sphere. Unlike the Giotto figure in the Arena Chapel program, she is

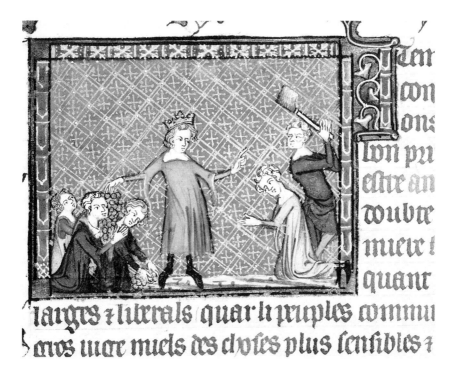

FIGURE 32 *A King Acting as Distributive and Remedial Justice. Avis au roys.*

not the foundation of a divine scheme unfolding above her in the main pictorial space. Nor, as in the Lorenzetti program, is Justice légale subordinate in scale to a ruler, or dependent on a superior force, Divine Wisdom. Instead, Justice légale is literally the uppermost ruler: in her own right she embodies a spiritual power independent of any overt Christian agent.

The ordering of the lower register of Figures 24 and 29 shows even greater differences from the Giotto and Lorenzetti images. Although subordinate to and subtypes of Justice légale, Justice distributive and Justice commutative enjoy greater status than their Italian counterparts. The sister Justices form centers of activity independent of the figure above. Unlike the Giotto pair, the twin Justices are both female. Whereas the Lorenzetti duo also expresses the notion of twinship, gender is less important than divine origin. In contrast, the sister Justices of *A* and *C* are clearly rooted in the earthly sphere, and those of *A* further assume an expressive, fully human identity. As concrete examples of the workings of Distributive and Remedial Justice, the miniatures of *A* and *C* more accurately define the Aristotelian concepts than the Italian works.

Most important, the Morgan *Avis au roys* (Figs. 25 and 26) provides abundant models for the iconography of Justice légale. This manuscript also introduces the concepts and adjectives describing the distinctive functions that characterize the twin Justices of the lower register.[69] An image from the *Avis au roys* embodies the operations of Justice distributive and Justice commutative. Figure 32 depicts a

king giving coins to a group at the left, while on the right he instructs an executioner to behead a subject. Here the workings of the Aristotelian subtypes of Justice are identified with the actions of a ruler represented in other miniatures of the cycle as a king of France. Indeed, the prominent representations of Justice in the program of MS *A* may ultimately derive from the mythic association of this virtue with the people and rulers of France.

10 GUIDES TO THE INTELLECTUAL VIRTUES
(Book VI)

In contrast to the all-embracing concept of Justice in Book V, defined in terms of its generic and particular qualities, individual virtues, characterized by intellectual rather than moral associations, are discussed in Book VI. This book also begins the second half of the *Nicomachean Ethics.* Following the exceptional size and configuration of the representation of Justice (Fig. 24), the illustration for Book VI in *A* (Figs. 33, 33a, and Pl. 4) returns to the format and dimensions of the column series. In *C,* however, the miniature for Book VI (Figs. 34 and 34a) starts a greatly enlarged and revised series of illustrations that reflects a critique of the first half of the cycle. Most probably, the patron, translator—or both—requested the changes. The scribe, Raoulet d'Orléans, and Oresme worked with the illuminators to make the revisions.

Although Figure 33 is less striking than its predecessor, within the structure of the book the miniature receives some emphasis. If the dimensions of Figure 33 are not exceptional, the illustration gains importance by its position at the head of the second column of text. The summary paragraph opposite the illustration informs the reader that the sixth book deals with the "vertus intellectueles" (intellectual virtues).[1] The introduction to Chapter 1 (in rubrics) directly below the miniature states that at this point Aristotle sets forth his intention and a definition necessary to his proposition.[2]

Chapters 1 and 2 of Oresme's translation of Book VI explain how knowledge of the intellectual virtues relates to moral virtue as defined in Book II.[3] Book VI discusses the rational principle or right rule as a guide to moral choice, an intellectual operation that includes the nature of practical wisdom. Furthermore, since human happiness or well-being depends on an activity of soul in accordance with virtue, it is important to know what is the best type of virtue.[4]

Oresme states that after Aristotle's treatment of the moral virtues, which belong to the irrational part of the soul, the Philosopher turns to the intellectual virtues. These are associated with the rational part of the soul, which in turn is divided in two. The first of these subdivisions is the scientific faculty, by which the mind contemplates things of unchanging principles, such as mathematical science. The other part of the soul is calculative and contemplates things that are variable.[5] Oresme uses the terms *scientifique ou speculative* (scientific or speculative) for the

FIGURE 33 *Art, Sapience. Les éthiques d'Aristote, MS A.*

118 *LIVRE D'ÉTHIQUES, BOOK VI*

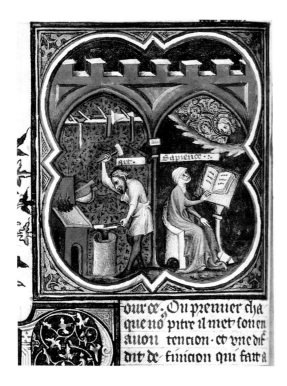

first part of the rational division of the soul; *raciocinative ou pratique* (calculative or practical) for the second.[6]

Oresme follows Aristotle in naming and defining five intellectual virtues: art, science or knowledge, prudence or practical wisdom, philosophical or theoretical wisdom, and comprehension or intelligence. Translation of these concepts into French may have presented difficulties, as the terms Oresme used had connotations in French different from their Aristotelian definitions. The translator was scrupulous in his efforts to supply the proper linguistic context for the intellectual virtues: *art, science, prudence, sapience,* and *entendement.* The contemporary reader may also have known Prudence as one of the four cardinal virtues, but here it is one of Aristotle's set of five intellectual virtues. Indeed, the new secular readership may have had problems in understanding the abstract concepts and philosophical vocabulary introduced in Oresme's discussion. It is, therefore, not surprising that Oresme includes selected terms in the glossary of difficult words, such as *accion, active, contingent, faccion,* and *factive* (action, active, contingent, doing, making).[7]

The visual definitions of two intellectual virtues, Art and Sapience, in *A* (Fig. 33a) are selective subject guides, inasmuch as Oresme chooses them over Science, Entendement, and Prudence. Prudence is the only one of the group particularly associated with the qualifications and conduct of the ideal ruler. Since Charles V was known for *sagesse,* his identification with a representation of Prudence might have been expected.[8] Perhaps Oresme wishes instead to allude to Charles V's personal search for and conscious identification with Sapience, the highest type of knowledge.

Although the omission of Prudence is puzzling, Oresme's choices of Art and Sapience are explicable on several grounds. On a conceptual level, the two are associated with different parts of the soul: Art with the calculative faculty; Sapience with the scientific or speculative faculty. For mnemonic and aesthetic purposes, the representation of Art as an active scene depicting a contemporary activity is clearly contrasted with a quiet, contemplative one. Here a male personification is associated with action in human affairs, and a female with passive reaction to a spiritual force. This pattern of masculine/feminine and active/passive contrasts is first established in the illustrations in *A* of Books III and IV (Figs. 15 and 20), which are also divided into two adjacent compartments. The same opposition of blue and red continues in Figure 33 (see Pl. 4), as do the assertive quadrilobe tricolor inner frame, the crenellated memory gateway, and the central supporting column. Once again color and gender contrasts reinforce the mnemonic functions of the images. Absent in Figure 33 and the subsequent miniatures of *A* is the fleur-de-lis motif, so prominent in the first half of the cycle. As before, the link between the visual and verbal definitions originates in the inscriptions. The reader can glance across at the headings in the first column of text (*A,* fol. 115) to find the chapters in which Art and Sapience are discussed. The first is found in Chapter 4; the second, in Chapters 7, 8, 13, and 14. The inscription "Art" is highlighted by the angle of the hammer head held by the male personification, while the chapter heading relating to Art is located almost directly opposite the lower left side of the miniature. Whereas the proximity of the chapter heading and the visual definition of Art are fortuitous consequences of the layout, the position of Art and Sapience on the left and right respectively again reflects the order in which they are discussed in the text.

ART

To the modern reader the choice of a blacksmith to personify Art may come as a surprise. But in Aristotle the term *Art* is defined as "a state concerned with making, involving a true course of reasoning."[9] Oresme makes the same point: art "est habit factif avecques vraie raison."[10] As Paul Oskar Kristeller makes clear, "the Greek term for Art (*techne*) and its Latin equivalent (*ars*) do not specifically denote the 'fine arts' in the modern sense, but were applied to all kinds of human activities which we would call crafts or sciences."[11] Aristotle's definition of Art "as a kind of activity based on knowledge" had a lasting influence.[12] Oresme follows Aristotle in giving building (architecture) as an example of Art.[13]

Yet the choice of a personification of Art in Figure 33 is a blacksmith, a craft mentioned neither in Aristotle's text nor in Oresme's translation. The clues for the selection of a blacksmith derive from a gloss by Oresme on the definition of Art:

> C'est ou .vi.ᵉ livre de *Methaphisique* ou il appert la différence entre accion et faccion. Car accion est operacion qui demeure en celui qui la fait, si comme veoir ou entendre. Et faccion est celle qui passe en aucune matiere dehors, si comme edifier, forgier, etc.

(It is in the sixth book of the *Metaphysics* that the difference between doing and making is revealed. For doing is an operation that remains within the one who does it, as in seeing or hearing. And making is one that passes into some external material, as in building or forging.)[14]

The word *forgier* appears in the glossary of difficult words in the entry for *faccion:* "Faccion est operacion qui passe en matiere dehors, si comme est edifier, forgier et teles choses" (Making is an action that passes into external matter as in building, forging, or such things).[15] Oresme's addition of the word *forgier* to the standard definition emphasizes the meaning of the term *art* to connote the skill or know-how needed to make things by transforming raw materials into finished products. It is characteristic of his efforts to provide the reader with familiar, specific examples of abstract ideas. Furthermore, Oresme may have also judged that the single figure of a blacksmith was visually more compelling in personifying Art than a mason or other craftsman associated with construction of a building.

Yet Oresme may have chosen a blacksmith for other reasons. In primitive cultures, smiths enjoyed high status and, because of their association with fire and the power to make useful objects by chemical processes, were considered magical, heroic, and in some instances, royal or divine beings.[16] Familiar examples from Greek and Roman mythology respectively are the gods Hephaestus and Vulcan. In medieval society, blacksmiths were valued members of the community who made all manner of iron and steel implements necessary for carrying on pursuits of peace and war. On the negative side, blacksmithing was looked down on as a dirty and menial kind of work. Because Oresme had a scientific mind, the blacksmith who had technological knowledge of chemical processes may have had special appeal. Certainly to the contemporary reader the blacksmith vividly translates the Aristotelian notion of Art. The smith's techniques based on practical knowledge enabled him to produce useful objects from raw materials.[17]

The Jean de Sy Master's depiction of the vigorous blacksmith is one of the liveliest scenes of the entire cycle. Dressed in a short violet tunic and whitish apron, the bearded blacksmith concentrates as he fashions a red-hot implement that rests on the anvil. The bellows and hot coals on the forge identify his pursuit, while tools of the trade set on a rack above his head further specify the nature of his activity. The smith's clenched hand and upraised arm gripping a hammer convey his inner absorption with his craft. Except for the bright red accents of the coals and the implement being forged, the colors are muted against the dark blue background to convey the sense of an enclosed interior space. All in all, the illuminator has produced an expressive personification of Art entirely consistent with the meaning of the term.

SAPIENCE

The right half of Figure 33 is devoted to the personification of Sapience, Theoretical or Philosophical Wisdom. As noted above, Sapience represents a different type of knowledge from that of Art or Prudence, better termed Practical Wisdom. For

Aristotle, Philosophical Wisdom, "the union of intuition and science," is "directed to the loftiest objects," such as "the heavenly bodies." Theoretical Wisdom encompasses not only philosophy but also mathematics and natural science. "Contemplation of these subjects," as discussed in Book X of the *Ethics,* is "in Aristotle's view the ideal life for man."[18]

Oresme follows Aristotle's definition of wisdom and identifies the highest of the intellectual virtues with metaphysics "qui considere les principes generals de toutes sciences et les causes principalx de toutes choses et les meilleurs et plus dignes choses qui puissent estre, comme sont Dieu et les Intelligences" (which considers the general principles of all sciences and the causes of all things, and the best and most worthy things that can ever be, such as God and the Intelligences).[19] In neither text nor gloss does Oresme allude to the traditional medieval identification, established by St. Augustine, of Wisdom and Christ, the second person of the Trinity.[20] Oresme is, however, not original in recognizing the classical Aristotelian definition of wisdom as knowledge "of first causes and principles" and in acknowledging metaphysics "as an autonomous human wisdom, independent of theology and naturally acquired by man without the aid of grace."[21] Thomas Aquinas had made these vital distinctions in the *Summa theologica* and other writings.[22] Aquinas, however, distinguishes between two types of wisdom. The metaphysical kind is close to Aristotle's definition. But the theological type is superior to the metaphysical, inasmuch as the former embodies a type of knowledge revealed by and known by God himself, a gift of the Holy Spirit. Theology "is a revealed knowledge of divine things, a human participation in the Word, which is Wisdom itself and an intellectual participation in the illumination and stability of the Ideas of God."[23]

The representation of Sapience in Figure 33 probably reflects this definition of theological wisdom advanced by Aquinas and other Christian thinkers. Chapters 7 and 8 of Book VI of Oresme's translation discuss the virtue of Sapience without any Christian reference. The personification of Sapience is clad in a blue mantle and a white, widowlike headdress (see Pl. 4). Facing right, she sits before a lectern holding an open book with her right hand. She gazes upward toward a bustlength cross-nimbed Christ and a group of angels in blue clouds. Her pose suggests that her knowledge of God and the first principles, equated with Christ and the angels, results in direct, visual communication with them. Christ looks down at Sapience, revealing that he is both the source and the subject of wisdom.[24]

The theological character of Sapience thus seems to lack a textual source. Moreover, the iconography adds to the ambiguity of the content. Sapience's reading of a book may indicate that the source of her knowledge is the present or a related text by Aristotle, such as the *Metaphysics,* that studies God and the first principles. More likely, her vision comes from reading the Christian doctrine inscribed in her book. Her pose, rooted in antique author-muse portraits, is common to various medieval types of personifications: the reading Evangelist and *vita contemplativa* are just two among many possibilities.[25] The context of the miniature, in which the left half is devoted to an active scene of physical work, indicates that the *vita contemplativa* figure is a more direct source. Since the contemplative life

had a Christian interpretation during the Middle Ages, it is likely that this tradition influenced the miniaturist.[26] In short, the extratextual associations of Sapience with Christian interpretations of wisdom suggest that a secular characterization of the virtue may have simply been judged unintelligible or unorthodox.

The illuminator emphasized essential aspects of the scene by use of color. In contrast to the more subdued tones of the left scene, the right half stands out. The vivid red of the background and Christ's mantle, as well as the gold of the angels' forms and the bright blue of the clouds, signify the heavenly realms. The quiet scene of contemplation of the divine shines forth in splendid hues, while the earthly labors of Art reflect the muted character of mundane toil. The psychological contrasts between Art and Sapience are well served, too, by their spatial separation and opposing orientations. As Kolve puts it: "The enterprises of art and wisdom are quite properly shown side by side, but they are also distinct from each other: two people are engaged in them, as it were in different rooms."[27]

THE INTELLECTUAL VIRTUES IN *C*

The illustration in *C* of Book VI (Figs. 34 and 34a) dramatically reveals the first major revision of the second half of the program. Most obvious is the increase by two thirds of the height of the illumination from that of Book V.[28] The large size is undoubtedly a response to the crowding of figures and inscriptions noted in the miniatures of Books IV and V. The ample space now available accommodates the expanded subject-guide function of this illustration, which now occupies about half the folio. The two-register format also permits an orderly sequence for presenting not just two of the intellectual virtues (as in Fig. 33) but all five. The enhanced frontispiece status of Figure 34 is emphasized by its placement between the *rinceau* of the upper left border and the large initial *P* containing a ferocious dragon below. The exquisitely refined, softly modeled grisaille figures stand out against the apricot and blue backgrounds of the upper and lower registers. The Master of the Coronation of Charles VI himself appears to have executed the first miniature of the revised part of the program. Yet the process of revision brought new challenges and problems for Oresme, Raoulet d'Orléans, the illuminator, and the reader.

As usual, the sequence of personifications begins on the upper left of the top register and proceeds to the right. The same order is observed in the lower zone. The system of presenting the five intellectual virtues in a sequence follows the order of the chapters in Oresme's translation. When Oresme and Aristotle name them in Chapter 2 of Book VI, however, Art comes first, followed by Science, Prudence, Sapience, and Entendement. In Figure 34, Science, Art, and Prudence (Practical Wisdom) occupy the upper zone, and Entendement (Intuitive Reason) and Sapience, the lower one. It thus appears that chapter order has priority over other principles of grouping, since in Aristotle's discussion of the intellectual virtues Science belongs with Entendement and Sapience as parts of the scientific faculty of the soul concerned with theoretical wisdom.[29] Figure size and placement

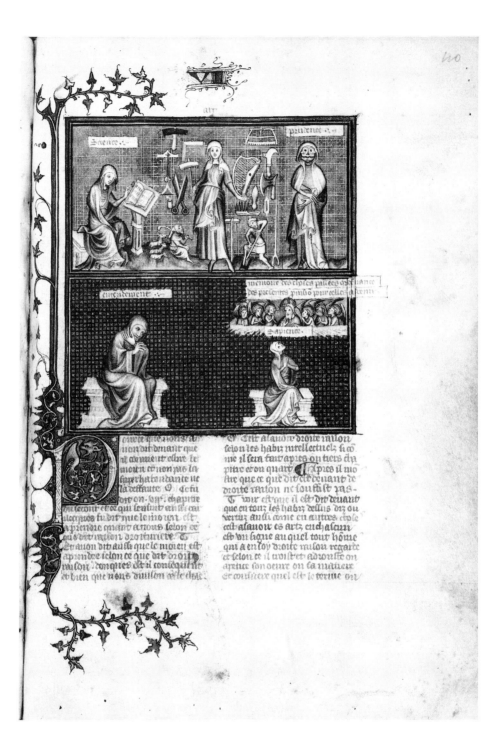

FIGURE 34 Above, from left: *Science, Art, Prudence;* below, from left: *Entende-ment, Sapience. Les éthiques d'Aristote,* MS *C.*

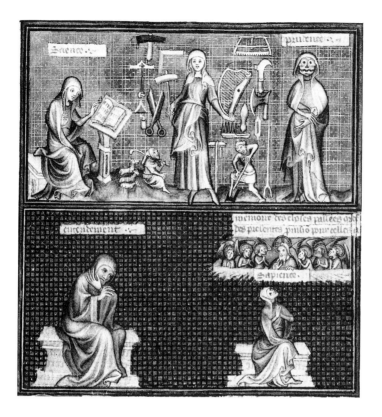

FIGURE 34A Detail of Fig. 34.

in the pictorial field emphasize the importance of Entendement and Sapience. Indeed, the disparities in scale, not only between the figures of the upper and lower zones but also between those of Entendement and Sapience, create a somewhat unharmonious effect. Still, the contrast between the relatively busy upper zone and the spacious quality of the lower one suggests a more tranquil environment for the loftier concerns of Entendement and Sapience.

Science (*Episteme*), the first virtue represented in the upper register of Figure 34, is seated on a low bench, arms upraised, gazing at an open book supported on a lectern. Her iconographic type is extremely similar to that of Sapience in Figure 33. Like all the other female personifications in *C*, she wears a nunlike costume. Her small scale, gesture of wonder, and slight features give her a somewhat childish appearance, quite at variance with the formidable values she personifies. Science, as defined by Aristotle and translated by Oresme, stands for pure knowledge, which can be taught, involves a rational principle, and is concerned with what is necessary, eternal, and invariable. Science proceeds by the syllogistic process,

beginning with induction, "which supplies the first principles."[30] Obviously, the visual characterization of Science is a difficult task. Oresme and the illuminator limit the representation to suggest that Science involves an authoritative knowledge based on book learning.

The next personification, Art, is exceptional in several ways. The experimental nature of the representation is first revealed by the unusual position of the identifying inscription above the frame. In comparison to the blacksmith in Figure 33, the representation of Art in *C* shows a radical transformation. Most obvious is the sex change. The reversed gender is part of the attempt in the program of *C* to make all the personifications, except for Fortitude, uniformly feminine. Although there was a complex tradition of personifying the liberal arts in the Middle Ages by both masculine and feminine figures, there also existed textual and visual sources for cycles of mechanical, or nonliberal, arts.[31] An early fourteenth-century manuscript of Brunetto Latini's *Li livres dou trésor* contains a full-page frontispiece in which the seven liberal arts are depicted in a central column flanked on left and right by the same number of representations of practical and mechanical arts respectively.[32] All but the personification of Weaving are represented as men.[33] Despite such cycles of mechanical arts, the representation of Art as a generic concept seems quite rare.

Also unusual is the manner in which Art is portrayed. Lined up with the running title of the folio and the space between the two text columns, she is the central figure of the upper register. Moreover, she stands full-length and almost totally frontal in a majesty pose. Despite these signs of her importance, her tucked-up apron reveals that, unlike her sister virtues, she belongs to the working class.[34] This unusual tribute to Art continues in the extensive surface area devoted to the depiction of the various tools grouped under her aegis that symbolize the useful arts and crafts. In addition to the mallet and harp that Art holds in her right and left hands, the other implements are a hammer, carpenter's square, scissors, plumb line, saw, pruning hook, axe, spindle, comb, and a pronged implement.[35] Figures working on either side of Art personify the cultivation of sheep and agriculture. Such a tribute to the arts is consistent with the high status they enjoyed in the encyclopedic tradition represented by Vincent of Beauvais or Hugh of St. Victor.

The productive activities of medieval society in which tools are also symbols of the human ability to make useful objects from raw materials give the definition of Art a wider compass than the representation in Figure 33 of the solitary and engaging blacksmith. The comprehensive nature of this visual definition accords with the didactic aims of the cycle of illustration in *C*. Finally, the importance of Art among the intellectual virtues is conveyed by the mode of representing her and her attributes. Together with her frontality, the vertical deployment of the tools and implements calls to mind such popular devotional images as the Man of Sorrows, in which Christ is surrounded by instruments of the Passion.[36] This example of the migration of an image from the religious to the secular sphere raises the question of the degree of spiritual value assimilated by the secular representation. Even without such an association, the image of Art is a compelling creation.[37]

Another dimension of the depiction of Art is its ingenuity. It is characteristic of Oresme's inventive spirit that he found so apt an iconographic formula to suit the needs of his concept of Art. The mode of depiction not only informs the reader but invites participation in identifying the crafts symbolized by the tools. Such a process of naming these pursuits is a form of visual riddle that also serves as a learning device. In effect, the reader is re-creating the visual definition as a way of understanding the verbal concept. The radiating presentation of Art's domains is also consistent with the mnemonic function of the image.

A further example of Oresme's visual imagination and wit is the next and last figure of the upper register of Figures 34 and 34a, Prudence, or Practical Wisdom (*Phronesis*). In Aristotle's ethical system, Prudence has a key role, as it embodies "the power of good deliberation" in human affairs.[38] Practical Wisdom guides activity in both individual and political affairs through reason "with regard to things good and bad for men."[39] As noted earlier, this type of wisdom, one of the four cardinal virtues, had for obvious reasons long been associated with the ideal ruler. Book VI of Oresme's translation of the *Ethics* discusses Prudence in ten of the seventeen chapters. Moreover, Oresme's commentary in the last chapter speaks of Prudence as a cardinal virtue and voices pragmatic considerations about various levels of interaction with the other virtues.[40] In addition, Chapter 9 explores the connections between practical and political wisdom.[41] Oresme then goes on to explain the parts of Prudence, some of which directly involve the political process itself.[42] The glossary of difficult words provides six (of a total of fifty-two) definitions relating to the parts and qualities of Prudence.[43] Thus, Oresme's verbal definition is consistent with the central importance of Practical Wisdom in individual and political conduct.

The image of Prudence is compressed and cryptic, as spare and contained as Art is expansive. But both virtues stand in a dignified, frontal position. Prudence's hands are crossed on the hips of her draped mantle and lend an illusory repose to her figure, for below her nunlike head covering a strange apparition appears. A grotesque, mummified set of features, highlighted by sunken eyes and gaping teeth, stares out at the reader. Further study of the masklike head with a triangular protuberance on each cheek turns out to reveal three faces—two in profile on left and right and a central frontal one.[44] This is the *vultus trifrons*, an iconographic type with antique roots.[45] The three faces are identical and refer both to past, present, and future aspects of time and to Prudence's three psychological faculties associated with them: memory, intelligence, and foresight. The appearance of Prudence as a death's-head or skull also is a characteristic of this iconographic tradition.[46]

Whether this startling image was intelligible to the contemporary reader is a legitimate question. Oresme, however, was not convinced that the visual definition alone was sufficient to convey the *trifrons* symbolism. An inscription was added to explain the threefold orientation and faculties of Prudence: "Mémoire des choses passées, ordenance des présentes, provisions pour celles à venir" (Memory of things past, ordering of things present, provision for those to come).

Oresme's instructions were apparently misunderstood, so that the words were placed not above Prudence's head but over that of Sapience, below. Surprisingly enough, the source of the inscription does not occur in Oresme's translation. This literary formulation goes back at least to Cicero, whereas its medieval history can be traced to a sixth-century bishop, Martin of Braga. Martin's formula, thought to be an authentic writing of Seneca, found its way into medieval encyclopedias. Martin's words on Prudence are almost identical to those of the inscription in Figure 34: "set in order the present, foresee the future, recall the past."[47] Among the popular late-medieval encyclopedias mentioned by Erwin Panofsky as a source of the tripartite definition of Prudence is the *Repertorium morale* of Pierre Bersuire,[48] whose influential French translation of Livy was discussed in Chapter 1.

The Ciceronian tripartite division of Prudence and her intellectual capacities is also found in Mirror of Princes texts. In the French translation of Giles of Rome's *De regimine principum* executed for Philip the Fair, the three capacities of Prudence are considered necessary qualities for the ideal ruler.[49] The Morgan *Avis du roys* (fols. 27v–28v) also stresses the necessity for the king to have memory of the past to ordain the future and to provide for the present. In the *Summa theologica* (2a 2ae 49) Thomas Aquinas follows an eight-part division of Prudence in which the three capacities are included.[50] In short, many medieval sources made the inscription originally intended for Prudence in Figure 34 an obvious choice for explication of the *trifrons* aspect of the image.

In contrast, direct visual sources for Prudence are difficult to find, particularly in northern art. Relevant as an analogous type of knowledge is the tripartite crown worn by Philosophy. This personification figured in a miniature of the *Hortus deliciarum* (now destroyed), the famous twelfth-century encyclopedia compiled by Herrad of Landsberg.[51] In Christian iconography the tricephalic head also symbolizes opposing concepts of good and evil: the Holy Trinity and Beelzebub.[52] More immediate precedents for the iconography of Prudence come from trecento Italy. In addition to a fresco representing a *trifrons* in Pistoia cathedral dated 1347, an illuminated frontispiece of a Bible shows a two-headed Prudence among the virtues surrounding King Robert of Anjou.[53] The motif of the death's-head in Figure 34 may also have been suggested by the skeleton featured in the story of the Three Living and the Three Dead. A famous example of this type is the bifolio in the Psalter of Bonne of Luxembourg, mother of Charles V.[54]

Once again, Oresme's choice of an image reflects his predilection for a visual riddle. In the case of Prudence, the need for an explanatory inscription, which was then misplaced, shows that sometimes his imagination and learning may have led to overambitious experiments. To put it another way, the didactic goals of the cycle in *C* gave rise to complex, as well as complete, visual definitions. On some occasions the scribe and miniaturists capably translated Oresme's instructions into an intelligible, aesthetically pleasing sequence of images. For various reasons, not easy to explain, other attempts were less successful. While certainly arresting, the personification of Prudence belongs to the category of daring and memorable illustrations. Perhaps these representations served as talking points for Oresme's oral explication requested by his patron.

The two intellectual virtues of the lower register stand out against the checker-board pattern of the dark blue and gold background. Entendement and Sapience are more isolated from one another than are Science, Art, and Prudence, above. The empty space between them leaves the center of the composition open, thus emphasizing the importance of Art in the upper register. Although Entendement, like the parallel figure of Science directly above her, sits on a thronelike bench and faces to the right, she is far larger than her sister virtue. As noted earlier, one reason for such a disparity in scale is that the lower zone houses two instead of three figures. Furthermore, Entendement is not equipped with any identifying attributes, such as Science's book and lectern. Entendement (Intelligence) also dwarfs the figure of Sapience or Theoretical Wisdom (*Sophia*) with whom she shares the lower register. Sapience is also seated on another familiar throne-bench. Yet the reduced size of her figure results from the inclusion of the accompanying celestial vision and the misplaced inscription. The net effect of the disparity in scale is to diminish Sapience in favor of Entendement. This emphasis may be unintentional, since in Oresme's translation and Aristotle's text, Sapience holds the highest place.

The unusual emphasis on Entendement is surprising, given the succinct defini-tion of the virtue in Chapter 6 of Aristotle's text and Oresme's translation. *Entende-ment* (the equivalent of the Greek term *Nous*) is translated variously as comprehen-sion, intuitive reason, or intelligence. As Oresme puts it, Entendement is the way "nous cognoisson les premiers principes; et la vertu intellective par quoy nous les cognoisson, c'est entendement" (we recognize the first principles; and the intel-lective power by which we recognize them is understanding).[55] In this same gloss, Oresme cautions that the word *entendement* is used in a different sense from that in Chapter 2, where it means a division or faculty of the soul.

These specific philosophical and Aristotelian meanings of *entendement* may have presented problems of visual definition, compounded by the multiple meanings of the word in contemporary language. Thus, representation of Entendement called for a visual formula free of verbal reinforcement or elaborate attributes. The image in Figure 34 depends solely on body language. Entendement's slightly bent head conveys a state of alertness. Her raised right shoulder and left hand with fingers held upright and spread apart suggest a tense, almost listening attitude. Her outstretched and bent right hand, crossed over the left at shoulder level, further contributes to a sense of inner awareness and of internal recognition. Together, the pose and gesture express the idea of straining to grasp a concept or principle. Pictured as a mature, solid form contained within her generously draped mantle, Entendement appears to listen to an inner voice. Although the intensity of Enten-dement's awareness recalls similar qualities among the seated Sibyls of Giovanni Pisano's Pistoia and Pisa pulpits, the virtue is entirely self-sufficient and free of explicit religious context.[56] Among the representations of the intellectual virtues of Figure 34, Entendement is preeminent both in size and expression.

In contrast to Entendement, Sapience is a slightly formed, almost wraithlike figure. Unlike her counterpart in Figure 33, Sapience no longer needs a book to reveal the subjects of her contemplation. With hands in an attitude of prayer, she sharply turns her upraised head to gaze at the figures of God and the angels. Separated from Sapience by a cloud and outlined in gold, the heavenly apparition changes from its earlier formulation in Figure 33. The blessing figure of Christ is still cross-nimbed but now is bearded. His bust is frontal and occupies the center, not the corner, of the heavenly space. On each side, three angels in praying attitudes turn toward him and create a symmetrical composition. The increased equilibrium of the heavenly component makes an impression of greater order than the analogous group of Figure 33. Yet Christ (or possibly God the Father) no longer returns the gaze of Sapience, as he did in Figure 33. Here, Sapience has become more active than her counterpart in *A*. The precedent for her sharply turned head and heaven-directed glance lies in another type of Evangelist portrait in which the saint turns his head toward the symbol of his inspiration.[57]

As discussed above, the placement of the inscription intended for Prudence above the head of the Sapience scene diminishes its importance not only by reducing the size of the main figure but also by introducing an extraneous and misleading verbal element. The inscription sits oddly on the heads of the heavenly hosts. It ignores the enframement and extends awkwardly into the right margin. The position in the middle of the cloud formation of Sapience's identifying inscription also indicates alterations in the original design.[58] Misplacement of the inscription flaws the representations of, and distinctions between, the two types of Wisdom, the most important of Aristotle's five intellectual virtues.

The origins of Sapience reveal that a variety of personifications relied on relatively few iconographic types for representational formulas. Among these, the reading or inspired Evangelist appears as the most versatile. The models for secular images such as the blacksmith are much rarer, although several cycles of the mechanical arts existed.[59] The image of Art in Figure 34, however, shows how religious types migrated to the secular sphere. Both the frontality and the deployment of the symbols of the arts and crafts lend the unusual working-class female depiction of Art a solemnity and dignity normally associated with religious or royal iconography.

The compelling qualities of Art, Prudence, and Entendement are further evidence that Oresme held with Thomist artificial memory theories in selecting visually distinctive images to express moral concepts.[60] He also enjoyed composing visual riddles or encouraged the reader to participate in naming or identifying essential aspects of a concept encoded in the visual image. Oresme's role in setting ambitious goals for the revised program may have resulted from a challenge presented by and for his primary reader and patron, Charles V.

II REASON AND DESIRE: MORAL DECISIONS
(Book VII)

The illustrations accompanying Book VII in *A* and *C* offer the first examples within the cycles of the representational mode of the decision allegory (Figs. 35, 35a and 36, 36a). Panofsky, who coins the term in his essay "Hercules Prodicius," defines the situation as the response of a central protagonist faced with a moral conflict. As was noted in Chapter 4, Panofsky emphasizes the unique character in medieval art of the representations in *A* and *C* as decision allegories based not on divine intervention but solely on an individual's voluntary action.[1]

The decision allegory, which occurs for a second time in the illustration of Book IX in *C* (Fig. 41), overlaps other representational modes in the *A* and *C* cycles. Personifications, as abstractions of good and evil forces or of psychological states, interact in ways similar to the personification allegories of Books II and V (Figs. 11, 12, 24, and 29). In these earlier examples the initiator of an action represents a transcendental spiritual force. In contrast, the protagonists in the illustrations of Book VII are distinctly mundane. Figures 35 and 36 also serve their customary function as subject guides to the contents of the book.

Why do the principal subjects of Book VII call for such a distinctive mode of illustration? In one sense, Aristotle continues his discussion from the preceding book of how a variety of intellectual virtues brings about morally positive or negative actions in human life. But Aristotle's focus in Book VII is not so much the rare, ideally virtuous man (or his entirely "vicious" opposite) but the more common human plight of exhibiting moral strength or weakness as reactions to the essential conflict between intellect and desire. The Greek terms for these concepts, *Enkrateia* and *Akrasia*, have a complex history in Greek and subsequent philosophy. Because of present-day medical usage, the customary translation of these terms as "continence" (*Enkrateia*) and "incontinence" (*Akrasia*) both in English and French is unfortunate.[2] In the Middle Ages, however, "continence" and "incontinence" referred to sexual chastity or the lack of it.[3] Moreover, Aristotle does not consider continence and incontinence virtues in themselves. Unlike a person who possesses the virtue of temperance or moderation without conflicts regarding sensory pleasures, the continent or morally strong person has a passionate nature, which he controls only after experiencing a struggle through which the voice of reason guides him.

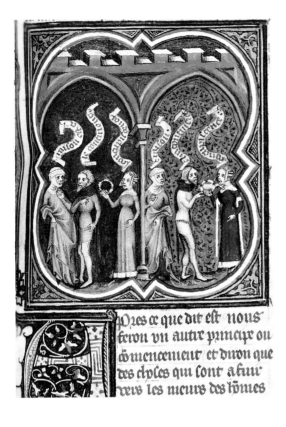

FIGURE 35A Detail of Fig. 35.

LE CONTINENT AND L'INCONTINENT IN *A*

Because of the complex meanings of the terms, Oresme defines both *continent* and *incontinent* in his glossary of difficult words. The translator takes great pains to emphasize the Aristotelian meaning of the words and to distinguish them from contemporary Christian usage:

> CONTINENT. Celui est continent qui a mauvaises affeccions et temptacions par con-
> cupiscence a gloutonnie ou a luxure. Et avecques ce, il a bon jugement de raison,
> lequel il ensuit, et par ce il refraint ses mauvais desirriers. Et ce fu dit ou .xxi.ᵉ cha-
> pitre du premier en glose et appert plus a plain ou procés du .vii.ᵉ livre. Et si
> comme il fu dit en l'onzieme chapitre du .ix.ᵉ, il est dit continent pour ce que il se
> tient avecques raison et entendement. Car par ce il se tient avecques soy meïsmes;
> car chascun est principalment son ame intellective ou son entendement, si comme
> il fu dit ou quint et en le .xi.ᵉ chapitre du .ix.ᵉ et ou .xiiii.ᵉ chapitre du .x.ᵉ.

> (CONTINENT. The continent man is one who through concupiscence is subject to
> bad desires for and temptations to gluttony or lechery. And at the same time he has
> good rational judgment, which he follows and by which he restrains his bad de-
> sires. And this was stated in the twenty-first chapter of the first book in a gloss and

is more fully discussed in the course of the seventh book. And as it was stated in the eleventh chapter of the ninth book, he is called continent because he conducts himself with reason and understanding. For by these means he restrains himself, for the intellective soul or understanding is the basic element of each of us, as was stated in the fifth and eleventh chapters of the ninth book and in the fourteenth chapter of the fifth book.)[4]

Oresme remains faithful to the text in including gluttony with sexual passions as temptations that the continent person can avoid by using good judgment founded on reason. In contrast, the incontinent man, subject to the same desires as his opposite number and holding "vrais principes morals" (true moral principles) and "bon jugement et raison" (good judgment and reason), is unable to resist these temptations. Instead, L'Incontinent is "vaincu et seürmonté par concupiscence, et delaisse raison et ensuit ses desiriers" (vanquished and overcome by concupiscence and abandons reason and follows his desires).[5]

Oresme's efforts to make clear the Aristotelian meanings of Continence and Incontinence in the glossary continue in other locations within the text and glosses. The summary title for Book VII introduces the words and offers a brief explanation of them: "Et aprés commence le .vii.ᵉ qui determine de continence, laquelle est une disposicion a vertu; et de incontinence, sa contraire; et de delectacion" (And here begins the seventh book, which examines Continence, which is a disposition toward virtue; and Incontinence, its opposite, and of pleasure).[6] The titles repeat the terms in thirteen of the twenty chapters that follow. Moreover, Oresme's commentary explaining not only the difference between the continent and incontinent persons but also two other states of virtues and vices appears on the same folio as the illustration. Thus, Oresme incorporates a variety of verbal definitions of Continence and Incontinence to which the reader can refer. The inscriptions provide clues for the translator's selection of the main concepts. The term *Le Continent* identifies the central figure in the left half of the illustration; *L'Incontinent* occupies the same position on the right. Once again, the inscriptions combine lexical and indexical functions.

Figure 35 is embedded in the first text column following the chapter headings and is placed above the introductory paragraph signaled by the six-line dentellated and foliated initial *A*. Although the position and dimensions of Figure 35 do not indicate importance within the cycle, the illustration has a unique feature. The miniature is divided into two vertical halves based on the contrast of the opposing characters of Le Continent and L'Incontinent. Previously, lateral division of the picture space in the illustrations of Books III, IV, and VI (Figs. 15, 20, and 33) correspond to identification and explanation of two separate subjects. This new ordering of the picture space by Oresme thus corresponds to the verbal definitions and contrasts he established in the glossary and commentary. Furthermore, the opposition between Continence and Incontinence is immediately set up in the first two paragraphs of the text, directly below and next to the miniature. As noted above, in his commentary Oresme further explains the essential distinctions

between Continence and Incontinence. There the reader also finds the relationships of these states to virtues and vices of different degrees. Even the contrasts of colors in the backgrounds and costumes of the figures carry out the theme of opposition and internal conflict set forth so emphatically in the text and commentary. To bring out these differences, the memory gateway places the opposing characters in separate but adjoining spaces divided by the central column.

The compositions, costumes, and gestures further clarify the contrasting choices made by Le Continent and L'Incontinent. Another way of putting the reader in the picture is Oresme's transformation of the adjectives *Continent* and *Incontinent* into nouns.[7] Le Continent and L'Incontinent become masculine equivalents, or concrete exemplars, of types of behavior analyzed by Aristotle. These physical doubles and opposites are identified by inscriptions unfurling vertically over their heads. Their short, tightly fitting jackets, low-slung belts, pointed shoes (*poulains*), and colored hoods with trailing ends (*liripipes*) distinguish them as fashionable, secular types. Both occupy the center of the shallow picture stage that avoids a strict axial or symmetrical organization. Instead, a more fluid composition pairs Le Continent with the figure on the left. The inscription identifies this personification: "Raison est ce" (this is Reason). Her widowlike headdress and ample blue robe resemble those of virtues like Actrempance and Liberalité (Figs. 15 and 20). Raison also occupies the same position in the right half of the miniature. The third figure, common to both scenes, stands on the right. Her inscription identifies her as Concupiscence (Sexual Desire). Her worldly status as a young woman of fashion is established by her braided tresses and fur-trimmed low-cut gown. In both scenes she proffers a chaplet of flowers, emblem of sensual pleasures.

The decision taken by Le Continent and L'Incontinent toward or away from the two types of conduct is expressed by the movement of their figures. Le Continent has literally turned his back on Concupiscence. His proximity to Raison, reinforced by his glance, the touch of his arm, and the position of his right foot emphasizes that he listens to her counsel. Yet, Le Continent indicates a struggle with his passions by pointing toward the eager and expectant figure of Concupiscence. A sense of uncertainty or anxiety about the outcome derives also from the expression of Raison's face and the tense gestures of her upraised and rigid hands. But the void between Le Continent and Concupiscence confirms the nature of his decision. The opposite conclusion takes place in the right half of the miniature, where L'Incontinent turns his back on Raison and moves in the direction of Concupiscence. Not only do his feet advance toward her, but he touches her shoulder with his outstretched left arm and with his other reaches for the wreath of flowers. Raison's resigned expression and upraised hand acknowledge that L'Incontinent has taken a step in the wrong direction. The vivid body language, expressed in visual metaphors such as "turning his back" or "taking a step in the right direction," reinforces the verbal language of the inscriptions.

The decision allegory in *A* is marked by a concrete and specific action taken by a contemporary secular figure. The visual evidence of moral struggle based on the protagonist's conflict between Reason and Desire is effectively conveyed. Whereas Aristotle did not single out sexual pleasure as the only area of moral

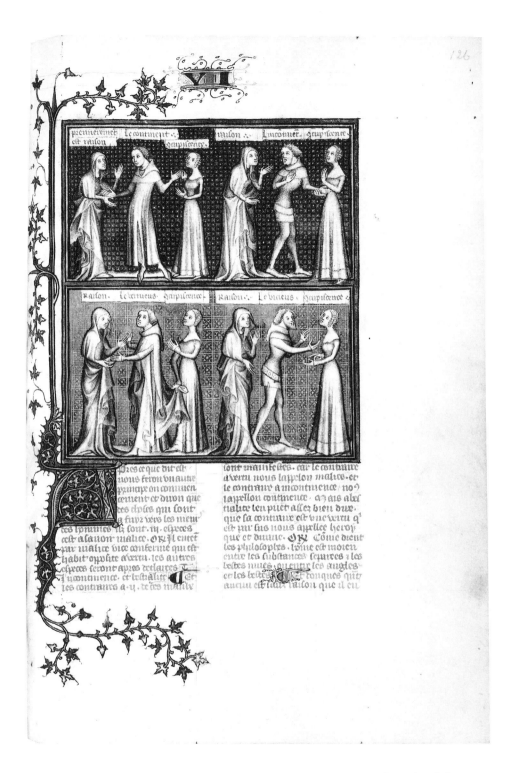

FIGURE 36 Above, from left: *Raison, Le Continent, Concupiscence; Raison, L'Incontinent, Concupiscence;* below, from left: *Raison, Le Vertueus, Concupiscence; Raison, Le Vicieus, Concupiscence. Les éthiques d'Aristote, MS C.*

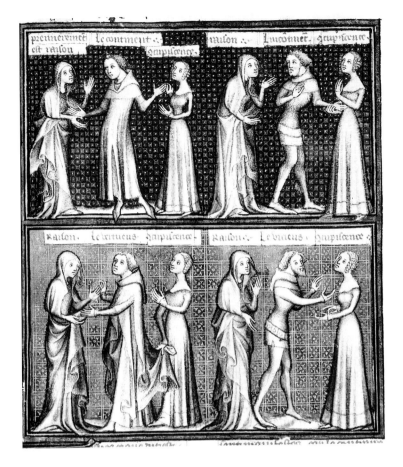

conflict, Oresme may have chosen to do so because of the traditional medieval associations of the term *Continence*. Nevertheless, thanks to the fluent style of the Jean de Sy Master, the illustration makes clear the essence of the verbal definition. Oresme's instructions probably specified details of costume, gesture, and identity of the opposing protagonists. Such a program is an ingenious solution to the visual and verbal translations of subtle philosophical concepts clearly conveyed to Oresme's secular audience. Rooted in rhetorical strategies, complex visual devices such as repetition, opposition, and single versus double identities are designed to engage and enhance the cognitive and mnemonic responses of these readers.

THE EXPANDED DECISION ALLEGORY OF *C*

The decision allegory illustrating Book VII in *C* (Figs. 36 and 36a) keeps the basic scheme established in *A* but adds a second register that expands and shifts the scope of meaning. Consistent with Oresme's editorial revision of the program in *C* and the physical changes noted in the second half of the book, the illustration

has grown larger. Figure 36 is almost twice the height of the miniature introducing Book V (Fig. 29). Moreover, in the decision allegory of *C*, the figures dominate the image. Except for the rectangular inscriptions placed at the top of each scene, there is no setting analogous to the crenellated wall or tricolor inner frame of Figure 35. Indeed, the lack of any internal division (such as a line) makes it difficult at first to understand the contrasts between what constitute two separate scenes on the left and right of each register. The situation is slightly clearer in the lower register, since a double vertical line belonging to the background motif serves to separate the two halves of the scene. This lack of demarcation may have resulted from the miniaturist's misunderstanding of Oresme's new or revised instructions. Placed at the top of the folio following the chapter headings on the previous leaf, Figure 36 seems very much more a frontispiece illustration than Figure 35, which is located nine lines below the top of the first column. The grisaille figures of Figure 36 stand out sharply against the deep blue geometric background of the top register and the contrasting apricot and gold tones of the lower one.

Certain minor but significant changes are noticeable in the top zone of Figure 36. For one thing, instead of the inscription "Raison est ce" on the left of Figure 35, the phrase in Figure 36 reads "premièrement est raison" (first comes reason). The word *premièrement* suggests that Le Continent has as his first resource deliberation and use of reason. Omitted from the top register is the wreath of flowers held by Concupiscence in Figure 35. Such a decision is consonant with a rejection in the *C* cycle of visual emblems. Instead, an increased reliance on hand gestures signifies tension or conflict among the figures. Indeed, the awkwardly shaped hands, as well as the outsized feet and elongated proportions of both women and men, are hallmarks of the workshop of the Master of the Coronation of Charles VI. Also different in the top left scene of Figure 36 is the compositional relationship among the figures. Le Continent stands almost equidistant from the two females, while with outstretched hands he touches both of them. Although, as in Figure 35, Le Continent again turns his back on Concupiscence and looks at Raison, the play of hands suggests a continuing struggle to choose between the female forces. A similar indecision of the male protagonist is apparent in the upper right scene. Here ambivalence is conveyed by the manner in which L'Incontinent glances toward Raison while still turning his back on her. He seems to be listening to Raison's exhortations, suggested by the forward tilt of her head and the pleading gestures of her hands. An important change from Figure 35 noted by Panofsky is the difference in dress between Le Continent and L'Incontinent.[8] In Figure 36 the former wears a plain, full-length mantle associated with a cleric or scholar, while the latter retains the contemporary, fashionable dress worn in Figure 35 by both figures. In other words, instead of the more subtle concept of likeness between the two types of conduct established in Figure 35, the analogous scenes of *C* introduce a social and moral dichotomy.

The left and right scenes of the lower zone repeat the same contrast between the behavior and status of the male figures. Le Vertueus (the virtuous man), personalized in a similar way to his analogue Le Continent, contrasts with Le Vicieus (the man given to vice), the counterpart of L'Incontinent. The two female figures,

however, remain the same as on the upper register. What is the rationale for this second level of the decision allegory? First, the explicit, didactic character of the entire program of *C* surely figures in the expansion. Second, Oresme may have responded to questions about the relationships among Continence and Vertu and their opposites as points of philosophical debate. Addition of a second level also permits clarification of Aristotle's distinctions between degrees or states of moral behavior. A textual basis for such clarification is provided by Oresme in his lengthy commentary in *C* (fol. 132) cited above as the basis for his definitions of Continence and L'Incontinence. A relevant passage reads:

> Et entre ces .ii. estas sont .iiii. autres; c'est a savoir, incontinenz et vicieus et continenz et vertueus. Donques .vi. estas sont de quoy les .iii. sont mauvais et different ainsi. Car a bien ouvrer sont requises .iii. choses; c'est a savoir, deliberacion et vray jugement et droit appetit. Le incontinent a deliberacion et vrai jugement universel, mais il fault an appetit. Le vicieus a deliberacion et fault en jugement et en appetit.

> (And between these two states are four others, to wit, incontinent and given to vice and continent and given to virtue. So there are six states, of which three are bad and differ as follows. For to act well three things are required: to wit, deliberation, true judgment, and right appetite. The incontinent man has deliberation and true judgment overall, but he fails with regard to appetite. The man given to vice has deliberation and fails with regard to judgment and appetite.)[9]

Both verbal and visual links help the reader to associate on two levels similar and contrasting moral types. Visually, parallel placement and repetition of costume help the reader to forge the connections between the figures in the left halves of Figure 36, Le Continent above and Le Vertueus below, and on the right, L'Incontinent and Le Vicieus. Of course, on two levels, the opposition also continues between the morally strong and weak types depicted on the left and right. The reader's reference to the first sentence of Oresme's commentary, cited above, explains the basis of such pairing. For example, the figure of Le Vertueus meets the three requirements listed: deliberation, true judgment, and right desire. He has turned his whole body and stepped toward Raison, who welcomes him with outstretched hands. His back is turned away from Concupiscence, who vainly tugs at his mantle. Two further passages from the same commentary elucidate the contrast. A gentle expression and contained stance confirm that "Le vertueus n'a point de tele rebellion ou peu" (The virtuous man possesses little or no such rebellion within him). Such resoluteness contrasts with Le Continent, who "a en soy grant rebellion de l'appetit sensitif" (who is capable of resisting his appetite for sensual pleasures). Following the opposite track, Le Vicieus, who lacks judgment and desire to do right, opts for Concupiscence by stepping toward her with arms outstretched and turning his back on Raison. Le Vicieus no longer even listens to Raison, as does L'Incontinent in the zone above him. In short, the scenes of the upper register convey the sense of moral struggle and temporary, tentative choices, while those below depict decisive and habitual modes of conduct.[10] Moreover, the

repeated difference in costume between the two types of character in the lower register suggests that the continent and virtuous modes of life are practiced by scholars or clerics, whereas those who exemplify moral weakness and wicked indulgence in bodily pleasures inhabit a fashionable, secular world.

THE EMBODIMENT OF MORAL DILEMMAS

At first glance, the miniature for Book VII in *A* (Figs. 35 and 35a) is modest, unremarkable for either size or position on the folio. But the illustration has considerable importance as a decision allegory. The illuminator successfully employs body language as visual metaphors for actions and choices made by an individual. In this first instance of the decision allegory, position in the center of the picture field expresses another aspect of the Aristotelian concept of the mean in which man occupies a moral position between the angelic and the bestial. The central position also embodies the dilemma faced by the man in the middle, pressed by conflicting moral choices. The preference for a triadic ordering scheme is consistent with Aristotle's advice that it is easier to recollect a central idea by relating it to concepts on either side of it.

Consistent with the pattern established in the cycle, the spiritual forces are represented as feminine, while the main protagonists are male. In Figure 35, Concupiscence is the sole depiction in the cycle of *A* of a negative feminine force, although in *C,* similar representations of vices appear in the illustrations of Books III and IV (Figs. 16 and 21). In both Figures 35 and 36, however, as in Figure 24b, the distance between the spiritual and "real" worlds is obscured by naturalistic scale, contemporary costumes, and shared gestures and expressions. Such a veristic approach, only partially related to style, gives particularly to the male figures the character of concrete, human exemplars rather than the more general personifications of abstract ideas.[11] Fashionable contemporary dress especially emphasizes the exemplary nature of Le Continent, L'Incontinent, and Concupiscence and distinguishes them from the sexually neutral Raison.

The illustration in *C* (Fig. 36) differs from that of Figure 35 because of the wider contrasts of moral states established in the lower register of *C*. It is also possible that the illustration in *A* offered too subtle a contrast between Le Continent and L'Incontinent, whose similarity of appearance suggests too great an identity of character. Again, Oresme may have responded to his own or the king's criticism, when in Figure 36 he differentiates by their costume the morally strong Le Continent and Le Vertueus from the weak-willed L'Incontinent and Le Vicieus. Oresme may also have intended that the social identification of the ethically strong with the intellectual and scholarly university élite serve as a warning to Charles V's worldly courtiers. Oresme may also have enjoyed the opportunity to explicate these ideas orally to Charles V and his circle. Such an occasion would have allowed him to expand on previous warnings about prodigality and unwise expenditure, particularly those expressed in the illustration of Book IV in *C* (Fig. 21). Oresme may have welcomed the opportunity to voice the views of a clerical moralist addressing his secular court audience.

12 FRIENDSHIP: PERSONAL AND SOCIAL RELATIONSHIPS
(Book VIII)

A dramatic instance of the revision in the cycles' illustrations occurs in the respective miniatures of *A* and *C* introducing Book VIII (Figs. 37, 37a and 38, 38a). Within the program of *A,* Figure 37 offers a generic visual definition in the form of an unusually cryptic but elegant personification allegory. Figure 38 provides a detailed subject guide composed of six scenes that exemplify specific definitions of the main subject. The miniatures in *A* and *C* thus approach from two distinct vantage points Aristotle's classic discussion of Friendship (*Philia*), a theme that encompasses both Books VIII and IX of the *Ethics*.

Aristotle, and Oresme in his translation, anticipates the reader's initial surprise that Friendship should occupy so prominent a place in an ethical treatise. The first sentence of Book VIII states: "After what we have said, a discussion of friendship would naturally follow, since it is a virtue or implies virtue, and is besides most necessary with a view to living."[1] Aristotle's generic definition of Friendship is based on a reciprocal and acknowledged affection, liking, or sympathy (independent of sexual attraction) between two people who have common interests.[2] Aristotle also applies the concept of *Philia,* better translated in some contexts as "relationship" or "association," to the bonds created by goodwill and acting well toward others in the family and in social and political communities, including the state. Thus, Aristotle's lengthy analysis of Friendship, like his discussion of Justice in Book V, involves not only moral states and actions of the individual but relationships with other people. Of Aristotle's three main types of *Philia* among persons of equal status—relationships for profit or utility, pleasure, and goodness—the last is the most noble, enduring, and disinterested. The third type of Friendship involves the habits of wishing and acting well to another that closely resembles the behavior of a virtuous person.[3]

Aristotle's discussion of Friendship and that of Cicero in the *De amicitia* were not rejected by Christian thinkers and theologians.[4] Although Thomas Aquinas thinks of Friendship in terms of man's relationship with God, he conceives of "love of friendship" on a human level as "the highest form of love."[5] Oresme, however, carefully differentiates God's love of man and man's love of God from the Aristotelian definitions of Friendship.[6]

Left column:

u premier chapitre il prueue que
determiner damistie apartient a lae
er morale

u secont chapitre il treate aucuns
anciens opinions de amistie

u tiers il enquiert que est amistie
et en met la diffinicion

u quart il met iij especes de amistie
et determine d ij de elles

u quint il determine de la tierce es
pece cest asauoir damistie honneste

u sixte il compare ensemble les es
peces damistie dessus dites

u vij il determine des especes da
mistie en les comparant aleur faut

u viij il determine des especes da
mistie en les separant aleur subiet
en quoy il sont

u ix il dit aucunes choses en espe
cial de lamistie des princes

u v il distingue ou deuise les espe
ces damistie qui est entre persones
inequales

n le xj il compare ensemble amie
er estre auec et parle de puissance
damisties et damistie de gens dessemblables

u xij il monstre que les especes da
mistie dessus dites sont prises selon
les parties de communicacion politique z les
ensuiuent

u xiij il distingue ou deuise les
especes de communicacion politique

u xiiij il distingue les communica
cions yconomiques ou domestiqs
selon similitude as especes dessus dites

u xv il distingue les especes dami
stie selon les communicacions dessus dites

u xvj il subdiuise aucunes especes
damistie z traicte damistie de lignage

u xvij il determine damistie de
manage

u xviij il monstre coment accusa
cions z complaintes sont faites en amis
ties et par especial en amistie selon equalite



Ou xix chapitre il monstre coment
accusacions sont faites en amisties qui
sont selon inequalite Ci commence le viij
Ou premier chapitre il prueue que determiner
damistie apartient a science morale

pres les choses deuant dites
il ensuit que nous deuon
passer oultre et traicteron
de amistie Premiere
ment cest raison pour ce que
damistie est une vertu ou
elle est auecques vertu

Item amistie est
une chose tres grande
ment necessaire en
vie humaine Car il
nest nul qui eslist
uiure sens amis sup
pose que il eust tous
les autres biens Car
par especial ceuls qui
ont les grans richeces
et optienment les pri
cipautes et les grans
puissances ilont tres
grandement mestier
dauoir amis Car
quel proffit seroit de
auoir tele bonne fortu

Marginal notes (right):

de amistie Apres
il prueue par vi raisos
que len doit in consider
et traicter de amistie

auecqs vtu Car
si come il sera dit aps
amistie est vn habit
electif en la maniere
que est vertu z aussi
come vne espece de
vertu reduite ou ra
menee a iustice et
conques science mo
rale qui considere des
vertus doit considerer
de amistie
dauoir amis et
de ce il assigne deux
causes

FIGURE 37 *Amistié. Les éthiques d'Aristote, MS A.*

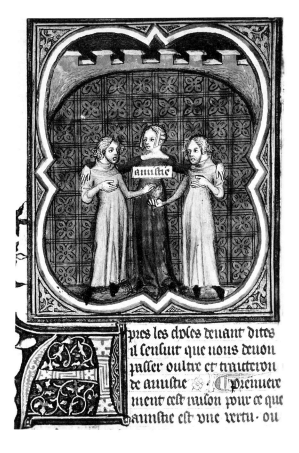

FIGURE 37A Detail of Fig. 37.

Because of the assimilation of classical ideas of Friendship to medieval thought, it is difficult to determine if the Aristotelian definitions of the term retained a separate identity. Amistié is included in a treatise on the virtues or vices known as the *Somme le roi* compiled in 1279 for King Philip III by the Dominican Frère Laurent. Amistié (translated alternatively as "Love" or "Friendship") is in this text one of a set of Christian virtues related to gifts of the Holy Ghost and the Beatitudes.[7] In this scheme, Amistié is opposed to Hate (Envie). In one series of *Somme le roi* illustrations (Fig. 39), Amistié is depicted on the upper left of four scenes as a standing, crowned figure who crushes a dragon and holds a disk containing an image of a bird (probably a dove). The bird is a symbol of love; the dragon, of evil associated with the mouth of Envie.[8] Below Amistié, a depiction of David and Jonathan embracing offers a biblical exemplar of the virtue.

The Amistié illustration in *Somme le roi* manuscripts, including a copy of 1294 in Charles V's library, apparently constitutes the main medieval figural tradition of depicting Friendship.[9] Written in Paris and dated 1373, a manuscript of a related text known as *Le miroir du monde* continues this pictorial tradition.[10] The new treatment of Amistié in Figures 37 and 38 suggests that Oresme seeks to define the virtue in specifically Aristotelian terms.

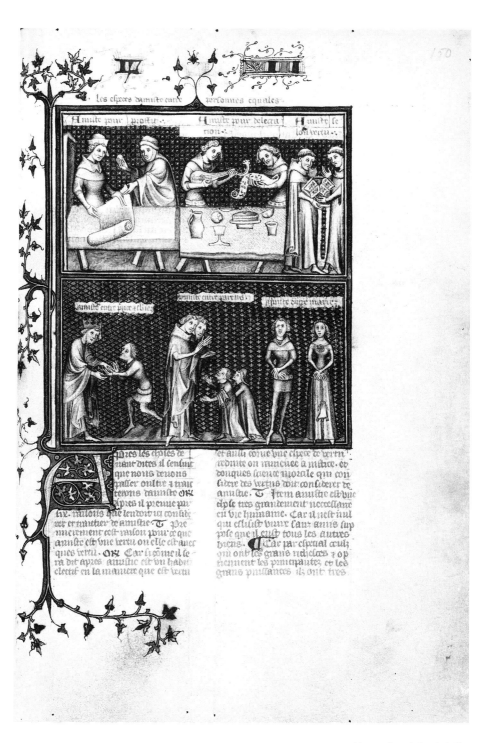

FIGURE 38 Above, from left: *Amistié pour proffit, Amistié pour delectacion, Amistié selon vertu;* below, from left: *Amistié entre prince et subiez, Amistié entre parens, Amistié entre mariez. Les éthiques d'Aristote,* MS C.

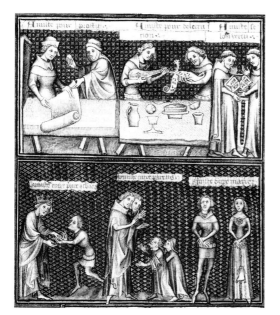

FIGURE 38A (*left*) Detail of Fig. 38.

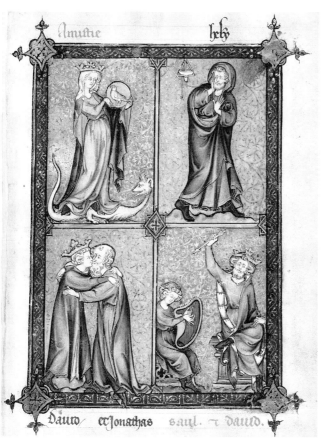

FIGURE 39 Above, from left: *Amistié,
Envie;* below, from left: *David and Jona-
than, Saul and David.* Frère Laurent,
Somme le roi.

By way of a subject guide, the illustration introducing Book VIII in *A* (Figs. 37 and 37a) offers a charming personification allegory. The miniature occurs five lines from the top of the second column of text and gloss on folio 157. Bracketed between the upper right foliate border pointing to the running title and the initial *A*, Figure 37 follows the chapter headings. The miniature is composed of three symmetrically disposed standing figures placed within a tricolored quadrilobe spanned by an unbroken crenellated wall segment. Figure 37 does not have the frontispiece status of Figure 24, the illustration of Book V. One of four undivided column illustrations in *A,* Figure 37 and the illustration of Book II (Fig. 11) are the largest and therefore the most important of the column illustrations.[11] Another feature of Figure 37 is a departure from the usual red-white-blue color scheme in favor of a distinctive gray-blue-rose palette. Since these more subdued colors are repeated in the next miniature, which introduces Book IX (Fig. 40), this color harmony may signify the continuity of subject matter between Books VIII and IX.[12]

The configuration of three figures in Figure 37 is unusual as well. The central and largest person is a fashionably coiffed young woman wearing a simple gray-green gown. Her figure lines up with the vertical points of the quadrilobe, the geometric background, and the center of the second column. Although her body is depicted frontally, her head is turned to look at one of two bearded men, who are identically dressed in long rose mantles. Each one turns his head and gestures toward his double. With the other hand, each supports a pink heart. In turn, the female figure extends her disproportionately long arms to embrace the shoulders of the two men. The only inscription in the miniature identifies the woman as Amistié, or Friendship. The position of the inscription at chest level of the personification instead of above her head is unusual. Such a placement may allude to the heart directly below it as the source of the emotions associated with Friendship.

Although *Amistié* is the sole verbal clue within the miniature, the layout of folio 157 assures the repetition of this key word to guide the reader. In the first column opposite the miniature, the word *Amistié* occurs in seventeen of the nineteen chapter titles. Chapter 3 is especially important, as the title designates it as the place where the term is defined. Indeed, in the closing gloss of that chapter Oresme explains: "Amistié est benivolence non latente ou manifeste entre pluseurs personnes de l'un a l'autre ou entrechangeable pour aucun bien" (And Friendship is goodwill, which is manifested among people toward one another or given and taken for [mutual] benefit).[13] When the reader moves to the second column of the folio, rubrics above the miniature make the important point that in Chapter 1 Aristotle demonstrates that Friendship belongs to a discussion of "science morale" (moral science). Directly below the illustration, the first paragraph states the necessity of Friendship to human life. With particular relevance for Oresme's primary reader is the declaration that Friendship is essential for the rich and politically powerful.[14] Finally, in the second of three glosses on this folio Oresme makes clear

how Aristotle relates Friendship to virtue.[15] Thus, a variety of introductory verbal information linked to the inscription and miniature on the same folio associates essential concepts with the image.

How does the personification allegory visually express essential aspects of Aristotle's generic definition of Friendship as translated by Oresme? As in the illustrations of Book VII (Figs. 35 and 36), body language is essential in communicating certain points about Amistié. To begin with, the figure's embrace conveys the notion that Friendship depends on reaching beyond the self to someone else. The mutual awareness of Amistié and the two men, conveyed by their turned heads and gazes, indicates their recognition of the bond united by and characteristic of Friendship. Another important element is that the two men support the single rose heart. If in this context the heart symbolizes the soul, the concept expressed may be that the highest type of Friendship symbolizes putting "one soul in two bodies."[16]

Costume again plays an important role in elucidating significant aspects of the concept. For example, the same rose-colored robes worn by the two men, as well as the resemblance of their facial features, hairstyles, and beards, establish that they are identical twins. This kinship metaphor picks out an essential point in Aristotle's definition of Friendship: the similarities between two individuals and the bonds that bind them are summed up in the saying, "A friend is another self." Since the mantles worn by the friends resemble those worn by Le Continent and Le Vertueus in the illustrations for Book VII (Figs. 35 and 36), the allusion here is to Aristotle's highest type of Friendship. Based on virtue, this kind of Friendship has "qualities [which] are alike in both friends," and men are described as "alike in virtue; for these wish well alike to each other *qua* good, and they are good in themselves."[17] Oresme puts it this way: "Et pour ce dient il un proverbe, que chose semblable aime son semblable et que .i. oysel va a son semblable si comme un estourneau va a un estourneau; et ainsi de quelzconques teles choses" (And for this reason there is a proverb that "like cleaves to like" and that "a bird flocks to its own kind" just as a starling flocks to another starling; and other such things).[18]

The costume and hairdo of Amistié in Figure 37 are those of a contemporary and fashionable young woman, although her mantle lacks the fur trim of the dress worn by Concupiscence in Figure 35. Thus, Amistié does not share the sexual neutrality of Raison or virtues like Attrempance or Sapience conveyed by their widowlike headdresses (Figs. 16, 33, and 34). Nor does she wear the crown that distinguishes the fashionably clad Vertu in Figure 11. The only sign that Amistié represents an elevated spiritual ideal is her height, a mark of her superiority to the twins. Perhaps the lack of a crown or other mark of Amistié's high status was unintentional. Or Oresme may have wished to distinguish Amistié, who is personified by a feminine, transcendent ideal, from the unnamed masculine "Friends," who operate in a different sphere. Although a triadic ordering scheme appears again, as in Figures 11, 16, and 35, the figures surrounding the woman in the middle here are identical, not antithetical.

The prominent emblem of the heart is an apparently extratextual allusion to the ancient notion that the heart is the seat of the soul, the emotions, or of love.

During the Middle Ages, the heart had both secular and religious connotations.[19] In trecento art, a flaming heart is the symbol of Caritas in the figure by Giotto in the Arena Chapel and Ambrogio Lorenzetti's altarpiece in Massa Marittima and his Good Government fresco in the Palazzo Pubblico, Siena.[20] Furthermore, the secular context of heart symbolism in fourteenth-century French art occurs in a group of ivories, probably made in Paris.[21] For example, two mirror cases depict the offering of the heart to a lover.[22] In an illustrated manuscript of the *Roman de la rose,* the god of love locks up the beloved's heart.[23]

The heart in Figure 37 operates in a secular context, as the hairstyles and costumes of the three figures imply. Although the illustration of Amistié ingeniously conveys many key notions of Aristotle's concept of Friendship, the reading of the image may have presented difficulties to the contemporary reader. An area of possible confusion is the link between the heart, symbol of heterosexual love, and the two males, who are embraced by the female Amistié. Another complication is the double connotation in French of the word *ami,* as both sexual partner and friend. Thus, ambiguous gender roles may have occasioned a request for a more explicit visual definition than that of the elegant but cryptic personification allegory of Figure 37.

A DETAILED SUBJECT GUIDE OF MS C: THE UPPER REGISTER

The total revision of the program of Figure 37 in the analogous miniature of *C* (Figs. 38 and 38a) departs from the adaptation noted in the illustrations of the previous book (Figs. 35, 35a and 36, 36a). There, the addition of a second register in Figure 36 intensifies and deepens the original meaning established in Figure 35. Here, Figure 38 abandons the single visual definition of Amistié in Figure 37 in favor of specific definitions of the word. Without any internal separation by frame or line, Figure 38 accommodates six separate scenes divided equally between the two registers. The expansive setting of the first two scenes gives the upper zone a crowded appearance. The top-heavy effect also results from the disproportionate space reserved for the extensive inscriptions. Because the third scene of the top register is squeezed into a small area, the lack of harmony is even more obvious. As a possible response to these aesthetic defects, the inscriptions in the lower register are shorter, the settings eliminated, and the figures diminished in scale. These changes show the experimental nature of the revised program of *C*. The challenge of depicting so many different scenes apparently caused difficulty for the illuminator, a less-gifted member of the workshop of the Master of the Coronation of Charles VI than the miniaturist responsible for the illustrations in Books VI and VII (Figs. 34 and 36).

Such uneven aesthetic effects thus result from an expanded and more overtly didactic program. Figure 38 claims a frontispiece status emphasized by its ample dimensions.[24] The carefully written inscription above the border of the upper register identifies the categories to which the subjects depicted below belong: "les especes d'amistié entre personnes equales" (types of relationships among people

of equal rank).[25] The inscription refers to Aristotle's three main types of friendships or associations among people of equal rank discussed in Chapters 4 through 8 of Oresme's translation. The phrase ".iii. especes de amistié" that begins the title for Chapter 4 introduces the reader to the explanation of two of the three types of relationships, those based on usefulness and on pleasure. In Chapter 5 is found the definition of the third, most perfect and lasting, type: Friendship based on virtue and excellence. Once again, left-to-right placement of the three scenes accords with sequence in the text.

The first scene on the upper register is labeled "Amistié pour proffit." The relationship represented depends not so much on affection as on the utility or material gain that such an association brings. Oresme puts it this way: "Et en ceste maniere, ceuls qui aiment pour bien utile, il ne aimment pas les personnes pour elles, mais pour le proffit que ilz en ont ou actendent avoir" (And in this way, those who love in order to gain something of practical value do not love people for themselves, but for the benefit that they get from them or expect to get).[26] The two merchants exchanging goods behind a table exemplify this type of relationship. A piece of cloth unfurled by the figure on the left brings the offer of a gold coin from the other man, who reaches out to feel the merchandise. Oresme explains that love of gain is the bond that holds this association together. The translator cites as an example of such an association "amistié de pelerins" (relationship of pilgrims), which he explains in a gloss: "Il entent de ceulz qui de lointain paÿs vont et communiquent ou conversent ensemble pour marcheandise et pour gaaing" (He means those who from distant countries go and communicate or associate for merchandise and profit).[27]

The second scene depicts "Amistié pour delectacion." The relationship of two young men for the sake of companionship and pleasure is illustrated by the food and drink displayed on a table and the playing and singing of music. The figure on the left plucks a stringed instrument, while his companion holds an unfolded scroll with words and notes written on it. About friendship for pleasure, Oresme says in the text: "Mais l'amistié des joenes gens semble estre plus pour delectacion, car il vivent selon les passions des concupiscences et quierent et poursivent mesmement ce qui leur est delitable selon le temps present" (But the friendship of young people seems to be more for pleasure, for they live according to the passions of concupiscence and they seek out and pursue especially that which gives them immediate pleasure). Food and drink may stand for both the short duration of pleasure and the intense relationships characteristic of young people, whose friendship "ne dure que un seul jour ou moins" (lasts but for one day or less).[28]

The most worthwhile and lasting type of friendship among equals is "Amistié selon vertu." Ironically, the most excellent category of Amistié has been squeezed into the remaining space of the upper register. The compression into a small corner of the third scene, composed of two men who stand facing each other, could indicate that for some reason the illuminator (or the instructions) did not divide the picture space proportionately. The text states that in this type of friendship the affection derives from the good and virtuous character of the parties, as well as from the good or pleasure they derive from the relationship. Because their charac-

ters are good, the friends wish each other well beyond any benefit that accrues from the association. As a result, this kind of relationship is not casual or ephemeral but will endure. Following Aristotle, Oresme notes that such friendship is rare, as few people are good and virtuous.[29] Perhaps this observation—rather than an error of the illuminator—accounts for the small space allotted in Figure 38 to "amistié selon vertu." Such a division of the picture field would reflect not only sequence in the text but also the idea of the prevalence of the first and second types of friendship and the rarity of the third. In any case, the depiction of the good and virtuous friends as tonsured clerics is a deliberate choice. Holding open books that they discuss, the friends exemplify the life of the mind as the lasting source of pleasure and virtue. In the Middle Ages, the intellectual life in monastic or university settings is associated with the clergy.[30] While Oresme may be simply updating and concretizing the ideal of the contemplative life, his choice of clerical figures may reveal his own personal and social identification with such pursuits.

FRIENDSHIP IN MS C: THE LOWER REGISTER

Despite an aesthetic ungainliness, the upper register of Figure 38 provides clear visual exemplification of "les especes d'amistié entre personnes equales." But the lower zone contains no equivalent inscription to indicate the different relationships among the three types of associations. Chapters 15 through 17 and other locations explore the topics of "amistiés entre personnes non equales" (types of relationships among persons of unequal rank). As in the upper zone, left-to-right placement of the scenes follows sequence in the text.

The first scene devoted to relationships among persons of unequal rank depicts "Amistié entre prince et subiez" (relationship between prince and subject). This theme would, of course, have especially interested Charles V. The background pattern of tiny fleur-de-lis of the lower register may have signaled the importance of the topics taken up there.[31] Particularly relevant is the depiction of a standing king wearing a gold fleur-de-lis crown. He receives the homage of a kneeling subject, who places his hand within the prince's.[32] In the tenth chapter of Book VIII Oresme mentions and distinguishes among the three types of relationships in which the parties have different roles or obligations "selon superhabondance ou inequalité des personnes" (according to superiority or inequality of the parties).[33] In all of them, one party has greater power or authority than the other. Because of his moral excellence and political authority, the ruler can do more for his subjects than they for him.[34] The scene of the king receiving homage clearly conveys the superior authority of the prince. Similar to the depiction of the virtuous clerics of the upper register, the representation of a medieval ceremony translates Aristotle's concepts to familiar, contemporary contexts. Especially telling are the upright position of the king, identified by his crown, the kneeling posture of the fashionably clad subject, and the hand gestures.

The second type of relationship, represented in the central scene of the lower zone, is "Amistié entre parens" (relationship among kindred). Two standing male figures give orders to two tiny children. The disparity in scale accentuates the

dependence of the latter, while their upturned heads and outstretched arms convey their acquiescence to authority. If the iconographic formula repeats the scheme of the first scene, such a resemblance is appropriate. Following Aristotle, Oresme states that the authority parents exercise over their children is similar to that a king wields over his subjects. Although the text acknowledges the differences between the two types of relationships, the resemblances are great. For example, both the father and the king love their dependents more than their respective dependents love them, since the more powerful are superior to the weaker in virtue and the ability to do good. Oresme's detailed analysis of these relationships in several glosses of Chapter 15 permits a rationalization of the benevolence and superiority of kingly authority based on the model of paternal rule.[35]

Although the language and imagery of the first two scenes of the lower register in Figure 38 stress masculine representations, the third includes a prominent female figure. She is the bride in "Amistié entre mariez." Wearing a gold circlet in her hair and a large brooch on her bodice, she stands frontally with crossed hands. A large, dangling purse may stand for the dowry she brings to the marriage. To her right stands the groom clad in a short doublet and hose. Oresme discusses the association of marriage in Chapter 17, as well as in other locations, such as Chapters 14 and 15. In the former, the marriage relationship is compared to one of the six forms of political association outlined by Aristotle in Chapter 37 and developed more fully in the *Politics*. If the relationship between a father and son resembles a monarchy in its absolute rule, Friendship between husband and wife is compared to aristocracy. In this regime, the man's preponderant authority rests on the principle of superior virtue and command of affairs appropriate to him, whereas the female has control over certain restricted domestic areas.[36] In Chapter 17 Oresme discusses the relationship between husband and wife as a natural one, and a primary unit in the association of families that makes up the political community. Marriage is also described as a relationship that brings profit and pleasure to both parties. If the characters of husband and wife are both good and just, marriage can also be described as a relationship for the sake of virtue. Of course, Oresme explains in a gloss, the virtues and actions of the husband are different from those of the wife.[37]

The depiction of "Amistié entre mariez" in Figure 38 does not reflect the inequality of status expressed so clearly in the other two scenes of the lower register. Both husband and wife are the same size and stand frontally with hands and feet in identical positions. The failure of the scene to demonstrate superior male status may lie in Oresme's instruction to depict a bride and groom. Limited by constraints of space, such a representation does not permit overt expression of the power relationships between husband and wife or differentiation of their work roles. These distinctions appear in the illustrations to Book I of Oresme's translation of the pseudo-Aristotelian *Economics* (Figs. 80 and 81).[38] It may also be the case that the disparate roles of man and wife were understood by the contemporary reader and required no visual demonstration.

Thus, the apparently simple scenes of "les especes d'amistié qui sont entre personnes non equales" in the lower register have complex interrelationships to polit-

ical ideas of fundamental importance to Charles V. Compared to the more expansive and detailed scenes of the upper register, the three below are reduced in scale and format. While the fleur-de-lis background and king's crown signal their importance, it is hard to say if the different treatment of the two zones results from pictorial experiment or Oresme's desire to rely in the lower register on his reader's familiarity with the institutions identified. Such a hypothesis may seem paradoxical, but by 1376, when *C* was completed, Charles V and other influential readers had had the opportunity to familiarize themselves with Oresme's translation of the *Politics*. Dating from about two years earlier, Charles V's first illustrated copy (*B*) of this text may have provided an opportunity for oral explications. If so, Oresme may well have discussed the important analogy between paternal rule and kingship.

In short, the illustrations for Book VIII in *A* and *C* (Figs. 37, 37a and 38, 38a) show radically different approaches to the visual definition of Aristotle's concept of Friendship. The former relies on an elegant and subtle personification allegory to communicate profound psychological and social characteristics of Friendship. As a whole, the triadic scheme presents a variation on the man-in-the-middle theme not only in gender but also in representing an embracing ideal rather than a set of contrasts. In comparison, the radical revisions undertaken in Figure 38 attempt far more ambitious visual definitions. Based on Aristotle's insightful division of personal relationships according to the power of one party over another, Oresme's ingenious program represents the most advanced example in *C* of the subject-guide type. Within their separate representational modes, Figures 37 and 38 conceive sophisticated and contrasting strategies for ordering the two types of visual definitions presented to the readers of Book VIII.

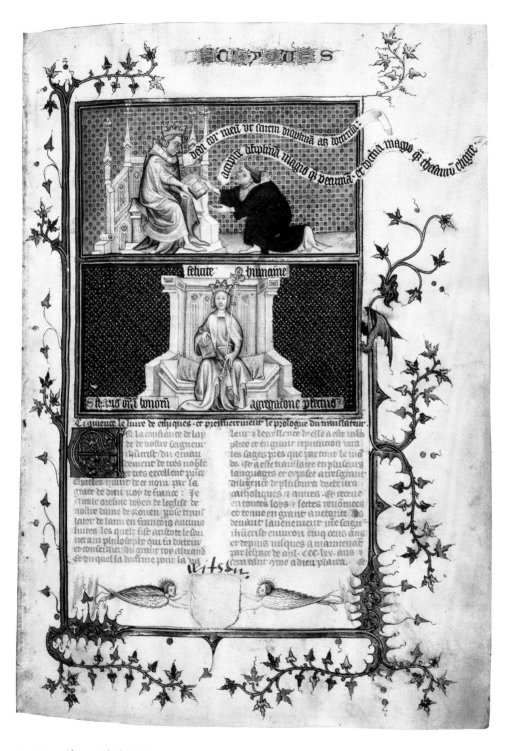

PLATE I Above: *Charles V Receives
the Book from Nicole Oresme;* below: *Feli-
cité humaine. Les éthiques d'Aristote,*
MS C.

PLATE 2 *Superhabondance, Vertu, Def-faute. Les éthiques d'Aristote, MS A.*

PLATE 3 Above, from left: *Justice légale with Fortitude, Justice particulière, Mansuétude, Entrepesle;* below, from left: *Justice distributive, Justice commutative. Les éthiques d'Aristote,* MS *A.*

PLATE 4 *Art, Sapience. Les éthiques d'Aristote*, MS *A*.

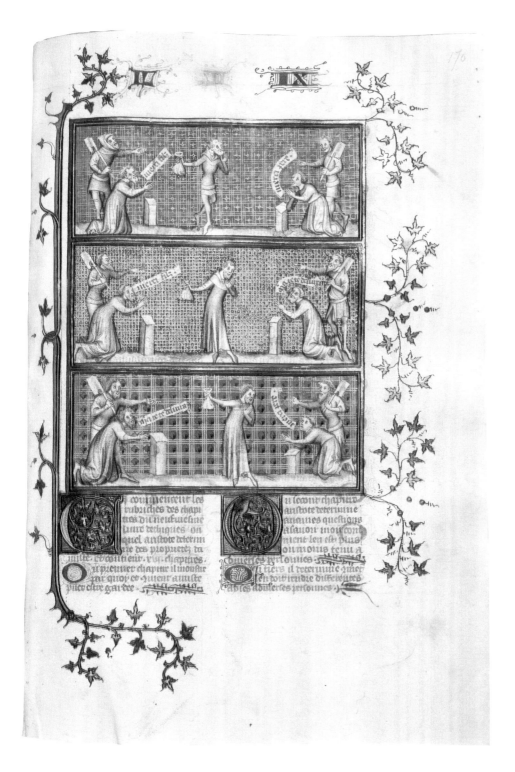

PLATE 5 *A Ransom Dilemma,* from
top: *Father or Son, Father or Friend,
Friend or Son. Les éthiques d'Aristote,*
MS *C.*

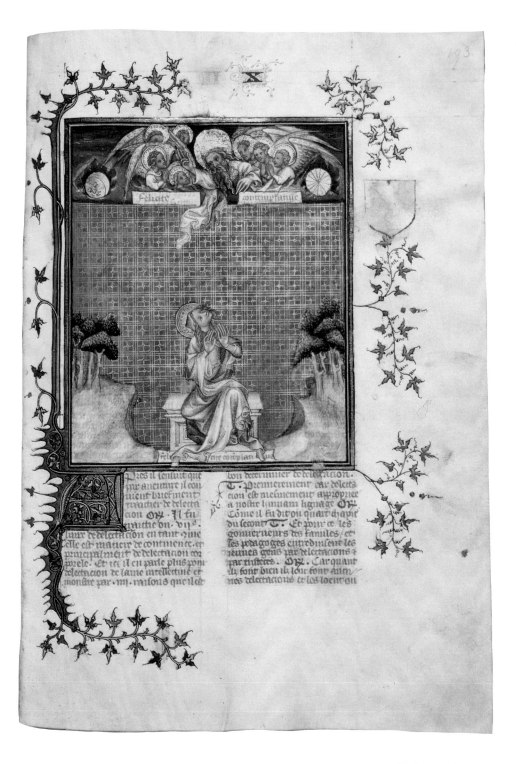

PLATE 6 *Félicité contemplative. Les éthiques d'Aristote*, MS C.

PLATE 7 From top: *Tyrannie, Olygar-*
chie, Democracie. Les politiques d'Aristote,
MS *D.*

PLATE 8 From top: *Royaume, Aristo-
cracie, Tymocracie. Les politiques d'Aris-
tote, MS D.*

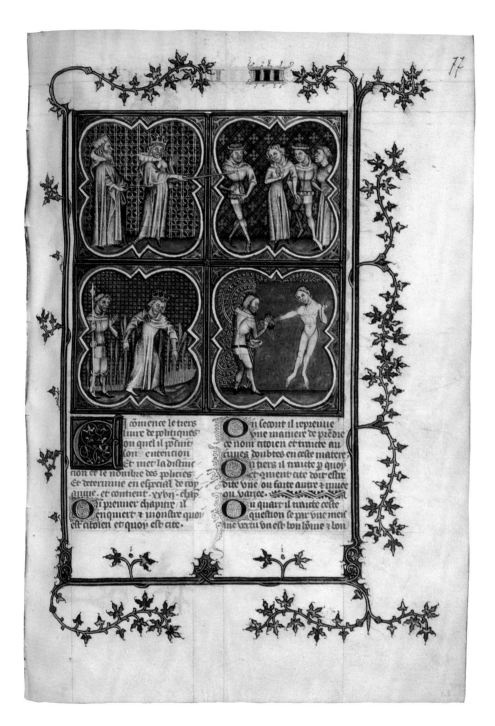

PLATE 9 Above: *A King Banishes a
Subject;* below, from left: *A King Cuts
off the Tallest Ears of Grain in the Presence
of a Messenger, A Palmer Erases an Error.*
Les politiques d'Aristote, MS D.

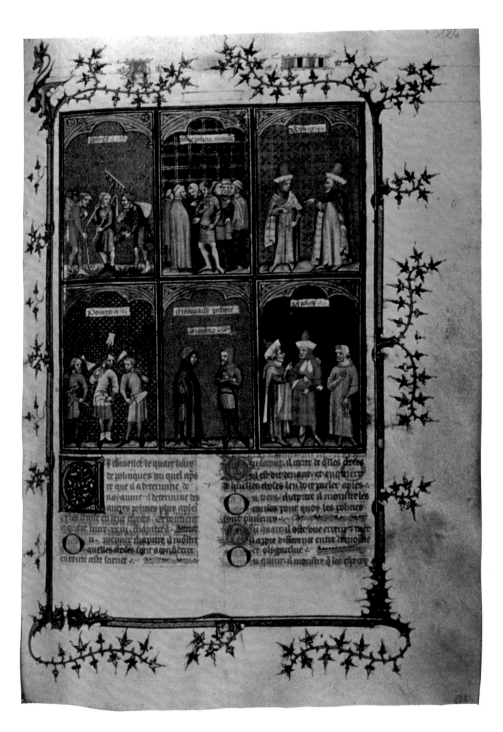

PLATE 10 Above, from left: *Povres gens, Bonne policie—Moiens, Riches gens;* below, from left: *Povres gens, Mauvaise policie—Moiens, Riches gens. Les politiques d'Aristote,* MS B.

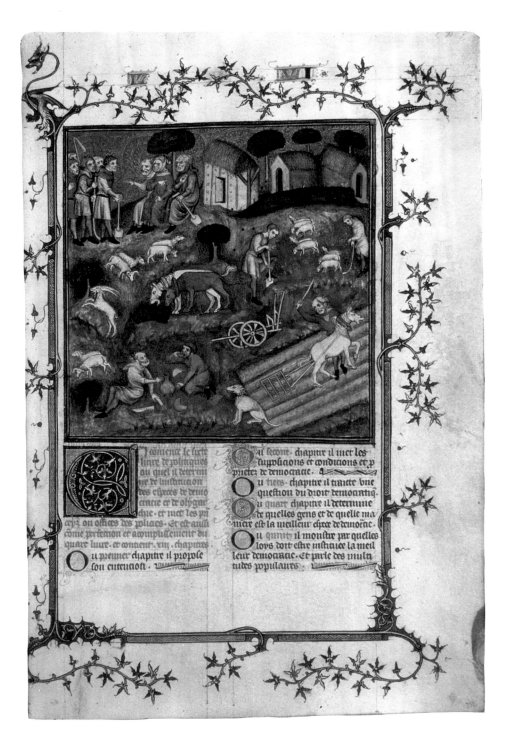

PLATE 11 *Bonne democracie. Les poli-*
tiques d'Aristote, MS B.

13 MORAL OBLIGATIONS OF FRIENDSHIP
(Book IX)

PROBLEMATIC RELATIONSHIPS BETWEEN FRIENDS

The illustration for Book IX in *A* (Figs. 40 and 40a) shows various physical similarities to the preceding miniature of this manuscript (Fig. 37). The images share the distinctive rose and blue colors that may signal the continuity of subject matter between the two books. But Figure 40 is not only smaller than Figure 37 but also is below average in its vertical dimension.[1] The reduced size of Figure 40 may indicate its secondary status in comparison to the considerably larger Figure 37, which introduces the subject of Friendship.

The program for Figure 40 is also reduced, with only two of the three figures from Figure 37. Perhaps in response to criticism about the unidentified males in Figure 37, each is labeled "Amy" (friend). Identical in size, facial type, and costume, the friends stand in three-quarter poses facing one another. The figures are symmetrically placed within the picture field, and their bodies occupy the same number of squares of the geometric background pattern. Most unusually, the center of the composition is empty, save for a large gold ring held by the man on the right. With outstretched hand, he offers it to his companion, who reaches out to accept or call attention to this prominent object.

This pared-down personification allegory seems even more cryptic than that of Figure 37. As mentioned above, the personification of Amistié in the illustration for Book VIII may have led to ambiguities about her relationship to the two males. In contrast, the two companions of Figure 40 leave no doubt that Friendship is a relationship reserved for men. Yet the gesture of Amistié in Figure 37 conveys the notion of the unifying spirit characteristic of Friendship, while the heart held by the two men expresses the idea of one soul in two bodies. In Figure 40, however, the relationship of the Amis is difficult to define both visually and textually. Of course (as in Fig. 37), the twinlike appearance of the two Amis repeats the notion that "a friend is another self."[2]

Indeed, several interpretations of Figure 40 are possible. This first alternative draws on the costumes and the ring as clues. The fashionable dress of the Amis differs from the modest attire worn in Figure 37 by the friends who are associated with the noblest, spiritual type of Friendship. Together with the ring, the worldly dress of the Amis in Figure 40 may signify the less worthy types of Friendship, those for profit or pleasure. In Chapter 1, directly above the miniature, the rubrics

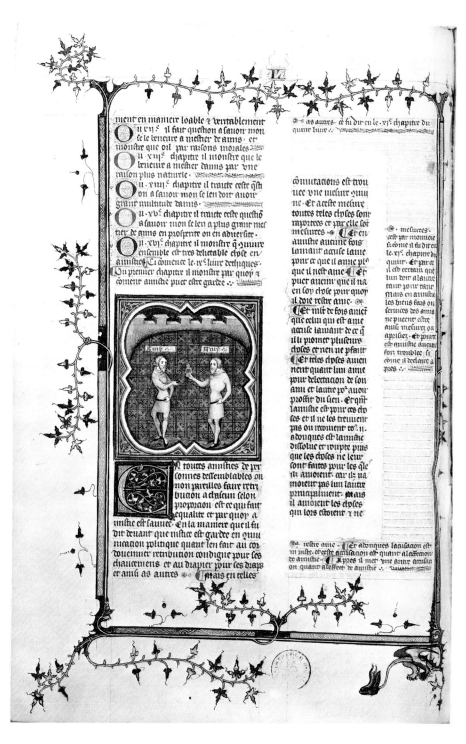

FIGURE 40 *Two Friends. Les éthiques d'Aristote, MS A.*

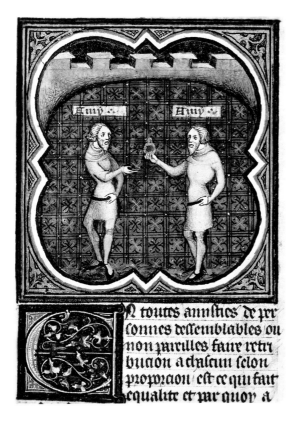

N toutes amistics de per
(onnes dessemblables ou
non parcilles faire retri
bucion achascun selon
proporcion est ce qui fait
equalite et par quoy a

FIGURE 40A Detail of Fig. 40.

read: "Ou premier chapitre il monstre par quoy et comment amistié puet estre gardee" (In the first chapter he shows by what means and in what manner friendship may be preserved).[3] The text column directly next to the illustration contains Oresme's discussion of Aristotle's explanation that problems result when one friend seeks pleasure and the other, profit.[4] In other words, each likes the friend not for himself, but for what he can get out of him. In this type of temporary and disingenuous Friendship, the gold ring may symbolize the material gain sought by each party. More positively, Figure 40 may stand for a principal theme of Book IX: the various obligations of friends. Thus, the giving of the ring may signify a generous act, or one of the four actions of Friendship, called beneficence, discussed in Chapters 5 and 9 of Oresme's translation.[5] In the ninth chapter Oresme takes up Aristotle's theme of the different attitudes to one another of the benefactor and the recipient. Such an interpretation of Figure 40 is difficult to define verbally because of the weak links among the parts of the miniature and the meager inscriptions.

Using a popular saying to explain the identity of the two Amis suggests another avenue for interpreting the image. The starting point is Aristotle's quotation of proverbs about Friendship, found in Chapter 10 of Oresme's translation.[6] The Philosopher considers whether a man should love himself more than another and

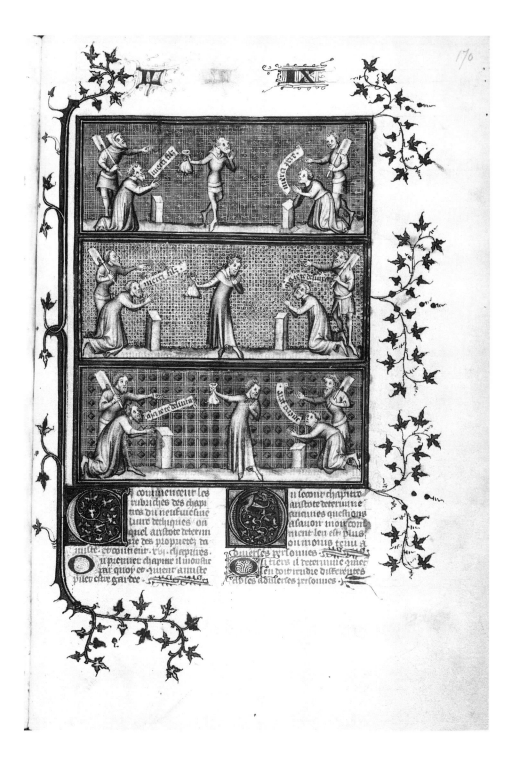

FIGURE 41 *A Ransom Dilemma,* top:
Father or Son; center: *Father or Friend;*
bottom: *Friend or Son. Les éthiques
d'Aristote,* MS C.

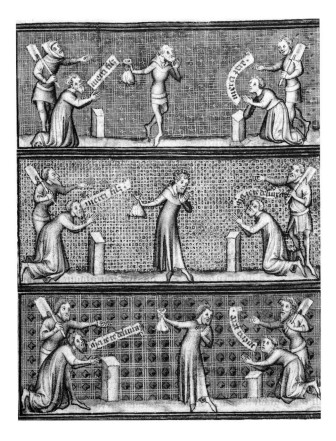

FIGURE 41A Detail of Fig. 41.

regard himself as his own best friend. The twinship of the Amis may be a witty allusion to the theme of self-love. But in Figure 40 a more obvious relationship of the identical friends to the proverbs is also possible. The sameness of the Amis can reflect the sayings, quoted in this passage, that friends have one soul and that Friendship is equality. The ring bears out the proverb that friends hold everything in common. If the modern English translation of the last proverb in Chapter 10 is read as "Charity begins at home," another reference to the ring is also possible: identity of the friends equates the offer of the ring with a gift to one's self.[7] Although the textual source of the proverbs explains many visual aspects of Figure 40, again the cryptic verbal links of the inscriptions in this image make a single interpretation arbitrary. Perhaps Oresme relied on his readers to furnish the appropriate proverb or interpretation.

THE DECISION ALLEGORY OF MS *C*

Possible dissatisfaction with the obscure personification allegory of Book IX in *A* (Fig. 40) accounts for Oresme's revision in *C* of the program of the illustration. Yet the physical characteristics of Figure 41 (Fig. 41a, Pl. 5), the miniature that

introduces Book IX in *C,* indicates that the illustration may represent a second version or a last-minute addition to the manuscript. First of all, the folio that contains the miniature was added to the existing quaternion.[8] Second, Figure 41 does not follow the usual image-to-text relationship in *C,* as it comes before the chapter headings. Moreover, the scale and format of Figure 41 are unique in the cycle. The miniature is the largest and the only one divided into three registers. Even the decorative system is different. Two elaborate, foliate initials head the two columns of text written below the miniature, while the three *rinceaux* on the left margin consist of an unusual two-leaved spray issuing directly from the outer frame. With their expressive gestures and more normal proportions, the crisply outlined figures suggest that a different member of the workshop executed the miniature.[9]

Study of the textual sources of the illustration reveal the reasons for the prominence of Figure 41. The chapter headings of the second column below the miniature establish links with crucial locations in Book IX. The dragon-headed initial *O* draws the reader's attention to this title: "Ou secont chapitre Aristote determine aucunes questions a savoir mon comment l'en est plus ou moins tenu a diverses personnes" (In the second chapter Aristotle examines certain questions, to wit, how one may be more or less bound to various people). A smaller initial introduces a sentence that completes the column: "Ou tiers il determine comment l'en doit rendre differentes choses a diverses personnes" (In the third chapter he examines how one may render various things to different people).[10] In short, the reader will find in Oresme's translation that Chapters 2 and 3 of Book IX contain Aristotle's discussion of an individual's varying obligations to different kinds of friends. Of specific relevance to Figure 41 are the text passages and Oresme's glosses in Chapter 2 on difficult choices that arise in times of crisis. The particular situation involves a timely problem of ransom demands, specifically the question of who should be rescued, if only one of two people can be saved. For example, if a man is ransomed from the hands of robbers, should he "ransom his ransomer in return, whoever he may be (or pay him, if he has not been captured but demands payment) or should he ransom his father? It would seem that he should ransom his father in preference even to himself."[11] In a gloss on this passage, Oresme explains the various points at stake. Among them is the claim that a son owes more to the father who gave him life than he does to himself. The translator acknowledges that certain commentators bring out the superior claims of the ransomer of the individual who faces such a difficult moral decision. At this point, Oresme opts for the father's claim on the grounds that nature, which has the force of a divine ordinance, dictates such a choice.[12] Chapter 3 of Oresme's translation continues Aristotle's discussion of a person's moral obligations to different types of friends, family members, and benefactors.[13] Oresme stresses, however, that judgment among conflicting loyalties is complex, if the friends are not the same type and the circumstances difficult. In Gloss 3 of Chapter 8 Oresme holds forth on moral dilemmas. Then there follows a separate Question that sums up Oresme's views on the problem.[14] In Gloss 8, Oresme discusses Aristotle's argument that decisions about conflicting obligations are not hard to make, if they involve two people

such as a father and son, who share the same type of relationship, called *amistié de lignage* (relationship among family members). Oresme points out that several commentators have not dealt with the tough choice a person has to make between saving the life of his father or his son.[15] To make the question more vivid, Oresme gives as an example a ransom situation:

> Posé que un homme ait son pere et son filz bonnes gens, et sont pris en la main de leurs adversaires lesquelz octroient a cest homme que pour certain chose il li rendront seulement ou son pere ou son filz, l'un des deux, et l'autre tantost il mectront a mort, a savoir mon lequel il doit eslire.

> (Take, for example, a man whose father and his son, both upright men, have fallen into the hands of their enemies, who for a consideration, agree to give him back either his father or his son, but not both, and the other they will put to death. Which of the two is he to choose?)[16]

In Gloss 8, Oresme runs through a gamut of arguments regarding the dilemma. He first comes down on the side of the individual who prefers to save his father's life rather than his son's. Then he raises the important point that a man loves his son more than his father. Nevertheless, the man must deliver his father, who is his benefactor. Oresme concludes the gloss by stating that the man's obligation to his father rests on legal grounds, whereas his son's claim is moral, based on Amistié. In this case, Justice has a preferred standing.[17]

In the lengthy Question following this gloss, Oresme continues his analysis of moral choices and takes up once again the case of a man required to deliver from his enemies one of two parties. Here the choice lies between his father on the one hand and on the other, his "amy tres vertueus" (his most virtuous friend).[18] The translator summarizes the superior standing of *amistié de lignage* (a relationship among family members exemplified by the father) but restates Aristotle's position that the individual concerned must weigh many factors. One problem is that *amistié vertueuse* (friendship between virtuous people) and *amistié de lignage* are different types of relationships that do not permit a proper comparison. Sometimes a person owes more to a friend than to a family member.[19]

This lengthy summary of Oresme's gloss and Question in Chapter 3 identifies the textual sources and contexts of Figures 41 and 41a. The three-register format permits a visual structure that depicts the moral choices to be made in the ransom situation. Each level represents a decision between two different and deserving parties. Study of the miniature reveals how ordering of the separate units offers a close visual analogue of Oresme's verbal arguments. In more than one way, the reader must decipher the visual puzzle offered in the illustration and decide the question on its merits.

A strategic device in ordering the illustration is the repetition on all three levels of the constant and variable figures who exemplify the moral dilemma. The center of all three zones is occupied by the man who must make a choice. In his right

hand he holds a purse containing the ransom. Standing in a full-length, three-quarter pose, he faces or glances at the party on the right of the composition. His upheld left hand conveys a gesture of deliberation or hesitation. The central figure does, however, vary in age and costume. On the top zone, he appears to be an older man and wears fashionable dress. On the two lower levels each protagonist wears a long mantle and seems to be mature. Standard, too, are the executioner figures placed at the left and right of each compartment. Although they vary in age and dress, these six figures hold an axe in one hand and stretch out the other to receive the ransom. On each level, next to their captors, there kneel before the blocks the two prisoners who gesture entreatingly. Adding to the image's complexity is the reader's problem in identifying these figures and their relationship to the man in the middle. The only verbal clues are the inscriptions, which represent words uttered by the captives. By comparing them, it is possible to deduce the choice called for between the two types of Amistié on each level. Once again, position in the center symbolizes both moral power and the ability to choose.

The situation in the top zone is perhaps the most comprehensible. The central figure must decide between an older figure on the left who says "merci filz" (thank you, son) and a younger one on the right whose inscription reads "merci père" (thank you, father). The decision is the one Oresme sets forth in Gloss 8 of Chapter 3: the man with the ransom must save either his father or his son. Although the predicament is clear, the resolution is not so obvious. Two elements suggest, however, that the decision advocated in the text is followed. First of all, the ransomer holds the money bag in the direction of his father and that man's executioner. Furthermore, he is physically closer to the left side, and the movement of his bent left leg indicates that he leans toward them.[20]

More puzzling are the actors and predicament depicted in the middle zone. On the left, an aged male figure in a pleading posture says, "merci filz." Both words and gesture identify this man as the father. But what is the identity of the bearded figure on the right who says the words "merci je te delivre" (thanks, I'm saving you)? Perhaps he represents the claim of the *amy vertueus* who, in some situations, possesses qualifications for salvation as strong as an *amy de lignage*.[21] Or does this figure represent the person who ransomed the man in the middle from robbers? In the text and a gloss of Chapter 2 Oresme elaborates on the choice between a father and a ransomer.[22] In this instance, it is more difficult to judge the outcome. Although the man in the middle stands closer to the friend and glances sympathetically at him, he once more extends the money bag toward his father.

Most problematic is the choice depicted in the lower register. Here the prisoner on the left varies slightly the message of the man on the right in the middle zone: "merci je te delivray" (thanks, I saved you). The figure on the right who says "merci père" is the double of the young man on the top zone. The man in the middle appears to choose between his son on the one hand and on the other, his ransomer or *amy vertueus*. This dilemma typifies the difficult decision mentioned by Oresme when the choice involves two different types of Friendship. Again the result is not easy to interpret. The central figure holds the purse firmly in his

outstretched right hand toward the man on the left. At the same time, he stands closer to his son. Perhaps the lack of resolution of the dilemma relates to Oresme's method in posing the question to the reader. As a whole, the illustration reflects Aristotle's view that when conflicting obligations make a decision difficult, an individual must use his best judgment.[23]

A MEANINGFUL REDEFINITION OF THE DECISION ALLEGORY

Several features of Figure 41 follow the larger pattern of revision in the program of *C,* including a change in the representational mode adopted in the analogous miniatures of *A* (Figs. 37 and 40). A precedent also exists for the decision allegory in the illustrations for Book VII (Figs. 35 and 36). Despite these precedents, Figure 41 is unique not only in its size and three-register format but also in the development of its theme. For the treatment of the content offers a decision allegory of a different type from that of Figures 35 and 36. In Figure 41 the scenes depicted do not involve a choice between personifications of competing abstract forces but a moral quandary based on conflicting social obligations. The father, son, and ransomer or friend of the man in the middle exemplify certain relationships or types of Friendship, while the moral dilemma centers on a particular situation of dramatic human crisis. If the ransom dilemma is timeless and applicable to many different conditions, it is more specific and concrete than the generalized moral conflict between Raison and Concupiscence treated in Figures 35 and 36. Another somewhat startling aspect of Figure 41 relates to its visual translation of Oresme's Question following Gloss 8 of Chapter 3. The textual source of this figure underscores not only the translator's role in inventing the program but also an increased intervention that resulted in changes affecting the physical structure of the manuscript. The addition of Figure 41 to the existing quaternion reflects the importance attached to the illustration by Oresme as a visual analogue of his personal views expressed in the Question. Figure 41 seeks to replicate in summary form the method of the *Quaestio,* a tool of scholarly discussion and open debates at the University of Paris called the *Quodlibeta.*[24] In his writings on miracles and marvels of nature, Oresme uses the *Quaestio* format to organize the structure of his inquiry.[25]

The transfer of the *Quaestio* to Oresme's translation of the *Ethics* follows naturally from the commentary tradition and the methods of scholastic philosophy. Harder to grasp is the transfer of this mode of argument to court circles. Yet, as mentioned above, Christine de Pizan writes that Charles V enjoyed intellectual disputation with the clerics in his entourage.[26] Moreover, as was noted in Chapter 4, the prologue of the *Songe du vergier* states that the king took pleasure in having selections from the *Ethics* read to him. It is possible that Charles V heard Oresme discuss the ransom question in one or the other of these situations and requested a visual aide-mémoire and summary of the translator's views. Perhaps the king's interest was stimulated after the execution of an earlier illustration for Book IX in MS *C.* Or, at the last minute, Oresme may simply have decided to change the

format of Figure 41. In any case, Figure 41 represents a full visual expression of Oresme's own mode of thought that alters the physical structure of the manuscript.

The patron's enthusiasm for the ransom question may first have arisen from the timeless human interest in the moral dilemma of an agonizing choice between competing loyalties. After the French defeat in 1356 by the English at the battle of Poitiers, Charles had the experience of securing the release from prison of his own father, King John the Good. As regent, Charles had to negotiate the payment of a hefty ransom, which necessitated the imposition of heavy taxation.[27] The continuing demands of raising funds for the ransom presented lasting problems for Charles V's administration. Monies were also required for dealing with brigands, former soldiers who ravaged France after the signing in 1360 of the treaty of Brétigny. Thus, for Charles V the decisions examined in Figure 41 about ransom, robbers or brigands, and obligations to one's father had both personal and political relevance. Oresme's association with his patron during and after the initial crisis of John the Good's imprisonment may have alerted him to Charles's particular interest in the ransom theme. The exceptional characteristics of Figure 41 may well reflect the high degree of interaction between Oresme and Charles V based on shared historical experience and intellectual understanding. Expressive of the translator's ingenious turn of mind, the riddle or puzzle aspect of Figure 41 would also have appealed to the king as a tribute to his mental acuity. Together with the extratextual inscriptions the illustration could certainly have furnished talking points and another occasion for the translator's explication of and dialogue with his patron regarding subtle moral issues.

14 CONTEMPLATIVE HAPPINESS AND INTELLECTUAL ACTIVITY
(Book x)

The difficulties of interpreting Figures 42 and 42a, the illustration of Book X in *A,* do not arise from its placement, size, or color. Following the chapter titles, the miniature occurs in the second column of folio 198v. Of average size for a column illustration, in format this figure belongs to the category of undivided quadrilobes. After the preference for more muted tones noted in the images of Books VIII and IX (Figs. 37 and 40), the bright hues of Figure 42 mark a return in the *A* cycle to the usual red, blue, and white palette. In the upper right, gold delineates the cross-nimbed halo of Christ and an accompanying host of angels. The crown worn by the seated figure is also gold. A mediating, light beige tone depicts the central element of the composition: an open book resting on a lectern. This color reappears in the thronelike, low-backed chair in which the main figure sits.

An inscription above the head of the crowned figure identifies her as Félicité, or Happiness. In the preliminary summary of the contents of Book X at the top of the first column, the reader finds the first mention of the word: "Ci commence le .x^e. livre ou il determine principalment de Félicité" (Here begins the tenth book, where he chiefly examines Happiness).[1] The next sentence explains further that Book X begins with a discussion of Pleasure, considered by some as identical with Happiness. Thus, the reader learns that Félicité is not the first concept discussed, although it is the most important one. In fact, the word *Félicité* first occurs in the titles for Chapters 11 through 15. Lacking a descriptive adjective, the inscription in the miniature does not specify whether Félicité is a general or particular type of Happiness. Aristotle discusses the first category in Chapter 11; a second kind, Félicité speculative, in Chapters 12 through 14; and compares the latter to a third, Félicité active, in Chapter 15. Like the inscription of the illustration of Book IX in *A* (Fig. 40), the term used in Figure 42 does not provide the reader with a firm link to a text location where the verbal definition of a particular concept occurs. Nor does the term *Félicité* distinguish it from Aristotle's analysis in Book I of the concept of Human Happiness.[2]

The iconographic formulas selected for representing Félicité also do not help the reader to understand the particular characteristics of Happiness discussed by Aristotle in Book X. The crown worn by Félicité may indicate the superiority or excellence associated with Félicité speculative (Speculative or Contemplative

FIGURE 42 *Félicité. Les éthiques d'Aristote*, MS *A*.

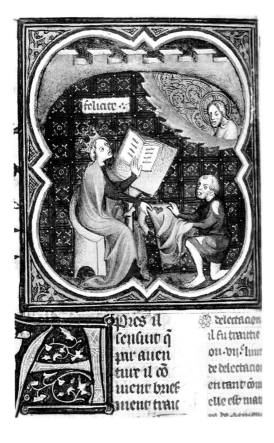

FIGURE 42A Detail of Fig. 42.

Happiness) referred to in Chapters 12 through 15. In these sections of Book X Oresme attempts to explain Aristotle's conclusion that the greatest happiness in life derives from the activity of contemplation, identified with the intellectual pursuit of philosophical wisdom.[3] According to Aristotle, the superiority of this type of activity depends on several criteria, including association with the highest type of virtue derived from "the best part of us, which is reason."[4] The activity of reason connotes a life of contemplating "truth already attained," or knowledge of the most sublime, divine beings associated with metaphysics. The well-being or happiness derived from such lofty activity of the intellect is also superior. Not only are its objects unchanging, but the pursuit of philosophic wisdom is continuous and lasting and is based on the self-sufficiency and leisure of the philosopher.[5]

In the text and glosses of Chapters 12 through 15, Oresme explains many of Aristotle's crucial points about the happiness derived from the contemplative life. Yet, the translator does not explicitly supply the context for the profound changes medieval thought made in the antique ideal of the contemplative life. The "speculative life" of the classical model, based on the "self-reliance and self-sufficiency of a process of thought which is its own justification," was completely transformed. The contemplative activity of the medieval thinker or scholar had "meaning and

justification not in itself but in the establishment of a relationship with the Deity." Located within the hierarchical structure of the church and later of the university, the medieval thinker used "his reason scientifically," not as "the creator of an intellectual world centered in himself" but as part of a tradition in which he served as "heir and transmitter," as "critic and mediator," and as "pupil and teacher."[6]

How does Figure 42 re-present the contrasting classical and medieval concepts of the contemplative life and the happiness that derives from it? Oresme's program depends on a personification allegory that borrows essential aspects of the iconography of Sapience depicted in the miniature of Book VI (Fig. 33). Félicité, like Sapience, sits next to a lectern with an open book and gazes toward the heavens. In both cases, the object of contemplation is definitely Christian. The cruciform halo identifies the bust-length figure as Christ, who is surrounded by a host of angels. The resemblance between Félicité and Sapience is based on a common model of an inspired personification. Yet the particular kind of Contemplative Happiness discussed in Chapters 11 through 15 is known only to "celui qui a la vertu de sapience" (he who has the virtue of wisdom).[7] In other words, the similarity between the personifications of Books VI and X echoes the close relationship between their intellectual activity and the objects of their study.

Other concepts expressed in the text about the character of Félicité contemplative relate to the iconography of Figure 42. As noted above, the crown worn by Félicité indicates the superiority or excellence of this type of Happiness. The open book refers to the intellectual activity that contemplation encompasses: "et tous sages confessent que de toutes les operacions qui sont selon vertu, la tres plus delitable est speculacion ou contemplacion selon la vertu de sapience" (And all wise men acknowledge that of all the activities that accord with virtue the most enjoyable is that of speculation or contemplation in accordance with the virtue of wisdom).[8] The study of "choses divines" (divine things), exemplified by the inhabitants of the celestial sphere, imitates most closely "l'operacion de Dieu" (the activity of God) and is therefore "la tres plus beneuree" (the most highly blessed).[9]

Thus far the iconography of Figure 42 is consistent with textual definitions of the happiness derived from the contemplative life. But another aspect of the illustration, Félicité's handing of a cloak to a kneeling beggar, is somewhat confusing, for the charitable gesture seems to link her to a mode of life opposed to the contemplative ideal. The contrasting type of the *vita activa,* or active life, as defined by Aristotle, is one based on "moral virtue and practical wisdom."[10] Its sphere encompasses the practical activities of politics, military affairs, the family, and the like. The feelings of well-being that result from good actions taken on this level bring about what Aristotle calls Human Happiness, translated by Oresme as Félicité humaine.[11] The Christian assimilation of the concept of the *vita activa* associates its operation with works of charity.[12] Thus, the generosity of Félicité seems to link her with a personification of *vita activa,* sometimes exemplified by Martha, sister of Mary of Bethany, who, in turn, was identified with the *vita contemplativa.*[13]

Oresme may have instructed the miniaturist to use a model based on a personification of *vita activa,* or Charity, for the depiction of Félicité. Yet an actual textual

source in Chapter 15 of Book X can explain the motif of the cloak and beggar as part of a consistent definition of Félicité contemplative. In several places, following Aristotle, Oresme states that the happiness derived from the contemplative life needs little in the way of material goods to sustain it. Indeed, earthly possessions constitute an obstacle to contemplation or study. As Oresme explains: "Mais celui qui vaque et met son entencion a speculacion, il ne a mestier de nulle tele chose quant a son operacion; mais l'en puet dire que teles choses li sont un empeesche-ment a sa speculacion" (But he who is at leisure and turns his mind to speculation has no need of any such [material] thing for his activity; and one can even say that such things are an impediment to speculation).[14] In other words, the action of Félicité conveys her intention of giving away extraneous worldly possessions to pursue the contemplative life. Oresme refers in a gloss to a source in the Gospels to clarify this point: "Car grans richesces requierent sollicitude par quoy l'en est empeschié de contemplacion. Et pour ce en *l'Evangile* ilz sont comparees a es-pines" (For great riches require one's attention, which acts as a hindrance to one's contemplation. And for this reason in the Gospel they are compared to thorns).[15] Such a moral attitude is consistent with Oresme's admonitions to his secular audi-ence against undue expenditure and self-indulgence, conveyed in the programs for Figures 21, 35, and 36. Despite the textual justification of the motif of cloak and beggar, Félicité's charitable gesture may have confused the contemporary reader. The association of good works with the Christian virtue of Charity, or even with the action of a saint, may have obscured Oresme's definition of Félicité contemplative. The lack of a descriptive adjective in the inscription identifying the personification contributes to the ambiguous meaning of the image.

FÉLICITÉ CONTEMPLATIVE: A MONUMENTAL PERSONIFICATION ALLEGORY

Following the pattern of revising the program of *A,* Figure 43 (Fig. 43a and Pl. 6) shows certain marked changes in iconography. Like the illustrations for the two preceding books in *C* (Figs. 38 and 41), the content of the miniature for Book X becomes more specific and focused, even though Figures 42 and 43 share the same representational formula: a seated female figure gazing up at the inhabitants of a celestial sphere. But in Figure 43 a process of simplification brings about not only the elimination of the book and lectern but also of the cloak and beggar. New to Figure 43 is the setting of hills and trees on either side of the principal figure, now identified specifically as Félicité contemplative. Her seat is a low bench similar to that of Sapience in Figure 34. The heavenly contingent has also changed. Instead of the bust-length image of Christ tucked in the corner, the godhead in Figure 43 is a commanding, dynamic force who occupies the center of the heavenly sphere. Accompanied by adoring angels and the sun and moon, he blesses Félicité con-templative. While these iconographic revisions in Figure 43 reveal important alter-ations in the program of Figure 42, physical and formal features show an even more dramatic character. For one thing, in its size Figure 43 is, after its predecessor

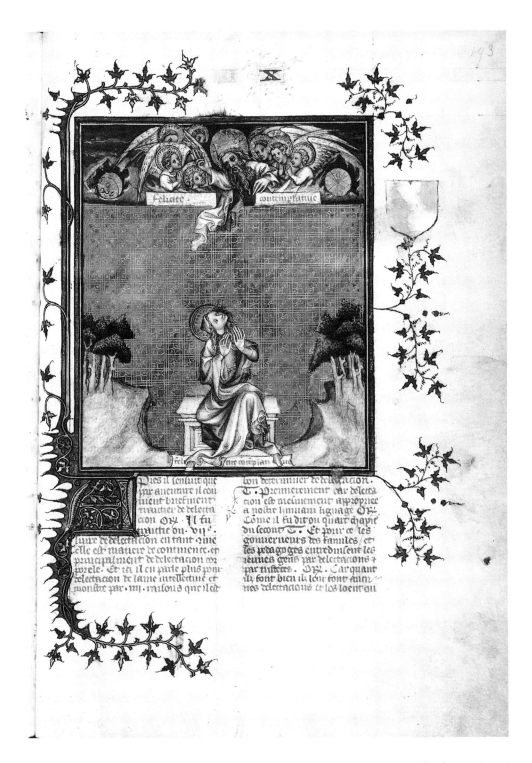

FIGURE 43 *Félicité contemplative. Les*
éthiques d'Aristote, MS C.

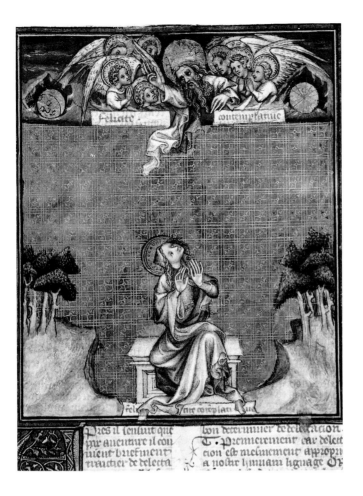

FIGURE 43A Detail of Fig. 43.

(Fig. 41), the second largest miniature in the cycle. The gold leaves of the outer borders of Figures 41 and 43 suggest another link between them: the execution of the last two miniatures of the *C* cycle by a separate workshop.

Figure 43, however, shows characteristics that set it apart from the illustration for Book IX. The scale of the figure of Félicité contemplative shows a striving for monumentality unique in the cycle. The care taken to render the drapery folds of her robe and that of the deity is also unusual. Because the figures are modeled in grisaille, their resemblance to, and reliance on, sculptural prototypes seems even more pronounced. The size and beauty of Félicité contemplative, as well as the power of God's head and gesture, mark them as "*imagines agentes*" or "*corporeal similitudes*" of ethical ideals.[16] Also distinctive to Figure 43 are the touches of color: green for the clump of trees and blue for the clouds. The use of gold for God's crown, the angels' heads, the sun and moon, and the belt and halo of Félicité contemplative shows the lavish treatment of this illustration.

The extraordinary formal qualities of Figure 43 certainly deserve notice both in themselves and as evidence for the emphasis given to the illustration. Remarkable though it is, the miniature contains a few irregularities that suggest haste or misunderstanding of instructions. Haste is suggested in the blurring of the frame directly above the head of God the Father and above the word *delectacion* at the lower right. God's flowing drapery, apparently painted over the background, shows evidence of reworking. Inspection of the inscription below the bench of Félicité contemplative also indicates last-minute additions. Compared to the identical words set on either side of God within the usual rectangular boxes, those below Félicité are irregularly shaped and outlined in pen. The use of abbreviations, the small scale of the letters, and the interruptions of words by drapery folds suggest that the lower inscription was added after the upper one. Perhaps Oresme thought that the placement of the higher one confused the reader by identifying the celestial figures with Félicité contemplative rather than with the personification herself. An alternative explanation is that the repetition of the inscriptions affirms the resemblance between the activity taking place in each realm.

Also difficult to interpret is the distance between the head of Félicité contemplative and the celestial sphere. Is the program meant to convey the vast space of an outdoor setting and the separation between the earthly and divine? Or is the miniaturist incapable of locating a monumental figure in a naturalistically conceived space? The too-small trees and rocks indicate a conventional approach to representing a figure in a landscape. Despite these incongruities, the setting signifies that mountains are a traditional location for contemplative activity.[17]

The striving for effects of grandeur in Figure 43 is obvious not only in the composition and the style but also in the expressive quality of the principal actors. Changes from the iconography of Figure 42 noted above also play their part in bringing out characteristics of God and Félicité contemplative inherent in their verbal definition by Aristotle and Oresme. For example, the translator is careful to emphasize that speculative activity takes place in a state of leisure, marked by disengagement from labor, or, in Oresme's words, "repos ou cessacion de labeur ou de occupacions en negoces."[18] *Vacacion,* the word used by Oresme to describe this state, is a neologism included in the glossary of difficult words at the end of the volume.[19] Oresme also supplies a Christian context for associating the term both as noun and verb with contemplation of the divine. To contrast the active and speculative ways of life, the translator cites St. Augustine as the source of the distinction and the biblical exemplars of the two types of existence:

> Ainsi disoit St. Augustin de Marie et de Marthe, que l'une vaquoit et l'autre labouroit. Donques il veult ainsi argüer: Félicité est en vacacion, et les vertus morales ne sont pas en vacacion; mais la speculative, etc.

> (Thus spoke St. Augustine of Mary and Martha: one took her rest and the other toiled. Therefore he wishes to argue thus: Happiness lies in leisure, and moral virtues are not passive, but the speculative virtue is, etc.)[20]

In another gloss at the end of Chapter 13, in which the term *vacacion* is introduced, Oresme again turns to Scripture to emphasize the superiority of the contemplative life: "Et est meilleur que n'est félicité de vie pratique ou active. Et pour ce dit *l'Escripture:* 'Maria optimam partem elegit, etc.'" (And it is better than the Happiness that comes from the practical or active life. And for this reason Scripture says, "Mary chose the better part").[21] In Figure 43, Félicité contemplative shows no sign of the apparently worldly activity that marks her counterpart in Figure 42.

Other aspects of Félicité contemplative's character absent in Figure 42 emerge in this illustration. The deletion of the cloak-and-beggar motif emphasizes the self-sufficiency or independence of others that constitutes a great advantage of the contemplative life. The large gold halo accorded Félicité contemplative conveys the divine quality of such a mode of life stripped of "passions corporeles" (bodily passions).[22] In a gloss to Chapter 15, Oresme explains that because of Félicité's disregard of such emotions, "elle n'est pas a dire humaine, mais divine" (She is not to be called human, but divine).[23] Her halo also relates her to the inhabitants of the divine realm. Of all the female personifications in the *A* and *C* cycles, Félicité contemplative is the only one awarded a sacred status, an honor that refers to the idea that speculative activity expresses within human beings "aucune chose divine" (something divine).[24]

The posture and gesture of Félicité contemplative reveal her character. Unlike the analogous personification in Figure 42, Félicité contemplative no longer needs a book to inspire her activity. With sharply turned head and upraised hands, she glances directly at God and the celestial sphere. Figure 43 emphasizes the meaning of the verb *contempler* as an act of actually looking at something.[25] Furthermore, the gaze of Félicité contemplative affirms her independence of earthly things and her direct communication with the objects of her contemplation. Since Félicité's activity is based on the intellectual virtue of Theoretical Wisdom (Sapience), which encompasses Intuitive Reason (Entendement) and Knowledge (Science), she seeks to express the best elements encompassed by the human intellect. The act of contemplation, which resembles the activity of divine beings, brings directly to her sight the objects of her speculation.[26] Not surprisingly, the model for Félicité contemplative is the same inspired Evangelist mentioned for the figures of Sapience in the illustrations of Book VI (Figs. 33 and 34).[27]

The gesture of Félicité contemplative may also provide clues about the antecedents and interpretation of the figure. Her eloquently upraised hands may indicate astonishment, submission, striving, or prayer. Stemming from her exalted activity and relationship to the deity, such expressions are appropriate also to personifications of the *vita contemplativa*. As previously noted, a process of medieval exegesis identified the sisters Martha and Mary of Bethany as exemplars of the *vita activa* and *vita contemplativa* respectively.[28] But various medieval writings cite the Virgin Mary as one who unites both categories of experience.[29] Although Oresme does not mention the Virgin in such a context, he may have referred the miniaturist to an image of Mary. The ideal beauty, blue mantle, and long hair of Félicité contemplative are attributes of the Virgin appropriate to such an allusion.

The representation of God the Father also conforms to medieval iconographic tradition.[30] The deity as a creative and unifying force of the cosmos is symbolized by his command of the heavenly host of angels and the depiction of the sun and moon. God's blessing gesture and the fall of his drapery into Félicité's sphere indicate the spiritual affinities between them. As Oresme's text states, of all human activities, the one closest or most like the activity of God is the most blessed.[31]

Although in his discussion of Félicité contemplative, Oresme does not give an explicit Christian definition of God as the object of her activity, it is difficult to say whether he envisioned a philosophical rather than a theological frame of reference. At the point in Chapter 15 where Oresme speaks of the excellence of Félicité contemplative, he refrains from defining her character as a task beyond the scope of the present inquiry. His gloss also evades a clear interpretation: "Car ce appartient a la methaphisique et a la science divine. Mais par ce que dit est, plus excellente que n'est félicité active" (For this belongs to metaphysics and theology. But by what is said, [it is] more excellent than is happiness of the active life).[32] Furthermore, Oresme does not carry on the distinction made by Thomas Aquinas that the contemplative life in this world yields only "imperfect happiness," compared to the "perfect happiness attainable only in the next life consisting principally in the vision of God."[33] The imagery of Figure 43 does not resolve this problem either. Although God is not associated with specifically Christian symbols as in Figure 34, it is hard to imagine that Oresme or his readers understood the text or the image in secular, philosophical terms. Even if Oresme wished to convey such notions, the conceptual and linguistic transformation of the *vita contemplativa* during the Middle Ages into a Christian context makes such an interpretation difficult. Likewise, the visual associations of Figure 43 are also founded on religious iconography. As is the case with the visual language chosen to represent Justice légale in *A* (Fig. 24), the illustration of Félicité contemplative has an ambiguous or multivalent character. Yet the absence of overt Christian symbols may furnish a clue to Oresme's perceptions, if not to his audience's reading of them.

The relationship between God and Félicité contemplative also deserves comment. By virtue of his position in the celestial hierarchy, his crown, and his commanding gesture, the image of the deity is the dominant force. It is consistent with Aristotle's outlook that the highest creative and intellectual powers are masculine. Also traditional is the contrasting passivity of Félicité contemplative, a compliant and beautiful young woman. Yet the size, monumentality, and halo of Félicité give her figure visual and spiritual authority. Ironically, the representation by a feminine personification of the highest type of happiness derived from intellectual activity is perhaps the most dramatic instance in the *Ethiques* cycles of a disjunction between the image and Aristotle's views of female mental, moral, and physical inferiority.

AFFIRMATION OF THE CONTEMPLATIVE LIFE

Although the illustration in *A* (Fig. 42) of Book X, the last book of the *Ethiques,* receives no special emphasis, in size, format, and style, its counterpart in *C* (Fig.

43) is a deliberate climax to the cycle. In one sense, Figure 43 contrasts with the representation of Félicité humaine, combined in the first miniature of *C* with the dedication scene (Fig. 10). Even if allowances are made for the changes in the size of the illustrations in the second half of *C,* the prominence and preeminence of Figure 43 are still remarkable.

Apart from Oresme's appearance in a leading role in the dedication frontispiece of *C* (Fig. 10), the translator does not figure in any other illustration. Yet the editorial and visual alterations noted in the second half of *C* indicate that Oresme's quasi-authorial intervention in the choice and ordering of the program of illustrations strengthens perceptibly. It is, therefore, tempting to see the translator's continued influence in the strong emphasis of Figure 43. Like its predecessor in *C* (Fig. 41), Figure 43 seems distinct from the other miniatures in format, iconography, and expressiveness. Oresme certainly took part in reordering the program to stress in a monumental and simplified format the grandeur of Félicité contemplative. The visual realization of this concept is both formally and thematically exceptional in contemporary French manuscript production.

The question now arises of Oresme's motivation in highlighting Figure 43. After all, glorification of the happiness that comes from the contemplative life is only one of several themes Aristotle explored in Book X. As a scholar and thinker, Oresme would naturally have a special affinity for the contemplative life. Chapter 12 of Oresme's text speaks of the wonderful pleasures of philosophy, marked by purity and permanence.[34] His gloss on these delights reveals an enthusiasm quite probably derived from his own experience. Oresme explains:

> Elles sont merveilleuses pour ce que elles sont excellentes et precieuses et ne sont pas communes. Car le plus des gens se delictent en choses materieles. Item, elles sont pures, car elles sont vers choses esperitueles et immaterieles.

> (They are wonderful because they are excellent and precious and are not common to all and sundry. For most people delight in material things. Item, these are pure, for they incline toward spiritual and nonmaterial things.)[35]

Oresme's emphasis on *vacacion,* or leisure, as a condition and advantage of intellectual activity may also reflect a preference or enjoyment familiar from his own career. The translator may here have reflected on his years in Paris working on the Aristotle translations when, with the king's assistance, he took leave from his ecclesiastical duties in Rouen. Oresme's glosses thus express a consciousness of the rarity of the withdrawal from material pleasures that typifies the classical ideal of the life of the mind, soon to be revived in the writings of the Italian humanists.[36] Even the setting of mountains and trees in Figure 43 conveys the idea of a peaceful retreat in which contemplative activity takes place. Oresme was also personally engaged in writing about the objects of Félicité contemplative's intellectual activity. Oresme's Latin and French treatises on natural science, including physics and the study of the movement of celestial bodies, approach from various vantage

points knowledge of "les choses divines." Thus, drawing on his own life and work, the program of Figure 43 may well express Oresme's reverence for the happiness that comes from the contemplative life. Likewise, the ambiguities of the philosophical/theological context of this illustration may reflect the wavering in his scientific views between orthodox Christian beliefs and "radical philosophical ideas."[37]

If Figure 43 displays Oresme's preferences, what interest might the illustration have held for Charles V? Chapter 13 and other locations in Book X unfavorably contrast the field of political action, driven by an incessant search for power and honors, with the leisure and tranquility that characterize the happiness of the contemplative life. But the translator explains in a gloss that political action supplies the preconditions for people to enjoy the contemplative life.[38] In addition, Oresme states in the final gloss of Chapter 14 that the active life is sometimes more desirable and necessary than the contemplative mode, particularly when it assures the safety of the common good.[39]

Certainly the idea that good political action assures the possibility of the contemplative life is relevant to Charles V's own tastes and his patronage of literature and the arts. The massive translation project is just one aspect of his cultural policy. The king was also known for his love of learning and his intellect.[40] The various mentions of Charles V's "Sapience" in dedicatory poems and prologues to translations are more than literary convention. For him, as well as for Oresme, the happiness of the contemplative life was a concept that had personal meaning and merited special honor in the climactic illustration of the king's personal copy of Oresme's translation of the *Ethics*. In Figure 43 the illuminator creates a monumental and exceptional figure worthy of his reader's recollection. This memorable image certainly could have provided the basis for the translator's eloquent oral explication of the delights of the contemplative life.

PARADIGMS OF THE BODY POLITIC

The Programs of Illustrations in Charles V's
Copies of the *Livre de politiques* and the
Livre de yconomique

15 CONTRASTS AND CONTINUITIES

If Oresme's translation of the *Ethics* stems from the moral side of the Mirror of Princes literature, those of the *Politics* and *Economics* speak to their primary readers as guides to the theory and practice of political and domestic life. In his brief prologue to the *Politics,* Oresme stresses that of all forms of worldly knowledge, the science of politics is the most fundamental for princes:

> Et donques, de toutes les sciences mundaines ce est la tres principal et la plus digne
> et la plus profitable, et est proprement appartenante as princes. Et pour ce, elle est
> dite *architectonique,* ce est a dire princesse sus toutes.
>
> (And thus, of all the sciences of the world, this is the most basic, the most noble,
> the most useful, and properly concerns princes. And for this reason, it is called *archi-*
> *tectonic,* that is to say, reigning over all the others.)[1]

The translator emphasizes that the *Politics* is the most perfect of Aristotle's works and, since the time of its composition, the most authoritative and universally regarded guide to the subject. For these reasons, Oresme continues, the *Politics* has achieved almost the status of a book of natural law in its explanation of how all other legal systems—universal, local, or temporal—are ordained, instituted, interpreted, corrected, or changed. He explains further that because the text of the *Politics* is so valuable, and difficult matters are more easily and agreeably understood in their native language, by command of Charles V, he (Oresme) undertook the translation of the text.[2]

CONTINUITIES BETWEEN THE *POLITIQUES* AND THE *ETHIQUES*

Continuities are deliberate between King Charles V's first two illustrated copies of the *Politiques* (including the short pseudo-Aristotelian *Yconomique*) with those of the *Ethiques*. As sister texts, conceived as a unity, the counterpart of *A* (the Brussels *Ethics*) is *B,* a manuscript in a French private collection, completed be-

tween 1374 and 1376. They share a common physical format in size, page layout, and graphic design. *B*, like *A*, is an official, library copy, lavish in all aspects of its writing and decoration. In both *A* and *B* the text is separated from the glosses, which are written on both sides and in the lower margin.[3] A companion to *C*, King Charles's smaller copy of the *Ethiques,* is *D*, a manuscript of the *Politiques* and the *Yconomique,* now in Brussels. Like *C*, *D* was written by Raoulet d'Orléans, completed by 1376, and also shows the intermingling of text and gloss. *D* lacks certain important textual features present in *B*, such as the prologue and the two instructions to the reader.[4]

The two sets of manuscripts also share the same ateliers of miniaturists patronized by Charles V. For *B*, major shares went to the Master of Jean de Sy, whose shop was responsible for all the miniatures in *A*, and the Master of the Coronation of Charles VI, later assigned the cycle in *C*. The last two miniatures of *B* were entrusted to the Master of the Coronation Book of Charles V, whose shop executed the cycle in *D*. Familiar from work on other Charles V manuscripts is the hand identified with Perrin Remiet, who executed the two small preliminary miniatures of *B*.

TEXTUAL DIFFERENCES FROM THE *ETHIQUES* MANUSCRIPTS

Beyond these and related similarities to Charles V's *Ethiques* manuscripts, those of the *Politiques* show important differences regarding both texts and images. First, the fact that the *Politics* was the favored text had various implications. Documents reveal that Oresme received generous payments from Charles V for this translation and that the king intervened with the canons of Rouen cathedral to excuse Oresme's absence from his post as dean there. Oresme worked on the translation from 1370 to 1374 and made three redactions of the text, compared to only one of the *Ethics*.[5] Delisle was the first to recognize the original copy of Oresme's text in MS 223 of the Bibliothèque Municipale in Avranches.[6] This manuscript contains all three redactions, the fragments of a fourth one, the author's corrections and modifications, and the ex libris of Henri Oresme, Nicole's nephew, who inherited the volume.[7] The Avranches manuscript must have been accessible to the scribes who copied the text during its various stages of corrections and emendations.

Oresme worked from the translation of the *Politics* from Greek into Latin made by William of Moerbeke in 1269. Unlike the *Ethics*, the *Politics* was not known in earlier medieval translations.[8] Oresme drew heavily on the influential commentaries that had been produced in the century since Moerbeke's Latin text appeared. The first of these commentaries was by Albert the Great and was the one most frequently cited by Oresme. Although he sometimes disagreed with his predecessor, Oresme shared his adventurous attempts to provide etymologies and identification of historical personalities and places.[9] In his efforts to apply the *Politics* to medieval institutions, Oresme appreciated Albert's attempt to do the same, as well as his more colorful style. While undoubtedly well acquainted with the commentaries of Thomas Aquinas, completed by Peter of Auvergne, Oresme used them

sparingly.[10] Oresme's attempt to present the *Politics* to a lay audience in a vernacular language led him to prefer the gloss/commentary form rather than the paraphrases or analyses of Aristotle's arguments. He was thus able to provide step-by-step guidance for his readers. It is worth mentioning again Babbitt's classifications of the types of glosses Oresme used. These include references to, and locations in, the text, "identifications and definitions," "etymologies," "explanatory examples," and his own judgments or "critical observations." In addition, Oresme provided extensive commentaries, some several folios in length, that Babbitt terms "small treatises or essays." Such expositions frequently reveal Oresme's opinions on crucial contemporary social or religious issues, such as reform of the church or voluntary poverty of the clergy. Other subjects deal with political institutions, such as forms of kingship and universal monarchy.[11] As is noted in Chapter 3 above, the translator also expanded the number of terms included in the glossary of difficult words to almost three times the number in the analogous feature of the *Ethiques.* To facilitate the reader's understanding of key terms, Oresme added a new verbal aid to the vernacular version of the *Politiques:* an index of noteworthy subjects organized in alphabetical order and placed at the end of the volume. So concerned was Oresme about the intelligibility of the neologisms and other unfamiliar terminology that in the first redaction he included a separate glossary and index of subjects after several books of the *Politiques.*

Oresme gives precise directions to the reader in the first instruction that follows the prologue. He begins by stating that the contents of the work are clear from the chapter titles and the index of noteworthy subjects at the end of the book. Next he mentions the glossary of difficult words as a source for learning the meaning of unfamiliar terms. He then names four specific terms that are essential for understanding the treatise.[12] He ends the instruction by explaining the different methods of citing a chapter in an individual book in which a reference is made, as well as in other books of the text. In short, Oresme employs the techniques of academic translation and commentary to make intelligible to his lay audience the difficult Latin version of William of Moerbeke. As noted above in Chapter 3, Oresme thus appropriates for the vernacular the prestige of the Latin translation and commentaries.

As Babbitt points out, Oresme's efforts to apply this version of Aristotle's text to contemporary problems and institutions give his translation its particular value and interest. Oresme uses Aristotle's text in one area vital to his primary readers: confirmation of the public sovereignty of the territorial nation-state, viewed as an instrument of the common good. In discrediting universal monarchy, linked with the Holy Roman Empire, Oresme exploits Aristotle's arguments for a geographically and linguistically surveyable territory. Like other medieval commentators, Oresme elevates kingship to the apex of the hierarchy of political communities. But he also emphasizes the special claims of the French monarchy by virtue of its quasi-religious character, its distinguished ancestry, and its distinctive national symbol, the fleur-de-lis. Oresme's treatment of the church as a political community not only leads him to define its rights but also allows him to treat it as a subject open to criticism and reform. The Aristotelian concept of the mean permits him

to urge the church to avoid the extremes of too great wealth or absolute poverty. Oresme also takes a middle position in affirming the temporal independence of the king from the church while recognizing the political and judicial rights of the church over the clergy.[13]

DIFFERENCES IN THE PROGRAMS OF ILLUSTRATIONS

In various ways the programs of illustrations of *B* and *D* also reflect the greater attention devoted to the text of the *Politics*. To be sure, the density of illustration—one miniature at the beginning of each of the eight books of the *Politiques* and the two of the *Yconomique*—is the same as that of the *Ethiques*. Yet in terms of scale, the illustrations of *B* are larger than those of *A,* its sister manuscript. In *B* the miniatures occupy about half the height and the entire width of the folio. Furthermore, *B* and *D* have bifolio frontispieces and another miniature of full-page dimensions. The rest of the illustrations of *B* and *D* are no longer confined to a column format, as are nine of the eleven miniatures in *A*. The limiting quadrilobe frame appears only in four text illustrations in *B* and three in *D*. Also more complex in *B* and *D* than in *A* and *C* are the visual structures of the miniatures. Only one miniature of the *Ethiques* cycle in *C* (Fig. 41) includes the three-register format adopted in two illustrations of the *Politiques*. Also, *A* and *C* offer only two instances of the two-register type (Figs. 7, 10, 24, and 29), in which the relationships between the upper and lower zones are less complex than the three examples in *B* and *D*. The latter also offer two unusual examples of single-register scenes that occupy the width of the text block and produce the effect of panel paintings (Figs. 70, 71, 80, and 81).

ORESME'S ROLE AS DESIGNER

Oresme's greater involvement with the program of *B* may have resulted from his or his patron's dissatisfaction with the cycle of *A*. As mentioned above, Oresme's second instruction to the reader in *B* affords proof of his design of the *Politiques'* programs.[14] Two other aspects of his involvement also deserve comment. First, he created visual links to the *Ethiques* cycles in two of the *Politiques* miniatures, where the illustrations of Books III and IV contain references to the concepts of the mean and proportionality established in Books II and V of the *Ethiques*. Second, unlike the marked revisions between the programs of *A* and *C,* those of *B* and *D* show relatively minor differences that result mainly from the smaller size and the more regular, simpler format of the second manuscript (*D*).

Evidence of Oresme's increased personal and textual authority emerges from several features of the *Politiques* translation. Already noted is the expansion of his explanatory glosses to include his individual opinions and critical observations, either separately or in relation to disagreement with previous commentaries. Like Oresme's commentaries, the illustrations of the *Politiques* also had the important

function of making Aristotle's text intelligible in terms of the political life of his own day. Essential to this process is imagery that updates and concretizes Aristotelian concepts.[15] Also relevant as a sign of the translator's authorial identity is the feature in *D* (as in *C*) of the scribe's designation of Oresme's glosses and commentaries by abbreviated (*O* or *Or*) or full references to his name instead of the more customary use of the impersonal *G* for "Gloss."

Confirmation of Oresme's increased self-confidence is found in the first sentence of his prologue, in which he refers to his official ecclesiastic positions and his relationship to the patron:

> A tres souverain et tres excellent prince Charles, quint de ce nom, par la grace de Dieu roy de France: Nicole Oresme, doyen de vostre eglise de Rouen, vostre humble chapellain: Honeur, obedience et subjection.

> (To the very sovereign and very excellent prince, Charles, fifth of this name, by the grace of God king of France: Nicole Oresme, dean of your church of Rouen, your humble chaplain—honor, obedience, and subjection.)[16]

An analogue to Oresme's increased visibility is the first of two portraits that accompany the introductory matter in *B*. Although Figure 44 is a conventional likeness of the translator, Oresme is pictured alone, in his function as a writer; his visual identity does not depend on his relationship to the king. In this respect, the portrait follows a medieval iconographic tradition in which the translator of a text, and not its original author, is the subject of the portrait. The appropriation of language seems to create a visual analogue in the transfer of authorial identity to the translator.

Also by Perrin Remiet, Figure 45 is an intimate dedication portrait like that of *A* (Fig. 6), on which it is modeled. The occurrence of Figure 45 in the text after the prologue, the two instructions to the reader, the bifolio frontispiece, the table of contents, and the chapter headings for Book I reinforces the translator's didactic position as master of the text. The dedication portrait also may allude to the long-standing mentor relationship between Oresme and Charles V. In this connection, a passage in Oresme's prologue mentions another work by Aristotle (*Liber de regno*), written for his pupil Alexander the Great, that has the specific function of teaching the latter how to rule.[17]

Oresme's greater involvement with the illustrative program for the *Politiques* may also have resulted from the difficulties of finding both a suitable representational mode and an existing iconographic tradition. The context of the *Politics* focuses on collective social and political relationships and institutions of ancient Greece. There were no readily available, comprehensible visual and verbal equivalents for these in contemporary France. The translator had to develop concrete and updated imagery related to the contemporary historical experience of his readers. Unlike the moral and spiritual imagery of the *Ethiques,* for which the rich iconography of virtues and vices provided an accessible typology, existing models

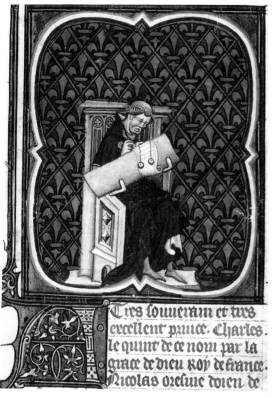

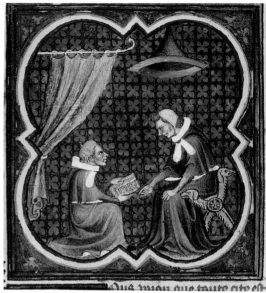

FIGURE 45 *Nicole Oresme Presents the
Book to Charles V. Les politiques d'Aris-
tote*, MS B.

FIGURE 44 *Nicole Oresme Writing. Les
politiques d'Aristote*, MS B.

for the *Politics* in the Mirror of Princes literature and relevant examples from legal
iconography were less abundant. Although simplified in content, a precedent for
the representation of certain political themes exists, however, in the Morgan *Avis
au roys.*

Moreover, the didactic purpose of the *Politics* translation called for a more dia-
grammatic and lexically oriented program of illustrations. As indicated in the first
instruction, Oresme was concerned with the reader's understanding of generic
and specific terminology. It is not surprising, then, that the inscriptions, which
mark the intersection of the verbal and visual languages of the translation, play a
prominent role in Oresme's strategies for re-presenting Aristotle's text. The glos-
sary of difficult words contains explanations of essential terms of Aristotelian logic,
such as *difference, diffinition,* and *gerre* (genus).[18] This emphasis on definition, a pri-
mary task of the translator, carries over into the programs of illustrations. Oresme's
frequent citation of Aristotle's *Rhetoric* in his translation of the *Politics* shows his
awareness of the various strategies that writers employ in enlightening and per-

suading their audiences. As the probable oral commentator on the text, Oresme would have known how to convey his interpretation by means common to verbal and visual exposition. Certain rhetorical devices such as parallelism, contrast, juxtaposition, paradox, and irony are combined with visual definitions of both generic and specific terms in the cycles of the *Politiques* and *Yconomique*.[19] Always concerned with inventing effective mnemonic structures, Oresme provides special architectural enframements that set apart the most important illustrations. In several cases, he also carries over from the *Ethiques* programs the triadic scheme of organization connected with Aristotle's theory of the mean. More broadly, Oresme seems conscious of how sequence and order within images play important roles in the reader's association and recollection of complex verbal and visual concepts.

In contrast to the more allusive representational modes of personification and allegory chosen for the *Ethiques* cycles, Oresme adopts a paradigmatic type for the *Politiques*. The term *paradigm* or *example* is defined by Aristotle in the *Rhetoric* (I.2 1356b) as one of two main types of persuasion or argument. As a rhetorical figure, a paradigm has a double sense of serving as both model and illustration.[20] Compared to the cycle of *C,* in which scenes drawn from everyday life serve as examples of individual virtues and vices, in the *Politiques* cycles Oresme uses a paradigmatic mode in both ways. Like the operation of language, the paradigmatic mode is appropriate for transferring meaning between verbal and visual language. Oresme's application of paradigms was essential in providing both contemporary models and specific examples of the various bodies politic so carefully defined in Aristotle's text. Indeed, the persistent and powerful metaphor of the state as a physical body was certainly well known to Oresme's politically aware readers.

Another challenge in presenting a coherent overall program of illustrations is the confusing order of the books and the overlapping subject matter of all versions of the *Politics* text. Where, how, and in what order to present and visually highlight key concepts was as demanding a task as constructing verbal aids for the readers. On the plus side, the varied subject matter gives the program great diversity and range. Using the various verbal and visual strategies mentioned above, Oresme needed to apply Aristotle's text to the historical experience of his readers. Sometimes the relationships are overt; on other occasions, potentially dangerous references are disguised. Of course, the translator was again dependent on the imaginative and expressive resources of the illuminators entrusted with carrying out his verbal instructions. Oresme also had the considerable help of Raoulet d'Orléans, whose intervention in clarifying the textual and visual program of *D* reveals his crucial role in supervising the production of the manuscript.

Although the differences between the programs of *B* and *D* are not as great as they are between *A* and *C,* the method of discussing the illustrations of the former group, established in Part II of this study, remains the same. Comparing the cycles of *B* and *D* will again offer further insights into the dynamics of contemporary Paris book production. The revisions, editing, and reformating of King Charles's manuscripts of the translations of Aristotle's *Politics* and *Economics* illuminate the different functions and uses of text and image by their primary readers.

16 THE SIX-FORMS-OF-GOVERNMENT FRONTISPIECES
(Book 1)

COMPOSITION AND ARRANGEMENT

The frontispieces of Charles V's first and second copies of the *Politiques* (Figs. 46–47 and 48–49) provide evidence of the translator's authority as master of the text. Oresme's verbal exposition of the importance of these illustrations shows also his control of the visual images he chose as keys to understanding the content of the entire volume. These representations boldly apply Aristotle's classic typologies of political communities to medieval institutions. Within their carefully ordered structures Oresme includes generic visual definitions of key Aristotelian concepts such as the types of perfect political communities, their identification with the common welfare, the rule of law, and the consent of the governed.[1] This visual summa conceals within a deceptively simple format a subtle and concise exposition of a complex system of thought designed to instruct and persuade its primary audience: the politically attuned king and his counsellors.

The close relationship between the frontispieces of B and D shows that the program of the second depends on that of the first. Yet the changes between them demonstrate that in the interest of uniformity and consistency a deliberate re-editing of B took place to produce D. As was the case with A and C, simplification of the layout and overall design of the volume was a goal in transforming the elaborate library copy of B to the compact, portable format of D.

Despite the position of the two miniatures on two folios opposite one another in B, they do not match up in all respects. Figure 46 is larger than Figure 47. The latter, despite its smaller size, includes the running title above and twelve lines of text below the miniature introducing the summary paragraph and chapter headings of Book I. Examination of B discloses that Figure 46 has been added to the first gathering, while Figure 47 belongs to the second.[2] Disparities between the border decoration and exterior architectural enframement of the top register and the interior arcades of Figures 46 and 47 offer further evidence that the two miniatures were not perfectly coordinated. Although executed by the same master, a last-minute change of program or layout may have prevented the integrated planning of Figures 46 and 47.

In D, however, the two halves of the frontispiece (Figs. 48–49 and Pls. 7–8) constitute a perfectly matched bifolio layout.[3] The facing illustrations on folios 1v and 2 correspond in terms of dimensions, divisions of the picture field, en-

framement, and decoration. One factor contributing to this uniformity is the elimination of all prefatory text matter, except for the chapter titles and the scribe's colophon on the recto of the first folio. The search for consistency characteristic of the program of *C* probably motivated Oresme and Raoulet d'Orléans to produce similar effects in the frontispiece of *D*.

One reason for such an aesthetic uniformity is the integrated mnemonic structure created by the architectural enframements and interior settings. If the three registers suggest ordered sequences of corresponding spaces or rooms within which the various regimes are situated, these locations invite the reader's association of a particular place with the appropriate term.

TEXTUAL SOURCES

The lavish layouts of the frontispieces relate directly to the importance of their content: representations of the six basic forms of government analyzed by Aristotle in the *Politics* and translated and reinterpreted by Oresme for medieval readers. As usual, the inscriptions furnish the internal verbal links to the text. The terms chosen for Figures 46 and 48 are *Tyrannie, Olygarchie,* and *Democracie,* the three forms of bad government. For the three good forms of government in Figures 47 and 49, the inscriptions read *Royaume, Aristocracie,* and *Tymocracie.* In *B* Oresme's first instruction to the reader that follows his short prologue explains the importance of these terms to the reader's understandings of Aristotle's concepts: "Item, par especial cest livre ne peut bien estre entendu en pluseurs lieus sans savoir la signification de ces .iiii. mos: *aristocracie, commune policie, democracie, olygarchie.* Et ces mos sunt appropriés a ceste science" (Item, this book in particular cannot be understood in several places without knowing the meaning of these four words: *aristocracy, polity, democracy, oligarchy.* These words are appropriate to this field of learning).[4]

Oresme's insistence on the definition of the four generic terms indicates that in an Aristotelian context they were unfamiliar to his audience. Indeed, the words *tymocracie* (a synonym for *commune policie*), *aristocracie, democracie,* and *olygarchie* are neologisms introduced into French in Oresme's translation. The inscriptions thus correspond to Oresme's verbal explications in the text and their reinforcement in his glosses, commentaries, glossary of difficult words, and index of noteworthy subjects. Their visual representations function as analogues to the verbal definitions of these important concepts.

Also included in *B,* Oresme's unique second instruction to the reader spells out his reasons for featuring the six forms of government in the bifolio frontispiece:

> Et donques ces .vi. policies sont principals, et sont aussi comme les elemenz et les
> principes de toutes autres. Et pour ce sont yci au commencement du livre pourtrait
> tes et figurées. Et sont trois bonnes, c'est à savoir royaume, aristocracie et tymocra
> cie. Et trois autres qui sont transgressions ou corruptions des bonnes, c'est à savoir
> tyrannie, olygarchie et democracie.[5]

FIGURE 46 From top: *Tyrannie, Olygarchie, Democracie. Les politiques d'Aristote,* MS B.

FIGURE 48 From top: *Tyrannie, Oly-garchie, Democracie. Les politiques d'Aristote*, MS D.

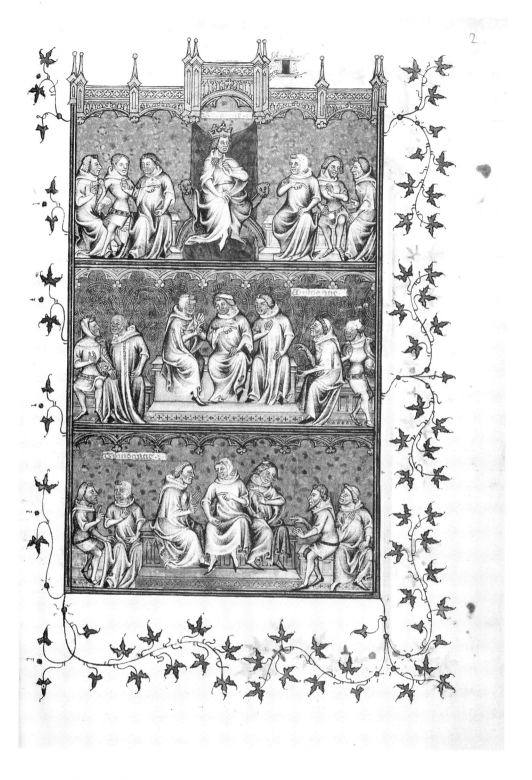

FIGURE 49 From top: *Royaume, Aris-*
tocracie, Tymocracie. Les politiques d'Aris-
tote, MS D.

Oresme further informs the reader that the definitions of these six terms are located in the glossaries of difficult words placed at the end of both the *Ethiques* and the *Politiques.* Oresme may have thought that such reminders were necessary, since the frontispiece occurs at the beginning of Book I of the *Politiques,* whereas the six forms are not systematically discussed until Book III. This separation, which contradicts the normal procedure of closely connecting the illustration with the text of the book it introduces, again shows the importance that Oresme attached to his readers' understanding of Aristotle's generic terminology.

How does Oresme define these terms in the glossary? Among the good forms, *Royaume* does not appear as a separate entry but is included in the definition of *Monarchie:* "*Monarchie* est la policie ou le princey que tient un seul. Et sunt .ii. especes generales de monarchie; une est royalme et l'autre est tyrannie" (Monarchy is the form of government in which one person holds power. There are two general types of monarchy: one is kingship and the other is tyranny).[6] *Aristocracie* is, however, accorded a separate entry: "*Aristocracie* est une espece de policie selon laquele ou en laquele un petit nombre de personnes bons et vaillans tiennent le princey et ont domination sus la communité et entendent a gouverner au profit commun" (Aristocracy is a type of government according to which, or in which, a small number of good and excellent people hold power and rule over the community and intend to govern for the common good).[7] The third of the good regimes, *Tymocracie,* is found under its synonym, *Commune policie:* "*Commune policie* est la ou une grande multitude tient le princey au profit publique; aussi comme en aristocracie un petit nombre tient le princey, et en royalme un seul le tient et tout au profit publique" (Timocracy is that [form] in which a large number holds power for the public good; as in aristocracy, a small number holds the power, and in kingship, only one holds it, all for the public good).[8]

As for the bad regimes, *Tyrannie* is defined succinctly as "princey ou policie ou domination ou fait de tyrant" (power, form of government, rule, or act of a tyrant).[9] A more elaborate characterization occurs under the word *Tyrant:* "Premierement, ce est un seul qui tient le princey et la monarchie a son propre profit et contre le bien publique" (First, it is one person who holds the power and monarchy for his benefit and contrary to the public good).[10] *Olygarchie,* the second bad form, is described as follows: "*Olygarchie* est une des .vi. especes generales de policie mises en le .viii.ᵉ et ou .ix.ᵉ chapitre du tiers livre. Et est la ou gens riches et puissans, qui sunt en petit nombre, tiennent le princey et gouvernement a leur propre profit et contre le profit publique" (Oligarchy is one of the six generic types of government located in the eighth and ninth chapters of the third book. And it is a regime in which a small number of powerful and rich people hold the power and government for their benefit and contrary to the public welfare).[11] The last of the corrupt regimes is *Democratie:* "*Democratie* est une espece de policie en laquele la multitude populaire tient le princey a leur profit. Et ne est pas bonne policie" (Democracy is a kind of government in which the popular multitude holds the power [of offices] for their own benefit. And it is not a good system).[12]

A diagram that appears in Chapter 10 of Book II of the *Politiques* (Fig. 50) reinforces Oresme's verbal distinctions among the three good and three bad forms

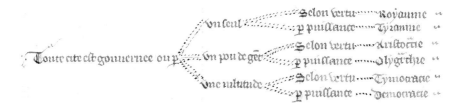

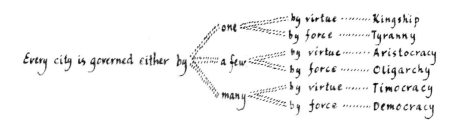

FIGURE 50 Diagram of *The Three
Good and the Three Bad Systems of Gov-
ernment. Les politiques d'Aristote,* MS D.

in the glossary and second instruction. Following the procedure of similar figures
in his scientific translations such as the *Traitié de l'espere,* this diagram clarifies the
distinction between forms in terms of the numbers of people who rule and their
ethical and moral goals. Thus, the inscriptions and the second and first instructions
lead the reader to generic definitions and classifications of basic terms and con-
cepts. Oresme's verbal directions compress and summarize ideas that occur in parts
of the text physically separated from the frontispieces.

VISUAL STRUCTURES

The visual adherence of the frontispieces to the definitions and diagram empha-
sizes the paradigmatic character and function of these prominent illustrations. The
use of an alternating and contrasting red and blue color scheme for the geometric
backgrounds of the three registers of each miniature reinforces and sets off such
parallelism. While the illustration for Book VII in *D* shares a three-register, full-
page format (Fig. 75), Figures 46–47 and 48–49 are the only instances of a bifolio
arrangement that draws together visual definitions summarizing basic concepts and
terms of the entire text.

 The representation of Bad Government (Fig. 46) is an outstanding achievement
of the Master of Jean de Sy, who was entrusted with the most important minia-
tures of the cycle. The soft draperies, expressive gestures, and convincing move-
ments of the figures depicted in the overall red, blue, gold, and gray color scheme
enliven the diagrammatic character of the scene. The smaller Good Government

miniature by the same master on the opposite folio (Fig. 47) shares the lavish use of gold with its counterpart and extends the architectural motif of arcades to the two lower registers. Yet the illustration lacks the liveliness of Figure 46. Despite the Jean de Sy Master's attempt to introduce variety in the poses and gestures of the seated figures on all three levels, the composition remains more static. As in representations of heaven and hell, the prevailing peace and harmony of the morally excellent is less arresting than the disorder and tortures of the morally corrupt. Emphasis on the grotesque and terrible as an aid to distinguishing and remembering the ethically negative perhaps accounts for the exceptional attention given to the various tortures. Furthermore, the artist may well have taken particular pleasure in their depiction.

The miniaturist who executed the bifolio frontispiece of *D* (Figs. 48 and 49) is the Master of the Coronation Book of Charles V. As in the miniatures of *C,* the figures are executed in grisaille enhanced with color washes. Nevertheless, the abundant use of gold and the brilliant tones of the geometric backgrounds contribute an effect of richness. With some minor changes, the miniaturist follows the compositions of *B.* For example, the tortures on the first and second registers of Figure 48 are varied from those of Figure 46: the scenes of flaying and burning a victim with hot pincers are shifted from the punishments inflicted on the hapless subjects of Tyranny to those of Oligarchy. In the respective scenes of Good Government (Figs. 47 and 49) the attendant figures in Aristocracy and Timocracy are reduced from three to two. Although the nude forms of the tortured prisoners are lively and expressive, in general, the dry style of the Master of the Coronation Book tends to emphasize the schematic, diagrammatic aspect of the program.

Principles of parallelism and contrast order the paradigms. For one thing, the placement of the bad forms on the left of the bifolio conforms to medieval practice in assigning position on the left of the picture field to negative values or associations; placement on the right, therefore, connotes positive ones.[13] Juxtaposition of the two folios promotes the reader's understanding of the paradigms represented. First, the design encourages the reading of each miniature vertically from top to bottom. Two organizing principles correspond to Oresme's definitions and diagram. The first is the number of people who hold political power in both the good and the bad forms of government. In contrast, the horizontal comparison of the two types of regimes reinforces the analogies on each level among the three categories according to ethical values and goals. On the right in both sets of illustrations (Figs. 47 and 49), kingship (*Royaume*) occupies the top register. Among the three good forms, *Royaume* represents political power held by one person; in the middle zone, Aristocracy (*Aristocracie*), power held by a few; and in the lowest, Timocracy or Polity (*Tymocracie* or *Policie commune*), power held by many.

Reading from the top down also corresponds to a descending hierarchy of value. Kingship is the best of the good forms; Aristocracy, the next; and Timocracy, or Polity, the least good. In a reverse but related sequence among the three bad forms, tyranny (*Tyrannie*) on top is the worst form; oligarchy (*Oligarchie*) in the middle, less bad; and Democracy (*Democracie*), the least bad. One index of this order is the types of tortures inflicted on the subjects of the three bad regimes.

While disfiguration and death are the fates of the victims of Tyranny and Oligarchy, the pillorying, beating, and expulsion of the victims in Democracy are not so dire.

This system of relationships conveys the notion that among the three good forms debate and deliberation encourage peaceful communication among the rulers and the ruled. Instead of such communication, the images of the three bad forms show orders issued by the central authorities without consulting their subjects. In these regimes gestures of command authorize tortures and other punishments.

Costume and other accessories are key signifiers distinguishing between good and bad regimes. For example, the money bags of the tyrant and the oligarch demonstrate that personal gain motivates their rule. In contrast to the civilian dress of the three ranks of the good governors, the armor and weapons of the bad rulers indicate that they hold power by force. The verbal equivalent of these notions is the phrase "par puissance" (by force) in Oresme's diagram (Fig. 50), which explains both the ethical goals and methods by which the corrupt systems maintain power.

Another visual accent emphasizes that the apex or culmination of the three good forms of government is kingship. Highlighted by the enframing central tower, a gold cloth spread behind the monarch in *B* and a red one in *D* (Figs. 47 and 49 and Pl. 8) accentuate the position of honor at the top of the hierarchy. The monarch's blue-and-gold fleur-de-lis mantle in Figure 47 promotes the association of the French monarchy with the best form of government.[14] Oresme's judgment follows one strand of the medieval interpretation of Aristotle's model of the *communitas perfecta,* the Greek city-state, as the culmination of the hierarchy of social communities formed to assure the good life.[15] Although not always consistent, Oresme tries to extend and associate Aristotle's ideal community with the royal rule of the emerging nation-state. Such a position is supported by his statement that "the royal form of government is the best possible one and is also the rule and measure of the other."[16] Although the king in Figure 49 does not wear a fleur-de-lis mantle, the frontispieces clearly evaluate *Royaume* with the best form of government.

The architectural settings of the frontispieces not only have mnemonic and paradigmatic functions but also promote associations with deliberative and judicial chambers in which the rulers exercise their sovereignty. As noted above, the consultative character of the good regimes is characterized by communication among the rulers and the ruled. In all three registers of the bifolio frontispieces of *B* and *D* (Figs. 47 and 49) the latter sit on stone benches placed on a level lower than those of the former. The seating arrangement and composition of the figures on all three levels convey the ideas that ongoing discussion typifies the good regime as an association of citizens based on friendship and the goal of working together for the common good. The idea of the common good developed in the *Politics* was as eagerly taken up by medieval interpreters as the hierarchy of communities.[17] Implied also from the exchanges among the ruled in Figures 47 and 49 is the notion that decisions are made with the consent of the governed.[18] The grouping

FIGURE 51 *A King and His Counsellors. Avis au roys.*

of the figures and their communication by turns of the head and gestures associated with speech are two visual means that transmit these concepts. In *D* (Fig. 49), even more than in *B* (Fig. 47), the figures communicate vigorously. The king turns his body toward his officers, whose close seating promotes their animated interaction.

The composition also reflects Aristotle's view of a constitution "as the arrangement of magistracies in a state, and especially of the highest offices. The nature of the constitution depends on the seat of authority."[19] Thus, in Figure 49 the higher benches of the rulers of the three forms indicate their political sovereignty. But the position of the ruled on either side of the sovereign power demonstrates that as citizens they participate actively in the life of the state. On each register at least one member of a group communicates with the central authority.[20]

Costumes and attributes also suggest that different social classes participate in deliberations as officeholders. For example, in the upper two registers of Figures 47 and 49 men holding falcons are associated with the aristocracy; those with tonsures, the clergy; and those wearing long cloaks with fur lappets, lawyers. It is difficult to decide if a contemporary institution is specified, particularly in the cases of Aristocracie or Tymocracie, where the numbers of rulers and costumes are not differentiated. The case of Royaume, however, may allude to the king's council.[21] The miniature representing a king communicating with his counsellors in the Morgan *Avis au roys* offers an iconographic precedent of the treatment of the theme in the two frontispieces (Fig. 51). The compositions, architectural set-

tings, and accessories of Figures 47 and 49 allude to the function of the state to secure justice by the rule of law. Such an association accords with Aristotle's conviction that the good forms of government will seek justice in distributing "the offices of the state among its members on a plan or principles."[22] An even broader association identifies the three good constitutions with the rule of law. Oresme follows Aristotle in stating that the laws of the state must serve the public good.[23] Both the rulers and the ruled participate in the judicial process. One confirmation of this association lies in the evidence to be found in miniatures of French manuscripts of Gratian's *Decretals* dating from the thirteenth and fourteenth centuries that depict judges of both civil and ecclesiastical courts seated on benches.[24]

A comparison with the opposite scene of the three bad forms (Figs. 46 and 48) reinforces these visual paradigms. For example, the ruled do not participate in the processes of government. Instead of communication and deliberation, unilateral orders issue from those who hold authority. Indeed, all decisions made for the profit of the rulers result in horrible injustices to, and punishment of, their subjects.

HISTORICAL ASSOCIATIONS

Among the contemporary historical associations that the readers of Oresme's translations of the *Politics* might have made, one deserves particular emphasis. As noted above, the money bag in Figures 46 and 48 highlights the argument that, unlike the king whose concern for the welfare of his subjects motivates his reign, personal financial gain drives the tyrant. This distinction had long been a leitmotif of Oresme's writings. In his influential treatise *De moneta,* written by 1356, he discusses the debasement of the coinage as a method of the tyrant.[25] This subject of contemporary debate became urgent during the monetary crisis of the 1350s and was particularly acute because of the ransom demanded for the captured King John the Good. In chapters 25 and 26 of the *De moneta,* Oresme quotes the *Politics* in warning against debasement of the coinage, since "whenever kingship approaches tyranny it is near to its end, for by this it becomes ripe for division." Oresme further warns that "neither can a kingdom survive whose prince draws to himself riches in excess as is done by altering the coinage." To make his points more clearly, Oresme explains that "the prince should not enlarge his dominion over his subjects, should not overtax them or seize their goods, should allow or grant them liberties and should not interfere with them or use his plenary powers but only a power regulated by law and custom."[26]

In the conclusion to the *De moneta,* Oresme mentions the specific dangers to the French monarchy, if by debasing the coinage, it becomes a tyranny. At the time Oresme was pleading for monetary reform in the context of the political crisis of the 1350s and meetings of the Estates General during which opposition to the monarchy was evident:

> Whoever, therefore, should in any way induce the lords of France to such tyranni-
> cal government, would expose the realm to great danger and pave the way to its

end. For neither has the noble offspring of the French kings learned to be tyran-
nous, nor the people of Gaul to be servile; therefore if the royal house decline from
its ancient virtue, it will certainly lose the kingdom.[27]

Charles V was certainly familiar with the distinction between tyranny and kingship
drawn by Oresme in the *De moneta* and its French translation, the *Traité des mon-
noies*. Thus the Aristotelian framework of these treatises could have formed the
link with the Philosopher's theoretical classifications of the regimes. Such associa-
tions would have recalled the crises threatening the French monarchy that inspired
Oresme's treatises and enframed them as references to a dangerous past, a para-
digmatic present, and admonitions for the future. In this respect, the allusion to
the French monarchy (particularly in Fig. 47) as the incarnation of the best type
of the good regimes that seeks the *commun proffit* shares a common theme of politi-
cal writing during Charles V's reign: his devotion to the *chose publique*.[28]

The communication among members of Royaume and Aristocracie in Figures
47 and 49 might also have recalled particular political events associated with the
production and reading of the *Politiques*. Scholars have suggested that the election
by Charles V's council in 1371 and 1372 of a royal chancellor, previously ap-
pointed by the king, was an innovation influenced by Aristotle's advocacy of pub-
lic participation in the selection of high officers of the state.[29]

ICONOGRAPHIC SOURCES

Oresme's second instruction to the reader in the first illustrated *Politics* provides in
all major respects the textual key to the visual structures of the bifolio arrangement
of the frontispieces. Yet in addition to the Morgan *Avis au roys,* a few general
iconographic precedents for the overall layout come to mind. One finds in book
illustration a type of bifolio arrangement in which good and bad moral qualities
figure opposite one another. For example, a manuscript from Ratisbon dating from
1165 depicts in three registers the virtues on the right and the vices on the left,
respectively juxtaposed with human exempla.[30]

Similarly, an English manuscript of the *City of God* dated 1120 (possibly from
the abbey of St. Augustine, Canterbury) has a three-register frontispiece, which
on the second and third levels represents Bad Government and Good Government
(Fig. 52).[31] Bad Government depicts a scene of warriors killing one another, while
in Good Government two plowmen work peacefully in the fields. These two
scenes correspond to the effects of good and bad government rather than to a
classification of the six regimes. A more recent instance of this theme is, of course,
Ambrogio Lorenzetti's famous fresco cycle of 1337 to 1340 in the Sala dei Nove
of the Palazzo Pubblico in Siena (Figs. 53 and 54). As discussed in Chapter 9
above, personifications of Good and Bad Government are depicted in spaces sepa-
rate from the effects of their rule. Although a general similarity of subject matter,
possibly derived from Aristotelian sources, exists between the themes of these

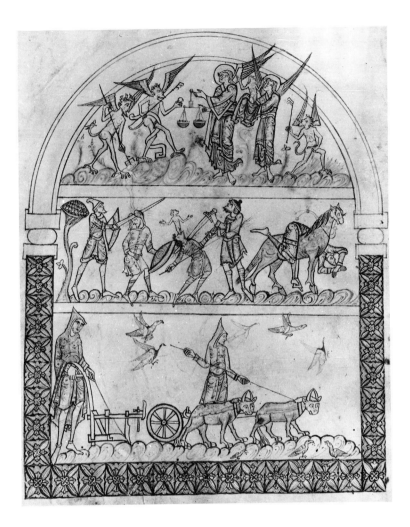

FIGURE 52 *Good and Bad Govern-*
ment. St. Augustine, *De civitate Dei.*

frescoes and the *Politiques* frontispieces, in my opinion no direct dependence is
evident.[32] The illustrations designed by Oresme are far more narrowly related to
the text of the *Politics* than to the Lorenzetti frescoes.

Indeed, the frontispieces of the illustrated *Politiques* executed for Charles V are
unique among their cycles in their scale, format, and explicit relationship to lan-
guage. Moreover, among the later fourteenth-century illustrated manuscripts of
Oresme's translation of Aristotle's text, no other miniatures for Book I offer a
comparable program. The paradigmatic character of the frontispieces, emphasized
by the architectural enframement, sets the tone for the entire program. Taken
together, texts and images could function as aids to memory and talking points
for Oresme's oral explication of these themes to his primary audience, the king
and his counsellors.

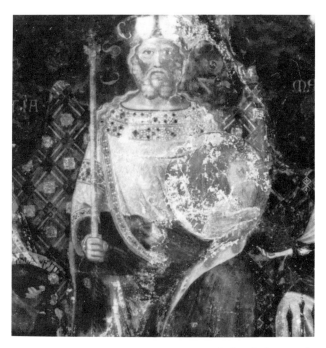

FIGURE 53 Ambrogio Lorenzetti,
Good Government.

FIGURE 54 Ambrogio Lorenzetti,
Bad Government.

17 CLASSICAL AUTHORITIES ON POLITICAL THEORY
(Book II)

Inasmuch as they relate directly to the content of the specific book before which they appear, the illustrations for Book II in *B* and *D* (Figs. 55, 56, and 57) are more typical of the rest of the *Politiques* cycles than the frontispieces. Yet the programs of Book II reveal a change of strategy in the relationship of image to text. Such a divergence says something about Oresme's limited choices in providing a viable program of illustrations for the text, as well as his judgment about the relevance of its contents for his primary readers.

In Book II of the *Politics* Aristotle discusses the theories of four ancient writers on the ideal state: Socrates, Plato, Phaleas of Chalcedon, and Hippodamus of Miletus. Following a medieval tradition discussed further below, in Figures 55 and 57 Socrates and Plato are represented together as master and pupil respectively. Although the four thinkers are identified in internal inscriptions, the miniatures offer few clues to their theories. The limited allusions to their writings are handled within the chosen representational mode: portraits of the philosophers. Unlike the frontispieces, in which the lexical functions of the illustrations dominate, these images have an indexical purpose, since they offer a guide to the sequence of authors whose ideas are presented in Book II.

Why did Oresme choose to focus on the thinkers rather than on their thoughts? One reason may be the abstract character of the theories put forward by the four sages. Oresme may have judged that the subjects were too radical or too remote to have any direct, practical application to contemporary problems faced by his readers. Furthermore, it is difficult to conceive of intelligible visual translations of such topics as Plato's "community of wives and children," Phaleas's "proposal for the equalization of property in land," or Hippodamus's plans for developing states according to triads of classes, territory, and laws.[1] Thus, recourse to the ancient iconographic type of the author portrait may have offered the only possible alternative for a visual program.

THE DESIGNS OF THE MINIATURES

In *B* the cryptic and conservative representational mode of the illustration contrasts with the lavish layout of the two folios on which the three portraits are

FIGURE 55 From left: *Socrates Dictates to Plato, Phaleas. Les politiques d'Aristote, MS B.*

FIGURE 56 *Hippodamus. Les politiques d'Aristote, MS B.*

FIGURE 57 Top, from left: *Socrates Dictates to Plato, Hippodamus;* bottom: *Phaleas. Les politiques d'Aristote,* MS D.

placed (Figs. 55 and 56). Executed by the artist known as the Master of the Coronation of Charles VI, folios 32v and 33 are the most lavish in this deluxe manuscript. For the first time the arms of Charles V (azure shields bearing three fleur-de-lis) appear twice on the lower margin of folio 32v and once on folio 33. Fleur-de-lis also appear as the overall geometric motif in the backgrounds of the miniatures of folio 32v. The decoration of this folio is exceptionally enhanced by the appearance of a rabbit and three birds among the ivy-leaf sprays of the upper and side borders.

All three miniatures are isolated by gold outer and tricolor interior quadrilobe frames. A continuous relationship between the two folios is assured not only by repetition of the shield but also by the alignment and color symmetry of the third miniature on folio 33. A blue-red-blue color scheme unites the layout. Placed after the chapter headings and above the introductory paragraph of Book II, Figures 55 and 56 are distinguished by their large size. The grisaille modeling of the figures, associated in the *B* cycle with this illuminator, increases their monumentality. The mannered elegance of the master's style, evident in the figures' drapery, hands, and feet, is echoed by the elongated proportions of the quadrilobes. Yet intensity of gesture and expression coexists with the somewhat archaic style. Compatible with the overall design of the folios, both figures and frames contribute to an antinaturalistic effect characteristic of the three miniatures in *B* executed by this master.

In contrast to the lavish layout of Figures 55 and 56, the illustration for Book II in *D* (Fig. 57) is more modest. Consistent with the re-editing of this manuscript, the three miniatures have been compressed into a two-register format on a single folio. The first and third exceed the width of the first column of text with which they are aligned. Each miniature is about half the size of its counterpart in *B*. A member of the workshop of the Master of the Coronation Book of Charles V followed the design of the miniatures of *B* in the interior quadrilobe frames and the color scheme of the background. The grisaille modeling of the figures in *D* is a feature characteristic of the entire cycle. As is usually the case in these two manuscripts, the miniatures appear below the running title identifying the book and above the chapter headings and summary paragraph. This order helps the reader to connect the image and its inscriptions with specific information about the contents of the individual book. For example, the general relationship of the images to text occurs in the introductory paragraph: "Cy commence le secont livre de politiques ou quel il traite les opinions anciennes de communicacion politique et contient .xxii. chapitres" (Here begins the second book of the *Politics* in which he discusses the ancient theories of political organizations; [it] contains twenty-two chapters).[2] Figures 55 and 56 also provide a linkage between the chapter heading and inscription of each miniature. Thus, Socrates' name occurs in the titles for Chapters 1 to 5 and 7 to 9; Phaleas's in Chapters 11 to 12; and Hippodamus's in Chapters 13 to 14. The normal order of reading the miniatures from upper left to upper right is, however, not observed in Figure 57. Here, the process of consolidating the miniatures on one folio has resulted in an irregular presentation of sequence in the text, where Phaleas is the second, not the last, of the three

thinkers discussed. It is possible, though, that the unusual feature of reading each element of the two-register format as an isolated entity allows a vertical ordering of the miniatures.

ICONOGRAPHY AND INVENTION

As noted above, the well-established tradition of the author portrait serves as the basic iconographic source for two of the three representations of the ancient sages. It is particularly appropriate that this type, which originated in antiquity, should provide the ultimate models for the illustrations.[3] Yet the costumes and furnishings of these classical authorities in Figures 55–57 identify them as medieval teachers and writers. This practice exemplifies Panofsky's principle of disjunction between a classical theme and its medieval pictorial representation.[4]

The images of Socrates and Plato afford an apt example of such medieval interpretations of the conventions of the antique author portrait. One such strain is represented by the type of the Evangelist dictating to a scribe. Socrates sits in a high-backed, canopied chair dictating to the figure of Plato, who kneels at his feet. Each man wears academic dress that identifies him with his status as a "Regent Master of Theology."[5] Among the key elements of the costume is the plain *super-tunica,* with its fur-trimmed hood. Plato's costume also includes two furred lappets on the chest, while Socrates wears a skullcap with an apex. Plato's tonsured head indicates that he is a cleric. Age differentiates the two thinkers: Socrates is depicted as a mature man with a long beard; Plato, as youthful and clean-shaven. The updating of the portrait types by these costumes and accessories places these thinkers within a recognized institutionalized structure for disseminating late medieval thought: the University of Paris. The use of French for the inscriptions identifying Phaleas and Hippodamus and for recording Socrates' ideas affords additional evidence for the authority invested in the vernacular and in French culture particularly.

Plato turns his upraised head, seen in profile, toward Socrates, whose pointing finger conveys the fact that he is speaking (Fig. 55). While listening to Socrates, Plato has written on his scroll the words dictated to him: "soit tout commun" (let everything be [held in] common). The iconography thus conveys the medieval tradition of interpreting Plato as the transmitter of Socrates' ideas rather than as a great thinker in his own right. The miniature also presents the oral communication of knowledge within a teaching situation: the *magister cum discipulo* relationship.[6] The Socrates-Plato image thus relates to another variation of the medieval author portrait: the writer as teacher, lecturer, or preacher.[7] The rise of universities and the mendicant orders contributed to making such themes popular. In particular, the assimilation of Aristotle's thought into the university curriculum made the depiction of the Philosopher as a teacher a popular theme in historiated initials placed at the beginning of the many Latin translations of his works.[8] A contemporary variation on the theme of the scholar as lecturer occurs in the lower left quadrilobe of Figure 7, the dedication frontispiece of *A.*

The Socrates-Plato image thus combines two types of the medieval author portrait. But in Figure 55 the inscription on Plato's scroll highlights a particular subject in Book II. The featured text "soit tout commun," highlights the origin in Socrates' teaching of Plato's theory that property and wives should be held in common. Since the text of the *Republic* was not known in the Middle Ages, it is not surprising that Oresme, referring to a commonality of wives and property, cites the second part of Plato's *Timaeus* and Apuleius's *De dogmate Platonis.*[9] The prominence given the words *soit tout commun* accords with the lengthy discussion of this concept in the text and glosses of the first nine chapters of Book II. The remaining seven chapters of Book II on ancient constitutions are not represented in the program of the miniature. The "soit tout commun" inscription may also highlight what Oresme considered a politically explosive or subversive theme. In the re-edition of *D,* however, Plato's scroll no longer carries an inscription (Fig. 57). Despite the addition of a curtain to suggest an interior setting, Figure 57 lacks the intensity of expression characteristic of the figures in Figure 55.

In both Figures 55 and 57 Phaleas's (*Felleas*) attributes, not words, characterize the theories of this writer. Since his ideas relate to the redistribution of land and property, he is depicted with symbols of measurement. In his left hand he holds a T square on which is draped a length of string weighted on one end. A vertical rod and an unidentified instrument wrapped in string are also depicted. Facing and striding to the right, Phaleas gestures with upraised hand toward these implements. Standing in the middle of the picture field, he appears as an aged figure with a short beard. His plain bonnet and simple mantle, which lacks the fur-trimmed hood that indicates the academic status of Socrates and Plato, suggest a lesser, secular rank. The elongated proportions of his figure, visible especially in his thin feet shod in pointed *poulains,* are typical of the style of the Master of the Coronation of Charles VI. Although the iconography may derive from the representation of a standing author holding his writings, the figure of Phaleas also recalls the depiction of a sacred person identified by his attributes. Precedents for the appropriation of this scheme occur in the *Ethiques* illustrations of Justice in *A* of Book V (Fig. 24) and of Art in Book VI of *C* (Fig. 34). Phaleas's vertical posture may have been chosen to balance and vary the seated figures on his right and left. Yet the lack of any kind of setting to which Phaleas might relate results in a discordant effect. The addition of a building in *D* (Fig. 57) may have been an attempt to remedy the lack of a concrete object appropriate for Phaleas's instruments of measure.

Hippodamus of Miletus (*Hypodamus*) is the last theorist represented (Figs. 56 and 57). He wears a skullcap similar to that of Socrates. The lack of a fur-trimmed hood on his plain mantle appears to disassociate him from university status. His white hair and long beard suggest advanced age. Facing right, he is seated on a low-backed chair equipped with a stool to which a writing stand is attached (Fig. 57). Next to it lie two upended books. Hippodamus is engaged in writing with pen and scraper on a ruled sheet. Although in Figure 56 it is possible to read individual letters and several words (*le* and *les*), the writer's hands conceal the ensemble. Thus, unlike the images of Socrates and Plato or Phaleas, those of Hip-

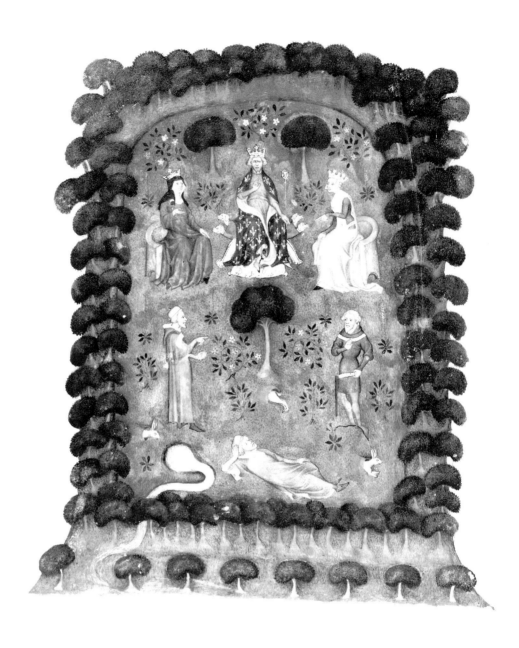

FIGURE 58 *The Dream of the Author.*
Le songe du vergier.

podamus do not reveal any clue about his ideas. Yet in all three portraits authoritative doctrine and wisdom are embodied in mature, masculine figures characterized by their white hair and beards.

In another sense, however, the attention given to the ancient writers of secular works may signify a shift in attitude toward establishing the notion of individual authorial identity.[10] By means of an inscription or attributes the portraits of Socrates and Plato and Phaleas characterize their works as distinct entities. Placement of the portraits within separate frames further concentrates attention on each one as an individual unit. The inscription of the name within the picture field helps the reader associate the thinker's appearance with the sequential presentation of his theories in Book II. The relationships governing the thinker's name, figure, and activities have indexical and memory functions.

These variations on a theme may well have served Oresme as convenient talking points in an oral explication of Book II. In particular, the Socrates-and-Plato miniature could have easily led to a discussion of the "soit tout commun" subject. Although seemingly remote from contemporary experience, Plato's theories about the commonality of property and wives may have struck a chord with Oresme's primary readers because of the dynastic disputes concerning inheritance of the French throne via the female line. In a similar vein, Phaleas's ideas about redistribution of land had a practical application in view of the protracted struggle with the English about claims to territories in France. Oresme's ability to relate the ideas of the ancient sages to contemporary events is revealed in his long commentary on the issue of voluntary poverty of the clergy, inserted in a refutation of Socrates' views on common ownership of property.[11]

Oresme's long-standing mentor relationship with Charles V and the oral transmission of knowledge exemplified in the Socrates-Plato miniature seem to present appropriate analogues for discussions suggested by the writings of the ancient sages. In visual terms the prominence accorded these secular writers reflects the growth of individual authorial identity. Other contemporary portraits in which the author forms part of a narrative or addresses an audience seem far more adventurous than Figures 55–57 in asserting the writer's identity. The unknown writer of the *Songe du vergier,* a manuscript commissioned by Charles V in the 1370s, appears in the frontispiece by the Jean de Sy Master as a sleeping figure whose dream unfolds in the discussions of the figures deployed above him (Fig. 58).[12] Also executed by the Jean de Sy Master and also dating from the 1370s is a highly individualized portrait of Guillaume de Machaut in one of two frontispieces of his collected poetic works that shows him introduced to important characters in his writings (Fig. 59).[13] By comparison, the exactly contemporaneous illustrations of the ancient sages in Book II of the *Politiques* seem almost deliberately archaizing: perhaps the *retardataire* style of the illuminator of Figures 55 and 56 was an attempt to assert their antiquity.

Oresme's historical interest in classical theories and theorists is consistent with his search for understanding of ancient culture. At the same time, presenting the

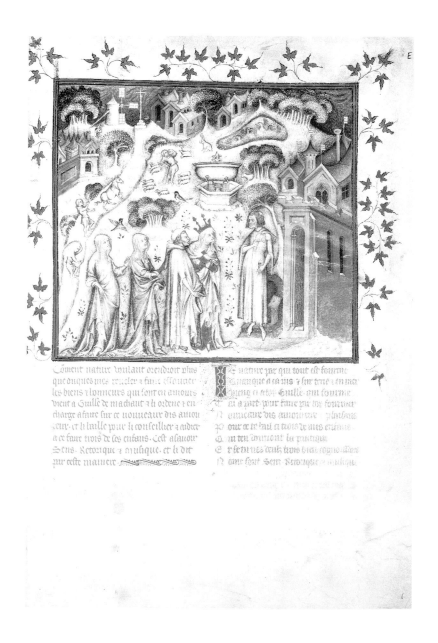

Côment nature voulant cendroit plus
que onques mes renieler a fait essouacer
les biens t honneurs qui sont en amours
vient a Guillé de machaut t li ordene t en
charge afaire sur ce nouueaux dis autou
seur. et li baille pour li conseiller t aidier
a ce faire trois de ses enfans. Cest asauoir
Sens. Retorique t musique. et li dit
par ceste maniere.

E nature par qui tout est fourme
Ei quanque a ca ms t li ui tenu en mo...
oyeng a aton Guille. ont fourme
ai a part pour faire par ton fourmar
R amiraux dis amoureux ... plusons...
po our ce te faut et trois te mes enfans...
Q. ui ten conuient la pratique
e r se tu nes ceulx trois bien cogneu Ter
n ome sont Sens Retorique t musique.

FIGURE 59 *Nature Introduces Her Chil-
dren to the Poet Guillaume de Machaut.
Collected Works of Guillaume de Machaut.*

ideas of the ancient sages in the vernacular claims for French culture the means of
inheriting, transmitting, and interpreting these authoritative sources. While Fig-
ures 55–57 are among the most conservative of the *Politiques* cycles, their icono-
graphic tradition bestows on the author portraits a new cultural importance.

18 THREATS TO THE BODY POLITIC
(Book III)

The illustrations of Book III are the first in a series of three that deal with the metaphor of the body politic. While Oresme may have chosen the subject of the miniatures for Book III because of practical considerations, his selection of the theme is highly significant for several reasons. Most obviously, Oresme thought that Aristotle's discussion of threats to, or maintenance of, the health of the body politic was a subject of the greatest interest to his primary readers. Second, in interpreting Aristotle's ideas both textually and visually, Oresme had the means to put forth his own counsel on these subjects. Of course, as translator he was bound to present these ideas in representational modes grounded in the text. Indeed, the variety of modes evident in the series reflects both the illustrations' overt lexical and other more allusive, deceptively nonverbal metaphorical functions.

In format and layout the illustrations for Book III of the *Politiques* in *B* and *D* (Figs. 60 and 61) are very similar. Occupying two thirds of the text block, both miniatures adopt two-register formats and appear at the head of the text above the summary paragraph and the beginning of the chapter headings for the book.[1] The decoration of Figure 60 is, however, more elaborate than that of Figure 61. The bas-de-page of the first repeats the bird and arms of Charles V familiar from Book II in *B* (Figs. 55 and 56). In addition, a graceful crane occupies the outermost ivy-leaf spray on the lower right margin. The elegant, mannered style of the Master of the Coronation of Charles VI is again recognizable in Figure 60, while the drier, blockier forms of a member of the workshop of the Master of the Coronation Book of Charles V are evident in Figure 61 (Pl. 9).

Yet in two respects the illustrations for Book III of Charles V's copies of the *Politiques* are highly unusual. First of all, the two-register format is organized in a distinctive manner. Although set within individual quadrilobe frames, the upper two panels are designed to be read as a single unit. Second, for the only time within the cycle, the illustrations carry no inscriptions of any kind. Indeed, in *B* even the running title for the book is lacking. Although this error was corrected in *D,* and various changes were made within the individual scenes, inscriptions are not included. Since the illustrations of Books VI and VII in *D* (Figs. 71 and 75) add inscriptions lacking in *B,* it is fair to assume that the elimination of this feature in Figures 60 and 61 was deliberate. Oresme's motives in adopting such a strategy require some discussion.

FIGURE 60 Above: *A King Banishes a Subject;* below, from left: *A Peasant Cuts off the Tallest Ears of Grain, A Painter Erases an Error. Les politiques d'Aristote, MS B.*

FIGURE 61 Above: *A King Banishes a Subject*; below, from left: *A King Cuts off the Tallest Ears of Grain in the Presence of a Messenger, A Painter Erases an Error. Les politiques d'Aristote*, MS D.

One problem that faced Oresme in designing the program of illustration for Book III is that the first two main topics discussed in Chapters 1 through 12 are citizenship and the six forms of government. The organization of the overlapping subject matter of the *Politics* may have prompted Oresme to choose the crucial subjects discussed in the first part of Book III as the three-register frontispiece of Book I. Citizenship is the topic of the illustrations of Book VII (Figs. 74 and 75). Therefore, Oresme had to select a topic that appears in the last third of Book III. Without clues to sequence and a linking inscription, Oresme's readers would have found it difficult to decipher the relation of the image to the text.

The first indication of a connection between the meaning of the miniature and a text passage occurs in the heading for Chapter 18: "Ou .xviii.ᵉ chapitre il monstre comme l'en met hors des cités ceulz qui ont superhabundance de puissance oultre les autres" (In the eighteenth chapter he shows how they turn out of cities those whose power too greatly exceeds that of others).[2] The title for the following chapter continues the discussion: "Ou .xix.ᵉ chapitre il monstre comment ceulz qui excedent ou superhabundent en puissance politique sunt mis hors des cités justement ou injustement" (In the nineteenth chapter he shows how those who have an excess or superabundance of political power are turned out of cities justly or unjustly).[3] To narrow the search for a key word that can link text and image, the reader searches further in Chapter 18. There, the noun *relégation* provides a vital lexical clue to the identification of the theme of the miniature. Not surprisingly, the translator provides a verbal definition of the term: "Et relégation, ce est assavoir bouter hors les gens excellens et les chacier de la cité ou du païs, a ceste meisme puissance ou cest effect" (Banishment is, to wit, to kick out people who excel and to drive them out of the city or country, with the same power or with this effect).[4] A synonym for ostracism or political exile, *relégation* figures in briefer form in Oresme's glossary of difficult words: "*Relégation* est prins en cest livre largement pour toutes manieres de exil ou de bannissement" (*Relégation* is taken in this book in a broad sense [to mean] all manners of exile or banishment).[5] In Chapter 19 Oresme uses the word extensively to discuss the efficacy and dangers of such a policy.[6]

Thus, the first challenge to Oresme's readers is to supply a key element of his method as a translator: the essential definition of a generic term. For a modern reader, even so distinguished a one as Léopold Delisle, the word-image relationship proved too difficult.[7] In Figure 60, not only the lack of an inscription but also the mannered figure style of the miniaturist may have hindered Delisle's train of association. Indeed, the first identification of the illustration of Book III with the concept of ostracism occurs in an article on a manuscript of the *Politiques* executed in 1396–97 for Charles V's son, Louis of Orléans (Fig. 62).[8] Here the isolation of the leftmost figure of the upper right quadrilobe may have offered the vital clue to association with ostracism or exile.

FIGURE 62 Above: *A King Banishes a Subject;* below, from left: *A King Cuts off the Tallest Ears of Grain in the Presence of a Messenger, The Confrontation of a Nude and a Clothed Figure. Les politiques d'Aristote,* Paris, Bibl. Nat.

Perhaps at this point a description of the upper two quadrilobes of Figures 60 and 61 is in order. A king, accompanied by a richly clad, gesticulating figure, extends a baton or rod bridging the gap between the upper left and right quadrilobes. In Figure 60 the baton just touches the right hip of the fashionably dressed figure standing with crossed legs at the left of the second scene.[9] The quadrilobes interrupt the length of the baton and make the gesture more difficult to read. A small, but significant, void, emphasized by the tree-like pattern in the background,

separates him from the other three men standing together to form a group. As a sign of wealth or status, the elegant feather in the hat of this figure distinguishes him from his companions. Although this telling detail is omitted from Figure 61, the comparable person in this miniature stands next to the left frame of the quadrilobe, where the king's baton touches his chest more decisively.

In the lower register, more significant changes between Figures 60 and 61 take place. On the lower left of Figure 60 a single male figure, who wears a peasant's short jacket and hose, fingers the tall ears of a stalk of grain. In the same place in Figure 61, a king accompanied by a figure carrying a spear performs the same action. This scene depicts Aristotle's account of the advice given by the tyrant Periander of Corinth to another tyrant, Thrasybulus, on how to deal with the threat to his rule posed by citizens who had become too prominent and powerful. Since Oresme's version of the story is broken up by glosses, the comparable passage from Barker's translation of the *Politics* is easier to follow:

> Thrasybulus, according to the tale that is told, sent an envoy to ask for advice. Periander gave no verbal answer; he simply switched off the outstanding ears, in the corn-field where he was standing, until he had levelled the surface. The envoy did not understand the meaning of his action, and merely reported the incident; but Thrasybulus guessed that he had been advised to cut off the outstanding men in the state.[10]

This passage makes possible an interpretation of the actions that take place in Figures 60 and 61. On the top register a king (possibly Thrasybulus) singles out a leading citizen for banishment or exile. Whereas Aristotle states that the offending personages will be killed, Oresme's gloss states that the passage must be interpreted in the sense of banishment.[11] On the lower left, the ears of grain are being pulled off. Instead of the solitary peasant of Figure 60, in Figure 61 a king, accompanied by the envoy, performs the action. This substitution incorporates the notion of the uncomprehending envoy as witness and reporter of the silent advice enacted by Periander.

The lower right quadrilobe also shows significant changes between Figures 60 and 61. Common to both, however, is the representation on the left of a man washing off with a sponge and bowl the arm of the figure on the right. But in Figure 61 the latter is nude and stands out against a large, dark panel set behind him. These alterations make it easier to decipher the possible meaning of the scene, which is derived from a passage in Chapter 19. Following the discussion of how regimes deal with citizens who have amassed too much power, Aristotle declares that in order to assure the well-being of the state the relationship between classes or groups must stand in right proportion to one another.[12] Aristotle here draws the analogy to a painter, who, in creating a form, cannot represent one part, such as a limb, as too large without destroying the harmony of all the parts. In other words, the lower right quadrilobe depicts a painter or an artist correcting his mistake of making the right arm of the accompanying figure too long. This

notion is clearer in Figure 61 than in Figure 60. The substitution of a nude for a clothed form more readily promotes the association with a work of art rather than with a living human being in contemporary costume. Such a relationship is encouraged further in Figure 61 by the contrasting dark panel behind the nude. Together, nude and panel suggest that the painter is erasing or washing his error off a painted form. Although the nonnaturalistic features of the scene's style and setting somewhat obscure this interpretation, an English translation of the text supports such a reading: "This rule of proportion may also be observed in the arts and sciences generally. A painter would not permit a foot which exceeded the bounds of symmetry, however beautiful it might be, to appear in a figure on his canvas."[13] Oresme's version makes the same point, although instead of a man he uses the example of an animal:

> T. Et la raison appert par ce que l'en fait es autres ars et sciences; car un peinteur ne lesse pas ou ne seuffre pas quant il fait en peinture une beste que elle eust un pié qui excedast et passast la commensuration et proportion qu'il doit avoir en quantité ne aussi ne seuffre il pas que en beauté il soit trop different des autres membres. (T. And the reason is evident from what is done in the other arts and sciences; for a painter, when he paints an animal, does not allow or permit one paw to exceed and surpass the measurement and proportion that it should have in size, nor does he permit it to be too different in beauty from the other members.)
> G. Car se il passoit mesure ne en quantité ne en beauté, tout l'ymage en seroit plus lait. (G. For if it were disproportionately large in size or in beauty, the whole picture would be uglier as a result.)[14]

In the fourth chapter of Book V Oresme returns to the theme that no one party or group in the state should acquire too much power. Here the context relates to the undermining and changes of regimes caused by undue concentration of power: a reflection of a lack of proportion among the parts of the body politic:

> T. Item, transmutations de policies sunt faites pour excrescence, qui est pour proportion. (T. Item, transmutations of forms of government come about through abnormal growth for the sake of achieving proportion.)
> G. Ce est a dire pource que aucune partie de la policie est creue et faite grande oultre proportion deue. (G. That is to say, because any part of the government has been increased and enlarged beyond due proportion.)
> T. Car aussi comme un corps est composé de ses parties et convient qu'elles cressent et soient faites grandes proportionelment afin que la commensuration et la mesure des unes parties ou resgards des autres demeure et soit gardee. (T. For just as a body is composed of its parts and it is proper that they grow and increase proportionally so that the size and proportion of the parts in regard to one another are fixed and may be preserved.)
> G. Et ceste proportion doivent savoir ceulz qui funt les ymages. (G. And those who make pictures must know [this system of] proportion.)[15]

This passage thus reinforces the general interpretation of the fourth panel of the quadrilobe as an artist's correction of an error in making the arm of a figure disproportionately long. More specifically, the analogy in the text emphasizes the obligations of image makers to construct the parts of the body according to a consistent canon of proportion.

THE ANALOGY OF THE BODY POLITIC

This aesthetic canon rests on a basic metaphor of Western political thought: the analogy of the body politic. First developed by Plato in the *Republic* and the *Laws,* it is restated by Aristotle at the beginning of the *Politics:* "The polis is prior in the order of nature to the family and the individual. The reason for this is that the whole is necessarily prior [in nature] to the part. If the whole body be destroyed, there will not be a foot or a hand." [16] Substantially expanded by John of Salisbury in the *Policraticus* to create specific equivalents among parts of the body and parts of the state, the analogy of the body politic figures in Oresme's glosses and commentaries on Chapter 9 of Book II, Chapter 4 of Book V, and Chapter 10 of Book VII of the *Politiques*. [17] Oresme also includes a reference to the analogy in the index of noteworthy subjects of the *Politiques* under the heading *Moiens en richeces:* "Item, encor appert par une bele consideration qui compare la policie et ses parties a un corps et a ses membres" (Item, it again appears [through] a beautiful metaphor that compares the form of government and its parts to a body and its members). [18]

A rare visualization of the body-politic metaphor occurs in the Morgan *Avis au roys* (Fig. 63). Adapted from the iconography of the zodiacal man, a nude, well-proportioned, crowned, and bearded male figure represents the physical embodiment of the political body. Inscriptions identify parts of the human body with functions and offices of certain social classes and institutions of government. The resulting hierarchy of political and social values corresponds to the traditional evaluations of the organs of the human body in ancient and medieval anatomical and philosophical texts. For example, occupying the representational and metaphorical top of the hierarchy of the body politic is the king who is its head. As the most distinctive part of the human anatomy, in which the soul, reason, intelligence, and sensations reside, the head is the ruling principle to which all other parts of the human body and the body politic are subject. Next, associated with the vital human faculties of vision and hearing, the seneschals, bailiffs, and provosts and other judges are compared to the eyes and ears of the body politic. The counsellors and wise men are linked to the essential function of the heart. As defenders of the commonwealth, the knights are identified with the hands. Because of their constant voyages around the world, the merchants are associated with the legs. Finally, laborers, who work close to the earth and support the body, are its feet.

Oresme's interpretation of the analogy emphasizes the economic context of undue concentration of power in a few hands as a threat to the welfare of the

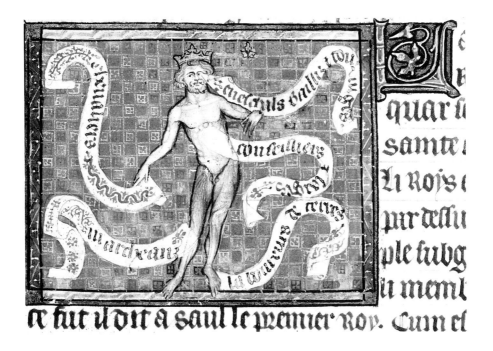

FIGURE 63 *The Body Politic. Avis au roys.*

body politic. As noted earlier, Oresme had sounded this theme in his influential treatise of about 1356, *De moneta*.[19] Because of his reference to the *Politics,* Oresme's treatment of the analogy is worth citing:

> The state or kingdom, then, is like a human body and so Aristotle will have it in Book V of the *Politics.* As, therefore, the body is disordered when the humours flow too freely into one member of it, so that member is often thus inflamed and overgrown while the others are withered and shrunken and the body's due proportions are destroyed and its life shortened; so also is a commonwealth or a kingdom when riches are unduly attracted by it.[20]

Interwoven with the body-politic analogy is Aristotle's concern with proportional relationships in aesthetics, ethics, and politics. Oresme's translations of the *Ethics* and the *Politics* reflect these important concepts. In addition, from a mathematical point of view, about 1350 he wrote a treatise on proportion, the *De proportionibus proportionum*.[21] A visual reference to Oresme's numerical use of proportional relationships occurs in the illustration of Justice distributive in Book V of *A* (Fig. 24). The program of the illustrations for Book IV of the *Politiques* will explore further the connections between political stability, the undue concentration of wealth in the hands of a few, and the analogy of the body politic.

While the lower right quadrilobe of Figures 60 and 61 ties together diverse strands of Oresme's writings, the question remains whether without inscriptions the references in the first three quadrilobes to Periander's advice were intelligible to contemporary readers. Appearing in Herodotus, as well as in Aristotle, the story was certainly well known in antiquity.[22] Periander was one of the Seven Sages, whose wise sayings or deeds were collected in both Greek and Latin sources.[23] The Greek form of the tale is also included in a classical source of the third century A.D.: Diogenes Laertius's *Lives of Eminent Philosophers*.[24] A Latin version of the story contained in the first book of Livy's *History of Rome* concerns the advice Tarquinius Superbus gave to his son Sextus in regard to the Gabii. While striking the heads of poppies (instead of the ears of grain) in the presence of messengers, Tarquinius's advice was understood by his son to mean "that he rid himself of the chief men of the state."[25] Livy's account of the Periander/Tarquin tale exists also in the *Factorum et dictorum memorabilium* of Valerius Maximus.[26]

In the Middle Ages the Latin version of the Periander/Tarquin tale survived through various channels. For instance, the writings of Valerius Maximus provide ample material for exempla used in popular forms of medieval literature such as sermons, commentaries on the Bible, and other sacred texts. Indeed, as Beryl Smalley points out, the original text of the *Factorum et dictorum memorabilium* itself was a collection of exempla "avant la lettre."[27] Moreover, it was a common practice to introduce quotations from diverse classical sources, including Livy's *History of Rome,* into Psalter commentaries and other types of exegetical and didactic literature.[28] Also used in sermons and other books of moral instruction were citations from Aristotle's *Ethics, Politics,* and *Economics.* It is, therefore, likely that the Periander/Tarquin story was well known from popular medieval literature.

The king and his counsellors also had at hand vernacular versions of the accounts by Livy and Valerius Maximus. As discussed in Chapters 1 and 3 above, Pierre Bersuire's French translation of the first, third, and fourth Decades of Livy executed for John the Good between 1354 and 1356 survives in a lavishly decorated manuscript commissioned by Charles V.[29] Since the Tarquinius story occurs in Book I of Livy, it was included in Bersuire's translation. Furthermore, the original copy of Simon de Hesdin's translation of the first four books of Valerius Maximus commissioned by Charles V still survives.[30] In short, Oresme could have assumed his reader's familiarity with the Periander/Tarquin tale through popular, classical, or vernacular sources.

THE VISUAL STRUCTURES

Investigation of both the internal and textual sources of Figures 60 and 61 shows that Oresme's initial challenge to the reader of identifying the precise content of the upper register may not have been too difficult. A second exercise, supplying a

definition of the missing word, *relégation,* might possibly have presented a greater obstacle. Yet recognition of the ostracism/exile theme might also have sparked comprehension of the climactic message of the lower left quadrilobe, to cut down men of the state who had become too powerful. More problematic is the reader's understanding of the meaning of the lower right quadrilobe both in itself and in relation to the preceding scenes.

Does the visual structure of the illustrations help the reader to interpret the ensemble? The four-scene format certainly requires that the tale be compressed. The treatment of the upper register as a single unit, tied together by the king's baton, combines the request for advice with the action of ostracizing a powerful person. In verbal terms the act parallels a definition of the word *relégation.* Justifying the action taken, the lower left quadrilobe is the equivalent of a maxim or proverb summarizing a message such as "Off with their heads." The scene on the lower right constitutes a concluding moralizing judgment or warning about the preceding episodes. A possible moral might be: "Rectify disproportionate power relationships in the body politic." In structuring the illustration Oresme could have applied certain techniques used in his translations: definition, compression, comparison, and exemplification.[31] In Chapter 18, Oresme refers to the Periander/Tarquin tale as "en parabole." Oresme's apparent use of the term to mean a proverb would explain the pithiness of the visual structure of Figures 60 and 61. Yet another stratagem may have guided Oresme in proposing the program. In all versions of the Periander/Tarquin tale a constant characteristic is "silent communication." This theme is embodied in Periander's action (or that of the peasant in Figure 60) of pulling up the tallest plants, identified in the various versions of the tale as corn, wheat, or poppies. The corollary of silent communication is the understanding of the message by the person requesting advice via the report given by the uncomprehending envoy. Søren Kierkegaard alludes to the Periander/Tarquin tale in the epigraph to his famous work *Fear and Trembling:* "What Tarquinius Superbus said in the garden by means of the poppies, the son understood but the messenger did not."[32] Oresme's elimination of inscriptions may well have carried out in the illustration the important theme of silent communication. As the illustration of Book IX in *C* shows (Fig. 41), Oresme enjoyed providing riddles for his readers to solve. What greater compliment to their acuity could he offer than the silent communication of the Periander/Tarquin tale?

THE PERIANDER/TARQUIN TALE AND CONTEMPORARY HISTORICAL EXPERIENCE

Another facet of the silent-communication theme is that the action recommended by Periander was too dangerous to be written down or transmitted orally by the messenger. The effectiveness of the stratagem depends on confidentiality, secrecy, and surprise. For, if the intended victims somehow learned about their intended fate, they might have exercised their own power to rid themselves of the person who sought the advice.

Charles V and his counsellors may well have recalled the unstable situation facing the Valois dynasty in 1356 following the crushing defeat of French forces by the English at Poitiers. The monarchy was threatened by the dynastic claims of Charles the Bad of Navarre, as well as the rural revolt of the Jacquerie and the opposition in Paris led by the provost of the wool guild, Etienne Marcel, who was murdered in 1358.[33] The Aristotelian concept of preserving a proportional system of relationships among groups holding political power in a state may have seemed a useful theoretical legitimization of a policy calling for the exile or banishment of current or future opponents of the monarchy.

Furthermore, the readers of the *Politiques* could well have recalled a recent example of official policy. In the context of negotiations with Charles the Bad for the exchange of certain territory, Charles V's ordinance of 8 March 1372 pronounced that the right of banishment in a criminal case was an exclusive royal prerogative.[34] Perhaps Oresme's design of the miniature was intended as references to Charles the Bad and potential opponents of the regime that were more prudent to veil by means of the Periander/Tarquin tale and the device of silent communication.

Thus, the miniatures in Charles V's copies of Book III of the *Politiques* (Figs. 60 and 61) represent a departure from Oresme's usual strategies in devising the programs of illustrations. The first feature entails a special challenge to the reader to identify the subject matter, locate the content within the text, and supply the missing key word of the verbal definition. Oresme may have relied on some of his basic rhetorical techniques as translator in setting forth such an unconventional program and in calling for his readers to supply the missing definition, maxim, and metaphors. It is entirely possible that he did not underestimate the abilities of his politically sensitive and acute audience. Their historical experience, knowledge of royal prerogatives in the matter of exile, and possible targets for such a policy could have simplified their task in deciphering the illustrations and increased their appreciation of their subtle construction. Any oral explication by Oresme might well have taken account of the receptivity of his audience to the theme of silent communication, especially in view of his seemingly paradoxical violation of its rules.

19 FOUNDATIONS OF POLITICAL STABILITY
(Book IV)

A DIAGRAMMATIC AND PRESCRIPTIVE PARADIGM

In an important sense the illustrations for Book IV in *B* and *D* (Figs. 64 and 65) continue the theme of stabilizing or neutralizing threats to the body politic inaugurated in the program of Book III, even though they contrast sharply with those of Figures 60 and 61. The allusive and cryptic representational mode chosen for the illustrations of Book III gives way in Book IV to a diagrammatic and prescriptive paradigm that serves as both model and example.

In the opinion of some scholars, Books IV to VI of the *Politics* provide a practical and unified treatment of the types and subtypes of the six forms of government. Whereas Aristotle examines Kingship and Aristocracy in Book III, in Book IV he analyzes the remaining four: Polity, Tyranny, Oligarchy, and Democracy.[1] Aristotle's discussion is based on his profound knowledge of the historical development and contemporary practice of forms of governments in ancient Greece. Once again Oresme had to translate the verbal concepts and historical context of the *Politics* into terms and institutions intelligible to his readers. Essential to his task are his selection, definition, and clarification of key terms both verbally and visually.

STYLES, DECORATION, AND LAYOUT OF THE ILLUSTRATIONS

Figure 64 (also Pl. 10) introduces a sequence of four illustrations executed by the Master of Jean de Sy and his workshop. In comparison to the *retardataire* elegance of the illustrations of the previous two books executed by the Master of the Coronation of Charles VI, the more naturalistic style of the Jean de Sy Master stands out strongly. His ability to give expressive vitality to the poses and gestures of the figures is clearly apparent in the diagrammatic illustration of Book IV. Fluid modeling and subtle alternation of the customary red-blue-green color chord and geometric backgrounds of the three compartments of the upper and lower register both unify and contrast them. A more naturalistic presentation results from eliminating the restrictive quadrilobe enframement of the two preceding illustrations. Instead, the entire miniature and the six individual compartments of Figure 64 are divided by slender gold exterior frames and pink, blue, and white painted interior ones.[2] The figures stand on narrow ground planes beneath rounded gold arches

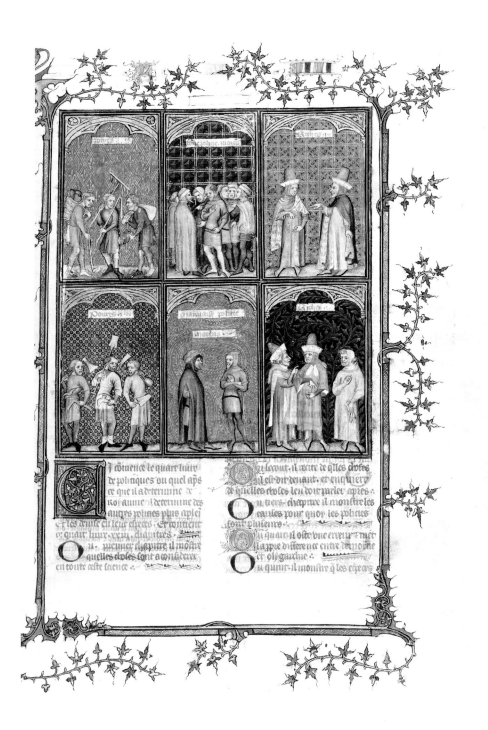

FIGURE 64　Above, from left: *Povres gens, Bonne policie—Moiens, Riches gens;* below, from left: *Povres gens, Mauvaise policie—Moiens; Riches gens. Les politiques d'Aristote,* MS B.

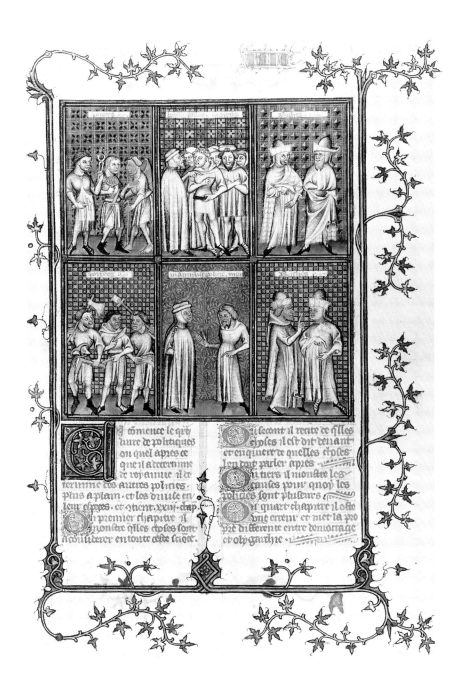

FIGURE 65 Above, from left: *Povres
gens, Bonne policie—Moiens, Riches gens;*
below, from left: *Povres gens, Mauvaise
policie—Moiens, Riches gens. Les poli-
tiques d'Aristote,* MS D.

decorated with corner lozenges and ending in bosses. Together with the frames, this abbreviated architectural element suggests a unified stagelike space in which the six compartments are separate but spatially united in a common structure.

In *D* the comparable illustration of Book IV (Fig. 65) closely follows the format and layout of Figure 64. The dimensions show a proportional similarity, as each miniature occupies about two-thirds of the folio. In the interests of economy, two major changes have been introduced. The gold arcades of Figure 64 are lacking and the figures are modeled in grisaille. Alternating red and blue geometric backgrounds, green washes, and other touches of color are, however, used for the ground plane and accessories held by the figures. The miniaturist is a member of the workshop of the Master of the Coronation Book of Charles V. Reduction of the modeling of the figures and accentuation of their linear contours emphasize the diagrammatic nature of the program. With their large heads, rigid stances, and exaggerated gestures, the individual forms seem like puppets. The central compartment of the lower register is somewhat marred by the carelessly written inscription that exceeds the allotted space.

THE MISSING DEFINITION

A last feature missing in Figure 65 is the empty rectangular band in the center space above the frame of Figure 64, where the intended inscription was not inserted. While it is possible that the omission was an oversight, it may also be the case that Oresme may have intended that readers should "fill in the blank" with the word *policie*.[3] A key term in Aristotle's text derived from the Latin *politia, policie* is a neologism in French defined by the translator in the glossary of difficult words as a political system, form of government, or constitutional government:

> *Policie* est l'ordenance du gouvernement de toute la communité ou multitude civile. Et policie est l'ordre des princeys ou offices publiques. Et est dit de *polis* en grec, qu'est multitude ou cité.

> (Polity is the arrangement of the government of the whole community or city population. And polity is the arrangement of authority or public offices. And it comes from *polis* in Greek, which is population or city.)[4]

In addition to this general usage of the term, Oresme employs *policie* as a synonym for Timocracy, the third of the good forms of government after Kingship and Aristocracy. As Oresme notes in a gloss, Timocracy is used in Book VIII of the *Ethics* to connote the particular form of constitution in which the multitude rules for the common good.[5] In English, this third form of government is sometimes called a Republic or, more frequently, Polity. Here it seems preferable to use the latter term as a synonym for the more archaic Timocracy.

Oresme's program for Figures 64 and 65 includes both meanings of *policie*. This double form of visual definition corresponds to the Aristotelian concept of definition as genus and species.[6] In Chapters 12 and 13 of Book IV Aristotle discusses Polity in a specific sense as the third of the good forms. Polity is a mixed constitution: a blend of Oligarchy and Democracy that avoids the extremes of these perverted forms.[7] Furthermore, Aristotle distinguishes between the social class that holds power according to wealth in the bad regimes: the poor rule in Democracy, and the rich in Oligarchy. But the economic group that holds sovereign power in Polity is the middle class. Thus, if the reader supplies the missing word for the inscription in Figure 64 as *policie,* examination of the headings for Chapters 12 and 13 would lead to definitions of that term. The first title reads: "Ou .xii.ᵉ chapitre il determine de une espece de policie appellee par le commun nom policie" (In the twelfth chapter he discusses one kind of government called by the common name of Polity).[8] The next heading states: "Ou .xiii.ᵉ chapitre il monstre comme ceste policie doit estre instituee" (In the thirteenth chapter he shows how this Polity must be instituted).[9]

Figures 64 and 65 also refer to the more general use of *policie* as a system of government. The index of noteworthy subjects offers references to the context of Oresme's terminology under the entry for *policie:* "La principal condition qui fait toute policie estre bonne en son espece et forte et durable—IV, 15, 16. Et de ce soubz cest mot *moiens en richeces*" (The basic condition that makes every polity in its individual way good, strong, and lasting—IV, 15, 16. And more about this under the heading *moiens en richeches* [the mean in wealth]).[10] This cross-reference leads to the entry under that heading:

> La principal chose qui fait policie estre tres bonne en son espece et seure et durable est que les citoiens soient moiens sans ce que les uns excedent trop les autres en richeces, mes en proportion moienne. Et tant sunt plus loing de cest moien de tant est la policie moins bonne—IV, 16, 17.
>
> (The principal thing that makes a polity very good of its kind and sure and lasting is that the citizens should be of average means, without some exceeding the others too much in wealth, but proportional to the mean. And the further they are from this mean, the less good is the polity—IV, 16, 17.)[11]

In this context, Oresme refers to Polity not as a specific constitution but as a generic system of government.

INSCRIPTIONS AND THE INDEX OF NOTEWORTHY SUBJECTS

Inscriptions above the central compartments of Figures 64 and 65 lead the reader to further entries in the index of noteworthy subjects relating to the roles of the

classes depicted respectively in the upper and lower registers: *bonne policie—moiens* (good polity—the middle class) and *mauvaise policie—moiens* (bad polity—the middle class). Under *povres gens* (poor people) in the index, two references to Book IV reinforce the message that the poor are less desirable governors than the middle class. Within the same heading a second entry explains: "Comment selon une consideration vraie, ce est inconvenient que aucune partie de la communité ou aucun estat soit simplement de povre gens—IV, 16" (How, according to a valid argument, it is not good that any part of the community or any estate be composed only of poor people).[12]

The linking function of the inscriptions to further explanations in the text continues in the right-hand compartments of the upper and lower registers of Figures 64 and 65. There the word *riches* leads to four references in the index of noteworthy subjects under the heading of *riches gens* (rich people). All four entries cite Chapters 12, 16, and 17 of Book IV. The first of two relevant references states that the moderately rich are better than the poor: "Que les riches sunt melleurs que ne sunt les povres, et est a entendre des richeces moiennement—IV, 12."[13] The second says that regimes are more likely to be destroyed by the rich than by the poor: "Que les policies sunt plus destruictes par gens tres riches que par autres—IV, 17."[14] Guided by these intriguing entries, the reader could turn directly to Chapters 16 and 17 of Oresme's translation to follow Aristotle's argument regarding the crucial role of the middle class. One such passage reads:

> Et donques appert que la communion ou communication politique qui est par gens
> moiens est tres bonne, et que les cités politizent bien et ont bonne policie qui sunt
> teles qu'en elles la plus grande partie ou la plus vaillante ou plus puissante est de
> gens qui sunt ou moien.
>
> (And thus it appears that the community or political association which is [formed]
> by the middle class is very good, and that states which work well politically and
> have a good form of government are those in which the most active or most power-
> ful part is of the middle class.)[15]

The presence of a sizable middle class, then, ensures the political stability of a constitution.

THE VISUAL STRUCTURE OF THE ILLUSTRATIONS

To combine the lexical and indexical functions of the illustrations in a coherent, comprehensible system was no easy task. Although the design of the format reveals complex political, social, and economic relationships, the scheme adopted seems simple and clear. The two-register format conforms to a contrast between good and bad entities on the top and bottom respectively. This type of contrast between opposites is found in Aristotle's writings and "was common in classical, medieval,

and Renaissance logic."[16] The subdivision of each register into three compartments provides further horizontal and vertical comparisons of individual units to each other and to the register as a whole. Position on the left, right, and center also communicates ethical and social oppositions.

Allied to the visual and lexical structure as a means of communicating social contrasts is costume. The clothes worn by the figures in the six compartments signal and reinforce the differences among the social classes in a polity. The long mantles or short *pourpoints* and tight hose of the middle class in the central compartment are distinguished from the lavish, fur-trimmed robes and high-domed hats of the rich on the right and the short tunics, torn hose, and bare feet of the laboring poor on the left. The poor are also characterized as to occupation and status by their tools.

The number of figures in the various compartments explains key concepts. The most obvious example relates to the contrast between the middle class in Bonne policie above and Mauvaise policie below. In the Good Polity the middle class is represented by a crowd, while in the Bad Polity this group has suffered a severe reduction to two members. The tightly packed central group in Bonne policie engrossed in speech gives the impression of a closely knit body united in a common goal. The circular group of Figure 64 conveys the idea of animated, cooperative communication. By way of contrast, the two figures in the central compartment of the lower register of Figure 65 face each other across a central void that emphasizes their isolation. The treelike form of the background pattern intensifies the effect. In Figure 64 the rich in Mauvaise policie have increased by one third over the two imposing figures of the Bonne policie.[17] The most subtle device of the visual structure of Figures 64 and 65 is the use of the central compartment to signify the mean in relation to physical position, socioeconomic status, and political/ethical orientation. Standing in the center of the composition, the middle class occupies the mean position between the extremes of poverty and wealth.

The clarity of Oresme's program for Book IV contrasts with an illustration in the Morgan *Avis au roys* that also deals with the middle class as a stabilizing force in the body politic (Fig. 66). A blank for an inscription, like that of Figure 64, occurs in the center of the composition. On the left, a king points with his right hand to the seated figure in the center, representative of the middle class, who counts out the money in his purse. Also pointing to the central figure is the person standing on the right, who may represent a member of the wealthy class. The contrast between the classes, characteristic of the costumes, visual structures, and inscriptions of Figures 64 and 65, remains undeveloped in the Morgan miniature.

THE MIDDLE CLASS AND THE ARISTOTELIAN CONCEPT OF THE MEAN

The placement of the middle class between two extremes in Figures 64 and 65 could remind readers of similar concepts and illustrations in the *Ethiques*. Of paramount importance is the essential Aristotelian concept of Virtue as a mean be-

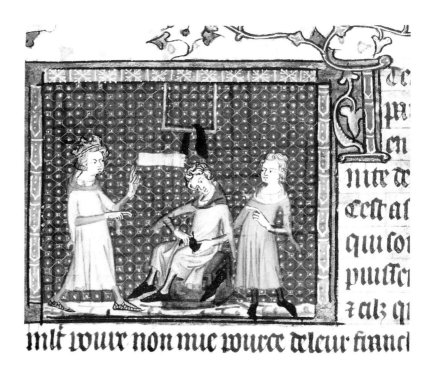

FIGURE 66 *Social and Economic Classes of the Kingdom. Avis au roys.*

tween too much or too little of a moral quality. Oresme gives stunning visual form to the generic concept in the personification allegories of Book II (Figs. 11 and 12); specific examples occur in the miniatures of Books III and IV of *C* (Figs. 16 and 21). Oresme makes an interesting analogy between ethical and political character. In a gloss on Chapter 13 of Book IV of the *Politiques,* the translator explains that Polity (in the sense of a good regime) mixes elements of Oligarchy and Democracy in the same way that Liberality is "composee et moienne de pro-digalité et de illiberalité" (composed [of] and [is the] mean [between] Prodigality and Illiberality). Oresme goes on to make the same point about Fortitude: "Et ainsi diroit l'en que la vertu de fortitude est moienne et composée de hardiece et de couardie" (And thus one could say that the virtue of Fortitude is the mean and [is] composed of Courage and Cowardice).[18]

Oresme's association of the middle class with the group that holds the ideal mean position in terms of wealth and political power relates to other key Aristotelian concepts previously explored in the *Politiques* and other writings. For example, Oresme's commentary on ostracism in Chapter 19 of Book III of the *Politiques* declares that banishment is an extreme remedy for the concentration of wealth and possessions in the hands of any one group. A wise ruler or regime would avoid such an obvious threat to political stability.[19] Warnings against correct proportional relationships among the members of the body politic is a main theme also of *De*

moneta.[20] Thus, the illustrations for Book IV continue Oresme's and Aristotle's concern for correct proportional relationships in society and politics. Although ethical considerations play a part in the textual and visual foundations of the predilection for the middle class, in this analysis pragmatic considerations of political utility exercise a preponderant role.

The adjective *moiens* on the central inscription ties together the complex power relationships among the three groups. Most significant is the mediating political role of the middle class. In Chapter 15 of Oresme's translation the discussion focuses on which form of government is most suitable for the majority of states. The text explains why both the rich and the poor dislike princes. The poor feel oppressed by the central authority of the prince and will carry out machinations against him, while the rich are anxious to obtain power for themselves.[21] But, Oresme states in a gloss, the middle class is free of envy and lives without fear. Furthermore, the *gens moiens* will not take part in "les seditions et commotions et rebellions" (seditions and disturbances and rebellions) in which the poor and rich participate.[22] Avoiding the extremes of oligarchy when the rich rule or the disorder of the worst types of democracy, the middle class serves as a moderating force in political life. Chapter 16 continues the explanation of how the middle class contributes to political stability. At this point Oresme inserts a lengthy commentary that deals with the unsatisfactory methods of the contemporary church in distributing wealth.[23]

THE IDEALS OF BONNE POLICIE AND CONTEMPORARY HISTORICAL EXPERIENCE

The programs of Figures 64 and 65 present Aristotle's generic and specific definitions of polity. Even though costumes differentiate the social classes and their relationships that promote or destroy effective political systems in contemporary terms, the illustrations suggest only a few explicit historical references. For example, representation of the agricultural poor in Bonne policie might have recalled the revolt in 1358 of the Jacquerie. On the other hand, Oresme considers agricultural workers the least politically active and dangerous group.[24] The poor depicted in Mauvaise policie appear to belong to the group of workers who have more leisure for subversive political activity. Their tools identify them as artisans connected with the building trades.[25] In the insurrections of 1358 craftsmen actively opposed the Dauphin. Charles V's mistrust of this group led in 1372 to his regulation of their economic life in Paris by a royal official, the provost of the city.[26]

The presence of the rich might also recall the pressure for a more equitable fiscal system brought about by the financial reforms of 1360, as well as the earlier opposition to the future Charles V of the wealthy merchants and the Parisian *haute bourgeoisie* led by Etienne Marcel.[27] Yet other contemporary issues addressed in Oresme's commentaries on Book IV, such as the proper distribution of wealth among the classes making up the political community of the church, are not represented in the illustrations.[28] All in all, rather than a subversive plea for establishing Policie as a specific form of government, it seems more appropriate to interpret

the programs of Book IV as general prescriptions for securing effective political rule and avoiding the type of class warfare that leads to political instability. Such a function of the program for the illustrations of Book IV is consistent with its position as the second of a series devoted to the theme of the dangers to, and the means of, preserving political stability within a state. In Figure 64 the abbreviated architectural settings constitute a unified environment suggestive of a spatially related community and memory structure.

Although Figures 64 and 65 fulfill apparently straightforward lexical and indexical functions, their visual structures are in fact quite sophisticated and rare examples in secular iconography of the presentation of such complex concepts of social and political theory. Furthermore, the lucidity of the visual structure reflects and translates Aristotelian methods of argument. Among the most unusual of these devices is the identification of the central area of the pictorial field with the Aristotelian concept of the mean to embrace the ethical, political, and social realms. The allied preference for a triadic ordering scheme promotes understanding and recollection of the central positive and off-center negative opposite qualities. If in oral exposition Oresme was called upon to elaborate on the propositions selected for the illustrations of Book IV, the program he devised would have provided substantive talking points from which his discussion could embark.

20 UNDERMINING THE BODY POLITIC
(Book v)

PATHOLOGY OF THE BODY POLITIC

The illustrations for Book V of the *Politiques* (Figs. 67 and 68) are the third of a series concerned with means of preserving or undermining political systems. The underlying theme is the metaphor of the health or disease of the body politic. Unlike the illustrations of Book IV, the set of miniatures for Book V relies on visual definitions, which serve as invented exempla of the paradigmatic representational mode. Although Oresme's program continues the two-register format of the illustrations for Books III and IV, here he employs the visual structure for narrative and dramatic ends.

The text of Book V provides the basis for such a dramatic treatment. The subject is what Ross calls the "pathology of the state," since Aristotle plays the role of a physician in "diagnosing the causes and in prescribing the cure for the diseases of the body politic." Book V discusses the causes of revolution and the means of preventing it in both good and corrupt regimes.[1] Enhanced by a wealth of examples drawn from Greek history, Aristotle's practical treatment of the means of preserving even the most corrupt regimes from revolution has led scholars to consider Book V as an ancestor or model of Machiavelli's *The Prince*.[2] Within the context of the causes of sedition, Oresme's commentary on the fourth chapter of Book V discusses the tradition of the concept of the body politic.[3]

FORMAL ASPECTS OF FIGURES 67 AND 68

To realize Oresme's program for the updated and concrete presentation of the dramatic subject of revolution, the illuminators had to enlarge their visual vocabulary. In one of his most accomplished miniatures (Fig. 67), the Master of Jean de Sy constructs for the first time in the cycle elaborate internal architectural settings and an abbreviated landscape background. The challenge of representing verbal and emotional interplay among different social groups suits his fluent figure style. Animated gestures, varied postures, and individualized facial expressions enliven the scenes. The miniature occupies two-thirds of the folio.

The same mise-en-page is followed in Figure 68. Executed by a member of the workshop of the Master of the Coronation Book of Charles V, in dimensions

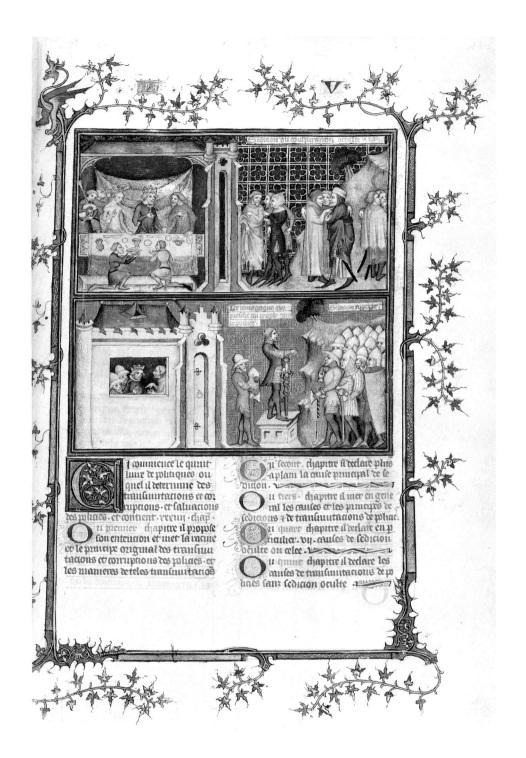

FIGURE 67 Above: *Sedition ou Conspiracion occulte*; below: *Le Demagogue qui presche au peuple contre le prince, Sedition apperte*. *Les politiques d'Aristote*, MS B.

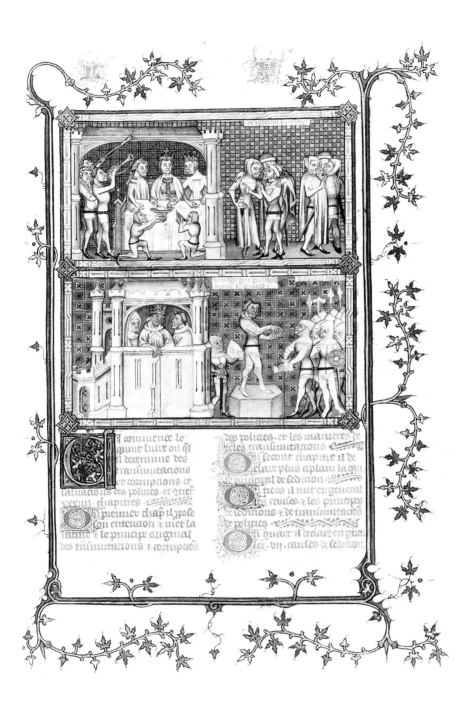

FIGURE 68 Above: *Conspiracion oc-
culte;* below: *Demagogue preschant contre
le prince, Sedition apperte. Les politiques
d'Aristote,* MS D.

and layout this miniature replicates the proportional relationship of image to text of Figure 67. Yet within this consistent pattern several elements mark an elaboration of the miniature. Although the figures are modeled in the usual grisaille technique, color differentiates parts of the architectural setting, such as the green gate, red roof, and blue turrets. Gold is also visible in the table furnishings, crowns, and musical instruments. White and black take on important roles in delineating key areas such as the tablecloth or the armor, belts, and shoes of military uniforms. One exceptional feature that appears for the first time in this cycle is the bold exterior frame that surrounds the miniature and divides the two registers. Several elements of the enframement are fashioned in gold: the thin outer band and the six diamond-shaped lozenges embossed with trefoils. The most conspicuous feature is the wider inner band decorated with zigzags and alternating vertical and horizontal geometric motifs painted in pink and white on the upper register and in black and white on the lower one. Altogether the effect enhances the existence of each scene as a separate entity and emphasizes its three-dimensional aspect. Despite these enrichments of Figure 68, certain reductions are evident in comparison to similar elements in Figure 67. For one thing, landscape features are entirely eliminated. Architectural elements, numbers and groups of figures, and certain accessories, such as the tableware, are simplified and reduced in size. Despite these changes and the dryness of the illuminator's style, the expressive character of the miniature remains intact.

THE VERBAL DEFINITIONS

The summary paragraph directly below Figures 67 and 68 immediately alerts the astute reader to the dramatic content of Book V: "Ci commence le quint livre ouquel il determine des transmutations et salvations et corruptions des policies. Et contient .xxxiiii. chapitres" (Here begins the fifth book in which he ascertains the changes and corruptions and salvations of governments; it contains thirty-four chapters).[4] Oresme emphasizes two important themes: the transformation of the forms of government and their corruption. To understand Aristotle's discussion of the processes by which such changes take place, Oresme offers the reader a detailed series of verbal aids. The first clue is the inscription found just below the top of the upper register. Figure 67 gives a double definition, "Sedition ou conspiracion occulte" (sedition or hidden conspiracy), while Figure 68 uses the second phrase only. The neologism *sedition* appears immediately below the miniatures in the headings for Chapters 2, 3, and 4. In a gloss on the first chapter of Book V Oresme defines the term by a series of synonyms: "Sedition, si comme il me semble, est conspiration ou conjuration ou commotion ou division ou dissention ou rebellion occulte ou manifeste d'un membre ou partie de la cité ou de la communité politique contre une autre partie" (Sedition, as it appears to me, is a conspiracy or plot or disturbance or division or dissension or rebellion—hidden or open—by a member or part of the city or political community against another part).[5] Oresme includes definitions of sedition in both the index of noteworthy

subjects and the glossary of difficult words.[6] Indeed, the latter uses the exact words such as *conspiration occulte* and *sedition aperte* (open sedition) that appear in the inscriptions of the upper and lower registers respectively.

The inscription on the lower right of Figure 67 reads: "Le demagogue qui presche au peuple contre le prince" (The demagogue who rails against the prince). In Figure 68 the phrase is shorter: "Demagogue preschant contre le prince." The neologism *demagogue* does not appear in the chapter headings, but it does figure in the index of noteworthy subjects and the glossary. Oresme defines it in the latter place: "Demagogue est qui par adulation ou flaterie demeine le menu peuple a sa volenté et qui les esmeut a rebellion contre les princes ou le prince" (A demagogue is one who by false praise or flattery excites the populace to rebellion against princes or the prince).[7]

VISUAL DEFINITIONS AND VISUAL STRUCTURE

The programs of Figures 67 and 68 clearly function as updated and concrete visual definitions of key terms such as *sedition, conspiracion,* and *demagogue.* The visual structure offers a close fit with the paradigmatic representational mode, the definitions, and their textual amplification. To begin with, the two-register format permits division of the picture field into two separate units that organize the action sequentially and chronologically. Within each unit, lateral subdivision into interior and exterior areas represents simultaneous action. The initiators or agents are depicted in the right half of the scene; the objects of the actions, in the left.

On the upper left, a royal meal takes place within the cutaway walls of a palace banqueting hall. Flanked by a male companion and a queen, a king in the center is drinking from a goblet. (The queen is the only female figure represented in the eight miniatures of the *Politiques* cycle.) Three musicians play while two kneeling servants offer food. The sumptuous gold curtain behind the table accentuates the luxurious character of the repast. The expressions of the royal couple and the gesture of their companion who points to the right reveal an awareness of the *conspiracion occulte.* In Figure 67 an open portal leads to the outside where a hill is crowned by a clump of trees and where three groups of figures in civilian dress converse. All three men on the left point toward the palace door, toward which two are walking. Locked in a circle defined by the arms of the man in the middle, the three face-to-face figures of the closely knit central group engage in earnest conversation. The fragmentary group on the right is also united in an embrace. In Figure 68, the same arrangement of figures appears within a more simplified palace interior. Here, however, only two groups of figures converse on the right, and the specific landscape setting is eliminated. Both figures represent an enactment of sedition and secret conspiracy against a royal regime. In fact, the action of the figures on the right carries out another part of Oresme's definition of these terms: "Et avient communelment que murmure precede sedition" (And whispering generally occurs before sedition breaks out).[8]

The lower register of Figures 67 and 68 represents a second phase of the conspiracy, *sedition apperte*. The left half of the register indicates a *transmutacion* of regime. In another room within the castle seen from above, the bust-length figure of the king of the upper register is visible through a small rectangular pictorial opening of a solid wall. The door of the castle is now shut. The two helmeted soldiers on the left and the gesturing figure on the right suggest that the king is now a prisoner. In Figure 68 the imprisonment of the king is even more clearly represented than in Figure 67. The former scene shows the king in a frontal position; his crossed hands suggest resignation or acceptance of his new situation.[9] The discussion that takes place in Figure 67 between him and his military and civilian guards gives way in Figure 68 to wary surveillance. The transfer of the closed portal and gateway from the right to the left emphasizes the isolation of the imprisoned ruler from the military force outside the castle walls.

On the right of Figures 67 and 68 the apparent agent of the change of regime is the "demagogue qui presche au peuple contre le prince." The groups of civilian conspirators of the upper register yield to one armed leader. Accompanied by an aide who holds his helmet, he stands on a rostrum addressing his audience. The full-length figure and profile head of the demagogue in Figure 67 display a confidence conveyed by his sword and the gesture of his outstretched arm. His audience is dramatically grouped within the rocky landscape setting. Also standing (mostly) in profile, their expressions and gestures indicate their rapt attention to his address. The profile view of speaker and audience is part of a gestural code that associates it with low social status and irresponsibility or treachery.[10] The armor, helmets, and shields that the demagogue and his listeners wear indicate that a military coup d'état is under way or about to take place.

As in the illustrations of Books III and IV, the visual structure of Figures 67 and 68 again employs parallelism and contrast of the upper and lower registers. The program for Book V, however, contains novel narrative elements derived partly from the definitions. The extensive architectural settings and the landscape in Figure 67 reinforce associations with the respective political antagonists. The castle is a visual metaphor of the monarchic regime in which power is located. More specifically, Oresme's program suggests the rhetorical figure of synecdoche, in which the part stands for the whole of a conceptual relationship.[11] The exterior setting in which the sedition takes place presents a similar figure for those who stand outside, or divided from, the political regime.

The two-register format also indicates a temporal sequence, as the hidden conspiracy of the upper register gives way to the open rebellion and transfer of power to the conspirators in the lower. Several references to time derive from the forms of the definitions: hidden and open conspiracy or sedition; whispering preceding sedition; and the demagogue preaching against the prince. Parallel settings establish an ironic contrast in terms of the "ins" and "outs" who hold political power. In the left half of the upper register, those inside the banquet hall exercise sovereignty. Directly below this scene the castle becomes a prison for the prince, who is now "out." Conversely, the "outsiders" on the upper right become the "insiders" of the lower right with respect to holding political power. In addition, the

lateral division of each register also permits a cause-and-effect relationship be-
tween the actions and actors of the left and right halves of the miniatures. Cos-
tumes and gestures reinforce the contrasts and parallelism of the visual structures.
Oresme's program fashions a fictive exemplum of the paradigm enunciated in the
generic verbal definitions.

THE APPEAL TO HISTORICAL EXPERIENCE

The programs of Figures 67 and 68 could certainly recall to their primary audience
the formative historical experiences of the present regime. Oresme's selection of
the themes of sedition and demagoguery as they affect kingdoms, and not the
other systems of government, reflects a conscious attempt to raise associations with
contemporary political events. To be sure, the miniatures do not permit specific
identification of the ruler as either king or tyrant. Indeed, Oresme may have in-
tended that the distinction remain ambiguous in view of Aristotle's discussion in
the *Politics* (Book V, Chs. 21 and 22) on the corruption of monarchy and its
transformation to tyranny.[12] The banquet scenes emphasize the dangers to rulers
of secret plots or conspiracies. Oresme may be alluding to Aristotle's statement
that rulers tend to be corrupted by excessive wealth.[13] Accumulations of riches
and honors invite the envy of subjects and are the source of sedition. Aristotle
further points out that in hereditary monarchies kings may indulge themselves in
bodily pleasures at the expense of their responsibilities to their people:

> T. Mes es royalmes qui sunt selon lignage, ovec les choses qui sunt dictes il con-
> vient mettre une autre cause de corruption. Et est ceste: que pluseurs telz roys sunt
> faiz de legier contemptibles et despitablez. (T. But in hereditary kingdoms, in addi-
> tion to things already mentioned, it is necessary to set out another cause of corrup-
> tion. And it is this: that several such kings readily merit contempt and scorn.)
> G. Pource que il vivent trop delicieusement et sunt negligens si comme il fut dit ou
> .xxii.ᵉ chapitre. (G. That is because they live too much for pleasure and are negli-
> gent, as was stated in the twenty-second chapter.)[14]

Perhaps certain features of the upper left scene of Figures 67 and 68 allude to
the types of excessive expenditure that corrupt and endanger hereditary kingdoms.
In Figure 67 particularly, the elaborate feast, gold curtain, and musicians indicate
such dangers. Figure 68, however, may depict another type of threat to hereditary
kingdoms. There the companion of the royal couple wears a mantle whose dis-
tinctive fur strips indicate a member of the royal family.[15] In a gloss at the begin-
ning of Chapter 24, Oresme mentions sedition provoked by a person already tak-
ing part in government: "Si comme quant aucuns du lignage du roy ou autres
grans seigneurs de son royalme funt conspirations contre lui" (As when some
persons of the king's lineage or other great lords of his kingdom conspire against
him).[16]

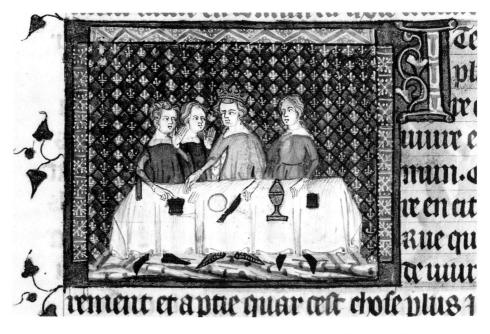

FIGURE 69 *A Royal Banquet. Avis au roys.*

Charles V and his counsellors were personally aware of the dangers of sedition fomented by a close relative. During the political crisis of 1358–60, Charles's brother-in-law, Charles of Navarre, known as the Bad, contested the regent's claim to the throne.[17] In 1356 the alliance of Etienne Marcel with Charles the Bad almost cost the regent his future throne and his life.[18] Furthermore, in the context of *Sedition apperte* the scene of a demagogue addressing his troops might well recall to Charles V the plots of Etienne Marcel and Charles the Bad. As a way of updating the definition of a demagogue in the glossary, Oresme cites as an example the earlier fourteenth-century bourgeois leader, Jacques d'Artevelde.[19]

The immediacy of historical recollection offered in Figures 67 and 68 to its primary audience may have formed part of Oresme's strategy in designing the program of Book V. While the total visual structure of the illustrations contains novel elements, individual sections rely on standard iconographic types. For example, the banquet scene of the upper left is familiar from a wide variety of medieval secular and religious visual and textual sources, including a miniature from the Morgan *Avis au roys* (Fig. 69). The scene of the demagogue addressing the troops adopts the Roman iconographic theme of *adlocutio*.[20]

In addition to the dimension of historical experience, Oresme's program for the illustrations of Book V incorporates another didactic level. Oresme refers in several glosses to Aristotle's discussion in the *Rhetoric* of anger and hate as motives for the overthrow of kingdoms and tyrannies.[21] Oresme thus may have intended

Figures 67 and 68 as a warning to his readers to avoid such patterns of dangerous conduct and expenditure. He may also have expected that these themes of threats to political stability would lead his politically aware readers to connect the most relevant message of Book V to those advanced in the previous two books of the *Politiques*. Oresme's predilection for visual emphasis of the dangers to the health of the body politic conforms to the warnings in Aristotle's text. Yet the unified but varied treatment of the theme in three successive illustrations reveals also the translator's personal preoccupation with these subjects, evident in early writings such as the *De moneta*. In terms of the metaphor of the pathology of the body politic, the overthrow of a regime corresponds to its death. Charles V and his counsellors could not have remained indifferent to such a dramatic outcome as the one examined in Book V. If some implications of these textual and visual interweavings may have escaped his readers, Oresme's oral explications could have knit together the threads.

2I GOOD DEMOCRACY: A PASTORAL VISION?
(Book VI)

In several respects the illustrations for Book VI of the *Politiques* (Figs. 70 and 71) are unusual. For the first time in the cycle the picture field of a large-scale frontispiece remains undivided and permits the depiction of a continuous landscape. The naturalistic style of these illustrations is a landmark in the development of this genre in late medieval art. In fact, the aesthetic and formal aspects of these images are so engaging that they obscure the textual basis of Oresme's program. Nevertheless, as in previous frontispieces, a close relationship exists among the representational mode, the text, and Oresme's interpretation of its content.

The surprising format and formal qualities of Figures 70 and 71 are related to Aristotle's move from the two previous books, where he treats the typology, destruction, and preservation of actual states, to problems of constructing constitutions in ways that will enable states to survive securely.[1] In Book VI Aristotle discusses the types and suitable structures for oligarchy and democracy, two of the six paradigmatic regimes that he had classified as the vitiated forms of rule by the few and the many. At the beginning of Book VI, however, Aristotle considers combinations of forms of regime, a possibility not previously considered.

While the unbroken picture field in Figures 70 and 71 lends the illustrations a feeling of monumentality, the miniatures are of normal dimensions. Both occupy about two-thirds of the text block. The extraordinary format and formal qualities of these images eclipse the splendid mise-en-page and decorative layout. Free of inscriptions, the undivided rectangular space of the illustrations gives them the appearance of small panel paintings. Except for the foliate, scroll-like pattern of the geometric background at the top, human figures and animals are freely set within a continuous landscape sloping gently upward in a series of three diagonally sectioned planes. Strategically placed trees, animals, and implements lead the eye from the foreground eating and plowing scenes to the grazing horses and shepherd guarding his flock in the middle distance. The third plane contains a group of figures in the upper left, and in the center and upper right planes, thatched buildings nestle among trees.

In Figure 70 (also Pl. 11) the Master of Jean de Sy creates a persuasive naturalistic space. Although figures and objects do not diminish consistently in size as they recede into the distance, the illuminator creates the effect of a harmonious

relationship between figure and natural setting. The unbroken perspective also has the effect of empowering the reader to gain visual control over the subjects portrayed. The men eating in the lower left are set within an ample pocket of space marked off on the top, bottom, and side by plants and a tree; on the right, by a vigilant dog. To the right of this scene, and also on the front plane, the Master of Jean de Sy creates another pocket of space occupied by a steeply raked plot of ground being harrowed by a farmer and his horse. Also convincingly placed in the middle ground are two grazing horses and a flock of sheep, a gamboling goat, and a shepherd. The diminished scale of figures and animals in the middle distance is skillfully executed. Less successful are the spatial relations of the farthest plane, in which the figure groups, trees, and houses seem too large.

The illuminator's judicious use of color also creates the effect of spatial unity. An overall gray-green tone encompasses the entire landscape, with the only exception being the beige and black area of the plowed furrows. On closer inspection this dominant tonality is shaded by stony outcrops painted in a lighter gray. The dark green of the distinctive tree clumps punctuates and marks off planar subdivisions of the picture space, as do the lightly brushed-in, brown forms of vegetation. The same dark green sets off a planted area in front of the three buildings set at sharp angles to one another. Except for the brown of the foremost grazing horse, a contrasting white tonality defines all the animals. White is also used for the walls of the buildings, whereas brown is used for the thatched roofs. A more neutral grayish rose depicts the costumes of all but three of the human figures. The man eating bread, the farmer harrowing the field, and the central figure of the group seated under the tree furnish bright red accents picked up by the background motif and the foliate initial and rubrics below. The Master of Jean de Sy both enlivens and unifies the picture space with this subtle use of color. Although his range is more limited, in Figure 71 the Master of the Coronation Book of Charles V employs similar means. Here a deeper greenish blue delineates the fields and trees of the landscape. Only the gray-brown diagonal swath of the plowed area in the foreground and two gray-blue areas occupied by the grazing horses and the figure groups of the middle and farthest zone relieve the dominant color chord. The grisaille of the figures offers the other major color tonality. Muted tones prevail elsewhere: implements and buildings, yellow-brown for the roofs, whitish brown for the horses, and bluish white for the sheep.

The simplification of color in Figure 71 is echoed in the abbreviated elements of the overall composition. Except for one tree in the middle distance, landscape features are reserved for the farthest zone. Missing also from Figure 71 are several groups of sheep, the gamboling goat, the dismantled cart, and the figure stepping on his spade in the middle distance of Figure 70. Another facet of the reductive character of Figure 71 is the flattening of the spatial recession. The clear definition of the three planes accentuates the sharp, rapid tilt upward. Furthermore, the larger size of the figures and animals decreases the harmonious relationship of men and nature that is a hallmark of Figure 70. Yet in Figure 71 the Coronation Book Master makes positive changes in the composition. For example, the extension of the plowed strip adds coherency to the foreground plane. The same holds true of

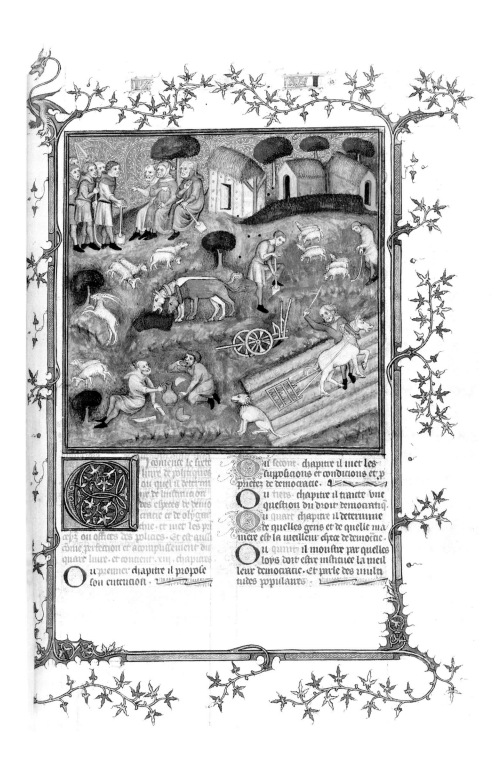

FIGURE 70 *Bonne democracie. Les poli-
tiques d'Aristote*, MS B.

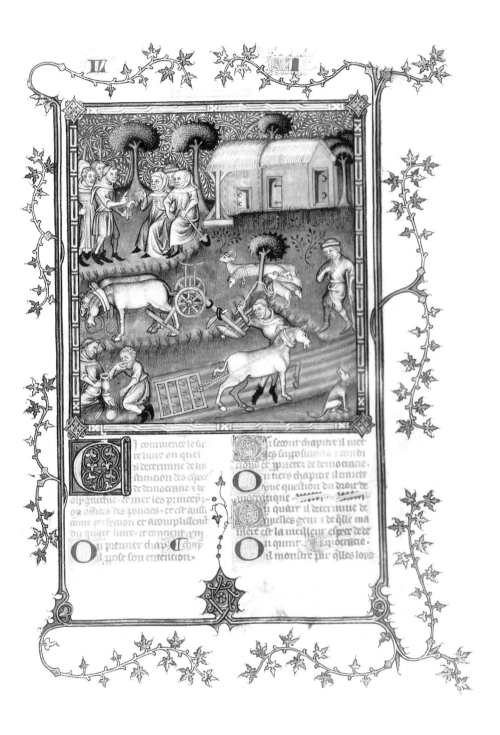

FIGURE 71 *Bonne democracie. Les poli-*
tiques d'Aristote, MS D.

the relationship among the grazing horses and the cart or plow in the middle ground and the harrowing taking place in the foreground. Two charming touches added by the Coronation Book Master are the upraised head of the dog and the pipe played by the strolling shepherd. Altogether, Figure 71 maintains the convincing representation of figures and animals within a unified landscape setting.

Both images communicate the miniaturists' sympathy for these scenes of rural pursuits. The labors of the peasants and shepherd are portrayed in a positive way. The Master of Jean de Sy seems particularly aware of the plight of agricultural workers, the poor, and politically marginal, as the illustrations for Books IV and VII (Figs. 64 and 74) show. The intensity of expression and the freedom of movement of the men eating and plowing are but two examples of this type of sympathy. Even more marked is the naturalistic observation and representation of animals. Both illuminators effectively convey their different movements and expression. Particularly noteworthy are the absorption of the grazing horses, the patience and suffering of the horses attached to the harrow, the vigilance of the dog, and the sprightliness of the goat. By way of contrast, the men on the upper left of both miniatures seem stiff in pose and gesture. The observations of Schapiro and Panofsky that the lower classes of society and animals are more naturalistically represented than sacred, royal, or aristocratic figures seem to hold true in the context of the *Politiques* cycles.[2] Panofsky's further observation that the upper classes enjoy the *genre rustique* as an ironic and parodic commentary on their own pursuits seems appropriate in view of the primary readers of the *Politiques*.[3] Recent scholarship has raised additional questions about the extent to which this representation of the peasantry expresses the ideology of the ruling classes. These points will be discussed in the concluding section of this chapter.[4]

VISUAL DEFINITIONS AND TEXTUAL LINKAGE

Thus far analysis of Figures 70 and 71 has focused on their formal qualities as related to the single-register format. As noted above, the change from an overtly didactic and diagrammatic representational mode closely tied to verbal descriptors to one free of such ties may appear to mark a striking departure from the previous illustrations of the *Politiques* cycle. Yet these appearances are deceptive, since Oresme follows the same procedure of linking text and image noted in previous programs. Since Figure 70 lacks any inscription, the reader must turn to the introductory paragraph below the miniature to identify the essential concepts discussed in Book VI. Oresme offers the following summary: "Ci commence le sixte livre ouquel il determine de l'institution des especes de democracie et de olygarchie. Et met les princeys ou offices des policies. Et est aussi comme perfection et acomplissement du quart livre. Et contient .xiii. chapitres" (Here begins the sixth book in which he defines the requirements of the [different] types of democracy and oligarchy. And he sets forth the ruling powers or functions of these forms of government. And it [Book VI] is in a sense like the completion and fulfillment of Book IV. And it contains thirteen chapters).[5]

Since *democracie* and *olygarchie,* the two principal terms, are neologisms, the reader could turn to the glossary of difficult words to recall their meaning:

Democratie est une espece de policie en laquele la multitude populaire tient le princey a leur profit. Et ne est pas bonne policie. Et olygarchie, ou les riches qui sunt en petit nombre le tiennent, est pire, et tyrannie tres malvese. Et de democracie est determiné ou .iv.ᵉ livre ou quart chapitre et ou tiers livre ou .xi.ᵉ chapitre. Et est dit de *demos* en grec, qui est peuple; et de *archos,* prince ou princey.

(Democracy is a kind of regime in which the people [at large] rule for their own benefit. And it is not a good regime. And oligarchy, in which the rich who are few in number rule, is worse, and tyranny is very bad. And democracy is defined in the fourth chapter of the fourth book and in the eleventh chapter of the third book. And it [the term] is derived from *demos* in Greek, which is people; and from *archos,* ruler or rule.)[6]

Because the definitions of both terms link them with Aristotle's corrupt constitutions, the reader might have been puzzled by an apparent contradiction between the positive qualities conveyed in Figures 70 and 71 and the negative connotations of these terms. To avoid such confusion, an inscription was added above Figure 71: *Bonne democracie.* The unusual placement of the inscription between the ivy-leaf sprays of the upper border and the enframement indicates its likely addition after the completion of the miniature. The irregular shape of the rectangular band and the faint color of the ink also point to an unplanned intervention by the scribe, Raoulet d'Orléans. Perhaps he and Oresme responded to a suggestion— possibly from Charles V—that the reader needed verbal guidance to understand the scope of the miniature.

The term *Bonne democracie* is helpful to the reader in several ways. First, the adjective *bonne* indicates that it is a species or subdivision of the generic term that has positive qualities. The reader could then recall that Democracy is the least bad of the three corrupt regimes and not so far removed from the good form of Polity, visually defined in the illustrations of Book IV. Furthermore, the means of connecting the phrase "Bonne democracie" with a positive connotation occurs directly below the miniature in the heading for Chapter 4 of Book VI: "Ou quart chapitre il determine de queles gens et de quele maniere est la melleur espece de democracie" (In the fourth chapter he defines what kind of people and what manner of organization yield the best type of democracy).[7] When the reader turns to Chapter 4, the first sentence contains the phrase "Bonne democracie": "Comme les especes de democracie soient .iiii., celle est tres bonne qui est la premiere en ordre, si comme il fu dit devant" (As democracy is of four types, the one [that] is best is the first in rank, as was said before).[8] The next passage further clarifies the social classes of the population of Bonne democracie: "Et je di celle estre premiere si comme se aucun distinguoit ou divisoit les peuples, cellui qui est tres bon et le melleur, ce est le peuple qui est cultiveur de terre" (And I declare

that one superior, as if someone were distinguishing among the various peoples, to be the one that is very good and the best, that is, the people who cultivate the earth). According to Aristotle's classification, the second-best type is pastoral democracy. Thus, the second group that figures in Bonne democracie appears in the next section of text: "Et pour ce avient il que democracie est legierement faicte la ou la multitude vit de labeur de terre ou de pasturage" (And for this reason it happens that democracy is easily instituted when the multitude makes a living from tilling the soil or from raising herds).[9] In turn, these passages lead to further references to these social classes and their characteristics in the index of noteworthy subjects under the headings *Cultiveurs de terres, Multitude,* and *Pasteurs.*[10] In short, the beginning of Chapter 4 identifies the best type of democracy with the conditions of an agricultural and pastoral economy in which the inhabitants are farmers and shepherds.

THE VISUAL STRUCTURE OF BONNE DEMOCRACIE

Beyond the function of a visual definition of a specific type of democracy, what other insights about the character of Bonne democracie does the structure of Figures 70 and 71 afford the reader? The undivided, single-register format frames and bounds a united political community, Bonne democracie. Quotations from Chapter 4 of Book VI cited above provide the clues. The sequence of text passages sets up a parallelism between the order of discussion of the four subtypes of democracy and their quality: the first one (Bonne democracie) is also the best. The composition of the illustration follows the same system of sequence and parallelism: the inhabitants of the best type of democracy are the *cultiveurs de terres.* Oresme's program literally "foregrounds" their activities in the front plane of the miniature. As in previous illustrations, the program adopts the same strategy of updating the activities of the social classes discussed by Aristotle. The outdoor setting, dress, farm implements, and animals define the nature of the work. Even the vignette of the peasants' repast reveals their life-style. Seated directly on the ground next to the plowed field, they eat simply with crude implements.

The second group of inhabitants mentioned in the text occupies the middle ground. As the text suggests, the activities of the *pasteurs* literally overlap those of the *cultiveurs de terres.* The index of noteworthy subjects indicates: "Que les melleurs populaires apres ceulz qui cultivent les terres sunt ceulz qui vivent de pasturage—VI, 5" (That the best people after those who cultivate the earth are those who raise herds.—VI, 5).[11] In Chapter 5 a text passage reads:

> Et le peuple qui est tres bon apres la multitude qui cultive la terre, ce est la ou il
> sunt pasteurs et vivent de bestail. Car tele vie a en soi mout de choses semblables a
> la cultiveure des terres et as actions ou operations de elle.

(And those who are very good after the people who cultivate the earth are those who are shepherds and make their living off their herds. For such a life has many things in common with the cultivation of the earth and shares actions or operations with it.)[12]

It is, therefore, appropriate that the second type of inhabitants of Bonne democracie in Figures 70 and 71 follows the text sequence and appears on the second plane, or middle ground, of the illustrations. Their walking posture conveys the nomadic and solitary character of their labors. Unlike the collaborative enterprise of the agricultural workers, the shepherds commune only with their flocks. The *pasteur* of Figure 70 seems particularly solitary, as he bends his head in the direction of his sheep. The gesture of his crossed hands further expresses weariness and resignation. In contrast, the forward stride and piping of the shepherd of Figure 71 give a jauntier tone to his demeanor.

To the modern reader the shepherd's pipe and the peaceful setting suggest an early form of arcadian imagery. Indeed, Oresme's second gloss in Chapter 4 of Book VI regarding *cultiveurs de terres* seems to confirm such an association:

La vie et l'estat de teles gens descript et recommande Virgille ou secunt livre de *Georgiques,* et dit: O fortunatos nimium sua, si bona norunt agricolas, etc. Et estoient jadis teles gens en la terre de Archade mesmement.

(The life and calling of these people Virgil describes and commends in the second book of the *Georgics,* and says, "Oh happy husbandmen! too happy, should they come to know their blessings!" And in former times these people were in the very land of Arcadia.)[13]

Likewise, Oresme's gloss on Chapter 5 that explains the virtues of shepherds cites Virgil's *Bucolica* and biblical examples of "pluseurs bonnes gens" (many good people) who "anciennement vivoient de pasture et de bestail; si comme Laban, Jacob et ses filz, et Job et pluseurs autres. Et a teles gens annuncia le angel la nativité Nostre Seigneur" (in ancient times made their living from raising sheep and livestock; such as Laban, Jacob and his sons, and Job, and various others. And to people like that the angel announced the birth of Our Lord).[14]

Although Oresme shows an awareness of the arcadian and bucolic tradition, both the text and glosses of Book VI reveal another aspect of this attitude related to the personages of the third zone of Figures 70 and 71. Oresme explains in his third gloss on Chapter 4 how the best form of democracy depends on the moral and political character of *cultiveurs de terres* and *pasteurs:* "Apres il met les causes pourquoi cest peuple est habile a ceste policie; et sunt .iiii., car il ne est pas machinatif ne conveteux ne ambicieux, et est obedient" (Afterwards he sets out the reasons why this people is predisposed toward this form of government; and there

are four: because they are not manipulative, covetous, or ambitious, and they are obedient).[15] The next gloss explains further:

> Car il convient que il entendent a leur labeur pour avoir leur vie. Et ne ont cure de assambler souvent. Et es assemblees sunt faictes les machinations ou l'en peut parler et soi alier ensemble. Et ainsi tel peuple ne fait pas machinations ne conspirations contre les riches ne contre les princes.

> (First, it is necessary that they attend to their work in order to live. And they are not interested in meeting together often. And it is in assemblies where people can speak and form alliances that plots are made. And thus such people do not plot or conspire against the rich or against rulers.)[16]

Thus, the obedient, contented character and busy lives of this population prevent them from taking part in political activity. The text states that these classes prefer labor to political activity of any kind and are patient and tolerant under oligarchies and tyrannies.[17] Farmers and shepherds prefer working to participating in politics and earning money to receiving the honors of office. In some forms of democracy, Aristotle states, instead of serving themselves, they are content to elect officers, such as magistrates. In the city-state of Mantinea, Aristotle continues, the populace was content merely to deliberate with the magistrates, who were "selected from the body of the people on a system of rotation."[18]

The two groups on the upper left of Figures 70 and 71 refer to the practice in agricultural democracies of the majority's election of, or consultation with, judicial or deliberative bodies. By their implements and costume the standing figures on the left in Figure 70 are identified as agricultural workers. On the other hand, although one man holds a spade, the three seated figures clad in hooded, full-length mantles seem to belong to a somewhat higher social class. The two groups are apparently debating a controversy. The miniature may refer to the example in Mantinea of agricultural workers deliberating along with magistrates or, more generally, of electing counsellors of higher social status than themselves rather than insisting on participating directly in these activities. In the first of two glosses on Chapter 4 of Book VI that refer to Mantinea, Oresme explains:

> En aucunes democracies les cultiveurs des terres et autres populaires eslisent les officiers comme dit est, et ne sunt pas esleus, mez les riches. Et en aucunes il ne eslisent pas, et sunt esleus selon partie; car tous ceulz d'une office ne sunt pas de tels genz, mes aucuns.

> (In some democracies the tillers of the soil and other men of the people elect the officeholders, as is stated, and they [themselves] are not elected, but [only] the rich. And in some [democracies] they do not elect [officeholders] and [such men] are chosen according to qualification, for not all those would be of this class, but only some.)[19]

In the second gloss Oresme elucidates the following text passage: "T. Et en mont de democracies il souffist a telz gens ce que il sunt seigneurs de conseiller ou du conseil" (And in many democracies, it is sufficient for such people that they are magistrates or counsellors). "G. Car il sunt appellés as conseulz des grandes choses" (For they are called into consultation on important matters).[20] Or the debate in Figures 70 and 71 might refer to a procedure discussed in Chapter 3 of Book VI called *sortition:* "a means of settling disputes."[21] Thus, the scene on the upper left alludes to a council, court, or assembly in which agricultural workers have an elective or consultative voice.[22]

ICONOGRAPHIC SOURCES

The political participation of the *cultiveurs de terres* and *pasteurs* of Bonne democracie adds a distinctive character to the landscape setting of Figures 70 and 71. The insertion of the two groups on the upper left prevents the scene from being interpreted simply as an illustration of peaceful agricultural pursuits. Rather, the hybrid character of the miniatures poses a challenge in discovering their iconographic sources. Yet the derivation of the scene in terms of its associated political content and representation of the landscape, agricultural labor, and peasant life are worth exploring as guides to interpreting the meanings and reception of the images.

Scholars base the association of political content with representations of peaceful work in the fields on the depiction of Good Government from the twelfth-century English *City of God* manuscript discussed in Chapter 16 above (Fig. 52). Recently, Michael Camille and Robert Calkins have grounded the image in the concept of the secure social order founded on the three-class system of medieval society: the *oratores* (clergy), the *bellatores* (knightly class), and the *laboratores* (working class).[23] The next image that fosters the associations of work in the fields with good government is the fourteenth-century fresco of the Effects of Good Government in the Country by Ambrogio Lorenzetti in the Palazzo Pubblico, Siena (Fig. 72). As in Chapters 9 and 16, my opinion remains that there is only a thematic but no direct connection between the Oresme programs of illustrations in the *Ethiques* and *Politiques* and the Italian paintings.

As for the morphology of the landscape, recent studies support its derivation from calendar illustrations, occupations of the months, and seasons of the year not only in liturgical manuscripts, such as books of hours, but also cathedral sculpture.[24] In France, and in northern Europe generally, the third quarter of the fourteenth century witnessed an accelerated naturalism in the depiction of landscape that reached its height in the first two decades of the fifteenth century. François Avril has sketched these developments during the reign of Charles V. He finds the delight and pleasure of the miniaturists in representing the natural world not only in books of hours but also in other religious texts, such as Gauthier de Coincy's

Miracles de Notre Dame, and secular works illustrating the poems of Guillaume de Machaut, like the miniature of the Enchanted Garden from *Le dit de lion* (Fig. 73), which is among the earliest landscapes without figures.[25] The Jean de Sy Master himself executed scenes from Machaut's work (Fig. 59) in which the landscape settings have many features in common with the *Politiques* illustration of Figure 70.[26] The Jean de Sy Master also executed the charming, but more stylized, landscape setting of *Le songe du vergier* (Fig. 58).[27]

Studies by Michael Camille and Jonathan Alexander discuss the social and political context of the representations of agricultural labor and peasant life.[28] These scholars raise many new questions regarding the hidden assumptions about issues such as the value of work, the role of agriculture and technology in medieval culture, and the effect of class bias in representing peasant life. Such considerations are applicable to the interpretation of Figures 70 and 71, in which the relationships between text and image and patron and translator provide further guidelines. As a whole, the insights of Camille and Alexander contribute to understanding the representation of agricultural laborers in both positive and negative terms by their royal patron and aristocratic readers. The spatial organization of the miniatures emphasizes the social distance from, and control of, these viewers over the subjects represented.

PARADOXICAL RELATIONSHIPS

The illustrations for Book VI of the *Politiques* present several paradoxes. As unusual as the absence of inscriptions within the picture field are the unified subject matter and the naturalistic representation of landscape. The lyrical tone of Figures 70 and 71 encourages a formalistic and positive reading of them as glorifications of the virtues of rural and pastoral pursuits. Consistent with such an attitude is the association of earlier images of the peace and harmony of agricultural life with a secure social order.

At the same time, negative aspects of the representations arise from the context of the *Politiques* in general and of Book VI in particular. The inscription "Bonne democracie" alerts the reader to a specific definition of a regime that Aristotle considers generically corrupt. Initially the inscription seems to be a contradiction in terms. But "Bonne democracie" can refer to Aristotle's definition of the best of the four types of democracy that he classifies. Furthermore, in the text and glosses of the *Politiques* Oresme maintains Aristotle's practical considerations for favoring the type of democracy in which agricultural and pastoral workers are the characteristic social classes. In short, the political malleability or lack of interest in politics on the part of its population is what makes this kind of democracy good.

Nicole Oresme may have had other reasons for selecting the workings of Bonne democracie as the subject of the illustrations of Book VI. On a personal level, Oresme may have had firsthand experience of rural pursuits. Although little is known of his early life, scholars generally agree that he came from a Norman family of humble origins.[29] He could have observed and appreciated the character

and virtues of the ways of life followed by peasants and shepherds. In a gloss he notes their desire and ability to rise to a more honorable estate.[30] By contrast, Oresme stresses the political docility of this group. In a gloss on Chapter 4 he updates Aristotle's text about the patience of the peasants in tolerating the injustices of tyranny and oligarchy: "Il seuffrent et prennent en gré les oppressions des tirans et des princes olygarchiques, comme sunt tailles et exactions et teles choses ne mes que l'en lesse labourer et que l'en ne les pille" (They suffer and accept willingly the oppression of tyrants and oligarchical rulers, such as the taille, exactions, and such things, if only they are allowed to work and are not robbed).[31]

If Oresme's views on Bonne democracie remain enigmatic, it is even harder to understand how the primary audience of the manuscripts may have read and reacted to the images. Charles V and his counsellors could have understood the message of the programs in several ways. One possibility is the contribution made by farmers and shepherds to the stability of a political regime, including a kingdom. In this respect, the political inactivity of these groups is a great asset. Another is an indirect exhortation for favorable legal treatment of this productive socioeconomic group. At the same time, the concept of Bonne democracie might have appeared ironic and paradoxical given the inferior social position of agricultural and pastoral laborers in medieval culture. Here the proximity of men and animals or the rude repast of the peasants in Figures 70 and 71 may well have appeared puzzling, if not grossly comic. The notion that in the past these classes held political power under a democratic regime may also have provoked an ironic reaction. Charles V's experience during the 1350s with rural unrest may have also inspired a dubious attitude toward viewing any version of Bonne democracie as a stable political regime. Such a response is later supported in the text and images of Book VII by the exclusion of the *cultiveurs de terres* from citizenship in the political community.

Thus, Figures 70 and 71 present several potentially contradictory interpretations. To modern eyes, the images may seem to offer a picture of a medieval *communitas perfecta*. Yet Oresme's text and glosses suggest a more negative context for understanding the character of this political and social community. In an oral explication Oresme may have clarified the various meanings of Bonne democracie in ways that permitted him to illuminate what may have appeared to his audience a puzzling juxtaposition of terms. Indeed, Oresme may have adopted the rhetorical strategy of posing a paradox as a means of explicating a politically acceptable position on the notion of Bonne democracie.

22 CITIZENS AND NONCITIZENS
(Book VII)

THE CHOICE OF THE PROGRAM

By virtue of their size, format, and architectural enframement the illustrations for Book VII (Figs. 74 and 75) rank with the frontispieces (Figs. 46–49) as the most important in the cycle. The program itself again shows Oresme's efforts to present visually arresting and contemporary paradigms of central Aristotelian concepts. In Book VII of the *Politics* Aristotle returns to the definition of the ideal state and its citizens, discussed previously in Book III. According to Ernest Barker, a correct ordering of the *Politics* would place Book VII immediately after Book III.[1] Such an arrangement would continue the discussion of citizenship within the context of the classification of the six forms of government. As noted above, in Books IV, V, and VI Aristotle is concerned with the morphology, pathology, and organization of actual states. Books VII and VIII then return to "the theme of political ideals" and outline "an ideal state."[2] Again the problem of the overlapping and discontinuous subject matter of the *Politics* presents problems to the person responsible for choosing from each book a suitable and visually representable theme.[3] Among the topics discussed by Aristotle in Book VII, the important questions of the size, population, and planning of the ideal state may have appeared too difficult to depict visually. The representation of another theme, the system of educating future citizens of the polis, is reserved for Book VIII. The remaining subjects of Book VII, pictured in Figures 74 and 75, are the definition and discussion in Chapters 15 to 20 of the groups who are and who are not citizens of the ideal state.

Oresme had an even more difficult task than usual in translating into contemporary terms Aristotle's concept of citizenship founded on the experience of the polis, the Greek city-state. In his redefinition of the term as *cité*, Oresme had to adapt it to the very different form of the emerging nation-state and its institutions. He also had to consider the church as another form of *cité* both in itself and in relationship to secular forms of government. Not surprisingly, Book VII contains some of Oresme's longest commentaries on crucial issues.[4] Although Figures 74 and 75 can communicate only a small part of Oresme's views, the format and verbal underpinnings of the illustrations signal to the reader the importance of the contents of Book VII.

FIGURE 74 Above, from left: *Genz d'armes, Genz de conseil, Gent sacerdotal;* below, from left: *Cultiveurs de terres, Genz de mestier, Marcheans. Les politiques d'Aristote,* MS B.

FIGURE 75 Top, from left: *Genz d'armes, Genz de conseil;* center, from left: *Gent sacerdotal, Cultiveurs de terres;* bottom, from left: *Genz de mestier, Marcheans. Les politiques d'Aristote,* MS D.

The model for Figure 74 is the illustration of Book IV (Fig. 64). A similar two-register structure divided laterally into three compartments is a common feature, as is the use of an architectural enframement composed of gold arches that end in bosses and are decorated with corner lozenges. The increased dimensions of Figure 74 reduce the normal size of the initial of the introductory paragraph, which is not rubricated. A new feature of Figure 74, the rubricated inscriptions above the upper frame and in the lower margin, will be discussed shortly.

A rubricated inscription also appears above the enframement of Figure 75. The reformatting and re-editing of *D* bring about a change in the structure of this illustration, which now occupies the entire folio. The model for Figure 75, executed by the Master of the Coronation Book of Charles V, probably after consultation with Oresme and Raoulet d'Orléans, is the format of the full-page bifolio frontispiece of the *Politiques* in MS *D* (Figs. 48 and 49). The same type of architectural enframement and border decoration is repeated in Figure 75. Even more significant, instead of the two zones of Figure 74, Figure 75 adopts the three-register format of Figures 48 and 49. Most unusually, the summary paragraph appears before Figure 75; it is the only verbal component of the second column of folio 262v, the folio preceding Figure 75.

What motives may have influenced the choice of models for Figures 74 and 75? First, a reasonable inference is the availability to each miniaturist of an actual model book. Then, the miniatures' reference to the similar layout and format of an earlier illustration may have been intended to promote the reader's association of the contents of Book VII with the earlier ones. Thus in the case of Figure 74, Book VII relates to Book IV; Figure 75, to Book I. Since the bifolio frontispiece of *D* (Figs. 48 and 49) contains the only other full-page and three-register illustrations of the cycle, it appears that Figure 75 gains in status and importance over Figure 74. Yet the change in format brings about certain problems in the reading of Figure 75 apparently unforeseen by the translator and scribe.

EXTERNAL AND INTERNAL INSCRIPTIONS

The rubricated sentences of the upper and lower margins of Figure 74 indicate that the scribe had to insert unplanned explanations as supplements to the internal inscriptions after the miniature was completed. The uneven spacing of the rubricated portions in the upper border is due to the prior placement of the ivy-leaf *rinceaux*. These verbal reinforcements represent a new level of graphic intervention and authority in the structure of text-image relationships within the manuscript. Oresme may have responded to his own judgment, or to a wider criticism, that the usual system of graphic and visual interface did not communicate essential points. Furthermore, the introductory paragraph, an important link between text and image, does not mention the specific subject of the illustration: "Ci com-

mence le .vii.ᵉ de politiques ouquel est determiné comment la policie qui est tres bonne simplement doit estre instituee et contient .xxxix. chapitres" (Here begins the seventh book of the *Politics* in which [it] is determined how the form of government that is simply very good must be instituted; [the book] contains thirty-nine chapters).[5]

To make clear the significance of the groups represented in the upper register of Figure 74, the following phrase appears on the same folio: ".iii. estaz qui sont partie de cité ou citoiens" (three estates who are part of the city, or citizens). The counterpart to this explanation is placed in the bas-de-page: ".iii. manieres de gens qui ne sont pas citoiens ne partie de cité" (three types of people who are not citizens or part of the city). Unlike the location of these rubrics directly above the top register, the second insertion is separated from the lower register by seven lines of text comprising the introductory paragraph and the headings of the first three chapters. This distance, which obscures the relationship of the rubricated phrase to the part of the image specified, again reveals the unplanned nature of the graphic intervention.

Another indication of problems concerning the verbal explanations of the concepts represented in Figure 74 appears in the disparities between the inscriptions of the upper and lower register. Since no space was reserved in the upper zone for identifying inscriptions, the words are written in large black letters over the gold arcades. Their size and irregular placement constitute a second graphic intrusion that contrasts with the neat rectangular areas set aside above the arches at the top of the lower register. The brown ink and symmetrical placement of the lower three inscriptions show that the illustration was planned to incorporate them.

The external inscriptions of Figure 75 are even more dramatic than those of Figure 74. For one thing, the full-page format of the former totally divorces it from the text, so that only internal inscriptions identify the six groups. Furthermore, instead of the two-part organization of Figure 74 in which three groups are placed on each level, in Figure 75 the division of the illustration into three registers with two groups of figures on each level alters the basic relationships among them. As the rubrics explain, in Figure 74 citizens appear on top, noncitizens below; yet this simple order no longer exists in Figure 75. The meaning of these terms will be discussed shortly.

In Figure 75, following Oresme's instructions, the scribe Raoulet d'Orléans comes to the rescue. In a two-line rubricated message placed above the architectural setting, he explains:

.vi. manieres de gens dont les .iii. sont parties de cité ou citoiens et les autres .iii. ne sont pas citoiens ne partie de cité. Et pour cognoistre eulz qui ne sont pas citoiens ne partie de cité je les ay escripz de vermeillon.

(Six types of people of which three are parts of the city, or citizens, and the other three are not citizens nor part of the city. And to recognize those who are not citizens or part of the city, I have written them in red.)[6]

Indeed, the internal inscriptions that identify the second group of three divided between the second and third registers are written in red: *cultiveurs de terres* (farmers), *genz de mestier* (craftsmen), and *marcheans* (merchants).

Raoulet d'Orléans and Oresme collaborated on another extratextual device to explain the subject matter of the revised frontispiece. For the only time in the cycle, an introductory paragraph is inserted before, rather than after, the illustration. In the second column of folio 262v, which is left blank after the completion of Book VI, the following revised paragraph appears:

> Ci apres commence le vii^c–viii^c de politiques dont cy est l'ystoire en laquelle a .vi. manieres d'estaz de genz, dont les .iii. sont partie de cité ou citoiens, c'est assavoir genz d'armes, genz de conseil et gent sacerdotal; et les autres .iii. manieres de genz ne sont pas citoiens ne partie de cité, c'est assavoir cultiveurs de terres, gens de mestier et marcheanz. Et determine Aristote en ceste .vii.^c livre comment la policie qui est tres bonne simplement doit estree instituee. Et contient .xxxix. chapitres.

> (Hereafter begins the seventh to eighth [book] of the *Politics,* of which this is the illustration [story], in which there are six conditions or estates of people, of which three are part of the city or citizens, to wit, men-at-arms, counsellors, and clerics. And the other three types of people are neither citizens nor part of the city. That is to say, farmers, craftsmen, and merchants. And Aristotle determines in this seventh book how the form of government that is simply very good should be instituted. And [it] contains thirty-nine chapters.)[7]

As the first element of the introductory paragraph, a very important feature of this summary is the exceptional reference to the *ystoire*. The detailed explanation of the contents apparently compensates both for the separation of the illustration from the text and for the conflation in the second register of citizens and noncitizens. Oresme must have considered it more important to discuss the illustration before the text, which, as in *B,* is summarized briefly after the description of the *ystoire*. Another extraordinary element of this summary paragraph is that to catch the reader's attention Raoulet underlines every word in red. Although Oresme composed the paragraph, Raoulet may well have suggested its placement and underlining. In short, the rubricated information on top of Figure 75 and the summary paragraph that precedes it constitute the improvised extratextual information necessary to explain the confusing format of the altered three-register illustration.

DEFINITIONS OF TERMS

What, then, are the key terms highlighted in the rubricated phrases? As mentioned above, in terms of contemporary political structures and institutions, the words *cité* and *citoiens* need both careful generic and specific definition. Oresme defines

the different meanings of *cité* in a lengthy commentary in Chapter 3 of Book III. Among the different meanings of the term acknowledged by Oresme as legitimate is the following:

> Item, cité est dicte plus proprement des hommes, et pour ce, il fu dit ou premier chapitre que cité est une multitude de citoiens par soy souffisante. Et tele cité est dicte une, non pas pour le lieu ne pour les gens, mes pour limite de la policie, si comme il appert en ce chapitre.

> (Item, "city" is applied more properly to people, and for this reason: it was said in the first chapter that a city is a multitude of citizens sufficient unto itself. And a given city is said to be one, not according to the place, nor of the people, but according to its jurisdictional limits, as is stated in this chapter.)[8]

In the same commentary, Oresme goes on to a further definition of *cité:*

> Apres je di que selon la propre significacion dessus mise, cité peut estre dicte d'une multitude de citoiens habitans en un lieu et en une cité, a prendre cité selon la premiere significacion. Et selon ce dit l'en que Paris est une cité, Rouen est une autre cité, etc.

> (Afterwards I say according to the proper meaning set out above, "city" can be used of a multitude of citizens living in one place and in one city, taking "city" according to the first meaning. And accordingly, one speaks of Paris as a city, Rouen another city, etc.)[9]

From this point Oresme gets to a vital expansion of the term:

> Item, chescune multitude de citoiens qui se gouverne par une policie et par uns princes ou par un prince peut estre appellee cité; car policie est la forme de la cité et qui la fait une, comme dit est. Et en ceste maniere, tout un royalme ou un pais est une grande cité, qui contient pluseurs cités partiales.

> (Item, each multitude of citizens that is administered as a unit by one or more rulers can be called a city, for the form of government is the form of the city and what makes it a unit, as it is stated. And in this manner, a whole kingdom or a country is one large city, comprising several individual cities.)[10]

As an example of *cité* Oresme thus includes the emerging nation-state, of which the kingdom of France is an example. In transferring the concept of the polis to the nation-state, in Book I Oresme states that the "natural and mutual affinity of

the French makes them seem like members of one lineage." Oresme mentions in glosses on Book VII as a distinctive French tradition the legend of the fleur-de-lis, as well as the unifying factor of a common language.[11] In the spirit of the *translatio studii* Oresme also speaks in Book VII of France as the inheritor of the extensive powers and heritage of the Persian, Greek, and Roman empires: "Item, aucune foiz tele majesté fu en Perse et puis en Grece et puis a Rome et apres en France" (Item, at one time such majesty was in Persia, and then in Greece, and then in Rome, and later in France).[12] Oresme refers to specific French royal political and administrative institutions, including, in Book VII, "the assizes and exchequer."[13]

Thus, while Oresme adheres faithfully to the Latin translations of the *Politics* in the text, his glosses and commentaries on Books III and VII extend the definitions of Aristotle's city-state to include larger, unified political entities: ancient imperial Rome, its medieval descendant, the Holy Roman Empire, and the institutional church. In his long commentary on the proper size of a *cité* in Chapter 10 of Book VII, Oresme discusses further the criteria for assessing the types of regimes that possess the qualities that make them governable.[14] In this context, Oresme again invokes the analogy of the body politic to limit the size of a kingdom. The reader can also conveniently locate Oresme's ideas on *cité* in the index of noteworthy subjects, where nineteen separate entries bring together crucial aspects of the term. Nine of these references derive from Book VII.[15] Oresme also voices his views about competing medieval institutions. The translator's 150 references to the church in his glosses show that he accepts the inclusion by earlier commentators on the *Politics* of the institutionalized church as a form of Aristotle's city-state.[16] In Book VII particularly Oresme explicates several issues of special interest to Charles V. Among these he deals at length with the question of the power and jurisdiction of the papacy vis-à-vis royal sovereignty.[17] All in all, as a champion of moderate Gallicanism, Oresme limits papal initiative, advocates church councils as an instrument of reform, and promotes the independence of the French kings in temporal matters.[18]

Like *cité,* the word *citoien* is not a neologism but has a technical meaning in the *Politiques* different from medieval usage of the term as a resident or inhabitant of a town.[19] Oresme supplies a definition of *citoien* in both the glossary of difficult words and the index of noteworthy subjects. In the former he states:

> *Citoien* est celui qui a puissance de communiquer en aucun temps en princey consiliatif ou judicatif; ce est a dire qui peut aucune foiz avoir vois et aucune auctorité es conseulz ou es jugemens de la cité ou de partie de elle.

> (A citizen is he who has power to share at some time in deliberative [*consiliatif*] or judicial government; that is, one who can sometimes have a voice and some authority in the councils or courts of the "city" [state], or component thereof.)[20]

The last reference to *citoien* in the index leads directly to the rubricated phrase on the upper margin of Figure 74: "Et ou .xix.ᵉ chapitre appert quelz sunt citoiens et quelz non, et que en policie tres bonne .iii. estas sunt citoiens, ce est assavoir gens d'armes et gens de conseil et gent sacerdotal" (And the nineteenth chapter relates who are and who are not citizens, and that in a very good form of government three estates are citizens, to wit, men-at-arms, counsellors, and clerics).[21] In left-to-right order the reader could then make the connection with the three groups of the upper register, where the superimposed inscriptions confirm their identity. Of these the first and third find a place in the index, while Oresme extensively defines the adjective *sacerdotal* in the glossary.[22] From these references Chapter 16 of Book VII emerges as a source that immediately explains the context for the citizenship of these three groups. Aristotle states that to ensure the work of an ideal state, six types of services have to be provided. These consist of agriculture, arts and crafts, defense, land ownership, public worship, and political deliberation and civil jurisdiction.[23] Although certain functions necessary to the life of a state are fulfilled by all six groups, only three of these are entitled to citizenship. In this scheme, the citizens are those groups entrusted with defense, political deliberation, and public worship. The *gens d'armes* or warriors fight for the state; the *gens de conseil* perform judicial or deliberative functions; and the *gent sacerdotal* take care of religious worship.[24] These groups contribute to attaining the best way of life for the state; the requisites for such a contribution are knowledge, education, and leisure for living the good life according to the practice of moral virtue.

The other three *estas* are also necessary to promote the life of the ideal state but are not entitled to citizenship. Aristotle insists that those engaged in the other three essential services—agriculture, arts and crafts, and trade—do not have the leisure or knowledge to contribute to "the best way of life." These three groups, *cultiveurs de terres, genz de mestier,* and *marcheans* are pictured in the lower register of Figure 74 and in the right half of the second and in the lowest zone of Figure 75. Eight out of fourteen references to *cultiveurs de terres* in the index of noteworthy subjects cite locations in Chapters 17 to 22 of Book VII. In all but one entry Oresme gives reasons why, despite the vital need this group fulfills in providing food for the state, it is excluded from citizenship.[25] In Chapter 17 the reader could find a familiar argument that this group does not have the time necessary to participate in political activities.[26]

The same holds true of the other two noncitizen groups. Of the five references to *gent de mestier* in the index of noteworthy subjects, three derive from Chapters 17 and 19 of Book VII. In a gloss on Chapter 17 Oresme explains that craftsmen and artisans lack both the leisure to participate in political activity and the necessary moral virtue.[27] Moreover, the *gent de mestier* are also excluded from service as judges and from holding priestly office.[28] The third group of noncitizens, the *marcheans,* are mentioned neither in the glossary nor in the index of noteworthy subjects. The reasons for their exclusion from citizenship are similar to those offered for the *cultiveurs de terres* and *gent de mestier.*[29] In short, Figures 74 and 75 provide ample textual links for defining the generic terms *cité* and *citoien* as well as their specific parts, functions, and opposites.

While the formats of Figures 74 and 75 have already been discussed, other features of their visual structures deserve comment. As a whole, the illustrations offer paradigms or models of the body politic arranged in a hierarchical sequence. Following established conventions, the top zone of Figure 74 corresponds to high or positive values; the lower register, to contrasting negative spiritual, social, and political ones. When, as in Figure 75, a middle zone is added, the basic antithesis embedded in the two-register structure threatens the paradigmatic definition of the body politic.

The settings of both Figures 74 and 75 offer simplified memory structures in which the reader could place in an ordered sequence concepts emphasized in the text. As noted above, however, extratextual inscriptions reinforce or correct textual sequence and order. In both miniatures architectural elements repeated and combined within an internal enframement imply containment within the embracing and limited physical space signifying the *cité*. The repeated gold arcades of the six compartments of Figure 74 emphasize the common space inhabited by the six groups.[30] But the internal frames that divide each compartment create an impression of a separate existence for each group. Like the poor, middle class, and rich in the illustrations of Book IV (Figs. 64 and 65), the six groups of Figure 74 are defined in terms of social and economic status. But the setting repeated from the Book IV programs is not entirely appropriate for that of Book VII. The earlier pairs foster a parallelism among groups placed in the same left-to-right order in the upper and lower registers that is not applicable to those in Figures 74 and 75. Moreover, the miniatures of Book IV confer an honorific value to the central compartment as an embodiment of the mean that in Figures 74 and 75 is not appropriate for the occupants of this location. Finally, the simplified setting of Figure 74 does not in itself communicate the notion of the ideal state. In contrast, the expanded architectural features of Figure 75 that recall a similar element of the frontispieces (Figs. 46–49) convey the model aspect of the visual paradigm. Most prominent are the gold pinnacles of the upper frame capping the arcades repeated in each register.

Unlike the groups in Figure 74, those in Figure 75 are no longer separated by internal frames. The effect of this change is to emphasize the unity, rather than the division, among groups. To tie these groups together the Master of the Coronation Book inserts a linking element in the center of each register. In the top zone a sword bridges the gap between the *gent d'armes* and the *gent de conseil;* in the middle one a crozier fulfills a similar function; and in the bottom register, the *liripipe,* or dangling hood, of a merchant and a stony ridge tie that group to the *gent de mestier.* A further linking device is the glance that at least one member of the group on the left casts toward the right-hand group.

In Figure 74 the Master of Jean de Sy varies the positions of each of his six groups. All occupy a narrow, stagelike ground plane against which they are silhouetted in contrasting red and blue tones that alternate with rose, gray, and green

ones. The scale of the figures is kept proportionate to the height of the compartment. Especially in the lower register they gain individuality because of the space left between them and the way they interact. In the upper register two frontal groups on left and right flank the central *gent de conseil,* subdivided into three standing and three sitting figures who face each other. Below, the scheme is inverted: the central group of the *gent de mestier* stands in frontal positions, while the groups on either side turn toward each other. By these devices, as well as varied hand gestures that convey communication among group members, the Master of Jean de Sy avoids a strictly diagrammatic lineup.

As in Figure 74, the three groups of citizens in Figure 75 tend to be greater in number than the noncitizens. In fact, the greater dimensions of the full-page illustration permit the inclusion of more figures per group. On all three levels the proportion of figures to space make them dominate the picture field. The heavy modeling of their sharply outlined grisaille figures accentuates their corporeality. Placed on a narrow green ground plane, they stand out against the alternating red-blue-red backgrounds. Accents of gold pick out identifying attributes of the citizen groups. The composition of Figure 75 also clearly contrasts the tightly knit groups of the three citizen classes and the more loosely strung out noncitizens. The former cluster together to perform their essential political functions. Although the latter also communicate with one another, only their work defines their function. Despite his dry style, the Master of the Coronation Book conveys the notion of the six classes as united groups rather than as separate individuals.

COSTUMES AND ATTRIBUTES

As in previous illustrations, costumes and attributes differentiate one class from another and relate the institutions discussed by Aristotle to those of contemporary society. A precedent for such a representation occurs in a miniature of the Morgan *Avis au roys* (Fig. 76) illustrating four classes necessary for the support of a kingdom. From left to right are depicted an agricultural worker, a craftsman roofing a house, and the learned professions represented by two men conversing and a man-at-arms. No distinction is made, however, about their respective political status.

In Figures 74 and 75 clear articulation of the citizen groups is particularly important for both generic and specific visual definitions. In this process certain important revisions occur between Figures 74 and 75. For example, the *gent d'armes* in Figure 74 wear civilian, knee-length, belted jackets and carry swords and spears. Their weapons, upright postures, and hand gestures identify their function as potential defenders of the *cité:* in modern terms, reservists rather than professional soldiers. In Figure 75, however, the *gent d'armes* make up an organized fighting force. Their armor, helmets, and weapons (including a crossbow) emphasize that they are a professional army. The *gent de conseil* of Figure 74 also differ from the equivalent group in Figure 75. The former comprises three standing figures, who may be exercising a deliberative function. The one on the right wears the distinctive domed hat associated with the rich class in the illustrations of Book

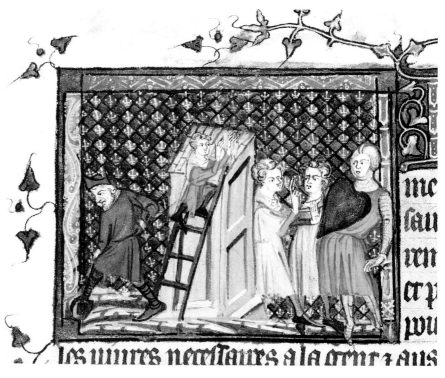

FIGURE 76 *The Classes Necessary to the Realm. Avis au roys.*

IV (Figs. 64 and 65). The other three figures are seated on a bench in earnest discussion. Previous illustrations, particularly the frontispieces (Figs. 46–49), suggest that the bench signifies a judicial or legal function. Figure 75 makes these roles more explicit. Two figures at the left stand next to a larger group seated on a bench. The two ermine strips on the mantle of the first standing figure identify him as a member of the royal family.[31] His deliberation with the figure facing him abuts the legal or judicial activities of the larger group. The connection between the two groups reveals the dual function of this class. The *gent sacerdotal* also undergo a change in identity. In Figure 74, the tonsures and brown robes of the figures at the extreme left and right indicate members of monastic orders. Only the cleric wearing the black rectangular headdress is distinguished in rank from the rest. In contrast, high ecclesiastical rank is emphasized in Figure 75, where two full-length bishops predominate and a third is partially visible among the background figures.

Fewer changes between Figures 74 and 75 take place among the noncitizen groups. Two of them are identical to the poor class of Book IV (Figs. 64 and 65). With the addition of one figure and a slight variation of implements, the *povres* of Bonne policie reappear as the *cultiveurs de terres* of Book VII in the upper register of Figure 74 and the central zone of Figure 75. Similarly, the three *povres* of Mau-

vaise policie in Figures 64 and 65 materialize as the *genz de mestier* in Figures 74 and 75. The former adds one figure; the latter, two. Except for the blacksmith, in both series this class is associated with the building trades. Particularly striking is the change in the appearance of the *genz de mestier.* Whereas the three figures in Figure 74 project an innocent appearance as they casually display the tools of their trade, their rigidly lined-up counterparts in Figure 75 seem to wield their firmly gripped implements as weapons. Rather than the rich in the Book IV illustrations, the *marcheans* of Book VII bear some resemblance to the pair represented in Book VIII of the *Ethiques* (Fig. 38). In both Figures 74 and 75, however, two pairs of merchants are depicted in separate exchanges. The man on the right of the first pair pays for a garment he purchases, while the pair in Figure 74 shake hands on a transaction involving two pigs. Their counterparts in Figure 75, however, add a third member, and the animals involved in the exchange are two sheep. The alterations made in Figure 75 pointedly refer to transactions in the wool trade.

THE APPEAL TO HISTORICAL EXPERIENCE

The updated costumes and attributes of the figures in the illustrations of Book VII raise the question of how closely Oresme wished to tie Aristotle's definitions of *cité* and *citoien* to the political life and institutions of contemporary France. As Susan Babbitt convincingly explains, in Book VII Oresme equates Aristotle's identification of the polis and the good life with the kingdom of France and the city of Paris.[32] As noted above, Oresme states that France has a distinctive heritage, language, and institutions that make it an extended form of the polis.

How then do Figures 74 and 75 reflect Oresme's views on certain of these issues as explained in his glosses? The first question to ask is whether the *cité* and *citoiens* pictured in them contain deliberate references to contemporary France. The architectural setting certainly defines an ideal political order, a *communitas perfecta*. Furthermore, all six classes are represented in the population and social organization of Oresme's time. Yet the identification is complicated by readers' associating the illustrations of Book VII with the medieval theory of organizing the perfect society into three orders or estates. Georges Duby cites a classic formulation of this organization:

> Triple then is the house of God which is thought to be one: on Earth, some pray [*orant*], others fight [*pugnant*], still others work [*laborant*]; which three are joined together and may not be torn asunder; so than on the function [*officium*] of each the works [*opera*] of the others rest, each in turn assisting all.[33]

Several elements in Figures 74 and 75 suggest a conflation of Aristotle's six classes with the three-orders scheme. First, the external inscriptions use the word *estas,* or estates, to describe the citizen and noncitizen classes. Second, the three-register

format of Figure 75 suggests adherence to the tripartite scheme of the orders. Then, the hierarchic character of the three estates finds resonance in the Aristotelian system in which the noncitizen classes are subordinate to the politically and socially empowered citizens. Both the two-register and three-register formats encode an analogous hierarchical system, in which the politically powerful inhabit the upper sphere; the powerless, the lower zone. Furthermore, the six Aristotelian classes can be assimilated to the three-estate orders. The warrior class, which had the obligation of offering military aid, can be identified with the *gent d'armes;* the clergy, or *oratores,* with the *gent sacerdotal;* and the *cultiveurs de terres* with the laborers who support the efforts of the other two classes. Furthermore, the other *estas* in Figures 74 and 75 can be accommodated in later versions of the three-orders system, such as the *Policraticus* of John of Salisbury.[34] In this influential treatise, the category of agricultural workers expands to include various ways of earning one's living, such as the arts and crafts.

Despite the similarities between the three-estates system and the representation of Aristotle's six classes in Figures 74 and 75, there are some important differences. Where in the former system do the *genz de conseil* belong? Furthermore, the order in which Aristotle's six categories is presented in the illustrations does not conform to that of the three estates of the medieval system. In this scheme the clergy comes first and the nobility second. Also, a considerable distance separates the broad, theoretical associations of the three estates and specific royal and political institutions of fourteenth-century France. For example, in terms of French contemporary political practice, the third estate, which included merchants, was entitled to send representatives to the meetings of the Estates General. In short, readers may have associated the three-orders theory in general with the Aristotelian classifications in Figures 74 and 75, but the specifics of the latter remain distinct.

What other clues does Oresme provide in associating the representation of Aristotle's six classes in the ideal *cité* of Figures 74 and 75 with contemporary France? Such a detail as the royal member of the *genz de conseil* in Figure 75 aids the reader in associating this group with institutions of the French kingdom. Oresme speaks glowingly in a long commentary on Chapter 32 of Book VI of the advantages to a prince of choosing and listening to virtuous counsellors. As Jean Dunbabin points out, in certain glosses in the *Politiques* Oresme encouraged widened participation in the legislative process.[35] Oresme may have been thinking of his own role as counsellor, while the king may have recollected his dependence on the royal council during the crises of 1356 to 1358, as well as the election of the chancellor by this body as a response to the recommendations in his translation.[36] Likewise, the redefinition of the *gent sacerdotal* in Figure 75 could encourage an association of the bishops and other high-ranking officials represented (and the absence of the pontiff himself) with Oresme's pleading for a church council as a means of both reform and limiting papal power.

The primary readers of the *Politiques* could also make negative associations between the groups represented and the threats to royal authority during the political crises of the 1350s. The meetings of the Estates General during this decade presented a potentially very dangerous attack on many areas of royal authority and

prerogative. Particularly in Figure 75, the weighty groups of the noncitizens may have recalled to Charles V and his counsellors the many meetings of the Estates General from 1356 to 1358, the years of greatest crisis. During this time the three noncitizen groups could also evoke thoughts of overt civil rebellion that confronted Charles as regent. For instance, the *cultiveurs de terres* could recall the peasant revolt of the Jacquerie. The *gent de mestier* and the *marcheans* could suggest the resistance of Paris to Charles's rule between 1356 and 1358 under the leadership of the powerful Etienne Marcel, provost of the merchants. Marcel was actively engaged in the wool trade, depicted in Figure 75 as the activity of the *marcheans*. The menacing representation of the *gent de mestier* may have recalled their attack on the Dauphin's palace during his near-assassination in February 1358. Again, the presence of the building trades recalls Oresme's mention in a gloss on Chapter 5 of Book VII that masons were among the groups of day laborers who were covetous, malicious, and unjust. As noted in Chapter 19 above, a possible confirmation of these negative associations are Charles V's letters patent of 25 September 1372, in which regulation of the bodies of Parisian craftsmen was vested in a royal official, the provost of the city.[37]

In short, the visual definitions of *cité* and *citoien* in Figures 74 and 75 invite reference to the institutions and class structure of contemporary France. The format of the illustrations (particularly that of Fig. 75) emphasizes the ideal or paradigmatic character of the two concepts. Yet the updating and concretization of the definitions invite both translation of and comparison to contemporary institutions. Despite certain fundamental differences, the six classes represented also suggest an analogy to and assimilation of the hierarchic three-estates organization of medieval society. Oresme may have left to the reader the process of reconciling his definitions of these concepts with their own historical, political, and social experience. Or the occasion of oral explication of Book VII may have afforded an opportunity for him to reconcile the Aristotelian definitions with the very different institutions of his own day.

COLLABORATIVE PRACTICE AND ITS INTERPRETATION

The illustrations for Book VII reveal valuable information about the roles and cooperation of the translator and scribe in the production of Charles V's copies of the *Politiques*. The choice of the illustration of Book IV from MS *B* as a conceptual and pictorial model for Figure 74 and a shift to the frontispieces of MS *D* for Figure 75 probably represent such a collaboration. A similar working together results in the insertion of a revised introductory paragraph and external inscriptions for Figure 75. The credit that Raoulet d'Orléans bestows on himself for his graphic solutions to problems caused by an altered visual structure reveals the important role of the scribe in correcting and supervising the execution of the manuscript. Raoulet's status is amplified by the prominence he gives himself in the colophon at the beginning of *D* and his recording of his adjustment of Oresme's additional gloss to Book III. This evidence of Raoulet's importance ac-

cords with our knowledge from other manuscripts of his self-confidence and independent literary activity.[38] The revised introductory paragraph in *D* sheds further light on Oresme's role as inventor of the program of illustrations. His motives for these explications may have been prompted by the importance of the concepts defined in these illustrations, as well as by the changes in their formats.

Perhaps the difficulty Oresme experienced in translating Aristotle's generic terms for polis and citizenship made the visual structures of either Figure 74 or Figure 75 inadequate in themselves to construct parallel social and political equivalents signified by the French words *cité* and *citoien*. The need for the reinforcements of the internal and external inscriptions suggests a disjunction between the complex verbal arguments of Aristotle's text and Oresme's lengthy commentaries and the inherently limited visual means available for the translation of such concepts.

The question of how the primary audience understood the illustrations of Book VII is also difficult to answer. Part of the problem is how they perceived the six classes in social and political terms. Except for the larger inscriptions of the upper register in Figure 74, the miniaturist's treatment of the citizens and noncitizens is evenhanded. The changes in the depiction of the six groups in Figure 75, however, emphasize the power of the citizen groups and the social inferiority of the noncitizens. A certain menacing quality in the representation of the politically powerless groups emerges from a modern reading of the illustration. As always, it is impossible to evaluate such an interpretation as an instruction from Oresme to the Master of the Coronation Book, an intentional or accidental consequence of the miniaturist's style, or a subjective reaction. Since for the most part Oresme's glosses do not contradict Aristotle's negative comments about the noncitizens, it is reasonable to assume that the illustrations convey a continued justification for the hierarchical organization of society and the exclusion of these three groups from political life.

23 EDUCATION OF THE YOUNG
(Book VIII)

A LIMITED PROGRAM

The illustrations of Book VIII (Figs. 77 and 78), the last book of the *Politics,* relate to the education of the young, a subject already discussed by Aristotle in the previous book. The formats and settings of Figures 77 and 78 do not indicate, as they did in Book VII (Figs. 74 and 75), that Aristotle is addressing education in the ideal state. A comparison of the size and visual structures of Figures 77 and 78 to those of Book VII reveals a less inventive approach in the Book VIII series. Rather than the fully articulated models of complex concepts pictured in the miniatures of Book VII, the paradigmatic mode of representation affords selective and simplified examples. Indeed, a reading of both Aristotle's text and Oresme's translation suggests a disjunction between the profundity of the ideas expounded and the superficial character of the illustrations. An approach similar to that of the program of Book II (Figs. 55–57) of the *Politiques* diminishes the rich content of the text to a reductive subject-guide function.

A miniature from the Morgan *Avis au roys* (Fig. 79) represents a wider range of pursuits appropriate to the upbringing and education of a prince during the different stages of childhood. These phases begin on the upper left, where two attendants bathe a royal baby. The second scene, on the upper right, shows the young prince receiving instruction. In the lower register four youths play ball, an example of appropriate physical exercise. In contrast, Oresme selects for illustration two of Aristotle's main types of instruction necessary for future citizens of the ideal state at different stages of their development: physical education and music. Oresme omits letters (encompassing reading and writing) and drawing, the other two fields of training established by Aristotle.

FORMATS AND DECORATION

Figures 77 and 78 adopt a two-register format. The former presents an irregular example inasmuch as the lower register contains one, instead of two, units. The resulting imbalance creates an awkward gap between the left and right halves of the miniature. Although the lower right space is filled with chapter headings, following from where they begin below the lower left miniature, the verbal space

FIGURE 77 Above, from left: *Trop dure discipline, Bonne discipline pour les armes; Bonne discipline pour bonnes meurs. Les politiques d'Aristote, MS B.*

FIGURE 78 Above: *Excercitations corpo-reles;* below, from left: *A gecter le dart, En musique. Les politiques d'Aristote,* MS *D.*

FIGURE 79 *The Stages of Childhood.*
Avis au roys.

filler protrudes beyond the right margin of the first column and disturbs the symmetrical organization of the folio. With their sharp angles and central points, the elongated interior quadrilobe frames accentuate a discordance between the visual and calligraphic elements of the folio.

Figure 77 is the third folio in *B* to bear the king's arms, interior quadrilobe frames, and the naturalistically delineated birds and other animals. Like Figures 55 and 56, the author portraits of Book II, these illustrations are the work of the Master of the Coronation of Charles VI; the archaistic character of the style and the reductive program are similar. In Figure 77 the miniaturist introduces accents of colors contrasting with the alternating red and blue organization of the calligraphic and border decoration, such as the green of the ground plane and trees or the pale brown of the psaltery and shields. Most unusually, red and brown tones depict an interior brick wall of a cutaway structure in the lower left compartment. Moreover, the small scale of these figures—perhaps an effort to represent children—seems at odds with the large size of the inscriptions. In short, the delicacy and mannered quality of the grisaille figures contrast with the strong calligraphic and decorative structure of the folio.

In all respects, Figure 78, executed by a member of the workshop of the Coronation Book of Charles V, is far more robust and unified. To regularize the awkwardness of the three-unit configuration in Figure 77, the addition of a fourth

panel in Figure 78 evens out the layout of the folio. Occupying about two-thirds of the text block, Figure 78 thus represents a revision of the arrangement in the Book II illustration in *D,* where a three-unit, two-register format (Fig. 57) results in an imbalance similar to that of Figure 77. Also rejected in Figure 78 are the interior quadrilobe enframements. The removal of the quadrilobes and the substitution of the heavy interior frames result in small, independent panels that allow an uninterrupted presentation of the figural compositions.

In contrast to the small scale of the figures in Figure 77, those of Figure 78 dominate the space and, as usual, are modeled in grisaille. These forms stand out against the alternating blue and red geometric backgrounds. These features are greatly diminished in the upper left and lower right panels in favor of extended landscape and architectural settings. The miniaturist uses green abundantly to define naturalistic features such as the trees and the grassy, expanded ground plane of the three exterior scenes. A red tone picks out a roof that covers the gray building in the lower right. Despite the flaccid, clumsy style of Figure 78, the illustration shows a greater interest in naturalistic representation than does the archaizing mannerism of Figure 77.

INSCRIPTIONS AND TEXTS

Although the inscriptions of Figures 77 and 78 differ, in both miniatures the introductory paragraph forges the general link between text and image: "Ci commence le .viii.ᵉ livre de Politiques ouquel il determine de la discipline des joennes gens apres l'eage de .vii. ans. Et contient .xiiii. chapitres" (Here begins the eighth book of the *Politics* in which he discusses the education of young men after the age of seven. It contains fourteen chapters).[1] The inscriptions of Figure 77 quite effectively relate to this summary by repeating the key word *discipline,* used in the sense of education or training. In the upper left compartment the words read, "Trop dure discipline," or too difficult training. This phrase describes the activity of three youths. In a landscape setting suggested by three stylized trees, two youthful males are engaged in wrestling, while a third lifts a heavy stone. Opposite this scene, on the upper right, the inscription reads, "Bonne discipline pour les armes," or good training to bear arms. Again, three youths embody the activities named in the inscription. The two on the left are practicing with shields and sticks, while a third prepares to throw a long spear, perhaps a javelin. Below on the left, the inscription indicates "Bonne discipline pour bonnes meurs," or good training for good morals. Within a cutaway doll's-house interior, three standing figures make music. The person on the left plays a psaltery, while two others, guided by a scroll and book respectively, sing together.

In the headings for the first, second, and fourth chapters, further links among the inscriptions of Figure 77 and the text occur in the repetition of the word *discipline.* Although no reference to this term is found in the index of noteworthy subjects, several appropriate entries occur under *enfans,* a word that appears in

the headings of the second, fourth, and fifth chapters. Particularly relevant is this reference: "Comment pour disposer les enfans as armes il ne les convient pas nourrir durement ne les faire excerciter en fors labeurs—VIII, 5" (How, in order to prepare children for military pursuits, it is not appropriate to feed them roughly or train them in heavy work—VIII, 5).[2]

In turn this entry relates to a text passage and gloss by Oresme that refer specifically to the verbal and visual message in the upper left unit of Figure 77:

> T. Maintenant aucunes des cités qui semblent avoir mesmement cure et sollicitude des enfans, il leur impriment et funt avoir habit athletique, ce est a dire excercitations trop dures et trop fortes. (T. Now some cities which seem to be especially solicitous and concerned about children force them into a training more appropriate to athletes, that is to say, strong exercises which are excessively harsh and exacting.) G. Si comme luicter et porter pierres et vestir armeures pesantes ou faire teles choses. (G. Such as wrestling and carrying rocks and wearing heavy armor or other such occupations.)[3]

Oresme has selected for illustration in a left-to-right sequence, following the order of his gloss, the two examples cited: *luicter,* or wrestling, and *porter pierres,* or lifting heavy stones. The somewhat uncouth appearance of these youths in their short tunics and bare feet may allude to both the physical and mental effects of such harsh training. Oresme translates the relevant passage this way:

> T. Et ceulz qui renvoient ou mettent les enfans tres grandement ou tres longuement a ces excercitations corporeles, et ceulz qui ce funt et les y mettent sans pedagoge ou maistre qui leur monstre les choses necessaires, il funt les enfans bannauses, ce est a dire rudes de corps et de engin.
>
> (And those who send or put the children excessively or for too long a time to these bodily exercises, and those who do so and put them to it without an instructor or a master to show them what they need to know, make the children vulgar, that is to say, rude in body and mind.)[4]

The definition of the term *bannause* in the glossary of difficult words further explains the ill effects of such training. Oresme first uses the word to designate a man who engages in "oevres serviles ou deshonestes et viles ou ordes et a fin servile et pour guaing" (servile, dishonest, vile, or filthy work for a low end and for gain). The next sentence describes a physical or physiognomic disposition to such a state:

> Et aucuns sunt ad ce enclins de nature ou selon les corps qu'il ont gros et rudes et mal formés ou selon les ames sensitives pour aucune malvese disposition des sens de dedens. Et telz l'en seult appeller *vilains natifs.*

(And some are inclined to this by nature or according to the gross, uncouth, and de-
formed bodies or by the sensitive part of the soul to some bad disposition of the ex-
ternal senses. And such people one should call natural villeins.)[5]

In short, the text warns against the physical and mental dangers associated with
too-severe training. Such pursuits not only endanger the proper growth of youth-
ful bodies but also prevent the formation of habits for achieving the moral virtue
of courage necessary for an adult to fight in battle.

The more desirable forms of physical training represented in the upper right
compartment are associated in Oresme's text with lighter forms of exercise, *legieres
excercitemens*.[6] A further entry under *enfans* in the index of noteworthy subjects
clarifies this point: "Comment le nourrissement et l'excercitation des enfans pour
les disposer as armes doivent estre ordenés et moderés—VIII, 5" (How the diet
and training of children for military pursuits must be organized and moderate).[7]
The two forms of physical training seem also to be associated with differences in
body types and social classes. The larger heads and stockier forms of the youths
on the left contrast with the more refined proportions of their opposite numbers
who wear elegant, belted *pourpoints* or *jacques* and pointed shoes or *poulains*. The
change in the inscriptions of Figure 78 may result from the reformatting of the
miniature, specifically the addition of a fourth compartment. But the shift may
also originate in Oresme's dissatisfaction with the generic word *discipline* as the
essential term of the visual definition. Instead, he substitutes three specific descrip-
tors. In the upper register he uses the words *excercitations corporeles,* or physical
exercise. The noun appears in the upper left compartment; the adjective, in the
upper right. The phrase thus seems to join the two panels.[8] In contrast, the inscrip-
tions on the lower register lack grammatical coherence either as separate units or
as an ensemble. The verb phrase *a gecter le dart,* to throw an arrow or javelin,
may refer to the *excercitations corporeles* above, but its grammatical connection is
somewhat tenuous.

Even more cryptic is the juxtaposition of the lower left inscription with the
one opposite, *en musique,* applied to the seated music-making trio. While music
is the subject of the lower left compartment of Figure 77 and is a concrete example
of *bonne discipline pour bonnes meurs,* the word itself is not used. The naming
of music as the specific subject of the fourth compartment of Figure 78 reveals
Oresme's interest in a field to which, as later discussion will show, he made im-
portant contributions. His index of noteworthy subjects devotes over twenty text
locations to describing Aristotle's discussion of *musique*. The second entry is a
notable exception to Oresme's system of specific citations in informing the reader
that "tout ce qui s'ensuit de musique est en le VIII^e livre" (All that follows about
music is in the eighth book).[9]

Subsequent references cite Chapters 7 to 14 as sources of important information
about the subject. Such elaborate documentation is consistent with Aristotle's for-
mulation that education in music is an important part of the training of the future
citizen. As proper training in gymnastics prepares the bodies of young males in

promoting the virtue of courage, so study of and engagement in music cultivates the mind and serves as a means of moral training. Oresme points out this truth in the index of noteworthy subjects: "Comment soi delecter en musique deuement vault et profite a bonnes meurs—8" (To delight in music properly is valuable and benefits good morals—8).[10] Later entries under *musique* observe: "Comment bonnes melodies purgent de toutes excessives passions ceulz qui sunt de bonne nature—12" (How good melodies purge excessive passions from those who are of good character—12) and "Comment bonnes melodies meuvent a contemplation et a devotion—12" (How good melodies prompt contemplation and devotion—12).[11] In a reference that recalls the contrast with the harsh training associated with the lower orders, Oresme excludes certain types of music that appeal to inferior social classes: "Comment rudes villains se delectent en autre musique que ne funt ceulz qui sunt de franche nature" (How crude villeins delight in a [type of] music other than that which people of free status make).[12] Oresme also identifies Chapter 10 as the location of information about "Comment ce est expedient que les enfans apprennent musique, et de voiz et de instrumens" (How it is advisable that children learn music, both vocal and instrumental). He then specifies: "Quele musique les enfans doivent apprendre et quele non, et jusques a quele terme" (What music children should and should not learn, and to what point).[13] The lack of any inscription relating to music in Figure 77 and the elliptical reference in Figure 78 afford an example of a disjunction between Oresme's elucidation of profound Aristotelian concepts and their extreme condensation in the verbal and visual summary of the illustrations.

VISUAL STRUCTURES

The somewhat puzzling change from the tightly knit contrasts of the inscriptions in Figure 77 to the series of more fragmentary verbal references in Figure 78 suggests again that revision of the illustrations' formats affected their visual structures. As was previously noted, the most obvious change is the addition of a fourth unit in Figure 78 to the three of Figure 77. The extrapolation of the javelin thrower from the upper right unit of Figure 77 to form the lower left compartment of Figure 78 brings unity to the folio at the expense of certain basic visual relationships. For example, the two upper scenes of Figure 78 are grouped under the single heading of *excercitations corporeles*. Although the basic disposition of the two scenes preserves the visual contrast between the too harsh and the good types of training, the inscription shared by the two units also indicates parallelism and equivalence. It is possible that Oresme, or the miniaturist responding to instructions conveyed by Raoulet d'Orléans, here does not distinguish between the training with shields and sticks and wrestling and lifting heavy weights as opposite types of physical training. If this interpretation is correct, then the entire upper register of *excercitations corporeles* offers a united, if somewhat negative, contrast to the lower one.

It is more likely, however, that the additional unit on the lower right of Figure 78 affects the original contrast of good and bad pursuits set up in Figure 77. In the latter, the lower left scene of *Bonne discipline pour bonnes meurs* offers a clear-cut opposition to the *Trop dure discipline* in the scene directly above it. Of course, in one sense, the javelin thrower of Figure 78 provides an obvious contrast to the wrestling and stone-lifting figures above him. Unlike these stocky youths in their simple shirts, his clothing, hairstyle, and svelte figure identify him as a member of a higher social class. Since the shield wielders of the upper right also share these characteristics, a common class association seems to unite the two units.

While ambiguous relationships remain among the two scenes of the upper register and the lower left unit of Figure 78, another interpretation of the lower register is possible. By balancing a representation of a proper form of physical exercise with one that stresses cultivation of the soul, Oresme may prefer to suggest a distinction between the two types of training. In a gloss on Chapter 5 the translator amplifies Aristotle's point that

les excercitations qui profitent a faire le corps plus fort et plus agile ne sunt pas
profitables a l'entendement pour l'estude. Et au contraire la solicitude de l'estude
ne profite pas a la disposition du corps desus dicte. Et ne peut l'en bien faire ces .ii.
choses ensemble.

(The physical exercise that improves the agility of the body does not benefit the dis-
position to study. And in a contrary sense the disposition to study does not benefit
the body as stated above. And one cannot do these two things well together.)[14]

The significance of the lower right compartment remains intact. With certain changes in Figure 78, the choice of music as a field of training that develops the moral powers of the soul continues. Unlike the blank wall in the comparable scene of Figure 77, the setting of Figure 78 suggests an interior space with windows. This kind of location may allude to one of Oresme's glosses on Chapter 4 that refers to a persuasive interpretation by an unidentified commentator on a passage from Homer. The explanation concerns a remark by Ulysses on the enjoyment of music "quant les gens sunt joieus et assemblés sus les tecs des maisons" (when people are joyful and assembled on the rooftops of houses). Oresme elaborates:

Mes de ce que il dit quant les gens sunt sus les tects des maisons, ce est pource que
en pluseurs lieus les gens s'assemblent sus les terraces des maisons pour disner ou
pour eulz esbatre ou pour autre chose, jouxte ce que dit Nostre Seigneur: Quod in
aure audistis predicate super tecta.

(But he speaks of this when people gather on the rooftops of houses, that is because
in some places people assemble on the terraces of houses to dine, to take their plea-
sure, or for other reasons, [and to this] Our Lord says: "What you hear whispered
you must shout from the housetops.")[15]

Figure 78 also differs from Figure 77 in that the music makers are now seated, with the psaltery player in the center rather than on the left. The three figures exchange attentive glances that indicate the communication and coordination required in making music. Singing to the accompaniment of the psaltery again absorbs the people on the left and right, who respectively hold an open book and a scroll with notes. The emphasis on singing as the musical activity most suited to educating the young derives from the power of melody and rhyme to inspire the soul to virtuous activity.[16] Young people need instruction so that they can play and sing and, without becoming too involved in technical and mechanical matters, judge what distinguishes good music from bad. The group in Figure 78 look like mature individuals rather than youths. Since musical training in Aristotle's scheme belongs to youths between fourteen and twenty-one, in medieval terms this age group could well signify their status as young adults. The dress of the players, particularly the buttoned cloak of the figure on the left, suggests an upper-class context for this pursuit.

If the visual structure of Figure 78 presents certain problems of consistency, the lower register in itself provides contrasts that offer general equivalents of Aristotle's ideas. Proper education of the body that takes place outdoors parallels training of the soul in an interior setting. The meaning of the entire ensemble is, however, less clear than in Figure 77, where the moral consequences of the different types of training are more clearly differentiated in both the inscriptions and the visual structure of the miniature.

HISTORICAL AND MUSICAL EXPERIENCE

On the surface, the programs of Figures 77 and 78 do not seem directly to address the historical experience of the *Politiques'* primary readers. Yet it is possible that the emphasis on the ill effects of too-harsh physical training may have recalled to Charles, who was a sickly youth, disagreeable experiences of his own knightly training. More inclined to study, he had a reputation as a music lover. In her biography, Christine de Pizan mentions that after meals the king enjoyed listening to music of string instruments to raise his spirits.[17] Following Aristotle's advice in the *Politics,* Charles would have studied music as part of his education. The French translation of Giles of Rome's *De regimine principum, Li livres du gouvernement des rois,* prescribes musical training as an aid to the moral development of princes and noble youths.[18] In fact, by the fourteenth century music assumed an important part in religious and secular court ceremonials as emblematic of the rank and authority of the prince.[19] Furthermore, Paris had long enjoyed great prominence in the development of musical theory and practice.[20] The rapid growth during the fourteenth century of the *ars nova*—with its complex rhythms, separate national styles, and the rise of secular music—had strong ties in France not only to the University of Paris but also to the French court.[21] For example, evidence exists of close ties between the royal family—including Charles V—and the leading poet-

composer of the period, Guillaume de Machaut (1300–1377).[22] As François Avril has clearly shown, manuscripts of Machaut's works, illustrated by miniaturists who worked on books commissioned by John the Good and Charles V, reveal strong links between royal and aristocratic patronage of such works.[23] Especially interesting is Avril's finding that two hands who worked on the illustrations of Machaut's writings are the illuminators of Charles V's first *Ethiques* and his two *Politiques* manuscripts: the Master of Jean de Sy and the Master of the Coronation Book of Charles V. A common thread in the pattern of royal patronage is the preference for the vernacular as an instrument of national identity and cultural superiority.

Oresme had his own strong connection with the *ars nova* and its theorists. In a long gloss on Chapter 7 of Book VIII Oresme cites two of his own writings when he speaks of theories of harmonic proportions and the music of the spheres and their relationship to mathematical theory.[24] During his long association with the University of Paris, Oresme undoubtedly became acquainted with leading theorists of the *ars nova*. He dedicated his treatise on mathematical ratios, the *Algorismus proportionum,* to Philippe de Vitry, who in his treatise of 1320, *Ars nova,* named the new musical movement in which his ideas played a prominent part. As Menut points out, Oresme's dedication was appropriate inasmuch as Philippe's "interest in music was still primarily mathematical, deeply involved with harmonic ratios, isometric rhythms and strictly patterned tonal arrangements."[25] Oresme's contribution to music theory is rooted in his mathematical and scientific interests. V. Zoubov discusses Oresme's contributions in such works as the *De configurationibus qualitatitum et motuum,* the *De commensurabilitate vel incommensurabilitate motuum celi,* and the commentary in his translation of *On the Heavens.* Zoubov also mentions Oresme's still-unknown treatise on the division of the monochord.[26] Oresme's glosses on Book VIII of the *Politiques* confirm his genuine appreciation and knowledge of the theoretical, aesthetic, and intellectual traditions of music.

The involvement of Charles V and Oresme in contemporary musical life seems especially to contradict the rather terse illustrations of Figures 77 and 78. Aristotle's theories on the education of future citizens of the ideal state find updated and concretized visual summaries. As examples of a paradigm, the illustrations serve simple indexical rather than lexical functions. Perhaps the familiarity of Oresme's primary readers with the subject accounts for the perfunctory character of the scenes. As in the illustrations of Books II (Figs. 55–57), the simplified content of Figure 77 coincides with an archaistic style and elegant decorative presentation favored by the workshop of the Master of the Coronation of Charles VI.

24 FAMILY AND HOUSEHOLD
(Book I, *Yconomique*)

AN INFLUENTIAL TEXT

Oresme's translation of the eight books of the *Politics* in *B* and *D* is followed by his French version of a short treatise called the *Economics*. Considered as the third of Aristotle's moral works after the *Ethics* and the *Politics,* the *Economics* centers on the economic management of the household and family relationships. Aristotle addresses these subjects in Book VIII of the *Ethics* in the context of friendship and in Book I of the *Politics* as the fundamental unit of the city-state. Modern scholarship now considers that the *Economics* was assembled after Aristotle's death from diverse sources, including several parts of Xenophon's *Oeconomicus.* The *Economics* was, however, mistakenly introduced into the Aristotelian corpus in the twelfth century, when Averroes composed a paraphrase of the work that figures in a Latin translation dating from about 1260.[1]

Indeed, the history of the Latin translations of the text is extremely complex, as Menut's summary in his edition of Oresme's vernacular version indicates. Menut points out that two Arabico-Latin versions preceded William of Moerbeke's Latin translation of 1267 from the Greek of Books I and III of the *Economics.* Book II is not included in William's work, and the third book is numbered as Book II.[2] Oresme's French version, *Le livre de yconomique d'Aristote,* comprises two books. The first is based on Book I of the Greek and Latin originals; the second, on Book II of William of Moerbeke's version and an anonymous Latin translation of Book III.

The *Economics* belongs to a genre of didactic literature relatively rare during the earlier Middle Ages. Few texts on household economy and management were written until the thirteenth century. Menut points to classical prototypes such as Hesiod's *Works and Days,* the previously mentioned *Oeconomicus* of Xenophon, Virgil's *Georgics,* and other works on agriculture by Roman writers, including passages from Pliny's *Natural History.*[3] The growth of large feudal properties provided the impetus for treatises on their management. One such work was Peter of Crescenzi's *Duodecim libri ruralium commodorum* of about 1300, translated into French for Charles V in 1370. The vernacular version has two titles, *Le livre des prouffits champestres et ruraulx* and *Le livre appellé Rustican du champ de labeur.*[4] Other treatises on rural economy date from the same period, including the popular vernacular version of Peter of Crescenzi's text, the first original French work on the subject by

Jean de Brie, *Le bon berger* of about 1375, and Jean Boutillier's *La somme rurale* of 1380.

The allied subject of familial relationships discussed in both books of the *Yconomique* is the theme of two other contemporary treatises. *Le livre du chevalier de la Tour-Landry pour l'enseignement de ses filles* dates from 1371 and the anonymous *Le ménagier de Paris,* from 1393. In a separate but notable variation addressed to women, Christine de Pizan composed in 1404 *Le livre du trésor de la cité des dames* (known also as *Le livre des trois vertus*). In this book for women of all social classes, Christine offers practical advice on household management and personal conduct.[5] Oresme's translation of the *Economics* led to its incorporation in printed versions of Renaissance conduct literature. Vérard's 1489 Paris edition of Oresme's versions of the *Politiques* and *Yconomique* may have inspired the new French translation from the Latin version of Leonardo Bruni composed by Sibert Lowenborch and printed in Paris by Christien Wechel in 1532.[6] During the fifteenth and sixteenth centuries, various humanist treatises on the family were written, of which Alberti's *Della famiglia* of 1445 is the best known. Based in part on the *Economics,* Alberti's treatise circulated in French translations.[7] In short, the *Yconomique* is part of a long, multi-dimensional textual development.

ORESME'S COMPILATION OF THE TEXT AND ITS GRAPHIC TREATMENT

The *Yconomique* is the shortest of the three Aristotelian moral treatises translated by Oresme for Charles V. In *B,* the oldest illustrated copy of the *Politics* and *Economics,* 23 folios (373–396) make up the *Yconomique,* compared to 372 folios for the *Politiques*. A similar relationship occurs in *D,* where the *Yconomique* takes up 24 folios (363v–387) to 363 for the *Politiques*. Oresme notes that in logical terms the *Yconomique* should follow the *Ethiques* according to the number of people and social groups discussed in each.[8] Oresme also observes that Aristotle had discussed the household in Book I of the *Politics,* but to expound on the subject more fully, the *Economics* follows. In his translation Oresme adheres to his usual practice of dividing the text of the two books into short chapters and furnishing titles and summary paragraphs for them. Book I has seven chapters; Book II, eight. His glosses, which comprise two-thirds of the full text, are of the same types found in the *Ethiques* and the *Politiques*.[9] Oresme uses the glosses of earlier commentators such as Jean Buridan, William of Ockham, Ferrandus de Hispania, Barthélemy de Bruges, Albert the Great, and Durandus de Hispania.[10] He adds, however, original contributions in the form of cross-references to his translations of the *Ethics* and the *Politics,* other Aristotelian and classic works, as well as biblical sources. As later discussion will show, Oresme's updating and concretizing of the text contains significant observations on topics such as marriage. There are, however, only six glosses long enough to be called commentaries.[11] Furthermore, Oresme does not furnish an index of noteworthy subjects or a glossary of difficult words. At the conclusion of the *Yconomique,* he explains these omissions:

Cy fine le *Livre de Yconomique*. Et ne est pas mestier de faire table des notables de si petit livre et souffist signer les en marge. Et aussi tous les moz estranges de cest livre sunt exposés en la glose de cest livre ou il sunt exposés en la table des fors moz de *Politiques*.

(Here ends the *Book of Economics*. It is unnecessary to draw up a list of notable passages in such a small book and it is sufficient to point them out in the margins. Also, all the unusual words in this book are explained in the glosses or in the alphabetical table of difficult words in the *Book of Politics*.)[12]

Despite the more cursory textual treatment of the *Yconomique,* the layout and decoration of the introductory folios of *B* and *D* adhere to the standards observed in the *Politiques*. In *B* (Fig. 80) the running title *Yconomique* is composed of capital letters executed in blue and rose pen flourishes. A drollery on the upper left margin depicts a hybrid woman-monster spinning: a programmatic and satiric comment on the miniature.[13] Although the summary paragraph is not rubricated, a foliate initial of normal dimensions (six lines in length) introduces the text. A smaller foliate initial *L* ending in two ivy leaves calls attention to the beginning of the first chapter of the text. The alternating rose and blue two-line, pen-flourished initials of the chapter titles are also characteristic of the decoration, as are the enframement and borders. In *D* (Fig. 81) the title of the text appears on the previous folio, although the running title for Book I occurs above the ivy-leaf upper border. Accompanied by a foliate initial *C* of normal dimensions, the introductory paragraph is rubricated. While the usual type of initials for the chapter titles follows, an unusual feature is the eight-line flourished initial *Y* introducing the first word of Chapter 1 of the text without any line separation or space following the titles. The *Y* in Figure 81 may compensate for the fact that the sentence in Figure 80 that announces the completion of the chapter titles of Book I and the beginning of the text was dropped in the later version.

FORMAL QUALITIES OF THE ILLUSTRATIONS AND TEXT–IMAGE RELATIONSHIPS

Figures 80 and 81 provide a unique opportunity in these cycles to compare works from the atelier of the Master of the Coronation Book of Charles V. Although this workshop is responsible for all the miniatures in *D,* Figure 80 marks its first appearance in the cycle of *B*. While an overall resemblance of figure types and composition is striking, a more searching stylistic comparison reveals that Figure 80 is the work of a more refined and subtle artist who can be associated with the best illustrations in his most famous work, the *Coronation Book of Charles V*.[14] Figure 81 is close to, if not identical with, a member of the workshop who executed Figure 71, the illustration of Book VI in *D*. Indeed, Figure 71 seems to be the model for Figures 80 and 81. The most striking resemblance lies in the motif of

the diagonal path created by the figure plowing. The reversal of direction from Figure 71 to Figure 81 suggests that a traced drawing or a model book was available to members of the workshop. A common feature of all three scenes is the farmer standing beside the horse and plowing with the help of a servant. Also repeated are the parallel rows of furrows, the thatched building framed by trees, and the stylized plant forms.

The compositions in both Figures 80 and 81 are, however, more simplified than that of Figure 71. The rectangular shape of the two *Yconomique* illustrations leads to a horizontally oriented composition, essentially limited to two flat surfaces. The composition of Figure 80 accentuates this horizontality, while Figure 81 constructs a diagonal suggestive of a hilly rather than a flat terrain. Figure 80 also continues the parallel emphasis by the placement and framing of the building on the right connected with the plowing action on the left. In Figure 81, however, the house and its occupants are placed at a distance from and behind the farming operation. Figures 80 and 81 also differ in color. The former adheres to the red and blue tones adopted in the rest of the cycle but adds brown, beige, and green hues for definition of naturalistic elements. Figure 81 retains the practice in *D* of modeling the figures in grisaille while using browns, grays, and greens. A further point of contrast is the vivid red and gold background of Figure 80 with its rigid diamond pattern that occupies more than half the rear plane and accentuates the horizontality of the composition. In Figure 81, however, the blue and gold foliate pattern of the background plays a far smaller role and is subordinate to the representation of the landscape.

While the decorative features and layout of Figures 80 and 81 do not reveal any changes from those of the *Politiques,* in two respects these illustrations of Book I are different. First, the dimensions of Figures 80 and 81 are noticeably reduced. Second, neither image has internal or external inscriptions. Only the illustrations for Book III of the *Politiques* (Figs. 60 and 61) share this characteristic. Previous discussion of the Periander tale in Book III indicates, however, that omission of an inscription may have been a deliberate strategy. Yet Figures 80 and 81 can draw on two other textual features to serve both lexical and indexical functions. In Figure 80 the prominent title serves as a verbal signal of the beginning of the book. The large initial *C* draws attention to the opening paragraph, which summarizes the contents of the *Yconomique:*

> Cy commence le livre appellé *Yconomique,* lequel composa Aristote et ouquel il determine de gouvernement de maison. Et contient .ii. petis livres parcialz. Ou premier il determine generalment de toutes les parties de maison et de toutes les communications qui sunt en maison. Et contient .vii. chapitres.

> (Here begins the book called *Economics,* which Aristotle wrote and in which he sets forth the rules for household management. And it contains two short, separate books. In the first, he examines broadly all the parts of the household and all the interrelated divisions of a household. And it contains seven chapters.)[15]

FIGURE 80 *Household and Family. Le yconomique d'Aristote,* MS B.

FIGURE 81 *Household and Family. Le yconomique d'Aristote*, MS D.

If further guidance is necessary to determine the meaning of the neologism *yco-nomique*, the reader can find the word defined in the glossary of the *Politiques* under *Yconome*, as "celui qui ordene et dispense les choses appartenantes a un hostel ou a une maison" (he who arranges and dispenses matters pertaining to a household or a family), and *yconomie* or *yconomique*, as "art ou industrie de teles choses bien ordenees et bien disposees" (the art or industry of such matters well arranged and ordered).[16] A further source of information about the contents of the *Yconomique* can be found in the chapter headings below the illustrations. Of particular interest is the title for Chapter 2: "Ou secont chapitre il met en general les parties materieles de maison et traicte en especial de la partie appellee posses-sion" (In the second chapter he explains in general the material elements of the household and discusses particularly that part called possessions).[17] In other words, if the lack of an inscription signals the lesser importance of the *Yconomique*, such an omission does not deprive the reader of substantial links to the text.

VISUAL STRUCTURES

The undivided rectangular structure of Figures 80 and 81 is the second example of this feature in the two cycles. As was previously noted, the illustrations for Book VI of the *Politiques* (Figs. 70 and 71) provide the models for the setting and the overall structure of the *Yconomique* frontispieces. Also similar in all four minia-tures is the absence of an internal inscription, which again leads in Figures 80 and 81 to an initial reading of these miniatures as simple depictions of rural life. Yet, as in Book VI of the *Politiques*, the illustrations contain generic visual definitions of basic concepts in Oresme's translation, as well as a paradigmatic representa-tion interpreted as a universal model. The first source defines the essential compo-nents of the household. In the *Yconomique* (Book I, Chapter 2) Oresme refers to Hesiod's definition:

> Et de ce disoit un appellé Esyodus qu'en maison convient que le seigneur soit pre-mierement et la femme et le beuf qui are la terre. Et ceste chose, ce est assavoir le beuf, est premierement pour grace et affin d'avoir nourrissement et l'autre chose, ce est la femme, est pour grace des enfans.

> (And on this subject, a man by the name of Hesiod stated that a household requires first of all a master and then the wife and the ox to plow the land. And the last item, that is, the ox is primarily for the purpose of producing food and the wife is to provide children.)[18]

Oresme's gloss on this passage is worth citing:

> Pour les concevoir et nourrir. Et si comme il appert ou premier chapitre de *Poli-tiques*, le beuf qui are es povres gens en lieu de ministre ou de serf. Et donques

ces .iii. parties sunt neccessaires a meson quelconque, tant soit petite ou povre, ce est assavoir le seigneur et sa femme et qui les serve. Car la femme ne doit pas estre serve, si comme il appert ou premier chapitre de *Politiques*. Et se aucune de ces .iii. choses defailloit en un hostel ce ne seroit pas maison complectement et proprement selon la premiere institution naturele, mes seroit maison imparfecte ou diminute et comme chose mutilee et tronchie. Item, pluseurs autres choses et parties sunt neccessaires ou convenables a meson, mes cestes sunt les premieres et les plus principales.

(To give birth to them and to feed them. And as it is pointed out in *Politics,* I, 1 [1252b 11, quoting Hesiod, *Works and Days,* 405] in a poor household, the ox that does the ploughing takes the place of a worker or serf. And thus these three items are essential to any household whatsoever, regardless of its size or wealth—that is, the master, the wife, and someone to help them. For the wife must not be a servant, as is shown in *Politics* I, 1 [1252b 1]. And if any one of these three things is lacking, the household would not be complete and perfect according to natural law, but would be imperfect and a miniature, as it were, a mutilated and truncated household. Several other items, are required or desirable in a household; but these are the primary and principal elements.)[19]

Thus, it is quite clear that the illustrations represent the basic elements of the household: the farmer, the servant, the wife, and the child. The economic unit is thus synonymous with the family. The farmer is also the father of the family, and the wife, the mother.

The casting of this basic economic and domestic element in terms of agriculture goes back to Hesiod. But the *Economics* emphasizes that cultivation of the land is the most natural way of acquiring property and riches. Oresme's text then refers to other ancient authorities, familiar from previous discussion of agriculture in Book VI of the *Politiques*. He invokes Virgil's *Georgics* to reinforce the point that cultivation of the land is the "primary occupation, because it is honest and just."[20] Moreover, gaining wealth from agricultural work is justified, inasmuch as it is natural: "car a toutes choses leur nourrissement est et vient naturelement de leur mere. Et pour ce donques vient nourrisement a homme de la terre" (for the sustenance of all things is naturally derived from their mother. And therefore man receives his sustenance from the earth).[21] In his gloss following this passage, Oresme cites Virgil, Ovid, and Ecclesiasticus to explain the equation of the earth with the mother who provides nourishment for her children: "Et donques, aussi comme l'enfant est nourri du lait de sa mere, nature humaine est nourrie des fruis de la terre et est chose naturele" (Therefore, just as the child is nourished on its mother's milk, so mankind is nourished by the earth and this is a natural thing).[22]

The *Yconomique* then proceeds to enumerate the moral benefits of cultivating the land. As in the discussions of Book VI of the *Politiques,* outdoor life is seen to be healthful, promoting fortitude and the ability to withstand one's enemies. Oresme's glosses on these passages present a positive view of rural pursuits in

which he discusses the proper types of nutrition and exercise. Although Oresme refers to the arguments in Book VI that cultivators of the land are "moins machinatifs, moins convoiteus, moins ambitieus et plus obeissans que quelconque autre multitude populaire" (less scheming, less ambitious, less envious, and more obedient than any other segment of the populace), he stresses (again referring to Virgil) a highly positive view of this way of life: "Et donques raisonnablement ceste cure ou acquisition est la premiere; car elle est juste, elle est naturele, elle dispose a bien" (Thus this occupation or means of acquiring wealth stands first, for it is honorable, natural, and it disposes men toward the good).[23]

The presentation of the relationship between the units of the household in Figures 80 and 81 also conforms to Aristotle's exposition of their economic and familial roles. The gendered division of labor within the household is a major point. In the context of the marriage relationship discussed in Chapter 3, Oresme's text states:

> Et afin que l'en quere et prepare les choses qui sunt dehors le hostel, ce est le mari; et que l'autre salve et garde celles qui sunt dedens. Et convient que l'un, ce est le mari, soit puissant, fort et robuste a operation; et l'autre est fieble as negoces dehors. Et le homme est piere ou moins disposé a repos et melleur ou miex disposé a mouvemens ou a plus fors labours.

> (And in order that the husband may prepare and look after the outdoor work of the homestead while the wife attends to and watches over the indoor work. And the husband must be strong, capable and robust for physical work while the wife is less able to perform outdoor tasks. And the husband is less given to repose and is more disposed to action or to the heavier occupations.)[24]

This division of labor is clearly marked in the miniature between the scene of the plowing undertaken by the male farmer and servant outdoors and the wife spinning within the cottage. Taking place simultaneously, the woman's second occupation, suckling a child, alludes to another aspect of the economic/familial relationship: the procreative function of marriage. Oresme's text says: "Et des filz la generation est propre et le utilité est commune" (The production of children is the proper task of husband and wife and the benefits are common to both the parents and the offspring alike).[25] Oresme stresses that children exist "for the sake of unity or profit."[26]

Figures 80 and 81 also express another important element of the economic/familial relationship. Oresme takes up the point that the individual units of the household work together in a cooperative manner to assure its common welfare: "Item, en communication de masle et de femelle generalement apparoissent plus les aides que il funt l'un a l'autre et les cooperations que il funt et oevrent ensemble" (When man and woman live together one observes how frequently they assist each other and cooperate and work together).[27] The collaborative nature of

the labor and marriage relationship is more clearly evident in Figure 80. Here the outdoor and indoor units are placed on the same plane and are connected by the figure of the servant that overlaps the two divisions. The door that leads inward to the cottage links it to the larger opening in which the figures of the mother and child are represented. In Figure 81, however, the outdoor labor dominates the front plane of the scene. The focus shifts to the action of plowing and the servant's importance as an essential and independently defined agent. In contrast, the cottage takes a secondary role in respect to scale and separation from the main action.

A related feature is the change in Figure 81 of the representation of the mother and child. In Figure 80 the carefully delineated movement of the mother's extended right arm and the precise representation of her distaff and spindle emphasize her labor. The direction of her gaze suggests her absorption in her work. The blue of her robe picks up the same tonality in the short jacket of her husband, on the left, and links them across the intervening field. Supported on her lap, her child is depicted as a separate, three-dimensional form naturalistically represented and emphasized by its vivid red robe. The use of red relates him to the father, who wears a cape of this color. Facing the mother, the child's sturdy body is clearly visible, as he or she reaches toward her with outstretched hands. The miniaturist thus picks out and unites the principal members of the household. In Figure 81, however, consistent with the compression of the cottage scene, common grisaille modeling does not differentiate between mother and child, with a consequent loss of their separate identities. In its swaddling clothes the child takes on a gnomelike appearance. While the mother still wields a spindle, her economic activity is subordinate to her maternal function, as she grasps the child with her left hand and looks anxiously in the direction of her husband.

The motives for these revisions are not clear. In all but one example, the illustration of Book II, the revised program of *D* expands the format—if not the content—of the comparable illustration in *B*. The effect here reduces the importance of the female unit of the household and expands the male's. No other compositional unit can share the front plane with the diagonal path. It is possible, however, that dissatisfaction arose over the programmatic equality of each unit of the household, and this may have occasioned the switch to the diagonal model.

ORESME'S INTERPRETATION OF THE MARRIAGE RELATIONSHIP

The treatment of the differentiated female and male roles in Figure 80 may have some connection with Oresme's innovative glosses in Book I on marriage and familial relations. Although the chillingly patriarchal tone of the *Economics* remains intact in Oresme's text, some scholars consider that in the glosses he makes a contribution to the companionate concept of marriage. The theme of the third chapter of Book I of the *Yconomique* is "the relationship of husband and wife."[28] The chapter begins with the statement that the first responsibility of every husband is to his wife. Oresme's gloss gives the reason for this argument:

Car apres le seigneur, la femme est la premiere comme compaigne. Secundement
sunt les enfans et tiercement les serfs et les possessions. Apres il declare que ceste
cure doit estre premiere pour .vi. conditions qui sunt en communication nupcial de
homme a femme plus que en autre communication domestique; car elle est na-
turele, raisonnable, amiable, profectable, divine et convenable.

(Because next to the master, the wife as his companion holds first place. The chil-
dren come second and the slaves and possessions third. He next points out that this
concern should be primary because of six conditions which exist in the relationship
of husband to wife more than in any other domestic relationship: (1) because it is
natural, (2) rational, (3) amiable, (4) profitable, (5) divine, and (6) in keeping with
social conventions.)[29]

Oresme's text and gloss argue that the marriage relationship is natural because
living together is necessary for sexual reproduction. But such a union is "also the
fruit of reason and deliberation, and therefore it is even more natural (*plus naturele*)
than among the beasts."[30] Oresme goes on in the gloss to speak of love between
young people as a matter of choice and joy:

Mes il avient souvent que .ii. jennes gens, homme et femme, aiment l'un l'autre en
especial par election et plaisance de cuer et de amour qui est oveques usage de rai-
son, combien que aucune fois elle ne soit pas selon droite raison.

(But it often happens that two young people, man and woman, love each other by
special choice from a feeling of joy in their hearts, with a love that is accompanied
by reason, even though it may sometimes happen to be without correct reason.)[31]

Oresme says that even if this love is "chaste and prepares for marriage or exists in
marriage and if there is sin in it, it is a human sin."[32] In the context of the pre-
viously cited passage that man and woman live together in mutual assistance,
Oresme praises the marriage relationship in terms of Aristotle's discussion in the
Ethiques (Book VIII, Chapter 17). Oresme's gloss characterizes this relationship as
follows: "Car elle a en soi bien utile et bien delectable et bien de vertu et double
delectation; ce est assavoir, charnele et vertueuse ou sensitive et intellective" (For
this friendship comprises at once the good of usefulness, the good of pleasure, and
the good of virtue and double enjoyment—that is, both the carnal and the virtu-
ous or the sensual and the intellectual pleasures).[33] The gloss says further that the
sexual relationship among human beings was designed to bring about closer bonds
between husband and wife. Oresme extensively quotes scriptural sources ending
with Genesis to reach the conclusion that man and wife are "two persons in a
single skin."[34]

In Chapter 4 Oresme's text follows Aristotle's in prescribing the rules the hus-
band must lay down for his wife to follow. Again, although the context of the

discussion is consistently patriarchal, Oresme makes a genuine contribution to humane concepts of the marriage relationship. Not only does he speak of the husband's consideration of the wife in their sexual relationship, but he also states that he should fulfill her sexual desires. Oresme also elaborates on an ancient theme drawn from Hesiod that the husband should be older than the wife so that he can better mold her habits and preferences.[35]

Although it is impossible to draw exact parallels between Oresme's commentaries and Figures 80 and 81, certain resemblances exist. First, as mentioned earlier, the miniatures suggest the cooperative notion of marriage in the complementary labors conducted for the common good of the household. The visual structures of the illustrations also encourage the idea of the wife as companion and partner. Figure 80 may also refer to the desired age difference between husband and wife, as the former is depicted as a bald, bearded man whose appearance contrasts with that of the noticeably younger servant. It is, however, not so easy to guess the age of the wife, as she wears the concealing wimple headdress familiar from the *Ethiques* cycle. In short, the visual structure of the illustrations brings out in a general way Oresme's innovative comments on the marriage relationship in Book I of the *Yconomique*. Moreover, the sympathetic character of Oresme's remarks on marriage may have appealed to Charles V, whose relationship with Jeanne de Bourbon is known to have been an exceptionally happy one.[36] Oral explication of the companionate aspects of friendship in marriage could well have received a sympathetic hearing during the dinnertime readings mentioned by Christine de Pizan.

SOCIAL AND POLITICAL IMPLICATIONS OF THE FAMILY UNIT

The similarity of Figures 80 and 81 to the miniatures of Book VI of the *Politiques* (Figs. 70 and 71) may have caused the text's primary readers to relate them visually and conceptually. Several themes tie them together. The first is the favorable portrayal of agricultural life. Although Oresme does not neglect to mention in a gloss the political malleability of the *cultiveurs de terres,* in the *Yconomique* this theme is less prominent than in Book VI of the *Politiques*. Yet common to both Figures 80 and 81 and the Bonne democracie miniatures is the impression of the social stability of the rural class.

Oresme's choice of the rural agricultural economic and family unit for visual representation derives from the text quoted above. Yet the choice of this class as an image of the household is by no means inevitable. For example, an illuminated manuscript of Oresme's translation of the *Yconomique* dating from 1380 to 1390 (Fig. 82) chooses a bourgeois, or nonrural, household. It seems likely, therefore, as in the Bonne democracie miniatures, that Oresme's selection of a rural family unit in some way expresses his personal and political predilection for this class.

The gendered division of labor in Figures 80 and 81 deserves further comment. As the text's citation of Hesiod indicates, the patriarchal economic and familial unit is an ancient tradition. Because of the respective labors of Adam and Eve, the

FIGURE 82 *Household and Family. Le yconomique d'Aristote,* Paris, Bibl. Nat.

clear differentiation between the masculine and feminine spheres is also sanctioned in Christian texts. Also traditional is the assignment to the male and dominant authority of an expansive exterior space, and the confinement of the female's labor to the interior. Whereas the text does not specifically mention spinning as a pre-scribed activity of the wife, it is an ancient stereotypical metaphor of women's labor and character, in both negative and positive senses.[37] Thus, the wife spinning in Figures 80 and 81 stands for her industrious and virtuous character, while the drollery of Figure 80 seems to comment on the insidious, devious character of women as weavers of tissues of deception. Noteworthy, too, is the conflation of labor with the traditional figure of woman as synonymous with the earth, nature, and nurture. Although the female role in the household is confined and limited to the private sphere in Figures 80 and 81, she presides over it as her unchallenged domain.[38] In short, the visual definitions reinforce the textual claim that the basic unit of the agricultural and familial unit conforms to a natural order. Harmonious relationships generically defined by class and gender assure the paradigms and models of a seemingly unchanging social and political stability.

25 THE MARRIAGE CEREMONY
(Book II, *Yconomique*)

The illustrations for Book II of the *Yconomique* (Figs. 83 and 84) conclude the cycles of *B* and *D*. Compared to the miniatures of Book I of this text (Figs. 80 and 81), the program appears quite summary and routine. Even though the modern reader may find that the text of the *Yconomique* offers fascinating insights into both Aristotle's and Oresme's views on the institution of marriage, Oresme himself may have thought that the contents of Book II did not address the vital political interests of his primary readers. If Oresme felt this way, it could explain why the depiction of a wedding ceremony in Figures 83 and 84 provides such an extremely reductive version of the ideas expressed in the text. Indeed, the paradigmatic mode is that of neither a general model nor an example but that of a symbolic abbreviation. In this respect, the illustrations of Book II of the *Yconomique* recall those of Books II and, to a lesser extent, those of Book VIII of the *Politiques* (Figs. 55–57, 77, and 78). The common feature is a disjunction between complex textual development and radically simplified visual translations.

Figures 83 and 84 were again executed by the workshop of the Master of the Coronation Book of Charles V. Unlike Figure 80 in Book I, however, the hand of the master is not visible in these illustrations. Their composition depends on the scene of Charles V entering Reims cathedral from his *Coronation Book* (Fig. 85).[1] The most striking similarity is the representation of the church. Although far more simplified in Figure 83, the depiction in Figure 84 of the three bays and flying buttresses is quite close to those in the model. The motif of the priest standing at the main portal of the church derives from the reception of the king by the archbishop of Reims. It appears that a drawing in a model book was available for the use of members of the atelier, as is true of the miniatures of Book I.[2] It is obvious that Figure 83 is far smaller than Figure 84. This miniature is restricted to the width of the second column of the text, at the top of which it stands. Figure 83 is the first illustration in the *Politiques* and *Yconomique* program of *B* to share the column format and small dimensions after the prefatory miniatures of Oresme writing his translation (Fig. 44) and the dedication portrait (Fig. 45). These latter two examples precede the text proper of the *Politiques*. It is, therefore, correct to assume that Figure 83 occupies the lowest place in the hierarchy of importance among the text illustrations of this manuscript.

FIGURE 83 *A Marriage Ceremony. Le yconomique d'Aristote,* MS *B.*

The decorative structure of the folio of which Figure 83 is a part also reflects the lesser importance of the illustration. The ivy-leaf motif is confined to the miniature: the foliate borders in the margins of other illustrations from this manuscript are lacking. Also missing are rubrics to announce the introductory paragraph above which Figure 83 stands. The four-line foliate initial *C* of the opening word of this paragraph is also smaller than usual.

Figure 84, however, achieves greater prominence. As previous analysis has shown, the reformatting of *D* called for a regularity in the shapes of the illustrations. Thus, Figure 84 is a rectangle that occupies the width of the entire text block and achieves frontispiece status. This image—like the preceding illustration for Book I of the *Yconomique*—is somewhat smaller than the miniatures of the *Politiques* in the same manuscript. The decorative character of folio 375, where Figure 84 stands, is far more elaborate than that of Figure 83. Furthermore, the painted frame of Figure 84 establishes the miniature as a separate design element. In short, the revised format of *D* cedes to Figure 84 an importance that was lacking in Figure 83.

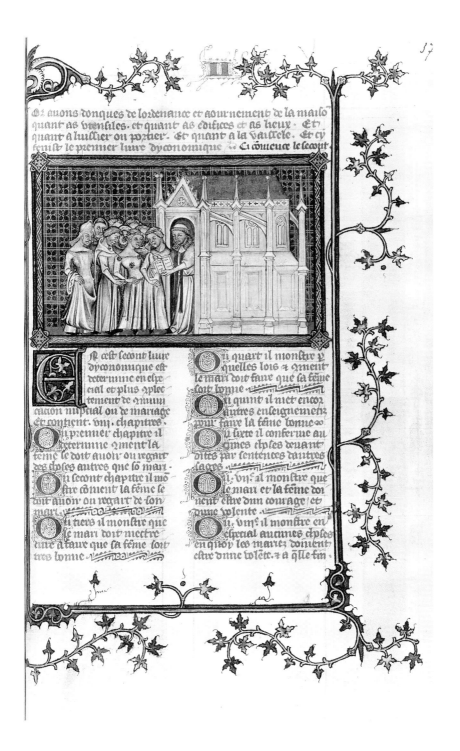

FIGURE 84 *A Marriage Ceremony. Le yconomique d'Aristote, MS D.*

FIGURE 85 *The Reception of Charles V at the West Portal of Reims Cathedral. Coronation Book of Charles V.*

Figures 83 and 84 retain the distinctive uses of color noted in the previous miniatures of the two manuscripts. The bride in the center, who wears a rose robe, is flanked by a male figure (possibly her father) and the groom, both of whom wear light blue mantles. A partially seen figure on the left repeats the rose of the bride's dress, which contrasts with a red hood. The priest in the center stands out in his white robes and gold stole from these brightly colored figures on the left and the monochrome gray tones of the church on the right. In Figure 84, the color of the roof and body of the church echo those of Figure 83. A larger company than the five people in Figure 83, the group in Figure 84 is delineated in grisaille with rose washes. In both cases the application of gold picks out the decorations of the bride's dress and the jeweled circlets in the couples' hair. The spiraling foliate motif of the blue-and-gold background of Figure 83 presents a more active, if more limited, contrast to the figures than the more extensive rust-and-gold geometric background of Figure 84.

The lack of inscriptions in Figures 83 and 84 repeats the example set by the illustrations of Book I of the *Yconomique*. The consequent abandonment of the miniature's lexical function probably reflects Oresme's assumption of the readers' familiarity with the subject of marriage. The indexical, summary character of the illustration supports this suggestion. On another level, the choice of a wedding ceremony as standing for the whole of the marriage relationship may also reflect the common rhetorical figure of synecdoche. The summary paragraph below the illustration echoes the cursory nature of the miniature: "Cy commence le secunt livre de *Yconomique,* ouquel il determine en especial et plus complectement de communication nuptial ou de mariage. Et contient .viii. chapitles" (Here begins the second book of *Economics,* in which he considers particularly and more fully married life or marriage. And it contains eight chapters).[3]

One reason that Oresme may have chosen the wedding ceremony to introduce the subject of marriage is that Aristotle discussed it in both the *Ethics* and the *Politics,* as well as in the previous book of the *Economics.* Thus, there is a preexistent textual link that might bring the reader to associate previous knowledge of the subject in these works with the forthcoming expansion of the theme in Book II of the *Yconomique.* In his commentaries on Book I of this text, Oresme refers to relevant passages in Books I and VII of the *Politiques* and Book VIII of the *Ethiques.*[4] Indeed, marriage as one of Aristotle's three types of relationships among people of unequal rank is depicted by the bride and groom in Figure 38, the illustration of Book VIII in *C.*[5] Oresme may have intended or hoped that the repetition of the motif of the bride and groom would constitute a visual and textual association with Aristotle's previous discussion of marriage in the *Ethics.*

By choosing a wedding ceremony Oresme may also have wanted to signal an aspect of the institution of marriage apart from its ethical, political, and economic implications. As a means of updating Aristotle's exploration of the theme, Oresme introduces the Christian view of marriage as an institution ordained by God. In the context of how the wife should conduct herself (Book II, Chapter 2), the text speaks of the procreative function of marriage as something that could not "be greater or more holy."[6] Oresme's gloss on the passage elaborates this point: "car societé de mariage, qui est pour procreation d'enfans et pour mutuel aide, est chose saincte et divine" (For the marriage relationship, which is for the procreation of children and for mutual help, is a holy and divine thing).[7]

Even more clearly than in Book I of the *Yconomique* Oresme glosses the idea of marriage as a "divine partnership."[8] The translator's assimilation of Aristotelian and Christian notions of marriage is quite clear:

> Et meismement en nature humaine, de laquelle Dieu a especial solicitude et cure. Et donques selon le Philosophe, mariage est de divine ordenance et se acorde a ce que dit Nostre Salveur, que Dieu fist ceste conjunction: Quod ergo Deus conjunxit, etc. Et aussi il fu né en mariage et fu present as noces la ou il fist le commence-

ment de ses signes par un gracieus et joyeus miracle en muant l'eaue en bon vin. Et par ce il approva mariage comme chose saincte, laquele Dieu beneÿ des la premiere creation: Masculum et feminam creavit eos et benedixit illis. Et est mariage un sacrement et donques est ce chose divine. Apres il met comment ce est convenable chose.

(And this accords with human nature, for which God has a special solicitude and attention. Thus according to Aristotle, marriage is divinely ordained and he agrees with the statement of our Saviour that God made this union: 'What therefore God hath joined together, etc.' [Matt. 19:6]. And our Saviour also was born from wedlock, and He was present at the wedding ceremony where He first demonstrated his powers by a gracious and joyous miracle, changing water into wine. In this manner He gave approval to marriage as a holy thing, which God blessed from the beginning of creation: 'Male and female created He them and He blessed them' [Gen. 1:27]. And marriage is a sacrament and is therefore a divine rite. He next indicates how this is a felicitous thing.)[9]

Oresme may have chosen the scene of the wedding in front of the church to emphasize marriage as a sacrament. He may have done this not so much from theological conviction but as a means of updating and concretizing the wedding ceremony as an intelligible shorthand or synecdoche for marriage.

VISUAL STRUCTURES

Although both miniatures belong to the single register type, the visual structures of Figures 83 and 84 are related to two distinct types of illustrations in the cycles. As was noted above, Figure 83 belongs to the single-column quadrilobe type represented by the portrait of Oresme writing (Fig. 44) and the dedication portrait of Oresme presenting the book to Charles V (Fig. 45). This is not to say that the use of quadrilobes was limited in the programs of both *B* and *D* to text-column illustrations. The quadrilobes were favored by the Master of the Coronation of Charles VI for the programs of Books II, III, and VIII of the *Politiques* (Figs. 55–56, 60, and 77). For this text, the workshop of the Master of the Coronation Book of Charles V repeated the same type of enframement as was used for the miniatures of Books II and III (Figs. 57 and 61). In all these illustrations, however, the quadrilobes are divorced from the column as individual units of an ensemble. Despite variations among them, the design of the quadrilobe units seems to focus on a single event or person in a series related to sequence in the text. As an index of its lesser textual value, Figure 83 stands apart from this practice and instead belongs to the prefatory quadrilobes devoted to portraits of the translator and patron.

By contrast, the visual structure of Figure 84 relates more clearly to the illustrations of Book VI of the *Politiques* (Figs. 70 and 71) and of Book I of the *Yconomique*

(Figs. 80 and 81). Although the rectangular shape and larger size of the former distinguish it from the *Yconomique* miniatures, both types share the representation of agricultural work carried out by farmers and peasants in an exterior landscape setting. Furthermore, the other two scenes also share another characteristic: several activities take place at the same time. Thus, Figure 84 is anomalous in respect to the social class represented, the type of setting, and the focus on a single event. These changes probably occurred because of the reformatting of the manuscript. Yet it is also significant that as a result of these physical revisions, the ritualistic character of the scene achieves greater prominence.

THE REPRESENTATION OF THE WEDDING CEREMONY

The ceremony in front of a church marked the second step in the medieval marriage ceremony. The first was "a betrothal in which one made a marriage promise for the future (*sponsalia de futuro*) and the actual wedding itself (*sponsalia de praesenti*)."[10] The betrothal, which guaranteed arrangements for the transfer of property, was legally binding, as it was based on the mutual consent of the couple. At the church door, the bride and groom expressed their desire to wed and administered the sacrament to one another. The priest's role was that of a witness. Following the ceremony at the church door, the couple entered the building to participate in a nuptial mass.[11]

The ceremony depicted in Figures 83 and 84 obviously corresponds to the second step, the marriage ceremony *in facie ecclesiae*. In both scenes the groom stands next to the priest and closer to the church door; the leafy spiral of the background in Figure 83 makes clear the separation of bride and groom. The groom places his right hand on his heart in a gesture that may signify a pledge of devotion to the bride, who is not so independent as her intended mate. In both scenes the figure at her left, probably her father, places his hand on her arm, perhaps an allusion to the fact that she leaves the paternal house and protection for that of her husband. The bride in Figure 83 seems to shrink backward in a modest way, as though she is somewhat fearful of the fateful step she undertakes. Her counterpart in Figure 84 appears, however, more forthcoming and removed from her father's protection. This bride is accompanied by a more numerous retinue than that attending her counterpart in Figure 83. Clad in white in both miniatures, the priest holds in his left hand an open book. The book may refer to the appropriate blessings contained in a pontifical or missal or to pledges made by the couple.[12] The lighted taper that the priest holds in his right hand in Figure 83 gives way in Figure 84 to the instrument for asperging the couple with holy water.

Several details of the costume of the bridal couple are worth noting. Following the fashion of the period, the bride wears a low-cut dress decorated with three jewels.[13] In Figure 83 she wears the *aumonière,* a purse suspended from a belt. This accessory may allude to the marriage custom of offering *arrhes,* a symbolic gift of coins or jewels relating to the bride's dowry.[14] Both bride and groom wear gold circlets on their heads, possibly suggesting wedding crowns.[15] Several fourteenth-

FIGURE 86 *A Husband Instructs His Wife. Le yconomique d'Aristote,* Paris, Bibl. Nat.

century illustrated manuscripts of Gratian's *Decretals* depict the bride and groom wearing either crowns or circlets in scenes of the wedding banquet following the nuptial mass.[16] Although such circlets were associated with grand attire worn by the aristocracy, such items may have been worn by other classes and were customary for such a festive occasion.[17] In short, the design and details of Figures 83 and 84 may accord with Oresme's intention of encouraging his readers' association of a contemporary wedding ceremony with the discussion of the social and religious institution of marriage in the *Yconomique*.

Although the text of Book II of the *Yconomique* continues the patriarchal attitude of Book I, Figures 83 and 84 do not reveal this perspective. As in the illustration of Book VIII of the *Ethiques* (Fig. 38), the bride and groom are represented

as equals. It is significant that a different passage from Book II was chosen as the subject of the illustration for a slightly later illustrated manuscript of the *Yconomique* (Fig. 86). Chapter 1 lists six rules by which the wife runs the household under her husband's guidance, while later chapters lay out her obligations to behave properly.[18] Figure 86 represents a husband instructing the wife with a commanding gesture of his right hand. The scene takes place in an arcaded porch or interior of a house. His standing figure occupies one bay; those of his wife and child, the second. She is seated grasping a chubby child, whose expression and clinging gesture indicate alarm about paternal admonitions. The husband's domination is clear from his commanding gesture and standing posture. The wife's submission is equally evident from her seated position and the inclination of her head. Her modest dress also accords with the desired deportment of the chaste and virtuous wife set forth in the text. Also significant is that, as in the illustration of Book I of the *Yconomique* from this manuscript discussed above (Fig. 82), the husband's costume and the domestic setting indicate the depiction of a middle- or upper-class household. Thus Figures 82 and 86 prefigure the future popularity of the *Economics* in both vernacular and Latin forms as an authoritative conduct book for regulating family life.[19]

While Oresme's text maintains the patriarchal point of view of the Latin medieval translations, certain of his glosses, such as those in Chapters 4 and 5 of Book II, emphasize the humane character of the husband's treatment of his wife.[20] Although Figures 83 and 84 do not refer to such text passages, they represent a moment of equality in the relationship symbolized by the wedding ceremony. In this way Oresme may have chosen to insert unobtrusively his own progressive views on the companionate nature of marriage. As noted in the previous chapter, in any oral explication of the text by Oresme such ideas could have appealed to and alluded to Charles V and Jeanne de Bourbon as exemplars of the partners in a harmonious marital relationship.

CONCLUSION

Commissioned by King Charles V in the 1370s, Nicole Oresme's French translations of Aristotle's *Nicomachean Ethics, Politics,* and *Economics* constitute an important episode in late medieval cultural history. By abandoning a simple linear definition of "translation" for a multifaceted concept, it became possible to map the king's translation project as a complex cultural process. An important starting point was the transfer to a lay readership of such authoritative texts into a vernacular language. A second feature of the process was the inscription of the translations in the material structure and finite space of the medieval manuscript book. Within this physical structure the linguistic translation formed part of a total system of communication among which the decorative and calligraphic elements served as visual means of organizing the presentation of verbal information. A further level of translation was the means by which verbal ideas were transformed into visual language. Integral to the cognitive and mnemonic representation of these texts were the new programs of illustration, which constituted a unique feature of the vernacular translations.

Oresme's work formed part of a larger undertaking of over thirty vernacular translations. Casting the French language as a vehicle for communicating and disseminating Aristotle's authoritative texts had significant political implications. Chief among them was the claim that under royal auspices the appropriation of the Aristotelian texts in vernacular versions marked the movement of political and literary power from the Latin academic, clerical elite to the secular authority of the monarchy. Nationalistic and dynastic goals also underlay the advancement of the French language during the struggles of the Hundred Years' War and motivated Charles V's translation project, as did his attempts to legitimize the new Valois monarchy as a promoter of art and culture. The *translatio studii* theme constituted a bold framework for such ambitions based on Oresme's statements that the transfer of linguistic authority from Latin to French was the equivalent of the movement of political and cultural authority from Greece to Rome.

Charles V's patronage showed a shift of monarchical style from military leadership to one modeled on the ideal of the wise ruler. By personal inclination, too, he favored an intellectual approach to ruling reinforced by diplomacy, personal eloquence, and the support of learned advisers able to interpret authoritative texts. The entire translation project represented an attempt to inform and disseminate

to the king's advisers the best available knowledge on how to rule effectively. Situated clearly within the traditional Mirror of Princes genre, Charles V's program became a conscious instrument of social policy. Aristotle's *Ethics* and *Politics* had already been assimilated in simplified form in encyclopedias and vernacular Mirror of Princes texts commissioned by French rulers. But Oresme's French translations and commentary, the first complete versions in the vernacular of these works, showed an ambitious expansion of social and political goals in addressing these texts in all their complexity.

Oresme had been involved in the political reform movement during the 1350s. His earliest vernacular writings showed his reliance on Aristotle's *Politics* as a guide to right principles of rule. Oresme probably encouraged Charles V to make the complete texts of the *Ethics* and *Politics* the capstone of the translation project. In preserving the academic structures of the Latin translations, Oresme appropriated their authority for the vernacular. He was, however, fully aware of the difficulties that confronted him and his readers. In their compilation, commentaries, glossaries, and indexes, his re-presentation of these texts attempted to make them accessible to their new audience.

As master of the texts, Oresme also had to design the new cycles of illustration for Charles V's first (MSS *A* and *B*) and second sets of the texts (MSS *C* and *D*). The luxurious presentation of the vernacular versions of the *Ethics* and *Politics* not only signified their textual value but also contributed to the prestige of the enterprise. Thoroughly immersed in Aristotelian and scholastic theory on the value of images in cognitive and mnemonic processes, Oresme devised innovative visual structures based on representational modes appropriate to their respective texts. Grounded in rhetorical figures and strategies, the programs of the *Ethiques* featured personifications, metaphors, and allegories; the *Politiques,* paradigms as models and examples of regime types and social structures. Triadic organization of the picture field and the use of architectural settings are further evidence of Oresme's awareness of mnemonic theory. Based also on his training in Aristotelian modes of argument such as definition, Oresme had inscriptions inserted within the picture fields as a means of creating visual definitions of key terms and concepts analogous to those introduced within the text itself or amplified in his glossaries or indexes. Although in some cases Oresme referred to iconographic models in moral treatises and Mirror of Princes texts such as the Morgan *Avis au roys,* he invented new programs, particularly in the *Politiques* cycle.

Oresme's revision of the programs of the luxurious library copies of Charles V's first set of translations became necessary when they were reformatted and re-edited for more modest portable versions. The most striking case of such revision occurred in the second *Ethiques* manuscript (*C*), possibly as the result of dissatisfaction expressed by the patron. Oresme probably furnished now-lost verbal instructions to the miniaturists, who headed three workshops favored by the king and identified with the Master of Jean de Sy, the Master of the Coronation Book of Charles V, and the Master of the Coronation of Charles VI. Supervising the production of the manuscripts was the scribe, specifically identified in *C* and *D* with

Raoulet d'Orléans, whose reputation with Charles V was well established. The collaborative nature of manuscript production, including intervention by the patron, dispersed control among those responsible for the execution of the book. Perhaps the most intangible contribution belonged to the miniaturists, whose personal styles, skills, and subjective biases could alter the content and reception of the illustrations. Oresme himself may, however, have been able to exercise some control over the interpretation of the programs by using them as talking points in oral explications or discussions during the readings favored by the king at mealtimes or other appropriate occasions.

Oresme's design of the programs of illustration thus afforded him a level of extratextual commentary that provided a way to update and concretize the verbal translations. He was thus able to appropriate and transform Aristotle's text to advance a contemporary fourteenth-century agenda of moral, political, and social principles. As a moralist, he came down against the fashionable and extravagant pleasure-loving classes in visual denunciations of hunting, excessive expenditure, and surrender to sexual temptation. Instead, Oresme identified the highest moral standards with representatives of the clerical or academic life. In an overt political compliment, a monumental personification allegory identified the kingdom of France as the stronghold of Justice. Even more to the point, in the frontispiece of Charles V's first copy of the *Politiques,* where Royaume is honored at the apex of Aristotle's three paradigmatic good regimes, the exemplary ruler was identified as a French king.

In the programs of illustrations Oresme also developed subjects or themes that translated textual concepts in terms of the historical experience of his readers, specifically the difficult period of the late 1350s and early 1360s, when the very existence of the Valois monarchy was threatened by military defeats, by the imprisonment of King John the Good during the first phase of the Hundred Years' War, and by the dynastic challenge of Charles the Bad of Navarre and his allies. Oresme's visual sermons addressed the political community as guides to moral and political conduct. The effect of these teachings on Oresme's readers is, of course, difficult to gauge. As far as public policy goes, Oresme's tract on the debasement of the coinage led to political reform, as did the election of a royal chancellor by the king's council for a few years coinciding with the publication of the *Politiques.*[1]

The illustrations affirmed medieval social hierarchies. In a positive sense the readers who were *genz de conseil* could have associated the importance of this institution with Charles V's council, of which they were part. Negatively, although vividly, portrayed were representatives of the lower classes. Chief among them in the *Ethiques* programs were the unforgettable giant and dwarf, metaphors of the generic vices of Superhabondance and Excès. Menacing urban craftsmen appeared as one of the three noncitizen groups in the illustrations of Book VII of the *Politiques*. In the same miniatures agricultural workers were also excluded from participation in political life. Yet in other illustrations, the life of the peasant was favorably depicted as the foundation of the stability of the political community. These illustrations carry multivalent, possibly ironic meanings.

In other, less political, contexts, however, Oresme took more unconventional positions. His own authorial identity grew more prominent in the inscription and dedication portrait of *C* and in the personalization of the glosses with abbreviations of his name. Likewise, Oresme's identification, and indirectly that of his patron, with the joys of the contemplative life in the pursuit of knowledge and wisdom emerges from the stunning climax to the cycle, the monumental personification allegory, in *C*. Another innovative element is Oresme's emphasis on Aristotle's theory of the mean imaginatively expressed in moral, social, and political terms. Departing from the medieval practice of assigning superior status to the largest figure, Oresme equates the center of the picture field and intermediate scale with normative values. While Oresme's emphasis on the ideal of the mean may have also signified his own personal taste, and perhaps that of Charles V himself, the translator's stress on the ability of the individual to make a moral choice based on reason and free will prefigures a central concern of humanistic thought. The invention of the decision allegory as a representational mode provides a visual confirmation of such a position. Channels of international exchange, such as diplomacy, and other contacts of Charles V's court with Petrarch and centers of early humanism such as Avignon and Naples, may have encouraged the development of themes relating to the moral and intellectual growth of the individual. Consistent with early humanism is Oresme's historical consciousness of the separation of contemporary society from ancient culture, in which he was deeply interested.

Charles V's commission of Oresme's vernacular versions of Aristotle's authoritative texts is both the climax of his translation project and an important precursor for future developments in the patronage of French art and culture. The use and enrichment of the French language as an instrument of the monarchy was an important aspect of his policy. Oresme's praise of and improvement of the French language come to mind as precursors of Joachim Du Bellay's famous *Deffence et illustration de la langue françoyse* of 1549. In a similar fashion, Oresme's lexical enrichment of French heralded Rabelais's achievement.[2] The climax to the monarchical effort to place literature and learning under royal control was the founding under Richelieu of the French Academy, an institution that exists to the present day.

More than a century passed following the death of Charles V before political conditions and the personality of the king permitted the resumption of an intensive monarchical patronage of an official royal library and a program of translations. During this time, members of the royal family, the dukes of Burgundy, and the aristocracy continued to sponsor individual translations of ancient and contemporary works, fostered also in the last quarter of the fifteenth century by the rising tide of humanism.[3] Only with the reign of Francis I did royal patronage of translations, particularly of ancient authors, again become an articulated cultural policy.[4]

Another influential precedent for Francis I was Charles V's attempt to establish under royal auspices a center for creating and disseminating information and knowledge independent of the conservative University of Paris. Under the influence of Guillaume Budé, Francis I founded in 1530 the establishment later known

as the Collège de France.[5] Open to the public, this institution was at first dedicated to the study of ancient and oriental languages, subjects favored by humanists and reformers.[6]

In short, Charles V's patronage of language, letters, and art, exemplified by Nicole Oresme's French translations of Aristotle, is rooted in a specific period of late fourteenth-century history. Yet, as this brief summary suggests, certain tendencies to centralize government control of language, culture, and art are permanent features of French culture still clearly evident today.

APPENDIX I MS *A*

Aristotle, *Ethica Nicomachea,* French translation of Nicole Oresme. Paris, after 1372 (Brussels, Bibliothèque Royale Albert Ier, MS 9505–06)

TEXT DIVISIONS

Fols. 1–1v, translator's prologue addressed to King Charles V of France: "*Ci commence la translacion des Livres de Ethiques et Politiques, translatez par Maistre Nichole Oresme.*[1] Le Proheme. En la confiance de l'aide de Nostre Seigneur Jhesu Crist, du commandement de tres noble et tres excellent prince Charles, par la grace de Dieu, roy de France, je propose translater de latin en françois aucuns livres lesquelx fist Aristote le souverain philosophe, qui fu docteur et conseillier du grant roy Alexandre." Fols. 1v–2, *Excusacion et Commendacion de Ceste Oeuvre:* "Prescian dit, en un petit livre que il fist des maistres de Terente, que de tous les langages du monde latin est le plus habile pour mieulx exprimer et plus noblement son intencion." Fols. 2–2v, chapter titles for Book I: "*Ci commence le Livre de Ethiques lequel fist Aristote le philosophe.*" Fol. 2v, incipit, Book I: "Tout art et toute doctrine et semblablement tout fait ou operacion appetent et desirent aucun bien." Fol. 221v, Book X, explicit: "Or dison donques et commençons. Ci fine le livre d'Ethiques. Deo gracias." Fols. 222–224v, *La Table des Moz Divers et Estranges:* "Pour ceste science plus clerement entendre, je vueil de habondant exposer aucuns moz selon l'ordre de l'a.b.c. . . ." Fol. 224v, colophon: "Du commandement de tres noble, puissant et excellent prince Charles par la grace de Dieu roy de France fu cest livre cy translaté de latin en françois par honorable homme et discret, Maistre Nicole Oresme, Maistre en theologie et doien de l'eglise de Nostre Dame de Rouen. L'an de grace m.ccc.lxxii."

The text comprises the full ten books of the *Nicomachean Ethics.* The second volume, containing the *Politics* and *Economics* of this deluxe, library set of Oresme's translations made for Charles V, is in a private collection in France. This manuscript is here identified as *B;* see Appendix III.

STRUCTURE AND LAYOUT

Parchment, 224 fols. ii (modern) + 224 + 2 (1 modern, 1 contemporary): I (1) 8; II (9) 8; III (17) 8; IV (25) 8; V (33) 6; VI (39) 10; VII (49) 8; VIII (57) 8; IX (65) 8; X (73) 8; XI (81) 8; XII (89) 8; XIII (97) 8; XIV (105) 8; XV (113) 8; XVI (121) 8; XVII (129) 8; XVIII (137) 8; XIX (145) 8; XX (153) 10; XXI (163) 6;

XXII (169) 8; XXIII (177) 8; XXIV (185) 8; XXV (193) 8; XXVI (201) 8; XXVII (209) 8; XXVIII (217) 4; XXIX (221) 4

318 × 216 (justification, 208 × 150) mm. Text written in 2 columns, 35 lines, ruled in red ink. Glosses in smaller script in separate columns of differing sizes surrounding text on 4 sides. Prefatory matter, chapter headings, and glossary of difficult words written in 2 columns, 49 lines. Gothic bookhand, unidentified scribe close to Raoulet d'Orléans, brown ink. Catchwords, lower right verso; modern foliation. Book numbers centered in upper margin, in alternating red and blue filigrees; contemporary chapter numbers in alternating blue and red Roman numerals in margins. Alternating blue and red line endings and paraphs. Rubrics indicate the introductory summary paragraph, incipit and explicit lines, chapter numbers corresponding to those in margins, chapter titles, and key words in glosses. Below miniatures at beginning of each book, 4–6-line gold initial, dentellated and foliated. Alternating red and blue 3-line initials for first words of chapters of text; 2 lines for chapter headings. Signature marks, diagrams explaining Félicité (Book I, fol. 5v), various aspects of proportional systems (Book V, fols. 95, 95v, 97, 99, and 100) and in margins the abbreviation for the word note (*no.*) written by the scribe, perhaps signaling important passages on fols. 6v, 15, 25v, 31v, 41, 70, 73, 81, 98, 122v, 130, 164v, 181v, and 193.

Capital letters stroked in red. *Renvois* in brown ink stroked with yellow. Drolleries: fol. 1 (nun or monk reading book); fol. 2v (male figure attacking vine). Dragons as upper terminals of initials, fols. 24, 89, 115v, and 177v.

Modern quarter binding by J. M. Marchoul, Belgium, 1970. Red leather spine, wooden boards, two metal clasps.

MINIATURES

Eleven, 9 column illustrations, 2 half-page, width of text block; interior tricolor quadrilobe frame; Master of the Bible of Jean de Sy and workshop. Prologue of translator, fol. 1, Charles V Receives the Book from Nicole Oresme (7.2 × 7.2)/ Book I, fol. 2v, Charles V Receives the Translation from Nicole Oresme, above left; Charles V and His Family, above right; A King and His Counsellors Attend a Lecture, below left; The Expulsion of a Youth from a Lecture, below right (14.8 × 15.2)/Book II, fol. 24, Superhabondance, Vertu, Deffaute (8 × 7.2)/Book III, fol. 39, Fortitude, Actrempance (7.1 × 6.9)/Book IV, fol. 66, Liberalité, Le Magnanime (7.7 x 6.9)/Book V, fol. 89, Justice légale with Fortitude, Justice particulière, Mansuétude, and Entrepesie, above; Justice distributive, Justice commutative, below (15.2 × 15.2)/Book VI, fol. 115v, Art, Sapience (7.5 × 6.7)/Book VII, fol. 132, Raison, Le Continent, Concupiscence, left; Raison, L'Incontinent, Concupiscence, right (7.3 × 6.5)/Book VIII, fol. 157, Amistié (8.1 × 6.7)/Book IX, fol. 177v, Two Friends (7.3 × 6.9)/Book X, fol. 198v, Félicité (7.6 × 6.9)

A palette of red, blue, gray, and white, sometimes enhanced by gold, is repeated in all but the illustrations of Books VIII and IX, in which more sober tonalities of

gray, green, and rose appear. Distinctive features of the illustrations are the crenellated architectural motif (interpreted as a city gateway) and, in the first half of *A*, a fleur-de-lis motif as the pattern of the geometric background.

A copy of a document dated 10 December 1371 mentions a payment of 100 livres to Nicole Oresme for his translation of the *Ethics* and *Politics*.[2] The patron, translator, and date of 1372 are mentioned in the colophon of this manuscript. In recent publications, scholars are reluctant to accept such a precise dating, as 1372 refers not to the manuscript itself but to the transcription of the translation. Since *A* is found in Gilles Malet's inventory of the Louvre library dating from 1373 (item A 237 and B 240; see Delisle, *Recherches,* vol. 2, no. 481, 81), the manuscript must have been completed by that year. On 7 October 1380, following the death of Charles V, his brother Louis, duke of Anjou, took the manuscript, along with its counterpart volume of the *Politics* and *Economics* (MS *B*), from the Louvre library. Both *A* and *B,* examples of the deluxe, presentation copies of Oresme's translations destined for stationary use in Charles V's library, found their way into the collections of the dukes of Burgundy. MS *A* appears in the inventories of the Burgundian library compiled in Dijon in 1404 and 1420, and again in the one prepared in Bruges about 1467.[3] An even more complete description of *A* occurs in a third Burgundian inventory dated 1485. The manuscript remained in the Burgundian collections in Brussels until the French Revolution. In 1796 *A* was taken to Paris, where it stayed in the Bibliothèque Nationale until 1815. After its return to Brussels, the red stamp of the Bibliothèque Nationale, located on the last folio of the volume, was erased and replaced by that of the Bibliothèque Royale.

PRINCIPAL REFERENCES[4]

Avril, "*Manuscrits,*" no. 281, 327; idem, *La Librairie,* no. 202, 117; idem, *Manuscript Painting at the Court of France,* no. 33, 105; Bibliothèque Royale de Belgique Albert Ier, *La librairie de Philippe le Bon,* no. 215; idem, *Trésors de la Bibliothèque Royale de Belgique,* no. 14; Delaissé, *Medieval Miniatures,* 78–81; Delisle, *Le cabinet des manuscrits,* vol. 1, 42; idem, *Mélanges de paléographie,* 260–64, 269, and 273–75; idem, *Recherches,* vol. 1, no. 55, 254–55, and vol. 2, no. 481; Dieckhoff, *Die Parler und der schöne Stil,* vol. 3, 116; Doutrepont, *Inventaire de la librairie de Philippe le Bon,* no. 91, 51; idem, *La littérature française à la cour des ducs de Bourgogne,* 121–22; Gaspar and Lyna, *Les principaux manuscrits à peintures,* vol. 1, no. 148, 354–56; van den Gheyn, *Catalogue des manuscrits,* no. 2902, 334; Grabmann, "Die mittelalterlichen Kommentare," 47; Hoeber, "Über Stil und Komposition der französischen Miniaturen," 193–94; Knops, *Etudes;* Masai and Wittek, *Manuscrits datés conservés en Belgique,* no. A 66, 70; Meiss, *French Painting,* vol. 1, 73, and idem, *French Painting:*

The Limbourgs, 418; Oresme, *Ethiques;* Panofsky, *Early Netherlandish Painting,* vol. 1, 36; idem, *Hercules am Scheidewege,* 150–51; Sherman, *Portraits,* 38–40; idem, "Representations of Charles V," 91–92; idem, "Some Visual Definitions," 320–30; de Winter, *La bibliothèque de Philippe le Hardi,* 10, 50, 87–88, 141, 222–25, and 263; idem, "The *Grandes Heures,*" 803 and 807; Wixom, "A Missal for a King," 164, 168, and 173.

APPENDIX II MS *C*

Aristotle, *Ethica Nicomachea,* French translation of Nicole Oresme. Paris, 1376 (The Hague, Rijksmuseum Museum Meermanno-Westreenianum, MS 10 D 1)

TEXT DIVISIONS

Fols. 1–4, glossary of difficult words (no title): "Pour ceste science plus clerement entendre, Je vueil de habondant exposer aucuns mos selon l'ordre de l'a.b.c." Fols. 5–6, translator's prologue addressed to King Charles V of France: "*Ci commence le livre de Ethiques et premierement le prologue du translateur.*[1] En la confiance de l'ayde de nostre seigneur Jhesu Crist, du commandement de tres noble et tres excellent prince Charles, quint de ce nom, par la grace de Dieu roy de France, Je Nicole Oresme doyen de l'eglise de nostre dame de Rouen propose translater de latin en françois aucuns livres les quels fist Aristote le souverain philosophe." Fols. 6–6v, *Excusacion et recommendacion de tel labeur:* "Prescian dit, en un petit livre que il fist des metres de Terente, que de tous les langages du monde latin est le plus habile pour miex exprimer et plus noblement son intencion." Fols. 6v–7, chapter titles for Book I: "*Ci commence le livre d'Ethiques lequel fist Aristote le quel livre contient .x. livres parcials.*" Fol. 7, explanatory note added by scribe, Raoulet d'Orléans: "Et pour ce que cest livre d'Ethiques soit plus legier a estudier, Je qui l'ay escript ay mis texte et glose tout en entresuyvant et ay signé le texte a tel lectre *T,* qui fait texte. Et quant la glose ou exposicion comme ce je y met tel lectre de vermeillon *O* qui fait Oresme. In nomine domini amen." Fol. 7, incipit, Book I: "Tout art et toute doctrine." Fol. 214v, Book X, explicit: "Or dison donques et commençons." Fol. 215, colophon: "Ci fine le livre d'Ethiques le quel fist faire tres noble, tres excellent et vray catholique prince Charles le quint, par la grace et loenge de Dieu roy de France, et l'escript Raoulet d'Orliens l'an M.CCC.LXVI. Deo gracias."[2]

STRUCTURE AND LAYOUT

Parchment, 216 fols. ii (parchment) + 216 + 1 (parchment). Fols. 4v, 149v, and 216 blank: I (1); II (5) 8; III (13) 8; IV (21) 8; V (29) 8; VI (37) 8; VII (45) 8; VIII (53) 8; IX (61) 8; X (69) 8; XI (77) 8; XII (85) 8; XIII (93) 8; XIV (101) 8; XV (109) 8; XVI (117) 8; XVII (125) 8; XVIII (133) 8; XIX (141) 8; XX (149) 8; XXI (157) 8; XXII (165) 8 + 1; XXIII (175) 6; XXIV (181) 8; XXV (189) 8; XXVI (197) 8; XXVII (205) 8; XXVIII (213) 4

218 × 152 (justification, 146 × 93) mm. Written in 2 columns, 48 lines; ruled in pale brown ink. Text and gloss intermingled. In rubrics, text = *T, Aristote,* or *Texte de Aristote;* gloss = *O, Or,* or *Oresme.* Gothic bookhand; one scribe, Raoulet d'Orléans, brown ink. Prickings for rulings visible. Catchwords and signature marks, lower right verso; modern pencil foliation. Book title, prologue, and book numbers centered in upper margin, alternating pen flourishes and red and blue filigrees; chapter numbers in blue Roman numerals in margins. Alternating red and blue pen line endings and paraphs; chapter titles in text in rubrics. Below miniatures beginning each book a 5–7-line gold initial, dentellated and foliated (those of fols. 110 and 170 have an interior motif of a dragon, which appears as an upper terminal on fols. 5 and 63). In glossary of difficult words, 3-line initials, alternating red and blue flourishes. Alternating red and blue, 2-line initials for chapter headings and summary paragraphs. Capital letters stroked with yellow. Diagrams (Book I, fol. 10; Book III, fol. 43v; Book V, fols. 89, 91, 92, and 92v). In the margins the abbreviation for the word note (*no.*) written by the scribe (fols. 8, 65, 156v, 170, 181, 182v, and 187v). Arms of Charles V effaced, fol. 5 (supporting angels still visible) and fol. 193.

Binding, 18th century, brown calf; spine, 4 raised bands; blue-colored edges, gold tooled. The placement of the glossary of difficult words at the beginning of the volume (instead of the end as in *A*) may have occurred when the book was rebound. Otherwise, the text and gloss do not differ significantly from those of *A*.

MINIATURES

Ten rectangular frontispieces, 1–3 registers. Last two illustrations executed by unidentified artists; the rest, by the Master of the Coronation of Charles VI and workshop. Book I, fol. 5, Charles V Receives the Book from Nicole Oresme, above; Félicité humaine, below (10 × 9.3)/Book II, fol. 24v, Excès, Bonne volenté, Vertu, Cognoissance, Deffaute (5.4 × 9.4)/Book III, fol. 37, Oultrecuidance, above left; Fortitude, center; Couardie, right; Désattrempance, below left; Attrempance, center; Insensibilité, right (5.5 × 9.3)/Book IV, fol. 63, Prodigalité, above left; Liberalité, center; Avarice, right; Convoitise, below (5.8 × 9.2)/Book V, fol. 84, Justice légale and the Virtues, above; Justice distributive, Justice commutative, below (5.8 × 9.2)/Book VI, fol. 110, Science, above left; Art, center; Prudence, right; Entendement, below left; Sapience, right (9.8 × 9.2)/Book VII, fol. 126, Raison, Le Continent, Concupiscence, above left; Raison, L'Incontinent, Concupiscence, above right; Raison, Le Vertueus, Concupiscence, below left; Raison, Le Vicieus, Concupiscence, below right; (10.5 × 9.2)/Book VIII, fol. 150, Amistié pour proffit, above left; Amistié pour delectacion, center; Amistié selon vertu, right; Amistié entre prince et subiez, below left; Amistié entre parens, center; Amistié entre mariez, right (10.5 × 9.3)/Book IX, fol. 170, A Ransom Dilemma: Father or Son, top; Father or Friend, center; Friend or Son, bottom (11.4 × 9.3)/Book X, fol. 193, Félicité contemplative (10.9 × 9.1).

The figures are modeled in grisaille with colored washes and frequent touches of gold for accessories. Large spiral or tiny geometric motifs of the backgrounds are painted in contrasting colors for upper and lower registers of apricot, blue, and blue-black, highlighted with gold. The sizes of the miniatures increase dramatically after Book V.

HISTORY

A copy of a document dated 10 December 1371 mentions a payment to Nicole Oresme of 100 livres for his translations of the *Ethics* and the *Politics*.[3] Raoulet d'Orléans was paid 5 livres for his work on the *Ethiques* and the *Politiques,* presumably MSS *C* and *D*.[4] In the colophon, the scribe states that he wrote the book in 1376. Charles V's signature, noted in the 1411 inventory of the king's library in the Louvre, is now erased.[5] The manuscript is mentioned in all 4 inventories of this library. After the death of Charles VI, in 1425, the manuscript was sold for 16 livres to the regent, John, duke of Bedford. Following his death and that of his wife, Anne, sister of Philip the Good, duke of Burgundy, the manuscript entered the library of that prince, according to inventories of 1467 and 1487. Around 1500 the volume came into the hands of Philip of Cleves, whose signature appears on fol. 215. The next owner of the manuscript to be identified is Nicholas Witsen (1641–1717), a magistrate of Amsterdam. The name *Witsen* appears on fol. 5, above the effaced coat of arms of Charles V supported by 2 angels. How and when the manuscript entered the collection of another Dutch family, the Meermans, is unknown. In 1824, at the Meerman auction, the manuscript (no. 874) was sold via the auctioneer—who bought it for 75 guilders. The buyer, Baron van Westreenen, paid 84 guilders for the manuscript.[6]

PRINCIPAL REFERENCES[7]

D'Alverny, "Quelques aspects du symbolisme de la *Sapientia*," 321–33; Avril, *La librairie,* no. 205, 118–19; Berliner, "*Arma Christi,*" 112; Bibliothèque Royale Albert Ier, *La librairie de Bourgogne,* no. 4, 19; Boeren, *Catalogus,* 92–94; Byvanck, Alexander W., *Les principaux manuscrits,* 110–15; Byvanck, Willem G. C., *Twee Fransche handschriften,* 5–16; Delaissé, *Medieval Miniatures,* 81; Delisle, *Le cabinet des manuscrits,* vol. 1, 36 and 41–42; idem, *Mélanges de paléographie,* 265–67 and 278–80; idem, *Recherches,* vol. 1, 252–53; Gaspar and Lyna, *Les principaux manuscrits à peintures,* vol. 1, 362–64; Knops, *Etudes;* Lieftinck, *Manuscrits datés,* vol. 1, no. 12, 56; Maumené and d'Harcourt, *Iconographie des rois de France,* vol. 1, no. 35, 48; Oresme, *Ethiques,* 47; Panofsky, *Hercules am Scheidewege,* 110, n. 1, 160, and 171; Rijksmuseum Meermanno-Westreenianum, *Verluchte handschriften uit eigen bezit,* no. 16, 14; Sherman, *Portraits,* 22–23; idem, "Representations of Charles V," 90; idem, "Some Visual Definitions," 321.

APPENDIX III MS *B*

Aristotle, *Politica* and *Oeconomica,* French translation of Nicole Oresme. Paris, 1375–76 (France, private collection)

Fol. 1, dedication of the translator: "A tres souverain et tres excellent prince Charles le quint de ce nom, par la grace de Dieu roy de France, Nicolas Oresme, doien de vostre eglise de Rouen, vostre humble chappelain, honeur, obedience et subjeccion." Fol. 1v, first instruction to the reader: "L'en peut veoir clerement les matieres tractiées en cest livre." Fol. 2, second instruction to the reader: "Aristote traicte en cest livre appellé Politiques, principalment de policies."[1] Fol. 4, incipit, Book I: "*Ci commence le livre de politiques ou quel Aristote traite et determine des manieres de ordener et gouverner les cités et les grans communités et contient .viii. livres particuliers.*"[2] explicit, Book VIII, fol. 352. Fol. 352, index of noteworthy subjects of Book VIII: "Notables choses du Livre VIII. En cest VIIIᵉ livre sont aucunes choses assez notables, et ou texte et en la glose, desquelles aucunes sont ici designées." Fol. 352v, glossary of difficult words of Book VIII: "Ci apres s'ensuivent les exposicions d'aucuns moz qui sont en cest VIIIᵉ livre de Politiques." Fol. 353, index of noteworthy subjects of the whole work: "Par les intitulacions des livres et des chapitres l'en peut veior les matieres de tout le livre, et en quelz lieux elles sont traittées; mais avecques ce sont pluseurs choses notables, tant ou texte comme es gloses, desquelles aucunes sont ci apres designées en table selon l'a.b.c." Fol. 367, glossary of difficult words of the whole work: "Ci après commence la table des exposicions des fors moz contenuz en cest livre de Politiques, et s'en va selon l'ordre de l'a.b.c." Fol. 373, incipit, Book I of the *Yconomique:* "Ci commence le livre appellé Yconomique lequel composa Aristote et ou quel il determine de gouvernement de maison et contient .ii. petiz livre partialz." Fol. 384, explicit, "Ci finist yconomique et ne convient ie faire table des notables de si petit livre."

The text comprises the eight books of the *Politica* and two books of the pseudo-Aristotelian *Oeconomica*. *B* is the second volume of the official library copy of Oresme's translations of these texts commissioned by Charles V and is the counterpart of *A* described in Appendix I. A unique feature of *B* is the second instruction to the reader and the glossary of difficult words of Book VIII. These last two elements are characteristic of the first family of manuscripts of Oresme's translations of the texts.[3]

Parchment, 396 fols. ii + 394 + 2?: I (1) 3; II (4) 8; III (12) 8; IV (20) 6; V (26) 8; VI (34) 8; VII (42) 8; VIII (50) 8; IX (58) 8; X (66) 8; XI (74) 4; XII (78) 8; XIII (86) 8; XIV (94) 8; XV (102) 8; XVI (110) 8; XVII (118) 8; XVIII (126) 8; XIX (134) 8; XX (142) 8; XXI (150) 8; XXII (158) 8; XXIII (166) 8; XXIV (174) 8; XXV (182) 8; XXVI (190) 8; XXVII (206) 8⁴

315 × 210 (justification, 210 × 145) mm. Text written in 2 columns, 34 lines, ruled in red ink. Glosses in smaller script in separate columns of differing sizes surrounding text on 4 sides. Prefatory matter, chapter headings, glossaries of difficult words, and indexes of noteworthy subjects written in 2 columns, 34 lines. Gothic bookhand, unidentified scribe (close to Raoulet d'Orléans), brown ink. Catchwords, lower right verso; correction marks (*Cor.*), lower left corner of last folio of gatherings. Except for titles of Book I of the *Politiques* (fol. 4) and the *Yconomique* (fol. 370), which are written out, book numbers appear in Roman numerals, upper margin, in red-and-blue filigrees; chapter numbers in blue and red Roman numerals in margin. Alternating blue and red line endings and paraphs. Rubricated introductory summary paragraph, incipit and explicit lines, chapter numbers corresponding to those in margins, chapter titles, and key words in glosses in rubrics. Below miniatures at beginning of each book, 5–8-line gold initial, dentellated and foliated. Alternating red and blue 3–5-line initials for first words of chapters of text; 2 lines for chapter headings. Diagrams, fols. 175, 227, and 278.

Renvois in brown ink stroked with yellow. Occasional fantastic pen initials (fish heads). Drollery, fol. 378 (woman spinning). Dragons as upper terminals of initials, fols. 128, 170, 220, and 254. Ivy-leaf borders: with birds and rabbits, fols. 2, 32, 75, and 327; with arms of France (3 fleur-de-lis), fol. 1 (1), 32v (2), 33 (1), and fol. 75 (2).

Binding, 18th century, brown calf, stamped with arms of owners. Remains of the original green silk binding described in 15th-century inventories still fixed to the parchment folio attached to the back board.⁵

MINIATURES

Seventeen, 3-column illustrations, 13 frontispieces, width of text block, 1 full page and facing 3/4-page bifolio, 1–3 registers. Four artists: Perrin Remiet (fols. 1, 4v); Jean de Sy Master and workshop (fols. 3v, 4, 128, 170, 230); Master of the Coronation of Charles VI (fols. 32v, 33, 75, and 328); Master of the Coronation Book of Charles V and workshop (fols. 370 and 381). *Politiques,* dedication of the translator, fol. 1, Nicole Oresme Writing (8.6 × 6.8)/Book I, fol. 3v, Tyrannie, top; Olygarchie, center; and Democracie, bottom (24 × 15)/fol. 4, Royaume, top; Aristocracie, center; Tymocracie (Polity), bottom (17 × 15)/Book I, fol. 4v, Nicole Oresme Presents the Book to Charles V (7.3 × 6.8)/Book II, fol. 32v, Socrates

Dictates to Plato (7 × 15); Phaleas (7 × 15); and fol. 33, Hippodamus (10 × 6.7)/ Book III, fol. 75, A King Banishes a Subject, above; A Peasant Cuts off the Tallest Ears of Grain, below left; A Painter Erases an Error, right (18 × 14.5)/Book IV, fol. 128, Povres gens, above left; Bonne policie—Moiens, center; Riches gens, right; Povres gens, below left; Mauvaise policie—Moiens, center; Riches gens, right (15.2 × 14.4)/Book V, fol. 170, Sedition ou Conspiracion occulte, above; Le Demagogue qui presche au peuple contre le prince, Sedition apperte, below (14.3 × 14.5)/Book VI, fol. 230, Bonne democracie (14.8 × 14.7)/Book VII, fol. 254, Genz d'armes, top left; Genz de conseil, center; Gent sacerdotal, right; Cultiveurs de terres, below left; Genz de mestier, center; Marcheans, right (17.5 × 14.7)/Book VIII, fol. 327, Trop dure discipline, above left; Bonne discipline pour les armes, right; Bonne discipline pour bonnes meurs (16.3 × 14.4). *Yconomique:* Book I, fol. 370, Household and Family (9 × 14.5)/Book II, fol. 381, A Marriage Ceremony (7.5 × 6.7)

A palette of red, blue, and white with contrasting geometric backgrounds, established in the cycle of *A,* is repeated in the illustrations executed by the Jean de Sy Master and the Master of the Coronation Book of Charles V. The Master of the Coronation of Charles VI models the figures in grisaille in fols. 4v, 32v, 33, and 75, along with quadrilobe frames, which also occur on fols. 1, 4v, and 380. Gold arcades appear as the setting for fols. 3v, 128, and 254. Fleur-de-lis backgrounds occur only on fols. 1 and 32v.

HISTORY

For documents pertaining to Oresme's translation of the *Ethics* and the *Politics,* see Appendix II. For the history of the manuscript until the French Revolution, see Appendix I. About the time of the revolution, *B* entered the collection of the family of the present owner. *B* appears in the library of Philip the Bold, duke of Burgundy, and is mentioned in two inventories of the Burgundian library: the earlier one compiled in Dijon in 1420 and a later one from Bruges dating from 1467.[6]

PRINCIPAL REFERENCES[7]

Avril, *La librairie,* no. 203, 118; idem, "Manuscrits," no. 282, 327; Delisle, *Le cabinet des manuscrits,* vol. 1, 41–42, and vol. 3, no. 484, 138; idem, *Mélanges de paléographie,* 260–63 and 275–78; idem, *Recherches,* vol. 1, no. 56, 255–56, and vol. 2, no. 485; Doutrepont, *Inventaire de la librairie de Philippe le Bon,* no. 90; idem, *La littérature française à la cour des ducs de Bourgogne,* 121–23; Grabmann, "Die mittelalterliche Kommentare," 47; Oresme, *Politiques,* 34; idem, *Yconomique,* 802; Sherman, "A Second Instruction," 468–69; idem, "Some Visual Definitions," 321; de Winter, *La bibliothèque de Philippe le Hardi,* 50, 87–88, 91, 141, 201, 222–25, and 263.

APPENDIX IV MS *D*

Aristotle, *Politica* and *Oeconomica,* French translation of Nicole Oresme. Paris, 1376 (Brussels, Bibliothèque Royale Albert Ier, MS 11201–02)

TEXT DIVISIONS

Fol. 1, introductory paragraph to Book I, "*Ci commence Le Livre de Politiques, ou quel Aristote traicte et determine des manieres de ordener et gouverner les citez et les grans communitez et contient .VIII. livres particuliers.*" Fol. 1v, colophon, "*Je Raoulet d'Orliens qui l'escri ay mis le texte premier ainsi signé T. Et apres la glose s'ensuit ainsi signé O qui fait Oresme.*"[1] Fol. 2v, incipit, Book I: *Politiques,* "Nous veons que toute cité est une communité. Et toute communité est instituée et establie et ordenée pour la grace et a la fin d'aucun bien." Fol. 363, explicit, Book VIII, *Politiques:* "Cy fenist le .viii.ᵉ de Politiques." Fol. 363v, incipit, Book I, *Yconomique:* "*Cy commence le livre de Yconomique lequel composa Aristote.*" Fol. 387, explicit, Book II, *Yconomique*: "Cy fenist Yconomique. Et ne convient a ici faire table des notables." Fol. 388, "Par les intitulacions des livres et des chapitres l'en peut veoir les matieres de tout ce livre de Politiques qui contient .viii. livres." Fol. 388v, "*Ci commence la table des notables.*" Fol. 403, explicit, index of noteworthy subjects: "Cy fenist la table generale de tout le proces du livre de Politiques contenant .viii. livres."

The text comprises the eight books of the *Politica* and two books of the pseudo-Aristotelian *Oeconomica. D* is the second volume of the portable set of Oresme's translations of these texts commissioned by Charles V and is the counterpart of *C* described in Appendix II. *D* lacks the prologue, the two instructions, and the glossary of difficult words contained in *B* and described in Appendix III. *D* includes the integrated index of noteworthy subjects placed after the text of the *Yconomique.* Raoulet d'Orléans added the following marginal note, fol. 130v: "la glose qui vient apres est en la fin de ce tiers livre car cest livre estoit escript quant le maistre li adiousta." This gloss appears on fols. 134v–137.

STRUCTURE AND LAYOUT

Parchment, 403 fols. ii (modern) + 403 + 2 (modern): I (1) 1; II (2) 8; III (10) 8; IV (18) 8; V (26) 8; VI (34) 2; VII (36) 8; VIII (44) 6; IX (50) 8; X (58) 8; XI (66) 8; XII (74) 3; XIII (77) 8; XIV (85) 8; XV (93) 8; XVI (101) 8; XVII (109) 8; XVIII (117) 8; XIX (125) 8; XX (133) 12; XXI (145) 8; XXII (153) 8; XXIII (161) 8; XXIV (169) 8; XXV (177) 4; XXVI (181) 8; XXVII (189) 8; XXVIII (197) 8; XXIX (205) 8; XXX (213) 8; XXXI (221) 8; XXXII (229) 8; XXXIII

(237) 4; XXXIV (241) 8; XXXV (249) 8; XXXVI (257) 8; XXXVII (265) 8; XXXVIII (273) 8; XXXIX (281) 8; XL (289) 8; XLI (297) 8; XLII (305) 8; XLIII (313) 8; XLIV (321) 8; XLV (329) 8; XLVI (337) 4; XLVII (341) 8; XLVIII (349) 8; XLIX (357) 8; L (365) 8; LI (373) 8; LII (381) 7; LIII (388) 8; LIV (396) 8

226 × 15.3 (justification, 141 × 95) mm. Text written in 2 columns, 41 lines; ruled in pale brown ink. Prickings for rulings visible. Text and gloss intermingled. In rubrics, text = *T*, or *Texte;* gloss = *O, Or,* or *Oresme.* Gothic bookhand, one scribe, Raoulet d'Orléans. Catchwords lower right verso; modern pencil foliation. Book numbers in upper margin, alternating red and blue filigrees; chapter numbers in alternating blue and rose Roman numerals in margins. Alternating red and blue pen 2-line initials of chapter headings, line endings, and paraphs. Introductory paragraphs, chapter titles, and some diagram inscriptions in rubrics. Below miniatures beginning each book, a 5-line initial, dentellated and foliated. Alternating red and blue, 2-line initials for chapter headings and summary paragraphs. Capital letters stroked with yellow. Diagrams (Book IV, fols. 177v and 180v; Book V, fols. 186 and 237v; Book VI, fol. 254; Book VII, fols. 254, 289, and 318v; Book VIII, fol. 360; and *Yconomique,* Book I, fol. 372v). In the margins abbreviations for the word note (*no.*) written by the scribe (fols. 35, 38, 50, 131v, 188v, 196, 231, 254, and 369).

An earlier brown calf binding was replaced by a modern quarter binding in wood, red morocco spine and bands, gold metal strip with 5 small rivets, 2 metal clasps, morocco trim by M. J. Marchoul, Belgium, 1967.

MINIATURES

Ten rectangular frontispieces, 1–3 registers. The atelier of the Master of the Coronation Book of Charles V executed the entire cycle (Books I–VIII, *Politiques;* Books I–II, *Yconomique*). The head of the atelier himself was responsible for the frontispieces of the entire volume on fols. 1v and 2, as well as of the miniature of Book VI, fol. 241. *Politiques:* Book I, fol. 1v, Tyrannie, top; Olygarchie, center; and Democracie, bottom (16.5 × 9.4); fol. 2, Royaume, top; Aristocracie, center; and Tymocracie (Polity), bottom (16.5 × 9.4)/Book II, fol. 36, Socrates Dictates to Plato, above left; Hippodamus, right (10.2 × 9.2); and Phaleas, below left (5.4 × 4.7)/Book III, fol. 77, A King Banishes a Subject, above; A King Cuts off the Tallest Ears of Grain in the Presence of a Messenger, below left; A Painter Erases an Error, right (10.1 × 9.3)/Book IV, fol. 138, Povres genz, above left; Bonne policie—Moiens, center; Riches gens, right; Povres gens, below left; Mauvaise policie—Moiens, center; Riches gens, right (10.2 × 9.3)/Book V, fol. 181, Conspiracion occulte, above; Demagogue preschant contre le prince, Sedition apperte, below (10.2 × 9.5)/Book VI, fol. 241, Bonne democracie (10.7 × 9.6)/Book VII, fol. 263, Genz d'armes, top left; Genz de conseil, right; Gent sacerdotal, center left; Cultiveurs de terres, right; Genz de mestier, bottom left; Marcheans, right (15.5 × 9.3)/Book VIII, fol. 341, Excercitations corporeles, above; A jecter le dart, below left; En musique, right (10.6 × 9.6). *Yconomique:* Book I, fol. 363v,

Household and Family (6.5 × 9.6)/Book II, fol. 375, A Marriage Ceremony (6.2 × 9.4).

As in *C*, the figures are modeled in grisaille with colored washes. Two miniatures (fols. 36 and 77) have tricolored, quadrilobe frames. A new type of frame is introduced in the miniatures beginning with Book VI of the *Politiques* and continues throughout the cycle. A familiar repertoire of colored and gold geometric backgrounds occurs in all the miniatures but is diminished in those illustrations with a landscape or architectural background (fols. 241, 363v, and 375).

HISTORY

For the documents relating to the commission of the translations and the payments to Raoulet d'Orléans for his work on the *Ethiques* and the *Politiques,* see Appendix II. The manuscript is mentioned in all 4 inventories of Charles V's library in the Louvre and is identified from a description of 1411 by the librarian Jean Le Bègue.[2] Like *C,* the manuscript remained in the Louvre library until the death of Charles VI in 1425, when it was sold to the regent, John, duke of Bedford, for 16 livres. Following his death and that of his wife, Anne, sister of Philip the Good, duke of Burgundy, the manuscript entered the library of that prince and is described in inventories of 1467 and 1487. The manuscript remained in the Burgundian library in Dijon until the French Revolution. In 1796 *D* was taken to Paris, where it stayed in the Bibliothèque Nationale until 1815. It was brought to Brussels in 1830 to form part of the Bibliothèque Royale. The red stamp of the Bibliothèque Nationale is still visible on fols. 1 and 403v.

PRINCIPAL REFERENCES[3]

Avril, *La librairie,* no. 204, 118–19; Bibliothèque Royale Albert Ier, *La librairie de Bourgogne,* nos. 4–5, 19–20; idem, *La librairie de Philippe le Bon,* no. 216, 141; idem, *Trésors de la Bibliothèque Royale,* no. 13, 34–35; Calkins, *Programs of Medieval Illumination,* 139–41; Delaissé, *Medieval Miniatures,* no. 14, 70–73; Delisle, *Le cabinet des manuscrits,* vol. 3, no. 485, 138; idem, *Mélanges de paléographie,* 256–69 and 281–82; idem, *Recherches,* vol. 1, no. 54, 254, and vol. 2, no. 485, 82–83; Doutrepont, *Inventaire de la librairie de Philippe le Bon,* 127; idem, *La littérature française à la cour des ducs de Bourgogne,* 121–23 and 126–27; Gaspar and Lyna, *Les principaux manuscrits à peintures,* vol. 1, no. 152, 362–65; van den Gheyn, *Catalogue des manuscrits,* vol. 4, no. 2904, 336; Grabmann, "Die mittelalterlichen Kommentare," 47; Hoeber, "Über Stil und Komposition der französischen Miniaturen," 187; Masai and Wittek, *Manuscrits datés conservés en Belgique,* vol. 1, no. 73, 44; Oresme, *Politiques,* 34–35; Sherman, "Some Visual Definitions," 326–33; de Winter, *La bibliothèque de Philippe le Hardi,* no. 17, 222–25; idem, "Copistes, éditeurs, et enlumineurs," 193; idem, "The *Grandes Heures,*" 794.

Oresme's Second Instruction to the Reader of the *Politiques*

Aristote traicte en cest livre appellé *Politiques* principalment de policies.[1] Et est à savoir que de simples policies sont .vi. especes generales, et chascune de ces especes est divisée en plusieurs especes. Et de ces .vi. manieres de policies et de leurs especes sont composées et mixtes toutes autres policies. Et donques ces .vi. policies sont principals, et sont aussi comme les elemenz et les principes de toutes autres. Et pour ce sont yci au commencement du livre pourtraittes et figurées. Et sont trois bonnes, c'est à savoir royaume, aristocracie et tymocracie. Et trois autres qui sont transgressions ou corruptions des bonnes, c'est à savoir tyrannie, olygarchie et democracie. Et ces mos sont exposez en la fin du Livre d'*Ethiques* et aussi sont exposez en la fin de *Politiques*.

Item, les .iii. bonnes tendent au commun proffit. Et les autres trois tendent au propre proffit des gouverneeurs.

Item, en toute policie il convient ou que un seul ait princey et seigneurie ou un petit nombre ou une grande multitude.

Item, selon ce sont .vi. policies. Car se un seul seigneurist et pour le bien commun c'est royaume. Et se c'est pour son propre proffit c'est tyrannie.

Item, se un petit nombre seigneurist pour le proffit commun c'est aristocracie. Et se c'est pour leur propre proffit c'est olygarchie.

Item, se une grande multitude seigneurist pour le bien commun c'est tymocracie. Et se c'est pour leur propre proffit c'est democracie.

Item, des .iii. saines policies, tymocracie est bonne. Et aristocracie est meilleur. Et royaume est tres bonne. Et des corrompues, democracie est mauvaise. Et olygarchie est pire. Et tyrannie est tres mauvaise. Et est à entendre que ces .iii. sont mauvaises aucunement, car nulle n'est mauvaise simplement et sanz aucun juste.

Ci fine la seconde Instruccion ou declaracion des .vi. policies qui sont contenues en cest livre et lesquelles sont pourtraites et figurées cy-après au commencement de tout le livre.

TRANSLATION OF THE SECOND INSTRUCTION

Aristotle deals in this book called *Politics* chiefly with forms of government. And truly there are six general kinds of simple forms of government, and each of these

kinds is divided into several varieties. And from these six kinds of government and from their varieties are composed and combined all other forms of government. And thus these six forms of government are basic and are also like the elements and foundations of all the others. And for this reason they are portrayed and represented here at the beginning of the book. And three are good—that is to say, kingship, aristocracy, and timocracy. And there are three others which are deviations or corruptions of the good ones, that is to say, tyranny, oligarchy, and democracy. And these words are explained at the end of the book of *Ethics* and also at the end of the *Politics*.

Item, the three good ones promote the common good. And the other three promote the good of the governors.

Item, in every form of government it is necessary that power and sovereignty be held either by one person, or by a small number, or by a large multitude.

Item, according to this, there are six forms of government. For if one person rules and for the common good, that is kingship. And if it is for his own profit, it is tyranny.

Item, if a small number rules for the common good, it is aristocracy. And if it is for their own profit, it is oligarchy.

Item, if a large multitude rules for the common good, that is timocracy. And if it is for their own benefit, it is democracy.

Item, of the three sound forms of government, timocracy is good. And aristocracy is better. And kingship is the best. And of the corrupt ones, democracy is bad. And oligarchy is worse. And tyranny is the worst. And it is to be understood that these three are somewhat bad, for none is entirely bad and without any virtuous person.

Here ends the second instruction or declaration of the six forms of government which are contained in this book and which are portrayed and represented here at the beginning of the whole book.

ABBREVIATIONS OF
FREQUENTLY CITED WORKS

AB	*Art Bulletin*
Aristotle, *NE*	*Ethica Nicomachea*. Trans. and ed. W. D. Ross. Oxford: Clarendon Press, 1915.
Aristotle, *Politics*	*The Politics of Aristotle*. Ed. and trans. Ernest Barker. Oxford: Oxford University Press, 1958. Reprint, 1973.
Aristotle, *Rhetoric*	*The "Art" of Rhetoric*. Ed. and trans. John H. Frees. Cambridge, Mass.: Harvard University Press, Loeb Classical Library, 1959.
Avril, *La librairie*	François Avril, *La librairie de Charles V*. Exh. cat. Paris: Bibliothèque Nationale, 1968.
Avril, *Manuscript Painting at the Court of France*	François Avril, *Manuscript Painting at the Court of France: The Fourteenth Century (1310–1380)*. New York: George Braziller, 1978.
Babbitt, *Oresme's Livre de Politiques*	Susan M. Babbitt, *Oresme's Livre de Politiques and the France of Charles V*. Transactions of the American Philosophical Society, 75/1. Philadelphia: The Society, 1985.
BiblEC	*Bibliothèque de l'Ecole des Chartes*
Cazelles, *Société politique*	Raymond Cazelles, *Société politique: Noblesse et couronne sous Jean le Bon et Charles V*. Geneva: Droz, 1982.
CHMPT	*The Cambridge History of Medieval Political Thought, ca. 350–ca. 1450*. Ed. J. H. Burns. Cambridge and New York: Cambridge University Press, 1991.

Delachenal, *Histoire de Charles V*	Roland Delachenal, *Histoire de Charles V.* 5 vols. Paris: Picard, 1909–31.
Delisle, *Mélanges de paléographie*	Léopold Delisle, *Mélanges de paléographie et de bibliographie.* Paris: Champion, 1880.
Delisle, *Recherches*	Léopold Delisle, *Recherches sur la librairie de Charles V.* 2 vols. Paris: Champion, 1907.
DMA	*Dictionary of the Middle Ages.* Ed. Joseph R. Strayer. 13 vols. New York: Scribner, 1982–89.
Ethiques	*Maistre Nicole Oresme: Le livre de éthiques d'Aristote published from the text of MS 2902, Bibliothèque Royale de Belgique.* Ed. Albert D. Menut. New York: Stechert, 1940.
Fais et bonnes meurs	Christine de Pizan, *Le livre des fais et bonnes meurs du sage roy Charles V.* Ed. Suzanne Solente. 2 vols. Paris: Champion, 1936–40.
Gauthier and Jolif, *Ethique à Nicomaque*	Aristote, *L'éthique à Nicomaque.* Trans. and ed. René A. Gauthier and Jean Y. Jolif. 2 vols. in 4. 2d ed. Louvain: Publications Universitaires, 1970.
GBA	*Gazette des Beaux-Arts*
JWCI	*Journal of the Warburg and Courtauld Institutes*
Katzenellenbogen, *Virtues and Vices*	Adolf Katzenellenbogen, *Allegories of the Virtues and Vices in Mediaeval Art from Early Christian Times to the Thirteenth Century.* Studies of the Warburg Institute, 10. London: The Institute, 1939. Reprint. Nendeln, Liechtenstein: Kraus, 1968.
LCI	*Lexikon der christlichen Ikonographie.* Ed. Engelbert Kirschbaum. 8 vols. Rome: Herder, 1968–72.
Panofsky, *Hercules am Scheidewege*	Erwin Panofsky, *Hercules am Scheidewege und andere antike Bildstoffe in der neueren Kunst.* Studien der Bibliothek Warburg, 18. Leipzig: Teubner, 1930.
Politiques	*Maistre Nicole Oresme: Le livre de politiques d'Aristote.* Ed. Albert D. Menut. Transactions of the American

Philosophical Society, n.s. 60/6. Philadelphia: The Society, 1970.

RDK *Reallexikon zur deutschen Kunstgeschichte.* Ed. Otto Schmitt et al. 8 vols. Stuttgart: J. B. Metzler, 1937–86.

Ross, *Aristotle* W. D. Ross, *Aristotle: A Complete Exposition of His Works and Thought.* New York: Meridian Books, 1959.

SBAW *Sitzungsberichte der Bayerischen Akademie der Wissenschaften,* Philosophisch-Historische Abteilungen

Sherman, *Portraits* Claire Richter Sherman, *The Portraits of Charles V of France, 1338–1380.* Monographs on Archaeology and the Fine Arts Sponsored by the Archaeological Institute of America and the College Art Association of America, 20. New York: New York University Press, 1969.

Sherman, "Some Visual Claire Richter Sherman, "Some Visual Definitions in
Definitions" the Illustrations of Aristotle's *Nicomachean Ethics* and *Politics* in the French Translations of Nicole Oresme." *Art Bulletin,* 49/3 (1977): 320–30.

Viator *Viator, Medieval and Renaissance Studies*

Yconomique *Maistre Nicole Oresme: Le livre de yconomique d'Aristote.* Ed. and trans. Albert D. Menut. Transactions of the American Philosophical Society, n.s. 47/5. Philadelphia: The Society, 1957.

NOTES

CHAPTER I

1. For two illuminating studies dealing with the theoretical and cultural context of medieval vernacular translations, see Rita Copeland, *Rhetoric, Hermeneutics, and Translation in the Middle Ages: Academic Traditions and Vernacular Texts* (Cambridge and New York: Cambridge University Press, 1991); and Ruth Morse, *Truth and Convention in the Middle Ages: Rhetoric, Representation, and Reality* (Cambridge and New York: Cambridge University Press, 1991).

2. Gabrielle M. Spiegel, *The Chronicle Tradition of Saint-Denis: A Survey* (Brookline, Mass.: Classical Folia Editions, 1978), 72–75.

3. Marie-Thérèse d'Alverny, "Translations and Translators," in *Renaissance and Renewal in the Twelfth Century,* ed. Robert L. Benson and Giles Constable (Cambridge, Mass.: Harvard University Press, 1982), 421–61; Gordon Leff, *Paris and Oxford Universities in the Thirteenth and Fourteenth Centuries* (New York: John Wiley & Sons, 1968); *Ethiques,* 3.

4. For an excellent account of this process, see Serge Lusignan, *Parler vulgairement: Les intellectuels et la langue française au XIIIe et XIVe siècles,* 2d ed. (Paris: J. Vrin, 1987). See also Morse, *Truth and Convention,* 215.

5. *Politiques,* 27; Morse, *Truth and Convention,* 215–16.

6. Pearl Kibre, "Intellectual Interests Reflected in the Libraries of the Fourteenth and Fifteenth Centuries," *Journal of the History of Ideas* 7/3 (1946): 257, n. 2; Paul Saenger, "Silent Reading: Its Impact on Late Medieval Script and Society," *Viator* 13 (1982): 403–6; Malcolm B. Parkes, "The Literacy of the Laity," in *The Medieval World,* ed. David Daiches and Anthony Thorlby (London: Aldus Books, 1973), 555–57.

7. Spiegel, *Chronicle Tradition,* 74–76. For further discussion, see idem, *Romancing the Past: The Rise of Historiography in Thirteenth-Century France* (Berkeley and Los Angeles: University of California Press, 1993).

8. Ibid., 76; see also Anne D. Hedeman, *The Royal Image: The Illustrations of the "Grandes Chroniques de France," 1274–1422* (Berkeley and Los Angeles: University of California Press, 1991), intro. and Ch. 1.

9. Saenger, "Silent Reading," 406. See below, Ch. 3.

10. Lusignan, *Parler vulgairement,* 138–39.

11. Wilhelm Berges, *Die Fürstenspiegel des hohen und späten Mittelalters: Schriften des Reichsinstituts für ältere deutsche Geschichtskunde,* Monumenta germaniae historica, 2 (Leipzig: Verlag Karl W. Hiersemann, 1938), 320–22; Dora M. Bell, *L'idéal éthique de la royauté en France au moyen âge* (Geneva: Droz, 1962), 52. For Jean de Meun's translation of the *Consolatio* and its revealing dedication to Philip IV, see Copeland, *Rhetoric, Hermeneutics, and Translation,* 133–36, and Morse, *Truth and Convention,* 218–19.

12. François Avril, "Manuscrits," in *Les fastes du gothique: Le siècle de Charles V,* exh. cat. (Paris: Editions de la Réunion des Musées Nationaux, 1981), 279. For a discussion of specific patrons and texts, see Léopold Delisle, "Le livre royal de Jean de Chavenges: Notice sur un manuscrit du Musée Condé," *BiblEC* 62 (1901): 328–31.

13. Léopold Delisle, *Le cabinet des manuscrits de la Bibliothèque Impériale* (Paris: Imprimerie Nationale, 1868), vol. 1, 17; Avril, "Manuscrits," 279.

14. For this sumptuously illustrated volume, see Avril, "Manuscrits," 325–26.

15. Delisle, *Recherches,* vol. 1, 331.

16. Jacques Monfrin, "Humanisme et traductions au moyen âge," *Journal des savants* (1963): 171–72; idem, "La traduction française de Tite-Live," *Histoire littéraire de la France* 39 (1962): 363–71; and Giuseppe Billanovich, "Petrarch and the Textual Tradition of Livy," *JWCI* 14 (1951): 137–208. For a discussion of the manuscript closest to Bersuire's original, as well as to the translator's manuscript, see Marie-Hélène Tesnière, "Le livre IX des *Décades* de Tite-Live traduites par Pierre Bersuire, suivi du commentaire de Nicolas Trevet, édition critique," *Position des thèses* (Paris: Ecole Nationale des Chartes, 1977), 144–45.

17. For an account of this meeting, see Delachenal, *Histoire de Charles V,* vol. 2, 270–72. For Charles V's commission of a French translation of Petrarch's Latin work, *De remediis utriusque fortunae,* see below at n. 66.

18. Monfrin, "La traduction française de Tite-Live," 363.

19. Ibid., 359. For the whole prologue, see ibid., 359–61.

20. See below at nn. 49–53.

21. Many of the *Incidens* derive from Nicholas Trevet's commentaries on Livy's first and third Decades. See Monfrin, "La traduction française de Tite-Live," 371 and 379. For a breakdown of the *Incidens,* see Keith V. Sinclair, *The Melbourne Livy: A Study of Bersuire's Translation Based on the Manuscript in the Collection of the National Gallery of Victoria* (Melbourne: Melbourne University Press, 1961), 25–28.

22. For sample entries and the entire word list, see Monfrin, "La traduction française de Tite-Live," 383–86.

23. Sinclair, *Melbourne Livy,* 31; for further details about Bersuire's methods of translation, see ibid., 32–36.

24. Saenger, "Silent Reading," 406.

25. For examples, see Georges Tessier, *Diplomatique royale française* (Paris: Ricard, 1962), 305. This source is cited by Saenger, "Silent Reading," 406.

26. See Michael T. Clanchy, *From Memory to Written Record: England, 1066–1377* (Cambridge, Mass.: Harvard University Press, 1979), 201. This work is cited by Franz H. Bäuml, "Varieties and Consequences of Medieval Literacy and Illiteracy," *Speculum* 55/2 (1980): 244, n. 19. See also Michael T. Clanchy, "Looking Back from the Invention of Printing," in *Literacy in Historical Perspective,* ed. Daniel P. Resnick (Washington, D.C.: Library of Congress, 1983), 16–19.

27. For discussion of this evidence, see Sherman, "Some Visual Definitions," 321; Lusignan, *Parler vulgairement,* 149–50.

28. For examples, see Bersuire's explanation in Monfrin, "La traduction française de Tite-Live," 360. Among the translators working for Charles V, see Denis Foulechat's complaints in the prologue to his French version of the *Policraticus* of John of Salisbury (Delisle, *Recherches,* vol. 1, 89); for similar sentiments voiced by Simon de Hesdin, translator of Valerius Maximus, see ibid., vol. 1, 115.

29. Babbitt, *Oresme's Livre de Politiques,* 39, nn. 27 and 29. Babbitt cites Peter S. Lewis, *Later Medieval France: The Polity* (London: Macmillan, 1968), 65–66; and Bernard Guenée, "Etat et nation en France au moyen âge," *Revue historique* 481 (1967): 17–30.

30. "Car françois est un biau langage et bon, et sont pluseurs gens de langue françoise qui sont de grant entendement et de excellent engin et qui n'entendent pas souffisanment latin." See Roland Delachenal, "Note sur un manuscrit de la bibliothèque de Charles V," *BiblEC* 71 (1910): 37–38. This part of the *Quadripartit* prologue is repeated almost exactly in Oresme's preface to the last translation that he executed for Charles V, Aristotle's *On the Heavens.* See *Le livre du ciel et du monde,* ed. Albert D. Menut and Alexander J. Denomy (Madison: University of Wisconsin Press, 1968), 731. For my adherence to Delachenal's attribution of the *Quadripartit* to Nicole, rather than to Guillaume, Oresme, see below, Ch. 2, n. 34.

31. *Le songe du vergier,* ed. Marion Schnerb-Lièvre (Paris: Editions du Centre National de la Recherche Scientifique, 1982), vol. 1, 6–7. See also Donal Byrne, *"Rex imago Dei:* Charles V of France and the *Livre des propriétés des choses,"* *Journal of Medieval History* 7 (1981): 100–101.

32. *Ethiques,* 99–100; for the *Quadripartit* and *Du ciel du monde* prologues, see above, n. 30.

33. *Politiques,* 27. For a similar expression of these sentiments, see *Ethiques,* 101.

34. Jacques Monfrin, "Les traducteurs et leur publique en France au moyen âge," *Journal des savants* (1964): 5–20.

35. See Patrick M. de Winter, "Copistes, éditeurs, et enlumineurs de la fin du XIVe siècle: La production à Paris de manuscrits à miniatures," *Actes du 100e Congrès National des Sociétés Savantes* (Paris: Bibliothèque Nationale, 1978), 173–74. For a summary of the recent literature, see Hedeman, *Royal Image,* 305, n. 1.

36. For a recent discussion of these points, see Lusignan, *Parler vulgairement,* 134–35.

37. Charles V's own intervention in the compilation and illustration of this text seems certain. Among the major themes is the incorporation of the king's speech during the visit of his uncle the Holy Roman Emperor Charles IV justifying the resumption of the war against the English. See Anne D. Hedeman, "Valois Legitimacy: Editorial Changes in Charles V's *Grandes chroniques de France,*" *AB,* 66/1 (1984): 101–3.

38. Delachenal, "Note sur un manuscrit," 38.

39. *Fais et bonnes meurs,* vol. 2, 43.

40. Cited by Delisle, *Recherches,* vol. 1, 83–84. A modern edition of this work was published by Robert Püschel (Berlin: Damköhler and Paris: Le Soudier, 1881; Geneva: Slatkine Reprints, 1974).

41. Paris, Bibl. Nat., MS fr. 22912–13, fol. 4v. For a printed edition of the prologue, see Alexandre de Laborde, *Les manuscrits à peintures de la Cité de Dieu de Saint Augustin* (Paris: Edouard Rahir, Libraire pour la Société des Bibliophiles François, 1909), vol. 1, 63–67. See also Morse, *Truth and Convention,* 226.

42. Delisle, *Recherches,* vol. 1, 84.

43. Ibid., vol. 1, 89–90.

44. For a discussion of this and other astrological manuscripts, see below, Ch. 2.

45. Paris, Bibl. de l'Arsenal, MS 2247. The vernacular versions of these writings were ordered by an unknown woman, who gave the volume to Charles V. A tiny miniature at the beginning of the book depicts a king (probably a conventional portrait of Charles) accepting the manuscript.

46. See below, Ch. 3 at nn. 76–79.

47. For the complex textual history of the *Economics,* see Menut's summary in the introduction to Oresme, *Yconomique,* 786–88. For full discussions of the dating of Oresme's translations of the *Ethics* and the *Politics,* see above, Appendixes I–IV.

48. In his critical edition of this text, Richard A. Jackson leaves open the question whether Golein's work is a translation ("The *Traité du sacre* of Jean Golein," *Proceedings of the American Philosophical Society* 113/4 (1969): 307, n. 15). In his recent work, *Vive le roi!: A History of the French Coronation Ceremony from Charles V to Charles X* (Chapel Hill: University of North Carolina Press, 1984), Jackson includes the *Traité* among the group of medie-

val coronation texts collected in Appendix B (222–23). Jackson notes that the "structural framework of the piece" is based on manuscripts containing texts of two coronation orders. The *Traité* also includes much original material, as is often the case with medieval translations.

49. *Fais et bonnes meurs,* vol. 2, 47–49.

50. For the background of the *translatio studii* theme, see Lusignan, *Parler vulgairement,* 158–62. For a convenient summary of these ideas, see A. G. Jongkees, *"Translatio studii:* Les avatars d'un thème médiéval," in *Miscellanea mediaevalia in memoriam Jan Frederik Niermeyer* (Groningen: J. B. Wolters, 1967), 41–51. Jongkees cites the classic study of Werner Goez, *Translatio imperii: Ein Beitrag zur Geschichte des Geschichtsdenkens und der politischen Theorien im Mittelalter und in der frühen Neuzeit* (Tübingen: J. C. B. Mohr, 1958), esp. 278–81. See also David Gassman, *"Translatio studii:* A Study of Intellectual History in the Thirteenth Century" (Ph.D. diss., Cornell University, 1973).

51. Sandra L. Hindman and Gabrielle M. Spiegel, "The Fleur-de-lis Frontispieces to Guillaume de Nangis's *Chronique abrégée:* Political Iconography in Late Fifteenth-Century France," *Viator* 12 (1981): 387–89. See also William M. Hinkle, *The Fleurs-de-lis of the Kings of France, 1285–1499* (Carbondale: Southern Illinois University Press, 1991).

52. For Lusignan's important discussion, see *Parler vulgairement,* 154–58. See also idem, "La topique de la *Translatio studii* et les traductions françaises de textes savants au XIVe siècle," in *Traduction et traducteurs au moyen âge,* Colloque international du Centre National de la Recherche Scientifique, 26–28 May 1986 (Paris: Editions du Centre, 1989), 303–15.

53. *Ethiques,* 101; Lusignan, *Parler vulgairement,* 157.

54. A passage of Raoul de Presles's prologue to his translation of the *City of God* states that Charles V followed the example of Charlemagne, who, among all the books that he studied, read with special devotion the works of St. Augustine, particularly the volume in question (de Laborde, *Les manuscrits à peintures de la Cité de Dieu,* vol. 1, 66). Denis Foulechat's preface to his French version of the *Policraticus* refers to Charlemagne as sovereign emperor and most Christian king of France, as well as a student of the liberal arts devoted to Scripture and the *City of God* (Paris, Bibl. Nat., MS fr. 24287, fol. 4).

55. Paris, Bibl. Nat., MS fr. 437, fol. 2v; cited by Delisle, *Recherches,* vol. 1, 99, n. 1.

56. Paris, Bibl. Nat., MS fr. 437, fol. 43, cited by Franco Simone, "Il Petrarca e la cultura francese del suo tempo," *Studi francesi* 42 (1970): 403. Golein boldly uses the myth that the realm of France had returned to the heirs of Charlemagne through the maternal and paternal lines of Louis VIII, a twelfth-century Capetian ruler. See Gabrielle M. Spiegel, "The *Reditus regni ad stirpem Karoli Magni:* A New Look," *French Historical Studies* 7/2 (1971): 145–74. For further discussion of Charles V's cultivation of Carolingian roots, see Hedeman, *Royal Image,* 98–99 and 103–4.

57. For further details, see Hindman and Spiegel, "The Fleur-de-lis Frontispieces," 397.

58. Sherman, *Portraits,* pl. 22; Danielle Gaborit-Chopin, *Fastes du gothique,* no. 202, 249. The scepter also appears in a miniature from Charles V's copy of the *Grandes chroniques de France* (Paris, Bibl. Nat., MS fr. 2813, fol. 439). See Sherman, *Portraits,* pl. 21.

59. Cazelles, *Société politique,* 529. Charles V also exempted the merchants of Charlemagne's capital from customs duties. See Gaston Zeller, "Les rois de France, candidats à l'Empire: Essai sur l'idéologie impériale en France," *Revue historique* 173 (1934): 305.

60. Gaines Post, *Studies in Medieval Legal Thought, Public Law, and the State, 1100–1322* (Princeton, N.J.: Princeton University Press, 1964), 468.

61. Paris, Bibl. Nat., MS fr. 175, cited by Delisle, *Recherches,* vol. 1, 98; and Golein, *Traité du sacre,* ed. Jackson, 322.

62. *Le songe du vergier,* ed. Schnerb-Lièvre, vol. 1, 269–88. Schnerb-Lièvre has established that the unknown translator of the *Songe* added the above-mentioned chapters and others that do not exist in the Latin text (the *Somnium viridarii*) on which it is based. See ibid., vol. 1, lxvi.

63. Paris, Bibl. Nat., MS fr. 2813, fol. 470v. See Sherman, *Portraits,* pl. 33 and 42–43. For an exhaustive treatment of this cycle, see Hedeman, *Royal Image,* 128–33.

64. "L'original de Titus Livius en françois. La première translation qui en fu faite, escript de mauvaise lettre, mal enluminée, et point historiée" (Delisle, *Recherches,* vol. 2, no. 975, 160). Monfrin believes that the king's librarian, Gilles Malet, is referring to an earlier translation into French of the first Decade made in Italy in 1323 by Filippo da Santa Croce ("Humanisme et traductions au moyen âge," 171). In another inventory a citation seems to refer specifically to Bersuire's translation: "Titus Livius en françois, en très grant volume . . . de la translacion du prieur de Saint Eloy de Paris" (Delisle, *Recherches,* vol. 2, no. 981, 160; Monfrin, "Humanisme et traductions au moyen âge," 171).

65. This manuscript is identified by the colophon as Charles V's copy (Paris, Bibl. Ste.-Geneviève, MS 777, fol. 434v). For the literature on the manuscript, see Avril, *La librairie,* no. 189, 108–9. For a discussion of the miniatures of Charles V's illustrated copies of Bersuire's translation, see Inge Zacher, "Die Livius-Illustration in der Pariser Buchmalerei, 1370–1420" (Ph.D. diss., Freie Universität Berlin, 1971), 14–15.

66. Franco Simone, *The French Renaissance: Medieval Tradition and Italian Influence in Shaping the Renaissance in France,* trans. H. Gaston Hall (London: Macmillan, 1969), 90–92. See also Nicholas Mann, "La fortune de Pétrarque en France: Recherches sur le *De remediis,*" *Studi francesi* 37 (1969): 1–15. For a useful summary of recent scholarship on the development of early French humanism, see G. Matteo Roccati, "L'umanesimo francese e l'Italia nella bibliografia recente, 1980–1990," *Franco-Italia* (1992): 161–71.

67. Simone, *French Renaissance,* 55. See also Charity Cannon Willard, "Raoul de Presles's Translation of St. Augustine's *De civitate Dei,*" in *Medieval Translators and Their Craft,* ed. Jeanette Beer, Studies in Medieval Culture, 25 (Kalamazoo: Medieval Institute Publications, Western Michigan University, 1989), 329–46.

68. Beryl Smalley, *English Friars and Antiquity in the Early Fourteenth Century* (New York: Barnes & Noble, 1960), 108.

69. De Laborde, *Les manuscrits à peintures de la Cité de Dieu,* vol. 1, 69. See Willard, "Raoul de Presles's Translation," 335–42.

70. Sharon Off Dunlop Smith, "Illustrations of Raoul de Praelle's Translation of St. Augustine's *City of God* between 1375 and 1420" (Ph.D. diss., New York University, 1975); Willard, "Raoul de Presles's Translation," 333 and 341.

71. Marjorie A. Berlincourt, "The Commentary on Valerius Maximus by Dionysius de Burgo Sancti Sepulchri and Its Influence upon Later Commentaries" (Ph.D. diss., Yale University, 1954). See also Giuseppe Di Stefano, "Tradizione esegetica e traduzioni di Valerio Massimo nel primo umanesimo francese," *Studi francesi* 21 (1963): 403–17; and idem, *Essais sur le moyen français* (Padua: Liviana Editrice, 1977), 29–38.

72. Brussels, Bibl. Royale Albert Ier, MS 9091; see Delisle, *Recherches,* vol. 1, 257–58.

73. Cornelia C. Coulter, "The Library of the Angevin Kings at Naples," *Transactions and Proceedings of the American Philological Association* 75 (1944): 145 and 152–54; Monfrin, "Humanisme et traductions au moyen âge," 171.

74. François Avril, "Trois manuscrits napolitains des collections de Charles V et de Jean de Berry," *BiblEC* 127 (1969): 291–328. The texts of the manuscripts are a *Faits des Romains,* a *Histoire ancienne jusqu'à César,* and a Bible of Robert of Anjou.

CHAPTER 2

1. For a concise and illuminating account of Oresme's career, see Marshall Clagett, "Nicole Oresme," *Dictionary of Scientific Biography* (New York: Scribner, 1974), vol. 10, 223–30. For references to other biographical sources and Oresme's bibliography, see Babbitt, *Oresme's Livre de Politiques,* 1, n. 2. A full reconsideration of the life and work of Nicole Oresme and his family is included in the introduction to the new critical edition of his *Livre de divinacions* by Sylvie Lefèvre (Ph.D. diss., University of Paris III, 1992), 203–302. I am grateful to Mlle Lefèvre for sharing this information with me.

2. Delachenal, who wrote the definitive biography of Charles V, denies the existence of a formal relationship (*Histoire de Charles V,* vol. 1, 14–15). The tradition that Oresme was an actual tutor of the young prince has a long history. See Charles Jourdain, "Nicole Oresme et les astrologues de la cour de Charles V," *Excursions historiques et philosophiques à travers le moyen âge* (Paris: Firmin-Didot, 1888), 582. Jourdain cites a fifteenth-century manuscript (Paris, Bibl. Nat., MS fr. 1223, fol. 116), which uses the term "son instructeur." For a recent critique of Jourdain's interpretation, see Lefèvre, ed., *"Livre de divinacions,"* 218–20. See also Babbitt, *Oresme's Livre de Politiques,* 3, n. 14. Others believe that Oresme played the part of an informal director of studies. See Emile Bridrey, *La théorie de la monnaie au XIVe siècle: Nicole Oresme, étude d'histoire des doctrines et des faits économiques* (Paris: Giard &

Brière, 1906), 445; and *De proportionibus proportionum and Ad pauca respicientes,* ed. and trans. Edward Grant (Madison: University of Wisconsin Press, 1966), 6, n. 17.

3. For a summary of views on the influence of nominalism on Oresme, see *Nicole Oresme and the Marvels of Nature: A Study of His De causis mirabilium,* ed. and trans. Bert Hansen, Studies and Texts, 68 (Toronto: Pontifical Institute of Mediaeval Studies, 1985), 104–9.

4. For a short discussion of this topic with references to the literature, see Claire Richter Sherman, "The Queen in King Charles V's *Coronation Book:* Jeanne de Bourbon and the *Ordo ad reginam benedicendam," Viator* 8 (1977): 258, n. 9.

5. Raymond Cazelles, "Le parti navarrais jusqu'à la mort de Etienne Marcel," *Bulletin philologique et historique* (1960): 860–62. See idem, *Société politique,* 30 and 102.

6. *The De moneta of Nicholas Oresme and English Mint Documents,* ed. and trans. Charles Johnson (London: Thomas Nelson, 1956). For an evaluation of the *De moneta* in the scholarly literature, see Babbitt, *Oresme's Livre de Politiques,* 4, n. 25.

7. *De moneta,* 11 and 37–38. See Cazelles, *Société politique,* 102.

8. *De moneta,* 42. The references are to the *Politics,* V.3 1302b–1303a and V.11 1314a.

9. As evidence that Oresme himself translated the *De moneta,* in the *Ethiques* and *Politiques* he refers to "his" treatise by a French title. Oresme frequently cites works in the language in which they were written. See the introduction by John E. Parker to his edition of the *Traictié des monnoyes* (Ph.D. diss., Syracuse University, 1952), 8a–11a. For Oresme's citations, see *Ethiques,* Book V, Ch. 11, Gloss 6, 295, and *Politiques,* Book I, Ch. 10, Gloss, 64, and Ch. 12, Gloss, 67. The full title of the French translation, with spelling variants, is the *Traictié de mutacions de monnoies.*

10. *Traictié de la première invention des monnoies de Nicole Oresme et Traité de la monnoie de Copernic,* ed. M. Louis Wolowski (Paris, 1864; Geneva: Slatkine Reprints, 1976). The problems with the manuscripts on which Wolowski's translation is based are discussed by Bridrey, *Théorie de la monnaie,* 62–64. The revealing form of address appears in the conclusion of the *Traictié,* which states that the work is destined for "la correction des saiges et prudens hommes, et mesmement de vous, mon très chier et honnoré seigneur, qui en la plupart d'icelles vous congnoissez et estes expert; car selon que dit Aristote, les besongnes civiles sont plus souvent doubteuses et incertaines" (ed. Wolowski, 86).

Charles is referred to as "chier sire" in the frontispiece of the roughly contemporary *Livre des neuf anciens juges d'astrologie* (Fig. 1). See below at n. 23. The phrase "mon tres chèr et redoubté seigneur" occurs in the prologue of the French translation by Jean Daudin of Petrarch's *De remediis* commissioned by Charles V (Delisle, *Recherches,* vol. 1, 93). The *Traictié* couples a compliment to the wisdom of the "seigneur" with a reference to Aristotle. In the prologue, Oresme declares that certain basic arguments of the present treatise accord with "les raisons d'Aristote" (*Traictié,* ed. Wolowski, 2).

11. Bridrey, *Théorie de la monnaie,* 71–72; Parker, ed., *"Traictié des monnoyes,"* 14a, and Grant, ed., *De proportionibus,* 12, accept this early dating.

12. John Bell Henneman, *Royal Taxation in Fourteenth-Century France: The Captivity and Ransom of John II, 1356–1370,* Memoirs of the American Philosophical Society, 116 (Philadelphia: The Society, 1976), 117–18.

13. *Théorie de la monnaie,* 460–64.

14. The document cited by Bridrey (*Théorie de la monnaie,* 449) comes from a lost register of the Chambre des Comptes dated 2 November 1369. See Abraham Tessereau, *Histoire chronologique de la grande Chancellerie de France* (Paris: Pierre Emery, 1710), vol. 1, 22.

15. Ferdinand Lot and Robert Fawtier, *Histoire des institutions françaises au moyen âge* (Paris: Presses Universitaires de France, 1958), vol. 2, 87–89.

16. Bridrey, *Théorie de la monnaie,* 449. Lefèvre, ed. (Oresme, "*Livre de divinacions,*" 220), says that Oresme was not involved in this transaction, which dates from 1370. In general, Lefèvre challenges the accuracy of Bridrey's documentation.

17. "A Case Study in Medieval Nonliterary Translation: Scientific Texts from Latin to French," in *Medieval Translators and Their Craft,* ed. Jeanette Beer, Studies in Medieval Culture, 25 (Kalamazoo: Medieval Institute Publications, Western Michigan University, 1989), 308.

18. *De causis mirabilium,* 22. In her discussion of astrological translations made for Charles V, Shore seems to share Hansen's evaluation (see "A Case Study," 307–10).

19. "Christine de Pizan: The Astrologer's Daughter," in *Mélanges à la mémoire de Franco Simone* (Geneva: Editions Slatkine, 1980), 97–98. For further discussion see also Willard's recent study, *Christine de Pizan: Her Life and Works* (New York: Persea Books, 1985), 20–22.

20. *Fais et bonnes meurs,* vol. 2, 15–19.

21. Lynn Thorndike, *A History of Magic and Experimental Science* (New York: Columbia University Press, 1934), vol. 3, 585–86. Thorndike draws upon a fifteenth-century treatise by Symon de Phares (*Recueil des plus célèbres astrologues et quelques hommes doctes,* ed. Ernest Wickersheimer [Paris: Champion, 1929], 221–29). Phares gives the names of the astrologers connected with John the Good and others employed by the Dauphin in the 1360s.

22. See Shore, "A Case Study," 308–10.

23. See Camille Gaspar and Frédéric Lyna, *Les principaux manuscrits à peintures de la Bibliothèque Royale de Belgique* (Paris: Société Française de la Reproduction de Manuscrits à Peintures, 1937), vol. 1, 337–38; Avril, *La librairie,* no. 200, 116. The other copy of the text is Paris, Bibl. de l'Arsenal, MS 2872.

24. For the identification of the judges and the history of the Latin text, see Francis J. Carmody, *Arabic Astronomical and Astrological Sciences in Latin Translations: A Critical Bibliography* (Berkeley: University of California Press, 1956), 103–12. For Charles's image, see Sherman, *Portraits,* 18–19.

25. Delisle, *Recherches,* vol. 1, 267–68; Thorndike, *History of Magic,* vol. 3, 587; Sherman, *Portraits,* 22; Avril, *La librairie,* no. 99, 115; and Shore, "A Case Study," 310.

26. "Et se son estude bel à devis estoit bien ordenné, comme il voulsist toutes ses choses belles et nettes, polies et ordennées, ne convient demander, car mieulz estre ne peust" (*Fais et bonne meurs,* vol. 2, 42).

27. Emmanuel Poulle, "Horoscopes princiers des XIVe et XVe siècles," *Bulletin de la Société Nationale des Antiquaires de France* (1969): 63–77.

28. *De causis mirabilium,* ed. Hansen, 17–25.

29. Ibid., 21.

30. *Nicole Oresme and the Astrologers: A Study of His Livre de divinacions,* ed. George W. Coopland (Liverpool: University of Liverpool Press, 1952), 51. This edition has the French and English versions of the text on facing pages.

31. Ibid., 105.

32. Ibid., 107; *Politiques,* 44.

33. The Arabic commentary was translated into Latin by Aegidius de Thebaldis in 1256. For the history of this text, see Carmody, *Arabic Astronomical and Astrological Sciences,* 18–19. For an edition of Oresme's translation by Jay Gossner, see *"Le quadripartit ptholomée,"* edited from the text of MS Français 1348 of the Bibliothèque Nationale in Paris (Ph.D. diss., Syracuse University, 1951). For a recent discussion of this text, see Max Lejbowicz, "Guillaume Oresme, traducteur de la *Tetrabible* de Claude Ptolémée," *Pallas* 30 (1983): 107–33. On paleographic and textual grounds Lejbowicz believes that Guillaume Oresme is the translator.

34. Delachenal, "Note sur un manuscrit," 33–38; Avril, *La librairie,* no. 198, 114–15. Marshall Clagett, *The Science of Mechanics in the Middle Ages* (Madison: University of Wisconsin Press, 1959), 338–39, n. 11. See also *Ethiques,* 26, n. 33. Shore attributes the *Quadripartitum* to Guillaume Oresme ("A Case Study," 308–9), as do Lusignan (*Parler vulgairement,* 156) and Lefèvre, ed. (Oresme, *"Le Livre de divinacions,"* 245–46). The latter two scholars agree with Lejbowicz, "Guillaume Oresme," as in n. 33 above. My adherence to the attribution to Nicole Oresme is based on the iconography of the dedication portrait (Fig. 3) and the similar language of Nicole's prologues to those of his Aristotle translations.

35. Delachenal, "Note sur un manuscrit," 36. See Ch. 1 above, n. 30.

36. *Ethiques,* Book VII, Ch. 1, Gloss 5, 364, and Ch. 10, Gloss 8, 384; *Politiques,* Book VII, Ch. 10, 291, and Ch. 11, 297.

37. I was not familiar with this image until after the publication of *Portraits.* The style of the miniature can be attributed to the workshop of the Master of the Bible of Jean de Sy. This master and his atelier later worked on Charles V's official library copies of the *Ethiques* (MS *A*) and the *Politiques* (MS *B*). See above, Appendixes I and III.

38. Delachenal, "Note sur un manuscrit," 37–38.

39. Oresme states: "il veut aussi avoir des livres en françois de la plus noble science de cest siècle, c'est vraie astrologie sans superstecion et par especial ce que en ont composé les philosophes excellens et approuvés." Idem, "Note sur un manuscrit," 38.

40. Ibid.

41. Oxford, St. John's College, MS 164, fols. 1–32. This treatise, which contains no evidence of Oresme's authorship, was not attributed to him by Delisle (*Recherches,* vol. 1, 266). In *Portraits,* I mistakenly credited Pélerin de Prusse with authorship of this treatise, since the latter translated several astrological works collected in this volume. Although two critical editions of the *Traitié de l'espere* exist, neither is based on the St. John's College MS, perhaps the earliest extant example of the text. See "Maistre Nicole Oresme, *Le traitié de l'espere,*" ed. Lillian M. McCarthy (Ph.D. diss., University of Toronto, 1943), and "Maistre Nicole Oresme, *Le traité de la sphère,*" ed. John V. Myers (Master's thesis, Syracuse University, 1940). Both critical editions are based on Paris, Bibl. Nat., MS fr. 1350. Scholars now believe that Oresme's *Traitié de l'espere* is not a translation of John of Sacrabosco's *De sphaera* but an original work that uses that text as a source. See Shore, "A Case Study," 302. Nor is there general agreement on the dating of the St. John's College manuscript, which ranges from 1361 to 1367. Lefèvre, ed. (Oresme, *"Le Livre de divinacions,"* 245), dates the work around 1364 to 1365.

42. "A tout homme, et par especial a prince de noble engin" (Paris, Bibl. Nat., MS fr. 1350, fol. 37, ed. Myers, 83). The warning that the ruler should limit his knowledge of astrology in order to devote himself to the government "de la chose publique" echoes the message in the *Livre de divinacions,* to which Oresme then indirectly refers (ibid., fol. 37v, ed. Myers, 83).

43. For the glossaries in Oresme's translations, see below, Ch. 3 at nn. 35–39.

44. For documentation of these events in Oresme's career, see Babbitt, *Oresme's Livre de Politiques,* 3.

CHAPTER 3

1. For discussion of these issues, see Copeland, *Rhetoric, Hermeneutics, and Translation,* 15–21.

2. Mary J. Carruthers, *The Book of Memory: A Study of Memory in Medieval Culture* (Cambridge and New York: Cambridge University Press, 1991).

3. Ibid., Chs. 6 and 7.

4. Ibid., Ch. 2.

5. Richard Rouse, "La diffusion en occident au XIIIe siècle des outils de travail facilitant l'accès aux textes autoritatifs," *Revue des études islamiques* 44 (1976): 139–41.

6. For a recent study of an important center, see Mary A. Rouse and Richard Rouse, "The Book Trade at the University of Paris, ca. 1250–ca. 1350," in *La production des livres universitaires au moyen âge: Exemplar et pecia,* ed. Louis J. Bataillon, Bertrand G. Guyot, and Richard Rouse (Paris: Editions du Centre National de la Recherche Scientifique, 1988), 41–114.

7. Rouse, "La diffusion," 143–44.

8. "The Influence of the Concepts of *Ordinatio* and *Compilatio* on the Development of the Book," in *Medieval Learning and Literature: Essays Presented to Richard William Hunt,* ed. J. J. G. Alexander and M. T. Gibson (Oxford: Clarendon Press, 1976), 115–27.

9. Rouse, "La diffusion," 123.

10. Ibid.

11. The oldest manuscript to include a table of contents begins with a list of incipits of *Ethics* chapters, followed by an alphabetical table of contents (Pisa, Biblioteca del Seminario, MS 124). Ibid.

12. Ibid., 133.

13. Parkes, *"Ordinatio," 125,* citing Daniel A. Callus, ed., *Robert Grosseteste: Scholar and Bishop* (Oxford: Clarendon Press, 1955), 64. See also Jean Dunbabin, "Robert Grosseteste as Translator, Transmitter, and Commentator: The *Nicomachean Ethics,*" *Traditio* 28 (1972): 460–72.

14. "Methoden und Hilfsmittel des Aristotelesstudiums im Mittelalter," *SBAW* (1939): 5–191. Among the insights provided in this article is that King Robert of Anjou had shortened versions of many Aristotelian works made by a Franciscan theologian, Jacobus de Blanchis of Alexandria (78–84). For an illuminating discussion of the assimilation of Aristotle's thought, see Charles H. Lohr, "The Medieval Interpretation of Aristotle," in *The Cambridge History of Later Medieval Philosophy: From the Rediscovery of Aristotle to the Disintegration of Scholasticism, 1100–1600,* ed. Norman Kretzmann et al. (Cambridge and New York: Cambridge University Press, 1982), 80–98.

15. Bernard Guenée, *Histoire et culture historique dans l'occident médiéval* (Paris: Aubier-Montaigne, 1980), 234.

16. Ibid., 235. Guenée gives an interesting account of the development in historical texts of verbal aids to readers. Their evolution differs from that in theological or philosophical works. See ibid., 231–37.

17. Parkes, *"Ordinatio,"* 133.

18. *Ethiques,* vii and 5. For a critique of Menut's edition, see J. P. H. Knops, *Etudes sur la traduction française de la morale à Nicomache d'Aristote par Nicole Oresme* (The Hague: Excelsior, 1952).

19. The history of the Grosseteste translation is discussed in Gauthier and Jolif, *Ethique à Nicomaque,* vol. 1, pt. 1, 120–46. For a diagram of the family of Grosseteste MSS, including the hypothetical archetype *(Rp)* of the Oresme translation, see ibid., 129 and 138. For the edition of Grosseteste's work, see *Ethica Nicomachea, Translatio Roberti Grosseteste Lincolniensis,* ed. René A. Gauthier, *Aristoteles Latinus,* vol. 26, 1–3, fasc. 4 (Leiden: Brill, 1973). For further discussion of critical editions of Grosseteste's translation, see James McEvoy, *The Philosophy of Robert Grosseteste* (Oxford: Clarendon Press, 1982), 471–77. See also Georg Wieland, "The Reception and Interpretation of Aristotle's *Ethics,*" in *The Cambridge History of Later Medieval Philosophy,* 657–72.

20. See Appendix I for a description and history of the manuscript. In a letter to the author (27 November 1972) Menut stated that MS 2668 of the Bibliothèque de l'Arsenal had "priority" over *A,* constituting a *"redactio prima* in the best sense." An examination of the Arsenal manuscript by Carla Bozzolo of the Centre National de la Recherche Scientifique led her to conclude that the manuscript was not the author's copy. Its presentation is too elaborate and the appearance of cursive script beginning with folio 60 brings the date of the manuscript to the 1380s. Furthermore, the presence of several hands, particularly in the notes, indicates that the manuscript was not written at one time.

21. For the history of the Moerbeke translation, see *Politiques,* 24–26.

22. Ibid., 32; Avranches, Bibl. Municipale, MS 223. Léopold Delisle, "Observations sur plusieurs manuscrits de la *Politique* et de l'*Economique* de Nicole Oresme," *BiblEC* 30 (1869): 601–20.

23. *Yconomique,* 785–88. For further details on the textual tradition of the *Economics,* see Ch. 24.

24. Morse, *Truth and Convention,* 216.

25. Copeland, *Rhetoric, Hermeneutics, and Translation,* 7.

26. Jeanette Beer, "Introduction: Medieval Translators," in *Medieval Translators and Their Craft,* ed. Jeanette Beer, Studies in Medieval Culture, 25 (Kalamazoo: Medieval Institute Publications, Western Michigan University, 1989), 1.

27. *Ethiques,* 100.

28. Ibid.

29. Ibid., 100–101.

30. *Politiques,* 28, n. 5a; Babbitt, *Oresme's Livre de Politiques,* 10, n. 79. For a list of neologisms introduced by Oresme in the *Ethiques,* see *Ethiques,* 79–82. For a recent study, see F.-J. Meissner, "Maistre Nicole Oresme et la lexicographie française," *Cahiers de lexicologie* 40 (1982): 51–66.

31. See Morse, *Truth and Convention,* 217.

32. For examples of Oresme's interpolations in the text, explanatory translations, double translations, omissions and changes, and *calques,* see Knops, *Etudes,* 56–69, 70–76, and 82–86. For examples of etymological definitions, see *Politiques,* 28.

33. Beer, "Medieval Translators," 1; Morse, *Truth and Convention,* 218–19.

34. Brussels, Bibl. Royale Albert Ier, MS 9543. I am grateful to Michael Camille for calling this manuscript to my attention. For references both to the published glossary and the text, as well as to other information on the manuscript, see Marguerite Debae, *La librairie de Marguerite d'Autriche, Europalia 87, Österreich* (Brussels: Bibliothèque Royale Albert Ier, 1987), no. 30, 103–5. Particularly interesting is the fact that certain Aristotelian terms from the *Ethics* were used in the section on virtue.

35. Later copies of the text show that the numbers in the margin were dropped by scribes, who were perhaps unaware of their significance. Oresme describes the glossary this way:

> Item j'ay parlé en ce traictié, en aucuns lieux, prolixement et ay esté long afin que chascun de bon entendement puisse ce que j'ay dit legierement entendre et sans expositeur. Et encor pour ceste cause ay je yci en la fin faicte une table des mos estranges qui sont en ce traictié en laquelle table je signe les chapitre [sic] ou tielx mos sont exposés et les met selon l'ordre de l'A, B, C, affin que, quant l'en treuve un tel mot en aucun chapitre, l'en puisse avoir recours et trouver aisiement le chapitre en quel le mot est devant exposé ou diffini. Car chascun mot est exposé ou diffini ou chappitre la ou il est premierement trouvé. *Explicit.*

> (*Traitié de l'espere,* ed. McCarthy, 274; ibid., ed. Myers, 83–84).

36. "Pour ceste science plus clerement entendre, je vueil de habondant esposer aucuns moz selon l'ordre de l'a.b.c., lesquelz par aventure sembleroient obscurs a aucuns qui ne sont pas excercitéz en ceste science; ja soit ce que il n'y ait rien obscur, ce me semble, quant a ceuls qui seroient .i. peu acoustumés a lire en cest livre" (*Ethiques,* 541).

37. Guenée, *Histoire et culture historique,* 232–34.

38. See, for example, the reference to *gerre* (*Ethiques,* 544).

39. *Aristocracie, commune policie, democracie,* and *olygarchie* (*Politiques,* 45). The other two forms, *tyrannie* and *royaume,* were presumably well known to contemporary readers. For discussion of these concepts, see Ch. 16.

40. *Politiques,* 360.

41. The first two sentences explain: "Par les intitulations des livrez et des chapitres l'en peut veoir les matieres de tout le livre et en quelz lieus elles sunt traictees. Mes oveques ce sunt pluseurs choses notables, tant ou texte comment es gloses, desqueles aucunes sunt ici apres designees en table, selon a.b.c." (ibid., 358). For an exhaustive discussion of the index of noteworthy subjects, see Serge Lusignan, "Lire, indexer, et gloser: Nicole Oresme et la *Politique* d'Aristote," in *L'écrit dans la société médiévale: Divers aspects de sa pratique du XIe au XVe siècle,* ed. Caroline Bourlet and Annie Dufour (Paris: Editions du Centre National de la Recherche Scientifique, 1991), 167–81.

42. Oresme's concern for the readers' ability to make their way through the *Politiques* originally led him to conceive of separate glossaries and indexes for individual books. Several manuscripts preserve these aids for Books III, IV, and V; others for Book VIII (see *Politiques,* 34–35). Although Oresme does not say why he gave up these separate features in favor of integrated compilations at the end of the volume, it probably became clear that the latter scheme avoids repetition and is more convenient to use. Only *B* preserves the glossary and index for Book VIII; *D* lacks this feature as well as the integrated glossary. In *B* the glossary directly follows the index (fols. 367–72) and precedes the *Yconomique,* which begins on fol. 373. In *D,* the *Yconomique* (fols. 365–87) precedes the index (fols. 388–403) following the last folio of the *Politiques.*

43. Martin Grabmann, "Die mittelalterlichen Kommentare zur *Politik* des Aristoteles," *SBAW* 2/10 (1941): 50. For the relevant mnemonic tradition regarding the division of the text into short units, see Carruthers, *The Book of Memory,* 83–85.

44. See above, Ch. 1 at n. 53, and below, Ch. 5 at nn. 5–8.

45. See above, Appendix V. I published this text previously as "A Second Instruction to the Reader from Nicole Oresme, Translator of Aristotle's *Politics*," *AB* 61/3 (1979): 468–69.

46. Raoul de Presles, translator of the *City of God,* introduces a rubricated summary paragraph entitled "Exposition sur ce chapitre," with the words "Le translateur" also rubricated in the margin. These features are notable in Charles V's presentation copy of the manuscript (Paris, Bibl. Nat., MS fr. 22912–13). The king's copy of Simon de Hesdin's translation of Valerius Maximus's *Factorum et dictorum memorabilium libri novem* (Paris, Bibl. Nat., MS fr. 9749) contains new exempla labeled "Addicions" set apart from the text by rubrics and painted initials.

47. *Yconomique,* 795.

48. *Le livre du ciel et du monde* contains the greatest proportion of commentary of the four Aristotelian translations, twice as much interpolation as the *Politiques* (*Le livre du ciel et du monde,* ed. Menut and Denomy, 14). Oresme addresses some of the leading problems of fourteenth-century science and tries to reconcile them with Christian cosmology. For a summary of the commentary, see ibid., 16–31.

49. *Oresme's Livre de Politiques,* 11–13. Babbitt also gives an excellent account of the commentary tradition of the *Politics* in Ch. 2 of her work, including full bibliographic citations of primary and secondary sources.

50. Babbitt (ibid., 12–13) mentions the following topics (numbers refer to the pages in Menut's edition of the *Politiques*): natural slavery, 59–60; voluntary poverty, 83–84; Old Testament kingship, 149–50; elective versus hereditary monarchy, 153–56; rule by law in the church, 159–61; sedition, 203–5; moderate kingship, 242–44; the active versus the contemplative life, 285–86; universal monarchy, 289–94 (the longest commentary); geography and distribution of power, 297–99; the necessity of the presence of a sacerdotal element in the state, 302–4; voluntary poverty, 306–8; jurisdiction and distribution of the goods of the church, 311–14; government of the church seen in Aristotelian terms, 319–20.

51. Grabmann, "Die mittelalterlichen Kommentare zur *Politik* des Aristoteles," 49.

52. According to Mario Grignaschi, Oresme depends more heavily on the commentary of Albert the Great than on that of Thomas Aquinas, since Albert tended to relate the text to contemporary conditions. See his "Nicole Oresme et son commentaire à la *Politique* d'Aristote," in *Album Helen Maude Cam, Studies Presented to the International Commission for the History of Representative and Parliamentary Institutions,* 23 (Louvain: Publications Universitaires de Louvain, 1960), 103. For further studies of the commentaries on the *Politics,* see Ferdinand E. Cranz, "Aristotelianism in Medieval Political Theory: A Study of the Reception of the *Politics*" (Ph.D. diss., Harvard University, 1938). For a listing of Charles H. Lohr's articles on this subject, see Babbitt, *Oresme's Livre de Politiques,* 152. See also Jean Dunbabin, "The Reception and Interpretation of Aristotle's *Politics,*" in *The Cambridge History of Later Medieval Philosophy,* 723–37.

53. *Yconomique,* 794.

54. *Politiques,* 45, n. 3; MS *D,* fol. 1.

55. For an exhaustive study of the illustrated cycles of the *Grandes chroniques de France,* see Hedeman, *Royal Image.*

56. *Truth and Convention,* 215.

57. For colophons using the word *parfere* (bring to completion), see Delisle, *Recherches,* vol. 1, 155, 229, and 259. More common are colophons stating that the king had commissioned the manuscript and had it written.

58. *Fais et bonnes meurs,* vol. 2, 42. For the translated passage, see Patrick M. de Winter, "The *Grandes Heures* of Philip the Bold, Duke of Burgundy: The Copyist Jean l'Avenant and His Patrons at the French Court," *Speculum* 57/4 (1982): 811–12, n. 72.

59. De Winter, "*Grandes Heures,*" 806, n. 65, and 812–13, n. 78.

60. Sherman, "The Queen," 261–64; Hedeman, "Valois Legitimacy," 99; idem, *Royal Image,* 95–133; and *Le songe du vergier,* ed. Schnerb-Lièvre, vol. 1, lxix–lxx.

61. Sherman, "The Queen," 261–62; for the Livy text, see Paris, Bibl. Ste.-Geneviève, MS 777, fol. 434v, and Ch. 1 above, at nn. 16, 18–19, 21–23, and 64–65.

62. "Une *Bible historiale* de Charles V," *Jahrbuch der Hamburger Kunstsammlungen* 14–15 (1970): 73.

63. See Ch. 4 at nn. 25–28.

64. For a selected bibliography on these topics, see *De causis mirabilium,* ed. Hansen, 7, n. 10.

65. See *"Memoria,"* in Index verborum et nominum, in ibid., 415; and "Nicholas Oresme's *Questiones super libros Aristotelis De anima,*" ed. Peter Marshall (Ph.D. diss., Cornell University, 1980), vol. 1, Chs. 2 and 3.

66. "Late Scholastic *Memoria et Reminiscentia:* Its Uses and Abuses," in *Intellectuals and Writers in Fourteenth-Century Europe,* ed. Piero Boitani and Anna Torti, The J. A. W. Bennett Memorial Lectures, Perugia, 1984 (Cambridge: D. S. Brewer, 1986), 23. Coleman cites the translation and commentary of Richard Sorabji, *Aristotle on Memory* (Providence, R.I.: Brown University Press, 1972), 449a 9f.

67. *The Art of Memory* (London: Penguin Books, 1969), 93–113; Carruthers, *The Book of Memory,* 64–71. See also Lina Bolzoni, "The Play of Images: The Art of Memory from Its Origins to the Seicento," in *The Mill of Thought: From the Art of Memory to the Neurosciences,* ed. Pietro Corsi (Milan: Electa, 1989), 19–21; John B. Friedman, "Les images mnémotechniques dans les manuscrits de l'époque gothique," in *Jeux de mémoire: Aspects de la mnémotechnie médiévale,* ed. Bruno Roy and Paul Zumthor (Paris: Vrin, 1985), 169–84.

68. For a modern edition of this work, see Ch. 2, n. 14.

69. *Ethiques,* 284–85.

70. For a description of the production of deluxe manuscripts, see de Winter, *"Grandes Heures,"* 787–88.

71. Idem, "Copistes, éditeurs et enlumineurs de la fin du XIVe siècle," 176–80. For an excellent discussion of the role of the illuminator within medieval manuscript production, see Sandra L. Hindman, *Christine de Pizan's Epistre Othéa: Paintings and Politics at the Court of Charles VI,* Studies and Texts, 77 (Toronto: Pontifical Institute of Mediaeval Studies, 1988), 63–68. See also idem, "The Roles of Author and Artists in the Procedure of Illustrating Late Medieval Texts," *Text and Image, Acta* 10 (1983): 27–62. For a recent work on the collaborative nature of book illumination, see Jonathan J. G. Alexander, *Medieval Illuminators and Their Methods of Work* (New Haven and London: Yale University Press, 1992). See ibid., Ch. 3, for a discussion of instructions to illuminators.

72. For the colophon of *C,* see above, Appendix II.

73. Delisle, *Recherches,* vol. 1, 71–79.

74. For the verses in Charles V's *Bible historiale* (The Hague, Rijksmuseum Meermanno-Westreenianum, MS B 23), see ibid., vol. 1, 74–76.

75. De Winter, *"Grandes Heures,"* 811.

76. *Les histoires que l'on peut raisonnablement faire sur les livres de Salluste,* ed. and intro. Jean Porcher (Paris: Librairie Giraud-Badin, 1962). On facing pages this edition pairs the specific instruction with the resulting miniature in Geneva, Bibl. Publique et Universitaire, MS lat. 54. For an excellent analysis of the program and its relationship to Lebègue's glosses, see Donal Byrne, "An Early French Humanist and Sallust: Jean Lebègue and the Iconographical Programme for the *Catiline* and *Jugurtha,*" *JWCI* 49 (1986): 41–65.

77. Paris, Bibl. Nat., MS fr. 14939. The text is published in Delisle, *Recherches,* vol. 1, 243–46. The manuscript is related to the *Somme le roi,* a moral treatise composed in 1279 by the

Dominican Frère Laurent for King Philip III. For further references to this text, see Ch. 12 at nn. 7–10.

78. Paris, Bibl. Nat., MS lat. 10843, fols. 2–4. This text was first published by Marcel de Fréville, "Commentaire sur le symbolisme religieux des miniatures d'un manuscrit du XIVe siècle par le miniaturiste lui-même," *Nouvelles archives de l'art français* (1874–75): 146–51. For a recent analysis, as well as the text and translation, see Lucy Freeman Sandler, "Jean Pucelle and the Lost Miniatures of the Belleville Breviary," *AB* 66/1 (1984): 73–96. For further references to the literature about instructions to readers and illuminators, see Avril, "Une *Bible historiale*," 74, nn. 62–67.

79. Avril, "Une *Bible historiale*," 75.

80. Smith, "Illustrations of Raoul de Praelle's Translation of St. Augustine's *City of God*," 63.

81. For examples, see Chs. 9, 11, and 13.

82. Hedeman, "Valois Legitimacy," 109–11.

CHAPTER 4

1. For other aspects of the prologues, see Ch. 1 above at nn. 32–33.

2. *Ethiques,* 97.

3. Ibid.

4. Ibid., 98.

5. Ibid.

6. Ibid., 99.

7. Ibid., 99–100.

8. For short descriptions of seventeen manuscripts, see *Ethiques,* 46–52. Four manuscripts containing Oresme's translations of the *Ethics* were unknown to Menut. All date from the fifteenth century: Rome, Vatican Library, MS reg. lat. 1341; Oxford University, Bodleian Library, MS 965a; New York, Columbia University, Rare Book and Manuscript Collections, MS 283; and London, Brit. Lib., Egerton MS 737. Only the last has a miniature, a frontispiece on fol. 1.

9. "Traducteurs et leur publique," 18.

10. Saenger, "Silent Reading," 407.

11. For further discussion of these images in Oxford, St. John's College, MS 164, and Paris, Bibl. Nat., MS fr. 24287, see Sherman, *Portraits,* 74–75; idem, "Representations of Charles V as a Wise Ruler," *Medievalia et Humanistica,* n.s. 2 (1971): 87–89.

12. For a discussion of this image, see below, Ch. 5 at nn. 19–24. For Saenger's interpretation, see "Silent Reading," 407.

13. *Ethiques,* 99. This phrase also appears in the *Politiques* prologue, 44.

14. The image suggests a parallel to university lectures, at which masters read out the text and then commented on or explained it.

15. Vol. 1, 222.

16. *Fais et bonnes meurs,* vol. 1, 47–48.

17. Ibid., vol. 1, 40.

18. *Le livre de la paix,* ed. Charity Cannon Willard (The Hague, Mouton, 1958), 68.

19. Prologue, vol. 1, 4.

20. Cited in de Laborde, *Les manuscrits à peintures de la Cité de Dieu,* vol. 1, 65.

21. See Astrik L. Gabriel, *The Educational Ideas of Vincent of Beauvais* (Notre Dame, Ind.: Notre Dame Press, 1962), 45, citing Vincent's preface to the *De morali principis institutione;* Gassman, "*Translatio studii,*" 534. The position continued at the court of Francis I. The title *lecteurs royaux,* applied to scholars who taught at the institution that Francis I founded, later called the College of France, was apparently unconnected with the earlier title and function. See William Nelson, "From 'Listen, Lordings' to 'Dear Reader,' " *University of Toronto Quarterly* 46/2 (1976–77): 113–14.

22. *Fais et bonnes meurs,* vol. 2, 62–63. In this account Christine adds the moving anecdote that the accidental death of Malet's young son did not prevent Malet from continuing his daily reading. I am grateful to Joyce Coleman for calling this passage to my attention and for sharing information drawn from her dissertation, entitled "The World's Ear: The Aurality of Late Medieval Literature" (Ph.D. diss., University of Edinburgh, 1993).

23. *Ethiques,* 461–62.

24. See below, Ch. 13 at nn. 8–24, for discussion of the lavish illustration of this topic in MS *C.*

25. Bäuml, "Varieties and Consequences of Medieval Literacy," 263–64; Beryl Smalley, *Historians in the Middle Ages* (New York: Scribner, 1975), 174–75.

26. See Clanchy, *From Memory to Written Record,* 230.

27. V. A. Kolve, *Chaucer and the Imagery of Narrative: The First Five Canterbury Tales* (Stanford, Calif.: Stanford University Press, 1984), 20–58. The following paragraph owes much to his discussion of these topics.

28. Ibid., 25.

29. Ibid., 43–45, referring to Yates, *The Art of Memory*, Chs. 3 and 4. See also above, Ch. 3 at n. 67; Carruthers, *The Book of Memory*, particularly 122–55.

30. For a full description of MSS *A* and *C*, see Appendixes I and II above. Henceforth, unless otherwise noted, references to Oresme's translation of the *Politics* also include that of the *Economics*.

31. The term for the second category of illustrations was suggested by the excellent article of Morton W. Bloomfield, "A Grammatical Approach to Personification Allegory," *Modern Philology* 60/3 (1963): 161–71.

32. *Hercules am Scheidewege*, 160.

33. Delisle, *Mélanges de paléographie*, 264. Dimensions of manuscripts are given in millimeters; those of miniatures, in centimeters.

34. Ibid., 272.

35. See Appendix II for further details.

36. See Ch. 3 above at nn. 60–62.

37. For the history of *B*, see above, Appendixes I and III.

38. MS *B* is usually dated after 1374, whereas MS *C* was finished in, or by, 1376.

39. See Ch. 22 below at n. 6.

CHAPTER 5

1. For further definition and discussion of this portrait type, see Sherman, *Portraits*, 21–22. The presence of a courtier at the extreme right of the dedication portraits of the *A* miniatures (Figs. 6 and 7) does not jeopardize the direct communication of Oresme and Charles V.

2. For previous discussion of the *Quadripartitum* miniature, see above, Ch. 2 at n. 37.

3. The homely cap called the *béguin* worn by Charles V in Figure 7 is a feature linked specifically to the Bondol portrait, while the crown of Figure 6 sets a more formal note.

4. The royal chamber, furnished with a bed, as the setting for literary presentations or discussions is attested by two miniatures of the early fifteenth century. The first depicts Queen Isabel of Bavaria receiving from Christine de Pizan the author's collected works (London, Brit. Lib., MS Harley 4431, fol. 3). See Sandra L. Hindman, "The Iconography of Queen Isabeau de Bavière, 1410–1415: An Essay in Method," *GBA* 102 (1983): 102–10, fig. 3. In another manuscript Queen Isabel's husband, King Charles VI, converses with the author Pierre Salmon in his curtained and canopied bedchamber (Geneva, Bibl. Publique et Universitaire, MS fr. 165, fol. 4). See Millard Meiss, *French Painting in the Time of Jean de Berry,* vol. 2, *The Boucicaut Master* (London: Phaidon Press, 1968), fig. 72. For a discussion of a ceremonial bed in a public space within the palace of the French king, see Robert W. Scheller, "The 'Lit de Justice,' or How to Sit on a Bed of State," *Annus Quadriga Mundi* (1989): 196.

5. *Ethiques,* 97.

6. Ibid.

7. Ibid. Oresme gives the date of the translation as 1370, a date that represents the number of years Aristotle's works had been popular since Christ's birth. He states in the same sentence that the books were written five hundred years before the Christian era.

8. Ibid., 98–99.

9. For this aspect of the design, see Donal Byrne, "Manuscript Ruling and Pictorial Design in the Work of the Limbourgs, the Bedford Master, and the Boucicaut Master," *AB* 66/1 (1984): 118–35.

10. The two brothers are the Dauphin, the future Charles VI, born in 1368, and Louis, duke of Orléans, born in 1371. Their sister, Marie, was born in 1370.

11. See *Li livres du gouvernement des rois,* ed. and intro. Samuel P. Molenaer (New York: Macmillan & Co., 1899), 189, ll. 8–28.

12. "Item bons princes est tenuz de bon enseignement a ses enfanz donner et comment li peres aime le fil que filz le pere" (fol. 59v). For a recent discussion of the *Avis au roys,* see Michael Camille, "The King's New Bodies: An Illustrated Mirror for Princes in the Morgan Library," in *Künstlerischer Austausch/Artistic Exchange,* Akten des 28. Internationalen Kongresses für Kunstgeschichte, Berlin, 15–20 July 1992, ed. Thomas W. Gaehtgens (Berlin: Akademie Verlag, 1993), 393–405.

13. Fols. 59v and 74.

14. See Delisle, *Recherches,* vol. 1, 260–62.

15. *Ethiques,* 105.

16. Ibid., 97.

17. "Amistiés royal et paternal sont semblables, comme il sera dit aprés" (ibid., Gloss 5, 438).

18. For this point and related images, see Claire Richter Sherman, "Taking a Second Look: Notes on the Iconography of a French Queen, Jeanne de Bourbon," in *Feminism and Art History: Questioning the Litany,* ed. Norma Broude and Mary D. Garrard (New York: Harper & Row, 1982), 108–10 and figs. 11–14.

19. *Ethiques,* 107.

20. Ibid., 99.

21. See Ch. 4 above at n. 13.

22. For my opinion that the bearded king wearing red should not be identified with the clean-shaven Charles V, clad in blue, who is depicted in the upper register, see Sherman, *Portraits,* 29; see also Avril, *Manuscript Painting at the Court of France,* 105.

23. *Ethiques,* 107.

24. Ibid., Gloss 5. Menut has printed Thomas Aquinas's commentary on these points, which Oresme apparently used (ibid., 108, n. 3).

25. This statement of the king's purpose comes from Ecclesiastes 1:13.

26. Sherman, "Representations of Charles V," 90–91.

27. For another version of this setting in the closely related presentation miniature of the *City of God* translation, see Sherman, *Portraits,* pl. 7, and 22–24.

28. A. W. Byvanck suggests that the figure was overpainted at a later date, although the argument he advances is not persuasive. See *Les principaux manuscrits à peintures de la Bibliothèque Royale des Pays-Bas et du Musée Meermanno-Westreenianum à La Haye* (Paris: Société Française de Reproductions de Manuscrits à Peintures, 1924), 112.

29. Each register is the same size: 5 × 9.3 cm.

30. *Ethiques,* 103.

31. The Latin words show signs of having been painted over the dark background. In the word *Stans,* the *S* is red, the *t* black, and the somewhat worn *a* is brown.

32. For discussion of frontality as a "theme of state" and the profile view as a "theme of action," see Meyer Schapiro, *Words and Pictures: On the Literal and Symbolic in the Illustration of a Text,* ed. Thomas A. Sebeok, Approaches to Semiotics, 11 (The Hague: Mouton, 1973), Ch. 2.

33. *Ethiques,* 129.

34. Ibid., Gloss 9, 135. For discussion of this comparison, see Knops, *Etudes,* 92.

CHAPTER 6

1. *NE*II.6 1106b–1107a.

2. For the antique and Christian sources of the cardinal virtues, see Michael Evans, "Tugen-den," in *LCI,* vol. 4, col. 364.

3. "Donques vertu est habit electif estant ou moien quant a nous par raison determinee ainsi comme le sage la determineroit" (*Ethiques,* 162).

4. For the glossary references, see ibid., 543–44; for the chapter headings, 157 and 159.

5. Figures 7 and 24, the half-page illustrations for Books I and V that take up the entire text block, also stand at the head of the folios.

6. The dimensions of 8 × 7.2 cm compare to those of 8.1 × 6.7 cm for Figure 37, the illustration of Book VIII.

7. Byrne, "Manuscript Ruling and Design," 119.

8. *Ethiques,* 146; *A,* fol. 23v.

9. Ibid., 162.

10. Ibid., 162–63.

11. I am grateful to Vicki Porter for suggesting this interpretation to me.

12. *NE*II.7 1107b; *Ethiques,* 165 and 167.

13. The qualifying inscription to the right of Vertu's head is the only one of the three that forms a complete sentence; those of the vices are only adjectival phrases.

14. Schapiro, *Words and Pictures,* Ch. 4.

15. See Sherman, "Taking a Second Look," 108–10. See also Ch. 5 above at n. 18.

16. For other images of Jeanne de Bourbon in the same dress, see Sherman, "Taking a Second Look," figs. 14, 15, and 18.

17. E. H. Gombrich, *"Icones symbolicae:* Philosophies of Symbolism and Their Bearing on Art," in *Symbolic Images: Studies in the Art of the Renaissance* (London: Phaidon, 1972), 130.

18. Yates, *The Art of Memory,* 101.

19. Ibid.

20. *Hercules am Scheidewege,* 150–51.

21. Figure 13 is related more closely to Figure 24, the illustration of Justice in *A.* See Ch. 9 below at n. 34. While the mean is mentioned in the relevant passage of fol. 48v of the Morgan manuscript (M. 456), it is associated with Prudence, considered the master virtue. In other illustrations of M. 456, the mean in regard to individual virtues is symbolized by a gold T square, signifying rule or measure.

22. Among later manuscripts, the cycle of the Rouen *Ethics* of 1452, Bibl. Municipale, MS fr. I.2 (927), also shares the frontispiece format of *C.*

23. The placement of the central figure in the space between the two text columns bears out Byrne's argument of the relationship between the image design and the folio layout ("Manuscript Ruling and Design," 119).

24. Such fillets are worn by brides in *C* (Fig. 38) and *D* (Fig. 84) and by the princess in the upper right quadrilobe of *A* (Fig. 7).

25. For kinship metaphors among personifications, see Robert Curtius, *European Literature and the Latin Middle Ages,* trans. Willard R. Trask (New York: Harper & Row, Torchbooks, 1963), 131–34; Gombrich, *"Icones symbolicae,"* 130.

26. *Ethiques,* 156, and Glosses 5 and 6.

27. For the *Psychomachia* illustration (Paris, Bibl. Nat., MS lat. 8318, fols. 62r–v), see Katzenellenbogen, *Virtues and Vices,* figs. 1 and 3.

28. *NE*II.8 1108b; *Ethiques,* 169.

CHAPTER 7

1. See Katzenellenbogen, *Virtues and Vices,* 30–33. The neologism *Fortitude* may, however, have presented a problem to Oresme's audience.

2. Ross, *Aristotle,* 197–99.

3. *NE*II.8 1108b–1109a; *Ethiques,* 165.

4. *NE*III.6–9, Fortitude; 10–12, Temperance.

5. Although the two personifications of Figure 15 increase in number to seven in Figure 16, only two of them interact.

6. Figure 15 is 7.1 × 6.9 cm; Figure 11, 8 × 7.2 cm. The width of Figure 15 is slightly narrower than that of Figure 11, since the first occurs on a folio laid out in two columns

of equal width, the usual format for the prefatory matter in this manuscript. The width of Figure 11 corresponds to the area taken up by a column of text plus a narrower one of gloss.

7. *Ethiques,* 80.

8. Ibid., 544. The definition by Oresme in Gloss 12 of Ch. 16 offers a slightly more detailed version than the one provided in the glossary (ibid., 210).

9. New York, The Pierpont Morgan Library, M. 456, fol. 33.

10. M. 456, fols. 35v–36. The miniature on fol. 34 depicts the seven types of Force.

11. *Fais et bonnes meurs,* vol. 1, pt. 2.

12. *Ethiques,* 219.

13. Ibid., Gloss 1, 219.

14. Kolve, *Chaucer and the Imagery of Narrative,* 81.

15. For examples of virtues placed within city walls, see a tenth-century manuscript of the *Psychomachia* of Prudentius (Brussels, Bibl. Royale Albert Ier, MS 10066–10077), reproduced in Richard Stettiner, *Die illustrierten Prudentius-Handschriften* (Berlin: Preuss [text] and Grotesche [plates], 1895–1905), pl. 176. For virtues in a tower setting in a manuscript of the *Liber scivias* of ca. 1175 (Wiesbaden, Landesbibliothek, Cod. 1, fols. 138v–139), see Katzenellenbogen, *Virtues and Vices,* figs. 46 and 47. For a Tower of Wisdom in a castle defended by the virtues in a thirteenth-century text, see Fritz Saxl, "A Spiritual Encyclopaedia of the Later Middle Ages," *JWCI* 5 (1942): 109–10. For a fifteenth-century adaptation of the *Psychomachia* in which two castles are defended (one by the three theological virtues, the other by the four cardinal virtues), see Saxl, "A Spiritual Encyclopaedia," 103–5 (Rome, Bibl. Casanatense, pl. 25a).

16. See Ch. 3 above at n. 67 and Ch. 4 at n. 29.

17. See Kolve, *Chaucer and the Imagery of Narrative,* 25–26.

18. Aristotle, *Rhetoric,* III.9, 7–10; Curtius, *European Literature and the Latin Middle Ages,* 65.

19. *Ethiques,* 208.

20. Ibid., Gloss 6, 209.

21. *NE*II.8 1109a.

22. Carruthers, *The Book of Memory,* 63.

23. *Ethiques,* 208–9.

24. The scene is linked to the rubric, "Item comment a bon prince attrempence appartient." Other illustrations of this manuscript (fols. 6v, 10v, and 38) also emphasize the necessity of the good king's exercise of moderation in regard to bodily pleasures.

25. For Oresme's association of "bodily pleasures" with Luxuria, or Lechery, see *Ethiques, Gloss 3, 222.*

26. *NEIII.1119a; Ethiques, 225–26.*

27. "Et se il est aucun auquel nulle viande n'est delitable et qui ne fait difference de l'une a l'autre, tele personne seroit bien loing de la commune nature et de l'estre des hommes" (*Ethiques*, 225).

28. For an interpretation of the association of Jews with horns, see Ruth Mellinkoff, *The Horned Moses in Medieval Art and Thought,* California Studies in the History of Art, 14 (Berkeley and Los Angeles: University of California Press, 1970), 121–37.

29. See Alfred Rubens, *A History of Jewish Costume* (New York: Funk & Wagnalls, 1967), 118. See Ch. 8 below at nn. 23–24.

30. Bolzoni, "The Play of Images," 19–20; Carruthers, *The Book of Memory,* Ch. 4.

CHAPTER 8

1. Carruthers, *The Book of Memory,* 63.

2. *Ethiques,* 230.

3. For the philosophical context of Liberality and Magnanimity, see the helpful discussion of Gauthier and Jolif, *Ethique à Nicomaque,* vol. 2, pt. 1, 251–62 and 272–97. See also Aristotle, *Nicomachean Ethics,* trans. and intro. Martin Ostwald (Indianapolis: Bobbs-Merrill, 1962), 306 and 310–11.

4. M. 456, fol. 39.

5. *NEIV.1 1120a; Ethiques,* 232.

6. Katzenellenbogen cites examples of the virtues acting in genre scenes dating from about 1245–55 on the right portal of the west façade of Reims cathedral (*Virtues and Vices,* 75–81, figs. 72–73).

7. For further discussion of these points, see Ch. 9 below at nn. 54–55.

8. Ross, *Aristotle,* 202–3.

9. *Ethiques,* Gloss 10, 256. See also Gloss 7, 250; Gloss 17, 252; and Gloss 10, 254.

10. Ibid., 247–48.

11. Ibid., 251.

12. Ibid.

13. Carruthers, *The Book of Memory,* 93.

14. *Ethiques,* 256. *Chaymes,* Oresme's transliteration of a Greek word, appears in the glossary of difficult words (ibid., 542).

15. For a discussion of this formula, see Ch. 1 above at n. 59. See also Hedeman, *Royal Image,* 128–33.

16. Prof. Carl Nordenfalk suggested the connection between the stag's head and the hunt ritual. For a description and illustration of the ritual presentation of the stag, see Francis Klingender, *Animals in Art and Thought to the End of the Middle Ages,* ed. Evelyn Antal and John Harthan (Cambridge, Mass.: M.I.T. Press, 1971), 468–69 and figs. 248–49. For a thorough account of the actual procedure of the hunt, see Marcelle Thiébaux, "The Mediaeval Chase," *Speculum* 42 (1967): 260–74. See also idem, *The Stag of Love: The Chase in Medieval Literature* (Ithaca, N.Y.: Cornell University Press, 1974), 21–40.

17. *NEIV.1* 1121a; *Ethiques,* 236.

18. *Ethiques,* 546.

19. For the tradition of moral criticism of the hunt, see Thiébaux, "The Mediaeval Chase," 263–65. For an illustration of this negative attitude in the French translation of the *Policraticus* of John of Salisbury executed for Charles V (Paris, Bibl. Nat., MS fr. 24287, fol. 12), see Sherman, *Portraits,* 76–77, and fig. 73.

20. "Quant est de exposer peccune ou richesces ou de les prendre et aquerir, liberalité est le moien; et la superhabundance, c'est prodigalité que nous povons apeller fole largesce. Et la deffaute est illiberalité et est avarice et convoitise" (*Ethiques,* 165).

21. Ibid., Gloss 2, 236. According to Menut, Illiberalité is a neologism (ibid., 80).

22. Ibid., Gloss 2, 239.

23. See Ch. 7 above at nn. 28–29. For the association of Avarice with usury, see Morton W. Bloomfield, *The Seven Deadly Sins: An Introduction to the History of a Religious Concept, with Special Reference to Medieval English Literature* (East Lansing: Michigan State College Press, 1952), 183, 197, and 231. For a horn as a symbol of other vices such as Pride, see Rosemond Tuve, "Notes on the Virtues and Vices," *JWCI* 27 (1963): 63. For the tradition that, like the devil, the Jews had horns, see Mellinkoff, *Horned Moses,* 135–36.

24. *Ethiques,* 240. *NEIV.1* 1121b refers to "those who lend small sums and at high rates." See also William C. Jordan, "Jews on Top: Women and the Availability of Consumption

Loans in Northern France in the Mid-Thirteenth Century," *Journal of Jewish Studies* 29 (1978): 53.

25. *NEIV.1* 1121b; *Ethiques*, 238.

1. For two basic definitions of Justice in the *Politics,* see I.2 and III.8–9. For Aristotle's discussion of Justice and associated concepts in the *Ethics, Politics,* and the *Rhetoric,* see *Politics,* Appendix 2, 361–72.

2. Morris D. Forkosch, "Justice," in *Dictionary of the History of Ideas,* ed. Philip Wiener (New York: Scribner, 1973), vol. 2, 654.

3. *Politics,* Appendix 2, 362.

4. Ibid.

5. Ibid., 363.

6. For a brief discussion of the transmission of these sources, see Michael Evans, "Tugenden," in *LCI,* vol. 4, col. 364.

7. Ernst H. Kantorowicz, *The King's Two Bodies: A Study in Mediaeval Political Theology* (Princeton, N.J.: Princeton University Press, 1957), 96–97.

8. Post, *Studies in Medieval Legal Thought,* 515, citing Berges, *Die Fürstenspiegel,* 43–46.

9. Berges, *Die Fürstenspiegel,* 121–22. For a recent discussion of the connections between the Mirror of Princes literature and theories of kingship in late medieval political thought, see Jean Dunbabin, "Government," in *CHMPT,* 477–93.

10. For relevant text passages, see Bell, *L'idéal éthique,* 65, 71, 73, and 74.

11. For the writings of the king's publicists and the tenor of the controversy, see Joseph R. Strayer, "Defense of the Realm and Royal Power in France," in *Medieval Statecraft and the Perspectives of History* (Princeton, N.J.: Princeton University Press, 1971), 295–99. For the Capetian's legal claims, see idem, "The Laicization of French and English Society in the Thirteenth Century," ibid., 251–65.

12. Joseph R. Strayer, "France, the Holy Land, the Chosen People, and the Most Christian King," ibid., 300–309.

13. Ibid., 310, citing Kantorowicz, *King's Two Bodies,* 249–59.

14. Strayer, "France, the Holy Land," 310.

15. For Joinville's famous description of Louis IX rendering justice, see his *Life of Saint Louis,* in Jean de Joinville and Geoffroi de Hardouin, *Chronicles of the Crusades,* trans. and intro. M. R. B. Shaw (Baltimore: Penguin Books, 1963), 177.

16. This discussion depends heavily on an unpublished paper by Sarah Hanley, "Charles V and Royal Propaganda, 1364–1380," Department of History, University of Iowa, 1970. I am grateful to Prof. Hanley for making this study available to me.

17. For the Latin and French forms of this treatise, see the introduction by Schnerb-Lièvre, *Le songe du vergier,* vol. 1, xix–xcii.

18. Ibid., vol. 1, 273–74.

19. This list was first incorporated in a register of the Parlement of Paris dated 8 March 1372 (ibid., vol. 2, 201–3).

20. Ibid., vol. 1, 5. For an earlier discussion of Charles V and sacral kingship in the prologues of translations commissioned by him, see above, Ch. 1.

21. For the *main de justice,* see Sherman, *Portraits,* figs. 18 and 22. In images other than the *Coronation Book,* see ibid., figs. 21 and 72.

22. Figure 7 is 14.8 × 15.2 cm; Figure 24, 15.2 × 15.2 cm.

23. *Ethiques,* 545. Also defined in the same place is the adjective *légal.*

24. Ibid., 278; see also the definition of *illégal,* 544.

25. Ibid., 277.

26. For a late twelfth-century treatise, *Quaestiones de iuris subtilitatibus,* attributed to Placentinus (d. 1192), see Kantorowicz, *King's Two Bodies,* 107 and 108, n. 61; and Hermann Kantorowicz, *Studies in the Glossators of the Roman Law: Newly Discovered Writings of the Twelfth Century* (Cambridge: Cambridge University Press, 1938), 183. For a summary of the "parts" or attendants of Justice in four classical medieval sources, see Rosemond Tuve, *Allegorical Imagery: Some Mediaeval Books and Their Posterity* (Princeton, N.J.: Princeton University Press, 1966), Appendix, unpaged.

27. Katzenellenbogen, *Virtues and Vices,* 52–53, n. 1.

28. For these symbols, see Johanna Flemming, "Palme," in *LCI,* vol. 3, cols. 364–65; for the ring, Alfonz Lengyel, "Ring," ibid., vol. 3, col. 554, and George Ferguson, *Signs and Symbols in Christian Art* (New York: Oxford University Press, 1961), 178–79. For the dog, see Peter Gerlach, "Hund," in *LCI,* vol. 2, cols. 334–35.

29. *Sub matris tutela: Untersuchungen zur Vorgeschichte der Schutzmantel Madonna,* Abhandlungen der Heidelberger Akademie der Wissenschaften, Philosophisch-Historische Klasse (Hei-

delberg: Carl Winter Universitäts Verlag, 1976), 9–37. References to the older literature are included.

30. Oxford, Merton College, MS 296, fol. 55.

31. See Michael Camille, "Illustrations in Harley MS 3487 and the Perception of Aristotle's *Libri naturales* in Thirteenth-Century England," in *England in the Thirteenth Century: Proceedings of the 1984 Harlaxton Symposium,* ed. W. H. Ormrod (Dover, N.H.: Boydell Press, 1986), 41, fig. 16. I am grateful to Prof. Camille for bringing this illustration to my attention.

32. Ibid., 34–35.

33. See Gertrud Schiller, *Ikonographie der christlichen Kunst* (Gütersloh: Gütersloher Verlagshaus Gerd Mohn, 1980), vol. 4, pt. 2, *Maria,* 195.

34. For a discussion of these points, see Ch. 6 above at n. 21.

35. *Ethiques,* 279.

36. See Sherman, "The Queen," 279, n. 83; and idem, "Taking a Second Look," 107–9.

37. *Ordonnances des roys de France de la troisième race recueillies par ordre chronologique,* ed. Denis F. Secousse (Paris: Imprimerie Royale, 1723–1829), vol. 6, 49–54.

38. Hedeman, *Royal Image,* 106–9.

39. See Sherman, "The Queen," figs. 3, 5, and 7.

40. "Et que ne Hesperus ne Lucifer n'est si tres merveilleuse" (*Ethiques,* 279).

41. Yates, *The Art of Memory,* Chs. 3 and 4; Carruthers, *The Book of Memory,* Ch. 4.

42. For such a literary monument developed in a twelfth-century dialogue, see Kantorowicz, *King's Two Bodies,* 107–11, and below at n. 56.

43. See Forkosch, "Justice," 652; Kantorowicz, *King's Two Bodies,* 97–115; Rainer Kahsnitz, "Justitia," in *LCI,* vol. 2, 466–71; and Frances A. Yates, "Queen Elizabeth as Astraea," *JWCI* 10 (1947): 27–37.

44. For an explanation of Aristotle's ideas, see the lucid translation of Ostwald, *NEV.*3 1131a.

45. *Ethiques,* 285.

46. The diagrams he includes use both letters and numbers (ibid., text, and Gloss 3, 286). For a modern explanation of Aristotle's terms, see Ross, *Aristotle,* 205.

47. The depiction of Justice with a measuring rod is, however, not new in medieval art. See Katzenellenbogen, *Virtues and Vices,* 55.

48. The Latin translation of Aristotle's text by Robert Grosseteste uses words and letters, and not numbers, to explain the proportions. See *Ethica Nicomachea, Translatio Roberti Grosseteste Lincolniensis,* V.3–4, 31a15–31b17. For several modern editions of Oresme's works on mathematics, see *De proportionibus proportionum and Ad pauca respicientes,* trans. and ed. Grant, intro., 81–82; and *Nicole Oresme and the Medieval Geometry of Qualities and Motions: A Treatise on the Uniformity and Difformity of Intensities Known as "Tractatus de configurationibus qualitatum et motuum,"* trans. and ed. Marshall Clagett (Madison: University of Wisconsin Press, 1968), Chs. 1 and 2.

49. Although Menut (*Ethiques,* 79–80) considers *commutatif* (like *distributive*) a neologism, the two words appear in the earlier Morgan *Avis au roys.* See Bell, *L'idéal éthique,* 65.

50. *NEV.*3 1132a, n. 2.

51. Ross, *Aristotle,* 205.

52. For a similar arrangement of the objects surrounding Art in MS *C,* see Ch. 10 at nn. 34–37.

53. *Ethiques,* 289–90.

54. Red robes were worn on some occasions by French judges. See W. N. Hargreaves-Mawdsley, *A History of Legal Dress in Europe until the End of the Eighteenth Century* (Oxford: Clarendon Press, 1963), 21–27.

55. The only exceptions in *C* are the illustrations of Félicité humaine in Book I (Fig. 10) and Félicité contemplative in Book X (Fig. 43).

56. See above, nn. 26 and 42.

57. For an excellent study of Italian Aristotelianism, see Nicolai Rubenstein, "Marsilius of Padua and Italian Political Thought of His Time," in *Europe in the Later Middle Ages,* ed. John Hale et al. (London: Faber & Faber, 1965), 44–75.

58. For a description of the Aristotelian sources, see Jonathan B. Riess, "French Influences on the Early Development of Civic Art in Italy," in *Machaut's World: Science and Art in the Fourteenth Century,* ed. Madeleine P. Cosman and Bruce Chandler, Annals of the New York Academy of Sciences, vol. 314 (New York: The New York Academy of Sciences, 1978), 292–99.

59. "Political Ideas in Sienese Art: The Frescoes by Ambrogio Lorenzetti and Taddeo di Bartolo in the Palazzo Pubblico," *JWCI* 21 (1958): 179–207.

60. "Ambrogio Lorenzetti: The Artist as Political Philosopher," *Proceedings of the British Academy* 72 (1986): 1–56.

61. Ibid., 48–56. In one sense Skinner builds upon Rosemond Tuve's idea that the *Moralium dogma philosophorum,* a treatise with Ciceronian roots, is the relevant source for the iconog-

raphy of the virtues and vices. See Tuve, "Notes on the Virtues and Vices," *JWCI* 26 (1963): 290–94.

62. "Ambrogio Lorenzetti," 3–6.

63. "The Republican Regime of the 'Room of Peace' in Siena, 1338–40," *Representations* 18 (1987): 1–32. For an expanded discussion of these views, see Randolph Starn and Loren Partridge, *Arts of Power: Three Halls of State in Italy, 1300–1500* (Berkeley and Los Angeles: University of California Press, 1992), 11–59. For a summary of recent bibliography on the Lorenzetti frescoes, see ibid., 313, n. 15.

64. *A Distant City: Images of Urban Experience in the Medieval World,* trans. William McCuaig (Princeton, N.J.: Princeton University Press, 1991), Ch. 6.

65. For the divergence of these subsidiary types of Justice from Aristotelian concepts, see Rubenstein, "Political Ideas," 182–83.

66. For an image of this second representation of Justice, see ibid., pl. 16b. For Skinner's interpretation of this figure, see "Ambrogio Lorenzetti," 35–36.

67. For an interpretation of the feminine personifications, see Marina Warner, *Monuments and Maidens: The Allegory of the Female Form* (New York: Atheneum, 1985), 155–56.

68. Yates, *The Art of Memory,* 100–101.

69. See above at n. 49.

CHAPTER 10

1. "Ci après commence les titres des chapitres du sexte livre d'Ethiques, ou il determine des vertus intellectueles qui sont en l'entendement. Et contient ceste livre .xvii. chapitres" (*Ethiques,* 330).

2. "Ou premier chapitre il met son entencion et une diffinicion qui fait a son propos" (ibid.).

3. Ibid.

4. Ross, *Aristotle,* 209; *Ethiques,* 332.

5. *NEVI.3* 1139a; *Ethiques,* 331.

6. According to Menut, these terms are neologisms introduced by Oresme. (*Ethiques,* 79–81).

7. Ibid., 541–42.

8. Sherman, "Representations of Charles V," 87–92.

9. *NEVI.*4 1140a.

10. *Ethiques,* 336.

11. *Renaissance Thought: Papers on Humanism and the Arts* (New York: Harper, Torchbooks, 1965), vol. 2, 166.

12. Ibid.

13. *Ethiques,* 336; *NEVI.*4 1140a.

14. *Ethiques,* Gloss 1, 336.

15. Ibid., 544.

16. See Mircea Eliade, *The Forge and the Crucible,* trans. Stephen Corrin (New York: Harper & Bros., 1962), chs. 8–10.

17. See R. F. Tylecote, "The Medieval Smith and His Methods," in *Medieval Industry,* ed. D. W. Crossley (London: Council for British Archaeology, 1981), 42–50, and in the same volume, Ian H. Goodall, "The Medieval Blacksmith and His Products," 51–62. See also W. A. Oddy, "Metalworkers," in *DMA,* vol. 8, 291–97. I am grateful to Prof. Natalie Zemon Davis for sharing material and ideas on medieval blacksmiths with me.

18. This series of citations is drawn from Ross, *Aristotle,* 211.

19. *Ethiques,* Gloss 3, 341. Although Aristotle's use of the term *Intelligences* probably refers to the highest intelligible things, Oresme probably means the word to connote heavenly spirits or angels included in the celestial hierarchies. I owe this explanation to Profs. Robert Mulvaney and Ellen Ginsberg.

20. See Eugene F. Rice, Jr., *The Renaissance Idea of Wisdom* (Cambridge, Mass.: Harvard University Press, 1958), 10–13.

21. Ibid., 15–17.

22. See ibid., 15, n. 41, citing *Sum. Theol.,* I, 2, col. 2.

23. Ibid., 49, n. 17, citing *Sum. Theol.,* Ia, Q. XLI, art. Resp. ad. 4.

24. For a recent discussion of the Christian emphasis in the Sapience miniature, see Kolve, *Chaucer and the Imagery of Narrative,* 79–81.

25. See Ursula Nilgen, "Evangelisten," in *LCI,* vol. 1, cols. 696–713; and Erika Dinkler-von Schubert, "*Vita activa et contemplativa,*" in ibid., vol. 4, cols. 463–68.

26. For further discussion of the contemplative life, see below Ch. 14.

27. *Chaucer and the Imagery of Narrative,* 81.

28. For a summary of editorial changes in *C,* see Ch. 4 above.

29. In other words, Art and Prudence, who fall into the sphere of practical wisdom, make a logical pairing on the top, whereas Science should more appropriately accompany Entendement and Sapience below. Or, if the upper register is equated with higher or spiritual values, as is often the case in medieval art, Science, Entendement, and Sapience should occupy the upper zone; Art and Prudence, the lower.

30. Ross, *Aristotle,* 210; *N EVI.*3 1139b; *Ethiques,* 334–36.

31. See Michael Evans, "Allegorical Women and Practical Men: The Iconography of the *Artes* Reconsidered," in *Medieval Women,* ed. Derek Baker, Studies in Church History, subsidia 1 (Oxford: Basil Blackwell, for the Ecclesiastical History Society, 1978), 305–28. For bibliography on the liberal arts, see Mary D. Garrard, "Artemisia Gentileschi's *Self-Portrait as the Allegory of Painting,*" *AB* 62/1 (1980): 99, n. 8; for further discussion of the liberal arts, see idem, "The Liberal Arts and Michelangelo's First Project for the Tomb of Julius II (With a Coda on Raphael's 'School of Athens')," *Viator* 15 (1984): 335–55, and for further bibliography, 337, n. 7. See also David L. Wagner, ed., *The Seven Liberal Arts in the Middle Ages* (Bloomington: University of Indiana Press, 1983).

32. London, Brit. Lib., MS Add. 30024, fol. 1v. See Evans, "Allegorical Women and Practical Men," 305–6, 319–28, and pl. 1.

33. The second part of Brunetto's encyclopedia is based on an abbreviated version of Aristotle's *Ethics* known as the *Summa alexandrina,* first translated into Italian by Maestro Taddeo of Florence, ca. 1260 (see *Ethiques,* 39). For Brunetto's work as a source of Ambrogio Lorenzetti's fresco cycle of Good and Bad Government, see Ch. 9 above at nn. 60–63.

34. I owe this important observation to Rieneke Nieuwstraten.

35. The Princeton Index of Christian Art identifies these tools.

36. For this association, see Rudolf Berliner, "*Arma Christi,*" *Muenchner Jahrbuch der bildenden Kunst* 6 (1955): 112.

37. For another example of the migration of Passion iconography, see Ch. 9 above at nn. 51–52.

38. Ross, *Aristotle,* 210.

39. Ibid., 211.

40. *Ethiques,* Gloss 6, 360–61.

41. Ibid., 344–46.

42. Prudence or Practical Wisdom is applied to the conduct of an individual, household management, legislation, and politics. Politics is subdivided into deliberative and judicial aspects (ibid., 345); for a diagram, see Ross, *Aristotle,* 212.

43. *Ethiques,* 542–46. These terms are *architectonique, demotique, eubulie, gnomé, rectitude,* and *synesie.*

44. The Princeton Index of Christian Art solved this puzzle.

45. For a history of this tradition, see Erwin Panofsky, "Titian's *Allegory of Prudence:* A Postscript," in *Meaning in the Visual Arts* (Garden City, N.Y.: Doubleday Anchor Books, 1955), 149–51.

46. See Samuel C. Chew, *The Pilgrimage of Life* (New Haven and London: Yale University Press, 1952), 136.

47. Martin of Braga, "Rules for an Honest Life (*Formula vitae honestae*)," in *Iberian Fathers,* trans. Claude W. Barlow, The Fathers of the Church, A New Translation, 62 (Washington, D.C.: Catholic University of America Press, 1969), 90; Cicero, *De inventione,* trans. and ed. H. M. Hubbell (Cambridge, Mass.: Harvard University Press, Loeb Classical Library, 1949), II.liv.160; and Panofsky, "Titian's *Allegory of Prudence,*" 149–50.

48. Panofsky, "Titian's *Allegory of Prudence,*" 149.

49. See *Li livres du gouvernement des rois,* ed. Molenaer, 40, ll. 10–14.

50. For the derivation of the eight-part division of Prudence from Macrobius, *In somnium Scipionis,* 1–8, see Tuve, *Allegorical Imagery,* 63–65, and Appendix 2.

51. See Garrard, "The Liberal Arts," fig. 13.

52. See Georg Troescher, "Dreikopfgottheit und Dreigesicht," in *RDK,* vol. 4, 501–12.

53. Malines/Mechelen, Grand Séminaire, Codex I, fol. 3. For other Italian examples, see Panofsky, "Titian's *Allegory of Prudence,*" 150, nn. 12–14.

54. New York, The Metropolitan Museum of Art, The Cloisters, 69.86, fols. 321v–322.

55. *Ethiques,* Gloss 6, 340–41.

56. For illustrations of Giovanni Pisano's Sibyls, see Michael Ayrton and Henry Moore, *Giovanni Pisano, Sculptor* (New York: Weybright and Talley, 1969), figs. 144–46 and 167.

57. Among early examples in Carolingian manuscripts of an image of St. Matthew, see the *Gospel Book of Lothair,* Paris, Bibl. Nat., MS lat. 266, fol. 22b; and for an image of St. Mark, fol. 75b. The manuscript is dated between 840 and 851. See Wilhelm Koehler, *Die karolingischen Miniaturen,* vol. 1, *Die Schule von Tours* (Berlin: B. Cassirer, 1930), (text), 247, (plates), 99a and b.

58. Similar problems with the inscription occur in Figure 43, the illustration of Book X in *C*. Here too the iconographic type is like that of Sapience in Figure 34.

59. For an example of Forgerie, see Evans, "Allegorical Women and Practical Men," fig. 1.

60. Yates, *The Art of Memory*, 101.

CHAPTER 11

1. *Hercules am Scheidewege*, 160. Although the context is different, the Lover stands at the "two ways" in the *Roman de la rose*. A fourteenth-century illustration represents Amant in the center between the God of Love on the left and Lady Reason on the right (Brussels, Bibl. Royale Albert Ier, MS 9574–75, fol. 32r). See John V. Fleming, *The Roman de la rose: A Study in Allegory and Iconography* (Princeton, N.J.: Princeton University Press, 1969), pl. 32. For the history of Lady Reason in medieval literature, see idem, *Reason and the Lover* (Princeton, N.J.: Princeton University Press, 1984).

2. Because they are used in Oresme's translation, the terms *Continence* and *Incontinence* are retained in this discussion.

3. For Aristotle's use of the terms, see Amélie O. Rorty, "*Akrasia* and Pleasure: *Nicomachean Ethics,* Book 7," in *Essays on Aristotle's Ethics,* ed. Amélie O. Rorty (Berkeley and Los Angeles: University of California Press, 1980), 267–84. For the history of the terms, see Gauthier and Jolif, *Ethique à Nicomaque,* vol. 2, pt. 2, 579–81.

4. *Ethiques,* 542.

5. Ibid., 544.

6. Ibid., 363.

7. According to Menut, the term *incontinent* is a neologism (ibid., 80).

8. *Hercules am Scheidewege*, 160, n. 1.

9. *Ethiques,* Gloss 2, 363–64.

10. The other two modes or states of conduct, the bestial and the heroic, were probably considered by Oresme too extreme to depict in a third zone. Yet he gives Hector as an example of heroic or divine virtue. Oresme notes: "De cestui Hector descendirent les François; ce dit un expositeur, et ainsi le dient les hystoires" (*Ethiques,* Gloss 3, 364). Oresme here refers to the legend that the French are descended from the Trojans. This claim, Oresme states, figures in the commentaries on the *Ethics* of Buridan and Burley (ibid., 364, n. 3). Although Oresme does not refute this claim, he does not accept it either. See Babbitt, who cites the gloss in the context of Oresme's awareness of a national heritage (*Oresme's Livre de Politiques,* 67, n. 173).

11. For exemplification and verisimilitude in illustrations of the *Roman de la Rose,* see the discussion by Fleming, *Roman de la Rose,* 31–36.

CHAPTER 12

1. *NE* VIII.1 1155a.

2. See the helpful discussion by William A. Wallace of "Friendship" in the *New Catholic Encyclopedia* (New York: McGraw-Hill, 1967), vol. 6, 203–5.

3. *NE* VIII.3 1156b.

4. Wallace, "Friendship," 204.

5. Ibid., 205.

6. *Ethiques,* Gloss 7, 427–28.

7. This set is added to the traditional four cardinal and three Christian virtues derived from the *Psychomachia* of Prudentius. See Ellen Kosmer, "A Study of the Style and Iconography of a Thirteenth-Century *Somme le roi* (British Museum, MS Add. 54180) with a Consideration of Other Illustrated *Somme* Manuscripts of the Thirteenth, Fourteenth, and Fifteenth Centuries" (Ph.D. diss., Yale University, 1973), pt. 1, 52. For a list of these virtues, see Tuve, *Allegorical Imagery,* Appendix. Tuve discusses the virtues in the *Somme le roi* throughout ch. 2 of this volume and in the second part of her lengthy article, "Notes on the Virtues and Vices" (1964): 42–72. See also Alexander, *Medieval Illuminators,* 115–20.

8. Kosmer, "*Somme le roi,*" pt. 1, 99.

9. For Charles V's manuscript, Paris, Bibl. Nat., MS fr. 938, fol. 82, see Delisle, *Recherches,* vol. 1, 236–39. See also Tuve, "Notes on the Virtues and Vices," (1964): 43, pls. 7b, c, and d.

10. Paris, Bibl. Nat., MS fr. 14939, fol. 105v. This manuscript contains a set of instructions to the illuminator for depicting the last ten of the set of fifteen miniatures. See Delisle, *Recherches,* vol. 1, 243–46; Kosmer, "*Somme le roi,*" pt. 2, 66–68. See Ch. 3 above at n. 77.

11. Figure 37 is 8.1 × 6.7 cm; Figure 11 is 8 × 7.2 cm. The third and fourth undivided miniatures (Figs. 40 and 42) for Books IX and X are 7.3 × 6.9 and 7.6 × 6.9 cm respectively.

12. It is also possible that a different member of the Jean de Sy workshop executed Figures 37 and 40, which would explain the change in color.

13. *Ethiques,* Gloss 10, 417.

14. Ibid., 412.

15. "Car, si comme il sera dit aprés, amistié est un habit electif en la maniere que est vertu, et aussi comme une espece de vertu reduite ou ramenee a justice; et donques science morale qui considere des vertus doit considerer de amistié" (ibid., Gloss 2, 412).

16. Wallace, "Friendship," 204, citing St. Augustine's *Confessions,* trans. William Watts (Cambridge, Mass.: Harvard University Press, Loeb Classical Library, 1942), vol. 1, 4.6.11; and Aristotle without specific reference, but possibly *NE*IX.8 1168b.

17. *NE*VIII.3 1156b.

18. *Ethiques,* 414.

19. See Guy de Tervarent, *Attributs et symboles dans l'art profane, 1450–1600: Dictionnaire d'une langue perdue* (Geneva: Droz, 1959), 102; Oskar Holl, "Herz," *LCI,* vol. 2, cols. 248–50; and Albert Walzer and Oskar Holl, "Herz Jesu," in ibid., vol. 2, cols. 248–54.

20. See R. Freyhan, "The Evolution of the Caritas Figure in the Thirteenth and Fourteenth Centuries," *JWCI* 11 (1948): 77–81, pls. 15a and 15c. Freyhan also states that while Amor with the flaming torch was well known, the Caritas figure with a flaming heart did not appear in fourteenth-century French art. Freyhan believes, however, that the flaming-heart motif derives from courtly love texts (ibid., 76 and 79).

21. For the role of the heart in medieval psychology, see Carruthers, *The Book of Memory,* 48–49.

22. See Raymond Koechlin, *Les ivoires gothiques français* (Paris: A. Picard, 1924), vol. 2, no. 1002, pl. 176, and no. 1109, pl. 187, with documentation. See also Danielle Gaborit-Chopin, *Ivoires du moyen âge* (Fribourg: Office du Livre, 1978), no. 219, 207.

23. Vienna, National Library, cod. 2592, fol. 15v. See Alfred Kuhn, "Die Illustration des Rosen-romans," in *Jahrbuch der Kunsthistorischen Sammlungen der allerhöchsten Kaiserhauses* 31 (1913–14): pl. 5.

24. Folio 149v is blank. Perhaps it was considered preferable to place the large frontispiece on the recto of fol. 150. In this manuscript all the miniatures, except that of Book II on fol. 24v, follow such a pattern.

25. Although Friendship is spelled *Amisté* in *C,* for the sake of uniformity, I have retained the spelling of the word in *A.*

26. *Ethiques,* 417.

27. Ibid., Gloss 7, 418.

28. Ibid.

29. Ibid., 419.

30. A further glorification of the contemplative life is found in the monumental illustration in *C* of Book X of the *Ethiques* (Fig. 43). For a more detailed account, see below, Ch. 14.

31. The other illustration in *C* with a similar background pattern is the Justice miniature (Fig. 25). In Book VIII Aristotle insists on the relationship between Justice and Amistié, both of which are essential to the peace and harmony of the political community.

32. For a helpful discussion of the various hand gestures involved in the homage ceremony in Charles V's copy of the *Grandes chroniques de France* written under his direction, see Hedeman, "Valois Legitimacy," 99–103.

33. *Ethiques*, 426.

34. Ibid., Gloss 2, 437.

35. Ibid., Glosses 9 and 10, 438.

36. Ibid., 436. Oresme further defines the wife's domain in Gloss 3 of Ch. 17 as control of spinning and care of the dwelling (ibid., 444).

37. Ibid., Gloss 5, 444. Oresme follows Aristotle's formulation in the *Politics* (I.13 1260a) that while both men and women have moral goodness, men have it in a ruling mode, women, in an obeying or serving one (see *Politiques*, 53 and 73–74).

38. For the interpretation of the miniatures in this treatise on household management, see Chs. 24 and 25.

CHAPTER 13

1. Except for the miniature of Book III (7.1 × 6.9 cm), Figure 40 (7.3 × 6.9 cm) is the smallest in the *A* cycle.

2. *Ethiques*, 466.

3. Ibid., 452.

4. Ibid.

5. Ibid., 463–66 and 472–76.

6. *NEIX*.8 1168b; *Ethiques*, 477.

7. Oresme's translation that the friends are as close as "jambe et genouil" (*Ethiques*, 477) is nearer to the original Greek expression, "The knee is closer to the shin" (see *Nicomachean Ethics*, trans. Ostwald, 260, n. 26).

8. The small fold at the bottom of this folio and the string sewn in after the next one provide evidence for this procedure. See Petrus C. Boeren, *Catalogus van de handschriften van het Rijksmuseum Meermanno-Westreenianum* (The Hague: Staatsuitgeverij, 1979), 93.

9. The alternation of apricot and blue backgrounds touched with gold for the separate registers of the miniatures in *C* continues here (Pl. 5).

10. MS *C*, fol. 170. It is worth noting that in Figure 41 the decorative organization of the folio, rather than the inscriptions, forges the links between the image and text.

11. *NEIX.2* 1164b–1165a; *Ethiques,* 456.

12. *Ethiques,* Gloss 5, 456.

13. Ibid., 458–62.

14. Ibid., Gloss 8, 460–61; Question, 461–62. Menut (ibid., 460, n. 4) points out that this gloss (but not the Question) was included in the selection of favorite passages by Oresme collected in the translator's copy of the *Politiques* (Avranches, Bibl. Mun., MS 223, fol. 356). For an earlier Question in Book V, Ch. 19, see ibid., 316–21.

15. Menut names Albert the Great, Thomas Aquinas, Walter Burley, and Jean Buridan as the "pluseurs docteurs" mentioned by Oresme (ibid., 460, n. 5).

16. Ibid., Gloss 8, 460.

17. Ibid., 460–61.

18. Ibid., 461.

19. Ibid., 461–62. In this Question, Oresme stresses the claims of *amistié de lignage* but says that the closeness of family ties, the virtue and value of the nonfamily friend, and the good deeds or benefits received can vary and make the decision more difficult.

20. The sequence from the top to the bottom register generally follows Oresme's arguments in Gloss 8 regarding the claims of father versus son, while the obligations to a father or a friend are explained in the Question. The words in the inscriptions do not derive from these sources.

21. *Ethiques,* Question, 461.

22. Ibid., Gloss 5, 456.

23. *NEIX.3* 1165a; *Ethiques,* 460 and Gloss 8, 460.

24. Jacques Le Goff, *Les intellectuels au moyen âge* (Paris: Seuil, 1969), 100–104; Palémon Glorieux, *La littérature quodlibétique,* 2 vols. (Paris: J. Vrin, 1925–36). See also Leff, *Paris and Oxford Universities,* 171–73.

25. See Oresme, *De causis mirabilium,* ed. Hansen, especially 30–36.

26. *Fais et bonnes meurs,* vol. 2, 13 and 46; see also Ch. 4 above at n. 19.

27. See Henneman, *Royal Taxation in Fourteenth-Century France,* chs. 3, 6, and 8; Cazelles, *Société politique,* 354–55, 358–61, 376–99, 421–28, and 447–49.

CHAPTER 14

1. *Ethiques,* 496. I have consistently adopted modern usage in the spelling of *Félicité,* although in Menut's critical edition the first *e* is unaccented.

2. Félicité humaine, the subject of the lower half of the frontispiece of *C,* is discussed in Ch. 5 above at nn. 29–33.

3. *NEX.*7 1177a–1177b.

4. Ross, *Aristotle,* 226.

5. For the significance of Aristotle's development of the idea of the contemplative life, see Werner Jaeger, *Aristotle: Fundamentals of the History of His Development,* trans. Richard Robinson, 2d ed. (Oxford: Oxford University Press, 1948), 426–61; and Gauthier and Jolif, *Ethique à Nicomaque,* vol. 2, pt. 2, 848–66.

6. Raymond Klibansky, Erwin Panofsky, and Fritz Saxl, *Saturn and Melancholy* (London: Thomas Nelson & Sons, 1964), 243–44.

7. *Ethiques,* 530.

8. Ibid., 519.

9. Ibid., 527.

10. Ross, *Aristotle,* 226.

11. *NEX.*8 1178a; *Ethiques,* Gloss 9, 523–24, and 524–25.

12. For an illuminating discussion of conceptual and textual sources, as well as visual examples, see Dinkler–von Schubert, "*Vita activa et contemplativa,*" in *LCI,* vol. 4, cols. 463–68.

13. Ibid., 464.

14. *Ethiques,* 526.

15. Ibid., Gloss 15, 526.

16. Yates, *The Art of Memory,* 101; Carruthers, *The Book of Memory,* ch. 4.

17. L. Bowen, "The Tropology of Mediaeval Dedication Rites," *Speculum* 16 (1941): 472.

18. *NEX*.7 1177b; *Ethiques,* Gloss 1, 521.

19. *Ethiques,* 82; ibid., 547.

20. Ibid., Gloss 1, 521. For the meaning in the Christian tradition of *vacatio* as an activity that unites God to man, see Dom Jean Leclercq, *Otia monastica: Etudes sur le vocabulaire de la contemplation au moyen âge* (Rome: Herder, 1963), 49. The author discusses the changing meaning of the term in classical, biblical, and patristic sources. For a specific summary of classical terms related to contemplation, see ibid., 58–59.

21. *Ethiques,* Gloss 10, 522.

22. Ibid., 525.

23. Ibid., Gloss 8, 525.

24. Ibid., 522.

25. For a discussion of the term *contemplation* in Aristotle, see Gauthier and Jolif, *Ethique à Nicomaque,* vol. 2, pt. 2, 851–56.

26. See *Ethiques,* Glosses 2 and 5, 523.

27. See Ch. 10 above at n. 57.

28. See above at n. 20.

29. See Dom Jean Leclercq, *Contemplative Life,* trans. Elizabeth Funder, Cistercian Studies series, 19 (Kalamazoo, Mich.: Cistercian Publications, 1978), 189–93. The author cites monastic sources in *Etudes sur le vocabulaire monastique du moyen âge,* Studia anselmiana philosophica theologica, 48 (Rome: Herder, 1961), 150–51. For another text that makes this point, see John Beleth, *Summa de ecclesiasticis officiis,* ed. Herbert Douteil, Corpus Christianorum, Continuatio Mediaeualis, 41 A (Tournhout: Brepols, 1976), ch. 39b, 70. This twelfth-century work was first published in the fifteenth century as the *Rationale divinorum officiorum.*

30. See Wolfgang Braunfels, "Gott, Gottvater," in *LCI,* vol. 2, cols. 165–70.

31. *Ethiques,* 527.

32. Ibid., Gloss 9, 525.

33. Frederick Copleston, S. J., *A History of Philosophy: Mediaeval Philosophy, Augustine to Scotus* (Westminster, Md.: Newman Press, 1950), vol. 2, 402–3.

34. "Car philosophie a delectacions tres merveilleuses, et quant est en purté et quant est en fermeté" (*Ethiques,* 519).

35. Ibid., Gloss 11, 519.

36. Klibansky, Panofsky, and Saxl, *Saturn and Melancholy*, 244–45.

37. Clagett, "Nicole Oresme," 225. For the issue of philosophy versus theology, see *De causis mirabilium,* ed. Hansen, 96–101.

38. *Ethiques,* Gloss 5, 521.

39. Ibid., Gloss 9, 523–24.

40. See Sherman, "Representations of Charles V," 86–87.

CHAPTER 15

1. *Politiques,* 44.

2. For previous discussion of the prologue, see Ch. 1, at n. 33.

3. For full descriptions of the manuscripts, see above, Appendixes III and IV.

4. Codicological examination of *D* shows that these features were never part of the manuscript. The reasons for these omissions are not clear.

5. For the payments and other documents, see *Ethiques,* 15–18.

6. Delisle, "Observations sur plusieurs manuscrits de la *Politique,*" 607–19. Menut's critical editions of the *Politiques* and *Yconomique* are based on the Avranches manuscript (see *Politiques,* 34).

7. It is not clear whether the corrections were made by Oresme himself or by a scribe.

8. Moerbeke did an earlier translation of the first two books of the *Politics* ca. 1264, known as the *Translatio prior imperfecta,* to which Oresme refers as "l'autre translacion" (*Politiques,* 25–26). For other aspects of the history of Moerbeke's translation, see Babbitt, *Oresme's Livre de Politiques,* 15.

9. Babbitt, *Oresme's Livre de Politiques,* 25–27.

10. Ibid., 17–29. Oresme does not cite the *Quaestiones* on the *Politics* by his mentor, Jean Buridan, or the influential fourteenth-century commentary by Walter Burley.

11. Ibid., 11–13.

12. They are *aristocracie, commune policie, democracie,* and *olygarchie* (*Politiques,* 45). For further discussion, see Ch. 16 below.

13. This summary is drawn from Babbitt, *Oresme's Livre de Politiques,* 135–49. For a full discussion of Oresme's commentary, see Grignaschi, "Nicole Oresme et son commentaire à la *Politique* d'Aristote," 97–151.

14. For this text, see Ch. 3 at n. 45 and Appendix V above.

15. For the way illustrations update and concretize translations, see the imaginative study of Brigitte Buettner, "Les affinités séléctives: Image et texte dans les premiers manuscrits des *Clères femmes,*" *Studi sul Boccaccio* 18 (1987): 281–99.

16. *Politiques,* 44.

17. Ibid.

18. Ibid., 371.

19. For an interesting discussion of juxtaposition and contiguity in narrative representation, see Sixten Ringbom, "Some Pictorial Conventions for the Recounting of Thoughts and Experiences in Late Medieval Art," in *Medieval Iconography and Narrative: A Symposium* (Odense: Odense University Press, 1980), 38–69.

20. A recent study discusses the etymological development of *paradigm* as a term and a rhetorical figure in Latin and subsequent vernacular literature, where it becomes associated with nonlinguistic forms (John D. Lyons, *Exemplum: The Rhetoric of Example in Early Modern France and Italy* [Princeton, N.J.: Princeton University Press, 1989], 6–12). In his illuminating review of Lyons's book ("By Force of Example," *Times Literary Supplement,* 15 March 1991, 20), Terence Cave distinguishes between the rhetorical figure of *exemplum,* as paradigm, and its medieval or Renaissance usage, "as a short narrative that delivers a moral injunction."

CHAPTER 16

1. For an enlightening discussion of these points, see Babbitt, *Oresme's Livre de Politiques,* chs. 3 and 4.

2. Not only is the recto (fol. 3r) blank, but extra sewing reveals the insertion.

3. Fols. 1v and 2 belong to two separate gatherings (see Appendix IV).

4. *Politiques,* 45.

5. For the complete text and translation of this passage, see Appendix V above.

6. *Politiques,* 372.

7. Ibid., 370.

8. Ibid.

9. Ibid., 374.

10. Ibid., 373.

11. Ibid., 372.

12. Ibid., 371.

13. For the association in Christian iconography of the right side of a building or representational image with positive values and the left with negative ones, see Erica Dinkler–von Schubert, "Rechts und Links," *LCI,* vol. 3, cols. 511–15.

14. For a similar allusion, see the discussion of the fleur-de-lis background of certain miniatures in *A,* especially of Justice, in Ch. 9 above at n. 43.

15. Babbitt, *Oresme's Livre de Politiques,* 45–51.

16. *Politiques,* Book III, Ch. 20, Gloss, 145. For a discussion of the complexities of Oresme's position on the *communitas perfecta,* see Babbitt, *Oresme's Livre de Politiques,* 55–68.

17. Babbitt, *Oresme's Livre de Politiques,* 75. For Oresme's espousal of these ideas, see *Ethiques,* 432–33.

18. For Marsiglio of Padua's interpretation of this theme in the *Defensor pacis,* see Babbitt, *Oresme's Livre de Politiques,* 75.

19. Ross, *Aristotle,* 243.

20. Oresme states that "car tous les citoiens doivent aucunement participer en princey, si comme il fu dit ou premier chapitre, et par consequent il doivent participer ou profit" (*Politiques,* Gloss, 128).

21. Aesthetic considerations may account for the same three, rather than contrasting, numbers of rulers in Aristocracy or Timocracy called for in Aristotle's and Oresme's texts. The placement of many figures on a bench of the same or larger dimensions would have been difficult without adjusting the size of the picture field.

22. *Politics,* 117, n. 1.

23. Babbitt, *Oresme's Livre de Politiques,* 89–93; *Politiques,* Book III, Ch. 17, 142. Aristotle states that "rightly constituted laws should be the final sovereign" (*Politics* III.11 1282b). See also on these points, *Politiques,* 138.

24. See Anthony Melnikas, *The Corpus of the Miniatures in the Manuscripts of Decretum Gratiani,* Studia Gratiana, 18 (Rome: Libreria Ateneo Salesiano, 1975), vol. 1, Causa IV, pls. I and II; also Causa VI, pl. II; and Causa XIV, fig. 28.

25. For previous discussion of this treatise, see Ch. 2 above at nn. 6–13.

26. *De moneta,* 42, 44, and 45.

27. Ibid., 47.

28. Henneman, *Royal Taxation in Fourteenth-Century France,* 285–86.

29. *Politiques,* 9, n. 13, and 19–20. Menut gives as the source *Politics,* III.11 1281b.

30. See Katzenellenbogen, *Virtues and Vices,* figs. 54 and 55. The manuscript is now in Munich, Bayerische Staatsbibliothek, cod. lat. 13002, fols. 3v and 4.

31. This manuscript is discussed in C. M. Kauffmann, *Romanesque Manuscripts, 1066–1190* (London: Harvey Miller, 1975), 62. According to Kauffmann, this miniature is unique among the rarely illustrated Latin manuscripts of the *City of God.*

32. For recent discussions of the textual sources of the Lorenzetti frescoes, see above, Ch. 9, at nn. 59–67.

CHAPTER 17

1. *Politics* II.2 1261a; II.7 1266b; and II.8 1267b.

2. *D,* fol. 36.

3. See Joachim Prochno, *Das Schreiber- und Dedikationsbild in der deutschen Buchmalerei, 800–1100* (Leipzig and Berlin: B. G. Teubner, 1929); Dorothee Klein, "Autorenbild," in *RDK,* vol. 1, cols. 1309–14.

4. Erwin Panofsky, *Renaissance and Renascences in Western Art* (Stockholm: Almqvist & Wiksell, 1960), 84.

5. W. N. Hargreaves-Mawdsley, *A History of Academical Dress in Europe until the End of the Eighteenth Century* (Oxford: Clarendon Press, 1963), 38. Plate 3 (opp. p. 38) shows the lower left scene of our Figure 7 as a basis for identifying this academic costume.

6. For an identification and discussion of this subject, see Paulina Ratkowska, "Sokrates i Platon: Uwagi o ikonografii tematu Magister cum discipulo w sztuce XII–XIII w," *Biuletyn Historii Sztuki* 36/2 (1974): 103–21. A French summary appears on pp. 120–21. Reference to the inversion of this theme (Plato dictating to Socrates) inspired the work by Jacques Derrida, *The Postcard: From Socrates to Freud and Beyond,* trans. and intro. Alan Bass (Chicago and London: University of Chicago Press, 1987). The postcard reproduction of the miniature that led Derrida to write the book is the drawing by Matthew Paris in a collection of prognosticating tracts (Oxford, Bodleian Library, MS Ashmole 304, fol. 31v). The drawing is dated to 1250–55 by Suzanne Lewis, *The Art of Matthew Paris in the Chronica Majora,*

California Studies in the History of Art, 21 (Berkeley and Los Angeles: University of California Press, 1987), 386–88, fig. 230. John Tagg kindly called the Derrida publication to my attention.

7. For two informative studies of the subdivisions of the medieval author portrait, see Derek A. Pearsall and Elizabeth Salter, "Pictorial Illustration of Late Medieval Poetic Texts: The Role of the Frontispiece or Prefatory Picture," in *Medieval Iconography and Narrative: A Symposium* (Odense: Odense University Press, 1980), 100–123; and Jacqueline Perry Turcheck, "A Neglected Manuscript of Peter Lombard's *Liber sententiarum* and Parisian Illumination of the Late Twelfth Century," *Journal of the Walters Art Gallery* 44 (1968): 54–60. Michael Gullick kindly brought the second article to my attention.

8. Grabmann, "Methoden und Hilfsmittel des Aristotelesstudiums im Mittelalter," 13.

9. *Politiques,* Gloss, 76.

10. See Alastair J. Minnis, *Medieval Theory of Authorship: Scholastic Literary Attitudes in the Later Middle Ages,* 2d ed. (Philadelphia: University of Pennsylvania Press, 1988), 75 and 159.

11. *Politiques,* 83–84.

12. See Pearsall and Salter, "Pictorial Illustration," 118.

13. For further discussion of Guillaume de Machaut and his relationship to Charles V, see below, Ch. 23 at nn. 22–23.

CHAPTER 18

1. The dimensions are 18 × 14 cm for Figure 60 and 10.1 × 9.3 cm for Figure 61.

2. *Politiques,* 142.

3. Ibid., 143.

4. Ibid.

5. Ibid., 373.

6. Ibid., 144–45.

7. Delisle writes that he is unable to identify the subject of Book III (*Mélanges de paléographie,* 277–78 and 282).

8. See E. Miller, "Notice d'un manuscrit contenant la traduction de la *Politique* d'Aristote par Nicole Oresme et ayant appartenu à la Bibliothèque de St. Médard de Soissons," *Bulletin de la Société archéologique, historique, et scientifique de Soissons* 3/3 (1869): 106–7.

9. The gesture of the figure's bent arms, the left on his chest and the right on his hips, signifies assurance, resolve, and determination (François Garnier, *Le langage de l'image au moyen âge: Signification et symbolique* [Paris: Le Léopard d'Or, 1982], vol. 1, 185ff.).

10. *Politics,* III.13 1284b. Oresme's version in two successive text passages in Chapter 18 (*Politiques,* 143) is as follows:

> T. Et pour ce l'en ne doit pas cuidier du tout et simplement que ceulz qui vituperent et blasment tirannie et le conseil que Sybulo le poëte recite avoir esté donné par Periandre, car l'en dit que un appellé Taribulus envoia .i. message devers Periandre pour avoir son conseil. Mes il ostoit de son blé ou de tele chose les espis qui excedoient et passoient les autres afin que le are fust planee et onnie. T. Et quant le messager raporta a Taribulus ce que Periandre faisoit, de quoy il ignoroit la cause, lors Taribulus entendi par ce que l'en devoit occirre les hommes excellens.

11. "Mes il devoit entendre 'ou les bannir,' si comme il sera dit apres" (Ibid., 143).

12. *Politics* III.13 1284b.

13. Ibid.

14. *Politiques,* 143–44.

15. Ibid., 209.

16. *Politics* I.2 1253a. For Oresme's version, see *Politiques,* 49. For a helpful discussion and bibliography, see David C. Hale, "Analogy of the Body Politic," in *Dictionary of the History of Ideas,* ed. Philip Wiener (New York: Scribner, 1973), vol. 1, 68–70. See also Anton-Hermann Chroust, "The Corporate Idea and the Body Politic in the Middle Ages," *Review of Politics* 9/4 (1947): 423–52; and Jean Dunbabin, "Government," in *CHMPT,* 483. For the discussion by John of Salisbury, see *Policraticus: Of the Frivolities of Courtiers and the Footprints of Philosophers,* ed. and trans. Cary J. Nederman (Cambridge and New York: Cambridge University Press, 1990), Books V and VI, 65–144.

17. *Politiques,* 87, 209, and 290.

18. Ibid., 364.

19. See Ch. 2 above at nn. 6–13.

20. *De moneta,* 43.

21. See Ch. 9 above at nn. 46–48.

22. Herodotus, *History,* trans. A. D. Godley (London: William Heinemann Ltd.; Cambridge, Mass.: Harvard University Press, Loeb Classical Library, 1938), vol. 3, V.92.

23. For a list of antique sources, see *Leben und Meinungen der Sieben Weisen: Griechische und lateinische Quellen,* trans. Bruno Snell (Munich: Heimeran Verlag, 1971).

24. For a modern edition, see *Lives of Eminent Philosophers,* trans. R. D. Hicks (Cambridge, Mass.: Harvard University Press, Loeb Classical Library; London: William Heinemann Ltd., 1942), vol. 1, I.100. Although Walter Burley's *De vita et moribus philosophorum,* a widely disseminated treatise of the fourteenth century, draws on Diogenes Laertius as a source for the sayings of Periander, the tale of his advice is not included (Gualteri Burlaei, *Liber de vita et moribus philosophorum,* ed. Hermann Knust [Tübingen: Litterarische Verein in Stuttgart, 1886], 44–46). Prof. Paul O. Kristeller kindly directed me to these sources.

25. Livy, *History of Rome,* ed. and trans. B. O. Foster (London: William Heinemann, 1919), vol. 1, 1.44, 4–10. The story is also found in Dionysius of Halicarnassus, *The Roman Antiquities* (London: William Heinemann Ltd.; Cambridge, Mass.: Harvard University Press, 1939), vol. 2, IV, 56.

26. *Valerii Maximi factorum et dictorum memorabilium libri novem,* ed. C. Kemp (Stuttgart: Teubner, 1888; Stuttgart: Teubner, 1966), Book VII, Ch. 4.2, 1–22.

27. *English Friars and Antiquity,* 86–87. For citations of Valerius Maximus as a classical source of medieval exempla literature, see Jean-Thiébaut Welter, *L'exemplum dans la littérature religieuse et didactique du moyen âge* (Paris: Occitania, 1927; New York, AMS Press, 1973), 11, n. 1.

28. Smalley, *English Friars and Antiquity,* 85–87.

29. Paris, Bibl. Ste.-Geneviève, MS 777. For the translation, see Jacques Monfrin, "Les traducteurs et leur publique au moyen âge," 171. See also Ch. 1 above, especially nn. 16–23 and 64–65. Although the folios containing the Periander/Tarquin tale have been cut from Charles V's copy of the Livy translation, the story exists in later manuscripts (Paris, Bibl. Nat., MS fr. 20321, fols. 25–25v; and Cambridge, Mass., Harvard University, Houghton Library, MS Richardson 32, fol. 36). For the illustrations, see Avril, *La librairie,* no. 189, 108–9; and idem, *Manuscript Painting at the Court of France,* pl. 32, 102.

30. Paris, Bibl. Nat., MS fr. 9749. See Delisle, *Recherches,* vol. 1, 284. See also Ch. 1 above, especially n. 71.

31. See the illuminating discussion of theories and techniques of translation in Frederick M. Rener, *Interpretatio: Language and Translation from Cicero to Tytler* (Amsterdam and Atlanta, Ga.: Rodopi, 1989), parts 2 and 3.

32. *Fear and Trembling,* ed. and trans. Howard V. Hong and Edna H. Hong (Princeton, N.J.: Princeton University Press, 1983), 3. Kierkegaard borrowed the allusion from Johann Georg Hamann. I am grateful to Profs. Ellen Ginsberg and Robert Ginsberg for alerting me to this reference and to the element of silent communication.

33. For an account of these events, see Raymond Cazelles, *Société politique,* 318–37; idem, *Etienne Marcel, champion de l'unité française* (Paris: Tallandier, 1984).

34. See Lot and Fawtier, *Histoire des institutions françaises,* vol. 2, 41. The item referred to is Article VII published in *Ordonnances des roys de France,* ed. Secousse, vol. 5, 477–80.

CHAPTER 19

1. Ross, *Aristotle,* 229 and 249–50.

2. The dimensions of Figure 64 are 15.2 × 14.4 cm; left and right compartments are 7.8 × 5 cm, and the center ones are 4.5 cm.

3. For a previous example of such a blank scroll, see above, Ch. 6 at nn. 11–13. There the personification of Deffaute (Fig. 11) carries no identifying tag.

4. *Politiques,* 373. For Menut's comment, see ibid., 179, n. 2.

5. Ibid., Gloss, 179.

6. Ross, *Aristotle,* 52–57.

7. For Oresme's commentary on how Polity strikes a mean between the extremes of Oligarchy and Democracy, see *Politiques,* 180.

8. Ibid., 179.

9. Ibid., 181.

10. Ibid., 366.

11. Ibid., 364.

12. Ibid., 366.

13. Ibid., 368.

14. Ibid.

15. Ibid., 187. Barker's summary of this passage as an introduction to Chapter 11 of Book IV follows: "Goodness itself consists in a mean; and in any state the middle class is a mean between the rich and the poor. The middle class is free from the ambition of the rich and the pettiness of the poor: it is a natural link which helps to ensure political cohesion" (*Politics,* 179; IV.11 1295a).

16. Dilwyn Knox, *Ironia: Medieval and Renaissance Ideas on Irony,* Columbia Studies in the Classical Tradition, 16 (Leiden: E. J. Brill, 1989), 19–20.

17. The failure of the miniature in *D* (Fig. 65) to add a third figure is the most serious deviation from *B* in the illustration of Book IV.

18. *Politiques,* 182.

19. Ibid., 144.

20. For previous discussion of this theme, see Ch. 18 above.

21. *Politiques,* 186.

22. Ibid., Gloss, 187.

23. Ibid., 189. Oresme does not believe that equality of wealth between "frans et seigneurs" is possible, but he states that inequality should be governed by proportional means which are "non pas irreguliere ne escessive."

24. For references to this idea, see ibid., 176, and Ch. 21.

25. It would appear that the members of the building trades belong to the skilled crafts, whereas the unskilled laborers, who are called *bannauses,* do not. For this term, see *Politiques,* 167 and 370.

26. See Maurice Bouvier-Ajam, *Histoire du travail en France des origines à la Révolution,* 2d ed. (Paris: Librairie Générale de Droit et de Jurisprudence R. Pichon et R. Durand-Auzias, 1981), 381 and 387.

27. Cazelles, *Société politique,* 578; idem, *Etienne Marcel,* 105.

28. For Oresme's commentaries on reforms in the church, see Babbitt, *Oresme's Livre de Politiques,* 116–19.

CHAPTER 20

1. Ross, *Aristotle,* 253.

2. *Politics,* 247, n. 1.

3. *Politiques,* 209. For a previous reference to medieval concepts of the body politic, see Ch. 18 above at n. 16.

4. Ibid., 202.

5. Ibid., 203.

6. Ibid., 368 and 373.

7. Ibid., 371.

8. See the entry under *Sedition* in ibid., 373.

9. Garnier, *Le langage de l'image,* vol. 2, 152–54.

10. Ibid., vol. 1, 142–46. For the significance of frontal versus profile views, the author cites Schapiro, *Words and Pictures,* 37–49.

11. For a definition of synecdoche as "a substitution of two terms for each other according to a relation of greater or less extension," see the entry for "Metaphor" in the *Encyclopedic Dictionary of Semiotics,* ed. Thomas A. Sebeok (Berlin: Mouton de Gruyter, 1986), vol. 1, 535.

12. The latter subject is discussed separately, however, in Ch. 23 of the *Politiques,* 239–40; the former, in Ch. 24, 240–41.

13. Ibid., 235–36.

14. Ibid., 241.

15. For the fur strips, see Sherman, *Portraits,* 19, n. 13.

16. *Politiques,* 240.

17. For a discussion of Charles the Bad, his family, and the motives for his conduct, see Delachenal, *Histoire de Charles V,* vol. 1, 73–81, and Cazelles, *Etienne Marcel,* chs. 21, 22, and 25.

18. For a detailed account of these years, see Delachenal, *Histoire de Charles V,* vol. 1, 282–470, and Cazelles, *Société politique,* 229–385.

19. *Politiques,* 371.

20. For an example, see Richard Brilliant, *Roman Art from the Republic to Constantine* (London: Phaidon Press, 1974), fig. II.46a–b.

21. *Politiques,* 236 and 240; Aristotle, *Rhetoric,* II.4 1382a 31.

CHAPTER 21

1. *Politics,* 257, n. 20.

2. See Meyer Schapiro, "Style," in *Aesthetics Today,* ed. and intro. Morris Philipson (New York: Meridian Books, 1970), 91. See also Erwin Panofsky, *Early Netherlandish Painting* (Cambridge, Mass.: Harvard University Press, 1953), vol. 1, 66 and 70.

3. *Early Netherlandish Painting,* vol. 1, 70. For further discussion of this point, see below at n. 31.

4. For a recent discussion of late medieval landscape and depiction of the peasantry, see Jonathan J. G. Alexander, "*Labeur* and *Paresse:* Ideological Representations of Medieval Peasant Labor," *AB* 72/3 (1990): 436–52.

5. *Politiques,* 256.

6. Ibid., 371. Prof. Melvin Richter has pointed out that the correct etymology is *arche,* meaning rule.

7. Ibid., 261.

8. Ibid.

9. Ibid.

10. Ibid., 360–62 and 364–65.

11. Ibid., "*Pasteurs,*" 365.

12. Ibid., 263.

13. Ibid., 261. The translation from the Georgics (2, 458) is that of H. R. Fairclough, *Eclogues, Georgics, Aeneid, 1–6,* vol. 1 (Cambridge, Mass.: Harvard University Press, Loeb Classical Library, 1986).

14. *Politiques,* 263.

15. Ibid., 261.

16. Ibid.

17. Ibid., 262.

18. *Politics,* VI.4 1318a. Rackham's translation of this passage states that even if they do not elect the magistrates "as at Mantinea, yet if they have the power of deliberating on policy, the multitude are satisfied" (Aristotle, *Politics,* trans. H. Rackham [Cambridge, Mass.: Harvard University Press, Loeb Classical Library, 1972], VI.2 1318b).

19. *Politiques,* 262.

20. Ibid.

21. Babbitt, *Oresme's Livre de Politiques,* 64. The author translates Oresme's gloss on this process, which is found in the *Politiques,* Book VI, Ch. 3, 261.

22. It is possible that the buildings and field on the upper right may be the subject of this dispute or deliberation.

23. Michael Camille, "Labouring for the Lord: The Ploughman and the Social Order in the Luttrell Psalter," *Art History* 10/4 (1987): 426; Robert G. Calkins, *Programs of Medieval Illumination,* The Franklin D. Murphy Lectures, 5 (Lawrence, Kans.: Helen Foresman Spencer Museum of Art, 1984), 139. In Camille's note 33, he incorrectly gives the shelf number of Brussels, Bibl. Royale Albert Ier, MS 11201–02 as 11202–03; and Calkins's figures 93 and 94 incorrectly title MS Brussels 11201–02 as the *Ethics* rather than the *Politics.*

24. See Derek A. Pearsall and Elizabeth Salter, *Landscapes and Seasons of the Medieval World* (Toronto: University of Toronto Press, 1973), 119–60. For a recent discussion of these genres with bibliography, see Alexander, "*Labeur* and *Paresse*," 437–38.

25. *Manuscript Painting at the Court of France,* 24–25. For the Laborer and His Plow illustration from the *Miracles de Notre Dame* (Paris, Bibl. Nat., MS nouv. acq. fr. 24541), see ibid., pl. 13 B.

26. See ibid., notices for pls. 29 and 30, 96 and 98. Avril calls the Jean de Sy Master by the more traditional appellation, the Maître de Boqueteaux.

27. See ibid., note on pl. 31, 101.

28. See above, nn. 4 and 23.

29. Menut assumes that Oresme was the son of a peasant (*Politiques,* 13). Recent scholarship on Oresme's family and career finds no document on his life before 1348. See François Neveux, "Le clergé normand du XIVe siècle," in *Autour de Nicole Oresme: Actes du Colloque Oresme organisé à l'Université de Paris XII,* ed. Jeannine Quillet (Paris: J. Vrin, 1990), 10.

30. *Politiques,* 305.

31. Ibid., 262.

CHAPTER 22

1. *Politics,* xl.

2. Ibid., xxxix.

3. For previous analysis of these problems, see above, Ch. 15 at n. 20 and Ch. 18 at nn. 1–2.

4. See *Politiques,* 289–94 and 306–8. For important discussions of these issues, see Babbitt, *Oresme's Livre de Politiques,* 33–68 and 127–46.

5. *B,* fol. 254.

6. *D,* fol. 263.

7. For variant readings, see *Politiques,* 276, and n. 1.

8. Ibid., 119.

9. Ibid.

10. Ibid.

11. Babbitt, *Oresme's Livre de Politiques,* 66–67, citing Oresme, *Politiques,* 71 and 280. In his lengthy commentary on Ch. 10 of Book VII, where Oresme discusses a common language as necessary for governing a *cité,* he may have been thinking of French versus English in the context of the Hundred Years' War. See *Politiques,* 291.

12. *Politiques,* 298, cited by Babbitt, *Oresme's Livre de Politiques,* 67.

13. Babbitt, *Oresme's Livre de Politiques,* 66, n. 66.

14. Ibid., 289–94. For a discussion of this commentary in relation to Oresme's ideas about universal empire, see ibid., 53–54. See also Jeannine Quillet, "Community, Counsel, and Representation," in *CHMPT,* 529–31.

15. *Politiques,* 359–60.

16. See Babbitt, *Oresme's Livre de Politiques,* 100–103.

17. *Politiques,* Gloss, 311–14.

18. See Babbitt, *Oresme's Livre de Politiques,* 137–46.

19. Oresme suggests an adaptive use of the term in a gloss (Ch. 1 of Book III) when he says: "Et aucuns appellent telz citoiens bourgois, car il pevent estres maires ou esquevins ou conseuls ou avoir aucunez honnorabletés autrement nommees" (*Politiques,* 115).

20. Ibid., 370.

21. Ibid., 360.

22. Ibid., 362 and 373.

23. *Politics,* 297–98.

24. *Politiques,* 301–2.

25. Ibid., 360–61. For discussion of the positive view of agricultural workers, see Ch. 21 above at nn. 28–31. The contrast between meaningful intellectual pursuits and mundane labors occurs in the archivolts of the tympanums of the west portals of Chartres cathedral, where the labors of the months and the liberal arts are respectively represented. See Adolf Katzen-ellenbogen, *The Sculptural Programs of Chartres Cathedral: Christ–Mary–Ecclesia* (Baltimore, Md.: The Johns Hopkins Press, 1959), 24–25.

26. *Politiques,* 305.

27. Ibid., 360 and 305.

28. Ibid., 305 and 307.

29. Ibid., 305.

30. For a discussion of this point, see Ch. 19 above at n. 2.

31. For a previous discussion of this detail, see above, Ch. 20, n. 15.

32. Babbitt, *Oresme's Livre de Politiques,* 77. In a commentary on Ch. 6 Oresme speaks of how the city promotes the supreme end of the contemplative life, worship of God, the *cultivement divin:* "Et pour ce diroit l'en selon ceste philosophie que le royalme et la cité sunt beneurés la ou Dieu est bien servi et honoré. Et que ceulz sunt plus beneurés ou il est miex servi, si comme par la sienne grace ont esté et sunt le royalme de France et la cité de Paris" (*Politiques,* 286). For a pictorial commentary on Paris as the earthly paradise see Charlotte Lacaze, *The Vie de St. Denis Manuscript (Paris, Bibliothèque Nationale, MS fr. 2090–2092)* (New York and London: Garland Publishing, 1979), 120–32. Lacaze discusses the series of illustrations in the manuscript (figs. 35–46), presented in 1317 to King Philip V, that depict in contemporary terms peaceful and profitable pursuits taking place under monarchical rule. Lacaze points out that "these scenes are the earliest surviving images of *buon governo* represented by means of an extensive description of peaceful town life" and thus anticipate the Lorenzetti frescoes in the Palazzo Pubblico, 131.

33. See Georges Duby, *The Three Orders: Feudal Society Imagined,* trans. Arthur Goldhammer (Chicago and London: University of Chicago Press, 1978), 5. In a formulation of this theory, Duby cites the twelfth-century clerics Adalbero, bishop of Laon, and Gerard, bishop of Cambrai.

34. Ibid., 265. The passage in the *Policraticus,* ed. Nederman, occurs in Book VI, Ch. 21, 126. For Charles V's commission of a French translation of this text from Denis de Foulechat and his illustrated copy (Paris, Bibl. Nat., MS fr. 24287), see Sherman, *Portraits,* 74–78.

35. "Government," in *CHMPT,* 507.

36. See Quillet, "Community, Counsel, and Representation," 549–51.

37. See above, Ch. 19, n. 26. For Oresme's gloss, see *Politiques,* 264.

38. See above, Ch. 3 at nn. 72–75. For a recent bibliography on collaboration in medieval manuscript production, including the role of scribes, see the valuable article by Lucy Freeman Sandler, "Notes for the Illuminator: The Case of the *Omne bonum*," *AB* 71/4 (1989): 551–64. See also the bibliography in Alexander, *Medieval Illuminators,* 187–203.

1. *Politiques,* 339.

2. Ibid., 361.

3. Ibid., 343.

4. Ibid., 345.

5. Ibid., 370.

6. Ibid., 345.

7. Ibid., 361.

8. Oresme defines *excercitative* as a noun in the glossary of difficult words: "*Excercitative* est art et maniere de soi mouver et de frequenter aucun mouvement corporel pour santé ou pour esbatement ou pour soi habiliter a faiz d'armes ou a aucunes teles choses" (ibid., 371).

9. Ibid., 364.

10. Ibid., 365.

11. Ibid.

12. Ibid.

13. Ibid.

14. Ibid., 345.

15. Ibid., 343. Menut gives the source of the Latin quotation as Matt. 10:27. Here it appears that Oresme needs to justify in Christian terms the reference to pagan sensual enjoyment of music.

16. Ibid., 349–50. Ernest Barker explains that words "which always ought to accompany music" contribute to its moral value (*The Political Thought of Plato and Aristotle* [New York: Dover Publications, 1959], 442).

17. *Fais et bonnes meurs,* vol. 1, 45. An editorial note gives further information on payments to the king's musicians.

18. See *Li livres du gouvernement des rois,* ed. Molenaer, 200, ll. 11–18.

19. Edmund A. Bowles, "Music in Medieval Society," in *DMA,* vol. 8, 595–97.

20. For an interesting discussion of the importance of music in Paris university life, see Nan Cooke Carpenter, *Music in the Medieval and Renaissance Universities* (Norman: University of Oklahoma Press, 1958), 50–69.

21. See Andrew Hughes, "Music, Western European," in *DMA*, vol. 8, 594, and Carpenter, *Music in the Medieval and Renaissance Universities*, 64–68.

22. Armand Machabey, *Guillaume de Machaut, 130?-1377: La vie et l'oeuvre musical* (Paris: Richard-Masse, 1955), vol. 1, 46–68; Sarah Jane Williams, "Guillaume de Machaut," in *DMA*, vol. 8, 3.

23. *Manuscript Painting at the Court of France,* notices for pls. 26, 29, and 30, 90, 96, and 98; "Manuscrits," nos. 271 and 283, 318 and 328–29; and "Guillaume de Machaut," in *Colloque–table ronde, organisé par l'Université de Reims, 19–22 April 1978* (Paris: Editions Klincksieck, 1982), 117–32. For the future Charles V as the possible patron of certain illustrated Machaut manuscripts, see Donal Byrne, "A Fourteenth-Century French Drawing in Berlin and the *Livre du Voir-Dit* of Guillaume de Machaut," *Zeitschrift für Kunstgeschichte* 47/1 (1984): 81.

24. *Politiques,* 347.

25. Ibid., 15. Menut cites Albert Seay, *Music in the Medieval World* (Englewood Cliffs, N.J.: Prentice-Hall, 1965), 130–37.

26. V. Zoubov, "Nicole Oresme et la musique," *Mediaeval and Renaissance Studies* 5 (1961): 96–107. For editions of two treatises, see *Oresme and the Medieval Geometry of Qualities and Motions,* ed. Clagett; and *Nicole Oresme and the Kinematics of Circular Motion: Tractatus de commensurabilitate vel incommensurabilitate motuum celi,* ed. Edward Grant (Madison: University of Wisconsin Press, 1971). For Oresme's contribution to theory in terms of "the beauty of ratios other than those previously accepted," see Hughes, "Music, Western European," 583.

CHAPTER 24

1. This summary is a paraphrase of Menut's discussion in the introduction to his edition of Oresme's *Yconomique,* 786–88. Menut mentions that in the sixteenth century the humanist scholar Lefèvre d'Etaples questioned the attribution of the *Economics* as a genuine work of Aristotle and found the second book to be "entirely spurious," as it includes references to events and persons that postdate the Philosopher's death.

2. The Greek text of the third book is now lost. An anonymous Latin translation of 1310 from a Greek original included all three books.

3. *Yconomique,* 785.

4. Ibid., 786. For a discussion of illustrated manuscripts of the French translation of Crescenzi's text, see Calkins, *Programs of Medieval Illumination,* 141–48. For further discussion of

illuminated manuscripts of this text, see idem, "Piero de' Crescenzi and the Medieval Garden," in *Medieval Gardens* (Washington, D.C.: Dumbarton Oaks Research Library and Collection, 1986), 157–69.

5. For a modern English translation, see *The Treasure of the City of Ladies or The Book of the Three Virtues,* trans. and intro. Sarah Lawson (London: Penguin Books, 1985). For a discussion of this text, see Willard, *Christine de Pizan, Her Life and Works,* 145–53.

6. For the Vérard edition, see *Politiques,* 39. For a discussion of Laurent de Premierfait's version of Oresme's translation of the *Economics,* see Albert D. Menut, "The French Version of Aristotle's *Economics* in Rouen, Bibl. Municipale, MS 927," *Romance Philology* 4 (1950): 55–62.

7. *Yconomique,* 786. For a discussion of the widespread dissemination of Leonardo Bruni's Latin translation of the *Economics,* see Josef Soudek, "A Fifteenth-Century Humanistic Bestseller: The Manuscript Diffusion of Leonardo Bruni's Annotated Latin Version of the (Pseudo-) Aristotelian *Economics,*" in *Philosophy and Humanism: Renaissance Essays in Honor of Paul Oskar Kristeller,* ed. Edward P. Mahoney (New York: Columbia University Press, 1976), 129–43.

8. *Yconomique,* 808.

9. See Ch. 15 at nn. 10–11.

10. *Yconomique,* 796.

11. For Menut's discussion of the glosses, see ibid., 794–99.

12. Ibid., 847. All English translations of the *Yconomique* are furnished by Menut in the facing page of his edition of Oresme's work.

13. See Lilian M. C. Randall, *Images in the Margins of Gothic Manuscripts* (Berkeley and Los Angeles: University of California Press, 1966), 19; and in the Index of Subjects, Woman Carding Wool, 230, and Woman Spinning, 231.

14. For examples of the headmaster's work in this manuscript, see Sherman, *Portraits,* pls. 16–19.

15. *Yconomique,* 807.

16. *Politiques,* 372.

17. *Yconomique,* 809.

18. Ibid.

19. Ibid., 809–10.

20. Ibid., 810.

21. Ibid.

22. Ibid.

23. Ibid., 811.

24. Ibid., 815.

25. Ibid.

26. Ibid., 813.

27. Ibid., 812.

28. "Ou tiers chapitre il determine de communication de mariage" (ibid., 811).

29. Ibid.

30. Fabian Parmisano, O.P., "Love and Marriage in the Middle Ages—I," *New Blackfriars* 50 (1969): 600. I am grateful to J. B. Ross for bringing this article to my attention. The author is quoting *Yconomique,* 812.

31. *Yconomique,* 812.

32. Ibid. But Oresme makes a distinction between sexual activity as love and as fulfillment of lust. The latter is a bestial sin.

33. Ibid., 813. This passage is summarized by Fabiano, "Love and Marriage," 601.

34. *Yconomique,* 813.

35. Ibid., 816.

36. See Sherman, "The Queen," 287–91.

37. See H. Diane Russell with Bernadine Barnes, *Eve/Ave: Women in Renaissance and Baroque Prints,* exh. cat. (Washington, D.C.: National Gallery of Art, 1991), cat. nos. 115 and 184.

38. In the text of Book II, however, her authority is confined and limited. See *Yconomique,* 826–27.

CHAPTER 25

1. For a facsimile of this manuscript, see *The Coronation Book of Charles V of France (Cottonian MS Tiberius B. VIII),* ed. E. S. Dewick, Henry Bradshaw Society, 16 (London: Harrison and Sons, 1899). For discussion of these scenes, see Sherman, *Portraits,* 35–37, and "The Queen," 275.

2. See Ch. 24 above at n. 14.

3. *Yconomique,* 826.

4. Ibid., 812–13. See also Ch. 24 above at nn. 19 and 33.

5. See Ch. 12 above at nn. 36–38.

6. *Yconomique,* 830.

7. Ibid.

8. "Et en ceste maniere la nature de l'un et de l'autre, ce est assavoir, du masle et de la femelle fu devant ordenee ou preordenee de chose divine ou de par Dieu a communication" (ibid., 814).

9. Ibid.

10. Robert L. Benson, "Ceremonies, Secular and Nonsecular," in *The Secular Spirit: Life and Art at the End of the Middle Ages,* exh. cat. (New York: Dutton for the Metropolitan Museum of Art, 1975), 244.

11. Shulamith Shahar adds that "the bride's dowry as well as that portion of the bridegroom's property pledged to his wife in the event that he died before her were also guaranteed at the church door" (*The Fourth Estate: A History of Women in the Middle Ages,* trans. Chaya Galai [London and New York: Methuen, 1983], 81). For a discussion of the church porch as the setting of the ceremony, see Christopher N. L. Brooke, *The Medieval Idea of Marriage* (Oxford: Oxford University Press, 1989), 253–57.

12. For the specification of the priest's dress in an *ordo* of the twelfth century and other details of the ceremony, see Jean-Baptiste Molin and Protais Mutembe, *Le rituel du mariage en France du XIIe au XVIe siècle* (Paris: Beauchesne, 1974), 284–85. For pontificals and missals dating from the thirteenth century that describe the marriage rite at the church door, see ibid., 34–37, 284–91.

13. Eugène Viollet-le-Duc, *Dictionnaire raisonné du mobilier français* (Paris: Bance, 1861), vol. 4, 36. For illustrations of the same type of bridal dress with the three jewels, see Melnikas, *Corpus of the Miniatures in the Manuscripts of Decretum Gratiani,* vol. 3, figs. 28 and 45 (Causa XXXVI). Both examples come from fourteenth-century French manuscripts. The former (Paris, Bibl. Nat., MS lat. 3893, fol. 356) dates from the first decades of the fourteenth century, while the second (Paris, Bibl. Mazarine, MS lat. 1290, fol. 390) is contemporary with *B* and *D*. For further discussion of the Mazarine manuscript, see below, n. 16.

14. For a container for thirteen gold coins sometimes specified as the *arrhes,* see Molin and Mutembe, *Le rituel du mariage,* 153, n. 70; for a wider discussion, see ibid., 149–55.

15. No liturgical indication of crowns connected with the nuptial blessing occurs in Western sources. See ibid., 237–38.

16. Melnikas, *Corpus of the Miniatures in the Manuscripts of Decretum Gratiani,* vol. 3, figs. 43–45 (Causa XXXVI). Crowns are worn by the bridal couple in ibid., figs. 43 and 44 from two Bolognese manuscripts (Rome, Archivio della Basilica di S. Pietro, MS A. 24, fol. 315, and Paris, Bibl. Nat., MS nouv. acq. lat. 2508, fol. 321v). In the Mazarine manuscript mentioned in n. 13 above (fig. 45, Causa XXXVI) the bride and groom wear circlets. (Melnikas incorrectly attributes the illustration to the Master of the Coronation Book of Charles V and dates it to 1365 [ibid., 1144]. I believe it was executed by the workshop of the Master of the Rationale of Divine Offices. See Sherman, *Portraits,* 19 and pl. 3.)

17. Viollet-le-Duc, *Dictionnaire raisonné du mobilier français,* vol. 3, 320, and vol. 4, 36.

18. *Yconomique,* 826–28 and 836–39.

19. See Ch. 24 above at nn. 6–7.

20. *Yconomique,* 835–39.

CONCLUSION

1. See Ch. 16 above at n. 29.

2. For convenient summaries, see the entries under Joachim Du Bellay and François Rabelais in *Dictionnaire des lettres françaises, le seizième siècle,* ed. Georges Grente (Paris: Arthème Fayard, 1961), 242–48 and 587–94. I am grateful to Prof. Ellen Ginsberg for bringing this publication to my attention.

3. See Monfrin, "Humanisme et traductions au moyen âge," 176–83; idem, "La connaissance de l'antiquité et le problème de l'humanisme en langue vulgaire dans la France du XVe siècle," in *The Late Middle Ages and the Dawn of Humanism outside Italy,* ed. G. Verbeke and J. Ijsewijn, Proceedings of the International Conference, Louvain, 11–13 May 1970 (Louvain: University Press, 1972), 131–70.

4. See the entry "Traduction" in *Dictionnaire des lettres françaises, le seizième siècle,* 669–73. The passage by Du Bellay praising Francis I in the *Deffence* (cited on page 669) for his sponsorship of translations recalls Oresme's references to Charles V in his prologue to the *Ethiques,* 98.

5. See the entry "Collège de France" in *Dictionnaire des lettres françaises, le seizième siècle,* 186–92.

6. The teachers were called *lecteurs royaux* (royal readers). See also Ch. 4 above at n. 21.

APPENDIX I

1. Italics indicate rubrics.

2. Delisle, *Le cabinet des manuscrits,* vol. 1, 46, n. 9; and Doutrepont, *La littérature française à la cour des ducs de Bourgogne,* 121–23.

3. Delisle, *Mélanges de paléographie,* 263–64.

4. Complete citations can be found in the Bibliography.

APPENDIX II

1. Italics indicate rubrics.

2. See Appendix IV for the second volume containing the *Politics* and *Economics* of this portable set of Oresme's translations made for Charles V, here cited as *D.*

3. Delisle, *Le cabinet des manuscrits,* vol. 1, 49; idem, *Recherches,* vol. 1, 104, n. 2.

4. Delisle, *Le cabinet des manuscrits,* vol. 1, 36.

5. Idem, *Recherches,* vol. 1, 253.

6. Boeren, *Catalogus van de handschriften van het Rijksmuseum Meermanno-Westreenianum,* 93.

7. Complete citations can be found in the Bibliography.

APPENDIX III

1. For the complete text of the Second Instruction to the Reader, see Appendix V.

2. Italics indicate rubrics.

3. Delisle, *Mélanges de paléographie,* 277.

4. The collation is incomplete, as further access to the manuscript was denied to me by the owner.

5. Delisle, *Mélanges de paléographie,* 262.

6. Ibid., 262–63.

7. Complete citations can be found in the Bibliography.

APPENDIX IV

1. Italics indicate rubrics.

2. Delisle, *Recherches,* vol. 1, 254; and idem, *Mélanges de paléographie,* 265.

3. Complete citations can be found in the Bibliography.

APPENDIX V

1. The text and translation were printed in the *Art Bulletin,* 46/3 (1979): 468–69. Prof. Ellen Ginsberg helped with editing and translating the text.

BIBLIOGRAPHY

A. MANUSCRIPTS CONSULTED

Translations commissioned by Charles V

Bien universel des mouches à miel, Thomas of Cantimpré
Brussels, Bibl. Royale Albert Ier, MS 9507
La cité de Dieu, St. Augustine, trans. Raoul de Presles
Paris, Bibl. Nat., MS fr. 22912–13
Les collations, Cassian, trans. Jean Golein
Paris, Bibl. Nat., MS fr. 175
Epître consolatoire, Vincent of Beauvais, trans. Jean Golein
Paris, Bibl. Nat., MS fr. 1032
Faits et dits dignes de mémoire, Valerius Maximus, Books I–IV, trans. Simon of Hesdin
Paris, Bibl. Nat., MS fr. 9749
Homélies, Gregory the Great, and *Traitié de l'âme,* Hugh of St. Victor, trans. Peter of Hangest
Paris, Bibl. de l'Arsenal, MS 2247
Le livre de l'information des rois et des princes, trans. Jean Golein
Paris, Bibl. Nat., MS fr. 1950
Le livre des neuf anciens juges d'astrologie, trans. Robert Godefroy
Brussels, Bibl. Royale Albert Ier, MS 10319
Le livre du ciel et du monde, Aristotle, trans. Nicole Oresme
Paris, Bibl. Nat., MS fr. 1082
Le policratique, John of Salisbury, trans. Denis Foulechat
Paris, Bibl. Nat., MS fr. 24287
Le quadripartit, Ptolemy, trans. Nicole Oresme
Paris, Bibl. Nat., MS fr. 1348
Rational des divins offices, William Durand, and *Traité du sacre,* trans. Jean Golein
Paris, Bibl. Nat., MS fr. 437

Les soliloques, St. Augustine

Paris, Bibl. Nat., MS fr. 1382

Les voies de Dieu, St. Elizabeth of Hungary, trans. Jacques Bauchant

Paris, Bibl. Nat., MS fr. 1792

Related Manuscripts

Avis au roys, New York, The Pierpont Morgan Library, M. 456

Bible historiale, The Hague, Rijksmuseum Meermanno-Westreenianum, MS 10 B 23

The Coronation Book of Charles V, London, Brit. Lib., MS Cotton Tiberius B. VIII

Epîtres de Senèque à Lucilius, Brussels, Bibl. Royale Albert Ier, MS 9091

Grandes chroniques de France, Paris, Bibl. Nat., MS fr. 2813

Histoire romaine, Livy, trans. Pierre Bersuire
> Cambridge, Mass., Harvard University, Houghton Library, Richardson MS 32
> Paris, Bibl. Ste. Geneviève, MS 777

Late Fourteenth- and Fifteenth-Century Manuscripts of the French Translations of Aristotle

Chantilly, Museé Condé, MS 277, *Ethiques*

Chantilly, Musée Condé, MS 278, *Ethiques* and *Yconomique* (latter trans. Laurent de Premierfait)

Jena, Univ. Lib., MS gall. f. 91, *Politiques* and *Yconomique*

Paris, Bibl. de l'Arsenal, MS 2668, *Ethiques*

Paris, Bibl. Nat., MS fr. 204, *Ethiques, Politiques,* and *Yconomique*

Paris, Bibl. Nat., MS fr. 208, *Politiques* (Books II and V)

Paris, Bibl. Nat., MS fr. 541, *Ethiques*

Paris, Bibl. Nat., MS fr. 9106, *Politiques* and *Yconomique*

Paris, Bibl. Nat., MS fr. 22500, *Politiques*

Rouen, Bibl. Municipale, MS I.2 (927), *Ethiques, Politiques,* and *Yconomique* (latter trans. Laurent de Premierfait)

B. TRANSLATIONS AND EDITIONS

Aristotle. *Aristotle on Memory.* Edited by Richard Sorabji. Providence, R.I.: Brown University Press, 1972.

———. *The "Art" of Rhetoric.* Edited and translated by John H. Frees. Cambridge, Mass.: Harvard University Press, Loeb Classical Library, 1959.

———. *Ethica Nicomachea.* Translated and edited by W. D. Ross. The Works of Aristotle Translated into English, 9. Oxford: Clarendon Press, 1915.

———. *Ethica Nicomachea, Translatio Roberti Grosseteste Lincolniensis.* Edited by René A. Gauthier. *Aristoteles Latinus,* vol. 26, 1–3, fasc. 4. Leiden: Brill, 1973.

———. *L'éthique à Nicomaque.* Translated and edited by René A. Gauthier and Jean Y. Jolif. 2 vols. in 4. 2d ed. Louvain: Publications Universitaires, 1970.

———. *Nicomachean Ethics.* Translated by Martin Ostwald. Indianapolis: The Library of the Liberal Arts, Bobbs-Merrill, Educational Publishing, 1962.

———. *The Politics of Aristotle.* Edited and translated by Ernest Barker. Oxford: Oxford University Press, 1958. Reprint. Oxford: Oxford University Press, 1973.

Ordonnances des roys de France de la troisième race, recueillies par ordre chronologique. Edited by Denis F. Secousse. 21 vols. Paris: Imprimerie royale, 1746–1829.

John of Salisbury. *Policraticus: Of the Frivolities of Courtiers and the Footprints of Philosophers.* Edited and translated by Cary J. Nederman. Cambridge and New York: Cambridge University Press, 1990.

Li livres du gouvernement des rois: A Thirteenth-Century French Version of Egidio Colonna's Treatise De regimine principum. Edited by Samuel P. Molenaer. New York: Macmillan, 1899.

Ordonnances des roys de France de la troisième race, recueillies par ordre chronologique. Edited by Denis F. Secousse. 21 vols. Paris: Imprimerie royale, 1746–1829.

Oresme, Nicole. *The De moneta of Nicholas Oresme and English Mint Documents.* Edited and translated by Charles Johnson. London: Thomas Nelson, 1956.

———. *De proportionibus proportionum and Ad pauca respicientes.* Edited and translated by Edward Grant. Madison: University of Wisconsin Press, 1966.

———. *"Le livre de divinacions."* Edited by Sylvie Lefèvre. Ph.D. diss., University of Paris III, 1992.

———. *Le livre du ciel et du monde.* Edited by Albert D. Menut and Alexander J. Denomy. Madison: University of Wisconsin Press, 1968.

———. *Maistre Nicole Oresme: Le livre de éthiques d'Aristote published from the text of MS 2902, Bibliothèque Royale de Belgique.* Edited by Albert D. Menut. New York: Stechert, 1940.

———. *Maistre Nicole Oresme: Le livre de politiques d'Aristote.* Transactions of the American Philosophical Society, n.s. 60/6. Edited by Albert D. Menut. Philadelphia: The Society, 1970.

———. *Maistre Nicole Oresme: Le livre de yconomique d'Aristote.* Edited and translated by Albert D. Menut. Transactions of the American Philosophical Society, n.s. 47/5. Philadelphia: The Society, 1957.

———. *Nicole Oresme and the Astrologers: A Study of His Livre de divinacions.* Edited by George W. Coopland. Liverpool: University of Liverpool Press, 1952.

———. *Nicole Oresme and the Kinematics of Circular Motion: Tractatus de commensurabilitate vel incommensurabilitate motuum celi.* Edited by Edward Grant. Madison: University of Wisconsin Press, 1971.

———. *Nicole Oresme and the Marvels of Nature: A Study of His De causis mirabilium.* Edited and translated by Bert Hansen. Studies and Texts, 68. Toronto: Pontifical Institute of Mediaeval Studies, 1985.

———. *Nicole Oresme and the Medieval Geometry of Qualities and Motions: A Treatise on the Uniformity and Difformity of Intensities Known as "Tractatus de configurationibus qualitatum et motuum."* Translated and edited by Marshall Clagett. Madison: University of Wisconsin Press, 1968.

———. "*Le quadripartit ptholomée.*" Edited by Jay W. Gossner from the text of MS Français 1348 of the Bibliothèque Nationale in Paris. Ph.D. diss., Syracuse University, 1951.

———. "*Questiones super libros Aristotelis De anima.*" Edited by Peter Marshall. 2 vols. Ph.D. diss., Cornell University, Ithaca, N.Y., 1980.

———. *Traictié de la première invention des monnoies de Nicole Oresme et Traité de la monnoie de Copernic.* Edited by M. Louis Wolowski. Paris: Guillaumin, 1864; Geneva: Slatkine Reprints, 1976.

———. "*Traictié des monnoyes.*" Edited by John E. Parker. Ph.D. diss., Syracuse University, 1952.

———. "*Le traité de la sphère.*" Edited by John V. Myers. Master's thesis, Syracuse University, 1940.

———. "*Le traitié de l'espere.*" Edited by Lillian M. McCarthy. Ph.D. diss., University of Toronto, 1943.

Pizan, Christine de. *Le livre des fais et bonnes meurs du sage roy Charles V.* Edited by Suzanne Solente. 2 vols. Paris: Champion, 1936–40.

Le songe du vergier. Edited by Marion Schnerb-Lièvre. 2 vols. Paris: Editions du Centre National de la Recherche Scientifique, 1982.

Virgil. *Eclogues, Georgics, Aeneid, 1–6.* Translated by H. R. Fairclough. Vol. 1. Cambridge, Mass.: Harvard University Press, Loeb Classical Library, 1986.

C. SECONDARY SOURCES

Alexander, Jonathan J. G. "*Labeur* and *Paresse:* Ideological Representations of Medieval Peasant Labor." *Art Bulletin* 72/3 (1990): 436–52.

———. *Medieval Illuminators and Their Methods of Work.* New Haven and London: Yale University Press, 1992.

Alverny, Marie-Thérèse d'. "Quelques aspects du symbolisme de la *Sapientia* chez les humanistes." In *Umanesimo e Esoterismo,* edited by Enrico Catelli, 321–33. Atti

del V Convegno internazionale di studi umanistici, Oberhofen, Switzerland, 16–17 September 1960. Padua: CEDAM (Casa Editrici Dott. Antonio Milani), 1960.

Avril, François. *La librairie de Charles V.* Exh. cat. Paris: Bibliothèque Nationale, 1968.

———. *Manuscript Painting at the Court of France: The Fourteenth Century (1310–1380).* New York: George Braziller, 1978.

———. "Manuscrits." In *Les fastes du gothique: Le siècle de Charles V,* 276–82. Exh. cat. Paris: Editions de la Réunion des Musées Nationaux, 1981.

———. "Une *Bible historiale* de Charles V." *Jahrbuch der Hamburger Kunstsammlungen* 14–15 (1970): 45–76.

Babbitt, Susan M. *Oresme's Livre de Politiques and the France of Charles V.* Transactions of the American Philosophical Society, 75/1. Philadelphia: The Society, 1985.

Bäuml, Franz H. "Varieties and Consequences of Medieval Literacy and Illiteracy." *Speculum* 55/2 (1980): 237–65.

Beer, Jeanette. "Introduction." In *Medieval Translators and Their Craft,* edited by Jeanette Beer, 1–7. Studies in Medieval Culture, 25. Kalamazoo: Medieval Institute Publications, Western Michigan University, 1989.

Bell, Dora M. *L'idéal éthique de la royauté en France au moyen âge.* Geneva: Droz, 1962.

Berges, Wilhelm. *Die Fürstenspiegel des hohen und späten Mittelalters: Schriften des Reichsinstituts für ältere deutsche Geschichtskunde.* Monumenta germaniae historica, 2. Leipzig: Verlag Karl W. Hiersemann, 1938.

Berliner, Rudolf. *"Arma Christi." Muenchner Jahrbuch der bildenden Kunst* 6 (1955): 35–152.

Bibliothèque Royale Albert Ier. *La librairie de Bourgogne et quelques acquisitions récentes de la Bibliothèque Royale Albert Ier.* L'art en Belgique, 10. Brussels: Fondation Cultura, [1970?].

———. *La librairie de Philippe le Bon.* Edited by Georges Dogaer and Marguerite Debae. Brussels, 1967.

———. *Trésors de la Bibliothèque Royale de Belgique.* Lederberg-Ghent: Imprimerie Erasmus, 1958.

Boeren, Petrus C. *Catalogus van de handschriften van het Rijksmuseum Meermanno-Westreenianum.* The Hague: Staatsuitgeverij, 1979.

Bolzoni, Lina. "The Play of Images: The Art of Memory from Its Origins to the Seicento." In *The Mill of Thought: From the Art of Memory to the Neurosciences,* edited by Pietro Corsi, 17–26. Milan: Electa, 1989.

Bridrey, Emile. *La théorie de la monnaie au XIVe siècle: Nicole Oresme, étude d'histoire des doctrines et des faits économiques.* Paris: Giard & Brière, 1906.

Byrne, Donal. "A Fourteenth-Century French Drawing in Berlin and the *Livre du Voir-Dit* of Guillaume de Machaut." *Zeitschrift für Kunstgeschichte* 47/1 (1984): 70–81.

————. "Manuscript Ruling and Pictorial Design in the Work of the Limbourgs, the Bedford Master, and the Boucicaut Master." *Art Bulletin* 66/1 (1984): 118–35.

Byvanck, Alexander W. *Les principaux manuscrits à peintures de la Bibliothèque Royale des Pays-Bas et du Musée Meermanno-Westreenianum à La Haye.* Paris: Société Française de Reproductions de Manuscrits à Peintures, 1924.

Byvanck, Willem G. C. *Twee Fransche handschriften uit de XIVe en XVe eeuw van het Museum Meermanno-Westreenianum.* The Hague, 1900.

Calkins, Robert G. *Programs of Medieval Illumination.* The Franklin D. Murphy Lectures, 5. Lawrence, Kans.: Helen Foresman Spencer Museum of Art, 1984.

The Cambridge History of Medieval Political Thought, ca. 350–ca. 1450. Edited by J. H. Burns. Cambridge and New York: Cambridge University Press, 1991.

Camille, Michael. "Illustrations in Harley MS 3487 and the Perception of Aristotle's *Libri naturales* in Thirteenth-Century England." In *England in the Thirteenth Century: Proceedings of the 1984 Harlaxton Symposium,* edited by W. H. Ormrod, 31–44. Dover, N.H.: Boydell Press, 1986.

————. "Labouring for the Lord: The Ploughman and the Social Order in the Luttrell Psalter." *Art History* 10/4 (1987): 423–54.

Carmody, Francis J. *Arabic Astronomical and Astrological Sciences in Latin Translations: A Critical Bibliography.* Berkeley: University of California Press, 1956.

Carpenter, Nan Cooke. *Music in the Medieval and Renaissance Universities.* Norman: University of Oklahoma Press, 1958.

Carruthers, Mary J. *The Book of Memory: A Study of Memory in Medieval Culture.* Cambridge and New York: Cambridge University Press, 1991.

Cazelles, Raymond. *Etienne Marcel, champion de l'unité française.* Paris: Tallandier, 1984.

————. *Société politique: Noblesse et couronne sous Jean le Bon et Charles V.* Geneva: Droz, 1982.

Clagett, Marshall. "Nicole Oresme." In vol. 10 of *Dictionary of Scientific Biography,* 220–30. New York: Scribner, 1974.

Clanchy, Michael T. *From Memory to Written Record: England, 1066–1377.* Cambridge, Mass.: Harvard University Press, 1979.

Copeland, Rita. *Rhetoric, Hermeneutics, and Translation in the Middle Ages: Academic Traditions and Vernacular Texts.* Cambridge and New York: Cambridge University Press, 1991.

Curtius, Robert. *European Literature and the Latin Middle Ages.* Translated by Willard R. Trask. New York: Harper & Row, Torchbooks, 1963.

Delachenal, Roland. *Histoire de Charles V.* 5 vols. Paris: Picard, 1909–31.

————. "Note sur un manuscrit de la bibliothèque de Charles V." *Bibliothèque de l'Ecole des Chartes* 71 (1910): 33–38.

Delaissé, Louis M. J. *Brussels, the Royal Library of Belgium: Medieval Miniatures from the Department of Manuscripts (formerly the Library of Burgundy).* New York: Abrams, 1965.

Delisle, Léopold. *Le cabinet des manuscrits de la Bibliothèque Impériale*. 3 vols. Paris: Imprimerie nationale, 1868–81.

———. *Mélanges de paléographie et de bibliographie*. Paris: Champion, 1880.

———. "Observations sur plusieurs manuscrits de la *Politique* et de l'*Economique* de Nicole Oresme." *Bibliothèque de l'Ecole des Chartes* 30 (1869): 601–20.

———. *Recherches sur la librairie de Charles V.* 2 vols. Paris: Champion, 1907.

Dictionary of the Middle Ages. Edited by Joseph R. Strayer. 13 vols. New York: Scribner, 1982–89.

Dictionnaire des lettres françaises, le seizième siècle. Edited by Georges Grente. Paris: Arthème Fayard, 1961.

Dieckhoff, Reiner. *Die Parler und der schöne Stil, 1350–1400: Europäische Kunst unter den Luxemburgern*. Edited by Anton Legner, 116. Ein Handbuch zur Ausstellung des Schnütgen-Museums in der Kunsthalle Köln. Vol. 3. Cologne: Museen der Stadt Köln, 1978.

Dinkler-von Schubert, Erica. *"Vita activa et contemplativa."* In vol. 4 of *Lexikon der christlichen Ikonographie,* edited by Engelbert Kirschbaum, cols. 463–68. Rome: Herder, 1972.

Doutrepont, Georges. *Inventaire de la librairie de Philippe le Bon*. Brussels: Kiessling, 1906.

———. *La littérature française à la cour des ducs de Bourgogne: Philippe le Hardi, Jean sans Peur, Philippe le Bon, Charles le Téméraire*. Paris: Champion, 1909; Geneva: Slatkine Reprints, 1970.

Duby, Georges. *The Three Orders: Feudal Society Imagined*. Translated by Arthur Goldhammer. Chicago and London: University of Chicago Press, 1978.

Dunbabin, Jean. "Government." In *The Cambridge History of Medieval Political Thought, ca. 350–ca. 1450,* edited by J. H. Burns, 477–519. Cambridge and New York: Cambridge University Press, 1991.

Evans, Michael, "Allegorical Women and Practical Men: The Iconography of the *Artes* Reconsidered." In *Medieval Women,* edited by Derek Baker, 305–28. Studies in Church History, subsidia 1. Oxford: Basil Blackwell, for the Ecclesiastical History Society, 1978.

Fleming, John V. *The Roman de la rose: A Study in Allegory and Iconography*. Princeton, N.J.: Princeton University Press, 1969.

Forkosch, Morris D. "Justice." In vol. 2 of *Dictionary of the History of Ideas,* edited by Philip Wiener, 652–59. New York: Scribner, 1973.

Garnier, François. *Le langage de l'image au moyen âge: Signification et symbolique*. 2 vols. Paris: Léopard d'or, 1982.

Garrard, Mary D. "The Liberal Arts and Michelangelo's First Project for the Tomb of Julius II (With a Coda on Raphael's 'School of Athens')." *Viator, Medieval and Renaissance Studies* 15 (1984): 335–76.

Gaspar, Camille, and Frédéric Lyna. *Les principaux manuscrits à peintures de la Bibliothèque Royale de Belgique.* 2 vols. Paris: Société Française de la Reproduction de Manuscrits à Peintures, 1937–47.

Gheyn, Joseph van den. *Catalogue des manuscrits de la Bibliothèque Royale de Belgique.* Vol. 4. Brussels: H. Lamertin, 1904.

Gombrich, E. H. "*Icones symbolicae:* Philosophies of Symbolism and Their Bearing on Art." In *Symbolic Images: Studies in the Art of the Renaissance,* 123–95. London: Phaidon, 1972.

Grabmann, Martin. "Die mittelalterlichen Kommentare zur *Politik* des Aristoteles." *Sitzungsberichte der Bayerischen Akademie der Wissenschaften* 2/10 (1941): 5–83. Reprint, *Gesammelte Akademieabhandlungen.* Vol. 2. Munich: Ferdinand Schöningh, 1970.

——— . "Methoden und Hilfsmittel des Aristotelesstudiums in Mittelalter." *Sitzungsberichte der Bayerischen Akademie der Wissenschaften* (1939): 5–191.

Grignaschi, Mario. "Nicole Oresme et son commentaire à la *Politique* d'Aristote." In *Album Helen Maude Cam, Studies Presented to the International Commission for the History of Representative and Parliamentary Institutions,* 23, 97–151. Louvain: Publications Universitaires de Louvain, 1960.

Guenée, Bernard. *Histoire et culture historique dans l'occident médiéval.* Paris: Aubier-Montaigne, 1980.

Hedeman, Anne D. *The Royal Image: The Illustrations of the "Grandes chroniques de France," 1274–1422.* Berkeley and Los Angeles: University of California Press, 1991.

——— . "Valois Legitimacy: Editorial Changes in Charles V's *Grandes chroniques de France.*" *Art Bulletin* 66/1 (1984): 97–117.

Henneman, John Bell. *Royal Taxation in Fourteenth-Century France: The Captivity and Ransom of John II, 1356–1370.* Memoirs of the American Philosophical Society, 116. Philadelphia: The Society, 1976.

Hindman, Sandra L., and Gabrielle M. Spiegel. "The Fleur-de-lis Frontispieces to Guillaume de Nangis's *Chronique abrégée:* Political Iconography in Late Fifteenth-Century France." *Viator, Medieval and Renaissance Studies* 12 (1981): 383–407.

Hoeber, Fritz. "Über Stil und Komposition der französischen Miniaturen aus der Zeit Karls V. von Frankreich." *Zeitschrift für Bücherfreunde* 10/1 (1906/7): 187–93.

Hughes, Andrew. "Music, Western European." In vol. 8 of *Dictionary of the Middle Ages,* edited by Joseph R. Strayer, 578–94. New York: Scribner, 1982–89.

Kantorowicz, Ernst H. *The King's Two Bodies: A Study in Mediaeval Political Theology.* Princeton, N.J.: Princeton University Press, 1957.

Katzenellenbogen, Adolf. *Allegories of the Virtues and Vices in Mediaeval Art from Early Christian Times to the Thirteenth Century.* Studies of the Warburg Institute, 10. London: The Institute, 1939. Reprint. Nendeln, Liechenstein: Kraus, 1968.

Klibansky, Raymond, Erwin Panofsky, and Fritz Saxl. *Saturn and Melancholy.* London: Thomas Nelson & Sons, 1964.

Knops, J. P. H. *Etudes sur la traduction française de la morale à Nicomache d'Aristote par Nicole Oresme.* The Hague: Excelsior, 1952.

Kolve, V. A. *Chaucer and the Imagery of Narrative: The First Five Canterbury Tales.* Stanford, Calif.: Stanford University Press, 1984.

Kosmer, Ellen. "A Study of the Style and Iconography of a Thirteenth-Century *Somme le roi* (British Museum, MS Add. 54180) with a Consideration of Other Illustrated *Somme* Manuscripts of the Thirteenth, Fourteenth, and Fifteenth Centuries." 2 pts. Ph.D. diss., Yale University, 1973.

Kristeller, Paul Oskar. *Renaissance Thought: Papers on Humanism and the Arts.* Vol. 2. New York: Harper Torchbooks, 1965.

Laborde, Alexandre de. *Les manuscrits à peintures de la Cité de Dieu de Saint Augustin.* 2 vols. Paris: Edouard Rahir, Libraire pour la Société des Bibliophiles Français, 1909.

Lejbowicz, Max. "Guillaume Oresme, traducteur de la *Tetrabible* de Claude Ptolémée." *Pallas* 30 (1983): 107–33.

Lexikon der christlichen Ikonographie. Edited by Engelbert Kirschbaum. 8 vols. Rome: Herder, 1968–72.

Lieftinck, Gerard I. *Manuscrits datés conservés dan les Pays-Bas.* Vol. 1. Amsterdam: North Holland Publishing Co., 1964.

Lot, Ferdinand, and Robert Fawtier. *Histoire des institutions françaises au moyen âge.* 3 vols. Paris: Presses Universitaires de France, 1958.

Lusignan, Serge. *Parler vulgairement: Les intellectuels et la langue française au XIIIe et XIVe siècles.* 2d ed. Paris: J. Vrin, 1987.

Masai, François, and Martin Wittek. *Manuscrits datés conservés en Belgique.* Vol. 1. Brussels-Ghent: E. Story-Scientia, 1968.

Maumené, Charles, and Louis d'Harcourt. *Iconographie des rois de France.* Archives de l'art français, 20. Vol. 1. Paris: Armand Colin, 1933.

Meiss, Millard. *French Painting in the Time of Jean de Berry: The Late Fourteenth Century and the Patronage of the Duke.* Vol. 1. New York: Phaidon Press, 1967. *The Boucicaut Master.* Vol. 2. 1968.

———. *French Painting in the Time of Jean de Berry: The Limbourgs and Their Contemporaries.* 2 vols. London: Thames and Hudson, 1974.

Mellinkoff, Ruth. *The Horned Moses in Medieval Art and Thought.* California Studies in the History of Art, 14. Berkeley and Los Angeles: University of California Press, 1970.

Melnikas, Anthony. *The Corpus of the Miniatures in the Manuscripts of Decretum Gratiani.* Studia Gratiana, 18. 3 vols. Rome: Libreria Ateneo Salesiano, 1975.

Molin, Jean-Baptiste, and Protais Mutembe. *Le rituel du mariage en France du XIIe au XVIe siècle.* Paris: Beauchesne, 1974.

Monfrin, Jacques. "Humanisme et traductions au moyen âge." *Journal des Savants* (1963): 161–89.

———. "Les traducteurs et leur publique en France au moyen âge." *Journal des savants* (1964): 5–20.

———. "La traduction française de Tite-Live." *Histoire littéraire de la France* 39 (1962): 358–414.

Morse, Ruth. *Truth and Convention in the Middle Ages: Rhetoric, Representation, and Reality.* Cambridge and New York: Cambridge University Press, 1991.

Panofsky, Erwin. *Early Netherlandish Painting.* 2 vols. Cambridge, Mass.: Harvard University Press, 1953.

———. *Hercules am Scheidewege und andere antike Bildstoffe in der neueren Kunst.* Studien der Bibliothek Warburg, 18. Leipzig: Teubner, 1930.

———. *Renaissance and Renascences in Western Art.* Stockholm: Almqvist & Wiskell, 1960.

———. "Titian's *Allegory of Prudence:* A Postscript." In *Meaning in the Visual Arts,* 146–68. Garden City, N.Y.: Doubleday Anchor Books, 1955.

Parkes, Malcolm B. "The Influence of the Concepts of *Ordinatio* and *Compilatio* on the Development of the Book." In *Medieval Learning and Literature: Essays Presented to Richard William Hunt,* edited by Jonathan J. G. Alexander and M. T. Gibson, 115–41. Oxford: Clarendon Press, 1976.

Parmisano, Fabian, O.P. "Love and Marriage in the Middle Ages—I." *New Blackfriars* 50 (1969): 649–60.

Pearsall, Derek A., and Elizabeth Salter. "Pictorial Illustration of Late Medieval Poetic Texts: The Role of the Frontispiece or Prefatory Picture." In *Medieval Iconography and Narrative: A Symposium,* 100–121. Odense: Odense University Press, 1980.

Post, Gaines. *Studies in Medieval Legal Thought, Public Law, and the State, 1100–1322.* Princeton, N.J.: Princeton University Press, 1964.

Quillet, Jeannine. "Community, Counsel, and Representation." In *The Cambridge History of Medieval Political Thought, ca. 350–ca. 1450,* edited by J. H. Burns, 520–72. Cambridge and New York: Cambridge University Press, 1991.

Reallexikon zur deutschen Kunstgeschichte. Edited by Otto Schmitt et al. 8 vols. Stuttgart: J. B. Metzler, 1937–86.

Rice, Eugene F., Jr. *The Renaissance Idea of Wisdom.* Cambridge, Mass.: Harvard University Press, 1958.

Rijksmuseum Meermanno-Westreenianum. *Verluchte handschriften uit eigen bezit, 1300–1550.* Exh. cat. The Hague: Rijksmuseum Meermanno-Westreenianum, 1979.

Ross, W. D. *Aristotle: A Complete Exposition of His Works and Thought.* New York: Meridian Books, 1959.

Rouse, Richard. "La diffusion en occident au XIIIe siècle des outils de travail facilitant l'accès aux textes autoritatifs." *Revue des études islamiques* 44 (1976): 115–47.

Rubenstein, Nicolai. "Political Ideas in Sienese Art: The Frescoes by Ambrogio Lorenzetti and Taddeo di Bartolo in the Palazzo Pubblico." *Journal of the Warburg and Courtauld Institutes* 21 (1958): 179–207.

Saenger, Paul. "Silent Reading: Its Impact on Late Medieval Script and Society." *Viator, Medieval and Renaissance Studies* 13 (1982): 367–414.

Schapiro, Meyer. *Words and Pictures: On the Literal and Symbolic in the Illustration of a Text.* Edited by Thomas A. Sebeok. Approaches to Semiotics, 11. The Hague: Mouton, 1973.

Sherman, Claire Richter. *The Portraits of Charles V of France, 1338–1380.* Monographs on Archaeology and the Fine Arts Sponsored by the Archaeological Institute of America and the College Art Association of America, 20. New York: New York University Press, 1969.

———. "The Queen in King Charles V's *Coronation Book:* Jeanne de Bourbon and the *Ordo ad reginam benedicendam.*" *Viator, Medieval and Renaissance Studies* 8 (1977): 255–98.

———. "Representations of Charles V as a Wise Ruler," *Medievalia et Humanistica,* n.s. 2 (1971): 83–96.

———. "A Second Instruction to the Reader from Nicole Oresme, Translator of Aristotle's *Politics.*" *Art Bulletin* 61/3 (1979): 468–69.

———. "Some Visual Definitions in the Illustrations of Aristotle's *Nicomachean Ethics* and *Politics* in the French Translations of Nicole Oresme." *Art Bulletin* 59/3 (1977): 320–30.

———. "Taking a Second Look: Notes on the Iconography of a French Queen, Jeanne de Bourbon." In *Feminism and Art History: Questioning the Litany,* edited by Norma Broude and Mary D. Garrard, 101–17. New York: Harper & Row, 1982.

Shore, Lys Ann. "A Case Study in Medieval Nonliterary Translation: Scientific Texts from Latin to French." In *Medieval Translators and Their Craft,* edited by Jeanette Beer, 297–327. Studies in Medieval Culture, 25. Kalamazoo: Medieval Institute Publications, Western Michigan University, 1989.

Simone, Franco. *The French Renaissance: Medieval Tradition and Italian Influence in Shaping the Renaissance in France.* Translated by H. Gaston Hall. London: Macmillan, 1969.

Sinclair, Keith V. *The Melbourne Livy: A Study of Bersuire's Translation Based on the Manuscript in the Collection of the National Gallery of Victoria.* Melbourne: Melbourne University Press, 1961.

Skinner, Quentin. "Ambrogio Lorenzetti: The Artist as Political Philosopher." *Proceedings of the British Academy* 72 (1986): 1–56.

Smalley, Beryl. *English Friars and Antiquity in the Early Fourteenth Century.* New York: Barnes & Noble, 1960.

Smith, Sharon Off Dunlop. "Illustrations of Raoul de Praelle's Translation of St. Augustine's *City of God* between 1375 and 1420." Ph.D. diss., New York University, 1975.

Spiegel, Gabrielle M. *The Chronicle Tradition of Saint-Denis: A Survey.* Brookline, Mass.: Classical Folia Editions, 1978.

Strayer, Joseph R. *Medieval Statecraft and the Perspectives of History.* Princeton, N.J.: Princeton University Press, 1971.

Thiébaux, Marcelle. "The Mediaeval Chase." *Speculum* 42/2 (1967): 260–74.

Thorndike, Lynn. *A History of Magic and Experimental Science.* 8 vols. New York: Columbia University Press, 1923–58.

Tuve, Rosemond. *Allegorical Imagery: Some Mediaeval Books and Their Posterity.* Princeton, N.J.: Princeton University Press, 1966.

———. "Notes on the Virtues and Vices." *Journal of the Warburg and Courtauld Institutes* 26 (1963): 264–303; 27 (1964): 42–72.

Viollet-le-Duc, Eugène Emmanuel. *Dictionnaire du mobilier français: De l'époque carlovingienne à la Renaissance.* 6 vols. Paris: Bance, 1858–75.

Wallace, William A. "Friendship." In vol. 6 of *New Catholic Encyclopedia,* 203–5. New York: McGraw-Hill, 1967.

Willard, Charity Cannon. *Christine de Pizan: Her Life and Works.* New York: Persea Books, 1985.

———. "Raoul de Presles's Translation of St. Augustine's *De civitate Dei.*" In *Medieval Translators and Their Craft,* edited by Jeanette Beer, 329–45. Studies in Medieval Culture, 25. Kalamazoo: Medieval Institute Publications, Western Michigan University, 1989.

Winter, Patrick M. de. *La bibliothèque de Philippe le Hardi, duc de Bourgogne (1364–1404).* Paris: Editions du Centre National de la Recherche Scientifique, 1985.

———. "Copistes, éditeurs, et enlumineurs de la fin du XIVe siecle: La production à Paris de manuscrits à miniatures." *Actes du 100e Congrès National des Sociétés Savantes,* 173–98. Paris: Bibliothèque Nationale, 1978.

———. "The *Grandes Heures* of Philip the Bold, Duke of Burgundy: The Copyist Jean l'Avenant and His Patrons at the French Court." *Speculum* 57/4 (1982): 786–842.

Wixom, William D. "A Missal for a King: A First Exhibition." *Cleveland Museum of Art Bulletin* 50/7 (1963): 158–73.

Yates, Frances A. *The Art of Memory.* London: Penguin Books, 1969.

INDEX

Italicized page numbers refer to figures. Allegories, personifications, and personification allegories are listed under their English names; the French names are given in parentheses where they differ significantly from the English.

Christ, 166; blessing, 130; identified with Wisdom, 122

Christine de Pizan, 40, 73, 161, 291; *Le chemin de long estude,* 7; discussion of Charles V's interest in astrology, 17; discussion of Charles V's translation program, 6–9; images of, 351n.4; *Le livre des fais et bonnes meurs du sage roy Charles V,* 340n.26, 349n.22; *Le livre des trois vertus,* 281; *Livre du trésor de la cité des dames,* 281; quoted, 31

Les chroniques d'Espagne ou de Burgos (Gonzalo of Hinojosa), translation by Jean Golein, 8, 335n.56

church: as city-state, 253, 260; Oresme's commentary on (in *Politiques),* 229; as political community, 179

Cicero, Marcus Tullius, 128; *De amicitia,* 141

Cité de Dieu (Augustine), translation by Raoul de Presles, 7–8, 11–12, 29, 335n.54, 345n.46; illustration cycle of, 31, 33; quoted, 40

citizen, Aristotelian concept of, 260

Citizens and Noncitizens (paradigm), 254–55

citizenship: Aristotelian concept of, 253; exclusion of agricultural workers, craft workers, and merchants from, 252, 261

city, medieval, 103

City of God (Augustine), 196, 249, 376n.31; commentaries on, 11

city-state (polis): Greek, 193, 253; Italian, 111

civic science, concept of, 51–52

Clagett, Marshall, 19

class distinctions, 70, 73, 126, 135, 138–40, 150–52

classical culture, medieval appropriation of, 3

clergy, 194; as citizens, 254–55; depicted, 150, 264; role in ideal state, 261

cloak and beggar motif, 166–67

codicology, xxii. *See also* manuscripts

Coleman, Janet, quoted, 32

Coleman, Joyce, 349n.22

collaboration: in manuscript production, xxiii, 107, 305; in marriage and work, 288–89, 291; between Oresme and Raoulet d'Orléans, 258, 267–68

Collations (Cassian), translation by Jean Golein, 8, 10

Collège de France, 307

colophons, 32, 346n.57

color harmony, 146, 153

commentaries, by Oresme, 29–30

commentary tradition, 161

commonality of property, Platonic theory of, 205, 207

common good: Aristotelian concept of, 37, 193; and love of knowledge, 59

communitas perfecta, 252, 265; Aristotelian concept of, 193

Conciliation (Entrepesie) (personification), Pl. 3, *96–97,* 98

conduct, modes of, 139–40, 366n.10

conduct literature, Renaissance, 281

conflict between intellect and desire, Aristotelian view of, 131

Conspiracy (paradigm), *232–33,* 235

constitution, Aristotelian concept of, 194–95

contemplation, Aristotelian concept of, 165

Contemplative Happiness (Félicité contemplative) (personification allegory), Pl. 6, 163–64, 167–72, *168*

contemplative life, 122–23, 150, 165–67, 171–72, 306, 369n.30, 386n.32

Continence (personification), *132,* 133–37, *136,* 138–40, 147

contrast: in illustration programs, 192; between opposites, 226–27

Corbechon, Jean (translator), *Propriétés des choses* (Bartholomaeus Anglicus), 8

Coronation Book of Charles V, 10, 31, 95, 282, 293, *296*

counsellors, royal, 194, *194,* 305; as citizens, 254–55; depicted, 263–64; role in ideal state, 261

Covetousness (Convoitise) (personification), *86, 92*

Cowardice (Couardie) (personification), *76,* 79–80

craft workers, 120–21, 126, *210–11,* 265, 305; as noncitizens, *254–55,* 261

crenellated wall motif, 78, 83, 120, 146; in MS *A* illustration program, 103

cross-references, Oresme's use of, 281

crown, 58, 73, 99, 163, 166; of Philosophy, 128; wedding, 299–300, 391n.15, 392n.16

Daudin, Jean (translator): *Des rémèdes ou confors de maulx fortunes* (Seneca), 8; *L'enseignement des enfants nobles* (Vincent of Beauvais), 8; *Epître consolatoire* (Vincent of Beauvais), 9; *Les rémèdes de l'une et de l'autre fortune* (Petrarch), 8

"daughter" virtues, 98

Davis, Natalie Zemon, 363n.17

De amicitia (Cicero), 141

De anima (Aristotle), 32

debasement of coinage: by French government, 14; Oresme's discussion of, 195–96

De causis mirabilium (Oresme), 32

decision allegories, 42, 131, 306; age in, 160; costume in, 135, 138–40, 160; gender in, 135, 140; gesture in, 135, 140, 160; movement in, 135, 140; pose in, 160; position in, 140, 160. *See also names of decision allegories*

II illustrations *(Politiques)*, 203; Book II illustrations *(Yconomique)*, 293–96; Book III illustrations *(Politiques)*, 209, 213–16; Book IV illustrations *(Politiques)*, 221–24, 226–27; Book V illustrations *(Politiques)*, 231–37; Book VI illustrations *(Politiques)*, 240–44; Book VII illustrations *(Politiques)*, 253–56; Book VIII illustrations *(Politiques)*, 269–73; format of illustrations, 69; frontispieces *(Politiques)*, 191–95; illustrations in, Pls. 7–9, *188–89, 191, 202, 211, 223, 233, 243, 255, 285, 295;* relationship to MS *C*, 177–78. See also *Politiques; Yconomique*

Mulvaney, Robert, 363n.19
Munich: Bayerische Staatsbibliothek, cod. lat. 13002, 376n.30
music: in court ceremony, 278; role in education, 277–78

Naples, 306
nation-state, 253; and polis, 259–60
Natural History (Pliny), 280
neologisms, introduced by Oresme, 26, 32, 73, 97, 105, 170, 179, 185, 224, 234–35, 286, 306, 354n.1, 361n.49, 362n.6
New York: Columbia University, Rare Book and Manuscript Collections, MS 283, 348n.8; Pierpont Morgan Library, M. 456, 51, 355n.9. See also *Avis au roys*
Nicomachean Ethics (Aristotle), xxi, 14, 24; discussion of cardinal virtues, 72; discussion of justice, 93; discussion of marriage, 290; Latin translation by Grosseteste, 24, 361n.48; Oresme's view of, 37; paraphrase by Hermannus Alemannus, 113; quoted, 60, 120; views on spending, 85. See also *Ethiques*

Nieuwstraten, Rieneke, 364n.34
Nordenfalk, Carl, 357n.16
"noteworthy books," chosen for translation, 8

occupations of the months, 249
Oeconomicus (Xenophon), 280
Oligarchy (paradigm), Pl. 7, *186, 188, 190*
On the Heavens (Aristotle), translation by Oresme, 8; glosses and commentaries in, 29–30
oral explication, xxiii, 39–40, 54; by Oresme, 41, 71, 92, 128, 140, 152, 174, 183, 197, 207, 220, 230, 239, 252, 267, 291, 301, 305
oral reading, 3–4, 41
Order of the Star, 101, *102*
Oresme, Guillaume, 19, 340nn.33–34
Oresme, Henri, 178
Oresme, Nicole, 26; *Algorismus proportionum,* 279; appearance of, 20; and Aristotelian theory, 304; career of, xxii, 13–15, 21–22, 178; collaboration in manuscript production, 71; compilation of glossaries and indexes, 345n.42; as counsellor, 266; *De causis mirabilium,* 32; *De moneta,* 14, 195–96, 217, 228–29; *De proportionibus proportionum,* 32, 217; as designer of illustration programs, xxii–xxiii, 31–33, 67, 105, 117, 161, 173, 180–83, 199, 268, 304; discussion of contemplative happiness, 172; discussion of contemplative life, 173–74; discussion of friendship, 141; discussion of politics, 18; early life of, 13–14, 251, 384n.29; economic works, 14–15; French writings of, 14–21; Gallicanism of, 260; images of, Pl. 1, *19, 45–46, 46–48, 56, 56–57, 173, 181, 182;* instructions to illustrators, 43; interest in music, 275–76, 279; interpretation of Aristotle's *Politics,* 30; inven-

tiveness of, 67, 69, 80, 90, 127, 162; knowledge of Aristotelian corpus, 13; *Livre de divinacions,* 15, 18, 341n.42; *Le livre du ciel et du monde* (Aristotle), 8, 29–30, 345n.48; mathematical works, 279; as moralist, 305; official missions for Charles V, 22; opposition to astrological prediction, 17–18; payment for translation, 178; personality of, 55, 105, 128; and political reform, 304; *Quadripartit* (Ptolemy), 18; *Questiones super libros Aristotelis de anima,* 32; quoted, 9, 341n.39, 344n.41; relationship with Charles V, 13–27, 40–41, 45, 50–51, 57, 106, 130, 162, 181, 207, 350n.1; self-confidence of, 181; *Traictié des monnoies,* 14, 196, 338nn.9–10; *Traitié de l'espere,* 18, 20, *21,* 27, 39, 191, 344n.35; translation strategies, 25–31, 121, 219; as tutor of young Charles V, 337n.2; writings on astrology, 18; writings on natural science, 32, 173–74. See also *Ethiques;* neologisms; oral explication; *Politiques; Yconomique*

oriflamme, 10
Oxford: Bodleian Library, MS 965a, 348n.8; Bodleian Library, MS Ashmole 304, 376n.6; St. John's College, MS 164, 17, 27, 341n.41

Panofsky, Erwin, 42, 67, 128, 204, 244; "Hercules Prodicius," 131
papacy, and royal sovereignty, 260
paradigms, 191, 221; architectural settings in, 236, 262; attributes in, 263–65; contrast in, 236; costume in, 193, 227, 237, 263–65; demarcation in, 262; gesture in, 193–94, 237, 263; grouping in, 193, 227; hierarchy of value in, 192;

popularity of, 6; as "replacement" text, 23; as representation, 5; theory and practice of, 23

translation activity, accelerating pace in fourteenth century, 4

translatio studii theme, 5, 9–11, 20, 39, 260, 303

translator: and addition of new material, 336n.62; limits on, 209; as master of text, 181, 184; relationship to patron, 50; transfer of authorial identity to, 181, 306; unknown, 8–9. *See also names of translators*

translators' complaints, 6

Trevet, Nicholas: commentary on *City of God* (Augustine), 11; commentary on Livy, 332n.21

Tuve, Rosemond, 361n.61

Tyranny (paradigm), Pl. 7, *186, 188, 190*

Universal Justice. *See* Justice

University of Paris, 9, 13, 161, 204, 278–79; College of Navarre, 13

Urban VI, Pope, 22

Valerius Maximus: *Factorum et dictorum memorabilium libri novem,* 8, 218

Valois dynasty, 6, 13, 94, 101, 303, 305. *See also names of rulers*

Vanity (vice), 90

Vaudetar, Jean de, 45, 49

verbal aids, 234. *See also* readers' aids

vernacular: development of, 3; as instrument of abstract thought, 60; limitations of, 25–26; preferred to Latin, 3, 5, 279; rise to authoritative status, 25, 29, 204

vices, as lower-class male figures, 65–66

Vienna: National Library, cod. 2592, 368n.23

Vincent of Beauvais, 40, 126; *De eruditione filiorum nobilium,* 8; *Epître consolatoire,* 9

Virgil, *Georgics,* 280, 287

Virgin Mary, 171; cult of, 101; Justice and, 103

virtue: Aristotelian concept of, 60; as mean, 80, 227–28; Oresme's definition of, 60–63; perfect, *68, 93,* 99

Virtue (personification allegory), Pl. 2, *62–65,* 139; and Her Companions, in MS *C,* 69–71; as mean, 65–67, 70–71; as nun, 70; as queen, 63, 66

virtues, 367n.7; associated with ideal ruler, 89; cardinal, 60; as daughters of Justice, 109, 114; in everyday life, 88; intellectual, 117–19; pairing of, 75–78; traditional iconography of, 78; and vices, 181, 196. *See also names of virtues*

Virtues, *110*

Virtuous Man (Le Vertueus), *136,* 138–40, 147

virtuous person, 141

Visconti, Galeazzo, 4

visual definitions, 42–44, 73–80, 148–52, 184, 231, 235

visual metaphors, 135

visual riddles, 128, 130, 159, 219

vita activa. See active life

vita contemplativa. See contemplative life

Les voies de Dieu (Elizabeth of Hungary), translation by Jacques Bauchant, 8

voluntary poverty of clergy, Oresme's discussion of, 207

vultus trifrons, 127–28

Waleys, Thomas, commentary on *City of God* (Augustine), 11

warriors: as citizens, *254–55;* depicted, 263; role in ideal state, 261

Wechel, Christien, 281

Wiesbaden: Landesbibliothek, Cod. 1, 355n.15

Willard, Charity Cannon, quoted, 15

William of Moerbeke: Latin translation of *Economics* (pseudo-Aristotle), 280; Latin translation of *Politics* (Aristotle), 25, 373n.8

William of Ockham, 281

Winter, Patrick de, 32

Wisdom. *See* Philosophical Wisdom; Prudence; Science

wisdom, Aristotelian concept of, 122

women, as patrons, 334n.45

wool trade, 265, 267

working class, 126

Works and Days (Hesiod), 280

workshops, artists', xxii–xxiii. *See also names of workshops*

worship of God, as goal of contemplative life, 386n.32

Xenophon, *Oeconomicus,* 280

Yates, Frances, 32, 103; quoted, 67

Yconomique (pseudo-Aristotle), translation by Oresme, 8, 25, 151, 177, 281–82; as conduct book, 301; gloss, quoted, 286–87, 290, 297–98; glosses and commentaries in, 29–30, 281, 301; illustrations in, *284–85, 292, 294–95;* manuscripts of, 39; quoted, 282–83, 286–88, 297, 391n.8

zodiacal man, iconography of, 216

Zoubov, V., 279

Designer:	Steve Renick
Compositor:	Graphic Composition, Inc.
Text:	11/13 Bembo
Display:	Bembo
Printer:	Malloy Lithographing, Inc.
Binder:	John H. Dekker & Sons

DATE DUE